SHIVERS

DOWN

YOUR

SPINE

FILM AND CULTURE SERIES John Belton, General Editor

FILM AND CULTURE A series of Columbia University Press Edited by John Belton

SHIVERS

DOWN

YOUR

SPINE

ALISON GRIFFITHS

Cinema, Museums, and the Immersive View

COLUMBIA UNIVERSITY PRESS NEW YORK

Columbia University Press
Publishers Since 1893
New York Chichester, West Sussex
Copyright © 2008 Columbia University Press
All rights reserved

Columbia University Press wishes to express its appreciation
for assistance given by Baruch College toward the cost of
publishing this book.

Library of Congress Cataloging-in-Publication Data
Griffiths, Alison, 1963–
 Shivers down your spine : cinema, museums, and the
immersive view / Alison Griffiths.
 p. cm. — (Film and culture)
 Includes bibliographical references and index.
 ISBN 978-0-231-12988-6 (cloth : alk. paper) —
ISBN 978-0-231-12989-3 (pbk. : alk. paper) —
ISBN 978-0-231-50346-4 (ebook)
 1. Museums and motion pictures. 2. Museums—Social
aspects. 3. Museum exhibits. 4. Shared virtual environ-
ments. 5. Interactive multimedia. 6. Visual communica-
tion—Case studies. 7. Audiences—Case studies. 8. Public
spaces—Social aspects—Case studies. I. Title. II. Series.

 AM7.G59 2008
 069—dc22 2008018701
∞

For William

CONTENTS

I HAVE A HARD TIME staying away from museums, so my first round of thanks goes to Barbara Mathé in the Special Collections department at the American Museum of Natural History, whose knowledge of the museum's archive and support of the project contributed significantly to its eventual completion. Tom Baione in the department of library services could not have been more helpful, and I am deeply appreciative of his help with the figures. Many of these chapters evolved from conference papers and invited talks, so gratitude is due the organizers, respondents, and participants who created invaluable opportunities for feedback and intellectual dialogue: the early work on panoramas and IMAX is indebted to John Fullerton, who brought scholars in the fields of early cinema and new media to Stockholm University in June 2000. John Plunkett of Exeter University provided an opportunity to showcase the early medieval material in an exciting conference entitled "Multimedia Histories" in July 2003, while the intellectually rigorous "Science on Screen" Summer Academy at the Max Planck Institute in Berlin in August 2004 brought new perspectives from the field of history of science to bear on my work.

The following archives and archivists were vital in helping me amass primary materials gathered over ten years of research: Eveleyn Onnes-Fruitema and Marijnke de Jong at the Mesdag Panorama in The Hague; Vanessa Toulmin at the National Fairground Archive at Sheffield University; Hester Higton at the Bill Douglas Centre for the History of Cinema and Popular Culture at Exeter University; Amelia Adams at the Yorkminster Archive in York; Lynne MacNab at the Corporation of London, Guildhall Library; Julie Anne Lambert at the Jack Johnson Collection at the Bodleian Library, Oxford University; staff at the Science Museum Library in London; the British Film Institute library; and the British Library. In the United States, I am grateful to staff at the New York Public Library (including the Science, Industry, and Business Library); Thomas P. Campbell and Sarah Thein at the Metropolitan Museum of Art; the New York Historical Society; the Minnesota Historical Society; and the interlibrary loan staff at Baruch College's Newman Library. In Washington, D.C., thanks are owed to William Cox at the Smithsonian Institution Archives, Mary Jo Arnoldi at the National Museum of Natural History, and Paula Rich-

ardson Fleming at the National Anthropological Archive. Generous support for this book came from two Eugene M. Lang Junior Faculty Research Fellowships at Baruch College, the first funding travel to archives in 1999, and the second, in 2003, offsetting production aspects of the book. My thanks to Alyce Mayo, Administrative Director of Entrepreneurship Programs, for wisely guiding me through the Lang award process.

Funding for the book also came from half a dozen research and travel grants from the PSC-CUNY Program of the City University of New York, an NEH Summer Stipend in 2003, and a number of skilled research assistants; to see one's scholarship consistently supported in this way is deeply appreciated. Dean Myrna Chase of the Weissman School of Arts and Science at Baruch College shares my passion for history and has been a tireless supporter of my work throughout her tenure as dean. Associate Provost Dennis Slavin also deserves thanks for standing behind the project as it evolved into a book in his role as former dean of the Weissman School. I warmly thank my former department chair, Robert Myers, for unwavering support over the years and all my colleagues in the Department of Communication Studies, especially Jana O'Keefe-Bazzoni, whose interdisciplinary breadth I share and value. I owe a huge debt to Tom Gunning, who once again stepped in at a critical moment to offer precise suggestions for improving the manuscript; it is an honor to have my work read and commented on by him. I would also like to thank the anonymous reviewer for Columbia University Press whose suggestions for structural changes boosted my belief in the book at a critical time.

Colleagues and friends to whom I am indebted include Richard Abel, Charles Acland, David Birdsell, Jonathan Buchsbaum, Andy Coon, Scott Curtis, Elizabeth Edwards, Anne Friedberg, Nick Friendly, Sara Friendly, Jean Gallagher, David Gerstner, Heather Kelly, Antonia Lant, Lee Grieveson, Anna Grimshaw, Jim Latham, Jan Holmberg, Ivone Margulies, Chris Morton, Paula Massood, Charles Musser, Mark Otnes, Ford Oxaal, Dana Polan, and Haidee Wasson. Special thanks are owed to my untiring mentor Faye Ginsburg and to Jeffrey Ruoff, who in March 2003 organized a symposium on cinema and travel that served as a virtual laboratory for ideas in several chapters; thanks also to co-attendees Paula Amad, Peter J. Bloom, and Lauren Rabinowitz. William Uricchio, who read the proposal for Columbia University Press, offered incisive suggestions at a very early stage and could visualize the book with remarkable acuity. Thanks also to Pamela Sheingorn, who kindly let me audit her class on medieval performance and whetted my appetite further for medieval studies, and her former student Jill Stevenson, who shared vital resources and insight on directions to pursue in medieval visuality. Graduate students in my "Spectacular Realities" course at the CUNY Graduate Center in fall 2005 honed my thinking on several of the "big ideas" in this book, especially Diane Treon, whose experience working at the American Museum of Natural History proved enormously beneficial. The following research assistants at Baruch nudged this project closer to completion over the years, starting with Kyusok Cho, John Y. Zhang, Simone Senhouse-Gorham, Nurgul Erbil, Maria Goldman, John Wagner, Beena Asarpota, Ali-

cia Torello, and most recently, Gennady Rudkevich. Steve Luber and Kevin Byrne, CUNY Graduate Center research assistants, were helpful in several respects, but especially with image rights clearances.

Jennifer Crewe, Editorial Director at Columbia University Press, steered this project to completion with her usual professionalism and attention to detail (it was she who suggested a consideration of planetariums), and it was a pleasure to work with Juree Sondker and Afua Adusei, who guided the book through its final stages. John Belton also provided first-rate initial feedback and guidance along the way, and Roy Thomas, my copyeditor, was once again exemplary. My family in Wales, my phenomenal mother Val Griffiths and two brothers, Jim and Nigel Griffiths, assisted with countless intangibles and lent their ear when ideas and arguments needed to fall upon sympathetic listeners rather than the more intense conference arena. Other UK family, friends, and colleagues who offered assistance in ways large and small include Ruth Baumgarten, Tom Cheeseman, Philip Drummond, Susan Evans, Marie Gillespie, Beth Griffiths, Lowri Griffiths, Mick Harris, Paul Kerr, Karen Line, Fiona Rees, Leigh Taylor, and Victoria Trevor. My family in the United States has grown exponentially since this was project was initiated, and I owe a huge debt of gratitude to Evan, Tess, and Soren Boddy for their willingness to traipse with me to cities all over the world and indulge my enthusiasm for panoramas and cathedrals. Important figures in their lives, especially Terry Butler, Hannah Walker, Nirupa Jewat, and Marcia Alexander, were vital to the lifeblood of this book, insomuch as their tender care of my children gave me the freedom and peace of mind to conduct research and write. William Boddy gave selflessly to this book, supporting me on international travel to archives and diligently reading multiple drafts. His wisdom, sharpness of mind, and intellectual integrity has doubtless infused this book, as he has my life for close to two decades.

CREDITS: Portions of this book have appeared in different form in the following publications (cited chronologically):

"'Shivers Down Your Spine': Panoramas, Illusionism, and the Origins of the Cinematic Reenactment," *Screen* 44.1 (Spring 2003): 1–37;

"Media Technology and Museum Display: A Century of Accommodation and Conflict," in David Thorburn and Henry Jenkins, eds., *Rethinking Media Change: The Aesthetics of Transition* (Cambridge: MIT Press, 2003), 375–89; reprinted in *Informal Learning* 66 (May-June 2004), 1, 4–9;

"'The Largest Picture Ever Executed by Man': Panoramas and the Emergence of Large-Screen and 360-Degree Internet Technologies," in John Fullerton, ed., *Screen Culture: History and Textuality* (London: John Libbey Press, 2004), 199–220;

"Time Traveling IMAX Style: Tales from the Giant Screen," in Jeffrey Ruoff, ed., *Virtual Voyages: Cinema and Travel* (Durham: Duke University Press, 2006), 238–58;

"'They Go to See a Show': Vicissitudes of Spectating and the Anxiety Over the Machine in the Nineteenth-Century Science Museum." *Early Popular Visual Culture* 6.3 (Fall 2006): 245–71;

"The Revered Gaze: The Medieval Imaginary of Mel Gibson's *The Passion of the Christ*," *Cinema Journal* 47.4 (Winter 2006–2007): 3–39;

"'Automatic Cinema' and Illustrated Radio: Multimedia in the Museum," in Charles R. Acland, ed., *Residual Media* (Minneapolis: University of Minnesota Press, 2007), 69–96.

SHIVERS

DOWN

YOUR

SPINE

S HIVERS DOWN YOUR SPINE is a book about alternative modes of spectatorship, in particular immersive and interactive ways of experiencing visual spectacle that are not usually considered part of the canon of film spectatorship. The terms interactive, immersive, and spectatorship all come prepackaged in the discursive wrappings of academic tropes and biases, 1990s promotional culture, and aesthetic experimentation that traverse commercial and intellectual fields of inquiry, as well as historical and cultural contexts. My aim in this book is to explore an expanded paradigm of spectatorship, beyond the seated spectator in the darkened auditorium. My goal is to examine the complex spatial relations and embodied modes of encountering visual spectacle that accompany immersive and interactive spectating, moving way from traditional approaches to film spectatorship (including cognitive, psychoanalytic, historical, and ideological methodologies) in the pursuit of a more nuanced and flexible model that can take into account one of the most striking features of the case studies examined in this book: audience mobility around the viewing space. While not all of the examples discussed here conform to this model (certainly planetariums and IMAX involve immobile seated spectators), it is surprising that so little work has been done on these alternative forms of spectating, especially when what audiences are often looking at is in fact a filmic or electronic image.

One obvious way to expand the concept of spectatorship presented in this book is to consider less obvious exhibition sites such as the cathedral, planetarium, and

museum, for it is here, I argue, that spectators first encountered immersive and (possibly) interactive ways of experiencing the world. The museum, the focus of the entire second part of the book, works as a multisite case study for grasping the implications of a more fluid model of spectatorship. As a space that resonates in so many ways with the examples explored in part I, the museum becomes the perfect institutional venue for drawing these ideas into sharp relief. This expanded notion of film spectatorship perfectly befits the expanded frame, screen, and space greeting spectators in the museum; while there is something familiar about these alternative spectatorial sites—a museum often feels like a cathedral in terms of the degree of reverence it elicits from spectators, and the planetarium seems like a hybrid of the motion picture theater and panorama—we are also struck by how *dissimilar* they are to conventional viewing settings such as the film auditorium, television living room, or computer screen.

When we think about spectatorship within film and media studies, we are still beholden to models that, while discursively specific (few would confuse Bordwell with Lacan), are nevertheless generally premised upon the idea of an individual seated in a darkened auditorium or, in new media studies, viewing electronic moving images either on mobile platforms such as cell phones, or portable DVD players, or on television screens (home theater systems and flat screens notwithstanding, it's still a space that invites you to sit down). While film and television are capable of immersing viewers in the experience, they do not send shivers down the spine unless one is watching a horror film. What this book hopes to do, then, is formulate new ways of thinking about immersive and interactive viewing spaces that cannot be explained within existing theories of film spectatorship and that might be applied to areas not addressed in this book, such as theme parks, video games, and video installations.

Shivers Down Your Spine is not an exhaustive history of ideas of immersion and interactivity in film and the related arts (world's fairs would need to be covered in far greater detail, along with theme park rides, the waxwork, ghost trains, video art . . . and the list goes on). Even though the case studies examined in part I are eclectic, they are informing contexts that must be fully grasped *before* we can begin to appreciate twentieth-century examples of immersion and interactivity. In other words, rather than limit consideration to the obvious contemporary examples of immersive and interactive spectating, it's more important I believe to search for historical precursors and architectural spaces that have informed current screen practices and technological attractions. But what exactly do I mean by the terms *immersive* and *interactive*?

I use the term *immersion* in this book to explain the sensation of entering a space that immediately identifies itself as somehow separate from the world and that eschews conventional modes of spectatorship in favor of a more bodily participation in the experience, including allowing the spectator to move freely around the viewing space (although this is not a requirement). In this regard, the planetarium and IMAX film most closely resemble traditional practices of spectating, although the planetarium, while sharing features with the cinema, is also quite distinct from film. The spatial relations in immersive viewing practices are often more complex, chaotic, and improvised (with spectators being afforded a level of

freedom to move and, in the case of the panorama, look where they want, for however long they want). One feels enveloped in immersive spaces and strangely affected by a strong sense of the otherness of the virtual world one has entered, neither fully lost in the experience nor completely in the here and now. The term *interactive* is harder to define, since it is encrusted in so much hype (think "interactive features") along with utopian and dystopian scenarios, that it's hard to cut through the clutter and be precise. It is perhaps easiest to explain within the context of the museum where "interactive push-button" devices seem to aptly encapsulate the concept. And yet, one might argue that the liturgy is an interactive experience for spectators receiving communion, as is the panorama that offers spectators pullout orientation guides to consult while moving about the painting. Few would dispute that interactivity is an unwieldy, nonspecific concept, so the closest thing to a definition is the idea of it as an activity that extends an invitation to the spectator to insert their bodies or minds into the activity and affect an outcome via the interactive experience.

The "shivers down your spine" in the title refers not to the venerable genre of the horror film but to the report of a panorama spectator in 1799 describing his response to the giant circular painting, and more broadly to the visceral reactions and embodied modes of spectating invited by the historically sprawling case studies explored in this book. For example, when I walked into York cathedral for the first time and gazed up at the roof of the structure, the sense of the infinite, of the sheer overwhelming visual and somatic thrill of craning one's neck and gazing upwards, gave me shivers, the same shivers that I expe-

rienced when I walked into the Mesdag Panorama in The Hague, when I saw my first planetarium show at the London Planetarium, and when I initially viewed IMAX cinema in the form of *To Fly!* (1976) at the National Air and Space Museum (NASM) in Washington, D.C. All of these visual experiences demanded more of me—or at least promised to offer something more—than other 2-D representational media; their spectacular forms not only hailed me in the Althusserian sense but captured my attention through a visual excess and heightened sense of immersive engagement that was uncanny and unforgettable. Whether in a cathedral, museum, or planetarium, all of these spaces offer us visual spectacle that fills our field of vision especially our peripheral vision—drawing us deeper into the view than traditional forms of exhibition such as 2-D movies or panel painting.

This book is concerned with examining the distinct cognitive and visceral mapping skills we bring to bear on spectacular and immersive architectural structures, large-scale illusionistic media, and interactive modes of exhibition all designed to deeply affect us as spectators. Oliver Grau provides a useful definition for immersion in his book *Virtual Art: From Illusion to Immersion*, arguing that "in most cases immersion is mentally absorbing and a process, a change, a passage from one mental state to another . . . characterized by diminishing critical distance to what is shown and increasing emotional involvement."[1] Each of the case studies examined in *Shivers Down Your Spine* forces us to revise our existing visual competencies and perform a sort of cognitive remapping, in order to make sense of the experience and its impact on theories of spectatorship. Closely tied to the idea of immersion are

presence and aura, the sensation of being drawn into the mise-en-scène or being co-present with the artist/director as a result of the hyper-illusionism, a specific mode of address, a matrix of special effects, the unique properties of the object or space, or various forms of interactivity. A defining characteristic of a large number of the examples examined in this book is the sense of being present in a scene, the cognitive dissonance that comes from feeling like you're elsewhere while knowing that you haven't moved and forgetting for a moment about the mediating effects of the technology

One of the arguments running through *Shivers* is that there are so many antecedents for today's so-called "immersive and interactive new media" that a moratorium might be warranted on the use of the phrase; its ubiquity and semantic incoherence render it virtually meaningless, so much so that a new set of more precise terms is needed in order to explain the practices united under its banner.[2] Even the Internet, the trump card in the hand of new media theorists, has countless phenomenological correspondences in such earlier technologies as illustrated medieval manuscripts (hypertextual links), the telegraph (email, chat rooms, and IM [instant messaging]), the panorama (360-degree visualizing technologies and virtual reality), and nineteenth-century science museums (interactivity).[3] There is an unavoidable sense of déjà vu in much of the discourse surrounding new media; what is lacking, however, is evidence of how these correspondences might be traced with more precision and how these earlier practices created immersive and interactive experiences for spectators in the absence of a coherent epistemological framework for what the terms might mean. This book is therefore a response to the ahistoricism marking much new media theory and scholarship.

The aftershocks of earlier modes of spectacular image-making still felt in contemporary media forms and technologies testify to the persistent human desire to create highly illusionistic representational experiences. The architects, clerics, and laborers responsible for the Gothic cathedral were fully cognizant of the power of these structures as theological allegory; similarly, museum directors signing exhibition agreements with IMAX know only too well that large-format film exhibition can kill several birds with one stone, including providing an additional stream of funding revenue and luring new visitors through its doors. The hyper-real, a figure of late-twentieth-century postmodernist discourse, has countless visual antecedents that are too often overlooked in the hyperbole surrounding HDTV, VR (virtual reality), VE (virtual environments), and other contemporary digital technologies. It is to these moments of awe-inspiring, jaw-dropping spectacle that I turn to repeatedly in *Shivers Down Your Spine*. Whether considering the romantic sublime of the panorama or the techno-fetishism of a London Science Museum high-tech interactive gallery, my goal is to consider the highly variegated ways in which our minds and bodies assume an immersive relationship to the sight or object we behold.

TECHNOLOGIES OF VISUAL SPLENDOR

Part I of *Shivers Down Your Spine* expands our understanding of immersive or interactive spectatorship in four case

studies: the medieval cathedral, panorama, planetarium, and IMAX theater. I am interested here in how space, illusion, and presence privilege a mode of spectatorship that is remarkably similar in all of these sites. The pantheonistic dome, the iconic shape of the panorama rotunda that was resurrected in the planetarium, and even in IMAX screens featuring the 360-degree Dome (formerly OMNI-MAX) format (London's IMAX screen is in the shape of a glass dome), is an obvious shared feature of all these spaces bar the cathedral, although one could argue that the monumentality of cathedral architecture is even inscribed in the pantheon. *Shivers Down Your Spine* begins with an examination of how the medieval cathedral established specific protocols for viewing immersive spectacle. The first half of the book operates by accretion in terms of its ideas, arguments, and examples. Thus, panoramas are not dealt with and abandoned at the end of chapter 1, but serve as an epistemological frame for understanding the cinematic reenactment in chapter 2, and a formal antecedent to IMAX in chapter 3. Themes of travel, vision, spectacle, science, religious uplift, wonder, sobriety, and the evocation of death recur across the chapters, linking the diverse epochs and institutional contexts. I am especially interested in the geographies of the specific exhibition sites explored here and the ways of seeing they privilege and suppress. In his essay on the flaneur, Chris Jenks describes what he calls the "seen" or "witnessed" character of urban space—how people make sense of what it is they see (an idea I extend to the spaces traveled in this book),[4] how our experiences of cathedrals, panoramas, planetariums, and museums are informed by what Jenks calls the predisposed character of our "sight" and how we

come to view these spaces with certain expectations about the kind of visual spectacle that lies within.

Part 2 of *Shivers Down Your Spine* turns to the museum as a way of crystallizing ideas about expanded spectatorship, starting with a case study on the Science Museum in London. One of the main arguments shaping this section of the book is that since their emergence in the second half of the nineteenth century, museums of science and natural history have been preoccupied with the problem of striking an uneasy balance between popular appeal and educational rigor. Responding to what they saw as the fleeting attention span of the urban museumgoer, late-nineteenth-century curators charged with the task of making exhibits more accessible turned to immersive popular entertainments and interactive technologies as ways of continually attracting visitors and competing with for-profit entertainment centers. Three recurring issues have dominated these discussions and will be considered in detail in part 2: the role of electronic and digital media in what is seen as a "third evolution" in methods of museum exhibition (following earlier shifts at the turn of the last century and in the 1950s and 1960s); the nature of immersion and interactivity in contemporary museum exhibit design and their impact upon spectatorship; and the tension between the museum as a site of civic uplift and rational learning versus one of popular amusement and spectacle. If research on the implications of interactive media and IMAX screens on museums is still underdeveloped within museum studies, a striking feature of contemporary debates is the sense of déjà vu across the historically separated reactions to issues of modernization, interactivity and immersion, and the tension be-

tween education and entertainment. As I have shown elsewhere, current cautions about the "Disneyfication" of natural history museums echo concerns voiced by turn-of-the-century critics who argued that the use of popular display methods such as life groups (mannequins positioned in front of illusionistic backdrops), lantern slides, and motion pictures required careful supervision, lest their associations with popular culture contaminate the scientific seriousness of the exhibit and institution.[5] Discursive oppositions between science and spectacle, information and entertainment, immersion and distance, and passive and interactive spectators first articulated in relation to these visual technologies one hundred years ago have repeatedly resurfaced in contemporary debates over multimedia exhibits in public museums. And more to the point, it is in the increasing appropriation of immersive museum environments found in such exhibits as the Hall of Biodiversity at the American Museum of Natural History that some of these tensions play out.

While a new set of advanced display technologies such as IMAX, 360-degree Internet technologies, and interactive multimedia museum installations have engendered anxieties similar in some respects to those of their technological predecessors over a century earlier, what is even more striking is the way in which they look to visual spectacles that long predate them as a way of re-creating the sensation of wonder and being immersed in the experience. It's not without irony, then, that one hundred and sixty years after the heyday of panoramas, IMAX screens and electronic media have assumed an ever-greater presence in museums of science, technology, natural history, and fine arts and are trying to accomplish what the

panorama did with extraordinary success: namely, immerse spectators in the represented space and give them a heightened sensation of moving out of the immediate and into the hyper-real. If we consider the range of augmented-reality technologies in the modern museum—including interactive touch-screen kiosks, CD-ROMs, computer games, large-screen installations and videowalls, digital orientation centers, "smart badge" information systems, 3-D animation, virtual reality, downloadable podcasts, and increasingly sophisticated museum Web sites—what unites them all is their ability to take visitors beyond the "here and now" of the exhibit and into paratextual spaces and experiential modes.

Despite the fact that museums have been immersing their visitors in scenes since they came of age in the nineteenth century (dioramas and life groups containing human mannequins were stellar in this respect), we nevertheless find ourselves in the midst of new controversies over the way museums disseminate knowledge while entertaining their publics. These contemporary technologies have also altered the physical character of the museum, frequently creating striking juxtapositions between nineteenth-century monumental architecture and the electronic glow of the twenty-first-century computer screen, videowall, or handheld device. Via the Internet, the museum can transcend the fixities of time and place, allowing virtual visitors to wander through its perpetually deserted galleries and interact with objects in ways previously unimagined.

The museum thus serves as a centrifugal force in the book, a nexus of ideas about spectacle and immersion. It is a recurring figure in both parts 1 and 2, evoked in

controversies around IMAX as well as multimedia and interactive technologies. But what exactly is the nature of museum space? What modes of spectating, moving, seeing, listening, thinking, and feeling do, and should, museums engender? How do museum professionals mediate the persistent oppositions between public versus private space, science versus spectacle, civic versus corporate interest, hands-on versus hands-off, screen versus glass, and voice versus text? How do visitors make sense of screen culture in museums? What is the nature of film spectatorship in this institutional space, and what is the relationship between the objects on display and the moving images frequently surrounding them?[6] The differences between real and virtual mobility complicate theoretical assumptions about spectatorship; a lingering gaze is not the same as a snatched glance, just as entering a cathedral after a 300-mile pilgrimage is not the same as visiting a panorama in the 1840s or watching an IMAX show at a science museum. And yet these experiences, I argue, do share something in common.

This book is also concerned with the tensions and transgressions at play in public spaces that confound conventional distinctions between, for example, museum and home, museum and church, and museum and morgue, including the current international exhibits of human cadavers in *Bodies* and *Body Worlds*. Erwin Panofsky's 1934 discussion of the analogy between film production and the medieval cathedral (he called film the "nearest modern equivalent of a medieval cathedral") is testimony to the richness and ambiguity of the cathedral as a cultural sign, and even though Panofsky is referring to a mode of production rather than phenomenology, the metaphor is evocative.[7] A fundamental question pursued in this book is how ways of seeing and significatory practices associated with one space become frames of reference for understanding subsequent architectural spaces and visual technologies (the relationship between parts 1 and 2 of this book in a nutshell). What happens when, as in Laurent Mannoni's example of the 1793 Zograscope (designed in the shape of a cathedral and decorated with religious statuettes), devotional viewing, religious iconography, and the viewing apparatus collapse conventional boundaries between sacred and profane?[8]

From the crowds of nineteenth-century visitors to the Paris morgue to the sellout tuberculosis show at the AMNH in 1908 to contemporary audiences paying $26.50 to see the plastinated specimens in the New York *Bodies* show (cadavers that have been preserved and stripped of skin to display their inner workings), death on display has always posed a special challenge to ideas of immersion and interactivity.[9] Death is among the most privileged and highly charged significatory icons, speaking to our deepest desires to keep it at bay while animating the continual development of hyper-real immersive experiences aimed at bringing us ever closer to crossing over into the other world without actually making that journey. Visitors to the panorama spoke of its deathly aura; death and TB were indisputable bedfellows, and even the planetarium was a poignant reminder of our mortality and relative insignificance when compared to the cosmos.

Ideas of simulation and transportation underpin many of the technologies explored in *Shivers*, since by *being* and *going* we strive toward a deeper experience or understanding of some distant elsewhere. Whether produced by the

panorama, planetarium, museum period room, or IMAX travelogue, hyperrealism is seldom about conjuring up the prosaic and the here and now, but typically constructs a distant space of heightened geographical or cultural interest. And yet, as this book reveals, there are always anomalies and contradictions; why, for example, would early-eighteenth-century Londoners choose to visit Robert Burford's *Panorama of London* when they could climb to the top of St. Paul's cathedral and enjoy the view themselves? Was it the convenience of acquiring the visual experience without having to climb the stairs? Or was it the pleasure of mediation, of seeing someone else's rendition of what the London skyline looked like? Or possibly the idea of the panorama "experience" as a social event, a destination, where being seen and being able to say one has visited the latest painterly "rage" was as important or worth even more than the sight itself? Or, more pragmatically, was it because access to the cathedral roof was restricted at the time as a result of renovations? The desire to see Burford's panorama was probably motivated by some of the very same reasons today's tourists to London flock to the South Bank to ride the "London Eye," the "world's tallest observation wheel which offers unrivalled, panoramic views of up to 25 miles across London and the south east." Taking thirty minutes to revolve, the wheel stands 450 feet above the ground and was conceived and designed by Marks Barfield Architects (it is sponsored by British Airways). One hundred and thirty years on from the opening of the *Panorama of London* in 1829, spectators still gasp at the sight of their city from the privileged vantage point of the panoramic perspective.[10]

Strikingly absent in this book is extended discussion of virtual reality (VR), since what differentiates VR from the kinds of immersive spaces I write about in *Shivers* is the intrinsically asocial nature of the VR experience. While a trip to a science museum which hosts a VR simulator is social, the actual moment of donning the headgear and gloves separates participant from spectator in ways not routinely found in cathedrals, panoramas, planetariums, and museums. Despite the fact that every member of a group visiting a museum can theoretically have a turn in the VR simulator (as long as they can afford the additional fee), there is still something uniquely isolating about the experience that marks it as different, I believe, from the bulk of the examples discussed in this book. Sociality is a vital component of visiting the museum, planetarium, panorama, and motion picture; while we may drift into our own world while gazing at a stained glass window in a cathedral or fantasize about the universe while stargazing in the planetarium, we are never *unaware* of other bodies walking past or sitting next to us. Even when engaged in an interactive museum exhibit, people stand over our shoulders, either waiting their turn or wanting to share in our experience. To be sure, there are parallels between VR and the panorama, just not the kinds of parallels I find the most interesting or the most productive to examine given my interest in opening up spectatorship to new paradigms.

A dominant motif in the visual grammar of many of the immersive technologies explored here is gigantism, signified by such emblems of immersive popular culture as Disneyland and Disney World (Scott Bukatman points

out that Disney World is three times the size of Manhattan).[11] Even the Disney characters, which occupy no more than 8–10 inches on a regular TV screen, are huge in their physical incarnations, as my son discovered to his horror when he was traumatized at age three by a 7-foot Cookie Monster at the Manhattan Children's Museum. This is reality delivered in literally "larger than life" bites and yet, as I suggest in chapter 3, gigantism (IMAX's calling card) is attended by complex human emotions—of fascination, repulsion, ideas of gender and the nation—and becomes a rich metaphorical canvas upon which artists and literary scholars have projected immersive fantasies throughout the ages. While not strictly isomorphic with immersion, "bigness" conjures up metaphysical constructs such as the sublime and is frequently seized upon in the promotional marketing of many of the experiences explored in this book. The cathedral, panorama, planetarium, IMAX, and even museum (think of the giant whale in the Milstein Hall of Ocean Life at the American Museum of Natural History) all exploit the gigantic to create their desired effects, drawing us in, generating awe, and possibly leaving us with sensory overload.

We begin, therefore, with the oldest, certainly the largest, and perhaps the most phantasmagorical space of all, the medieval cathedral. Chapter 1, "Immersive Viewing and the 'Revered Gaze,'" examines medieval cathedrals as vital informing contexts for the prehistory of immersive spectatorship. This chapter introduces us to the concept of the "revered gaze," a way of encountering and making sense of images—especially of Christ's Passion—that are intended to be spectacular in form and content.

While distinct media clearly present unique possibilities for altering the nature of the Passion experience, I argue that there are remarkable consistencies in the aesthetics and practices of the crucifixion as a transhistorical story. As a way of understanding the complex genealogy of immersive modes of spectatorship, few spaces can match the subliminal excess of the cathedral, which engulfs the spectator from the very moment she or he enters.

Chapter 2 examines the panorama as a fascinating exemplar of nineteenth-century visual culture, moving beyond obvious comparisons between cinema and the panorama to consider *how* panoramas evoked the idea of cinematic spectatorship in a host of different ways, through content, organization of vision, especially as the form evolved throughout the nineteenth century, exhibition setting, and critical (and popular) reception. As a perceptual apparatus for framing human vision, promoters of the 360-degree and moving panorama frequently appealed to the notion of the reenactment as a way of foregrounding the reality effect of the technology and its mimetic prowess, a feature that creates a strong affinity with early actualities. In addition, audiences, it was felt, would fully appreciate the illusionistic effect of the panorama only if its subject matter were ontologically linked to ideas of grandness and monumentality; in other words, the locations and events painted by panoramists had to resonate as suitable subjects for this epic mode of representation.

Chapter 3, "Expanded Vision IMAX Style: Traveling as Far as the Eye Can See," examines the shared phenomenological and discursive features of panoramas, IMAX,

and 360-degree Internet technologies such as IPIX, to consider how a fascination with immersive, expanded vision has persisted over time. The chapter also considers how each of these technologies has been adapted to meet the needs of popular culture, moving out of their original venues to find new homes and uses in the realm of mainstream media. Since virtual travel and an Emersonian sublime operate as framing devices in each of these representational forms, this chapter also examines IMAX's reliance on the travelogue as its key structuring principle, combining theoretical material related to IMAX, travel, and human perception with more historically grounded trade and popular press discourses concerning the large-screen cinematic format. Through an analysis of the visual grammar of *Across the Sea of Time* (Stephen Low, 1995) and *Everest* (David Breashears and Stephen Judson, 1998), I argue that the formal proclivities and immersive effects of IMAX uniquely shape our attention as spectators. The use of turn-of-the-century stereoscope slides to showcase the late-twentieth-century technology of 3-D IMAX also raises questions about what happens to archival materials when they are subjected to IMAX's gargantuan scale and how IMAX films might function as cultural memory in distinction to the domestic uses of photography, home movies, and popular film.

Chapter 4, "'A Moving Picture of the Heavens': Immersion in the Planetarium Space Show," has several goals: first, to provide an overview of the emergence of the planetarium by considering its scientific progenitors and the manner in which it found an institutional home in museums of science and natural history in the 1920s and 1930s; second, to consider how its structuring principles, in particular its exploitation of a discourse of "armchair travel," is constructed in descriptions of the "planetarium experience," in promotional materials, popular and scientific press accounts, planetarium conferences, and guidebooks; and finally, to examine more closely planetarium spectatorship as an expression of a religious experience, as if looking to the sky de facto brings one closer to a better understanding of God and the universe.

As a bridge to the next section of the book, chapter 5 takes us back to mid-nineteenth-century London, the heyday of the panoramas examined in chapter 2, but here to a single institution, the Science Museum (London). Few contemporary commentators realize that many of the anxieties plaguing contemporary curators, such as the incursions of popular culture into the museum and the balance between science and spectacle, were rehearsed a very long time ago and that museums have always struggled with how to respond to new display techniques and more popularized modes of exhibiting. Thus, as the first generation of professional curators began dismantling (both literally and figuratively) the "storehouse of curiosities" model of traditional nineteenth-century museums, many of them worried that the shift toward more popular exhibit techniques would blur the boundaries between the museum as an institution of moral and social uplift and other less reputable cultural sites, including the nickelodeon and the sensationalist dime museum. The emergence of the London Science Museum in the nineteenth century thus serves as a fascinating window onto these debates, since not only was it an early advocate of inter-

active exhibits, but, along with its sister institution the Patent Museum, the subject of parliamentary debates in the UK regarding the impact of machines in motion and other popular exhibits strategies upon the overall mission of the institution.

Chapter 6 focuses exclusively on the emergence of film and related media at the Smithsonian Institution in Washington, D.C., examining four historical moments in its history (late nineteenth century, mid-1950s, late 1970s, and late 1990s). With an overarching goal of tracing the early conditions of possibility for screen culture in the museum, this chapter examines how a rationale was constructed for IMAX in both the National Air and Space Museum (NASM) where *To Fly!* premiered in 1976, and in debates around the idea of including IMAX in an orientation center at the National Museum of Natural History (NMNH). The chapter also provides a historical overview of how moving-image technologies were first integrated into exhibits at the Smithsonian as well as a case study analysis of the innovative, media-rich "African Voices" exhibit, which opened at the NMNH in 1999. This chapter vividly demonstrates how anxieties about public image and commercialization have stubbornly persisted in the museum world and the stakes involved for heritage institutions such as the Smithsonian.

"Film and Interactive Media in the Museum Gallery: From 'Roto-Radio' to Immersive Video," the final leg in our journey, builds upon the previous chapter by constructing a genealogy of audiovisual techniques in museums tracing contemporary uses of video screens and computer interactives to their mechanical predecessors.

The AMNH in New York City is singled out here, as we consider the sense of déjà vu pervading contemporary debates about digital technologies and so-called "augmented reality experiences" in museums via an examination of the ways in which contemporary curators at the AMNH (and elsewhere) confront perennial tensions between entertainment and enlightenment. With revenue-generating attractions such as IMAX screens a staple of many large natural history and science museums, curators may feel they have little alternative than to look to the spectacular, the popular, and the profitable as a three-pronged approach to fiscal health and client satisfaction. The chapter begins by examining some of the earliest examples of media use in museums of science and natural history, considering how the gramophone (used in a phenomenally successful TB show at the AMNH in 1908), radio, and 16mm film were enlisted in a multitude of ways, such as furthering an interactive model of learning or serving as "crowd movers," herding large numbers of visitors through gallery spaces. Rather than focus on how discrete film programs gradually became the norm in museum auditoriums, the goal in this chapter is to understand how the protocols of film spectatorship were adapted to meet the needs of the physical and social contexts of museum-going. For example, in preparing to include film exhibition in the gallery, how did curators anticipate and respond to the ambulatory modes of film spectatorship in museums and what strategies were used to mitigate (or accommodate) the distracted gaze of the visitor? The second half of the chapter examines the uses of film and audio technology in the AMNH from the 1960s through the

1980s, considering how audiovisual media were enlisted as part of a larger modernization effort in museum exhibition style, focusing specifically on the 1969 hit show "Can Man Survive?" The chapter concludes with a brief analysis of the National Waterfront Museum (NWM) in Swansea, UK, the youngest institution of all those examined in the book, since it only reopened (completely refurbished) in 2005. One could scarcely wish for a more fitting stopping point, since the NWM is one of the most compelling examples of the kinds of experiences curators expect museum spectators to take away with them when they visit museums today. The NWM could serve as a poster child of sorts for where museum-going is headed, but remains enmeshed in controversy over whether immersion and interactivity are really what people need or want. Despite their embrace by contemporary museum professionals and visitors alike, the growing prominence of digital media and IMAX screens in contemporary museums (modes of addressing visitors that rely upon immersion and interactivity as key features of the experience) has provoked a sharp and sustained debate within museum circles. At the heart of the matter are the perceived deleterious effect of electronic media upon the "aura" and privileged status of the museum artifact and the effect of digital technologies on the surrounding museum environment.

The conclusion invites us to reflect upon what we have learned about immersive and interactive ways of experiencing the world and where we might turn in the future for shivers down our spine when we increasingly consume media content via fragmentary daily encounters with digital billboards, handheld devices, and proliferating TV and computer screens. As media theorists rush to formulate new models of spectatorship to account for these shifts in media consumption, they might consider the fact that miniature prayer books that were hung from the belts of monks and lay individuals in the Middle Ages, and frequently consulted for spiritual guidance (or maybe to relieve boredom), have returned in the guise of these new devices that seem permanently attached to the hand like prosthetic devices. Our fingers may be the only things doing the shivering when they slide up and down the touch-screens in the middle of winter; and yet, our desire to become immersed in spaces that inspire awe and a sensation of being elsewhere is not likely to fade. We'll just have to remember to turn off our electronic devices when we step inside (if we can bear to be separated from them for that long).

I

FROM

CATHEDRAL

TO IMAX

SCREEN

CASE STUDIES

IN IMMERSIVE

SPECTATORSHIP

IMMERSIVE VIEWING AND THE "REVERED GAZE"

T HIS CHAPTER INVESTIGATES medieval Christian iconography as an instance of the "revered gaze," a way of encountering and making sense of images intended to be spectacular in form and content and that heighten the religious experience for the onlooker. As the first chapter of a book about visual technologies that send shivers down the spine and that complicate our traditional understanding of film spectatorship, this interdisciplinary examination of the discursive origins of religious iconography may also suggest new ways of thinking about the nature of religious viewing across art history, cultural, and visual studies. By examining the architectonics of the cathedral and visual representations of Christ's Passion, I hope to parse their unique signifying properties in order to produce a more historically sensitive account of

how ideas of spectacle and immersion, defining features of contemporary amusements such as IMAX, theme park rides, and highly illusionist museum installations, long predate their incarnation in contemporary forms.

This chapter also builds upon the emergence of postmodern theory within medieval studies, a paradigmatic shift that finds traction in medieval theater scholar Pamela Sheingorn's call for scholars to continually keep the Common Era in mind when conducting research, to excavate the "sedimentation of the Medieval" in contemporary discourse rather than simply view the Middle Ages as darkly "Other."[1] In response to medieval art historian Michael Camille's criticisms of studies of the history of visuality for lumping together medieval ways of seeing into an "Edenic, free-floating era before the 'Fall' into the

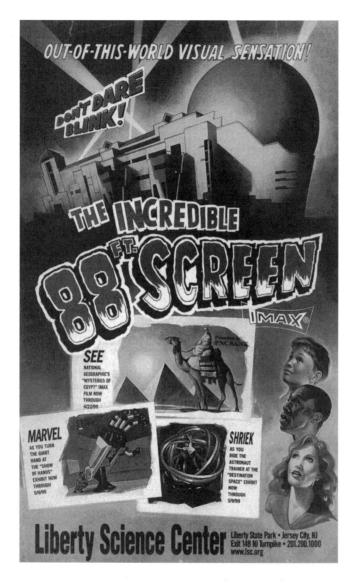

'real world' of Renaissance perspective vision," this chapter acknowledges the "period eye" and its reverberations in contemporary religious epics such as Mel Gibson's *The Passion of the Christ* (2004).[2]

Although it may seem strange to begin a book about the immersive view and the nature of spectacular viewing with a discussion of medieval cathedrals, as the iconic sign of Christianity, the cathedral inscribes several themes taken up in this book, including spectatorship, immersion, the reenactment, virtual travel, visual excess, mimesis, the uncanny, and death. The first part of the chapter considers how the space of the cathedral is both pre- and overdetermined by wonder and awe (how, for example, such a stunning architectural feat was accomplished). In light of these factors, it would be remiss of me not to consider the cathedral as a hugely significant pre-cinematic site of immersive viewing experiences. I am interested in how the viewing coordinates privileged by the cathedral—the upward gaze, large number of spectacular art objects (especially stained glass), and sense of being in closer communion with a divine being—are vital elements in a revered gaze that is transhistorical and that has transmuted today into theme park rides, IMAX films (seen here in this poster for IMAX at the Liberty Science Center, in which the spectator is shown looking awestruck not directly out at the screen, but upwards, toward the top of the frame, a rapturous gaze) (fig. 1.1), and other jaw-dropping spectacular experiences such as the exhibits at Disney's Epcot Center.

Fig 1.1 Poster for IMAX from Liberty Science Center (1999), showing the upward, "revered" gaze.

Some questions this chapter addresses include: Are there ways of seeing that are determined by the period eye, or might more fluid models of visuality across time and place be imagined? What did pilgrims and other spectators hope to achieve by visiting cathedrals and religious shrines, and how did the spectacle they encountered when they arrived shore up their belief? Given that it is impossible, as art historian David Freedberg has argued, to know whether modern spectators responded in the same ways to religious artifacts (or their secular substitutes) as their thirteenth-century contemporaries, we *can* explore, in Freedberg's words, "why images elicit, provoke, or arouse the responses they do . . . and why behavior that reveals itself in such apparently similar and recurrent ways is awakened by dead form."[3] If conjecture is the only tool available to the analyst of such historically distant and ephemeral practices of spectatorship, we can, as Michel de Certeau reminds us, "tentatively analyze the function of discourses which can throw light on [our] question" since these discourses, "written after or beside many others of the same order" speak both "*of* history" while inescapably "already situated *in* history."[4]

The second half of the chapter examines the representation of religious iconography as a form of spectacle that is both performative and immersive. From the Latin *spectaculum* (or *spectare*, meaning "to watch"), "spectacle" in *Webster's* dictionary is defined as "something exhibited to view as unusual, notable, or entertaining," although its use to define an object or person as a thing of curiosity or contempt is equally important.[5] While my use of the term *spectacle* incorporates both standard and pejorative connotations, I argue that when used in the context of religion,

spectacle threatens to disrupt traditional object/viewer relations, asking something different of us as viewers and requiring new models of spectatorship. This contradicts cultural theorist Susan Stewart's claim that the viewer of spectacle is "absolutely aware of the distance between self and spectacle"; on the contrary, religious-based spectacle, while sharing some of the same qualities as the model of spectacle outlined by Stewart, requires a form of identification that is mostly absent in the three-ring-circus spectacle commonly associated with the term.[6] Not only does religious spectacle invite identification for *some* (clearly not all) spectators, but it also does so via a performative mode of address inscribed in the Passion narrative, whether in the form of the Stations of the Cross or in the *imitatio Christi*.

The spectacular "effects" of the Crucifixion (and Christian iconology in general) will also be considered in relation to the idea of God as an absent presence and the phantasmagorical aspects of religious witnessing. Some preliminary disclaimers are in order. In making these arguments, I am neither implying an ancestral link between churches and modes of spectatorship found in panoramas, planetariums, cinemas, and museums nor attempting to construct a social history of religious spectatorship. Despite the fact that the architectonics of the cathedral, the panorama rotunda, planetarium, cinema auditorium, and museum gallery share something in common in several phenomenological aspects—one could argue that each constructs an experience for spectators premised upon a dialectic of belief versus disbelief and the notion of an absent presence—there is no teleological link between them. They are clearly historically *unique* ways of

representing the world, with their own ontologies, signifying practices, and ideologies. Second, while this chapter is concerned exclusively with Christian iconography, I am not claiming that Christian image-making and its attendant ideologies are sui generis or superior examples of religiously derived discourses of spectacle, immersion, and interactivity.

OTHER-WORLDLY SPACES: CATHEDRAL ARCHITECTONICS, PILGRIMAGE, AND SPECTATORIAL BLISS

Gothic cathedrals were a response to the desire for a building design capable of evoking a religious experience, "the representation of supernatural reality," or what art historian Otto von Simson calls an "ultimate reality."[7] And yet in sharp contrast to the other spectatorial sites examined in this book, "the tie that connects the great order of Gothic architecture with a transcendental truth is not that of optical illusion" (how can an architectural space be read as an "image" of Christ?) but rather Christian symbolism, or more accurately, the concept of analogy (the degree to which God can be discerned in an object).[8] As an architectural "language," the Gothic style developed local dialects, all of which strove to capture the ultimate reality of Christian faith, the "symbol of the kingdom of God on earth."[9] The Gothic style began to take root under the Abbot Suger in the Benedictine abbey church of St. Denis in the early twelfth century, spreading by the mid-twelfth century to the cathedrals of Noyon, Senlis, Laon, and Paris.[10] Platonic ideas of order, mathematical precision, and cosmic beauty dominated, and the principles of arithmetic and geometry inscribed in the physical design of the cathedral invited medieval spectators to intuit the order of the cosmos.[11] Von Simson's examination of the experience inspired by the cathedral sanctuary is concerned less with *what* the Gothic cathedral stands for than *how* the cathedral represents the vision of heaven, how as "enraptured witnesses to a new way of seeing," medieval worshippers would have experienced (in a religious and metaphysical sense) a divine presence as signified by the architecture, light, iconography, and the exterior and interior design of the building.[12] The walls, windows, and soaring vaults of the cathedral were conceived as a new form of architectural space that would have a powerful impact on the spectator. Gothic art was, as Camille states, "a powerful sense-organ of perception, knowledge, and pleasure."[13] The transcendental truth that medieval worshippers sought from the architectural design of medieval cathedrals can thus be seen as a "mystical correspondence between visible structure and invisible reality."[14]

With this in mind, it is easy to see how Gothic cathedrals were complex communicative structures, rising over the horizon like "three-dimensional sermons";[15] they were constructed as "advertisements in stone, heralding the promised glories of things to come."[16] The architectural design of these spaces bespoke a great deal about the nature of the immersive spectatorial experiences to be had within: spectacle and a heightened sense of immersion were not only expected but came to define the very nature of the overall religious experience; as Camille argues, "Medieval cathedrals, like computers, were

constructed to contain all the information in the world for those who knew the codes. Medieval people loved to project themselves into their images just as we can enter our video and computer screen." [17] The cathedral edifice thus took on a symbolic and aesthetic significance that far exceeded the structural functionalism of earlier church design (God himself was somehow mysteriously present within its walls); the architect and builder were less significant than the effect created by their work, as von Simson argues: "The author of the sublime achievement of this kind, paradoxically enough, recedes behind his work; we are absorbed infinitely more with the objective reality to which this work bears witness than we are with the individual mind that created it. That precisely is the experience the medieval architect wanted to convey." [18] In the design of the Gothic cathedral, a religious vision was translated into an architectural style in which the builder superseded the painter as the creator of the "singular convergence of structural and aesthetic values achieved by the geometrical functionalism of the Gothic system." [19] This yoking of the material to the spiritual appealed to the medieval mind which sought "true knowledge" through the penetration of the outward form of things to the inner meaning God intended; in the words of French Gothic scholar Emile Mâle, "all being holds in its depths the reflection of the sacrifice of Christ, the image of the Church and of the virtues and vices." [20] This divine being was none other than God himself, who in David Morgan's words, "greeted the devout in the icon." [21]

Cathedrals were intrinsically multimedia, multisensory spaces (the apotheosis of the sensorially rich pilgrimage), if we can appropriate a twentieth-century concept to describe a thirteenth-century edifice. The mixed media forms on display in the cathedral were the collective effort of artisans and craftsmen, who, far from imposing a personal vision on their artistry, worked in unison to produce "an art of multi-media combinations, in which whole environments are constructed by teams of masons, sculptors, [and] painters." Moreover, "Gothic artists disclosed a world of incredible intensity and color, constructing richly embellished three-dimensional objects into which people could enter psychologically." [22] The architecture and visual logic of the interior design formed the perfect backdrop for rituals involving the stimulation of aural, haptic, olfactory, and oral senses via the Mass and its attendant rituals. Spectators experienced their faith not only iconographically but corporeally, since attending the liturgy and receiving communion in a Catholic Mass was, and still is, an elaborately detailed theatrical performance (the priest is, after all, imitating Christ in the liturgy as an actor would); a simple upward gaze to the roof delivered visual pleasure as seen in this image of the brightly painted roof and flying buttresses of Exeter cathedral in England (fig. 1.2).

Churches in the Middle Ages were a riot of color radiating from the stained glass windows as well as other architectural features and art objects; at Exeter cathedral, for example, "tombs, bosses [decorated protrusions of wood or stone carved with foliage, heraldic, or other decorations], corbels, screens, the sedilia, the images of the west front, the minstrels gallery and other statuary, and to a certain extent, the walls themselves presented a rich tapestry of color and design." [23] The impact of these brightly colored images upon the medieval mind must

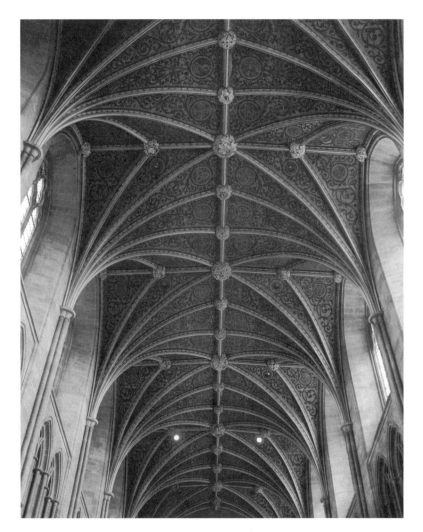

Fig 1.2 Painted roof of Exeter Cathedral showing flying buttresses and bosses. (Author's collection)

have been considerable, with no real equivalents for the image-saturated twenty-first-century sensibility. But these spatial forms do more than provide surfaces for color; the pointed-arch and canopy, for example, provided "a locus, a place for viewing [that] functioned something like a frame in modern painting," and light and luminous objects served a crucial role in evoking God's mystical presence within the cathedral, the radiating light palpable evidence of the perfection of the cosmos and a divination of the Creator.[24] Along with its nemesis, darkness, light was a powerful force in the medieval imaginary, central to notions of visual beauty in the twelfth and thirteenth centuries, and linked to the development of stained glass windows and to the preponderance of glittering objects and highly polished materials in the decorative arts.[25]

If the sacred reality medieval men and women sought in their encounter with religious emblems was ineffable, it could nevertheless be made present in the veneration of saints and their relics, which the devout encountered both on their journeys to cathedrals and in the churches themselves.[26] As Morgan argues in his analysis of the history of visual piety, "just looking upon relics afforded the forgiveness of sin."[27] But the act of pilgrimage, as the case of the medieval mystic extraordinaire and "autohagiographer" Margery Kempe so vividly illustrates, could be a performative—albeit dangerous—experience, where constructions of self are determined by the outward display of religious fervor (in Kempe's case, uncontrollable crying and erotic envisioning of the body of Christ), a masquerade of sorts where one "becomes" a pilgrim, in part through "pilgrimesque" demeanor and the purchase of relics on the journey.[28] Pilgrimage may therefore be

viewed as an especially rich site for ideas about immersive modes of spectatorship; here was a journey in which your involvement went beyond the purely pragmatic and where your subjectivity was shaped both by the physical act of traveling and the inner spiritual journey in which you immersed yourself in the attending rituals of being a pilgrim. The act of pilgrimage is thus a highly symbolic one, the journey shaped as much by the outward meanings attributed to it as to its inner resonances for individual travelers, who, in von Simson's words, crossed "the threshold that separates the known from the unknown, the customary from the wonderful."[29] The Franciscan practice of *via crucis*, observing the fourteen Stations of the Cross while on a pilgrimage, "amounted to the perfecting of a saint's imitation of Christ."[30] Marked as a devotee by dint of being on a pilgrimage, the pilgrim would reenact the Stations of the Cross at stops along the way, an act of devotion that imbued the entire experience with another layer of spirituality; upon reaching the journey's end, pilgrims and crusaders alike crossed the border from the terrestrial into the holy, a sacred space where relics, such as pieces of the cross, replicas of the Veronica (the cloth given to Jesus on his way to Golgotha and also known as the *vernicle* or the *sudarium*, meaning cloth for wiping sweat), or even relics purporting to be the baby Jesus' foreskin, became objects of veneration.[31]

Pilgrims to medieval cathedrals and shrines traveled long distances, measuring distance not in miles but in the number of days or weeks it took to reach their destination, making several stops on the way and greatly anticipating the spectacle that lay ahead. Living conditions for most people in the twelfth to fourteenth centuries involved dark, cramped, smoke-filled huts, in sharp contrast to what they would have encountered upon entering the doors of an enormous medieval church. Pilgrims arriving at cathedrals would hardly have been disappointed. According to medievalist Giorgia Frank, pilgrimage was a mulitsensory experience, with pilgrims "singling out individual senses in recounting their most transformative experiences." Not surprisingly, the visual was most venerated, with writers describing pilgrims as "seeing with the senses the holy places" and "seeing the signs of Christ's sojourn."[32] Of course, as Frank points out, the incarnation of God offered empirical proof of his existence, legitimizing "all forms of sense perception as a means of seeing God." According to medieval theology, even God privileged vision, giving humans two eyes (in case something happened to one) and positioning them closest to God at the highest level in the body.[33] In the modern era, when commodity fetishism and the accumulation of material wealth has largely replaced the worship of relics, it is striking to note the return of the relic in the religious merchandising spawned by Mel Gibson's 2004 controversial hagio-flick *The Passion of the Christ*, including pewter Crucifixion nail necklaces, replicas of the ones used in the film, offered for $16.99.[34]

Along with missionaries, merchants selling relics and other wares also traveled between holy pilgrimage sites in Medieval Europe, bringing with them a "new outlook that scattered the mists and the phantasmagoria"; according to George Duby, "real live beasts replaced the monsters that the heroes of chivalry used to encounter in the course of their adventures."[35] And as these new and wondrous visual representations entered the consciousness of

the medieval mind (though never entirely vanquishing the fantastic), they were quickly reflected in Gothic art. Naturalistic and phantasmagorical representations of animals, plants, flowers, and scenes from everyday life, and incidents from romantic literature, were the most common subjects (misericords, elaborately carved wooden seats used by church dignitaries in the quire, offer us especially rich glimpses into the visual and cultural imaginary of the medieval world).

The medieval mind was preoccupied with the symbolic nature of the world of appearances: "everywhere the visible seemed to reflect the invisible."[36] But there is a phantasmagorical dimension to the relationship between sign (religious icon) and referent (God) that the thirteenth-century pilgrim would have to tacitly understand. By renouncing itself as an absolute referent—one cannot empirically prove the existence of a divine or holy being—God exists in the mind of the believer in similar ways to the phantasm, since neither exists in any material sense. This idea of God as an absent presence helps bridge the conceptual leap from thinking about spectatorial reactions to the religious iconography of medieval churches and to the panorama, planetarium, motion picture, and museum exhibit, the case studies explored in this book. While it would be naive to equate Christian Metz's imaginary signifier to an act of faith, one could argue that spectators of churches, panoramas, planetariums, motion pictures, and museum are interpellated into the same kind of subject position as Metz's cinematic spectator vis-à-vis the immersive nature of the spectacle and the kinds of psychic investments (and adjustments) they are invited (and expected) to make when they enter each space. A common feature of spectacular image-making is the idea of the whole exceeding the sum of its parts, offering the spectator an experience that hovers between real and unreal, here and then, natural and supernatural. These acts of viewing also take place in the liminal space of the church that hovers between past and future, sacred and profane, heaven and earth.

What the medieval icon, panoramic painting, planetarium space show, motion picture, and diorama share, on a phenomenological level at least, is their power to transform abstract ideas and representations of the world into a decipherable visual language that can be decoded by the spectator within an enclosed space (church, rotunda, dome, auditorium, or museum). More significantly, these are spaces that privilege immersive modes of spectatorship, and that ask similar, yet paradoxically different, things of us as we either walk freely around the viewing space or are fixed in our seats for the duration of a performance. Furthermore, over the centuries, audiences witnessing spectacular religious iconography didn't simply just catch on to the notion of the affective power of devotional imagery but had been exposed to the *idea* of images standing in for something absent (i.e., God) and thus proved capable of eliciting powerful pious reactions (the Eucharist is a classic example of this) for a very long time. During a medieval Passion play, awareness of the performance as staged while simultaneously "real" defines the experience as one of constant oscillation between two states of being. I am thus arguing that the suspension of disbelief requisite for understanding cinema was also necessary for religious believers walking into a medieval cathedral in the thirteenth century or the *Cyclorama of Je-*

rusalem panorama in 1895 or even Mel Gibson's *Passion of the Christ* in 2004; for some people at least, while in these architectural spaces, seeing is *believing*.

The organization of vision in a cathedral and associated modes of spectatorship thus share something in common with the ways of seeing in cinema. For example, the structure of key iconic moments from the events surrounding Christ's Crucifixion into narrativized scenes called the Stations of the Cross (a series of fourteen crosses usually accompanied by images representing the Passion and its aftermath) was developed in the Middle Ages as a devotional substitute for actually following the Via Dolorosa (Christ's route from Jerusalem to Calvary). In addition to representing an event, each station signifies the actual site where it took place and was usually situated along the walls of a church or chapel, outdoors such as on a pilgrimage site, or wayside shrine, or in a freestanding group.[37] The Stations of the Cross require spectators have a tacit understanding of the principles of editing, a series of tableaux standing in for a linear narrative. Taddeo Gaddi's paintings in the basilica of the Baroncelli Chapel in Sante Croce, Florence, for example (fig. 1.3), a richly decorated private space where wealthy merchant families were commemorated, is composed of rectangular images organized around a central window that resemble the edited scenes one might find in a film of the Nativity. Besides representing emblematic moments from the Nativity, the images painted around the lancet windows are also concerned with light: the Annunciation of the Virgin, the flash of

Fig 1.3 Taddeo Gaddi's paintings in the basilica of the Baroncelli Chapel in Sante Croce, Florence (1330–1334).

light awakening the shepherds, and the Magi kneeling before a vision point to the association of light with revelation and serve as a visual compliment to the light streaming through the actual window.[38]

The Gothic cathedral is thus a powerful space for "engaging beholders in certain visual forms," whether stained glass windows, sculptural art, intricately carved ceiling bosses, misericords, frescoes, etc.[39] The inscription of objects and architecture into a visual style that bespoke a coherent sacred experience was the function of much Gothic art, a point underscoring the centrality of sight and vision in medieval cosmology. Cynthia Hahn, in an essay documenting changes in medieval vision, refers to three Augustinian hierarchical levels of vision: corporeal, spiritual (images in dreams or the imagination), and intellectual (occurring only in the highest levels of the mind where divine truths may be possible). Vision itself was perceived to be active and characterized by theories of intromission (effect of the objects upon the subject) and extramission (idea that the eye emits a visual ray, and, strengthened by the presence of light, the ray encounters an object, is shaped by it, and finally returns to the eye).[40] The act of looking was itself the subject of various medieval texts; Hahn, for example, refers to a fifth-century text on viewing frescoes of Christ's miracles at St. Martin's at Tours in which spectators were directed to not only prostrate themselves but to press their eyes into the dust before looking up at the images. Prostration was deemed "essential in achieving the grace of a vision of the divine," but even images themselves engendered a corporeal, haptic quality, what Robert Nelson describes as a form of seeing that was tactile and a means of "participating in what had once taken place at a holy event."[41] This "look that touches" (David Morgan's phrase) offered a stimulus for identification with the suffering Christ, through the *imitatio Christi* in which the body "participated in an integrated devotional practice of imitating Christ, of imagining him in one's own body."[42] But how were spectators invited to take up certain stances (both literally in terms of prostrations and figuratively) within the scopic regime of medieval visuality? What were the defining features of the spectacle that greeted audiences upon entering their respective exhibition sites? It is to the representation of the Crucifixion and its evolving iconography that we now turn.

THE REVERED GAZE: SPECTATORSHIP AS RELIGIOUS WITNESSING

Medieval art was a highly codified way of representing terra firma and the celestial heavens; the rules governing the representation of angels, devils, saints, and the natural world, and that a circular nimbus placed vertically behind the head expressed sanctity, for example, were tacitly understood by medieval spectators.[43] The *varietas* or pictorial richness of images incorporating flowers, animals, and architectural structures left an imprint on beholders, who, with varying degrees of sophistication, mined images for their symbolic value. Palimpsests were the order of the day; even time was multilayered, with past, present, and future at Chartres, for example, coexisting "simultaneously in the visual integration of the three doorways," the movement of time organized vertically as one's gaze

follows the columns upwards.[44] The rules and pleasures elicited by medieval art were by no means simple, however; according to Frank Kendon, "Medieval art had humor, horror, the grotesque, and a quaint expressive ugliness" which often coexisted in the margins as well as in illustrations from Books of Hours (personal prayer books).[45] Few would disagree with Kendon's summoning of horror and the grotesque as fitting adjectives; indeed, "medieval" is widely used as a synonym to characterize torture or an experience that is gruesome, brutalizing, or at the very least unpleasant.

If one accepts Morgan's argument that "the act of looking" itself is inextricably bound to one's religious identity and "constitutes a powerful practice of belief," it is possible to see how submitting one's gaze to an image of Jesus nailed to the cross can be read as an act of visual piety. But when was the Crucifixion first represented in the visual arts, what impact did the gradual introduction of more graphic realism have on the spectator's reactions to images of suffering, and how might the act of viewing Crucifixion iconography be considered an immersive experience for pious audiences that has major implications for the modes of spectatorship discussed in this book? It is in the Carolingian period, c. 600 A.D.—1000 A.D., that we first see a desire on the part of Christians for a visualization of the Crucifixion, and it was during this period that the image of the dead Christ on the cross first made its appearance in the West; indeed, as Hahn points out, "although the contemplation of the cross was a much-recommended visual exercise, its promise was limited.[46] However, representations of the Crucifixion during this period were not in the least bit concerned with realism or narrative; as Kendon notes, Christ's death was represented from a doctrinal and passive point of view with "no attempt at expressing anguish." Fully robed and lying, as opposed to being nailed, to the cross, the crucified Christ is shown alone and in no apparent discomfort.

However, the thirteenth and fourteenth centuries usher in two new developments: first, a desire to represent the Crucifixion with heightened verisimilitude via the "Man of Sorrows" trope (fig. 1.4), including, as religious art historian Gertrud Schiller points out in her magisterial study of Christian iconography, a shift toward extending the realism to the reactions and emotions of those who witnessed the event, and second, an interest in giving expression to Mary's suffering as she becomes a second object of meditation on the Passion.[47] Schiller sees this as a pivotal moment in the history of Christian art: "Biblical events are no longer interpreted; they are brought home to the spectator in a personal, visual confrontation. This relationship, in which the believer, in his [sic] meditations, follows Christ's way to the Cross, is reflected in pictorial realism."[48] The representation of blood and greater emphasis on physical pain is connected not only to the veneration of Holy Blood, as Schiller points out, but part of a larger shift toward more realistic depictions of the Crucifixion; as Kendon argues: "The denuding of the body of Jesus proceeds: men began to study the anatomy of agony His head droops; blood issues from the five wounds; his body sags under its own weight; the crown of thorns is added; and the abdominal muscles reveal the intensity of his suffering."[49] But, as Camille notes (echoing medievalist Mary Carruthers), this shift must be understood not simply as part of a move toward heightened

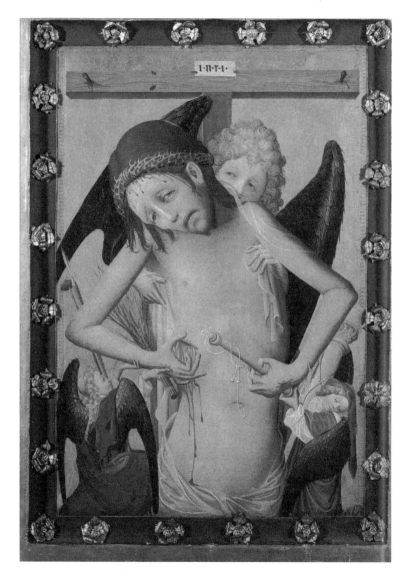

verisimilitude in the Middle Ages, but is inextricably bound to the notion of memory as affect; thus "it was not so much that the image of Christ as the 'Man of Sorrows' was 'realistic' that made this striking new image such a resonant one, but the fact that the emaciated body, the blood, the gaze of the suffering man/God carried them physically into the mind." [50]

Notwithstanding this epistemic shift in visualizing the Crucifixion, two other major influences have shaped the history of imaging Jesus Christ up to *The Passion of the Christ*: on the one hand, a Eurocentric bias in the suppression of Jesus' ethnicity as a first-century Palestinian Jew; and second, what Morgan sees as a "dense intericonic space" that can be traced to the fourth or fifth centuries. While it is impossible to extrapolate responses to graphic depictions of Christ's suffering from the historical archive, in part because we are haunted, in Michel de Certeau's words, "by presuppositions . . . by 'models' of interpretation that are invariably linked to a contemporary situation of Christianity," we can nevertheless still draw some tentative conclusions on the nature of being a spectator of the historical Passion from the representations themselves; in other words, how artists chose to represent the Passion betrays a good deal about popular perceptions of such notions as realism, torture, suffering, spectacle, and the interpellation of the spectator into the scene.

However, in order to fully understand the impact of representational shifts in Crucifixion iconography we

Fig 1.4 *Man of Sorrows* representation of Christ crucified, by Meister Francke (c. 1420). Museum der bildenden, Künste, Leipzig. (Courtesy Museum der bildenden)

must contextualize the Passion within a larger epistemological framework and consider the role of violence as a whole in medieval and early Renaissance culture. Medievalist Jody Enders points out that while violence has been a consistent feature of cultures going back at least to the first century, the question of "how audiences were to discern which violent, bloody struggles it was acceptable to enjoy is a question to which writers keep returning."[51] In the United States, at least, we find ourselves in a culture riddled with contradictions vis-à-vis the kinds of violent representations considered acceptable versus those deemed taboo, with the Christian right pressuring public officials and courts to morally legislate the entertainment industry. While avoiding the claim that violent medieval dramatizations of the Passion are identical to contemporary performances or rituals of self-mutilation (such as the 1995 Easter celebrations that took place in the Philippines, where believers were crucified with thin nails that had been dipped in alcohol), Enders does not deny that they both engender a "pleasure, obsession, or fascination eternally aroused in audiences."[52] Moreover, Amy Hollywood, in her essay "Kill Jesus" (about Mel Gibson's *The Passion of the Christ*), uses Carruthers's theories of medieval memory to explain why Passion narratives traditionally highlighted the violence of Jesus' last twelve hours; violent images are "more memorable than nonviolent ones" and "carry with them emotions of grief and fear that render the images even more memorable"; and finally, "through these emotion-laden images the believer scares, saddens, and shames himself or herself."[53]

In the 1547 Passion play staged at Valenciennes, special stage effects were used to create the illusion of flowing blood, from the bodies of the Innocents when they are massacred and from Christ's wounds in the Crucifixion scene.[54] These illusions, as French medieval theater scholar Darwin Smith points out, would have been the responsibility of a prop master trained in special effects, including the flash of light created with mirrors that appears on Christ's face after the transfiguration.[55] The appearance of blood loss was created via a mixture of vermilion and water added to a hydraulic system that moved the liquids from a barrel into pipes hidden behind the body of the actor playing Christ (the addition of different liquids would alter the pressure in the pipes and create the illusion of oozing bodily fluids). With blood seeping from every pore, "spattering upon the earth, such that the entire set 'glistens with blood,'" in the words of Enders, special effects masters in the Middle Ages performed "all manner of technological miracles . . . flesh-suits with pre-imprinted gash marks, unpeeled layer by layer and with great sleight of hand as the scourging progresses. The brutality is so overwhelming that viewers feel they must turn away, yet they are compelled to watch this piece of instructional entertainment that has been provided by their culture, by their community, and by their church."[56]

The profusion of blood in Mel Gibson's *The Passion of the Christ* would have not been out of place in the *Mistère de la Sainte Hostie* held in Metz, France, in 1513, during which, as one contemporaneous spectator tells us, "there emerged a great deal of blood. . . until the whole center stage glistened with blood and the whole place was full of blood And all this was accomplished by devices and hidden places."[57] And yet one crucial difference must be noted: sometimes the violence in Middle Ages performances was

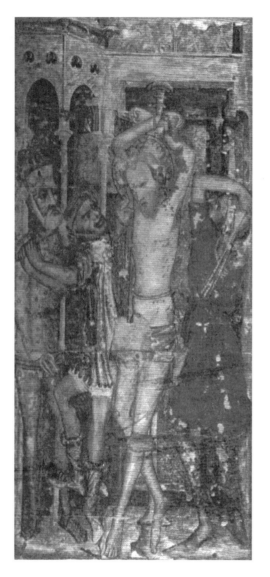

genuinely happening on stage, with stage directions for the Sainte Geneviève *Passion* specifying that "blows upon the body of Jesus must be genuine, not imitated." There is also the uncorroborated suggestion of the substitution of condemned criminals for actors so that they could be burned alive on stage.[58] Contemporary playwright Terrence McNally's controversial gay parable *Corpus Christi* contains stage directions that continues this tradition; the direction instructs that Joshua, the Christ figure, should be shown as a brutalized body when the cross is finally raised: "For the first time we see how horribly Joshua has been battered. Blood runs down His face and body. His eyes are half-swollen shut. It should be hard to look at him."[59] As the epitome of brutalization, the flagellation is one of those scenes where the boundaries between spectators and participants are paradoxically both elided and reinforced; at the same time as we're drawn into the frenzy, we're repulsed by its brutality.

First appearing in the twelfth century in sculpture, by the thirteenth century the flagellation was represented in stained glass and wall paintings (fig. 1.5) and most commonly on Passion altars.[60] By the Baroque period, relatively private meditations on Christ's suffering that had been the norm in the late Middle Ages moved out of the realm of the contemplative and into the public space of the church and village square. The representation of Christ's torturers as sadistically enjoying their work goes back to early images of the flagellation scene and Crucifixion; indeed Glending Olson refers to a medieval "sermon exem-

Fig 1.5 Medieval flagellation image (c. 1420) from Frank Kendon, *Mural Paintings in English Churches During the Middle Ages*

plum" uncovered by Siegfried Wenzel which suggested that "performers taking on the role of Christ's torturers in a passion play enjoyed what they were acting out on stage, perhaps to the point that their revelry came to obscure or interfere with the presumably religious goals of the presentation."[61] In Arnoul Gréban's *The Mystery of the Passion: The Third Day*, the miniature image of the flagellation shows the soldiers energetically engaged in their work, almost appearing as if they are dancing upon the elaborate black and white tile pattern on the floor (the torturer on the left in fig. 1.5 stands on one leg and looks directly up at Christ's face while delivering a blow). Halfway down the folio, the stage direction "They spit in his face" appears, proffering evidence that while the manuscript is primarily aimed at the reader, there are nevertheless ample indications of performative elements, the text not so much recording as *evoking* the idea of performance. Another stage direction reads: "here they beat him for a while without speaking."[62] Clearly we have no idea how long this beating might have ensued. But the distinction between spectator and performer wasn't always so clearcut. Camille's point about the interactive nature of mystery plays and chivalric tournaments where the borders separating spectators from participants were permeable holds true for contemporary digital environments and for much of the immersive viewing spaces analyzed in *Shivers Down Your Spine*; in fact, for Camille, this has simply been a very long wait for a return to interactivity and immersion that is now finally being realized through computer-imaging and virtual reality.[63]

This troubling surplus of dangerous pleasure was one of the reasons why the performance of miracle plays came under attack in the classic antitheatrical manifesto *A Tretise of Miraclis Pleyinge* (written sometime between 1380 and 1425) and characterized by Clifford Davidson as the "longest and most significant piece of dramatic criticism in Middle English." While the term "miraclis" in the document seems to refer to a broad range of dramatic activity and representation, religious drama, especially performances of the Passion, are singled out as "utterly reprehensible."[64] Medievalist Garth Epp argues that it is concern with "lustis of the fleyssh," mentioned innumerable times in the *Tretise*, that rubs the authors the wrong way; as Epp explains, the *Tretise* "treats theatrical performance and spectatorship as themselves inherently sexual activities, most dangerously so when they are centered on a representation of the actions and body of Christ . . . [which], unlike any other, must be seen as utterly antithetical to lechery; its theatrical representation cannot be seen to provoke erotic desire."[65] What extant commentaries on medieval performance such as the *Tretise* reveal is that "medieval audiences were clearly aware of varied dimensions of the dramatic activity they saw" and that performances were complex enough in tone that they engendered harsh critiques, including the attacks on stagings of Christ's Passion singled out in the *Tretise*.[66]

Expectation thus plays an important role in the encounter between spectator and religious iconography. When viewing religious spectacle, one *expects* a corporeal and possibly immersive engagement that could be as intense as the *imitatio Christi* (at the extreme end of the immersion chart) or as innocuous as possessing an image of Christ that returns one's gaze. Each of these spectacular

CYCLORAMA

OF

JERUSALEM

— ON THE DAY OF —

The Crucifixion.

THE GRANDEST

Permanent Exhibition of the Nineteenth Century.

— AT —

STE-ANNE DE BEAUPRE

SINCE 1895.

LOCATED IN THE LARGE ROTUNDA,

On the pier near the Railway Station

— Close in the winter time —

15c

modes of representing the Crucifixion foregrounds an immersive gaze and interactive encounter, the idea that the act of looking not only demands more of the spectator—a bodily engagement in the case of *imitatio Christi*—but somehow delivers more.[67] This idea of excess has a huge amount of leverage in relation to the case studies examined in this book, how we make sense of "extreme" images, viewing spaces, and highly illusionistic representations. But there is an important difference here in theatrical stagings of Passion plays, panoramas of the Crucifixion such as the *Cyclorama of Jerusalem* painted in 1895 and shown advertised here in this late-nineteenth-century poster (fig. 1.6), and versions rendered on film, including differences that speak to the representation and consumption of flesh;[68] according to Epp, "in medieval English passion plays, Christ repeatedly, even insistently, offers his flesh for the gaze of others, both on and off the stage."[69] In the cinema, that flesh is transposed onto the screen via the magic of light, and the looking relations, while similar in the construction of the gaze, are by no means identical. The "all-too-human body" of the medieval passion play actor on display "invites our collective gaze, and the meditative tradition of *imitatio Christi* invites our identification with that body's suffering," although in the case of the complete performances of the York plays, this would have resulted in no fewer than twenty-four actors playing the adult Christ in successive pageants, each in multiple performances, "one God in many persons," as Epp puts

Fig 1.6 Poster for the *Cyclorama of Jerusalem* panorama in St. Anne de Beaupré, Quebec (c. 1895).

it.[70] "Seeing" Christ was neither a predictable nor consistent experience for either mystery cycle audiences or those viewers of James Caviezel, star of Gibson's film (voted one of the fifty most beautiful people in the world by *People* magazine in 2004).[71] Desiring Christ's body as an ecumenical sign told only half the story; identification with Christ's body, especially when that body was played by a large number of the town's young men, might have been based upon any number of variables, including how one's version of Christ matched up to the various body types, visages, homoerotic or heterosexual desire, or other notions of "Christness."

Innumerable accounts of how mystics, saints, and sometimes ordinary citizens communicated the Passion through their bodies attest to the performative and immersive nature of the Passion narrative, subject to diverse appropriations, including extension to include the Last Judgment, and elision, to represent only the last twelve hours of Jesus' life, seen in Gibson's film. As R. N. Swanson observes, "Passion narrative structure allows individual events to be highlighted, or the isolation of particular sequences," although "different depictions, manifestations, manipulations, produce different responses, especially if further complicated by regional variations."[72] This point suggests that, while correspondences can be traced over time, the Passion story is a particularly open text, not so much a blueprint for performance but a series of emblematic tableaux. It also suggests that the Passion can be read as an event or experience rich in immersive potential, even more so when performed in the architectural space or halo of the cathedral. The performance of the Passion narrative, especially in the case of devotional images involving representations of the "instruments of the Passion (the *arm Christi*) including the hosts, chalice, and a pelican in piety," allows the devotee to "transport the Christ-who-suffered into the present, to become the Christ-who-suffers"—immersion becoming embodiment here—so that the "Man of Sorrows" context shifts from that of the Passion to that of the Eucharist, from a past event to one which may be both present and future.[73]

The case of Elisabeth of Spalbeck from the thirteenth century, a classic example of female medieval mysticism in which she would "perform all the major narrative events of the Stations of the Cross, ending with a kind of tableau representation of Christ's body crucified on the cross," reminds us of the intense corporeality surrounding the Crucifixion narrative (it is also an extreme example of the idea of immersion in relation to Passion experiences). Elisabeth's body became a performance text, and her use of location, props, and ability to embody both the tormentors and the tormented heightened the theatricality and supernatural aura of Christ's flagellation and Crucifixion. Her stigmata and bleeding from hands, feet, and side drew the attention of Costercian Abbot Philip of Clairvaux, who wrote a report, or *vita*, on her behavior.[74] As Elisabeth's performance illustrates, the elicitation of an empathetic, if disquieting, response in witnesses to Elisabeth's hitting, hair-pulling, self-starvation, catatonic episodes, and bizarre sounds was the raison d'être of medieval Passion cycles, as Morgan explains: "the task was to transform the pathos or suffering of Christ's Passion into a sensation of compassion—a suffering with—in the

viewer. This new form of piety, effected through visual means, sought a vicarious participation in Christ's suffering, death, and resurrection."[75]

But there is also a functionalist dimension to this: according to Morgan, the rhetoric of immediacy was the visual equivalent of the textual notion of *sola scriptura*, the idea of God making himself apparent in certain privileged forms of representation. Thus, the idea that "images were an expeditious avenue of disclosure—an illiterate person's Bible—had . . . been absorbed into medieval epistemology."[76] But absorption itself, the idea of entering into the image, was not simply an unexpected outcome of religious devotional practices, but a fundamental pretext for the idea of immersion.

THE SPECTRALITY OF DEVOTIONAL IMAGERY: IS SEEING REALLY BELIEVING?

Immersion and presence are not only paramount in the examples discussed in this chapter but resurface throughout this book in the panorama, planetarium, IMAX film, and interactive museum gallery; these related but ultimately distinct spaces do not evoke a consistent theological message or ideology so much as a suggestion of how vision, spectacle, memory, and, above all, affect are discursively constructed and manipulated in each experience, how spectatorship can engender a feeling of copresence so that "people feel themselves to be in a more direct relationship with the living God [or virtual reality] because of the imaginative power of newly animated images."[77] The metaphysics of the encounter between spectator and representation in each of these forms is reminiscent of the "peak experience" described by Abraham Maslow, where emotions of "wonder, awe, reverence, humility, surrender, and even worship before the greatness of the experience" are reported. According to Maslow, "unitive consciousness" is a core element of "peak experience," a "sense of the sacred glimpsed *in* and *through* the particular instance of the momentary . . . the worldly."[78] Not surprisingly, the cathedral is exemplary in this respect as a place likely to provoke a peak experience, especially given the strong (and familiar) associations between architecture and the sublime. The following description of visiting Chartres, although written by twentieth-century philosopher F. David Martin, might easily paraphrase the experience of a medieval visitor to the cathedral:

> In . . . Chartres I was completely centered and at a standstill, and thus I felt the attraction and support of the earth beneath me much more strongly than when I was on the outside. I became more explicitly aware of my place, my here and now, as being secured by a power over which I had no control and which seemed strangely "other."[79]

Not surprisingly, the panorama often elicits a similar reaction in the spectator who, like the churchgoer, is awestruck by the scale of the representation and architectural space. It is quite conceivable that visitors to the *Cyclorama of Jerusalem*—one of only four panoramas in North America and Canada and built in 1895—experienced something close to a peak experience when they stepped onto the viewing platform (I felt nauseous and my head was swimming when I entered the space). Conceived by

the Munich artist Bruno Piglheim, who "decided that something should be done about public ignorance of daily life in Biblical times," in particular the lack of attention devoted to landscape, customs, and dress, the panorama was painted by the famous French panorama artist Paul Philippoteaux, who also painted *The Battle of Gettysburg* (1883), extant and permanently housed at the Gettysburg historic site in Pennsylvania (it is discussed in the following chapter). In the brochure accompanying the *Cyclorama of Jerusalem*, we are told that "the sense of reality to an episode, not just another religious painting, but a canvas that would bring alive a period in time [through] an illusion of depth [such] that viewers feel they are among the crowd marching with Roman soldiers."[80] Through the immersive effects of trompe l'oeil, the spectator feels copresent at this event, looking down at the Crucifixion occurring on a single temporal plane (fig. 1.7). The "here-and-nowness" of the scene might well have brought on a

Fig 1.7 Detail of the Crucifixion from *The Cyclorama of Jerusalem* panorama. (Courtesy of *Cyclorama of Jerusalem* panorama, St. Anne de Beaupré, Quebec)

"peak experience" for the spectator; addressed as virtual time travelers, sightseers lining the city wall, we look down upon Jerusalem from a privileged vantage point in time and space. This sense of being immersed in the moment represented on the vast circular canvas is shored up by the descriptive language, the reference the *Times* critic makes to Christ being on the cross "*just after having breathed his last,*" the converted thief who "*painfully* turns his head," the "dark *threatening* clouds over the sky," and the Roman centurion "*pointing* his arm."[81] The present-tense quality of the *Cyclorama of Jerusalem* helps us appreciate its effectiveness as an example of the kind of devotional spectating discussed by Swanson, images that blur past, present, and future; while we cannot assume that all spectators gazed (or continue to gaze) at the scene through the same presentist frame of reference (or had

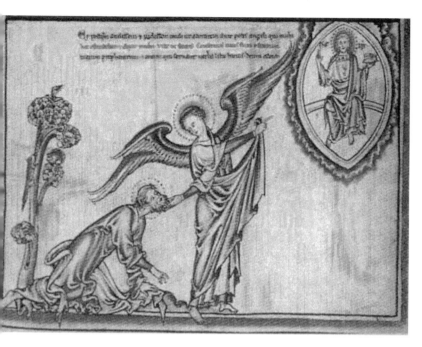

Fig 1.8 Apocalypse illumination of the angel showing *St. John the Heavenly Jerusalem* (detail), depicted in illustrations of the Book of Revelation (c. 1250). Illumination on parchment. (Pierpont Morgan Library, New York, MS 524, fol. 21 recto)

a peak experience), there is something about panoramic vision, I would argue, that clearly heightens the sensation of immersion. Indeed, part of the pleasure of viewing the Crucifixion panorama and a great deal of other popular religious art may derive from a "correspondence between what the believer sees and what he or she wants to or expects to see . . . expressed in a number of operations . . .

[including] recognition, interactivity, projection, empathy, and sympathy."[82]

The 1250 Apocalypse illumination of the angel showing *St John the Heavenly Jerusalem* (fig. 1.8) depicted in illustrations of the Book of Revelation serves as a rich meta-comment on the nature of religious spectacle and spectating in the Middle Ages. If we include the spectator's act of looking at the image in the overall tally, then we have no fewer than four paths of gaze transversing this image: God's gaze out at the spectator, the angel's gaze at John, and John's gaze up at the image of Jerusalem. The crossed arms of the angel and the undulating folds of fabric in the image echo the design and texture of the wings, which, spanning diagonally across the image, anchors another connotative connection between God and St. John. In its reflexive didacticism, the image instructs viewers on religious witnessing and looking relations in general. Indeed, St. John's Vision of the Apocalypse was such a popular subject for thirteenth-century picture books that the scenes represented in lavishly illustrated manuscripts were adapted for other art forms, including tapestry. The appearance of St. John as a witness and internal spectator in the illustration serves to "mediate the visionary experience for the beholder, sometimes looking through a window onto the action, but always registering an active response to what he is seeing."[83]

I have argued that all of these historically distinct ways of experiencing immersive views and representing religious spectacle share one feature: they all offer spectators access to things beyond ordinary ways of seeing. For the devout, the knowledge to be gained from medieval

art, a Crucifixion panorama, or a film about the Passion is knowledge that despite being already familiar—almost everyone knows the story—is "expressed in the language of enfleshed sensations," a feeling that, for some spectators at least, is that of being copresent with a higher being or force, of feeling empathy, but most of all, of encountering spectacle unlike anything else one might come across in daily life.[84] What unites these ways of seeing the Passion is that they attempt to transform theology into emotions and sensations (including pain, disgust, nausea, guilt, and exaltation) that are meant, through the palpable sense of being immersed in the image, to bring us into closer communion with a Christian God.

And yet even the act of seeing is subject to historically specific connotative meanings, as Clifford Davidson reminds us: "According to the understanding of vision prevalent in both learned and popular circles [in the Middle Ages], *seeing* meant coming into direct visual contact with the object, which if it were idolatrous would contaminate the viewer."[85] Seeing was no less potent in the testimonies of viewers leaving Mel Gibson's *The Passion*, who saw flesh torn asunder and, according to the Gibson master plan, had their faith reaffirmed. When the steam finally evaporated from the boiling pot of journalistic and scholarly rhetoric surrounding Gibson's *Passion*, what we were left with, I believe, was a residue of anxiety over mimesis itself and the burden of representing Christ's life.

Organized religion is one of the ways in which peak experiences can be communicated to others, but whereas the fear of death tends to disappear in the peak experience, it is ever-present, I would argue, in the image of the Crucifixion, the tragic highlight of the Passion. One might argue that death has served as a framing metaphor for immersive technologies of spectacle for quite some time, and may be a useful way of drawing the themes of this chapter together. The specter of death hangs heavily here, not only in the narrative of the Passion but also in the very ontologies of these religious spectacles. The panorama optically embalms its universe, while the presence of tomb sculpture and repositories of saintly relics in medieval cathedrals brings spectators quite literally into the company of the dead; death was commonly represented in the mystery cycles and celebrated in courtly poems, pageants, cities, and towns where the "Dance of Death" was popular.[86] Moreover, in addition to the apocalyptic ending of Gibson's *Passion* narrative, the film also gave death a quasi-human representation in the form of a bizarre grim reaper/androgynous milk-eyed devil who lurks in the shadows and floats in and out of the action, a character played by Rosalinda Celentano that Jack Miles describes as a "gray-faced, hollow-eyed terrorist . . . the most insinuatingly sinister Satan ever seen on screen."[87] But just as Christian faith depends upon a belief in the redemptive power of the Resurrection to validate Christ's status as the Son of God, so too do these spectacles work the alchemy of religious representation by imbuing these scenes with life. The reception of these ways of seeing the Passion involve what Morgan calls "the magical sense of making the abstract present . . . render[ing] for viewers the ontological presence of someone or something."[88] If seeing the face of Jesus in a tortilla or Mary in a vegetable can be a sign of divine presence and become an occasion

for visual piety, an encounter with Christian iconography through the powerful forms of monumental architecture, large-scale illusionistic painting, and modern filmmaking can transport worldly spectators into a transcendent realm. While there is nothing especially sacred about a movie theater ("temple of sin" would be a more apposite descriptor), a panorama rotunda, or even the bricks and mortar out of which a cathedral emerges, for the religiously devout these physical spaces offer a locus for a sense-altering experience, each delivering shivers down your spine. But they also created the conditions of possibility and deep-seated desire for an immersive engagement with illusionistic representational forms, a desire that would be sated in spaces with no ostensible link to religion, such as the panorama, IMAX theater, and planetarium. It is to these spaces that we turn in the three remaining chapters of this part of *Shivers Down Your Spine*.

SPECTACLE AND IMMERSION IN THE NINETEENTH-CENTURY PANORAMA

To realize that this magnificent pageant is, after all, only an illusion requires a stronger mental effort than to accept it for reality.

 —Brochure for *The Siege of Paris* panorama (1877)[1]

While looking at the picture he must *live* in its scene.

 —*Scientific American* (1886)[2]

P ICTURE YOURSELF WALKING through a darkened, narrow corridor that leads upwards to a staircase drizzled with light, feeling a little disoriented but nevertheless eager to reach the top. The year is 1793, and you have just paid to enter Irishman Robert Barker's patented 360-degree panorama entitled *The Grand Fleet at Spithead 1791* (fig. 2.1). When you finally reach the observation deck, a platform designed to resemble the poop deck of a frigate, emerging out of the darkness, you find yourself gazing out at sea, or so it seems, having left the throbbing streets of the bustling metropole for another time and space. As futile as it may seem to try and reconstruct late-eighteenth-century audiences' experience of panoramas for a twenty-first-century audience, and leery of reproducing contemporaneous hyperbolic accounts

of the "unsurpassed realism" of the attraction, I want to suggest that there nevertheless remains something very strange (even uncanny) about the nature of panorama spectatorship. The three extant painted panoramas from the nineteenth century I have seen (only the first two of which are in their original rotundas)—the Mesdag Panorama in The Hague, the *Cyclorama of Jerusalem* outside of Quebec City, and *The Battle of Gettysburg* panorama in Pennsylvania—invite a peculiarly embodied, and highly immersive form of spectatorship, evoking what film theorist Vivian Sobchack describes as a "radically material condition of human being that necessarily entails both the body and consciousness, objectivity and subjectivity into an *irreducible ensemble*."[3] It is this heightened sense of embodiment that makes the panorama a particularly

Fig 2.1 Cross-section of Robert Barker's panorama rotunda in London's Leicester Square (1793), showing *The Grand Fleet at Spithead* in the larger, lower level. Aquatint from Robert Mitchell's *Plans and Views in Perspective of Buildings Erected in England and Scotland, 1801.* Mitchell was the building's architect.

compelling example of immersive spectatorship, exemplary, in many respects, and a wonderful bridge between the cathedral and planetarium explored in part 1 of this book. But what exactly is a panorama?

From the Greek *pan,* meaning "all," and *orama,* meaning "view," panoramas were among the earliest and most commercially successful forms of mass visual entertainment, going in and out of fashion throughout the nineteenth century. A panorama is a huge 360-degree painting hung along the circumference of an interior wall of a specially designed circular building. At the center of the structure is a viewing platform (belvedere), reached by a flight of stairs; as art historian Lee Parry has noted, "the viewer's eye was intended to be directly opposite the horizon line of the painting." With nothing within which to locate the canvas, the spectator was more likely to accept the realism of the visual field than if the painting had been conventionally framed and exhibited. Unlike the frame, which functions as a window onto an illusionistically rendered space, the panorama attempted to create the sensation of the spectator's physical relocation into the center of such a space.[4] The *vellum* (an umbrella-like canopy over the spectator's head) and very bottom of the painting were concealed by a cloth of the same color stretching from the lower edge of the platform toward the bottom edge of the canvas (fig. 2.2).[5] With a newly invested omniscience, the spectator was enveloped in an artificial reality in which all boundaries delimiting the real from the synthetic had been putatively eliminated. As we can see from this image of the interior of the *Panorama of London,* which opened in 1829 (fig. 2.3), spectators entered through the center and walked around the belvedere,

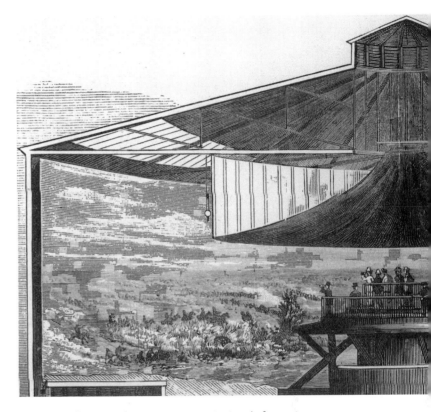

Fig 2.2 Vellum seen above spectators on viewing platform using eye glasses to obtain a closer look at the canvas, *The Battle of Gettysburg* panorama (1883). (Albert A. Hopkins, *Magic Stage Illusions, and Scientific Diversions* [New York: Munns, 1891])

possibly in silence or chatting with a family member or friend, until they decided they had looked at the vast painting long enough and then descended the staircase and exited the building (circular panoramas such as this were also called cycloramas between 1872 and 1885).

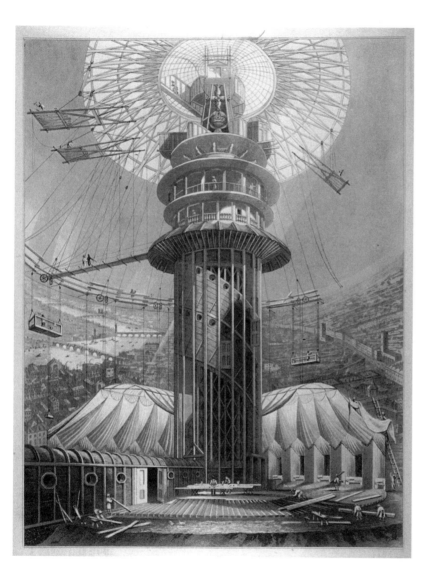

Several factors make the panorama extraordinarily well suited to the delivery of immersive spectacle: first, the mode of spectatorship invited by its scale (unlike looking at panel paintings or photographs, spectators gazed at huge canvases that literally surrounded them); second, its invocation of presence as a constituent feature of the panoramic experience, the sense of "being in a different time and space"; third, and linked to the idea of presence, its status as a mode of virtual transport; and last, the quasi-religious nature of the exhibition space, the fact that the sense of wonder felt by the spectators and the hushed tones in which they spoke, were reminiscent of behavior one might find in a church.[6] As Barker appreciated when he patented his *coup d'oeil*, the inner space of the panorama can be taken in with the turn of the head; in Barker's own words, "the grand and clear symmetry of the enclosing shell draws us into the center of the circle, the privileged position, beneath the 'eye' of the dome opening to a bit of the sky."[7] Barker was also very precise about the role of light in the panorama, instructing the artist in his patent that once he [*sic*] had "fixed his station," he should not only "delineate correctly and connectedly every object which presents itself to his view as he turns around . . . [but] observe the lights and shadows how they fall, and perfect his piece to the best of his abilities.[8] Natural light entering through the glass roof of the rotunda directly above the vellum heightens the illusion of being

Fig 2.3 Interior view of the Colosseum's *Panorama of London* shortly before its completion (1829). (Courtesy Guildhall Library, Corporation of London)

in another space; it also contributes in no small part to the verisimilitude of the experience, since moving clouds and variations in light create tonal shifts reminiscent of the contingent nature of outdoor viewing.

The idea that there are certain correspondences between the panorama and the twentieth-century motion picture is by now familiar to film historians, and while these associations have become something of a truism in the discourse surrounding the panorama, we should be cautious about perpetuating teleological arguments about panoramas "giving birth" to motion pictures. While panoramas had been around for almost a century before the emergence of cinema, they also existed simultaneously with film, so that to talk about one spawning the other is ridiculous. Nevertheless, long before contemporary art historians and cultural theorists connected the hyperrealism of these large-scale immersive paintings to the mechanized mimeticism of the cinematic image, previous historians linked the two representational forms. In 1933, Monas N. Squires argued that panoramas of the 1840s and 1850s were "ancestors of the modern moving picture," a label endorsed three years later by Bertha L. Heilbron, who called nineteenth-century panoramas "travel 'movies.'" Similarly, in 1959, panorama scholar Joseph Earl Arrington argued that the panorama was indubitably the "pre-photographic ancestor of the motion picture," and in his 1965 book *Archaeology of the Cinema*, C. W. Ceram discussed several panoramic precursors of cinema.[9]

Among the hazards of such linear accounts is a failure to consider the panorama on its own terms, and while cor-respondences can be noted across each form, we should remain sensitive to the unique social, cultural, and economic histories of the panorama and motion picture. With the cautionary tale now told and hopefully comprehended, my aim in this chapter is to consider how the panorama privileged an immersive mode of spectatorship that hovers somewhere in-between the experience of the cathedral and the motion picture. In other words, rather than arguing that one is intrinsically like the other, I am instead interested in identifying resonances across these spectacular forms of entertainment that can better help us grasp the nature of immersive viewing. In some respects the panorama rotunda evinced a hailing function similar to that of the Gothic cathedral, signaling to audiences from some distance that what lay inside was to be experienced as something unique, memorable, and uncanny. Like the medieval cathedral, the late-eighteenth-century rotunda rose majestically out of the earth, its domed, otherworldly profile promoting the virtual voyages audiences were invited to undertake upon emerging onto the viewing platform. But if the architectural pull of the pantheon is downward, given that circular buildings are among the most internally centered of architectural structures as they firmly root us into the earth, the opposite is true of the cathedral, where the "visual negation of the structural reality with the loading forces [leads] to an impression of floating and a sense of striving upwards."[10] Notwithstanding these differences, I argue in this chapter that the panorama and cinema both privilege an immersive mode of spectatorship and way of seeing that are frequently driven by spectacle and wonder. The cathedral,

panorama, and motion picture (especially large-format films such as 2-D and 3-D IMAX) are superlative at delivering large doses of awe and shivers down one's spine. However, rather than make broad, generalized comments about film and the panorama, my goal here is to hone in on a concept that can help bridge the gap between these two entertainment forms. That idea is the reenactment.

The reenactment was a key organizing principle of many nonfictional panoramas and, in a wider sense, came to define the very idea of panorama spectatorship as one of revisitation, of witnessing again, in modified form, that which has occurred in a different time and place. I argue that this sense of revisitation is central to our understanding of immersive modes of spectatorship, a driving force in the experience and one that demands careful and detailed explication in order to understand how it draws us in as spectators and cues us to respond with awe and wonder. The reenactment can also be seen as the phenomenological glue that binds the panorama and motion picture together, which is yet another reason for paying it close attention.

THE REENACTMENT: SEEING AGAIN, SEEING ANEW, SEEING AFRESH

Panoramas laid claim to the historical and geographical real through an indexical bond, premised on their status as topographically correct and authentic reconstructions of battles, landscapes, or ancient antiquities such as the Acropolis in Athens. But while the panorama shared some of the phenomenological and discursive features of the cinematic reenactment, there were important differences, the most obvious being that while the panorama *reconstructed* a scene from history, newspaper headlines, or nature for its audiences, it did not literally *reenact* this event for the spectator. Because the panorama was an image frozen in time—in other words, the scene was not literally reperformed for the spectator as in a film reenactment of a battle or an execution—there was no *action* per se in the painting. But if panorama exhibitors could not avail themselves of cinema's possibilities for literal reenactment (the panorama's only method of depicting movement involved the physical motion of the canvas from one roller to the other as seen in the moving panorama or when dioramic lighting effects gave the impression of shifting temporality as in Louis-Jacques-Mandé Daguerre's diorama), they compensated by explicitly foregrounding the panorama's status as a *reconstitutive* mode of address. Thus, the depicted events reassembled for the spectator were to be made sense of *as if* the action was happening along an immediate temporal and spatial presence and continuity. The reenactment as a cinematic trope may thus provide a useful theoretical frame for understanding the nature of panorama spectatorship, which in turn may help us better grasp the vicissitudes of immersive modes of spectacle. I argue that the reenactment and immersive types of viewing share a special communion, mutually informing one another through their similar interest in bringing back the dead and reconstructing an experience that invites the spectator to revisit that which has occurred or simply been.

The reenactment has assumed an ambiguous status in traditional cinema scholarship; easily identified, on the one hand, as a staple of both early actuality filmmaking

and contemporary docudrama, the reenactment has nevertheless failed to generate as much theoretical explication as its ubiquitous status—within both Hollywood and television "infotainment"—would seem to invite. While the reenactment has been the subject of some discussion, both descriptive and prescriptive, in standard documentary film texts, less attention has been paid to how its forms of spectatorial address were rehearsed in numerous pre-cinematic forms. As interstitial texts, straddling "high" and "low" culture in their blending of the promotional discourses and artistic techniques of both fine arts and popular amusements, panoramas often evoked the reenactment experience. Offering facsimiles of actual events and geographical locales, promoters of the nineteenth-century panorama exploited its spectacular and immersive mode of address; indeed, one could argue that the panorama can be considered the sine qua non of immersive entertainment experiences in terms of its appeal to spectators as an all-encompassing view that literally surrounds them.

This chapter begins by examining the emergence and early commercialization of the nineteenth-century panorama before considering two of its most common subject matters:[11] the battle panorama, an exemplary instance of the reenactment model of panorama viewing, and the river panorama, an example of what I call the "sublime vista" panorama, which offered spectators a form of "enriched vision" and an opportunity for virtual travel. The chapter concludes with an examination of how the theme of death serves as a unifying discourse in panoramas and cinematic reenactments, regarding not only their iconographies but also coming to consume their very ontologies.

THE EARLY COMMERCIALIZATION OF PANORAMAS

Hugely popular in Europe and the United States in the early nineteenth century, panoramas evolved, mutated, and waxed and waned in public appeal throughout the century, finally fading from memory around the time that motion pictures ushered in an era ringing loudly with the sounds and sights of modernity.[12] During their heyday, panoramas captured the imaginations of a wide swath of patrons, unlike panel painting, which largely appealed to the upper classes. As phenomenologically complex sign systems, panoramas helped spawn what art historian Shelly Rice calls a "panoramic consciousness" in the nineteenth century, evidenced in such paintings as Caspar David Friedrich's *Moonrise Over the Sea* from 1821, which includes two men "who have walked out onto the rocks extending into the sea so they can experience the thrill of being virtually encircled by the vast 'panoramic' horizon line."[13] In addition to influencing the fine arts (although, paradoxically, panoramas were condemned by artists for their poor quality), miniature panoramas came in innumerable shapes and sizes, including parlor toys and wallpaper, and helped inspire a vibrant movement in panoramic photography. The term *panorama* also entered the vernacular of the American literati, finding its way into Mark Twain's 1883 *Life on the Mississippi* when Stephen, in a manic outburst, describes his friend Yates as being not just a picture, but a panorama: "*Some* call him a picture; I call him a *panorama!* That's what he is—an entire *panorama.*"[14] Likewise, Edgar Allan Poe in his 1848 epic prose poem entitled *Eureka: An Essay on the Material and Spiritual Universe,* is quite at home with the term *pan-*

orama in his discussion of the miniscule percentage of the earth's entire circumference visible from a mountain top vantage point: in Poe's words "the entire *panorama* would comprehend no more than one 40,000th part of the mere *surface* of our globe." [15]

The methods by which these events were reassembled for the audience changed over time and even incorporated temporality as a design element; while early panoramas were premised on the idea of representing a single temporal and spatial situation (what a spectator would actually see were she situated at the center of a scene on a hill or on top of a tall building—what I call "naturalistic" panoramas), later panoramas, especially those concerned with depicting action, often constructed their scenes as "composite" views, combining discrete incidents from an extended battle or other events into an apparently 360-degree seamless visual field. There is thus a certain tension between the near perfect illusionism of the noncomposite, "naturalistic" 360-degree panorama and the edited composite view. While each of these distinct styles of panorama immerses the spectator in the view and has a quality of the cinematic about it, they evoke *ideas* of cinema and immersion in quite distinct ways, and rather than mimic cinema (how could they when it hadn't been invented) intriguingly preview a way of representing landscape and events that would surface again in the multi-edited film. If the "naturalistic" panorama remained faithful to Robert Barker's initial idea of circular "panoramic vision" in its foregrounding of spatial illusionism, the "composite" panorama included elements of multiperspectivism, narrativism, and selection of detail that audiences would go on to experience when cinema emerged. The sensa-

tion of immersion might also have operated differently in the naturalistic versus composite panorama, especially if the spectator of the composite panorama was expected to decipher the meaning of the different views from the pullout orientation map which helped observers identify specific points of interest via numbered items (fig. 2.4), while simultaneously looking at the painting. Orientation maps appeared on the inside covers of panorama booklets on sale at the exhibition site; the roughly 16 x 8 inch folded map could be pulled out for closer inspection of the enumerated points of interest, with the first item routinely appearing in the top left-hand corner (the panorama was always represented as two equal halves, one on top of the other). Reading the orientation map from left to right, spectators could find out more about each feature by turning the pages of the booklet to the section elaborating upon most, if not all, of the numbered items. [16] Combining a general introduction to the artist and subject with a legend that detailed each of the identified locales, these booklets, a cross between a conventional map and a tourist guidebook, often represent the best surviving records of the nineteenth-century panorama. Organizing the "views" as a series of attractions that should be seen in a specific order oriented or codified the ostensibly autonomous vision of the spectator by compiling a sequentiality reminiscent, in some ways, to viewing edited film images. Given we can never recover the nature of panoramic spectatorship for historical audiences, it is nevertheless important to raise the issue of the potential impact each type of painting might have had on spectators with regard to immersion. Another mitigating factor in the effectiveness of the immersive experience would have been the presence

1. Killah Shurah
2. Mountains of Kaffiristan
3. Bagh Aga Fakir; in front is a Huzara Husbandman
4. Bagh-i-Shah Ziman, or Garden of Shah Ziman
5. Village of Deh-i-Maran ; to the right of which is the Village of Khoja Ruwash
6. Quarter of the City called Deh-i-Aff bani, or the Affghan's Village
7. Bagh-i-Timour Shah, or Timour Shah's Garden
8. Killah, or Castle, of Jaffin Khan
9. Mountains of Taghau Sufi
10. Pahar, or Hill, of Deh-i-yaiya ; or Yaiya's Village
11. Bagh, or Garden of Husyn Khan
12. Kuzzilbash Killah R'
13. Castle of Mahomec han, containing the Commissa
14. Thung-i-Khar Defile f Charon
15. Iapa Maringan
16. Entrance to the Pas of Kh rd, or Little Cabul
17. Burj-i-Vuzeer, Pahlawan Khaneh or Court of Wrestlers
18. House of the Vuzeer Futti Khan
19. Chuman-i-Shahi, or King's Meadow
20. Mountain of Khurd, or Little Cabul
21. Parade Ground
22. House of the Nawab Jubar Khan
23. Palace of Timour Shah
24. Tope, or ancient Building, supposed to be the Tomb of Kadphises, an Indo Scythic Monarch
25. Range called Shakh-i-Baraata
26. Bala Hissar or High Fort
27. Tomb of Timour Shah
28. The quarter of the Town called Deh-i-Kalmuk, Village of the Kalmuks
29. Native and Armenian burial ground.
30. Pillar, called the Minar-i-Chakhri
31. Burgh or Tower of Ulako
32. Zearut, or shrine of Khoja Sufur, (the Saint of Victory.)
33. Bridge built by the Nawab Jubar Khan.
34. Quarter of the Town called Chundawul or Chandoo
35. Cabul River.

36. Hill of Khoja Sufur.
37. Hindoo Temple.
38. Pilgrim starting for Mecca.
39. Pass of Guzabjah.
40. Guzabjah Bridge.
41. Plain of Chehar Deh, or the four Villages.
42. Mountains of Kuruk.
43. Asha, or Assa Mahi Eve, the Mother of the World
44. Hindu Kosh, or Caucasus ; to the left are the Mountains of Pughmaa, and the Range known as the Paraparmissus of the Greeks
45. Mountains of Nejhau and Taghau
46. Native of the Khyber Pass
47. Cooking Kabobs ; to the right is a Horse of Dost Mahomed
48. Abdul Razaf Khan, Son of the Nawab Jubar Khan
49. Mortazu Khan, an old Kuzzilbash Servant of the Nawab Jubar Khan
50. Amir Khan, a Lohari of rank
51. A young Lohani
52. Abdul Rahin Khan, Son of the Nawab Jubar Khan
53. Suliman Khan, a messenger of Captain Wade's
54. Mahomed Ukhbar Khan, favourite son of Dost Mahomed
55. Hindoo Sepoys. The one in scarlet being a Syud or descendant of the Prophet, wears his cap as he pleases
56. Pir Khan Jemadar, or Captain of Artillery.
57. A defender of Ghuznee.
58. The Nawabs Musicians playing on the saringa, dokra, suntowa, and other instruments.
59. The Rajah of Tak Buno below Attok
60. Abdul Samud, a Persian General
61. Pilgrim from Kokan, on his way to Mecca.
62. Native of Badakshan.
63. Mirza Imaum Verdi.
64. Sir Alexander Burnes ; to his left is Capt ckovich, the agent from the Russ Ambassador at Herat.
65. Mirza dul Sameh Khan.
66. The N ab Jubar Khan.
67. Mr. N on.
68. Dost homed.
69. Abdu huneh Khan, and Abdul Gh Khan, sons of the Nawab.
70. Handing tea.
71. The Koh-i-nur (mountain of light) horse, brought to Lahore as a present to Runjeet Sing, during Sir H. Fane's visit.
72. Mr. Vigne.
73. Superintendant of the Nawabs Harem
74. A Kuzzilbash.
75. Making tea.
76. Chief Wrestler at Cabul.

Fig 2.4 Orientation guide of *A View of Cabul, the capital of Afghanistan*, which appeared at the Panorama, Leicester Square, in 1842. (Courtesy British Library)

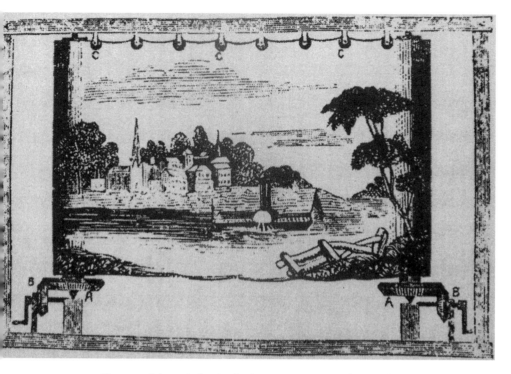

Fig 2.5 Schematic drawing for the moving panorama showing the canvas wound onto rollers and the winding mechanism indicated at "B" (c. 1880s).

was guided between two rollers before the viewer (fig. 2.5).[17] The canvas was framed by a proscenium arch, which varied in scale depending on the size of the painting. Originating in England as a theatrical attraction in itself or a feature of staged pantomimes in which background scenery would move to signify a journey,[18] the moving panorama was especially popular in the United States after 1846, when amateur scene painter John Banvard painted his giant panorama of the Mississippi River (fig. 2.6), which he claimed, in hyperbolic American style, to be three miles long.[19] Condensing days of actual travel time into an exhibition-performance of a few hours (Banvard's journey would have taken at least four days to complete by steamship), moving panorama paintings were either exhibited as one apparently continuous image, such as the banks of a river with occasional detours to river towns or Native American settlements, or as a series of separate scenes or "frames,"

of a lecturer, the norm in moving panorama exhibition and occasionally used in conjunction with circular panoramas. In this regard, such orientation guides fulfilled a similar function to intertitles and sequential tableaux one might find in early cinema reenactments.

An offshoot of the circular panorama was the moving panorama, in which a single continuous canvas 8–12 feet high and up to a thousand or more feet in length each displayed in the proscenium opening. River panoramas claimed less to represent the entire length of a river from start to finish in favor of highlighting the most picturesque aspects of the journey, which for Banvard usually meant representing Native American life. Selecting the highlights of the journey for visual representation on the canvas is akin in many ways to decoupage, where the filmmaker reassembles reality from temporally and spa-

tially distinct scenes. Closer to theatrical scene paintings (they were painted on distemper, a painting process used to create backdrops in which the pigments are mixed with an egg yolk emulsion) than to highbrow examples of fine art, the vast size of the painting necessitated broad brush strokes from which the spectator would have received impressions rather than details of the images represented on the canvas (parodied here in this *Punch* cartoon, fig. 2.7). Each of these frames contained a different scene or aspect of the route, which the lecturer would discuss as it was scrolled along the viewing frame; in the words of a contemporaneous *London Times* reviewer: "drawn along on two cylinders, a small portion [of the panorama was] exhibited at a time, so that the audience may imagine they are performing the journey along the river, especially as the illusion is heightened by diorama effects representing changes of the day."[20]

As a perceptual apparatus for framing human vision and immersing viewers in a scene, both the 360-degree and moving panoramas were frequently promoted with an appeal to the notion of the reenactment as a way of foregrounding the uncanny mimetic proclivities of the technology. Audiences, it was felt, would fully appreciate the illusionistic effect of the panorama only if its subject matter was ontologically linked to ideas of grandness and monumentality; in other words, the locations and events painted by panoramists had to resonate as suitable subjects for this epic mode of representation: "big subjects for big pictures." As avid consumers of both 360-degree and moving panoramas in the nineteenth century, when panoramas went in and out of fashion in the United States and Europe, audiences familiarized themselves with the

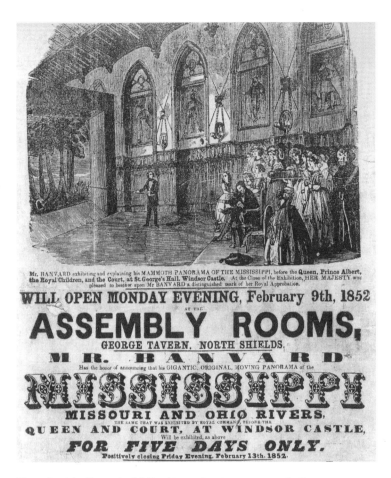

Fig. 2.6 John Banvard exhibiting his moving river panorama to Queen Victoria at the Egyptian Hall, London (1852).

Fig 2.7　Cartoon from *Punch* entitled "The Monster Panorama Manias," July 14, 1849, parodying the panorama painter. (Courtesy Guildhall Library, Corporation of London)

viewing protocols of a mass medium that didn't simply anticipate cinema but created the conditions of possibility for seeing the world either as an immense, immersive, illusion spread out before the eyes, as was the case in the naturalistic panorama, or as a seemingly whole, though actually fragmented, vision of reality as we find in the composite panorama.[21]

NINETEENTH-CENTURY BATTLE PANORAMAS: REENVISIONING THE PAST

One of the most popular genres of both circular and moving panoramas was the battle subject; as Dutch historian Yvonne van Eekelen has argued, "battle panoramas held an enormous appeal for the man in the street who liked to imagine himself being pitched into battle, crossing unexplored territories or stepping back into biblical times."[22] Yet the popularity of war as a panorama subject is not without irony, since of all the subjects available to panoramists, the battle seemed in some ways the least amenable to pictorial representation, given the abundance of action; as Evelyn Onnes-Fruitema and Paul A. Zoetmulder have noted, "the battlefield shows a tangle of moving soldiers and horses, whereas the immobility of 'moving' objects on the canvas disturbs the optical illusion."[23] There must therefore have been plenty in terms of spectatorial thrill to compensate for the stasis; perhaps the sense of being immersed in the middle of the battlefield which had by some miraculous power been suddenly frozen in time was affecting enough, especially when the lack of motion gave spectators the ability to scrutinize every detail of the surrounding carnage. Battle panorama spectators were obviously able to negotiate the peculiar blend of illusion and anti-illusion that greeted them in the panorama; immersion and spectacle were enabling forces that helped anneal the tension between credulity and incredulity.

Two main types of battle panoramas existed in the nineteenth century: illustrated newspaper panoramas, which depicted major news stories of the day and were exhibited mostly in purpose-built rotundas in European capitals, and national memorial panoramas, commemorative paintings celebrating victories that may have occurred many years prior to the picture's painting. According to Richard Altick, the democratizing conventions of panorama exhibition—in contrast to private galleries, anyone who could afford to pay the entrance fee and looked respectable could view the painting—played a major role in the rise of battle panoramas. While still of some public appeal, mythical, allegorical, and biblical subjects in England gave way to the depiction of major political and military events, such as the burning of the Houses of Parliament, which painter Charles Marshall constructed in one week,[24] the Coronation of King George IVth,[25] and the Battles of Waterloo, Sedan, Trafalgar, and Champigny-Villiers.[26]

Illustrated newspaper panoramas often appeared relatively soon after news of a major battle had reached the British shore; in 1801, English panoramist Robert Ker Porter painted the 270-degree *The Storming of Seringapatam* in a remarkable six weeks after reports of the battle reached Britain, in order to exploit topical interest in the event. (Porter used panorama inventor Robert Barker's term *coup d'oeil* to describe his painting, rather than "panorama," either because he wanted to differentiate his establishment from Barker's Leicester Square Panorama or because his paintings were never a full 360 degrees).[27] While it is unclear what sources Porter used representing the event in paint—most likely a combination of newspaper accounts, etchings, and verbal descriptions—he shared the arduous job of completing the scene with his 14-year-old apprentice William Mulready, whose job it was to paint the approximately 700 soldiers depicted in the panorama. Even though news of the British victory in southern India had taken months to reach England, Porter reacted swiftly with a panorama that might have had the same impact back then as today's 24-hour cable news in its ability to virtually transport spectators to the battlefront through a heightened sense of immersion and realism.[28] Reporting on the phenomenal popular success of the painting, the German magazine *London und Paris* stated that, "Those people were few in number who did not go several times to the Lyceum in the Strand to see the renowned painting of an unforgettable occurrence, for in addition to seeing accurate portraits of the main participants, almost all visitors were stirred by the sight of events on the subcontinent."[29] The idea of the repeat visit, the desire to witness again and again that which deeply moved or stirred one, is a conceit exploited by 24-hour cable news channels cognizant of the insatiable appetite viewers have for shocking or spectacular imagery, especially that from the war zone. For example, an opportunity to rebroadcast imagery of the events of 9/11 is seldom passed up by news organizations, even when there is little justification for showing the footage beyond some tangential link to terrorism, the NYFD, or public health concerns. Panorama exhibitors and painters were clearly cognizant of the significant public interest in topical subjects, plus the violent imagery made for a spectacular opportunity to showcase the new medium of the panorama.

Achieving overnight fame with *The Storming of Seringapatam,* Porter strove to repeat the success with other battle subjects and garnered a reputation as a painter of British military victories. Porter's second panorama, *The Siege of Acre,* painted in 1801, documented another recent British battle, Sir Sidney Smith's liberation of the British troops and their allies from Napoleon's army in Egypt. Explicitly signaling the status of this panorama as a reenactment, one reporter noted that

> To the extent that it is possible to re-create events on canvas, this picture succeeds in the opinion of knowledgeable visitors. . . . Go to the Lyceum at any time of day, and you will always find people there. Many go back to see the picture two and three times. The political importance of the event depicted, the variety of the scene, the enthusiasm with which the artist has painted it, and the great resemblance of the portraits to the participants in the battle have awakened an extraordinary amount of interest in the exhibit.[30]

Another example of the panorama-as-illustrated-newspaper-headline can be seen in R. Dodd's 1805 panorama, *View of Gibraltar and Bay,* which was exhibited at the Panorama in Leicester Square. The booklet accompanying the painting included an anarmorphotic drawing (bird's-eye view) in which sketches of the scenes appearing on the canvas were reproduced and numbered for further explication. Highlighting such notable events as the "Burning of His Majesty's Ships" and "Escape of the Grand Fleet from the Flames," the public was reminded that this panorama was "not so much in commemoration of that unfortunate event" but a demonstration of the "alacrity of the British seamen . . . [in] sending their boats to the relief of the distressed, and saving nearly the whole of the ship's company."[31] That panoramas such as these should have looked to the day's headlines for artistic inspiration should come as no surprise; there clearly would have been built-in public interest in having this military news from overseas dramatically visualized for patriotic citizens back home. Such nationalistic scenes also furthered the interests of the State, helping to secure public support for British naval operations and imperial adventures.

Audiences attending the typical nineteenth-century battle panorama would not only have been entertained by the spectacular painting but also interpellated into the roles of historical witnesses or war reporters via the subject matter and immersive mode of address. The ability to reexperience an event of enormous national significance, to step inside history, which was metaphorically enacted via the spectators' physical location and locomotion around the central viewing platform, was doubtless intended to trigger feelings of nationalistic fervor for early-nineteenth-century spectators. As Stephan Oettermann points out, Porter played a major role in popularizing the battle panorama and achieved recognition for his ability to transform major military events of the day into dramatic pictorial reenactments.[32] The propagandistic content and spectatorial address of Porter's panoramas cannot be underestimated; displayed in the commercial and political center of the world's foremost colonial power, the panoramas of military victory and colonial reign served

to enhance public support for empire by their transformation of war into visual spectacle. Lord Nelson said he was indebted to Barker for "keeping up the fame of his victory in the battle of the Nile for a year longer than it would have lasted in the public estimation"; indeed, the *Panorama of Waterloo* (1815) was so successful that Barker was able to retire from panorama painting and live off the profits generated from the painting.[33] This ideological role of the relatively rare contemporary panorama continues today; Onnes-Fruitema notes that eight of the ten panoramas constructed since 1960 portray patriotic national battles.[34] That panoramists should have turned to the day's headlines for inspiration is hardly surprising if we consider the role of anticipation in raising audience expectation and even shaping the experience. Whether battle panoramas were experienced as even more spectacular than other subjects is hard to ascertain; if the reviews are anything to go by, one definitely senses that the hype is ratcheted up even higher in the case of the battle subject.

SHIFTING STYLES: MULTIPLE PERSPECTIVES AND THE EMERGENCE OF THE COMPOSITE VIEW PANORAMA

Facing competition from moving panoramas and dioramas, by the 1840s circular panorama painters may have felt compelled to introduce more narrative incident and dynamism into their work since by now the medium had been around for over fifty years, and the novelty of the naturalistic, 360-degree static scene may have worn off.

What this meant in terms of spectacle and immersion is harder to ascertain, since reviewers for the most part still alluded to the panorama's heightened verisimilitude and sensationalism. One new feature of these composite panoramas, where images from various aspects of a culture or location are blended into a single view, is the increased emphasis on the idea of *action*, which reviewers often considered a benchmark of quality in panorama painting, as seen in this review of the Battle of Waterloo from the London *Globe*: "Few spectators can stand on the Central Platform and look out, without occasionally fancying themselves spectators of a *real action*."[35] The decision to combine general topographical views of the battlefield with representations of noteworthy military figures is vividly illustrated in Robert Burford's *View of the Battle of Sobraon, with the Defeat of the Sikh Army of the Punjab* (also appearing at the Panorama in Leicester Square) (fig. 2.8). In the panorama's orientation map (fig. 2.9), the action is represented on two levels, although the painting itself would have been viewed as one continuous image. In both the map's top and bottom levels we see distant Sikh villages, along with British and Sikh cavalry and guns; we are also presented with a high-angle view of the British and Sikh artillery on the page immediately following the orientation map. The events unfolding in the panorama seem to represent the battle as it played out in its entirety; the labeling of background features, which are almost too small to discern on the map, also gives the impression of lateral as well as horizontal movement and action. Identifying important Sikh and British personages by name, the panorama offers a narratively complex, even

DESCRIPTION

OF A VIEW OF

THE BATTLE OF

SOBRAON,

WITH THE

DEFEAT OF THE SIKH ARMY

OF THE

PUNJAB,

NOW EXHIBITING AT

THE PANORAMA, LEICESTER SQUARE.

———————

PAINTED BY THE PROPRIETOR, ROBERT BURFORD,

ASSISTED BY H. C. SELOUS.

———————

LONDON:

PRINTED BY GEO. NICHOLS, EARL'S COURT, LEICESTER SQUARE.

1846.

Fig 2.8 *A View of the Battle of Sabraon*: panorama poster (1846).
(Courtesy British Library)

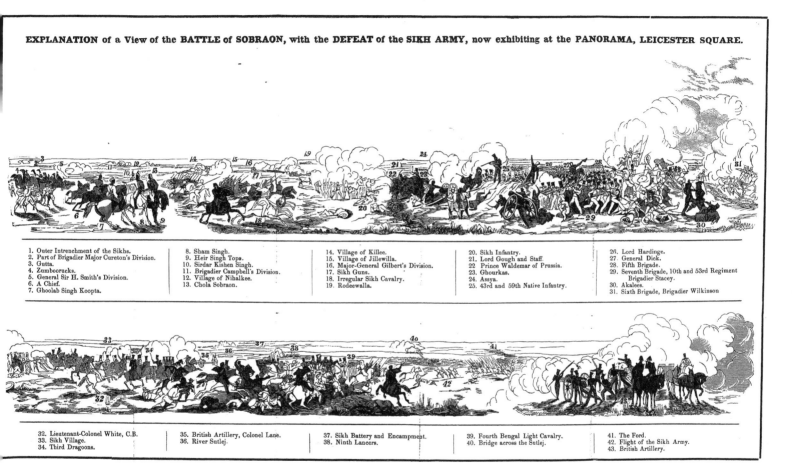

Fig 2.9 Orientation guide for *The Battle of Sobraon* (1846). (Courtesy British Library)

chaotic, representation of the battle, with Sikh and British artillery forces conjoined in episodes of conflict along both horizontal and lateral planes. While the panorama's orientation guide identifies scores of specific features in numbered sequence, the labels do not appear to follow any logic beyond their spatial arrangement on the canvas. For those spectators who had purchased an orientation guide before (or even after) entering the panorama, identifying all the features on the painting would have been onerous to say the least (there are 43 in total), although as a keepsake of the panorama visit the brochure itself was probably designed as much to be perused at home as serve as a guide during the actual viewing.

This ordering and labeling of locales and personages suggests that, conceptually at least, spectators were meant to view the painting with this narrative logic in mind and discover the numbered items in turn, as seen in the orientation guide of Robert Burford's *Description of a View of the City of Nanking, and the Surrounding Country,* which appeared at the Panorama in Leicester Square in 1845. The guide thus serves both to orient the spectator to the general location *and* direct his / her gaze across the painting in a left to right (clockwise) manner. Without stretching the analogy too far, one might argue that the spatial and temporal sequencing indicated on the map is in some ways analogous to early travelogues' use of establishing landscape shots, followed by medium long shots of the surroundings such as buildings, and finally, medium close-ups or close-ups of the metonymically rendered native peoples. In Burford's painting, after presenting the landscape and buildings in ascending numerical order,

we are introduced to such dignitaries as The Chief (no. 29), Chinese Gamblers (no. 30), Nieu Kien, Governor of Nanking (no. 33), and so on, until we finally arrive at the principal event, a meeting between "Her Britannic Majesty," the commanders in chief of the army and navy, and the three Chinese imperial commissioners. While a cinematic rendition of these sights would have been marked by cuts indicating spatial and temporal ellipses, the panorama is marked by a textualization premised upon a similar idea of ellipses, although in contrast to the edited film the only seams (barely) visible in the panorama painting would be where the canvas was cut for transportation to a new exhibition site. In other words, chances are that visitors to Burford's *Nanking* panorama would have realized that this painting was a composite view of Nanking, rather than a naturalistic, 360-degree view (in case there were any doubt, the orientation guide stated that "no such meeting [had taken] place precisely on the spot represented"). Burford defended his composite strategy by arguing that the technique afforded "an opportunity of presenting portraits of the principal persons engaged in the negotiations, and, at the same time, a characteristic and lively picture of the costume and customs of this singular people. . . . It has been introduced on a portion of the Panorama, not otherwise occupied by an object of particular moment," Burford said.[36] Immersion in the 360-degree space was insufficient to draw and retain an audience, the fear being that the "dead space" in portions of the canvas with little visual interest might lessen the overall impact of the painting. Perhaps as a way of alleviating boredom or injecting the panorama with topicality

and cultural specificity, Burford brought the spectator in for a closer view of Nanking life, identifying key personages by name. Ironically, what Burford was actually doing is reminiscent in some ways of today's digital special effects; by inserting personages into scenes where they never existed and creating composite views of geographical locales, Burford evinced a sophisticated grasp of how space and time can be manipulated on the canvas while giving the impression of a seamless 360-degree view.

And yet the panorama's blending of the topographical with the anecdotal threatened to undermine the very laws of verisimilitude governing it. While Burford was sensitive to issues of historical realism underpinning the panorama, he nevertheless saw in the composite view the potential for greater audience engagement and interest, and, with this in mind, created a more immersive depiction of life in Nanking and its environs. As the panorama form evolved, it prepared spectators for a more fragmented way of seeing the world, a more modern perception influenced by illustrated newspapers and the public's interest in seeing the key players and places making history; in theater historian Martin Meisel's words, "a temporal element might come into play through the discrete incorporation of successive phases in the scene, in spite of the presumption of synchrony."[37] Constructing a composite rather than a geographically accurate 360-degree view, Burford rejected the panorama's foundational premise, the idea of a circular view of a single location; but Burford must have considered this a reasonable trade-off, given that audiences would have enjoyed the panorama effect even if what they were seeing did not propose a single, hermetically sealed view.

Anecdotal battle scenes thus assumed a metonymic relationship to the battle as a whole, with the common soldier and a heightened attention to realist detail becoming increasingly important; as art historian Peter Paret notes, "changes in warfare, changes in aesthetic theory and taste, the new importance of the common soldier, all affected and gradually altered the character of battle paintings."[38] Metonymy allowed artists to paint an impressionistic scene, a synthesis of key historical events that would never have occurred in reality; audiences may or may not have caught on to this strategy, although for our purposes the issue is less about the organization of the panorama than about what impact these two different types of panoramas may have had on spectatorship. Before turning to that matter, it's worth noting that moving panoramas had far fewer problems condensing events into a continuous sequence, given their linear structure. For example, a moving diorama exhibited at the Rotunda in Great Surrey Street, London, represented "all the Great Events that have occurred during the Greek War" (books providing a history of the war were on sale for 6 pence and music began playing 15 minutes before the start of each exhibition),[39] whereas in *Mr. Charles Marshall's Great Moving Diorama Illustrating the Grand Route of a Tour Through Europe*, which appeared at Her Majesty's Concert Room in 1851, audience members were informed that the purpose of the diorama was to "reproduce in a series of pictures . . . the most striking and memorable scenes which are thus so frequently visited and well known."[40] But what evidence do we have for the way audiences responded to different types of panoramas, and, on a more general level,

what role did gender, age, or other demographic variables play in the overall experience?

LIFE ON THE VIEWING PLATFORM: GENDER AND PANORAMA SPECTATORSHIP

The viewing platform was an important element in the hyperrealism of the nineteenth-century battle panorama; the journey from the darkness of the corridor and staircase that led up to the brightly lit belvedere signaled the start of a perceptual shift in which spectators measured the success of a painting against a set of preconceived ideas (whether or not they had ever witnessed it first hand—unlikely in the case of a battle—or had seen representations of it). While contemporaneous reports of the experience of spectators looking across the vast painting are obviously impossible to generalize upon, van Eekelen argues that for some spectators the illusion may have become "unbearable," forcing them to leave the painting sooner than they had intended. There are numerous accounts of nineteenth-century spectators becoming faint or dizzy when looking at a panorama—a foreshadowing of apocryphal accounts of spectators ducking in their seats at the sight of an oncoming train in the Lumière Brothers' 1895 *Arrival of a Train*—even suffering from airsickness, as in the still-extant *Panorama of Thun* (1814).[41] Newspaper accounts went so far as to advise ladies of a nervous disposition to be on their guard when viewing panoramas lest the experience become overwhelming, although men, too, were not immune from the effects of motion sickness, as seen in a cartoon entitled *Le Panorama du "Vengeur,"* which shows what looks like a naval officer and

other dignitaries suffering from seasickness on a viewing platform designed to resemble the poop deck of a ship (fig. 2.10). (It's worth mentioning that when a prototype for IMAX film was first developed at Expo 67 in Montreal, officials feared that the physiological effects of the experience might be so intense that "overwhelmed audience members might suffer nervous breakdowns and heart attacks").[42] If the gendered nature of panorama reception is suggested in these scraps of historical ephemera, it may be worth posing some more specific questions about gender, war, and vision. For example, was the elevated point of view, the immensity of the canvas (the *Siege of Acre* was reportedly painted on 3,000 square feet of canvas),[43] and the spectator's sense of mastery in surveying such a scene experienced in the same way by men and women? Would female spectators (and many men for that matter) with no firsthand experience of the battlefield have responded to the reenactment genre in the same way as male veterans? Would the epic and aesthetic qualities of the battle reenactment have resonated as much (or perhaps even more) for women viewers than men (if the above cartoon is anything to go by, men, it would seem, were suitable targets for parody)? Was the battle subject itself a male-oriented genre, or was the viewing platform a social space little marked by gender?

What is known about nineteenth-century panorama exhibition is that women and children made up a large part of the audience, especially during the workweek daytime when attendance was generally lower. Virtually all the extant panorama promotional materials I have come across list a child's entrance fee, indicating that children, accompanied by women (or possibly alone if slightly older and seemingly not rowdy), were considered an important

viewing constituency. There is also some evidence of women's perceptions of war, especially during the Crimean War of 1853–1856. Women were not only central catalysts in ushering in new standards of medical hygiene and hospital management during this war (Florence Nightingale was pivotal in this respect), but they were also firsthand witnesses of some of its major battles, climbing up on the sides of hills to obtain bird's-eye views of the front line—direct correlatives, one might argue, of the elevated vision facilitated by the panorama.[44] And yet, for the most part, women have been denied firsthand experience of war, as Jean Gallagher has argued in her study of the construction of female visuality in the two World Wars. According to Gallagher, vision has always been one of the "crucial elements that has traditionally marked the gendered division of war experience: men 'see' battle; women, as non-combatants *par excellence,* do not."[45] One cannot help but wonder, then, how women's status in war as non-combatants inflected their experience of the battle panoramas of the nineteenth century. One possibility is that the presumed interests of female viewers were addressed by the subject matter of smaller panoramas that were occasionally exhibited in an upper rotunda in the same building, as seen in the case of Robert Barker's double-decker Leicester Square

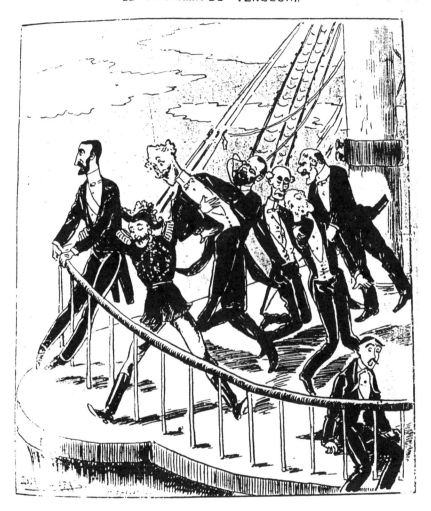

LE PANORAMA DU "VENGEUR,,

Fig 2.10 *Le Panorama du "Vengeur,"* cartoon showing effects of seasickness (c. 1880s). (Courtesy Mesdag Panorama, The Hagne)

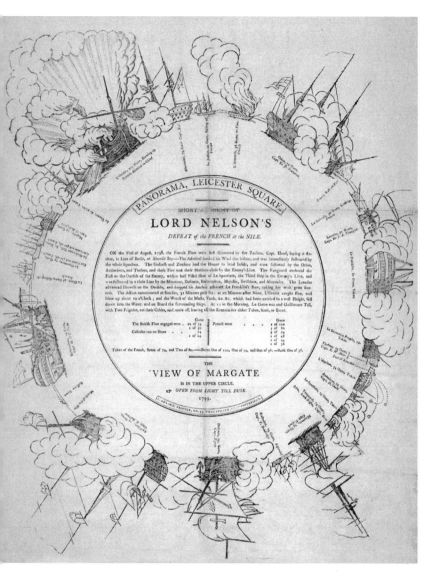

Panorama building in which a view of Margate was exhibited in the upper circle of the Panorama building (the then-fashionable seaside resort which had gained notoriety from the gossip columns of newspapers) and *The Battle of the Nile* panorama in the main rotunda located underneath (fig. 2.11).[46] While it may be tempting to view this setup as consanguineous with the cinema's short film appearing before the feature, in the case of Barker's rotunda we have no evidence of whether audiences would have had a say (or particularly cared) which painting they saw first. Nevertheless, there is a striking contrast in the subject matter of the two paintings, suggesting that panorama impresarios were not only sophisticated promoters of their artistic wares (placing a smaller and less sensational panorama in the same building as an epic one may have heightened audience reaction to the more spectacular of the two paintings), but found creative ways to leverage the maximum sensory appeal of the phenomenon itself.

Perhaps as way of catering to the possibly differing tastes of male and female panorama-goers, panoramic paintings may have been held to different standards of social and moral propriety when it came to graphic imagery than to other art forms such as the theater; in other words, women and children may have had fewer qualms viewing battlefield carnage in a painting than they would in less salubrious surroundings. Eschewing sweeping generalizations about panoramas and the female specta-

Fig 2.11 Anarmorphotic orientation guide to the 1799 panorama *The Battle of the Nile* (the *View of Margate* panorama appeared in the upper circle) showing Lord Nelson's defeat of the French. (Courtesy Guildhall Library, Corporation of London)

tor, there is nonetheless a surprising gendered dimension to the melodramatic structure of feeling shaping a great deal of writing about panoramas in the early nineteenth century. Submitting oneself to the trompe l'oeil effects, while not strictly gendered as an activity, nevertheless invites a cognitive dissonance that women, given the nature of their lives in the late eighteenth and nineteenth centuries, may have accepted more readily than men (one could argue that the tension between work and motherhood has never gone away). While genres of fantasy and escapism have been traditionally associated with women, panoramas nevertheless invited men as well as women to submit themselves to its magical spell. At the same time, if this description of Robert Barker's 1799 re-creation of *The Battle of the Nile* depicting a decisive battle between Napoleon's French fleet and the Royal Navy under Admiral Nelson in Abukir Bay at the mouth of the Nile is anything to go by (it is where the title of this book comes from), women may have found the graphic imagery harder to stomach than men:

> As soon as you enter a *shiver runs down your spine.* The darkness of night is all around, illuminated only by burning ships and cannon fire, and all is so deceptively real . . . that you imagine you can see far out to sea in one direction and the distant coastline in the other. . . . And if the whole scene is terrible, still it is the fate of the *Orient* that arouses the greatest horror: a ship with 120 guns . . . filled with gunpowder and flammable material, with its entire crew on board. . . . Perhaps no words can fully convey an impression of this inferno. . . .

Clinging to the masts and yardarms in desperate contortions are the poor sailors; some have been torn to pieces and catapulted into the air by the explosion; heads, limbs, cannon mounts, yards, masts, muskets, crates, shreds of ropes and all the other contents of the ship rain down on all sides.[47]

Not for the faint of heart, this panorama clearly went for the shock value of the battlefield carnage to convey the realism of the scene. According to Paret, the shift from idealization toward topographical accuracy in easel paintings of battles of the early nineteenth century gave audiences a much more realistic impression of the horrors of war (Paret notes that, in portraits of both military heroes and mass combat, artists began to emphasize the human costs of war).[48] But while the death of a military hero was often seen as the perfect vehicle for nationalist propaganda, verisimilitude went hand in hand with a healthy dose of spectacle, as Benjamin West, who had painted *The Death of General Wolfe* in 1770, observed at the time: "Wolfe must not die like a common soldier under a bush, neither should Nelson be represented dying in the gloomy hold of a ship, like a sick man in a Prison Hole." According to West, "to move the mind there should be spectacle represented to raise and warm the mind. . . . A mere *matter of fact* will never produce this effect."[49] Whether women would have responded to this graphic realism and emotional appeal in ways differently to men is impossible to know; men certainly worked in more occupations that would have given them privileged access to the bird's-eye or immersive view associated with the panorama; *The Panorama of London,* a circular painting

of the city as seen from the top of St. Paul's cathedral, provided a view that roofers, chimney sweeps, and builders might have experienced but not your average woman. The panorama therefore evinced a gendered address only in so much as it reproduced sights that men were more likely to have experienced firsthand than women—the Grand Tour for wealthy gentlemen would doubtless have included several of the same famous topographical scenes—and yet by the end of the nineteenth century, far more women could have drawn upon firsthand experiences of these locales as travel opened up to a wider swath of men and women.

THE NATIONAL MEMORIAL PANORAMA:
THE BATTLE OF GETTYSBURG (1884)

If issues of gender are informing but not critically divisive contexts in the panorama experience, how else might the experience be understood? Taking a closer look at the *Battle of Gettysburg* cyclorama (the preferred term for circular panoramas at this time), which opened in a rotunda in Boston in 1883 and is one of only three extant panoramas in the United States (there is another panorama in Atlanta and a much smaller painting at the Metropolitan Museum of Art in New York), might shed light on how the panorama was designed to be experienced as a form of visual spectacle. Painted by French artist Paul Philippoteaux, copies of the original cyclorama opened in Chicago and Philadelphia and the panorama was so successful that Philippoteaux was commissioned to paint a second, which is the one currently on display at the Gettysburg National Military Park (fig. 2.12). What the surviving information

on this panorama reveals is that visiting this battle subject was definitely considered a suitable form of immersive family entertainment (if this poster for *The Battle of Gettysburg* from Union Square, New York City—where one of the paintings obviously toured—is typical, the admission charge was 50 cents for adults, 25 cents for children) (fig. 2.13). Unlike his English counterpart Porter, who rushed to bring images of the Indian, Egyptian, and Napoleonic wars to the panoramic canvases of London, Philippoteaux approached his subject matter in a more leisurely fashion, spending several months on the battlefield of Gettysburg in 1879 making sketches, tracking down official military maps in Washington, D.C., obtaining firsthand accounts of the battle from Generals Hancock, Doubleday, and others, and even hiring a Gettysburg photographer to take panoramic photographs.[50] Philippoteaux's panorama was a much larger undertaking than those of Porter: instead of 3,000 square feet, Philippoteaux's measured 20,000 square feet, and in addition to daytime operation, the panorama was illuminated at night by hidden electric lamps.[51]

Descriptions of the painting in the panorama's accompanying booklet and in press reaction to the original *Battle of Gettysburg* Chicago reception indicate that this panorama was conceived of as a reenactment of the Gettysburg battle. A review in the *Chicago Tribune* makes explicit reference to the panorama's organization of the visual field as dynamic and as capable of representing an event *as it happened* and along several visual planes:

The battleground, with its dead and wounded soldiers, the smoke of cannon, the bursting of shells,

the blood stained ground are all drawn with a realism that is almost painful. The spectator can almost imagine that he hears the rattle of musketry and the brave regiments as they charge upon each other to sink amid the smoke and carnage. . . . Standing on the little platform, the spectator seems to look out for miles upon a stretch of cornfields and farms. . . . [And yet] the countenance[s] of some of the leading generals of both armies are veritable portraits, and the disposition of the contending regiments and the thrilling action of the great battle are reproduced as if by magic.[52]

Given that the painting could never be regarded in exactly the same way as cinema—the represented scenes were not viewed autonomously, and while the guidebook accompanying the panorama encouraged spectators to view the painting sequentially, this was by no means an ironclad requirement—it nevertheless gave spectators the impression of different perspectives of the scene, the distant images of the cornfields and farms juxtaposed with the seeming proximity of the generals, whose faces we can see. Dominating the trompe l'oeil was the *faux terrain* (seen under construction in fig. 2.14), the horizontal space between the canvas and the viewing platform, which would be filled with *attrapes* (hoax objects) appropriate to the subject matter of the painting. Faux terrains were constructed by specially recruited theater designers who

PRICE ---- FIVE CENTS.

THE BATTLE OF GETTYSBURG

THE NATIONAL PANORAMA COMPANY.
EMILE GLOGAU, Manager.

Fig 2.12 Frontispiece of guidebook *Panorama of the Battle of Gettysburg* (The National Panorama Company, W. J. Jefferson, Printer & Publisher, Chicago, c. 1884).

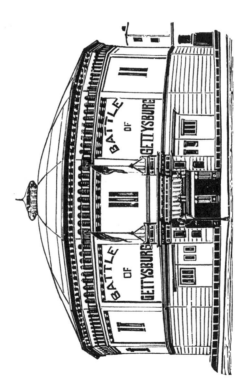

THE GREATEST WORK OF THE CELEBRATED FRENCH ARTIST,

PAUL PHILIPPOTEAUX.

Battle of ✻ ✻ ✻ ✻ Gettysburg,

UNION · SQUARE, · NEW · YORK,

(Fourth Avenue, 18th and 19th Streets.)

Open from 9 A. M. to 11 P. M. Sundays Included.

— ADMISSION —

ADULTS, 50 CTS. CHILDREN, 25 CTS.

PRESS OF BROOKLYN DAILY EAGLE.

Fig 2.13 Poster for the *Panorama of Gettysburg*, Union Square, New York City (1895). (Courtesy New York Historical Society)

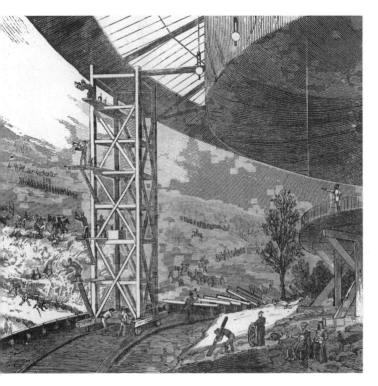

Fig 2.14 Faux terrain seen in lower right portion of image of Paul Philippoteaux directing the artists in his *Battle of Gettysburg* panorama (1883). (Albert A. Hopkins, *Magic Stage Illusions, and Scientific Diversions* [New York: Munns, 1891])

Fig 2.15 Illustration of 3-D effect in *Gettysburg* panorama using wooden figures and props that protrude from the canvas. (Albert A. Hopkins, *Magic Stage Illusions, and Scientific Diversions* [New York: Munns, 1891])

aimed to minimize the optical disjuncture between 3-D foreground and 2-D painted background, as seen in this illustration from *The Battle of Gettysburg* (fig. 2.15).[53] The faux terrains of panoramas were often singled out by critics as a marker of success as seen in the *Battle of el Kebir*

panorama displayed at the National Panorama in London in 1883; according to the *Daily Telegraph,* "the spectator is impressed by the completeness of an illusion, sustained by a skillfully contrived foreground, giving to a semblance of the horrors of war an aspect of grim reality." [54] In the

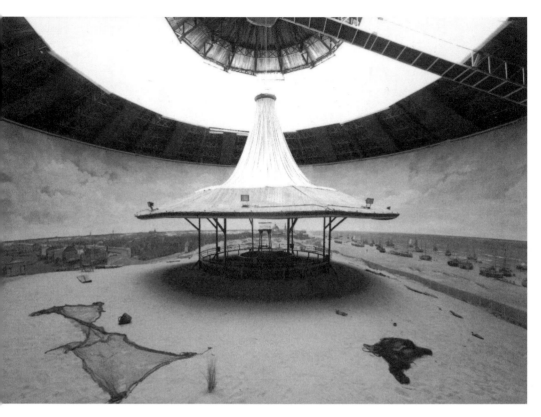

Fig 2.16 Hendrik Willem Mesdag Panorama in The Hague (1881), one of the few extant nine-teenth-century panoramas, showing the vellum canopy above the viewing platform. (Courtesy Mesdag Panorama, The Hague)

painting in such a way as to eliminate all signs of the presentational apparatus. As one author noted almost forty years before Mesdag painted his panorama,

> [A]n attentive observer will see that everything is removed which can tend to break the spell, to dispel the illusion, under which the senses temporarily lie; we are not permitted to see the top of the picture, nor the bottom of the picture, not the skylights; nor are any objects allowed to intervene between the spectator and the painted wall. We have therefore no standard with which to compare the picture, and thus it ceases to appear like a picture.[55]

This idea of spectators having "no standard with which to compare the picture" contributes in no small way to the sensation of being immersed in the scene, since eliminating reference points that might undermine the illusion is the first step in creating the sensation of having traveled back in time to witness "Pickett's Charge," the climactic Confederate attack on the Union center that took place on July 3, 1863. In Philippoteaux's Gettysburg panorama, the space between the viewing platform and the

case of Hendrik Willem Mesdag's 1881 panorama of Scheveningen (fig. 2.16), the heightened reality effect achieved by introducing three-dimensional foreground objects such as the sand dune, fishing baskets, and tufts of wild grass was reinforced by carefully framing the

canvas was carefully arranged with earth, lumber, trees, fence rails, bushes, logs, and camp equipment, merging with the tones and depicted scene of the painting in an attempt to create a unified visual field. A report on the panorama in *Scientific American* described how through the use of "real trees . . . shrubbery, portions of fences, and the like . . . a genuine landscape is produced."[56] The effect, one reviewer argued, "taxe[d] the ingenuity of the looker-on to tell where the real ends and where the work of the brush begins."[57] The deception of scale was so convincing that some spectators were surprised to discover that the largest depicted human figures, which appeared life-size, were in fact between three and four feet in height.[58] Vouching for the credibility of the foreground props, the *Scientific American*'s critic underscores the higher truth quotient afforded objects versus images—a tension that plays out starkly in the natural history museum when artifacts gathered in the field are exhibited alongside contextualizing photographs (as we shall discover in part 2 of this book). Yet the theatricality associated with this staging mitigates against its status as high art; to add real objects to art nudges the representation over the edge, turning it into crass spectacle in the minds of contemporaneous artists such as John Constable, who believed that the hyper-realist effects elevated deception above art. According to Constable, the panorama painter viewed "nature minutely and *cunningly*, but with no greatness or breadth."[59] While the inclusion of 3-D into the optical field of the Gettysburg panorama may have represented a distinction from cinema, audiences would have been thoroughly familiar with perceiving the American Civil War in 3-D as a result of the surfeit of stereoscopic slides produced of the event, es-

pecially since, by 1870, stereoscopes were present in most middle-class family parlors.[60]

Given the immersive and spectacularizing tendencies of the panorama, appreciating its symbolic monumentality was less of a challenge for audiences than deciphering the location and meaning of its seminal highlights. As the preeminent American battle panorama—the death of Lieutenant Cushing can be seen in the foreground of the panorama while the viewing platform represents the center of the Union line[61]—Philippoteaux's painting points up the reenactment's fundamental paradox, that notwithstanding how faithful a facsimile it claims to be, it can only ever produce a *rendition,* a version of the original that always runs the risk of slipping back into a fictional mode. As van EeKelen argues, "no matter how convincing the spatial aspects of a panorama, or how irresistibly the horizon draws us toward infinite distances, we can never completely ignore the actual surface of the canvas, if only because all movement on it has been frozen."[62] As an absent presence the panorama thus oscillated between being lifelike and drained of life as a result of its stasis; its mimeticism was always undercut by spectators' foreknowledge of its gimmickry, what we might call the "panorama effect" (the same can be said of cinema). Ironically, a visit to the *Battle of Gettysburg* panorama in the early part of the twenty-first century constructs an experience quite different from that of the late nineteenth century (as I write, the panorama building is under renovation so what follows is tentative—based on a visit in 2005—and subject to revision when the building reopens). Rather than enter a brightly lit rotunda from a darkened entrance way or ramp, spectators now enter a semidark viewing paltform

to experience a timed slide show, in which a male prerecorded voice delivers a lecture on different sections of the canvas.[63] The "show" more closely resembles the edited structure of film rather than a panorama, especially when Pickett's Charge, the decisive action that took place on the afternoon of the third day of the battle, is transformed into a series of photographic highlights.[64] The panorama is therefore only experienced as an evenly lit, 360-degree painting for a few minutes at the very end of the show with the house lights on; visitors are then brusquely instructed to leave the rotunda so that the next group waiting at the bottom of the spiral entry platform can begin to ascend. Giving spectators only a brief time to walk around the central viewing platform at the end—a time, we are told, when photographs can be taken—while necessary because of the ticketed admission, sadly undermines the very "panorama effect" that would have drawn audiences to the painting in the first place.[65] Let us now turn to the second group of panoramas, "sublime vista" paintings, to consider how they contribute to the panorama's legacy as one of the most immersive pre-cinematic media of all time.

"SUBLIME TRIUMPHS OF ART": RIVER PANORAMAS AS METAPHORICAL REENACTMENT

The river comes to me instead of my going to the river.
—Henry Wadsworth Longfellow (1846) [66]

As one of the most popular subgenres of American panoramas in the early to mid-nineteenth century, river panoramas differed considerably in presentational style from 360-degree panoramas, and the sensation of immersion was doubtless experienced differently, especially when we consider that audiences sat in front of the painting as opposed to walking around its center; these were *moving* panoramas, long strips of painted canvas that were gradually unfurled from one roller to another.[67] In order to hold the interest of American audiences, who were less taken with European history and ancient antiquities, and "relieve the monotony of the long, continuous river banks," in the words of Joseph Earl Arrington, river panoramists often included scenes of vessels, Native American life, and, in the case of John Stockwell, views of the river "under various aspects, by moonlight, at sunrise, during storms, and in fogs, and with the most picturesque effects." [68] While the spectator of the circular panorama would be quite literally surrounded by the painting, viewers of the moving panorama sat before an ambulatory painting in reception conditions that more closely resembled a concert or cinema.

Described by art historian Wolfgang Born as a "pictorial epic," the river panorama's most distinctive feature was its movement, which gave audiences the sensation of viewing a constantly shifting landscape; in the words of one critic, "you flit by a rice swamp, catch a glimpse of a jungle, dwell for an instant on a prairie, and are lost in admiration at the varied dress, in which, in the Western world, Nature delights to attire herself." [69] Like panoramas of antiquities or modern metropoles such as London or Paris, panoramas of landscape or natural wonders such as gigantic rivers privileged a mode of spectating in which viewers abandoned the spatial and temporal coordinates of the outside world and, for the duration of the exhibi-

tion, entered into an implied contract with the artist: for the price of admission, spectators would be metaphorically transported to the scene of the painting and become enraptured with its inalienable lifelike quality, or so the publicity promised.[70] This contract required that the panorama be seen not necessarily in the same way as a traditional painting or even theater, but as a trompe l'oeil effect that gained in illusionism what it may have lost in attention to artistic detail (according to contemporaneous reviews, the paintings shared more in common with scenic backdrops than traditional landscape painting, hardly surprising given their length).

The problem of vision in painting, the creation of perspective and delimitation of a view, had received a great deal of attention in the context of landscape painting since 1800, the landscape sketch becoming in art critic Peter Galassi's words "a ready vehicle for experiments in realism."[71] The interest generated by the landscape painting (particularly in oil) around the turn of the eighteenth century undoubtedly played a key role in the emergence of the panorama as a pictorial convention that, like landscape painting, lacked the status of "high art" but nevertheless drew attention because of its hyperrealism. This argument, of course, has a familiar ring to it, since it was also made in relation to photography; as Angela Miller argues, "The advancing frontier of illusionistic representation in the nineteenth century provoked concern over the very definition of art and the panorama's contested claims to artistic status, doing so in a manner that anticipates a century of debate over the artistic value of photography, then film, video, and electronic media."[72] While space precludes detailed analysis of the impact of photography upon panoramas, suffice it to say that panoramic vision (if we can call it that) inspired a number of late-nineteenth-century photographers to shoot 360-degree views of cities, and, following in the footsteps of Banvard and his river panorama cohorts, to photograph river banks in their entirety.

Another way of immersing audiences in the panorama experience was to exploit its illustrated newspaper function, something John Banvard discovered with his Mississippi painting. According to John Hanner, the Civil War brought renewed interest in Banvard's Mississippi panorama, leading Banvard to substitute the Ohio and Missouri sections for "new naval and military operations" on the Mississippi.[73] Rival river panoramist Henry Lewis also used his panorama to respond to local events, adding a panel showing the great fire of St. Louis, and, as we shall see below, Godfrey N. Frankenstein, painter of the Niagara Falls panorama, revised his moving panorama to reflect newsworthy events, such as a fatal accident at the Falls.[74] That Banvard had few qualms replacing river sections with current events suggests both the panorama exhibitor's need to draw new audiences (and entice back regulars) and the panorama's intermedial status as both art and illustrated newspaper. It is yet more evidence of the novelty effect of the panorama having worn off and exhibitors anticipating audience demand for scenes of topical interest; simply *being there* no longer cut it with audiences who came to expect some additional bang for their buck. It may also be worth pointing out that panorama exhibitors' reordering of sections of the painting anticipates in some ways early cinema showmen rearranging the order of their films in order to construct a

narrative or to respond to topical events or the interests of a particular audience.

Panoramas thus opened up the privileged art world to a broader cross-section of nineteenth-century society. As Altick explains, "The panorama's claim to dignity as a quasi-cultural institution and to patronage as a respectable alternative to the theater lay in its vaunted educational value. It was one of the several nineteenth-century commercial enterprises that were dedicated, on paper at least, to the dissemination of useful knowledge."[75] This is seen in an advertisement for Sinclair's *Grand Peristrephic or Moving Panorama of the Battle of Waterloo,* in which audiences were told that it was "nothing of a theatrical exhibition, so that no religious scruples need prevent any from visiting it."[76] Souvenir handbooks, such as an 1848 one for the Colosseum panorama *Paris by Night,* which in addition to providing historical background on countries had information on indigenous customs and anarmorphotic reproductions of the panoramas, can be considered the eighteenth- and nineteenth-century equivalents of today's educational study guides for IMAX films such as *Across the Sea of Time* (Stephen Low, 1995), a film discussed at length in the following chapter. Of course, the impermanence of panoramas—like other more certified art objects, they were never expected to be preserved—ultimately restricted their ability to convey lasting "truths" about history or geography; as virtual geography field trips or magnified history-book illustrations, they might be interesting to look at once or twice but had limited appeal as permanent entertainments. Charges of boredom became something of a refrain in some spectator accounts of panoramas, especially moving ones which seemed to take an interminably long time to unfold; however, an anonymous writer contributing to *All the Year Round* in 1860 felt as much, if not more, sympathy for the panorama lecturer, who must "absolutely loathe the thing he described, despite looking at *it* as he speaks with an air of affection. In his heart of hearts," the writer continued, "he must . . . be dead to all human feelings or repugnances."[77] Charges of monotony have also been directed at IMAX films, which can be "incredibly boring" in the words of *Design Week* contributor Matthew Valentine.[78] For Valentine, the "lack of anything decent to watch on IMAX" is its main drawback.

Unlike the 360-degree panorama, which was more often than not experienced in silence, moving panoramas were frequently accompanied by music. For example, an anonymous contributor to *All the Year Round* in 1867 wrote that "it is a law that the canvas can *only* move to music," which suggests that the moving panorama was exhibited (and actually experienced) far more as an immersive performance than as a gallery-type space where spectators entered at any time during opening hours and moved freely around the viewing platform until they had seen enough. Banvard hired composers to devise musical accompaniment for his Mississippi panorama (Banvard eventually married pianist Elizabeth Goodnow after she was hired to play waltzes during the performance) that was performed live at the exhibition (entering in near-darkness, the audience would find their seats while incidental music played).[79] At the scheduled start, the curtain would rise to reveal the first scene of the painting illuminated by footlights; standing at its side was Banvard, who, using a long pointer (as seen in fig. 2.7), would direct the audience's at-

tention to scenes passing by on the moving canvas.[80] According to Hanner, it was Banvard's showmanship over and above his knowledge of the geographical, social, and scientific aspects of the Mississippi delta that was the biggest draw with audiences (Banvard apparently told a much-embellished story of riverboat pirates who terrorized the West even though the gang had disbanded before he painted the panorama).[81] A critic for the *North of Scotland Gazette* remarked that Banvard proved "a very pleasant companion in this long voyage," introducing "some sly jokes . . . in true Yankee style," while another concluded that "in short, Mr. Banvard is a considerable part of the exhibition itself, but without the least varnish or paint."[82]

Among the luminaries to see Banvard's Mississippi panorama when it toured the UK was Charles Dickens, who began his review with some important disclaimers about what a panorama was *not*:[83] "It is not a refined work of art . . . it is not remarkable for accuracy of drawing, or for brilliancy of color, or for subtle effects of hues and shade." If the panorama failed to meet the standards of high art, it was nevertheless for Dickens a "picture irresistibly impressing the spectator with a conviction of its plain and simple truthfulness. . . . It is an easy means of traveling day and night, without any inconveniences from climate, steamboat company, or fatigue, from New Orleans to the Yellow Stone Bluffs."[84] As in the case of the Windsor exhibition, spectators remained seated before the 1,320-foot painting (an equivalent of 15,840 square feet, not the three miles claimed by promoters) gradually unfurled between rollers over approximately two hours while listening to Banvard's commentary and music provided by piano and seraphim.[85]

The conceit of armchair travel evoked by Dickens was only one of the ways in which the panorama traded on its immersive qualities and interpellated audience members into the role of virtual travelers; other aspects of the intersubjective relationship between Banvard and his audience are worth unpacking here, especially since they shed light on a potentially alternative form of immersive spectatorship. Striking in the nineteenth-century discourse on panoramas is the claim that the painting could metaphorically reenact the *original* journey experienced by the painter, not merely represent an uncanny likeness of a specific landscape. The river journey offered its audience an infinitely repeatable *exemplary* journey taken by the artist; as spectators retraced Banvard's travels (up or down the river, depending on the direction the painting had been scrolled during the previous performance), they were invited to assume *his* subject position and reenact *his* firsthand experience of the Mississippi. The corroborating value of the reenactment thus resides in the audience's foreknowledge that Banvard did in fact navigate his boat up and down the Mississippi; the very act of retracing Banvard's voyage thus lends it weight as an experience, even authorizes it as an event with sufficient national significance to warrant being reenacted in the first place. The yoking of the experiential to the performative—the fact that one is invited both to assume Banvard's subjectivity for the duration of the exhibition *and* to appreciate his showmanship—is a constituent feature of the reenactment. As texts that frequently signal their authored status in overt and self-conscious ways, so as not to deceive audiences (like the TV news and crime shows which label the footage "reconstruction"), reenactments are highly reflex-

ive speech acts. They invite audiences to step into a reconstituted past in order to better understand the present—to jog their memory of vital clues and leads in the case of unsolved crimes. The reenactment therefore depends upon immersion not only to activate a series of associated narrative chains, but to signal the experience as something that draws the body in, since it's premised upon an explicit acknowledgment on the spectator's part that this is not necessarily how it was, but how it has become, an idealized version of the events of history.

By drawing attention to the very idea of an action or journey as a reprise of the "original," Banvard's performance seems to anticipate the internal logic of the early cinema travelogue, especially Hale's Tours's patented "Pleasure Railway," with its blurring of the signifying practices of the amusement park ride and travelogue. Itinerant lecturers such as Burton E. Holmes, Lyman H. Howe, and Frederick Monsen, who merged "high" and "low" amusements in similar ways to Banvard through their hybrid lecture / film / lantern-slide performances testify to the popularity of the travel lecture (the National Geographic and Discovery channels on cable television keep the genre alive today). Whether or not the success of Banvard's panorama was more or less dependent on the novelty of the panoramic apparatus as opposed to Banvard's evocation of a simulated journey on the world's longest river is difficult to determine. It also becomes something of a moot point when we consider how phenomenally successful Banvard's panorama was with mid-nineteenth-century audiences. Banvard exhibited his panorama to over 400,000 people in America alone, and over the course of several years earned at least $200,000

on tours to Europe and a command performance before Queen Victoria at Windsor Castle in 1848.[86] Promoted as "by far the largest picture ever painted by man," Banvard's panorama was conceived as a "gigantic idea" that would reflect something of the vast scale of the "prodigious river [that] is superior to the streamlets of Europe."[87] Just as the 360-degree panorama made famous by Robert Barker served nationalist interests, so too did the moving panorama; according to Angela Miller, "it did not merely allow space to be imaginatively inhabited; it also put this space in the service of a specific historical ideology." Visual appropriation was a step toward conceptual control, which "accompanied the extension of America's and Europe's emerging urban-industrial order over increasingly wide areas of human experience."[88]

However, it would be misleading to imply that *all* moving panoramas were viewed in the same way as Banvard's. Spin-offs of 360-degree and moving panoramas, such as the Mareorama, located on the Champ de Mars near the Quai at the 1900 Paris Exposition, a hyperrealist spectacle conjoining the moving panorama with illusionist stage effects, was organized around a slightly different idea of virtual travel. Audiences stood on the decks of an enormous steamer that employed the Cardan suspension system, which used a mechanism to create the sensation of being out at sea through rolling and pitching of the vessel. As the steamer "moved," audiences saw views of the Mediterranean from Marseilles to Constantinople that unfurled on two enormous canvases (moving panoramas). The Mareorama was thus less a reenactment of a singular journey than a commodified touristic *experience;* according to a review in *Scientific American,* along with

the smell of tar "deck hands hurry about the deck, ostensibly to help any who may suffer from *mal de mer*."[89] Premised upon a similar idea of a virtual cruise, "Chas. W. Poole's Myrioramic Realizations" and "New Myrioramic Route Cairo to the Cape" (fig. 2.17) were explicitly organized around the idea of undertaking a journey for the first time *yourself* (metaphorically of course) rather than reenacting a journey from the (celebrated) point of view of an artist and, as cinema emerged, even integrated films into the performances.[90]

But what kind of performance did one expect to become immersed in when viewing a moving panorama, and were discourses of sobriety any more or less pronounced in moving versus 360-degree panoramas? For many critics, panoramas combined just the right amount of stolid respectability with popular amusement; during the heyday of the moving panorama in 1867, one critic called the art form "a demesne that seems to be strictly preserved for the virtuous and good. Those for whom the gaudy sensualities of the theatre are interdicted may here be entertained with the mild and harmless joys of an instructive diorama."[91] Reviewing Philippoteaux's *Gettysburg* panorama in the *Chicago Times* in 1883, one critic was at pains to point out that the panorama had been erected and promoted "without resort to any of the 'circussing' advertising techniques so common in our day." The writer also noted that the "stimulating influence of such an exhibition on the growth of a general public taste for the higher forms of art [could] hardly be overestimated."[92]

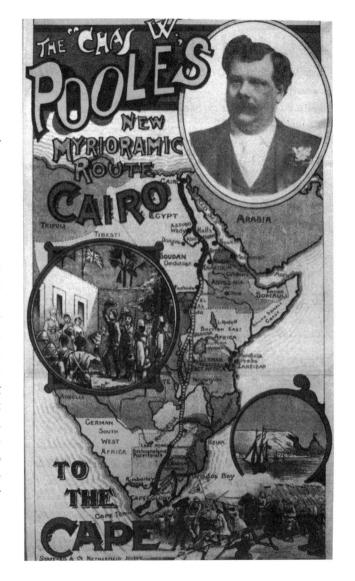

Fig 2.17　Poster for Chas. W. Poole's *New Myrioramic Route Cairo to the Cape* (c. 1890s).

Promoted as giant object-lessons in the higher arts, panoramas were discursively constructed as "moving geography lessons," their sheer size somehow validating the amount of knowledge that was about to be imparted. For example, in the "Descriptive Booklet" accompanying J. R. Smith's 1855 panorama of the Mississippi, advertised as "the largest moving panorama in the world," the panorama becomes a

> moving lesson, a pictorial guide, a refined and elegant manner of bringing before the mind of the spectator the appearance and characteristics of different countries; and when properly conceived and executed, forms a means of cultivating a public taste for the fine arts and of directing the attention of many to seek after solid intellectual entertainment instead of light frivolous buffoonery, to view a something that when you shall have returned home you can say, I have added a great deal to my stock of information, I have a better idea of certain things—I am more qualified than before to give an opinion on that subject; the mind has been set to work, an *impression* had been made that will cause you to reflect and to seek further after knowledge.[93]

The word "impression" here connotes both the perceptual molding of the experience as it registers in the spectator's mind and *Webster's* dictionary definition of "impression" as "an imitation or representation of salient features in an artistic or theatrical medium."[94] Not only does the word point to the panorama's close ontological bond with the reenactment, but it also speaks to an argument made by Ivone Margulies about reenactments conflating repetition with moral revision.[95] Panoramas thus fulfilled this didactic function in both their selection of subject matter and in their rhetorical claim to improve upon one's memory of viewing the real thing by providing a more comprehensive, all-embracing view. Though the cinematic reenactments of the 1950s and 1990s Margulies discusses are far removed from the panoramas explored here, her argument that what's most at stake in reenactments is "an identity which can recall the original event (through a second degree indexicality) but in so doing can also reform it" is central to our understanding of the origins of reenactments.[96]

This notion of enriched vision, of the panorama enhancing the original viewing experience through a superior form of visuality, is an enduring trope in panorama promotion, a key component of the immersive experience and, I would argue, an epistemological tenet of reenactments. The idea of the reenactment as an improvement upon the original (inasmuch as it provided more information or perspectives not normally available to the tourist) can be seen in countless reviews of panoramas of Niagara Falls. Godfrey N. Frankenstein's 1853 *Moving Panorama of Niagara,* exhibited at Broadway's Hope Chapel in New York City, is a prime example of this. For audiences who had either visited Niagara Falls or never been near the site (Kevin J. Avery points out that 1853 was the year the first railroad line ran to the site),[97] the panorama's multiperspectivalism, it was claimed, gave them "a better conception of it, than they ever had before" for the simple reason, one critic noted, that Frankenstein had spent the

last nine years sketching and painting the falls.[98] Reviewing the enormous painting in the *Literary World*, another critic praised the multiple viewpoints: "we see Niagara above the falls, and far below . . . We have it sideways and lengthways: we look down upon it; we look up at it; we are before it, behind it, in it . . . We are there in sunlight and moonlight, summer and winter, catching its accidental effects of mist and light, alternately awed by its subliminity and fascinated by its beauty."[99] Another reviewer noted that "looking upon it takes one back to the original, re-awakening the feelings of wonder and delight there experienced," while yet another felt that "one can almost realize they are standing within the roar of the mighty waste of water, or the cool refreshing vapors of its foamy billow."[100] Eschewing what Avery calls the "vehicular, linear conceit" of typical moving panoramas, Frankenstein's *Niagara* gave audiences edited highlights of the falls represented in different seasons; in addition to a tour of the Cave of the Woods and a virtual journey on the *Maid of the Mists,* Frankenstein updated his panorama with topical inserts such as the collapse of Table Rock at the Canadian Falls and a boatman's fatal plunge, which had dominated newspaper headlines for days, as the sailor clung to the rocks before finally losing his grip.[101]

The reenactment's mnemonic function, its ability to stimulate the memory sensors and transport spectators metaphorically (and phantasmatically) back to the depicted scene, is vividly captured in a review of the painting from the *New York Observer,* which states that while the "same emotions of sublimity which are excited by the natural scene, cannot, of course, be elicited by a picture . . . [it] serves to *revive the remembrance* of those emotions, and in reality brings before the eye a striking representation of Niagara itself."[102] This idea of the panorama appealing to audiences both familiar and unfamiliar with a certain locale was a fairly standard rhetorical trope in panorama promotional literature; for example, in a program advertising W. Hamilton's *New Overland Route to India, Via Paris, Mont Cenis, Brindisi, and the Suez Canal* (c. 1875), audiences were told that "those familiar with the scenes depicted will recognize the truthfulness of the representations, and enjoy the reminiscences, while others will form as accurate an idea of the appearance of the various places as if they had been visited in reality."[103] But while one reviewer claimed that it required "only the least degree of imagination to believe that our bodies are keeping company with our thoughts, and that we are in person surveying this indescribable work of the Almighty," another was at pains to point out that despite the "striking naturalness of the scene," the panorama was still "almost a reproduction" of the World's Wonder, not, we should note, the real thing.[104] Acknowledging that the panorama was never anything more than an illusion, most reviewers tempered their hyperbole with qualifiers, such as this one from the *Penny Magazine* in 1842: "if the groupings and general arrangement be natural, and if attention be paid to the modifying tint which results from the state of the atmosphere at different times of the day," the author noted, then the eye and the mind would be affected "nearly in the same way as by the original objects themselves."[105]

Nevertheless, as a recursive mode of representation, one premised upon the idea of spectatorship as an infinitely repeatable effect, the panorama invites us to share

communion with the artist whose "true" eye, we are told, "detects much of the beautiful that escapes the common observer."[106] Through the repetition of place, time, and a "seeing body,"[107] our vision is aligned with that of the artist; and yet, in witnessing the scene through the panorama artist's eyes, we are constantly reminded of its status as spectacle, especially in the 360 circular panorama, where, as Wolfgang Born argues, we are "expected to disregard traditional aesthetic standards such as unity of space and pictorial quality in favor of what might be called cosmic effect."[108] The panorama thus invited suspension of disbelief at the same time as it vividly reminded spectators of its plasticity.

DEATH AND ILLUSION: SOME FINAL THOUGHTS
ON THE PANORAMA AS TROMPE L'OEIL

In its status as a liminal form oscillating between fiction and fact, absence and presence, now and then, the reenactment seems on some levels to share a certain quality with the moment of death (and thus evoke Bazin's "mummy complex" behind's cinema's invention), when the body appears in the world, but can no longer be considered a part of it.[109] Of course the reenactment (and panorama) also share a great deal in common with the waxwork; not only were reenactments extremely popular and effective organizational principles of mid- to late-nineteenth-century waxworks, but the waxwork itself was in phenomenological concert with the idea of suspended or cheated death and an excellent example of immersive entertainment. The moist, luminous surface of wax shared a similar palor with the cadaver, and while panoramas and waxworks strove to suppress the moment of death, they could never escape the specter of death as an ominous referent. Popularized by Madame Tussaud around the same time as the emergence of the panorama, waxworks turned to the day's headlines, especially news about the monarchy and military exploits, for narrative vignettes that could be reproduced in wax. The same pedagogical rhetoric that was used to promote panoramas—uplifting and educational experiences—also surfaced in waxwork publicity.[110] Part and parcel of what historian Vanessa Schwartz calls the "spectacularization of reality," waxworks created endless opportunities for intertextuality; for example, despite competing for the same public, a wax tableau entitled *Les coulisses d'un panorama* at the Musée Grévin in Paris showed the military painter Edouard Détaille putting finishing touches on his panorama of *The Battle of Rezonville*.[111]

Many commentators, at the time and subsequently, have evoked the theme of death in an attempt to make sense of the ambiguous forms of the reenactment, panorama, and waxwork. On one level, death seems an apposite metaphor when thinking about reenactments and panoramas, since both still and moving panoramas were obsessed with death in their countless representations of nineteenth-century battle scenes. We should also not forget the fact that in today's world of 24-hour cable or satellite television, the reenactment has found a home in several infotainment genres, including true-crime programs in which acts of murder are reconstructed with actors in the hope of triggering the television audience's memory of the crime and furnishing additional leads in the investigation.[112]

Beyond its literal representation in many panoramas,[113] the specter of death seemed implicated in the medium's own mode of representation; like a cadaver, the hyperrealist canvas resembles a living being on the surface, but cannot really be considered alive. And yet there is a paradox in the reenactment's close resemblance to death on the one hand and its seeming ability to shake off death's grip on the other. As a "moment that nobody can describe, an event that nobody can escape, a process that nobody can narrate," in Mieke Bal's words, death also looks to the reenactment as a way of overcoming its finality, since the reenactment can show what escapes representation or what may be impossible to represent at all as a live event since there were no witnesses to it. The panorama thus seems to embody death and deny it at the same time, constructing a motionless universe that can stand in as a facsimile of the actual location or event.[114] In the same way that death is a challenge to representation, oscillating "between a state and an event," according to Bal, the panorama similarly hovers between being a sensation, an experience, and a two-dimensional representation.[115]

If death permeates the panoramic reenactment as a result of its fraught relationship to both the real and the imaginary, there is also a way in which the optical field of the circular panorama, with its arrested motion, gigantic scale, and immersive feel, exacerbated the deathlike aura of the form; with few competitors in the field of immersive entertainments, the panorama swallowed up spectators with a sublimity and breathtaking force that some analogized to an out-of-body, near-death experience. At least one contemporaneous spectator claimed that an "aspect slightly of death" could be sensed in the viewing of all cycloramas, particularly when the painting conveyed a great deal of action. Admitting that the same might be said of nonpanoramic paintings, the author nevertheless argued that panoramas demanded a great deal more of audiences than gallery works:

> We see the rush of waters, eddying and swirling at our very feet, but we hear no sound, none of the din and roar that accompanies the fall of a great cascade. The foreground has the appearance of being the real rock, ingeniously clothed with moss and grass, and illuminated by the actual daylight; beyond one sees a party of tourists enjoying the grand prospect of the tumbling waters, but all is still; we return to find them *fixed as death*.[116]

In the same way that Maxim Gorky found in the shadow plays of early cinema a ghostly, deathlike quality, some panorama spectators reported that the eerie stillness combined with the spectacular scale and illusionism lent a funereal solemnity to the occasion of viewing at least some panoramas.[117] Imbuing the landscape with a static quality reminiscent of the painted backgrounds of museums of natural history dioramas, panoramas placed spectators at the center of their optically embalmed scene. The effect might at times have been disorienting, if not outright disquieting, for unlike submitting one's gaze to a flat, moving panorama, or a two-dimensional moving picture screen, the spectator stands at the center of this reconstructed universe, breathing in the ghostly air without any sound, save the hushed murmurs of fellow spectators. While a lack of diegetic sound doubtless added to the deathlike effect in both panoramas and very early cinema,

not all panoramas were cloaked in silence; like films, moving panoramas were rarely if ever exhibited in silence, and there are some instances of music accompanying circular panoramas. Nevertheless, it was not uncommon to walk up the stairs and emerge from the darkened corridor onto the belvedere into a deathly silence, as noted by the above contemporaneous spectator.[118] Describing the spectatorial experience in 1900, long after the heyday of panoramas, W. Telbin claimed that "the audience . . . in sympathy with this immovable world, speak in undertones; we do not hear the free criticisms and the small talk and general gossip." Referring perhaps unwittingly to cinema's kineticism—one assumes that Telbin had heard of, if not yet seen, cinema by 1900—he goes on to argue that "possibly in the future we may have a pictorial exhibition combining all that art—and artfulness or trickery—can do."[119] Perhaps more so than battle panoramas, scenes of natural beauty invited a contemplative, reflective gaze that one might associate with a solemn occasion such as a funeral; as Bruno Ernst has pointed out, an encounter with a panorama, in this case the Hendrik Mesdag Panorama in The Hague, is "an encounter with stillness and peace," a reminder for nineteenth-century audiences of the transitory nature of life and their own mortality.[120]

As a form of mass entertainment that immersed spectators in a spectacular virtual reality, panoramas were hyperrealist representations on vast canvases that found a new lease on life in cinema's widescreen formats of the 1950s and today's 360-degree IMAX Dome (formerly OMNIMAX), where spectators are located in the middle of an image that is projected all around.[121] As Miller argues, "the panorama—like the cinema—manufactured a new reality, condensing time, editing the visual field, amplifying certain aspects of perceived reality while diminishing others."[122] The panorama revival of the late nineteenth century, as Miller points out, would have clearly inspired early cinema filmmakers, "both in their pursuit of particular visual effects and in their choice of subject matter."[123] Just as panorama painters turned to Niagara Falls and topical stories for inspiration, so too did early cinema exhibitors. And of course the panorama was exploited by earlier filmmakers as a shorthand for a 360-degree pan of a landscape, with numerous films including the word "Panorama" in the film's title to signal this circular motion.[124] That panoramas were drawn almost exclusively from actual events and real locations as opposed to literary or mythological subjects imbued them with a special cathartic or therapeutic value, a place to find repose in the rapidly industrialized metropolis, even if this meant being in full view of the battle panorama's horrors of warfare. A visit to the panorama immersed one in a parallel universe where the burdens of the everyday were temporarily lifted; looking at an elsewhere (or possibly an elsewhen) freed the mind, just as cinema delivers fantasy in 90-minute segments. By the second half of the nineteenth century, panoramas may have offered audiences temporary respite from the rush of modernity and, like the early motion picture theater, provided working-class audiences a place to exercise control over some portion of their daily lives increasingly ruled by the assembly line and transport schedule. If the visual excesses of battle

panoramas, which, in profiling developments in modern warfare, were hardly conducive to calming the overstimulated urban mind, the central elevated viewing platform of the circular panorama nevertheless gave cramped urban spectators a quick hit of immersive spectacle and momentary sovereignty over all surveyed, placing them at the heart of a simulated universe where they looked down upon the world. It was perhaps in this sense of mastery afforded by the sensation of immersion and downward gaze that the panorama laid claim to a gendered element, reassuring male spectators that their dominion over the world below lay unchallenged. But men were not alone on the viewing platforms, sharing the social space with women, who took as much pleasure in the visual sovereignty that came with surveying the panorama as their male counterparts. Indeed, one might argue that it was women's prior attendance at panoramas that established norms of spectating that would carry through into the early cinema period.

And yet there was something strange, even disconcerting, about seeing the world in this familiar yet obviously contrived way. Charles Baudelaire, for one, was not a fan of panoramas, arguing in his essay "The Salon of 1845" that Monsieur Horace Vernet's paintings of a recent French victory in North Africa "consisted merely of a host of interesting little anecdotes" and were fit only "for the walls of a tavern."[125] Baudelaire had even less sympathy for the military and patriotic panorama, a genre that was sweeping Western Europe at the time: "I hate this art thought up to the beat of drums, these canvases daubed at the gallop, this painting fabricated by pistol-shot, just as I hate the army, armed power and anyone who clanks weapons noisily around in a peaceful place. This enormous popularity, which, moreover, will last no longer than war itself, and which will fade away as nations find other ways of amusing themselves, this popularity, I repeat, this *vox populi, vox Dei,* simply oppresses me."[126] Needless to say, Baudelaire was probably not alone in despising the jingoistic appeal of panoramas and recoiling at any claim for their artistic merit. The panorama's success in exploiting the reenactment form was inevitably the result of a confluence of factors, ranging from the aesthetic and ideological demands of the era to the tireless efforts of individual panorama promoters who struggled to keep the medium of superlative immersion alive.

Panoramas aimed to evoke the sublime through both the eye and body of the spectator; size really did matter in this era of colonial and technological expansion, and panoramas offered spectators vicarious identification with the players of history and a privileged vantage point on some of nature's most prized beauty. As Onnes-Fruitema and Zoetmulder have argued, "the forceful way in which the panorama turned out to meet the visual needs of the public explains its resounding success as the cinema of the nineteenth century."[127] At the same time, early cinema audiences would have been thoroughly familiar with the cinematic idea of the reenactment long before the emergence of motion pictures; given the longevity of the panorama as a mode of visuality—they were around for a good hundred years or so before the emergence of cinema—it makes perfect sense that audiences had few problems understanding reenactments when they saw them

on the screen. Panoramas thus trained the nineteenth-century spectator to make sense of the large-scale circular or moving viewpoint and to appreciate the immersive and embodied pleasure of stepping into giant circular views, and in so doing, helped pave the way for cinema. While panoramas are certainly not the only significant aesthetic and ideological precursors to motion pictures, their legacy can be felt today in our continued desire to represent our world with perfect illusionism, especially those experiences which lay outside the realm of normal human events, such as ascending the heights of Mount Everest, being on the space shuttle *Discovery*, underwater scuba diving off the coast of the Galapagos Islands, to refer to just a few recent IMAX titles. Popular fascination with the 360-degree view has never been exhausted, but rather ebbed and flowed throughout the two hundred years since Barker first patented his *coup d'oeil* in 1787. As IMAX and virtual environments become enduring features of our cultural and commercial landscape in the twenty-first century, we should not lose sight of their giant, painterly antecedents.

EXPANDED VISION IMAX STYLE

Traveling as Far as the Eye Can See

Gigantism is their method as well as their style.

—Vincent Canby (1998)[1]

I N THIS 1950S-STYLE comic-book image of an Aryan cyborg, who has sprouted multiple eyes across his head and chin, hypervisuality is parodied through the iconography of the science fiction genre (fig. 3.1). The piercing blue eyes promising visual omnipotence, the ability to "See Everything! . . . [A]cross the Internet. Anywhere. Anytime. In any direction," along with the beams of light radiating from behind the head, symbolize a quasi-spiritualist techno-fetishistic future in which we too, if we buy into the rhetoric, can experience the world as never before. Of course, this 2000 *Newsweek* ad for IPIX, a company founded in 1986 specializing in 360-degree visual technologies, both promises and parodies the idea of "total vision" through the iconography of sprouting eyeballs and comic-book aesthetic, a nod per-

haps to male baby boomers who grew up on these cyborg narratives. While IPIX technology was promoting a new form of interactive spectatorship that needed to be vividly illustrated to Internet and non-Internet users (this ad came out in 2000 before the Web had fully taken off), the *idea* of visual omniscience along with its iconographic realization in the multiplying eyeballs is nothing new, as seen in this 1876 illustration from *Harper's Weekly* which is uncannily similar to the *Newsweek* ad (fig. 3.2). With the whimsical caption "How to See Everything in a Day. Patent Applied For," this image playfully anticipates the hypervisuality of the Aryan man in the IPIX ad.[2]

Not wanting to take anything away from the technological innovations behind 360-degree imaging companies such as IPIX and Be Here Corporation, which do a

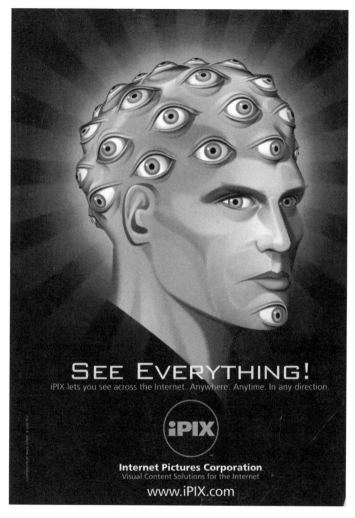

great job of enhancing Web content and are appealing for location-based companies in the travel and real estate industries, one can't help but notice (especially having read the last two chapters of this book) that the *idea* of being immersed in a virtual environment, while today steeped in the commercial culture of the Internet, is anything but new.[3] While we should proceed with caution in terms of inadvertently buying into the promotional rhetoric of companies such as IPIX—no one in their right mind would argue that staring at a low-resolution image on your computer screen that you can navigate around in any way approximates the experience of actually being in that very

Fig 3.1 Advertisement for IPIX Internet Pictures Corporation by Mark Otnes, *Industry Standard* magazine, Feb. 28, 2000. (Courtesy Mark Otnes)

Fig 3.2 Hypervisuality at the Centennial Exposition in Philadelphia, from *Harper's Weekly* (1876).

same space or even the visceral thrill of standing in the middle of a 360-degree panorama—we can nevertheless detect a sense of déjà vu at this significant moment in the history of 360-degree Internet technologies, when many of the panorama's fundamental precepts concerning embodied modes of spectatorship were being reactivated in relation to the Internet. Two themes run like leitmotifs throughout the marketing: first, the idea of sensory immersion; and second, the notion of armchair travel which, as we saw in chapter 2, has long been used as way of promoting (and making sense of) the reality effects of such visual spectacles as nineteenth-century landscape paintings, magic lantern slides, and motion pictures. I should also point out that since the 1920s, cinema audiences have also experienced several versions of moving wraparound panoramas in the forms of "Magnascope," Abel Gance's three-projector system of surrounding spectators with the action; "Vitarama," a 1938 horizontal projection system developed by Fred Waller to assist in fighter pilot training, and its commercial offshoot Cinerama, which had horizontal and vertical angles of vision of about 160 and 75 degrees, respectively; Walt Disney's "Cicorama," displayed at the 1958 World's Fair; and "Carousel" and "Panorama," 360-degree projections shown at Expo 67 in Montreal.[4] More recent versions of wraparound cinema include Circle-Vision 360 films; IMAX Solido, an immersive, domed 3-D format also known as OMNIMAX (now IMAX Dome);[5] and Cinedrome 360, a circular screen with surround sound. Despite lacking the scale of some of these 360-degree forerunners, 2-D and 3-D IMAX have nevertheless borrowed heavily from the panorama (and even the planetarium in the case of IMAX Dome) as a source of evocative metaphors of immersion. This fascination with immersive, simulacral experiences of virtual environments, then, is far from new. Moreover, as Allison Whitney argues in her detailed study of IMAX, the mythology surrounding this technology, along with its marketing rhetoric, "still positions it as constantly on the cusp of radical transformation in filmic experience, suggesting that it is itself cinema's mythological destination."[6]

However tempting it may be to construct a simple teleological account of circular panoramas begetting wraparound cinema screens begetting 360-degree Internet technologies, this model fails to do justice to the unique social, cultural, industrial, and historical circumstances under which these diverse technologies emerged. More importantly, it would also slight their very real technical and phenomenological differences, including the panorama-goers' freedom of movement around the central viewing platform versus the immobile Web surfer or IMAX spectator, and the scale and verisimilitude of the panorama versus the low resolution of the computer screen (Apple television, launched in 2007, promised to forever liberate the computer image, allowing laptops and iPods to be connected to a large-screen television set). Another reason for not constructing an ancestral link across these technologies is the existence of the planetarium, which complicates any notion of direct lineage, and, as we shall see in the next chapter, is a fascinating hybrid of the panorama, IMAX screen, and telescope.

Rather than provide an exhaustive account of the complex conditions under which each of these technologies emerged, this chapter looks specifically at how tropes of virtual travel *to* and immersion *in* a represented scene

serve as a unifying discourse (and myth) across time. What interests me most here is spectatorship: what can we learn about spectatorship from a close analysis of spectacular and immersive modes of entertainment such as the panorama and IMAX? And is it possible to include Internet companies such as IPIX, which, despite being compromised in scale, score high on the rhetoric of immersion and, technically speaking, do allow users to navigate 360-degree spaces. The first part of this chapter therefore considers how the idea of virtual travel and an Emersonian concept of the sublime operate as framing devices in panoramas, IMAX, and IPIX, and how each of these technologies has been adapted to meet the needs of popular culture, moving out of the world of experimental media into more mainstream markets such as malls and leisure complexes that combine family entertainment with retail, dining, and other leisure pursuits.

The second part of the chapter narrows the lens to focus exclusively on IMAX, tempering somewhat abstract ideas about IMAX, travel, and human perception derived from cultural theory with more historically grounded trade and popular press discourses concerning the large-screen cinematic format. I'm interested here in examining how motion itself—the kinetic impulse defining travel—is textually inscribed in IMAX through a consideration of such filmic tropes as the phantom ride, the structuring of human perception via shot composition, scale, and duration, and the presence (or absence) of the pan as camera movement. Through an analysis of the visual grammar of *Across the Sea of Time* (Stephen Low, 1995) and *Everest* (David Breashears and Stephen Judson, 1998), I hope to suggest how our attention as spectators is uniquely shaped by the idiom of IMAX. As exemplary IMAX travelogues, and in the case of *Sea of Time,* a film redolent with reflexive meaning about the very nature of 3-D imaging and immigration as an assimilationist parable, these films tell us a great deal about why IMAX seems so bound to the travelogue and how ideas of travel / mobility / kinesis play out on several discursive levels. Additionally, rather than make the case that IMAX simply exploits an age-old visual rhetoric and trope in a souped-up medium of ostentation (the teleological idea of IMAX films as technologically enhanced versions of eighteenth- and nineteenth-century panoramic paintings), I want to analyze sequences from *Sea of Time* and *Everest* that may advance our theoretical understanding of "panoramic perception" and how, paradoxically, it is more likely to be suppressed than showcased in IMAX films. In other words, while the popularity of the expansive IMAX screen suggests an enduring fascination with panoramic vision—in this case the ability to make use of our peripheral vision, giving us closer to a 250-degree (as opposed to the presumed 180 degrees) visual span of the world surrounding us—most IMAX films eschew the pan's horizontality in favor of a perpendicular movement into the frame which evokes the sensation of penetrating space through heightened depth cues. Panoramic vision no longer refers to a lateral sweep associated with the cinematic pan but functions more as a synonym for an overall view; as Søren Pold explains, "to a large extent [the panorama has] become naturalized as a general aestheticization of perception and urbanity."[7]

This repression of panoramic perception is clearly linked to the absence of a classical Renaissance perspective in a great many sequences in IMAX films; iconographically, we read the IMAX image quite differently from conventional 35mm, scanning it vertically for detail and meaning rather than panoramically from left to right. Not only is the screen's height promoted as one of its most prized assets (always comparing it to the number of stories it corresponds to) but, as Whitney rightly claims, "it would seem that the screen's verticality, regardless of the images projected upon it, contributes to a feeling of the sublime because of the imposing height."[8] In most IMAX films, panoramic vision is isomorphic with an omniscient gaze, a visuality of surveillance that comes from the aerial cinematography and sweeping crane shots—a classic IMAX film like *To Fly!* (Jim Freeman and Greg MacGillivray, 1976) can be considered the ur-IMAX film, since its visual rhetoric is composed of little else than that simulated movement through space. A question to be explored, then, is how IMAX directors foreground depth perception in their films, a technique anticipated in nineteenth-century panorama painters' use of perspective drawing and faux terrains (theatricalized, artificially arranged three-dimensional foregrounds of panorama paintings containing actual objects) to underscore the illusion of depth on the grand cyclorama canvases. By focusing on just two IMAX films that appropriate the travelogue as a structuring principle, I hope to generate a more theoretically informed and mutually informing body of knowledge about travel and large-format filmmaking.

BEING THERE: IMMERSION THROUGH VIRTUAL TRAVEL AND HYPERREALISM

One of the most enduring discourses characterizing panoramas, large-screen formats such as IMAX, and 360-degree Internet technologies over the past three hundred years is the idea of being virtually present at a depicted scene, what Charles R. Acland calls "the illusion of material presence."[9] Across the historical gulf separating panoramas from streaming iVideo are remarkably similar themes of virtual transportation and armchair travel; described by one critic as a "magnificent and faithful mirror of the earth's mysteries and industry,"[10] the panorama was viewed as nature's own counterfeit, so real to the original, in one account, that it seemed as if nature herself had replicated the exact scene and faithfully reproduced it in the new location. In a letter written by John Constable's friend and biographer Charles Robert Leslie in 1812, the overall reality effect of Robert Barker's *Siege of Flushing* and *Bay of Messina* panoramas was deemed "quite astonishing" and as a direct result of Barker's "strict adherence to nature." Their effect on Leslie was quite immediate: "I actually put on my hat imagining myself to be in the open air," he wrote in a letter to his brother.[11] Similarly, a reviewer of Howarth's *Wonders of the World* claimed that the panorama was "no fancy sketch but nature's own mysterious hand at work in this gorgeous and unfathomable laboratory" inspiring in the beholder "mingled emotions of Wonder, Reverence, and Admiration."[12]

Jennifer Peterson's notion of spectators being lured into a state of poetic reverie when watching early

cinema travelogues, "so enraptured by scenics that they fell into a dreamlike silence," seems a central component of the panorama experience.[13] But whereas for many early cinema spectators, travelogue-inspired reverie evoked a sense of loss or nostalgia for a former homeland (and the idea of reverie itself, as Peterson notes, borrowing from theorist Gaston Bachelard, is defined as a "flight from out of the real"), for the majority of more middle-class panorama patrons eighty years earlier, who were less likely to have left their native lands, panoramas conjured a different set of associative metaphors, a flight into the "hyperreal" of an elsewhere they had little likelihood of ever witnessing firsthand. Nevertheless, as a rhetorical trope, the idea of armchair travel reached an apex in the early cinema period, when, for the cost of a nickel, spectators could vicariously experience their homelands or catch a glimpse of the world's exotic peoples.[14] The idea of being "elsewhere," however, is in reality nothing more than a perceptual game the spectator is invited to play, since we never entirely submit to the illusion of virtual travel because we know it is precisely that, an illusion. Moreover, while in principle I agree with Whitney's argument about the double positioning of the IMAX spectator (what she calls the two "*theres*"), one in the profilmic space of the IMAX camera "designed to both challenge and conform to human vision" and the second *there* in the IMAX theater itself, "where viewers are continually reminded of their roles and responsibilities in the production and reception of images," I don't necessarily feel this is unique to IMAX, since one could argue that spectators of conventional cinema are also consciously aware of the embodied nature of film spectatorship.[15] Lauren Rabinovitz

makes this perfectly clear in her analysis of what she calls the "perceptual spectacular" of postcards, arguing that the "cinema of attractions," like the postcard, is not a simple reality effect but another specifically modernist mechanism for organizing and producing cognitive mastery by integrating the virtual space of visual observation and the physical space of bodily cognition for an affect of wonderment."[16]

If we exclude IPIX and Be Here technologies for a moment, the only apparent difference between the panorama's virtual traveler, the early cinema's armchair tourist, and IMAX cinema's tagline ("The next best thing to being there") is IMAX's superior geographical reach and the fact that the panorama-goer could physically move around the observation platform, unlike the stationary cinema spectator. As a way of experiencing 360-degree views, the observation platform has been reworked in Circle-Vision 360, a nine-screen, 35-millimeter surround system, best demonstrated in "The Wonders of China" at the China Pavilion at Disney World's Epcot Center. The audience, standing for the duration of the show, looks at the circular image as if from the promenade deck of a flying saucer.[17] In the same way that the chairman of Iwerks—one of IMAX's competitors—has argued that fifteen to twenty minutes is perfectly adequate for viewing a giant-screen movie, so, too, the same twenty minutes was generally deemed sufficient for early-nineteenth-century audiences to appreciate the artistry and artifice of the panorama.[18] The sensation of walking into and around a giant picture, of literally being placed at its center, has resurfaced in the context of IPIX, although the walking done here is purely metaphorical. According to former IPIX CEO James M.

Phillips, "Everyone we've showed this to says it's like teleportation. It's using ordinary cameras to give viewers the ability to literally walk into the picture."[19] Elsewhere Phillips described IPIX as "an application that transports you into spaces where otherwise you could not go."[20] The spectator's real mobility is thus substituted for what Anne Friedberg calls a "mobilized, virtual gaze,"[21] where Web surfers can gain access to a 360-degree horizontal range and either a 110- or 180-degree vertical range, depending on whether the system being used is either Be Here Corporation or IPIX (Be Here's CEO Ted Driscoll justifies his company's narrower range by arguing that anything beyond 180 degrees creates an unnatural viewing angle, since our eyes spend most of their time looking at a sphere around our head, unless we're at a sporting event or looking up at the sky).[22]

The immobility of the IMAX spectator, however, was compensated for by the magical mobility of the IMAX camera; as Richard Gelfond, IMAX co-chairman and co-chief executive, explains: "Historically, IMAX made its mark by taking people where they couldn't go themselves. To the top of Everest or the bottom of the ocean."[23] (Not surprisingly, IPIX also capitalized on Everest's commercial appeal, offering in 2000 a virtual tour of the summit to document the climb and "give millions of Internet viewers the first interactive, immersive images from the world's highest point.")[24] As film historian Iris Cahn has shown, there are striking continuities in the iconography of panoramas, great painters, and early landscape films, as evidenced in the photogenia of a tourist mecca such as Niagara Falls.[25] And as Whitney notes, the "perceived connection between IMAX and landscape emerges from the fact that many features of the IMAX screenings, as well as their prescriptive models for what IMAX ought to be, correspond to pre-existing frameworks for understanding rare and extreme experience, including wonder and the sublime."[26] Issues of iconography aside, we should not lose sight of the real differences between 360-degree panoramas and wraparound cinema screens: one of the reasons for the marginalization of wraparound cinema technologies (and perhaps for the panorama's eventual demise) is the challenge of taking in a moving 360-degree film, as opposed to leisurely absorbing a panorama; as Stephan Oettermann argues: "The human eye is incapable of taking in a 360-degree range of images at one time, and unlike the still pictures of a painted or photographic panorama, a film does not give the spectator time to walk around and absorb the whole." However, Oettermann points out that the sensory overload experienced by today's 360-degree cinema spectator was a familiar theme in the discourse surrounding panoramas; in fact, some critics used this argument to suggest that painted panoramas would never be popular.[27]

There are a great many parallels, then, between panoramas, early travelogues, and IMAX, since each of them became defined through discourses of sobriety as a result of their exhibition contexts and pedagogic remits; their largely nonfictional content and sober themes met with approval by religious, educational, and community leaders who often pitted them in opposition to more commercialized, mainstream fare, although IMAX has bumped heads with the religious right of late who objected to anti-Christian sentiment in films that refer to evolutionism.[28] Just as cinema, with the nickelodeon explosion, began as a

novelty for respectable audiences before becoming a mass medium, so too did panoramas begin as an experimental form that would eventually become part of mass culture. For example, in 1850 Charles Dickens in his journal *Household Worlds* created the fictional Mr. Booley, who at age 65, embarked upon a series of panoramic excursions:

> It is a delightful characteristic of these times, that new and cheap means are continually being devised, for conveying the results of actual experiences, to those who are unable to obtain such experiences for them-selves [sic]; and to bring them within the reach of the people—emphatically of the people; for it is they at large who are addressed in these endeavors, and not exclusive audiences. . . . Some of the best results of actual travel are suggested by such means to those whose lot it is to stay at home.[29]

In order to experience scenes that might otherwise have existed only in one's imagination, the panorama virtually transported spectators to famous cities such as Constantinople (a perennial favorite) and Paris, for a fraction of the all-but-prohibitive cost of actual travel.[30] On one level, topographical panoramas can be seen as democratic alternatives to the Grand Tour, that seventeenth- and eighteenth-century cultural rite of passage for the sons of aristocracy and gentry and, by the late eighteenth century, for the sons of the professional middle class (panoramas even became substitutes for the Grand Tour in the war years 1793–1815, when, as Altick notes, travel was prohibited).[31] In the same way that we pay much greater attention to the visual detail of landscapes or cityscapes that are not part of our everyday environment, so too did panorama spectators cast a gaze upon the painted canvas that was consanguineous with a touristic gaze, a gaze constructed through signs of famous landmarks and objects that are collected, as structuralist Jonathan Culler argues, as signs of themselves. But as John Urry has noted, the discourse of travel shifted from a Grand Tour based on emotionally neutral observation to the nineteenth-century "'romantic Grand Tour' which saw the emergence of 'scenic tourism' and a much more private and passionate experience of beauty and the sublime."[32]

If the formula of giant image combined with imaginary journey failed to enamor either of these nineteenth- or twentieth-century reviewers, then the idea of virtual travel has nevertheless endured within the discourse surrounding panoramas, IMAX, and 360-degree Internet technologies. But as a rhetorical trope, armchair travel is best understood as a viewing metaphor, a way of coming to grips with the uncanny mimetic effects of the panorama as a novel way of seeing the world. And yet one can't help but detect a certain self-consciousness in the appropriations of virtual travel as a rhetorical conceit by writers, who, tongue in cheek, send up the idea of real travel. Take, for example, this 1824 review of Barker and Burford's *Panorama of Pompei* from *Blackwood's Magazine*:

> Panoramas are among the happiest contrivances for saving time and expense in this age of contrivances. What cost a couple of hundred pounds and half a year a century ago, now costs a shilling

and quarter of an hour. Throwing out of the old account the innumerable miseries of travel, the insolence of public functionaries, the roguery of innkeepers, the visitations of banditti . . . and the rascality of the custom-house offices, who plunder, passport in hand, the indescribable *désagérments* of Italian cookery, and the insufferable annoyances of that epitome of abomination, the Italian bed. [In the panorama], the mountain or the sea, the classic vale or the ancient city, is transported to us on the wings of the wind. The scene is absolutely alive, vivid, and true; we feel all but the breeze, and hear all but the dashing of the wave.[33]

The idea of the panorama as an "experience" or an "effect" felt by the spectator can still be seen in advertisements for IMAX. For example, in these movie posters for IMAX *Extreme* (fig. 3.3), we are told that, "In nature's most volatile year, as its forces in the oceans and mountains unleashed new levels of power . . . the world's top extreme athletes finally found what they had been searching for. Are you ready for the experience?"[34] Through IMAX's marketing hype about the immersive and mimetic qualities of the experience, we are invited to vicariously take up the challenge of performing super-athletic feats such as extreme surfing or snowboarding; the implication here is that the experience of viewing the IMAX film will be so realistic that we will *feel* as though we are actually moving; as independent documentary filmmaker Ben Shedd put it, "the experience is so strong that the theater itself seems to move and fly."[35] This sense of our having little

control over the experience once we've bought our IMAX ticket and are ensconced in the IMAX theater—we can either accept the challenge or not—is seen in numerous trailers for IMAX technology, which struggle as much to convey the scale of the IMAX image as they do to convey the overall "effect" of "feeling" IMAX. IMAX sensation is often represented through the use of close-ups of the human face upon which is inscribed the physiological essence of the experience, the "oh wow" effect (see fig. 1.1). The shark jumping out of the screen in this brochure (fig. 3.4) describing the IMAX process is no accidental signifier since it succeeds in meshing the natural world generic output of most IMAX films with the anthropomorphizing tendencies of Steven Spielberg's 1977 classic film *Jaws* (1977). The heightened sense of being immersed in the image is also signaled in the large number of people pointing their fingers at the screen (out of fifteen rows of people, nine are pointing).

The idea of the technology's playing sensory tricks on the spectator is perfectly captured in this 1829 *London Times* review of John Burford's panorama of Geneva: "The beholder is involuntarily transported to the identical scene of his admiration—he believes himself contemplating not a draught, but in reality the overpowering majesty of Mont Blanc and the luxuriance of the valleys and hills which are strewn at its feet."[36] Striking in this reviewer's description of the Swiss Alpine scene is his invocation of the sublime, hardly surprising when we consider the status of the sublime as one of the informing concepts of the late eighteenth and early nineteenth centuries. But how, exactly, was the sublime evoked as a frame of reference in the

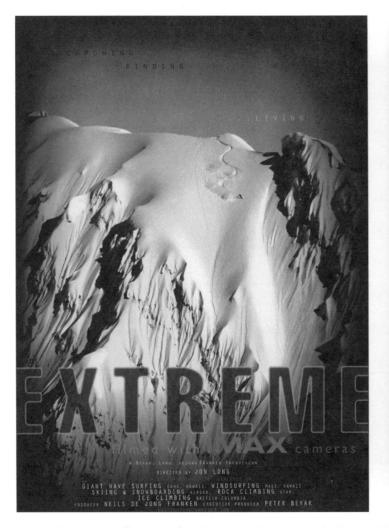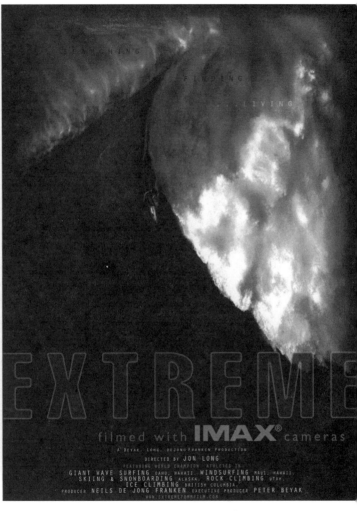

Fig 3.3 Two film posters for IMAX *Extreme* (Jon Long, 1999). (Courtesy IMAX Corporation)

INSIDE AN IMAX® THEATER

Dimensions vary from theater to theater, but one thing is for sure—they're HUGE!

HOW IS THE FILM PROJECTED?

In an IMAX projector, the film moves horizontally rather than vertically. Film is stored on 4-5 ft diameter platters, holding about 45-90 minutes each. It travels at 336.6 feet at 24 frames per second per minute through the projector onto an empty platter in a different section. At the end of each film, the projectionist rewinds the film just shown, then manually threads new film from the other platter through a series of tension-adjusting rollers and back through the projector.

The film is strong enough to pull a truck.

HEAR HERE

The soundtrack is separate from the film. Three CDs, sychronized with the film by computer, are used for each soundtrack.

The audience hears the sound through a six-channel, 12,000-watt, digital surround system.

HOW DO YOU SEE IN 3-D?

For 3-D films, two platters of film are used simultaneously, one for the right eye, and one for the left. First, a right-eye image is projected onto the screen, then a left-eye image. Viewers wear special headsets equipped with liquid crystal lenses. Infrared signals trigger the lenses to open and close in front of each eye in turn; then the brain combines these two rapidly alternating images into one 3-D picture.

The 3-D headsets also contain directional speakers. Combined with the theater's six-channel sound system, this means that sound seems to be coming from everywhere.

When the right eye sees an image, the left is blacked out.

There are no bad seats in the house. The steep slope of the auditorium ensures that even if a 6ft 6in giant is sitting in front of you, you'll see over his head.

The height of the screen can be as much as 80 feet. That's the equivalent of seven elephants on top of each other!

The width of the curved screen is about 100 feet.

Light from the 15,000-watt lamp in an IMAX projector is so bright that if it were on the moon we could see it on earth with the naked eye.

SHOOTING A PICTURE

15/70 film is so large that the cameras can only hold three minutes of film at a time.

To shoot a 3-D film, the cameraman has to load two film negatives into the 220-lb. camera, one for the right eye, and one for the left.

HEY, WHERE DID THAT HUGE SNAKE COME FROM?

If something even as small as a hair gets onto the film as it passes through the projector, the magnified result on the screen is really distracting. So there's no goofing off in the projection room while the film is running!

AND WHO WAS WEARING THIS HEADSET BEFORE ME?

Don't worry, the headsets are placed one by one into a high-tech vacuum system that cleans each pair with a disinfectant cleaning solution.

Fig 3.4 "Inside an IMAX Theater" (technical information leaflet). (Courtesy IMAX Corporation)

context of nineteenth-century panoramas? And how can eighteenth-century thinking on the sublime help us better understand the discursive construction of 360-degree display technologies?

THE LURE OF COMMERCIAL CULTURE:
PANORAMIC FUTURES

The Colosseum in Regent's Park, London (fig.3.5), which opened in 1829, was, in its day, a high-class version of Cinetropolis, an $18 million complex that made its first appearance at Foxwoods Casino and Entertainment Center in Ledyard, Connecticut, which opened in the fall of 1993 and closed in 2003. Cinetropolis is the brainchild of Donald W. Iwerks, the technical wizard behind Disneyland's ride, who in 1986 founded Iwerks Entertainment Inc. A hybrid casino, theme park, and multiplex, tickets at Foxwoods could be bought for several attractions including a simulator ride and 3-D movies. Called the "perfect playpen for the multimedia age" by *Business Week* correspondent William C. Symonds, cinetropolises were far cheaper to construct than theme parks and could be kept fresh by "constantly upgrading them with new entertainment software," another cost-saving initiative when compared to the expense of refurbishing theme park rides that may fall out of favor with visitors.[37] However, Cinetropolis is no longer a popular tourist destination in Connecticut, having been replaced by "The Tree House at Foxwoods," a two-level entertainment center featuring a MaxFlight FS2000 Flight Simulator and 140 video and redemption games. Cinetropolis has even more in common with the Colosseum, or so it would seem.

But whereas Cinetropolis was ensconced in the "World's Largest Casino" and targeted lower-middle and middle-class families, the Colosseum, or the "pleasure dome," as Altick referred to it, initially catered to the "more seemly pleasures of Regency Society" by combining the "advantages of a club house in town with the attractions of a rural villa," before downgrading to a less sedate site of popular amusement.[38] The ever-widening reach of interactive 360-degree Internet technology, too, from specialized applications within the U.S. military to Steven Spielberg–produced IPIX movies created in collaboration with RealPlayer, or virtual cosmetic sessions at MakeOverStudio.com, in which consumers could submit their photos and interact with their own image has also followed in a similar path to panoramas and IMAX, moving from the highbrow connotations of the museum or specialized delivery system to the arguably less elitist, though more expensive, retail/entertainment complex.[39] Issues of class appeal aside, what all of these commercial enterprises exemplify is an effort to locate panoramas, large-screen, and 360-degree Internet technologies within an array of related, decidedly immersive entertainments. In this regard, Cinetropolis's wraparound Cinedrome 360 does not stray far from the educational remit that was a defining feature of the panorama.

While appearing to be a dim version of what can be achieved today using 3-D visual technologies, digital surround sound, and real and simulated motion, the *Panorama of London* at the Colosseum was nevertheless a

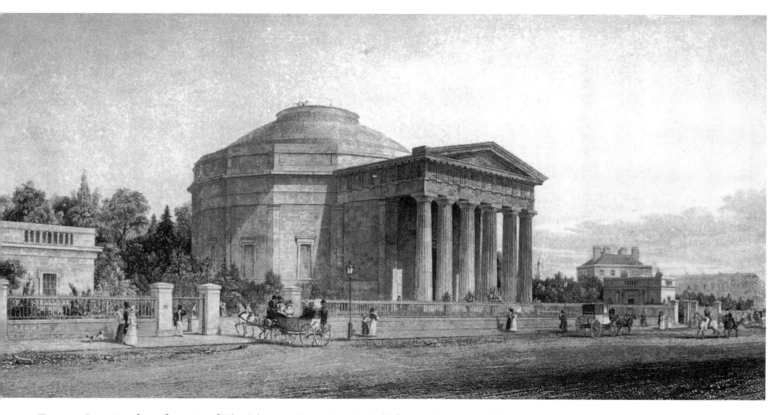

Fig 3.5 Engraving of west-front view of "The Colosseum Facing Regent's Park" from *A Picturesque Guide to Regent's Park* (1829). (Courtesy Guildhall Library Corporation of London)

remarkable undertaking: 60 feet high and 13 feet in diameter, the *Panorama of London* covered 40,000 square feet and cost £23,000 to construct (see fig. 2.2 for an image of the interior). Based on two thousand sketches completed by the Yorkshireman Thomas Horner from a viewing platform at the top of St. Paul's cathedral and transferred to the canvas by Horner and a host of assistants, the Colosseum panorama took four years to complete; spectators could either climb two circular staircases to reach the observation platform or use one of the first steam-powered passenger

elevators in the world.[40] The Colosseum offered patrons state-of-the-art entertainment in similar ways to the high-tech, luxury movie complexes being constructed around the world today; as Julie Rekai Rickerd observes: "These entertainment palaces are redefining the very essence of going to the movies by placing as much, if not more, emphasis on their peripheral visual and entertainment aesthetics as on their mandate to exhibit films in ultimate comfort and in keeping with the most advanced technologies available."[41] In contrast to panoramas and IMAX as location-based entertainment, IPIX and Be Here can tout their wares anywhere there's a wireless connection, making it possible to explore visual Internet content even on hand-held devices such as Blackberries and cellular phones.

But in the same way as the panorama was incorporated into the related arts—the use of the moving panorama in English pantomime being the best example—so too were the related arts incorporated into the 360-degree panorama and its two-dimensional spin-off, the large-scale panorama painting. In 1822, for example, the director and owner of London's Egyptian Hall, a museum containing antiquities, art, and curiosity objects, installed an exhibit in which a panorama-like painting served as a backdrop to a living family of Laplanders (fig. 3.6). The first display at the Egyptian Hall to use a partial panorama painting, *The North Cape with a Family of Lapps* showed the family surrounded by material artifacts and real reindeer (recall that actors and wax mannequins were also used in French panoramas).[42] However, in an effort to bring to the panorama that very element that had been missing since its inauguration in 1787, namely life itself, William Bullock sounded the death-knell for the panorama; as

Oettermann explains, "the perfect topographical accuracy and illusionistic style of the panorama pointed up the form's great flaw, namely the rigidity and lifelessness of the whole."[43]

But there is something prophetic about Bullock's popularized *North Cape* panorama (and we should bear in mind that the inclusion of the "living exhibits" was *strictly* meant to enhance the verisimilitude of the panorama, and not the other way round) that not only anticipates the enduring appeal of natural history museum life groups featuring mannequins posed in front of illusionistic backdrops but finds a new lease on life in a 1997 advertising campaign launched by the National Museum of Photography and Film in Bradford, UK, to promote the 3-D IMAX release *The Living Sea* (Greg MacGillivray, 1995). Like Bullock's Lap family, the billboard for *The Living Sea* used live performers to promote the film; under the slogan "The Living Sea on IMAX: Come Prepared," actors dressed as sailors, surfers, fishermen, or deep-sea divers were hired to sit in cinema seats bolted to a billboard located 40 feet off the ground. The actors would join the billboard installation during peak commuting hours and were replaced by mannequins at other times of the day. There are obvious differences, though, in the use of real people to promote these large-screen technologies; unlike Bullock's performers, the IMAX actors stand in not for the film's subjects, but for the film's spectators, who, responding to IMAX's hyperrealist mode of address and the ad's tagline, have come dressed in their nautical clothes. Bullock's *North Cape* exhibit and the commercial stunt of *The Living Sea* billboard also suggest a parallel attempt on the part of nineteenth-century panorama operators and IMAX exhibitors

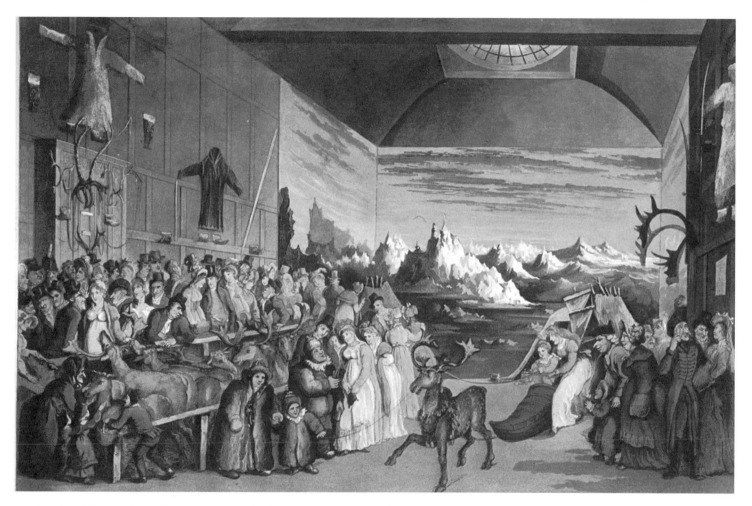

Fig 3.6 William Bullock's "Exhibition of Laplanders" (Sami people). Engraving by Thomas Rowlandson (1822). (Courtesy Guildhall Library Corporation of London)

to broaden their markets and, in the case of IMAX, to break into mainstream entertainment through what's called "location-based entertainment" (leisure complexes combining large- and regular-sized screens with thrill rides, retail, tourism, gambling, and other family attractions). In a similar fashion, nineteenth-century entrepreneurs attempted to use panoramas as the primary draw for entertainment complexes such as the Egyptian Hall, which integrated museum objects with other high cultural forms including panel art, concerts, and sculpture.

While panoramas did circulate across the world, their national specificity certainly played a key role in determining their success in foreign markets. For example, it was precisely the overt nationalistic content of many European 360-degree panoramas that limited their appeal within the U.S. panorama market, where Americans were more interested in their own geography and western frontier than in ancient ruins and European battles[44] although, as a modern invocation of the visual rhetoric and sublimity of American moving panorama subjects, 3-D IMAX's *The Last Buffalo* (Stephen Low, 1990) is a vivid example of how the iconography of the American West and discourses of nationalism endure in large-screen technologies; writing on a new millennium wave of 3-D IMAX productions in the *New York Times,* Matthew Gurevitch argued that "in these images, nature and art speak to us, and life and death, time and eternity, linked in ways that are as lucid as they are mysterious."[45] Of course, the sublime effect of viewing vast stretches of landscape could be extended for as long as the spectator was prepared to pay for the experience. Nowhere were these themes more effectively explored via IMAX's unique cinematic idiom than in the two case-study IMAX films discussed in the next section: *Across the Sea of Time* and *Everest.*

JOURNEYS ON THE (VERY) BIG SCREEN

IMAX made its mark by taking people where they couldn't go themselves. To the top of Everest or to the bottom of the ocean.

—Richard L. Gelfond[46]

Since its emergence more than thirty years ago, when Canadians Graeme Ferguson, Roman Kroiter, and Robert Kerr pioneered the use of a multiscreen presentation for the film pavilion Labyrinthe at Expo 67 in Montreal and three years later unveiled the IMAX technology with the first IMAX film *Tiger Child* (Donald Brittain, 1970) at Expo '70 in Osaka, Japan, IMAX has latched onto the twin ideas of immersion and the travelogue as the sine qua non of the large-screen format.[47] Being immersed in the image is the defining feature of the IMAX brand, whether in flat-screen theaters, 3-D, or Dome screens; "Be There" could easily be the corporation's trademarked tagline, and few companies could claim to have as much brand equity in this concept as IMAX. But travel comes a close second in terms of brand identification. On one level, the symbiotic relationship between IMAX and travel makes perfect sense when we consider the early institutional venues for IMAX exhibitions, chiefly world fairs and expositions, museums, science centers, and theme parks, where ideas of industrial progress, exploration, and cross-cultural encounters provided the perfect showcase for the new cinema technology. Like the artifacts severed

from their contextual referents in the museum, where "objecthood is invested with the aura of fate" in the words of Didier Maleuvre, IMAX takes the world "out there" and enlarges it to gigantic proportions, heightening the sensation of virtual presence and haptic immersion.[48] Ideas of travel are intrinsic to IMAX's genetic (and memetic) makeup, inscribed in the promotional discourse surrounding IMAX and in the way audiences themselves associate the experience as a de facto one of virtual travel and movement. And as film theorist Guiliana Bruno so eloquently explores in *Atlas of Emotion,* traveling, and the "voyage of dwelling in time-space," reside at the very core of cinema.[49]

Though a product of the collective imaginations of Ferguson, Kroiter, and Kerr, IMAX is as much an eclectic derivative of a cluster of pre-cinematic entertainments as it is of the multimedia pavilion of Expo 67: Gothic cathedrals, medieval tapestries, late-eighteenth- and nineteenth-century 360-degree and moving panoramas, oversized landscape paintings, stereocards (and their 3-D successors in the age of cinema and post-cinema, planetariums, Cinerama, CinemaScope, and 360-degree Internet-distributed technologies which, despite their modest scale and resolution, promise immersive experiences and virtual travel in similar ways to IMAX)—all influenced IMAX. In both a literal and chimerical sense, each of these representational forms latches on to the idea of being in another place or entering into the image. Leery of espousing a Bazinian teleology in which IMAX appears as the culmination of a centuries-long project of perfect filmic illusionism, a more nuanced approach is required that acknowledges IMAX's complex legacy and situates

it within a long history of spectacular, large-scale image-making. Though a handmaiden of twentieth-century modernity, the IMAX experience is a historically inflected one, indebted to centuries-old attempts at making illusionistic and spectacular representations, with each precursor embedded in diverse and sometimes contradictory impulses.

To characterize IMAX as virtual travel or armchair tourism is something of a truism today. It is trotted out in IMAX film publicity and echoed by film critics in countless reviews. Audiences have come to expect an element of travel or at very minimum a sense of being immersed in the image as a quintessential component of the entire IMAX package; for those baby boomers old enough to remember Cinerama, "fabulous travelogues and natural-history essays that combine the earnest, predigested scholarship of a National Geographic piece with the excitement of a roller-coaster ride" in the words of one critic, IMAX simply ups the ante in terms of technological prowess and sensation delivery.[50] And yet as Whitney rightly-explains, IMAX should not be confused with Cinerama since it emerged from "a very different set of traditions and with an aesthetic agenda that was distinct from, and even opposed to, the motivations for technological change in Hollywood."[51]

Notwithstanding these differences between Cinerama and IMAX, the semantics of travel imbues them both; being on the move defines everything about IMAX, from the neo-imperialist overtones of recent IMAX endeavors such as the corporation's twenty-first-century expansion into China, India,[52] and Eastern Europe,[53] to the active prepositions of such film titles as *Across the Sea of Time, Into the*

Deep (Howard Hall, 1994), and *Kilimanjaro: To the Roof of Africa* (David Breashers, 2002), to cite just a few, to the trademark phantom ride shot mentioned earlier. IMAX's interest in the travelogue has not been limited to 2- and 3-D films; it has branched out into *Back to the Future*–type simulation rides such as the IMAX Magic Carpet ride, which has two projectors running synchronously, one in front of the audience and the other projecting images through a transparent floor.[54] The idea of travel even informs IMAX teen-themed films for younger audiences seeking a higher-than-usual quotient of special effects in what comes to be, save from the scale, an interface indistinguishable from videogames. Some IMAX films, such as Belgian director Ben Stassen's *Haunted Castle* (2001), make the obligatory IMAX phantom ride the centerpiece of the film, although in the absence of any character development or dramatic situations the entire film is little more than a "special-effects demo," in the words of one critic.[55] The phantom ride reached ever-dizzying speeds in spring 2004, when the co-produced IMAX/Warner Bros. film *NASCAR: The IMAX Experience* (Simon Wincer) placed spectators in the driving seat to experience speeds of more than 200 miles per hour.[56]

One of the most obvious reasons why IMAX films rely so heavily on the travelogue format is the educational market that has been carved out for IMAX (or that IMAX carved out for itself). Traditional nature-documentary IMAX films are expository texts that, while not conforming exactly to John Grierson's vision of documentary film as an art/propaganda symbiosis which inculcates heightened social awareness and civic responsibility in the viewer, nevertheless contain a didactic element befitting the school-group audience which makes up a significant percentage of daytime box office receipts in noncommercial venues (of the 150 or so IMAX screens in the United States, approximately half are located in science and natural history museums, while the others are in multiplexes or purpose-built venues) and in commercial venues during the day when the theaters are traditionally empty.[57] IMAX has clearly found a niche audience in the museum where the recent trend of blockbuster shows adds legitimacy to what some curators perceive is IMAX's questionable status in the museum. IMAX has always gained legitimacy from the museum setting, its pejorative status as an overblown nature documentary mitigated by the larger informing (and elitist) context of the exhibition site.

However, it was IMAX's legacy as a museum-based educational resource that made Hollywood executives skeptical of its commercial appeal, especially 3-D IMAX, which required an image makeover with audiences who associated 3-D with uncomfortable glasses and gimmicky 1950s B movies. Hollywood's interest in large-format films grew in the mid-1990s, however, especially after the colossal success of *Everest*, which earned $91 million at the box office.[58] Aside from scouting out ever more lucrative locations for IMAX theaters (as a proprietary technology, IMAX depends upon leasing of projection equipment and its brand name to turn a profit therefore its eagerness to see new theaters constructed), at the start of the new millennium the company has set in motion the most ambitious commercial proposal to date.[59] In an effort to avert the feared saturation of its traditional museum venue and

nature documentary formats, IMAX has hedged its bets on its proprietary digital remastering technology (DMR) which allows conventionally shot 35mm "Hollywood event" films to be converted into a 70mm format for a cost of $2–4 million.[60]

DMR seems to have been successful; 2002 was the company's first profitable year since 1999, with $11.5 million fourth-quarter profits (up from $6.6 million in 2001), and at the time of writing there are more than 225 IMAX theaters in thirty countries.[61] The first Hollywood film to be converted to 3-D IMAX was *The Polar Express: An IMAX 3-D Experience* (Robert Zemeckis, 2004), which generated about a quarter of its original domestic box office ($45 million). The IMAX version of *The Matrix: Reloaded* (Andy and Larry Wachowski, 2003) began playing in theaters shortly after its May 15, 2003, release and the final film in the trilogy, *The Matrix Revolutions* (Andy and Larry Wachowski, 2003), was the first-ever simultaneously released 35mm/IMAX Hollywood release when it opened on November 5, 2003; *Spider-Man 3* (Sam Raimi, 2007) also opened simultaneously in both formats in 2007.[62] Quelling fears that audiences would not pay more for the "premium" experience—research suggests audiences will not only shell out an additional $3–4 to see the film in IMAX but also travel more than twenty miles for the experience—IMAX is hoping that recently acquired venues like the IMAX screen at the Paris EuroDisney will be a showcase for IMAX films.[63] Finally, IMAX has demonstrated considerable growth in its lineup of international theater signings and installations (signings almost doubled from twelve in 2001 to twenty-one in 2003), with

China slated to become the second-largest IMAX market in the world.[64]

What's interesting about these recent developments is that they mark a shift in IMAX's conflicted identity as the purveyor of visual spectacle on the one hand, and dramatic narrative on the other; as *New York Times* critic Peter Nichols characterized it: "[the] large screen lends itself to the spectacle, which in turn calls for dazzling clarity and stupendous sound. . . . Dramatic scenarios are often not effective with audiences conditioned to seeing roller coaster rides, bounding lions, 40ft waves and crashing avalanches."[65] Digital remastering has presented IMAX with a way out of the (overdetermining) education and museum market, which, while profitable, is a niche market that IMAX wishes to transcend. The fact that most new IMAX theaters are being constructed in shopping malls (aka "destination complexes") and other commercial sites rather than in museums is appealing to Hollywood studios which until recently maintained a wait-and-see attitude with regard to releasing their product in IMAX format.

But if the bond between nonfiction and the large-screen medium seems unlikely to be seriously challenged by IMAX's repurposing of standard Hollywood features, it is in no small part due to the legacy of early cinema, which not only created the conditions of possibility for large-screen projection (widescreen emerged as a way of skirting Edison's copyright patents) but created the perfect promotional vehicle for the representation of landscapes.[66] Viewed in this context, it is no surprise that promoters of Cinerama turned to the travelogues of Bur-

ton Holmes and Lyman Howe from the 1910s and earlier as models for their mid-twentieth-century-enhanced cinematic technology, or that IMAX, too, should appropriate the same genre, especially landscape films, as an obvious aesthetic model.[67] Premiering on September 30, 1952, Cinerama was a novelty few audience members had previously experienced; in John Belton's words, "The frame of the theater proscenium seemed to disappear, and the audience had the uncanny sensation of entering into the events depicted on the curved screen in front and to the side of them. . . . Cinerama launched a widescreen revolution in which passive observation gave way to a dramatic new engagement with the image."[68] *This Is Cinerama* (Merian C. Cooper and Gunther von Fritsch, 1952) took spectators on a virtual tour of Europe in the first half, followed by the United States after the intermission; *Cinerama Holiday* (Robert L. Bendick and Philippe De Lacy, 1955) juxtaposed a European couple's tour of America with an American couple's vacation to Europe.[69] Not surprisingly, these films were heavily nationalistic in tone, fetishizing the American landscape in Belton's words "as an index of technological prowess," and in the process becoming "an unlikely participant in the Cold War."[70]

A similar nationalist fervor marks *To Fly!*, produced as part of the 1976 Smithsonian Bicentennial celebrations and one of the first IMAX films ever made (the film's production background is discussed in detail in chapter 6). As we will see, the film links issues of national identity to technological developments in aviation through metanarratives of American progress and domination in flight technology. Many IMAX films address the nation as an

"imagined community," Benedict Anderson's much-cited construction of nationalist discourse, hailing spectators as proud consumers of images whose verisimilitude can be vouched for by the putative power of the nation itself, as an invisible sponsor of these epic undertakings (*The Last Buffalo* is another good example).[71] But in constructing this national imaginary IMAX is simply following in the footsteps of earlier large-format imaging techniques such as the panorama and nineteenth-century landscape paintings of such artists as Thomas Cole, Frederic Edwin Church, Albert Bierstadt, and Thomas Moran.[72] As a powerful symbol and nationalist allegory, the urban landscape functions as an equally potent icon, as we shall see in the ensuing analysis of *Across the Sea of Time*.

SEEING TIME THREE DIMENSIONALLY:
THE MAN WITH A STEREOSCOPE

Produced and directed by Stephen Low, son of IMAX pioneer Colin Low, *Across the Sea of Time* (1995) is a picaresque 3-D IMAX travelogue about an 11-year-old Russian immigrant, Tomas Minton, who in possession of little more than a stereoscope, stereocards, and faded letters sent by his great uncle Leopold Minton to his parents back home in Russia in the 1910s, comes to New York City to track down his extended American family, and, hopefully, find his uncle Leopold's surviving widow, his great aunt Julia. As part of a wave of Eastern European immigration to New York City in the early part of the twentieth century, Leopold Minton arrived at Ellis Island in 1908,

and soon began working as a photographer for a commercial stereoscope company shooting 3-D photographs of the city's emblematic sights (the letters sent back to his parents in Russia tell of him meeting his future wife Julia and experiencing all the wonders of the bursting metropolis). A parable of the American Dream and replete with tropes of American progress and assimilation,[73] the film casts itself as the "ultimate New York" experience; even the Sony Lincoln Square on 68th Street and Broadway, where it has played fairly regularly in repertory since 1995, is something of a tourist destination since it houses the city's only large IMAX theater (the IMAX screen at the American Museum of Natural History, although refurbished, is far smaller).

Located a few blocks north of the high cultural mecca of Lincoln Center, the Sony IMAX is a must for contemporary tourists in search of a large-screen visual orientation to the city's major sights, or so the publicity would have us believe (fig. 3.7).[74] The tourists lining up to see *Across the Sea of Time* may identify with both the contemporary and historical Mintons; with camera cell-phones and / or minute digital cameras tucked away in their bags, they too, are image-makers (although with much shrunken technology) intent on preserving a record of the city's iconic splendor. And yet the film promises to give spectators an unparalleled view of the city, unobtainable with a regular digital camera or even visible in 25-cent tourist postcards on sale a few blocks down at Columbus Circle; thanks to IMAX's vertiginous and immersive qualities, what they will see is, as the film's tagline touts, "New York as you've never seen it." The materiality and tactility of Leopold's

images thus contrast sharply to the digitized photographs taken by modern tourists, and while both sets of images circulate in global image markets (digital photographs posted on MySpace, Facebook, blogs, or emailed to friends and family around the world, and stereographs bought, sold, and traded across international borders, winding up in parlor sitting rooms after long, sometimes circuitous journeys across time and space), they are ultimately cut from the same discursive cloth, driven by a desire to become immersed in the city, to see, smell, and taste its glories.

Leopold Minton's historical stereographs are afforded as much visual weight in the film as the 1990s 70mm IMAX footage of New York City; not only are the century-old stereographs blown up to enormous proportions on the 3-D IMAX screen, but they trigger the film's syntagmatic chains, including the reading of a letter or the loading of a stereograph (stereocard) into the stereoscope which announces a new sequence in the film and cues the appearance of the giant black-and-white images (fig. 3.8). As an immigrant image-maker, Leopold's identity serves as an important metatext: Leopold is both a sight*seer* and a sight*maker*, becoming a professional observer whose "new occupation extends the city beyond its physical geography, carrying it to others who can witness its scenes in commodified stereograph images."[75] Stereocards and postcards were hugely popular in late-nineteenth- and early-twentieth-century visual culture; Rabinovitz notes that during the first four days of September in 1906, 175,000 postcards were mailed from Coney Island and 200,000 on September 7 alone.[76] But as Mark Neumann

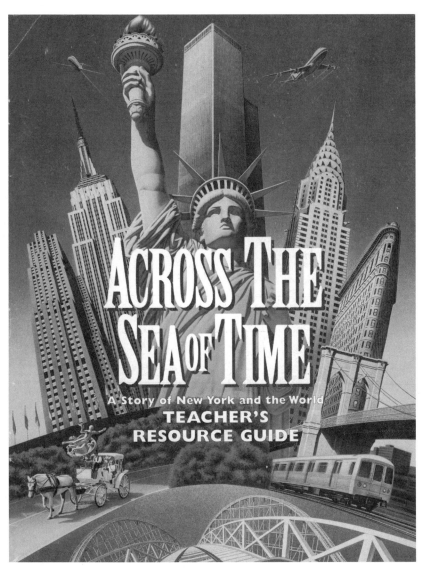

ACROSS THE
SEA OF TIME

A Story of New York and the World
TEACHER'S
RESOURCE GUIDE

observes, Leopold's journey is also one of assimilation, a process heightened by the ethnographer's cloak he wears in his role as a commercial documentary-maker of a burgeoning city. There is a tangible tension in the voyeurism of Leopold's attempts at acculturation—at one point he says, "I look into windows to see how Americans live" (a comment that finds creepy symmetry at the exact moment Tomas happens upon a topless woman sunbathing on a roof)—versus the transcendent ocularity of the IMAX camera, which transforms the intimacy of the private stereoscopic views into a 75-foot-high spectacle.

Across the Sea of Time thus enacts a series of interesting reversals that expose some of the ironies in global image-making and exhibition: stereocards made by Leopold for mass consumption end up being turned into privatized (fetishized) images by Tomas, holding as they do vital clues as to the location of his relatives (a brownstone on Gramercy Park in Manhattan is finally identified as the ancestral home, somewhat unlikely given the longtime exclusivity of the neighborhood, although it fuels the myth of the American Dream). The interiority suggested by the isolated, yet disquietingly immersive sensation of using the stereoscope is blown asunder when these same images become visual spectacle on the IMAX screen; and yet ironically, because we view *Across the Sea of Time* through 3-D glasses equipped with PSEs (Personal Sound

Fig 3.7 Collage of New York City icons, including Coney Island's roller-coaster ride in the foreground, which mimics the point-of-view shot of the phantom ride (*Across the Sea of Time* Teacher's Resource Guide, 1995). (Courtesy IMAX Corporation / Sony Pictures Classics)

Environment), we still experience them as relatively privatized images.[77] A sense of immersion in the viewing of a stereograph is quite different from the immersion experienced in a cathedral or panorama rotunda, and while space precludes pursuing these differences in any great depth, suffice it to say that the sense of "being there" intrinsic to panorama viewing and IMAX is somewhat lacking in the case of the stereoscope where the peep-hole viewing apparatus, despite delivering on the level of the illusion of 3-D, falls short.

In similar ways to Dziga Vertov's eponymous cameraman in the classic 1929 *Man with a Movie Camera,* who climbs to the top of buildings to better visualize the metropolis, Tomas scales rooftops to reexperience the stereoscopic images created by his great uncle (fig. 3.9) (there is another homage to Vertov in the Central Park carriage tracking-shot sequence which is reminiscent of the carriage scene from *Man with a Movie Camera* and evokes Eadweard Muybridge's experiments with serial photography where a galloping horse provided the illusion of continuous movement as well as winning an important bet). Vertov's kino-eye (camera/eye) metaphor ironically finds new expression in the super-mobile gaze of the IMAX camera, which in an aerial sequence sweeps down Manhattan's major arteries and flies toward the spectacularly crowded financial district from Staten Island; indeed, Vertov's belief that "I, a machine, am showing you a world, the likes of which only I can see . . . My road leads towards the creation of a fresh perception of the world . . . I decipher, in a new way, a world unknown to you," is elegantly rehearsed for us in the aerial photography scenes of *Across the Sea of Time* (and in the iconology of much

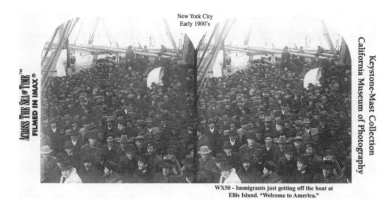

Fig 3.8 Stereo photograph (wx50, "Immigrants just getting off the boat"), c. 1900, used in the IMAX film *Across the Sea of Time*. (Courtesy of the Keystone-Mast Collection, UCR / California Museum of Photography, University of California–Riverside)

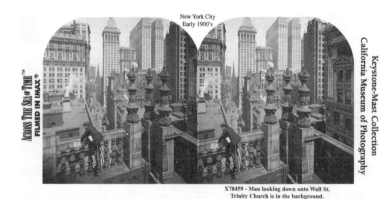

Fig 3.9 Stereo photograph (x78459, "Man looking down onto Wall St."), c. 1900, used in the IMAX film *Across the Sea of Time*. (Courtesy of the Keystone-Mast Collection, UCR / California Museum of Photography, University of California–Riverside)

IMAX footage in general), in what James Donald calls a "utopian will to visibility."[78]

Leopold's and Minton's shared experiences of the city suggest a transhistorical gaze, what Neumann calls the "panoramic vision of time" that is cued by the action of Tomas panning the city's landscape with the stereoscope (ironically, as Neumann points out, the stereoscope is used more as a telescopic device here since the camera does not pan to follow the movement).[79] In most instances, past and present images of iconic sites are linked via a dissolve, a formal device that serves as an apt metaphor for the blurring of subjectivities across distinct temporalities. However, the issue of whose memories are being evoked here is somewhat opaque. For example, when Tomas closes his eyes and there is a dissolve from the contemporary mise-en-scène to the same historical location (or vice versa), it is unclear whether Tomas is somehow accessing Leopold's memory of that place, or whether this is what Tomas *himself* now sees. Simply being in the same physical space as Leopold, though separated by nearly a century of history, triggers a memory trace that Tomas is able to access via the stereocards and the letters; indeed, Tomas and Leopold's subjectivities seem to merge at these moments of 3-D plenitude. The invitation extended to us to become immersed in the experience of 3-D IMAX is also an invitation to access the subjectivities of these characters, one constructed as a memory via voice-over narration and photographs, the other a vicarious desire to succeed in the quest to discover an ancestral tie. Leopold's letters to his family in Russia which Tomas has brought with him to the United States are double signifiers of sorts, since they represent both Leopold's memory of experiencing a particular place *and* the reactivation or mediation of these memories via Tomas's subjectivity when he reads them. Like that of any tourist, Tomas's gaze is both what Urry calls a "socially organized and systematized gaze" and one heavily inflected by personal memory and a strong psychic investment in the outcome of the pursuit of memory. The letters and slides also trigger a metaphorical / existential "departure" for Tomas and the IMAX audience—a vital component of any touristic act—what Urry describes as a "limited breaking with established routines and practices of everyday life and allowing one's senses to engage with a set of stimuli that contrast with the everyday and the mundane."[80] Sounding remarkably like an advertisement for IMAX, the idea of sensory simulation and immersion in both familiar and exotic locations clearly promises a substitute for actual travel.

Sea of Time thus provides a fascinating meta-commentary on the very idea of time travel through 3-D images; the use of turn-of-the-century stereoscope slides to showcase the late-twentieth-century technology of 3-D photography offers a compelling example of how the travelogue functions as a narrative glue, binding together old and new media. The stereocards carry a great deal of the emotional weight of the film, avoiding an overly sentimentalized look at the past that we often associate with *The American Experience* or Burnsian documentaries. There's a raw quality to the images, produced in part by the magnified scale and 3-D, which has a powerful visceral effect on us; while the contemporary scenes emphasize movement through space—either flying over Manhattan in a

helicopter or taking a phantom ride on a Coney Island roller coaster or NYC subway car—the stereopticon photographs "hold a quieter power," to quote Rick VanderKnyff, and force us to contemplate the ontological properties of black-and-white photographs versus color motion pictures. It is almost as if cinema itself is being rediscovered at this moment, our ability to see it differently via the scale and 3-D goggles undoubtedly contributing to this effect. Striking in several of the black-and-white images is the return gaze of the subjects; one of the first stereocards shown in the film is of a large group of recently arrived male immigrants (see fig. 3.8), many of whom are staring directly at the camera. The sensation of time travel to the historical scenes represented in the stereocards is heightened by the large number of men staring back at us from a 3-D limbo. But as Paul Arthur notes, this affective response also comes from the scale of the projection, "with an unprecedented vividness of detail and illusion of full-bodied volume, they startle like ghosts. It is in the brief appearance of these long dead black-and-white figures that the feeling of a shared space between screen and spectator, the impulse to reach out and make contact, is most acute."[81] Unlike the contemporary scenes which privilege motion over stasis, the stillness of the stereocards creates a heightened immersive sensation, the figures seemingly transcending the boundedness of the frame; as VanderKnyff notes, "with its immense scale . . . it's easy to feel one could walk into the scenes."[82]

Unfortunately, the IMAX camera fails to linger long enough on each image to give us the necessary time to absorb the rich visual detail. This is a perennial problem in IMAX; lost in the promotional hyperbole generated by IMAX are issues of legibility, intersubjectivity, and access. In light of IMAX's fondness for extreme spectatorial vantage points, one has to question whether viewing the world from the spinning wheel of a NASCAR racecar actually renders that world legible, or little more than a blur. By intensifying motion, depth cues, or what *New Stateman's* film critic Jonathan Romney calls "the hallucinatory properties of the screen itself," our eyes and minds are often challenged by the informational overload; as Romney explains: "attuned to 24 frames a second, we find ourselves outpaced by pictures projected at twice that speed: our eyes and minds aren't fast enough to spot the sleight-of-hand . . . we're effectively robbed of the critical distance our perceptions normally maintain in the cinema." For Romney, there's a fundamental paradox at play here: while IMAX fails to provide "anything resembling reality," it is nevertheless "haunted by an obsession with the real."[83]

Without the stereocards, the film is, as VanderKnyff points out, "a big, moving postcard of New York";[84] but, as Arthur opines, the film "enhances its display of vertiginous postcard vistas and Coney Island roller coaster plunges with an assortment of sensory assaults . . . intent on mobilizing as wide a range of sense impressions as the urban environment will yield."[85] One of the ways the film accomplishes this is via the depth perception of the 3-D photography; the immersive and haptical qualities of the image in both the stereocards and contemporary footage are enhanced through the layering of objects and the unexpected intrusion of a prop into the frontal plane, such as the sudden appearance of a huge chain in the

immediate foreground in the second shot of the film, the boiler room of a Russian freighter bringing Tomas to New York; a wok suddenly erupting into flame in a Chinatown restaurant; and, also in Chinatown, fish swimming in a tank. As director Low points out, "the trick is to have layers. The more visual cues for foreground, middle ground, and background the more effective the 3-D."[86] In the same way that the phantom ride became the trademark 2-D IMAX motif, shots that are very deep and that appear to jump out of the screen have become the stock-in-trade in 3-D IMAX films.[87] Ensuring the maximum effectiveness of the 3-D medium and avoiding the problems besetting the representation of human figures, which in close-up appear incredibly flat, "as if they've been steamrollered into the screen," is no easy task. Experimenting more with the relationship between the interocular cameras, perhaps working with narrower interoculars in close-ups, would in the minds of some product developers help suspend disbelief even further.[88]

The magical effect of these objects suddenly coming out of the space between spectator and screen recalls a much earlier optical illusion exploited by circular panorama painters who would construct faux terrains—the space between the viewing platform and circular canvas containing real artifacts that merged seamlessly with the painting—in order to heighten the illusionism of the image. The net effect is remarkably like 3-D IMAX, an implicit parallel drawn by Vincent Canby, who viewing IMAX noticed that, "The images are so brilliant and sharp that you don't feel as if you're outside looking in. In some ways, it's like attending so-called 'live' theater. The eye is free to look wherever it wants. And, as much as the eye, the mind is engaged through sheer sensation."[89] Not only does the theatricality Canby alludes to remind us of the panorama's faux terrain, but the visual autonomy he speaks of perfectly describes the spectatorial coordinates of panoramic viewing. And yet, this visual autonomy is radically undercut in the contemporary footage of *Sea of Time*, which rejects horizontal movement across the frame, the direction of panoramic vision around the circumference of the painting, in favor of lateral movement into the frame. Whitney argues that this sensation of penetration into the frame is bound up with one of IMAX's defining myths: "IMAX 3D demands a fundamental shift in the position and activity of its spectators—from looking *at* to looking *into*—and these dense and volumetric spaces . . . lead us to another central IMAX myth, of being absorbed into the image, of being in the movie."[90]

To compensate for the stasis of the blown-up stereocards in *Sea of Time* and to mimic the action of the spectator's eyes as they scan the image for detail, the camera gently directs our attention through panning and tilting, a technique in sharp contrast to the kinetic overload of much of the film's aerial, phantom ride, and tracking-shot footage in its contemporary sequences. While there is very little panning in the modern footage, the IMAX camera compensates for this by swooping down on locations and subjects, moving through space like a mechanized eagle (the canted camera angle is a standard IMAX trope causing audience members to concomitantly tilt their bodies). But what happens when the IMAX format is transported to a topography that, while sharing some traits with *Across*

the Sea of Time (the man-made monumentality of the urban landscape with its canyons and skyscrapers is substituted for a natural phenomenon), constructs a travelogue of quite different proportions.

SCREENED GIGANTISM: IMAX ON MOUNT EVEREST

Whereas we know the miniature as a spatial whole or as temporal parts, we know the gigantic only partially.[91]

A defining feature of early travel was the desire to survey the topography of the foreign land; as Judith Adler points out, travelers were advised to prepare for their Grand Tours by learning "something of math, perspective, drawing, and map-making, and to carry instruments for measuring temperature, height, and distance."[92] Unquestionably male, the traveler-as-surveyor was the "monarch of all he surveys,"[93] most often the son of an aristocrat, member of the landed gentry, or, by the end of the eighteenth century, the professional middle class. Between 1600 and 1800 the treatises on travel shifted from "a scholastic emphasis on touring as an opportunity for discourse, to travel as eyewitness observation."[94] The tourist gaze, a new way of seeing the world, coincided with the emergence of the nineteenth-century Grand Tour, which privileged a subjective, emotionally charged, and highly aestheticized appreciation of scenic beauty in general, and the sublime in particular.[95]

Referring to the travelogue in the context of IMAX brings into relief a set of ideas about travel, tourism, and sightseeing, ideas shaped in turn by oppositions between activity versus passivity, fake versus authentic, and the hegemony of sight versus other sensory modalities. While travel as a discursive concept has been freed of its earlier privileged connotations—everyone is pretty much on the move today, what James Clifford refers to as "dwelling-in-travel"—the cultural meanings of travel are still shaped to some extent by notions of mapping and surveillance, especially the idea of looking down upon a city and tourist destination, having conquered it through ascending space.[96] So when tourists visit Coba in the Yucatan Peninsula, Mexico, they feel obliged to make the long trek up the side of the crumbling pyramid to survey the surrounding terrain; similarly, visits to New York City, Paris, and Prague are deemed incomplete without ascending the Empire State Building, the Eiffel Tower, and the Castle district. Ascending and conquering are thus tropes associated with travel and ones most certainly co-opted by IMAX in its iconography and camera work. Ironically, this impulse to survey from above is thwarted to a large extent in *Everest*, given the enormous effort involved in transporting and using the camera at such elevations.

Released in March 1998, *Everest* set a new standard for IMAX; with a budget of $4.5 million, the film grossed $58 million in just thirty-two weeks and over $120.6 million by January 2003, making *Everest* the highest-grossing documentary and large-screen film of all time, breaking the record previously held by *To Fly!*, which has netted over $115.7 million since its 1976 release.[97] How do we account for the phenomenal success of this film?

Several issues are at stake: first, the film was able to capitalize on the enormous publicity surrounding the deaths of eight climbers on the face of Everest in May 1996 (as one of twelve other expeditions assembled on the mountain that spring, the IMAX team had the foresight—or good luck—to postpone their summit attempt until the storm had passed and the near-gridlock climber backup around Hillary's Step had dissipated). As an absent presence in the film, the deaths of fellow climbers imbues the IMAX film with a temporal specificity; this wasn't just *any* climbing season on Mount Everest but among the most memorable since the summit was first reached by New Zealand climber Edmund Hillary and Sherpa mountaineer Tenzing Norgay in 1953. While *Everest* conforms in many respects to a traditional travelogue, the publicity surrounding the deaths of the climbers drew into sharp relief questions about Everest's place in the political economy of Tibet, the ecological fallout from the rising numbers of summit attempts by for-profit multinational climbing organizations, and whether access to the mountain should be more tightly controlled by the Tibetan government.

Second, the film exploited a heightened public and trade-press fascination with the additional challenges of taking an IMAX camera to the "roof of the world." Even in the absence of human drama on Everest, the film was destined to generate a great deal of publicity, as Mark Singer, writing in *Sight and Sound,* observed: "the sense of scale and detail large-format can offer—let alone the achievement of getting both onto the film in the first place—would be impressive even if nothing untoward happened."[98] This near-fetishizing of the IMAX process, particularly an obsession with the weight of the camera, size of the batteries, logistical challenges of filming in subzero temperatures, and huge support necessary to transport the equipment up the mountain, all anthropomorphize the technology, transforming the IMAX camera into a VIP that must make it up the mountain at all costs (the camera was not unlike the ultra-rich amateur climbers who hire professional climber / guides—in addition to Sherpas—to get them to the summit).[99] The technology in this instance is isomorphic with the subject matter; IMAX and Everest are both behemoths that swallow up their subjects, contain them so to speak (what Susan Stewart refers to as being "enveloped by the gigantic, surrounded by it, enclosed within its shadow").[100] Unlike the miniature, which can be held in a privatized, individual space, the gigantic presents "an analogical mode of thought . . . the selection of elements that will be transformed and displayed in an exaggerated relation to the social construction of reality."[101]

Tibetan culture in general, and the Sherpa industry in particular, are metonymically signified via Jamling Tenzing Norgay (son of Tenzing Norgay Sherpa, seen here in this publicity photograph [fig. 3.10]), following in his father's footsteps. Jamling's spirituality and desire to climb Everest are thus motivated by a sense of destiny (and no doubt an Oedipal drive); he becomes our entry point into this "mystical" culture, and yet even his bifurcated identity is subjected to the relentless fictionalizing effects of the narration, music, and graphics used in *Everest*. In complex and contradictory ways, *Everest* evokes

and suppresses the cultures and identities of Nepalese people who become travelers themselves in their role as Sherpa guides. As Clifford observes, "cultures and identities reckon with both local and transnational powers to an unprecedented degree" in the twentieth (and twenty-first) centuries: "Cultural action, the making and remaking of identities, takes place in the contact zones, along the policed and transgressive intercultural frontiers of nations, peoples, locales."[102] Nepalese culture is thus reified through a heavily orientalist gaze, reduced to a series of highly stylized Hollywood-influenced ethnographic vignettes such as the reenactment scene in the Buddhist temple, which represents Jamling Tenzing Norgay as a little boy (an image we return to at the end the film when the young Norgay is surrounded by candles). The film's attempt to evoke the spiritualism surrounding Everest is undercut by the marginalization of the Sherpa economy that supports mountaineering in the region (one is clearly more photogenic and easier to represent than the other). Not only are the Sherpas who are responsible for transporting the IMAX camera and equipment up Everest largely invisible in the film (they are afforded *some* agency in the bonus DVD feature "The Making of *Everest*," but their contribution to the monumental team effort necessary to make the film is completely marginalized. The Sherpas gain visibility only through a series of still photographs interpolated into the closing credits (the credit mentions the ten Sherpas who carried the IMAX equipment, but photographs of only four are shown). The implicit racism in this afterthought representation of the Sherpas is echoed in a comment made by *American Cin-*

Fig 3.10 Publicity still from *Everest* (MacGillivray Freeman, 1998) showing climbers Jamling Tenzing Norgay and Sumiyo Tsuzuki spinning Buddhist prayer wheels for good fortune on the expedition (Norgay is in the center). (Courtesy IMAX Corporation)

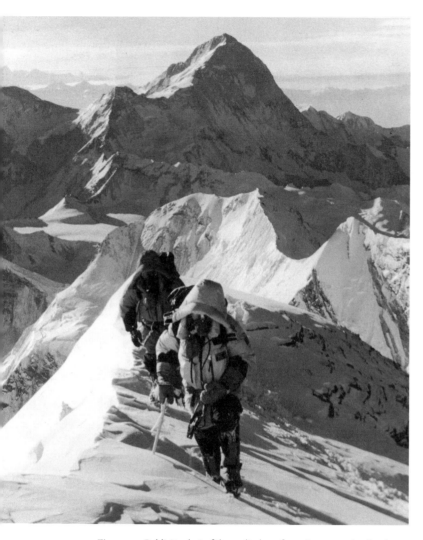

Fig 3.11 Publicity shot of three climbers from *Everest* on the Southeast Ridge of Mount Everest (1999). (Courtesy IMAX Corporation)

ematographer writer Naomi Pfefferman when she reduces Sherpas to little more than necessary equipment: "As it turned out, Sherpas, camera, and batteries performed 'flawlessly' as the crew traveled up to 12 miles a day." [103]

A Burksian notion of the sublime hangs heavily over Everest, defined by Burke as "Whatever is filled in any sort to excite the idea of pain, and danger, that is to say, whatever is in any sort of trouble, is conversant with terrible objects, or operates in a manner analogous to terror, is a source of the *sublime;* that is, it is productive of the strongest emotion which the mind is capable of feeling." [104] The destructive forces of nature, a central feature of the sublime, is the raison d'être of *Everest,* which has few problems ratcheting up the emotional tempo; after all, IMAX technology has surely met its match in a subject of such epic proportions. And yet, while the sublime qualities of the landscape are certainly evoked by the IMAX camera—the mountain's mysticism is signified via repeated shots of the moon—the actual summit is something of a cinematic anticlimax, since most of the images are photographic stills (fig. 3. 11) rather than IMAX-rendered breathtaking images; as Jerry Adler writing for *Newsweek* points out: "Since the subjects were mostly gasping for breath and barely able to lift their feet, this had the unfortunate effects of rendering the most important scenes as a series of gorgeous, but somewhat torpid tableaux." [105] The soundtrack has to compensate for the absent visuals at this moment, a switch in tone that ironically shifts the overall tenor of the film away from the epic (relentlessly signified by the overbearing score) toward the avant-garde, where the overpowering sounds of the climbers breathing through their oxygen masks

gives the film a distinctly underground feel reminiscent of early experimental film (the digital surround sound in the purpose-built IMAX theater enhances this effect; the sound is literally and metaphorically breathtaking).

However, the still photographs presented in collage fashion on the screen unfortunately take on the appearance of skiing vacation snapshots albeit with protective Tibetan sungdi blessing strings that are left to adorn the summit.[106] The IMAX camera is emotionally challenged when it comes to capturing quiet, reflective moments, including the Spanish climber Araceli Segarra's reaction to the deaths of fellow climbers; using the frame within a frame to signify the look of a handheld digital camera, the scene both evinces and effaces the IMAX gaze, which has to be recontextualized to evoke a more intimate video diary–type encounter between climber and audience. Marking the image as "other" than IMAX reads as a meta-comment on IMAX's inability to capture the private, the intimate, and the confessional, or at least a desire on the part of the production team to capitalize on the enormous success of reality TV, which relies upon the iconography of video (time-code, viewfinder, shaky camerawork) to shore up the purported realism of this unscripted moment. Shot in the aesthetic style of a video confessional, the iconic "money shot" of much reality television programming, the expedition team's prosaic reflections on the climb and tragedy are juxtaposed sharply with the lofty and clichéd prose of Liam Neeson's narration.

IMAX's inability to capture the intimate, the spontaneous, the small, and the fleeting is an inevitable by-product of its immersive excess; as Greg MacGillivray explains: "Certain things lend themselves to IMAX over and above other systems. The screen size requires a number of separate eye fixations, so shots need to be longer to allow the audience to take in the entire image. Quick cuts can be too jarring. A 2/3 horizon should be maintained. Human figures, especially heads, can be disconcerting in the top third of the frame." [107] Romney dittoes this point in his argument that "ironically, IMAX's most challenging possibilities may be as a cinema of intimacy and miniature." [108] Not only is it difficult to edit within scenes, but the monstrous proportions of the human body when blown up by the IMAX camera evoke something of Jonathan Swift's disgust at the human body in the Brobdingnag section of *Gulliver's Travels* (1726) where women's bodies—the breast in particular—become "a frightening symbol of growth and contamination" (one can't help but think of the monstrous size of Michael Jordan's hands or Mick Jagger's lips in *Rolling Stones at the Max* [Noel Archambaut, 1991]).[109] The body, in medium or close-up shots at least, assumes monstrous proportions under the magnifying lens of IMAX, especially 3-D IMAX, which not only increases the size but turns the human frame itself into a cardboard cutout if not carefully blocked within the mise-en-scène. But maybe it is not so much the human body we are aware of at moments of perceptual excess such as these so much as film's ontology and the nature of spectatorship; as Whitney explains, "[B]y evoking a sense of imminent transformation or perpetual futurism, IMAX manages to intensify the spectator's consciousness of the act of film-going, and in so doing, provides a valuable opportunity to contemplate cinema itself." [110]

What binds these somewhat disparate though indubitably linked ways of seeing the world is light, a need for a bright, legible image to convey the illusion of accessing a different space and possibly time. Robert Barker, inventor of the panorama, made explicit reference to the role of carefully recorded patterns of light in his elaborate patent, instructing the artist that once he had "fixed his station," he should not only "delineate correctly and connectedly every object which presents itself to his view as he turns around . . . [but] observe the lights and shadows how they fall, and perfect his piece to the best of his abilities."[111] Natural light entering through the glass roof of the rotunda directly above the vellum not only heightens the illusion of being in another space—exquisitely illustrated in the Mesdag Panorama in The Hague (see fig. 2.1)—but also contributes in no small part to the verisimilitude of the experience, since moving clouds and variations in light create tonal shifts reminiscent of the contingent nature of outdoor viewing. While projected light, cinema's *avant la lettre*, is not subject to the indeterminacy of the elements, in the case of IMAX projection it does rely upon a light that is considerably brighter than 35mm projection. Even IMAX shooting conditions require intense light, especially artificial lighting which is "so powerful that the heat quickly becomes unbearable for human or animal subjects"; the IMAX projector's xenon lamp is the brightest used in the industry and another source of corporate pride in publicity materials touting its amazing brilliance and

strength.[112] IPIX too, although hardly a shining beacon of light (located as it is on the small flat screen of the computer), nevertheless relies heavily upon light to create the illusion of virtual navigation around a three-dimensional space. Even contemporary virtual environments (VEs) are characterized by an intense luminosity, brightness so dazzling that it left VE scholar Ken Hillis with a severe headache after spending several days working with the technology.[113] For Hillis, vision is a "fundamental, even primary precept in virtual worlds," the technology affecting the human sensorium on a level far exceeding that of other mass media.[114] While bright light may be an expected feature of an IMAX screening and a prerequisite for IMAX filming, there are places that IMAX has visited where the light is entirely artificial, such as to the wreck of the *Titanic* in *Ghosts of the Abyss* (James Cameron, 2003) and to the moon in the Tom Hanks–narrated *Magnificent Desolation: Walking on the Moon 3D* (Mark Cowen, 2005). However, I would argue that the sense of immersion in a frameless world is ultimately more effective than the brightness of the light; indeed the absence of light, save for stars and big bang explosions, is what creates the illusion of being immersed in the nighttime sky in the planetarium space show, the subject of the next chapter.

If the meanings of *Everest* were dramatically shaped by the deaths of the climbers and continue to shift in the wake of increasing demands by amateurs to make an attempt on the summit, so too does our heightened state of terrorism alert and global instability in the wake of 9/11/01 shape the discursive meanings of *Sea of Time*, which becomes something of an ironic and politically

charged meta-commentary on American identity and urbanism. Despite being Canadian in origin, IMAX is often perceived as a super-sized North American medium churned out by a super-sized culture that thrives on "bigness" and ostentation; Leopold's eagerness to assimilate and embrace the American Dream thus rings a little hollow in the face of American imperialism overseas and its troubled international reputation. Shots in which the Twin Towers fade from view as one sublime image of the Manhattan skyline dissolves into another imbue *Sea of Time* with a pathos and nostalgia that exceeds the moving-postcard genre. In addition, the image of two planes on either side of the Twin Towers on the cover art of the video release of *Across the Sea of Time* (see fig. 3.7) is an ominous (and ironic) foreshadowing of the destruction of the towers and horror that beset America on that fateful day in 2001. Moreover, as homeland security is tightened and restrictive immigration policy taints the dream of a better life in the so-called "free world," the parable of Leopold Minton may ring true for far fewer immigrants in the years to come.

Sea of Time and *Everest* are travelogues that privilege spectacles of grandness and monumentality perfectly befitting a hyperbolic cinematic technology. They are calling-card films for IMAX, two very different cinematic subjects cut from the same discursive cloth. And yet as much as IMAX claims to be the *über* cinematic form—becoming as much a tourist destination competing with the very same sites it represents on its screens (visitors to the Grand Canyon are greeted by the IMAX film of the canyon, *Grand Canyon: The Hidden Secrets*

[Keith Merrill, 1984]), before being led to the rim, and, as this photograph (fig. 3.12) from the Yucatan Peninsula in Mexico attests, an IMAX film of a natural phenomenon vouches for the natural phenomenon itself, overshadowing even the actual sign to the Hidden Worlds cenotes)—we can't help but wonder how, in an attempt to push the envelope in terms of improving the "IMAX experience" and breaking into the mainstream, IMAX faces challenges that are endemic to its status as expanded cinema. Travel and IMAX thus seem ontologically bound, but whether the journeys will be those viewers want to take is another matter.

If the fate of the nineteenth-century's version of IMAX, the London Colosseum, is anything to go by—after numerous refurbishments and change of management, the Colosseum still struggled to turn a profit, and in an effort to compete with popular amusements, introduced such attractions as fire-eating conjurers, oxy-hydrogen microscopes, and dissolving views—overzealous developers who see large-screen technologies such as IMAX as sure winners in the competitive landscape of popular entertainments should take heed. As we have seen in this chapter, the attempt by IMAX in 1999 to move into more mainstream exhibition markets supported by a new emphasis upon 3-D animation productions, evidenced by an $8 million 19 percent equity stake in the animation company Mainframe, has yielded results but not revolutionized IMAX production and exhibition.[115] Years on, it still remains to be seen whether IMAX's attempts at brand diversification will be successful in the leisure marketplace. Regardless of the corporation's success, for film his-

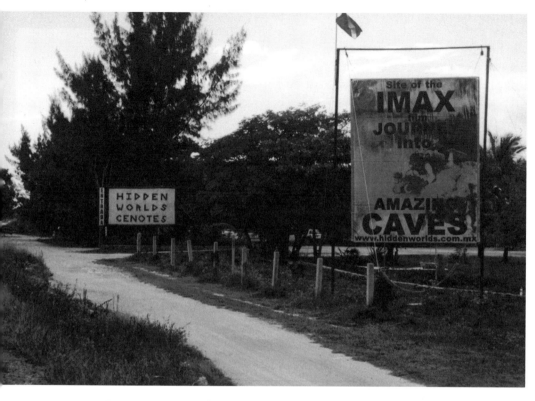

Fig 3.12 IMAX poster for *Journey into Amazing Caves* next to Hidden Worlds Cenotes entrance
sign, Yucatan Peninsula, Mexico. (Author's collection)

What's striking here, then, is the way in which the 360-degree view (hinted at but never actualized in IMAX) has clung on, almost by a thread at times, to the popular imaginary since the late eighteenth century, capturing public interest but rarely posing a threat to two-dimensional, 180-degree representational forms. The rhetorical construction of IPIX and Be Here as radically new ways of vicariously experiencing reality suggest a cultural and technological amnesia in terms of how quickly new technologies are absorbed into the mainstream (although forever rebranded as "new" to further product innovation and consolidate market share); they also seem blindly ignorant of the longevity of claims of virtual presence in large-screen imaging technologies, luring potential consumers to sites that purport to make you "feel as though you're in that house or building," as if the idea were being proposed for the first time.[116] The notion of being immersed in an online image—while still exploited in the marketing hype of 360-degree imaging companies —rings a little hollow in this era of media convergence and multiple delivery platforms. And yet as Web sites become ever more sophisticated, multisensory even, the pressure will be on to think of new ways to market or brand the experience for

torians and theorists alike the current period of economic and aesthetic recalculation by IMAX officials, as well as the proliferation of Web-based immersive and interactive technologies such as IPIX and Be Here, provide a privileged vantage point (panoramic in some senses) into the complex historical antecedents and cultural meanings of 360-degree screen technologies.

the "Websumer." Panoramic perception has thus become a metaphor for the World Wide Web, the idea of seeing everything, everywhere, all the time the defining experience. Whether or not Web surfers will come to demand 360-degree immersive visual content in *all* forms of their online interactions remains to be seen; and whether companies will use it more and more to extend the brand experience is unclear. What we do know is that we've been here before—despite Be Here's rhetoric—albeit in a different form; and while immersive realism and the 360-degree view are perhaps more exciting in principle than in practice (certainly on the Internet), they stubbornly refuse to go away as novel and intriguing ways of seeing the world.

4

"A MOVING PICTURE OF THE HEAVENS"

IMMERSION IN THE PLANETARIUM SPACE SHOW

As the heavenly objects swept from horizon to horizon, the specta-
tors twisted, sprawled and wrenched themselves around to follow the
celestial courses. They were only watching simulated stars shining on
the domed ceiling of the Hayden Planetarium in New York City. . . . But
to the spectators, these were exciting wonders.

—Anon., *Life* (1958)[1]

O NE OF THE MOST popular planetarium displays
presented at the Hayden Planetarium at the
American Museum of Natural History (AMNH)
(fig. 4.1) in the summer of 1953 was described by plan-
etarium chairman Robert R. Coles as "A simulated trip
on a rocket to the moon, in which spectators watching
the planetarium's domed ceiling were whisked a quar-
ter million miles through space for a landing at one of
the moon's craters."[2] Ten years later, a virtually identical
description of the planetarium show appeared in Hart's
Guide to New York City: "Here's a fascinating way to take
a trip to outer space. You sit in a comfortable chair in the
Sky Theater and are whisked anywhere in the solar sys-
tem. And, most surprisingly, you can travel in the past

and in the future, as well as in the present."[3] Attend the
Hayden Planetarium at the AMNH today, and you'll find
that whisking has been replaced by a rather more prosaic
"flying," although the theme of virtual travel is preserved;
for a price of $22 ($13 for children), visitors are "sent into
space using a Digital Dome System which flies audiences
through a scientifically accurate virtual re-creation of our
Milky Way Galaxy and beyond, to the 'edge' of the observ-
able universe."[4]

That the planetarium should have appropriated a
discourse of armchair travel both to construct and pro-
mote the experience to mid-twentieth-century spectators
should come as no surprise since, like its neighboring
technologies of virtual transport, the panorama (giant

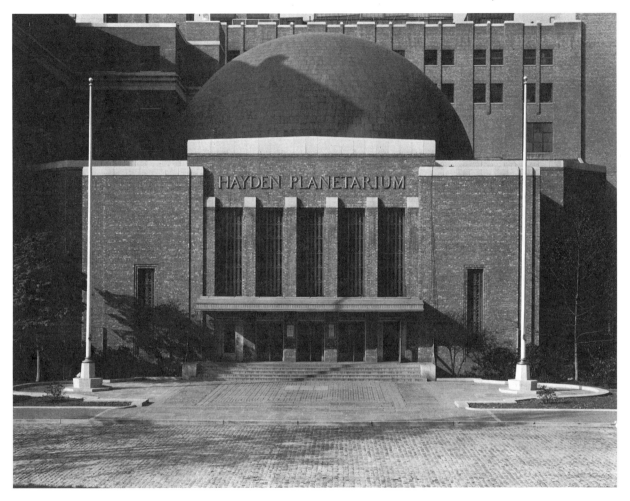

Fig 4.1 Exterior of Hayden Planetarium (1935). (Neg. no. 314924. Courtesy Department of Library Services, AMNH)

circular paintings, also known as cycloramas, that surrounded the spectator) and cinema, the planetarium is an intermedial screen practice that, while phenomenologically unique, shares a great deal with other screen- (or canvas-) based spectacular display techniques. The planetarium can also be traced to tabletop astronomy and scientific performances such as the magic lantern experiments that took place at the British Polytechnic and Mechanics Institutes and which are discussed in the following chapter. The analogies to these intertextual forms are complex, though, with the similarities both vestigial and blatantly obvious. Rather than attempt to explore all the possible ways in which planetarium shows function as intermedial events, my goal here is to examine some of the defining features of the planetarium in the hope that we may discover how it, too, like the cathedral and panorama, delivers a highly immersive experience for its virtual space-travelers. Issues to address include the planetarium's history as a conduit of popularized astronomy, especially in relation to ideas of spectacle and wonder; the struggle for perfect illusionism; theatricality and performance; and what I call, building upon a concept first introduced in chapter 1, the "revered gaze," how the exhibition space and spectatorship become bound up with a religio-spiritualist discourse.[5] An understanding of planetarium spectatorship is vital here since it promises to take us one step further in this important leg of our journey toward understanding the very nature of immersive spectacle. To some extent planetarium spectatorship represents the very epitome of immersive entertainments and for this reason can serve as an object-lesson in how the experience of immersion and, more importantly, the *discourse* of entering the world of the image, shapes audience expectations and the show itself.

INTERMEDIAL CROSSINGS: SITUATING THE PLANETARIUM PHENOMENOLOGICALLY

Like the panorama, the planetarium experience takes place inside a dome (fig. 4.2) where a "virtual" reality is illusionistically constructed; spectators are to imagine that once they take their seat, they are magically transported to outer space and possibly another time, depending on the subject of the planetarium performance or panoramic painting. Planetariums employ the principle of the panorama in the elaborate horizons constructed around the edge of the theater and, from the 1930s through the 1960s, the "panoramas" (as they were called) were an important part of the show.[6] However, unlike the panorama, spectators are seated rather than ambulatory, and the image is subject to considerable change as past, present, and future star constellations, galaxies, and universal phenomena such as black holes are projected onto the dome. Planetarium performances are also heavily intertextual multimedia performances with slide / digital projected images and special effects inspired from popular culture, motion pictures, and sci-fi apocalyptic narratives, as seen in this drawing of a tidal wave destroying the Manhattan skyline (fig. 4.3).

Each phenomenon takes place in a darkened auditorium, although the panorama is packaged less as a performance and more as a fairground-type attraction where payment guarantees entry that in most instances is not

timed, but rather contingent on the spectators' finally deciding they have seen enough and leaving the viewing platform in the rotunda (of course in the fairground, the ride is the key temporal determinant). The insulated planetarium dome that entombs the spectator for the duration of the performance certainly sounds a lot like cinema (and is, in many respects, trompe l'oeil par excellence), although in contrast to film, which requires spectators to look straight in front (or at a slight angle if they are seated at the edges of the auditorium), the planetarium requires an upward gaze, a look to the "celestial heavens." If in cinema the contiguity of time and space is provided by editing, in the planetarium stars tend to dissolve from one configuration to the next rather than change suddenly, although this is by no means a hard and fast rule, since principles of editing are also to be found in planetarium shows, and most of them today use a range of digital special effects along with projected images.

Configured something like a mathematical Venn diagram, where panoramas, planetariums, and cinema share phenomenological properties found in the middle space at the center of the three overlapping circles, each phenomenon must nevertheless be considered on its own terms in relation to issues of verisimilitude, the exigencies of the exhibition space, and popular culture as a whole. Rather than belabor the similarities and differences between the

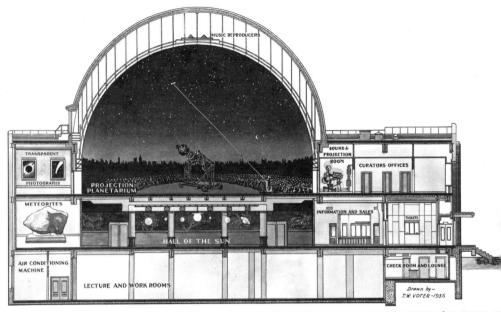

LONGITUDINAL SECTION OF THE HAYDEN PLANETARIUM

Fig 4.2 Cross-section of the Hayden Planetarium, showing lecture rooms and adjacent galleries (c. 1935). (Neg. no 315158. Courtesy Department of Library Services, AMNH)

three signifying practices, each of which is an important vector in this book about immersive modes of spectatorship, it is more productive to let their points of convergence and divergence become apparent to the reader through the ideas and examples discussed below. To be sure, my attempt to fully enunciate what a planetarium show is like may end up being as opaque and idiosyncratic as the one written by an anonymous contributor to *Vogue* in 1935, who in struggling to make sense of the planetar

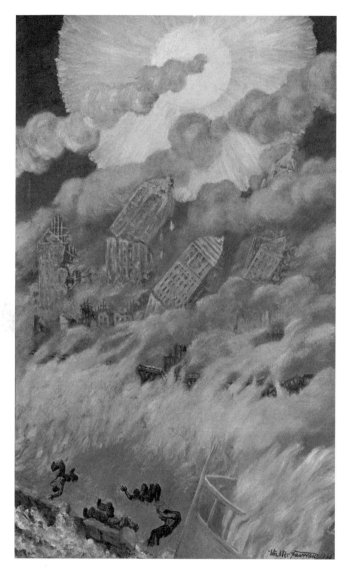

ium's contradictory vectors, embraced its paradoxes: "It is so far above the merely informative that it approaches the uplifting. And, ironically, it is also somewhat unearthly. It makes you feel successively, like an ancient philosopher, the weather man, and God."[7] The planetarium has always looked to neighboring technologies and visual techniques to enhance the experience; indeed, the notion of the performance as an "experience" can be seen as a semantic glue of sorts that binds these (and other) related amusements together. But what makes the planetarium "so far above the merely informative"? Why, and how exactly, does it conger up feelings of religiosity making spectators feel "like God"?

The planetarium is an exemplary intermedial form for the ways in which it employs modalities from the era of popular culture in which it finds itself; so, when it was first invented, it turned to theater (visionary theater designer Norman Bel Geddes's long career in design is an obvious reference point here, especially since he submitted designs for the Hayden Planetarium and was working during the planetarium's heyday in the late 1920s through late 1950s when modernist visual tropes and futurist design elements influenced by science fiction abounded); during the 1950s and 1960s, television and the Space Race were vital informing contexts; and some of today's modernized planetariums are influenced by theme park rides, video games, and digital special effects. For exam-

Fig 4.3 Apocalyptic tidal wave destruction of Manhattan as represented in planetarium show artwork from the late 1930s. (Neg. no. 315738. Courtesy Department of Library Services, AMNH)

ple, at the "all-Digital StarRider Theater," which is on the lower level of the Adler Planetarium in Chicago (the first planetarium to open in the United States, in 1930), audiences are invited to "take a thrilling ride to the center of a black hole." Along the way they discover a "range of cosmic wonders, fly through wormholes, experience the creation of the Milky Way Galaxy and witness the death of a star."[8] The techno-minimalist ambient music playing in the StarRider as the audience enters is in sharp contrast to the jazz one hears in the Adler's main planetarium one floor above; gone are the stiff upright chairs and in their place are padded leather recliners with headrests and interactive armrest touch pads; gone is the huge domed interior shell and in its place is a more intimate curved screen (although not fully surrounding the audience); and finally, gone is the quaint iconography of mythical star constellations, having been replaced by a voice-over narration and visuals that more resemble a Discovery channel documentary. The sensation of penetrating space (a phantom ride effect of moving rapidly into the screen) is definitely the highlight of the show, especially when the narrator informs us to fasten our (imaginary) seatbelts as we prepare to enter a black hole.

Notwithstanding the singular ways in which audience members are hailed as spectators in the diversified entertainment that is now on offer in the world's planetariums, the idea of the performance as an "experience" (as opposed to a less embodied "show") has become the phenomenological glue that binds these (and other) related amusements together (IMAX is an obvious parallel). But what makes the planetarium more than simply illustrated astronomy, what kind of entertainment does it offer, exactly, and why, despite the marketing rhetoric and hyperbole, does it sometimes put us to sleep? Let us begin with some history.

CELESTIAL VISION: TRACING THE HISTORY OF THE PLANETARIUM

The time may not be too far distant when planetariums will be as numerous as museums.

—Joseph Miles Chamberlain (1957)[9]

A fascination with the sphericity of the earth and the universe, especially questions relating to the "circular" motions of the sun, moon, and planets, has long captured the imagination of scientists, physicists, and astronomers (sculptors and artists in Ancient Greece "sought how best to place on record the appearance of the night sky," and in the first century BC, physicists used mechanical spheres and three-dimensional models to explain astronomical phenomena). According to Elly Dekker, "armillary spheres, astrolabes, globes and mechanical systems such as planetaria, were invented to demonstrate concepts of the sphere and to solve the practical problem of our relation with the sun and other planets without the need for such involved calculations."[10] The term *planetarium* was coined in 1397 by Italian scholar Giovanni de Dondi, who in his manuscript *The Planetarium of Giovanni de Dondo Citizen of Padua*, thanked God for his assistance: "I conceived the design . . . with *the help of God*, of . . . putting together this work out of rough and crude material, in which should be made manifest the motions of the

stars." Referring to the tabletop astronomical apparatus rather than the spherical dome planetarium which was invented much later, de Dondi tentatively justified the nomenclature he had chosen for his invention: "And this model, although many other things are to be known by it, is yet chiefly designed to demonstrate the orbs, motions and positions of the planets. Now it is right, as Aristotle says, that every name should arise from the purpose of the thing; and by this law this model can best be called a *Planetarium*.[11] However, it took until 1608 and the invention of the telescope by Dutch spectacle maker Hans Lippershey to definitively prove the status of the earth as yet another planet spinning around the sun (news of its invention soon reached Padua professor of mathematics Galileo Galilei, who immediately incorporated it into his research).[12]

Devices representing the movements of the planets and our moon in relation to the sun had been in use since the early days of Copernican astronomy (an epistemic shift heralded by the Polish monk Copernicus who published a book in 1543 challenging the Greek astronomer Ptolemy's theory of planet movements).[13] The sixteenth century ushered in a number of key developments in tabletop planetarium designs including the addition of moveable circles representing the sun, moon, and planets in later designs and a stand showing the horizon.[14] Commencing in the latter half of the seventeenth century, planetariums representing the solar system, including the geared device invented by Charles Boyle, the fourth Earl of Orrery, whose name was given to a particular type of planetarium, grew in popularity.[15] In the orrery, "the planets of a model solar system could be made to move in circular paths around a central sun by turning a handle connected to an ingenious system of gears and spindles," as seen in this oft-reproduced 1768 painting by Joseph Wright entitled *The Philosopher Reading a Lecture on the Orrery* (fig. 4.4).[16] The atmospheric candlelight on the faces of the members of the lecture party assembled around the orrery, especially the two younger children in the center of the painting, posits wonder as isomorphic with astronomy. While the two adult males cast their eyes toward the lecturer-philosopher whose downward glance at his notes with pen in hand confirms his role as the eminent source of rationale scientific knowledge, the three teenage-looking males and boy and girl in the middle ground lean forward into the device, satisfying a tactile desire to get closer to the apparatus through touching the hemispherical bars. However, it is the dramatically lit faces of the younger girl and boy who appear to be mesmerized by the orrery that attract our attention most, their wistful gazes a powerful symbol of the perennial human fascination with the cosmos. The light radiating from the apparatus makes it the terrestrial (and metaphorical) equivalent of a brightly shining sun or star glowing in the darkened room. A tension between the lecture as a serious object-lesson and as a magical, supernatural event explaining astronomical forces that, while scientific in nature, are nevertheless evocative of metaphysical, transcendentalist ideas is powerfully inscribed in this painting. The scene is reminiscent in many respects of a séance, with the orrery substituting for the Ouija board; "presence," suggesting both the literary sense of being "part of space within one's

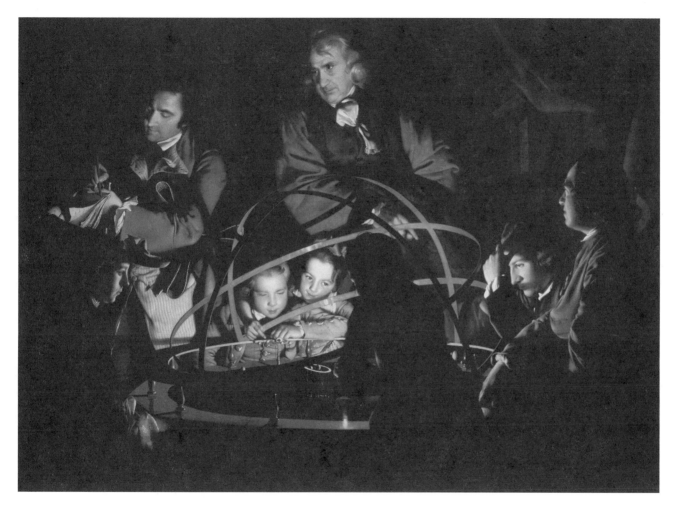

Fig 4.4 Joseph Wright, *The Philosopher Reading a Lecture on the Orrery* (1768). (Courtesy Derby Museum of Art, UK)

immediate vicinity" and the supernatural connotation of "something (as a spirit) felt or believed to be present" is powerfully evoked here and a recurring theme in planetarium discourse.[17]

The anonymous reviewer of the Hayden Planetarium show from its opening year in 1935 described being "in a state of hypnotic trance from beginning to end until the lights came up three quarters of an hour later."[18] In 1928, AMNH curator Clyde Fisher, who visited the Zeiss planetarium in Jena (Germany), purportedly felt overwhelmed by the illusionism, convinced that "due to subconscious imagination perhaps traceable to some psychologic or physiologic reason the artificial sky seems to possess the deep night blue of the real sky and yet there is no blue on the inside of the dome and none in the projection apparatus."[19] Fisher was not the only one who reacted ebulliently: the new planetarium was a sensation following its first public demonstration (which was standing room only) on the roof of one of the Zeiss factory buildings, as seen in figure 4.5.[20] *Scientific Monthly* writer Dorothy A. Bennette felt duped not only by the color of the nighttime sky but by the very air she breathed; for her, the "crispness of the night air is almost sensible beneath the *blueness* of the night sky."[21] Fisher's attempts to explain the realist lure of the planetarium illusion reminds us of Tom Gunning's "aesthetic of astonishment" from the early cinema period, in which audiences were conscious of the cognitive play between reality and illusion and yet spellbound by the verisimilitude.[22] This sense of seeing or feeling something that does not actually exist places the planetarium, cinema, and the séance into an interesting relationship; why else would Fisher turn to psychology and human per-

ception as a way of explaining a phenomenon that is at once scientific, metaphysical, and quasi-religious?

As in some of Wright's other paintings that include living scientific subjects, such as the cockatoo in *An Experiment on a Bird in the Air Pump* (1768), which appears mesmerizing for the little girl standing center frame looking up at the bird and distressing for the older girl, who covers the side of her face with her hand in order to avoid seeing the bird suffer, one can palpably sense the magical appeal of the parlor experiment. Indeed, one can even interpret the children's expressions in *Philosopher Reading a Lecture* as a desire for something more than just explanation and moving parts in the orrery. Gazing down wistfully at the apparatus—the child on the left is even resting his left arm on one of the orrery's metal supports—their disposition, proximity, and tactile encounter with the object seems to foreshadow the magical and supernatural qualities of the planetarium. The darkened drawing room housing the orrery has been transformed into a space of theatricality, the image of the drapes in the upper right-hand corner of the frame reinforcing this. Considered the inventor of the scientific Enlightenment subject, Wright was intrigued by the domestic science experiment, using light in his paintings to dramatically illuminate the faces of his subjects in dimly lit interiors.

However, it was not until the seventeenth century that a device consisting of a "slowly turning sphere," in which holes were cut out for the stars and that accommodated observers on the inside of a celestial dome, as opposed to seated or standing around a tabletop apparatus, was invented. In 1654, Adam Oelschlager, court mathematician and librarian to Duke Frederick of Holstein-Gottorp,

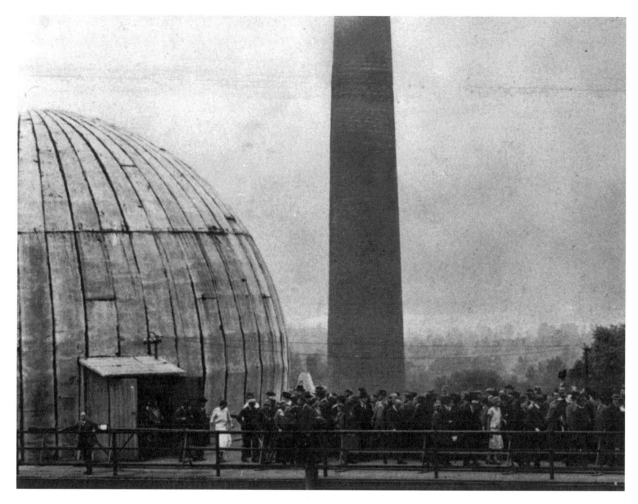

Fig 4.5 Crowds leaving the first demonstration of the Zeiss Planetarium in Jena, Germany (1924). (Neg. no. 259080. Courtesy Department of Library Services, AMNH)

designed a hollow globe large enough to accommodate several seated spectators: "Inside, a circular platform suspended from the axis of rotation held as many as ten people and as the globe rotated many stars and constellations drifted across the artificial sky in a way similar to that of the real sky." [23] Made of copper, the globe was 11 feet in diameter and on the inside showed gilded stars and constellation figures lit by two oil lamps. A map of the world was painted onto the outer surface, which could be examined in detail by spectators. [24] Another version was built by British astronomy professor Roger Long in 1758 at Pembroke College, Cambridge University; 28 feet in diameter, it seated thirty people. Stars were represented by holes of various sizes in the dome, and the entire device could be rotated by winch and rackwork.

A sophisticated version of the "hollow sphere"-type planetarium was constructed between 1911 and 1913 for the Chicago Academy of Sciences by Wallace Atwood; powered by an electric motor, the "Atwood Celestial Sphere," which was recently restored and is open to the public at the Adler, consists of a 15-foot sphere of galvanized sheet iron "rotated on bearings placed around its equator, thus eliminating any obstruction an internal axle would have created." [25] It has a stationary platform large enough to hold a small audience, which enters through an opening on the "South Pole"; once inside, a recorded narration points out significant constellations as the guide who travels inside the sphere points out the stars on the small dome. [26] Another famous version of the hollow dome–type construction was the large ceiling orrery completed in the early 1920s at the Deutches Museum (Munich) by Franz Meyer; [27] installed in a room 37 feet in diameter, a sun globe

hung from the ceiling in the center of the room contained a 300-watt light bulb that lit up the entire room; smaller globes were suspended from "electrically-driven carriages that moved on elliptical rails with speeds proportionate to their natural velocities. The spectator went round the model sun on a moving platform located directly beneath the earth globe, and by using a periscope could watch the planets as they moved against a background of constellations painted on the walls of the room." [28]

Essential to the development of a planetarium building that could house a far larger audience was an understanding of the principles of dome construction, which, dating back to the Romans (the Pantheon's dome spans 144 feet), saw spectacular achievements in the sixth century with the completion of the St. Sophia Mosque in Istanbul by the Emperor Justinian; the 138-foot dome in Florence from the fifteenth century; and the 131-foot dome of St. Peter's in Rome built in the sixteenth century. However, according to R. L. Bertin, "no essential progress in the theoretical and constructive art of dome construction was made until the first theories on domes of rotation for symmetrical loading known as the membrane theory, were developed by G. Lame and E. Clapeyron in 1828." [29] The invention of reinforced concrete at the beginning of the twentieth century led to a renaissance in dome architecture and set the stage for what would become the golden years of planetarium construction. Stretching a covering over the supports of the orrery and vastly expanding its dimensions so large numbers of people could witness astronomical phenomena firsthand had been the logical way forward for planetarium technology, although prior to the development of Carl Zeiss's projec-

tor between 1919 and 1922, "existing planetaria were essentially refinements of concepts developed during the Renaissance."[30] In 1913, Dr. Oskar von Miller, founder and director of the Deutches Museum, envisioned a large planetarium dome that would "show the movements of the heavenly bodies according to the Ptolemaic system on the interior of a hemispherical dome in the same manner as they appear to an observer on the earth." David Riesman, describing the history of the Zeiss Planetarium in 1928, summarized von Miller's dream as follows: "to find a means that would permit a considerable number of people to view astronomical phenomena in the most impressive manner possible."[31] Von Miller enlisted the services of the famous optical firm of Messrs Carl Zeiss of Jena to help design and construct such a building and projector. However, according to Riesman, the first Copernican planetarium constructed by Zeiss gave the observer an "erroneous notion of the alignment and distances of the planets, creat[ing] a false conception of the really extraordinarily small amounts of luminous material in space."[32] When Miller proposed a second model to the company, one that would "show the heavens as we see them from the Earth when out of doors," he pictured the observer standing upon a platform constructed at the center of a "great rotary metal dome, a celestial sphere." Attached to different mechanisms, the planets "were to be moved upon the inside surface of the sphere in accordance with their actual apparent motions."[33] As described by Joseph Miles Chamberlain in a Smithsonian Institution report on planetarium development in the United States, "the sun, moon, and planets were to be represented by illuminated disks driven by a suitable gearing in such a way that the epicycle of orbits of the objects would be truly represented."[34] However, the ultimate dream of constructing an "artificial sky" eluded the engineers and scientists at Jena for quite some time; at the fulcrum of the problem was the question of how engineering and design could work hand in hand to create an impression that was so ethereal (literally, "otherworldly") that mechanistic solutions appeared hopelessly inadequate for the task. As Riesman explained: "to secure a correct representation of Nature seems out of the question as long as one clings to the idea of reaching the goal through cumbersome mechanisms, that is, through constructions that can never be in a position to create the illusion of the mysterious, silent march of the worlds of Nature."[35]

Among the hurdles Jena scientists had to overcome in the late teens and early 1920s was an opposition between the planetarium as signifier of precision engineering versus a device capable of unparalleled illusionism (representing the sky at night as if spectators were actually looking at it). While we should tread with care when drawing too stark ontological comparisons between the planetarium and the motion picture, how each phenomenon was discursively constructed in the historical record as a superlative conveyor of illusion is worth briefly exploring. In contrast to the Zeiss Planetarium, which some German engineers felt would "never be in a position to create the illusion" of the nighttime sky and astral configurations, the film projector was from its inception often referred to as nature's ally in the early cinema popular press, a machine that could, in Gunning's words, "serve as both tool of discovery and means of verification in a new worldview constructed on an investigation of actual entities explored

through their visible aspects."[36] A "manufactured luminescence," a light that Antonia Lant argues was influenced by an orientalist discourse, especially Egyptological referents, cinema was in no ways ontologically challenged in the task of conjuring up reality; in fact, cinema, like the sun, created light where previously there was none. Citing early film theorist Vachel Lindsay, Lant sees valences in the metaphorical parallels he draws between cinema and the sun, a connection of especial interest to the subject of planetariums. According to Lant, Lindsay viewed filmgoing as akin to "sun-worshipping . . . a going to the sun" and considered cinema an instance of "our present ritual in the worship of light."[37] That Lindsey should be writing in 1924 at exactly the same time as the Zeiss Planetarium opened to the public leads us to speculate on whether he was at all familiar with the work going on at Jena (experiments open to the public began in 1919) or was simply satisfying an intellectual curiosity for theories of light and projection.

And yet, cinema's positivism (and doppelgänger, the uncanny) created a parallel universe and distinctly modernist subjectivity that, while signifying reality, did not pretend to represent it with the exact same perceptual coordinates as the human eye (the image, for one, is far larger than the corresponding reality, unless the vista on the screen corresponds to a distant landscape), something von Miller strove to attain in his early plans for the planetarium. The planetarium projector was thus charged with the engineering challenge of simulating vision into outer space, the sensation of *actually* gazing up at the nighttime sky, as if the roof of the dome had silently peeled back its covering to reveal the inky-black sky (fig. 4.6). However,

in the minds of Jena scientists and engineers, early versions of the planetarium were too mechanical, too cumbersome, and too terrestrial even to rise to the logistical and ontological challenge of replicating astronomical gazing. And yet, we shouldn't lose sight of the fact that while these very early blueprints of the planetarium may seem at odds with cinema in relation to how reality was represented on the screen, the planetarium quickly turned to the world of popular culture for inspiration on how to transform the celestial heavens into an entertainment medium as well as an object-lesson in astronomy. The repertoire of suitable planetarium topics quickly expanded, adding narrative, music, sound, and special effects to the original astronomy lesson.

For von Miller, the materiality of the projector made it ill-equipped to construct "the illusion of the mysterious, silent march of the worlds of Nature"; with no ontological link to nature, the projector was no match for the mystery and silence of outer space; and yet we can't help noticing a certain irony here given that Zeiss was the leading name in optical technology, manufacturing lenses and watches that in many ways were eminently capable of operating noiselessly *and* mysteriously (for members of the lay public at any rate), on a level, some might argue, with astronomical phenomena. The issue of noise in relation to the planetarium warrants further analysis, too, since there is an obvious tension in the discourse between the intrusion of noise created by the apparatus versus the noise made by spectators.

Soundproofing the planetarium shell had been an absolute must from the outset; the first dome in Jena had poor acoustics, although engineers found that stretching

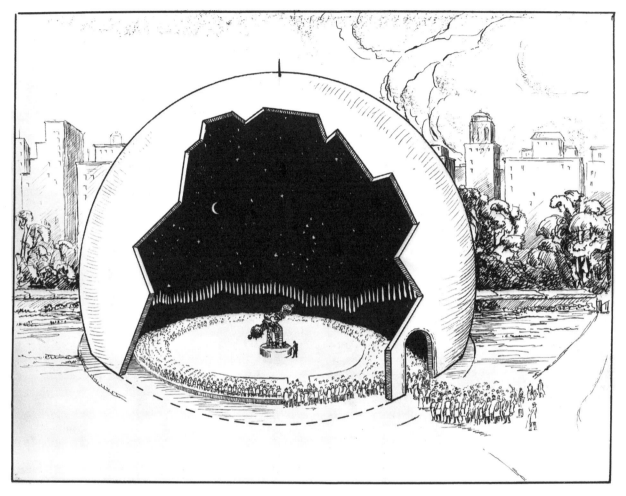

Fig 4.6 Artist's rendition of a planetarium with a section of the dome cut out and crowds pouring in from the street (c. 1935). (Neg. no. 117195. Courtesy Department of Library Services, AMNH)

linen along the inner surface helped reflect the sound waves and functioned as a reasonably effective sound buffer. In later domes where the projector ascended and descended from the floor, noiseless operation was also a must. The silence greeting audience members upon entry into the dome—unlike urban movie theaters where subway trains and the occasional sound of firetrucks and police sirens intrude into the diegesis—was touted as a means of escaping the hustle and bustle of the city; as guidebook writers Nils Hogner and Guy Scott wrote about the Hayden Planetarium: "Even if you don't like stars, you ought to come here, because it's probably the quietest spot in New York." [38] The silence also contributed to the immersive effects of the planetarium show, the sensation of being out-of-doors as reported in an AMNH *Bulletin* from November 1935, one month after the Hayden Planetarium opened to the public: "Not a single echo of Manhattan's bustling traffic filters through its cunning sound-proofed walls. . . . [It has become] one of the most soothingly quiet places in New York." [39] The churchlike stillness and quiet of the planetarium in between shows and when audiences finally took their seats and the lights were dimmed was occasionally shattered by the noisy reactions of spectators. If at times overdetermined by religious meaning, the actual goings-on within a planetarium may at times have been far from godly; the Laserium, from the very outset, was linked to psychedelia, drug use, and rowdy audiences, but even the planetarium (like the drive-in movie and motion picture theater) could be a place for romantic goings-on, as Steven M. Spencer pointed out in a 1954 *Saturday Evening Post* article: not only were planetariums

operating on government posts good for community relations, but because of the "romantically dark and starry environment, the planetarium has even been a popular place for the students to bring their dates." [40]

At a planetarium performance at the Allegemeine Krankenhaus in Vienna in 1928, for example, Riesman observed that as the light began to fade and one grew accustomed to the increasing darkness, "suddenly the prevailing silence was broken by a deep gasp from the whole audience." [41] Writing about the planetarium show in the *New York Times* the same year, Walter Kaempffert conflated religion, the sublime, and Gunning's "aesthetic of astonishment" in this single description:

> A miracle happens. A switch has been thrown, and that cerulean vault suddenly becomes a firmament of twinkling stars. Even trained astronomers who know exactly what to expect cannot suppress a long drawn "Ah-h-h" of astonishment and pleasure when they behold this dramatically presented counterfeit of the heavens for the first time. [42]

Reference to the audible sounds of audience astonishment were included in a 1935 review of the Hayden Planetarium performance from *Scientific Monthly*, which added that "so breathtakingly beautiful are the starry heavens that their first appearance, accompanied by music, never fails to draw a *gasp* of wonder from the audience." [43] The issue of how first to reveal the stars was the subject of some debate among planetarium directors, some of whom argued that the audience should enter into the space with the night sky already visible—as one would walk in to a

panorama with the illusion in situ, so to speak—others that it should be suddenly switched on to maximize the element of surprise; and still others who recommended that audiences be "properly prepared for the spectacle . . . by telling them to close their eyes for a few seconds and to imagine themselves on a starry night, on a peak somewhere in the Alps" upon which the houselights would dim and the stars would appear.[44] One cannot help noticing the obvious parallels between the presence of the sublime in spectators' reactions to planetariums and panoramas, where similar gasps at the verisimilitude of the giant paintings were recorded by lay audience members and art critics. As we saw in chapter 2, this mode of popular entertainment nevertheless drew a measure of skepticism, especially from artists, who claimed that principles of aesthetic merit were seriously compromised when verisimilitude became the tabula rasa of the art form.

Other issues relating to spectatorship that were discussed at the time include the comfort of spectators; research was conducted on the best seating to install, chairs that would support the neck while not impinging upon the unobstructed view. Arthur Draper of the Fels Planetarium complained that his "neck grew tired after the first few minutes of 'observing,' and increasingly so as time went on." A "tilting chair" designed with either a headrest or slanting backs would have made the second and third performances more enjoyable as opposed to "something of a trial."[45] Several prototypes were tested for the 742-seat Hayden Planetarium; as Wayne M. Faunce explained in a 1935 article on construction problems at the Hayden, "all suggestions—and they ranged from the *chaise langue*

[sic] through plain backless chairs, with head rests—were carefully considered." As identified by Faunce, the problem stemmed from the fact that in order to see "all sections of the 'sky,' the observer must do a certain amount of craning and the Hayden Planetarium chair is designed to minimize the strain on the neck and shoulder muscles. The back of the chair is shaped to allow free twisting of the shoulders and yet it supports the observer's back comfortably in a relaxed position."[46] As a way of eliminating the problem of neck strain, Hayden Planetarium designer Norman Bel Geddes came up with a radical solution: "turning the dome upside down and putting a glass floor over it so that stargazers could merely look down between their legs."[47] Not surprisingly, given the reverse direction of the gaze in this inverse dome (and a host of other logistical issues), Geddes's proposal was rejected.

A trip to the planetarium was therefore something of a leveling experience for native New Yorkers, who (one reviewer argued) mocked tourists for gazing upward at the skyscrapers; here was one place where "New Yorkers have to crane their heads just like the tourists they make fun of . . . [they too] must loll their heads to take it all in." Seating was a priority outside of the dome too, with "ornamental settees . . . distributed in the ambulatories at convenient points," to insure the "comfort and enjoyment of visitors."[48] The role of seating in and around the planetarium dome harks back to an earlier era in museological design, namely, the late nineteenth century, when some curators made a case for the inclusion of chairs as a way to stave off museum fatigue, a device intended to have a sobering effect on "museum drunkenness," a term once used

METROPOLITAN MOVIES
Trade Mark Reg. U. S. Pat. Off.

SEE
E RINGS AROUND
SATURN
5¢

Wortman

'Oh, no sir, that new Planetarium at the Museum can't compete with me. I got GENUINE stars.'

to describe the overstimulation and lethargy that creeps in toward the end of a museum visit (or even sooner for recalcitrant visitors).[49]

This focus on chair design and location also reminds us of the thoroughly somatic nature of the planetarium experience: eyes *and* shoulders will be actively engaged throughout the show as the body cranes slightly to witness special effects or star constellations situated behind the head or directly above. Walter Kaempffert, writing in the *New York Times,* described the effect of the planetarium show as "overpowering; our flesh prickles, and superlatives seem inadequate," while Hayden Planetarium chairman William A. Gutsch talked about the role of special effects in creating a "unique environment in the dome so that "we're right there, floating in space. Or, we're standing on the surface of Io next to a volcanic eruption. Or we're peering into a black hole." [50] Experiencing the planetarium show *within* the body, as a form of virtual reality, was a way of explaining the verisimilitude, although as this cartoon from the *New York World-Telegram* from 1935 attests (fig. 4.7), "genuine stars" seen for five cents through the telescope of an enterprising New Yorker wishing to capitalize on the buzz around the opening of the Hayden Planetarium ironically end up playing second fiddle to the planetarium's stars, which while fake are nonetheless read as more realistic.

Lauren Rabinovitz's work on somatic visual culture from Hale's Tours through to IMAX and theme park "ride-films" is prescient here, especially her argument about the development of a "triangulated relationship among a

Fig 4.7 Cartoon from the *New York World-Telegram* (Nov. 18, 1935).

compressed version of travel, heightened, and intensified relations between the body and the machine, and the cinematic rhetoric of hyperrealism."[51] While Rabinovitz does not refer to the planetarium show per se in her essay, there are certainly valences in her discussion of these technologies that resonate with many of the ideas explored here. For example, her argument about how the multisensory nature of the experiences creates a different kind of spectator reminds us of the planetarium's unique blending of the visual topoi of the panorama, magic lantern show, motion picture, and planetarium. These correspondences were recognized (and exploited in the promotion of planetarium shows) at a very early stage, as evidenced in this famous description of the panorama offered by the director of the Royal Danish Observatory in Copenhagen:

> Never was a medium of demonstration produced as intrinsic as this, never one more fascinating in the effect, and certainly never one which appeals to everybody as this does. It is a school, theater, and film all in one, a lecture hall under the vault of the heavens, and a drama in which the celestial bodies are the actors. No description, no photograph, no drawing can possibly reproduce the overwhelming impression made by a demonstration in a Zeiss planetarium.[52]

And yet at the same time as the planetarium clearly engenders a similar spectatorial experience as the cinema, the planetarium also challenges prevailing ideas about spectatorship based purely on a classical model (unified, trans-historical, disembodied spectator), returning the experience back to Gunning's "cinema of attractions," where the purely visual is complemented by a "pleasurable, physical self-awareness of coordinated perceptions within an architectonic space."[53]

However, the extent to which we can appropriate theories of embodied and interactive spectatorship developed in the context of Hale's Tours, IMAX, and modern ridefilms in any wholesale sense must be called into question here because while the gaze is not coincident with that of classical theories of spectatorship predicated on what Rabinovitz calls "a blissful state of disembodiment" in which the spectator is an "effect of a linear technological evolution from the camera obscura to photography to cinema," it is also *not* the same as the gaze implied by her theory of a more embodied spectatorship found in Hale's Tours, IMAX, and ridefilms. Designing a projector and an ideal viewing situation for early planetarium-goers demanded a sophisticated understanding of optics, electronics, precision engineering *and* more abstract discourses of illusionism, spectatorship, and the planetarium as a template upon which aspects of mythical and popular culture, especially science fiction, can be incorporated into the performance. Where the planetarium sits on the spectrum of immersive entertainments (and degrees of embodiment) depends to a large extent on the content of the show and whether the cinematic (and a sense of being immersed in the screen) is privileged over and above other ways of conceptualizing the performance. Planetarium professionals such as Dr. Charles Henry King, hardly a charlatan when it came to issues of scientific integrity, nevertheless let his opinion be known on the role of pleasure and amusement in his 1966 address to the Second International Planetarium Directors Conference in Bochum, Germany:

Give [the public] what they want—entertainment, thrills, and means of escape from the cares and worries of the "world outside." Provide excitement, drama, and spectacle. Let them see the sun, moon, and planets career across the sky. . . . In brief, do anything that will help conceal the unpleasant truth that a planetarium is primarily an educational device and is, or should be, concerned with astronomy.[54]

Long before the special effects intrinsic to King's conceptualization of the planetarium show were a reality, however, the problem of finding the right mechanical means to represent the nighttime sky was an ongoing concern until 1918, when chief engineer at Zeiss, Dr. Ing Walter Bauersfeld, "conceived the idea of placing numerous small optical projectors at the centre of a large, fixed hemisphere."[55] What became clear to Bauersfeld as he worked on the problem was that it was far easier to move only the stars as projected images from a moving light source across the inner surface of a fixed dome, rather than attempt to "move the artificial 'sky' that held the artificial 'stars'," as had been done in the earlier version of the dome-based planetarium.[56] Accuracy and illusionism went hand in hand from the very outset: not only did the projectors have to represent the appropriate paths of the stars on the white-painted inner surface of the dome, but "the various optical and mechanical features had to function so perfectly that a spectator seated beneath the planetarium dome had the illusion that he [sic] was in fact under nature's own sky."[57]

Five years in development, the Zeiss Planetarium was finally completed in 1919. A result of the cooperation of a large team of engineers, opticians, mechanics, workshop technicians, and lab assistants, the dome spanned 50 feet in diameter, but could only show stars visible from the Northern Hemisphere. This was soon rectified, though, through collaboration with Dr. Villiger, an associate of Bauersfeld, who devised a way to "show the appearance of the night sky as seen from any place on the earth's surface."[58] Cooperating with engineers from Dyckerhoff and Widmann, an affiliated company, the problem of constructing shell structures with relatively thin domes was finally overcome and the knowledge applied to the development of similar roofing materials for unrelated architectural constructions such as churches and industrial buildings.[59] The first thin-shell reinforced concrete planetarium dome roof ever constructed was that developed by Zeiss and collaborators to test the prototype for the Zeiss Planetarium in 1922. Marketed commercially across Europe, such domes became the design and material of choice for a large number of planetariums built in Europe in the 1920s and 1930s.[60]

However, it would take until 1924 for a standardized Zeiss projector to become available for widespread use. Referred to as the "universal instrument," it assumed hegemonic status in the world of planetarium construction and was unchanged until Messrs Zeiss of Oberkochen introduced technical modifications in 1953. Resembling what one critic called a "brooding two-headed monster from outer space" (fig. 4.8), the projector consisted of a 13 $\frac{1}{2}$-foot dumbbell-shaped assembly supported by steel

Fig 4.8 Zeiss V projector, which came out in 1957. (Planetarium Ephemera Collection. Courtesy Department of Library Services, AMNH)

latticework; it contained 29,000 individuals parts, 30 ball bearings, and 200 optical projectors. It was capable of projecting images of 8,900 stars, "all of them correctly graded according to brightness and spaced among themselves according to the corresponding spacings in the actual sky."[61] The era of the planetarium had truly begun.

ASTRONOMICAL WONDERS: THE MECHANICAL ARGUS AND THE DRAMA OF THE SKIES

It is a school, theater, and cinema in one, a schoolroom under the vault of heavens, a drama with the celestial bodies as actors.

—David Riesman (1929)[62]

Described by London Planetarium expert Dr. Charles Henry King as a "combination of the latest developments in optics, electronics, and precision engineering," the planetarium was in his view, "the eighth wonder of the world," capable of both dramatic and subtle effects. Conjoined in the discourse on planetariums is a tension between expressions of wonder and the centripetal force of scientific rationalism; located literally and metaphorically at the epicenter of the performance is the Zeiss projector, an overdetermined and visually stunning icon, invested with fantasmatic meaning far exceeding the technological sum of its individual parts. That planetarium promoters, critics, and writers should turn to science fiction for inspiration should come as no surprise, especially given the obvious thematic associations between stargazing and interplanetary fantasies. Across time and in a wide swath of professional and popular sources, the Zeiss projector is anthropomorphized into a cross between the Greek mythical monsters Typhon, a creature with multiple heads, and Argus, a monster with multiple sets of eyes. Kaempffert, for example, in 1928 called the projector "a god-like machine [that] makes the heavens do his bidding," while William L. Laurence, reviewing the Hayden show for the *New York Times* when it first opened in fall 1935, constructs an image of a threatening yet transient monstrous illusion: "From the moment the cosmic ray entered the cunning trap devised for it, filling the primeval-like darkness with the unearthly shriek of what might have been some prehistoric monster, the circular wall of the planetarium chamber, with its strange 'man from Mars' contraption standing in its centre, vanished not only from view but from consciousness as well."[63] Gendered and invested with omniscient powers coterminous with that of a Greek god, the projector seems capable of negotiating both Christian and Classical Greek epistemes and is summarily dismissed neither as a monster nor a benign mystical power. Riesman, for example, described what he saw as a "grotesque looking instrument like a huge dumb-bell or a caterpillar with sprawling arms," while an even earlier *New York Times* piece from 1926 referred to the projector as a "monstrous mechanical insect on a platform." This trope, or rather this tension between beauty and horror, has withstood the test of time; in 1984 a *New York Times* author reviewing the latest Zeiss projector speculated that the spectacle had been projected by nothing less than "a graceful yet grotesque machine."[64]

The discursive construction of the projector as a monster emerging from the Hadean deep is reinforced by the fact that in many exhibition spaces it is housed beneath

the floor of the dome, and in some locations becomes an object of display even when not in use (IMAX does this routinely, and in the Dome system the projector rises from the floor into the glass-enclosed doghouse); for example, at the London Planetarium in the late 1950s, the projector could be seen through the exterior glass walls of the building by passersby on the street; as King described: "[I]n its special protective glass cage it sits like some captive two-headed monster from another world, and an object of interest to people thronging the huge foyer, and the crowds passing along Marleybone Road." Like some Frankensteinian creation, at the "touch of a switch," blinds would fall around it, and through the assistance of four electrical motors it would "spring to life" and rise "slowly and majestically into the auditorium." [65] Even such relatively subtle projector effects such as the mechanism for making the planetarium stars dim naturally as they approach the skyline (by installing mechanical blinkers that "swing over the corresponding projection lenses like artificial eyelids") is framed anthropometrically. [66] The cavernous environment designed to house and display the monster-projector is thus a fitting locale; situated at the very center of the dome, it conjures up fantastical images of alien life imprisoned in the bowels of a spherical building. John J. O'Neill, in a review of the projector for the *New York Herald Tribune,* called it a "microscope of the fourth dimension . . . the Man from Mars encased in his metal carapace and steel girder legs as visualized by H. G. Wells in 'The War of the Worlds,' and it looks like a giant, bipedal, mechanical insect on its jointed steel truss legs and between them a great double-bulbed head that seems to be all eyes. More than

12 eyes populate these globular heads—a real mechanical Argus." [67]

Given how hard it is to display the gigantic, which even under normal circumstances, according to cultural theorist Susan Stewart, poses a challenge for the exhibitor, since it tends to "[become] our environment, swallowing us as nature or history swallows us," it becomes necessary to represent the larger-than-life as situated above and over the spectator rather than below, since a downward gaze, in Stewart's view, would offer spectators a transcendent position, something undesirable in representations of this nature. [68] But as Stewart points out, there is a reverse impulse at play in the representation of the gigantic in such seeing and travel devices as the hot-air balloon, a response in part to a nineteenth-century (and earlier) fascination with the horizon explored by Stephan Oettermann in his book on panoramas. Vantage points giving spectators unlimited access to 360-degree views of the horizon, such as hilltops, medieval churches, and in the nineteenth century, national monuments such as the Eiffel Tower and Statue of Liberty, "simultaneously [speak] to an abstract transcendence above and beyond the viewer and the possibility that the viewer can unveil the giant, can find the machinery hidden in the god and approach a transcendent view of the city himself or herself." Indeed, the phrase "broadening one's horizons" is associated with the era of the eighteenth-century Grand Tour, and referred to the act of seeking out the highest point in a given location and ascending it. Friedrich Johann Lorenz Meyer, canon of Hamburg cathedral, wasn't alone in making a point of "climbing a church tower for a first view of every city in which he arrived; only after acquiring

this overview would he set out to take in its various sights at ground level."[69]

Owning the monstrous through the visual senses was thus a way of exercising a certain degree of mastery over the vast horizon, an argument that may help explain the similar sense of awe experienced by both panorama and planetarium spectators. Indeed, the horizon was a standard feature of several planetariums, and was attained by cutting out the metal forming the dome. The panorama of the Boston-Cambridge skyline seen from Science Park is a unique feature of the Charles Hayden Planetarium in that city; using carefully modeled illumination and sixteen hydraulic cylinders, the three-dimensional horizon can be lowered out of sight when not in use.[70] Some urban planetariums eschew "true city skyline" panoramas, though, for the simple reason that an irregular skyline renders panorama projection difficult; others, such as the Fels Planetarium, part of the Franklin Institute in Philadelphia, believe that removing the skyline heightens the verisimilitude.[71] When the Hayden Planetarium opened in 1935, it featured a silhouette of the skyline of New York, which was cut out of the steel perimeter. The horizon was constructed from panoramic photographs taken in infrared light just inside Central Park and showed the AMNH on the west, Fifth Avenue buildings to the east, trees to the north, and skyscrapers of downtown to the south.

But here was a horizon that would never be affected by the external elements, as Dorothy Bennette pointed out in 1935: "the buildings of the skyline are never clouded from view by either haze or bright lights and above them the stars sparkle nightly in a cloudless sky."[72] Jacqueline Glass, writing in the *Travellers Beacon,* offered a similar pragmatic response to the benefits of faux night-sky views: "We do not have to wait for good weather and a clear night, for in a planetarium the stars can be brought to us while we sit comfortably, and released in the hushed atmosphere of the interesting place."[73] This pristine horizon that locates the planetarium show in a specific and highly iconic locale also underscores the terrestrial view of the spectator—we start by looking up at the sky *from* earth. But we are soon transported into the cosmos once the skyline disappears. Still, even in outer space, references to planet earth serve as a refrain. Star constellations named after Greek gods remind us of a long-standing desire to transpose human narratives onto scientific phenomena, as if the act of naming brings them somewhat closer to our planet and our cognitive realm. One is also reminded in this discussion of the skyline in planetariums of the "atmospheric" theater design of motion picture palaces of the late twenties and early thirties, which included elaborate mockups of horizons around the proscenium and the projection of stars on the ceiling. While space precludes in-depth analysis of the influence of the planetarium in theater design of this period, suffice it to say that the "atmospheric" motifs doubtless contributed to the collapse of discourses of travel, fantasy, magic (think Merlin the wizard with his moon and stars), wonder, and both human and celestial stars.[74] Indeed, Gunning, in his research on Loïe Fuller and visual spectacle, mentions that images of stars and moons were projected by magic lantern onto Fuller herself (and her prop extensions) in the early 1890s, a fascinating play on light, motion, and astronomical fantasy.[75]

As a potent referent and the hub of the immersive spectacle that appears within its dome, the theater auditorium is an effective way of framing what goes on in the planetarium show as exceeding the scientific; the fact that theater and planetarium design were mutually reinforcing during the 1920s and 1930s should come as no surprise. For example, addressing an audience gathered to celebrate the 1939 opening of the Buhl Planetarium in Pittsburgh, Director Dr. Charles F. Lewis claimed that ancient civilizations like the Greeks considered the stars "the world's first motion picture theater," for they "had no broad, smooth highways upon which to speed in automobiles. They had no cinema. They had no brightly lighted concerts halls. The heavens at night were their theater."[76] The "ancients" thus turned to their rich mythology as a way of explaining star constellations, creating such imaginative nomenclature as Orion the hunter with his two dogs, and Cygnus the Swan. Lewis was not alone, however, in framing the planetarium along these lines; London Planetarium director King was unapologetic in his yoking of the stars to the world of illusion and performance: "The Zeiss projection planetarium, the instrument of Man," he argued, was "in truth a theatre of the skies in which the celestial bodies are the actors—a theatre set under the infinite vault of heaven and providing beauty, entertainment, and drama in an entrancing and awe-inspiring spectacle."[77] Theatricality functions here as a metaphor not just for the planetarium show, but for the entire apparatus, as Armand Spitz, American manufacturer of portable pinpoint planetariums from the 1950s, argued in 1959: "'Planetarium' connotes an experience, and, in this light, must be differently planned and executed than any single facet of operation. It is more or less like 'theatre' as a general term, including every detail that goes to make the experience—theater building, stagecraft, playwriting, acting etc."[78] Despite being man-made, the planetarium's chief concern is with representations that, while mediated, are *not* constructed in exactly the same way as other modes of popular culture, although the dividing line between the planetarium as popular astronomy and as mass entertainment is increasingly hard to distinguish. *Rebel Without a Cause,* released in 1953, staged its climax in the Griffith Observatory, a dramatic location that provided the perfect thematic and discursive context for Sal Mineo's shooting by a police officer.

The idea of the planetarium as a performative space is signaled not only in the debate around the need to have a lecturer present, versus a "canned" show, but in the appropriation of theatrical terms:[79] the stars are literally the *stars* of the show, the backdrop envisioned as one enormous theatrical setting, "the infinite vault of heaven." Kaempffert, writing in the *New York Times* in 1928, referred to the planetarium as a "playhouse in which the majestic drama of the firmament is unfolded." As the performance gets under way, "A hush falls over the spectators. No *play* is ever more intently followed than this in which constellations, stars, planets, sun and moon enact their parts."[80] The 1935 *Book of the Hayden Planetarium* referred to the exhibition space as a "great domed hall . . . where the stars 'perform.'"[81] Finally, we see a theatrical metaphor morph with a science fiction frame of reference in this 1945 promotional blurb accompanying the "World of Wonders" show (fig. 4.9) at the Hayden: "As act follows act in the Drama of the Skies, you hear a human voice

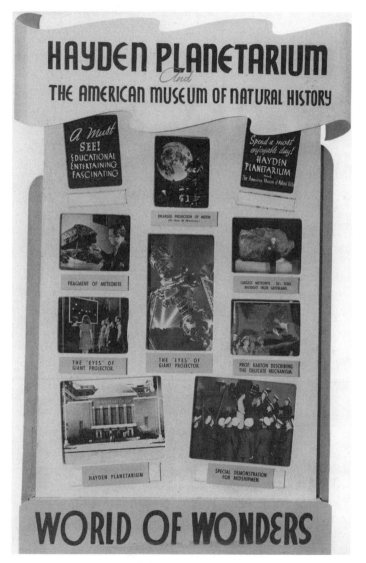

describe the stellar actors and the thrilling plot. Unseen in the dark, with a control board before him, stands a lecturer who has the universe at his fingertips. The control board seems to become the common bridge of a time-and-space ship and the lecturer is the pilot."[82] The meshing of astronomy to modes of popular representation drawn from science fiction writing, theater, and even the circus (William Laurence referred to the Hayden's first lecturer in 1935 as the "ringmaster of the stars") betrays a great deal about the place of the planetarium at the nexus of the museological world, astronomy, and highbrow amusements such as theater.[83] The poster accompanying this show consists of eight photographs of various iconic "views" from the planetarium, with the projector occupying center stage in the middle of the poster. The images are reminiscent in some ways of shots from a moving picture of the Hayden Planetarium, with the two captions at the top of the image resembling intertitle cards from the silent film era.

And yet showmanship, both the bourgeois type found in sedate dramas and the more sensational form born of the dime museum, has always been an intrinsic part of the planetarium experience, an inevitable outcome of the fusion of science and popular culture. As a way of drawing a broad audience and staving off potential boredom, the planetarium show had to steer a careful path between astronomy and spectacle, as Franz Fieseler surmised in 1932: "Far too little attention is paid to the fact that the adult visitor does not as a rule, want to be instructed and

Fig 4.9 Poster for "World of Wonders" show at the Hayden Planetarium (c. 1950s). (Planetarium Archives. Courtesy Department of Library Services, AMNH)

only comes to look round; he merely wants to gaze and wonder and he ought not be prevented from doing so."[84] Catering to the distracted gaze of the museum spectator who had little interest in the object-lesson of displays of astronomy was no easy task, and concerns about the possible degradation of astronomy were voiced as early as 1928, by which time in Germany alone, some 200 million people had seen a planetarium show. Referring to the German context, Riesman argued that "everywhere care is taken that the demonstrations do not degenerate into sensational exhibitions but that they remain a means of giving the spectators an insight into cosmic occurrences."[85] These concerns were echoed six years later in 1934 by Adler Planetarium director Philip Fox, who, by carefully choosing his metaphors and terminology, voiced a cautionary tale: "[V]isitors come to see a stirring spectacle, the heavens brought within the confines of museum walls. Not a trivial plaything, a mimic aping firmament, but the heavens portrayed with great dignity and splendor, inspiring in a way that dispels the mystery but retains the majesty."[86] Fox's dignified spectacle is clearly a reactionary response to the fear of popular culture contaminating the planetarium, what Spitz referred to as a "Buck Rogers type of planetarium show" in which special effects brought a certain razzmatazz to the performance, as Spitz explained: "Special effects play a very definite part in a Planetarium, but they should never be allowed to dominate . . . [they] are the icing on the cake—extremely tasty, adding zest to the wholesome cake if used with discretion. But if one attempts to eat only the icing, it can make one ill—and would destroy appetite for the cake."[87] Maintaining the right balance between science and spectacle was

clearly going to be a perennial challenge for the museum and not something easily resolved through policy; a memo written by Hayden Planetarium chair T. D. Nicholson to Dr. Albert E. Parr at the AMNH in 1961 in response to a planetarium show got straight to the point: "It's very easy to go completely overboard on the part of showmanship," opined Nicholson, "just as it is very easy to go completely overboard on the part of science." The bottom line, Nicholson concluded, was that it was "hard to combine the two."[88] And yet at the Third International Planetarium Directors Conference (Vienna, 1969), Manitoba Museum of Art and Science planetarium director Dennis H. Gallagher weighed in on the need for special effects to attract and retain audiences; recognizing that the planetarium "cannot keep up with the admirable techniques of television and cinema," Gallagher instead recommended special effects that could include "the sudden appearance of a strange panorama, a characteristic fanfare or a flying saucer, motionless in the sky and then suddenly rushing away" (the rapid editing here sounds very much like an appropriation of television's structuring principle of "flow," where images, sounds, and the transition from program content to sponsored material is seamless).[89]

If the formula for the right balance between factual demonstration and special effects was impossible to crack and dependent to a large extent on the subjective biases of the director and team of curators / designers / technicians, there was nevertheless consensus within the planetarium community that "a distinction should *not* be drawn between popular demonstrations for visitors who only come once out of curiosity, and more scientific demonstrations arranged in courses with a special instructional object."[90]

What Adler director Fox and his associates would have made of the psychedelic, drug-associated Laserium shows that began in the 1970s and where "fantastic light leaps at you," is anyone's guess.[91] His reference to "trivial plaything" also sounds like a dig at commercial planetarium kits like the Pinpoint Planetarium designed by Spitz. But at roughly the same time Fox cautioned against sensationalist renditions of the "heavens," Dr. Charles Lewis (of the Buhl Planetarium) made a case in favor of translating science into a language that could be widely understood by the masses. Critical of the general lack of scientific education, which had inhibited the growth and success of what Lewis called "social controls," Lewis argued that "for too long new scientific discoveries were the prized and secret possessions of scientists who regarded popularizations as vulgarizations. There was for years an attitude in many scientific quarters that seemed to say that the people could not be made to understand science; and it was a little short of unethical to put scientific truths into plain English. Fortunately that day is passing."[92]

If sensational exhibits were not exactly what Dr. Lewis had in mind, they were nevertheless extremely hard to resist, especially when they drew a large crowd. For example, some planetariums, like the Morehead in Chapel Hill, North Carolina, went so far as to stage "spectaculars" for their audiences:

In one of the several exciting and colorful portions, patrons will experience a simulated ice age and hear a two-way broadcast between the staff of an artificial satellite and the last remainder of humanity on earth trapped by huge panoramic glaciers, which completely surround the Planetarium audience. In another sequence, great fingers of lightning streak across the Planetarium dome, accompanied by simulated storms and tidal disturbances.[93]

The incorporation of special effects into planetariums had been de rigueur since the 1950s, when the term "drama" began to be used to describe performances. A guidebook entry on the Hayden Planetarium from 1964 describes a long list of effects available to the lecturer sitting at the controls (fig. 4.10): "rainbows, solar eclipses, lunar eclipses, even the Aurora Borealis. He can enliven proceedings with swirling snowfalls, or crashing thunderstorms, with ear-filling sound effects and musical accompaniment."[94]

Interlacing visuals and special effects into sections of a 40-minute planetarium show was considered vital in the war against waning spectator interest (and somnambulism), as seen in a published exchange among a group of Franklin Institute planetarium show designers and technicians in 1971; discussing the role of film loops and other visual effects, one of them determined that "we're going to need more visuals. The center section is pure astronomy and we might begin to lose people's attention if we don't break it up a little."[95] A more cynical assessment of a planetarium's aims was voiced even earlier in a memo from William H. Barton Jr. to Hayden Planetarium director A. E. Parr in the 1950s: "The function of a Plan-

etarium is to present simple, popular shows to the general public. . . . A Planetarium is a very limited instrument. Its effective use requires constant work to prevent the presentations from becoming monotonous and dull. You have to give the same show over and over. The trick is not to let the audience know that you are." [96]

The Buhl Planetarium in Philadelphia used the term "sky dramas" to categorize shows with such names as "Challenge of Space" and "Weather Wonders." As recounted in the Buhl's publication *Orbit,* these productions "utilize numerous special effects, including panoramic projections which re-create unusual settings . . . through the use of a great variety of audio-visual means." [97] The planetarium dome thus becomes a blank canvas upon which curators, in consultation with audiovisual personnel, display both the art *and* the science of astronomy, as Donald S. Hall, administrative and education director of the Strasenburgh Planetarium in Rochester (N.Y.), surmised: "A planetarium show is a combination of the art of the theatre and the science of astronomy. . . . A script outline is prepared, artwork drawn, projectors built, music and sound effects recorded." [98] A show entitled "Shots Seen Around the World" that played at the Charles Hayden Planetarium, Boston, in 1962, promised such visual thrills as "storms on the sun . . . hot dough-

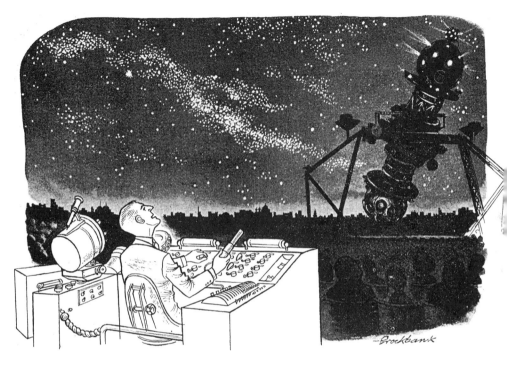

Fig 4.10 Illustration of the planetarium controller / lecturer sitting at the consol (from *Punch,* Mar. 19, 1958).]

nuts girdling the earth . . . a lighthouse in the sky . . . with *close up views* of rocket launching, a spinning satellite, the earth's moon, and deadly Van Allen belts, and much, much more." [99] Planetariums also came of age in the 1950s and 1960s during the era of theme parks and Disney entertainment, other vital informing contexts. But where was the heavenly in all this Hollywood style / Las

Vegas showmanship? Let us now turn to this important discursive strand, which ironically had few problems fusing with the popular.

"HEAVENLY ADVENTURES": CLOSER TO GOD IN THE CELESTIAL DOME

And this God of the machine makes the heavens do its bidding.
—Walter Kaempffert (1928)[100]

The idea of the planetarium performance as a "drama of the heavens" (phrase used in 1938 by Nils Hogner and Guy Scott, authors of a *Cartoon Guide of New York City*),[101] or the notion that "with the most common of man-made instruments, the heavens can be brought to earth," is a recurring trope in twentieth-century planetarium discourse, best articulated perhaps in 1928 when Spitz proclaimed that "no more versatile method of spreading a knowledge of the heavens has ever been devised."[102] Given heaven's purported location in the upper atmosphere, the mapping of one discourse onto the other, or their mutual imbrication, is hardly surprising. The uncanny realism of the planetarium dome's sky is also ubiquitous, especially the illusion of an immensity of space descending deep into the vast unknown. Of course, the shape of the domed building may also have contributed to the association; in 1958, for example, writer Billy Arthur felt that "the unique nature of the building makes it seem a spiritual as well as a cultural heaven," a sentiment echoed the same year in a Zeiss Planetarium brochure pronouncing that, "An hour in a Zeiss planetarium is like an hour in a mysterious temple, where we can leave the world and its everlasting rush far behind."[103] Spitz broadened the religious metaphor to include a more abstract form of spirituality that would possibly ease the tension engendered by the Cold War; writing in 1959 he said:

> [A] Planetarium can inspire, almost to the point of being a semi-religious experience without being narrowed by sectarianism. It can be used to develop an appreciation of the abstract, and can give the most cynical members of the audience a sense of identity with other human beings who, like themselves, have the privilege of understanding something of the universe of which they are part. . . . [A] Planetarium can be a psychologically therapeutic experience. It can be employed for release of tension, for changing attitudes toward things, which are obvious, for relaxation, as well as for sheer aesthetic delight.[104]

The idea of the planetarium as a conduit for universal humanism, art appreciation, and a Zen-like meditative state was echoed in 1966 by Bochum (Germany) Planetarium director Heinz Kaminski, who saw the planetarium as an "enclave in which the visitor can find himself free from everything and especially from every-day life and to relax under the impression of music under a starry sky by *diving into a mood* of contemplation which may grow to a degree of deep meditation."[105] As eager as Kaminski was to promote the planetarium as a shrine for good karma, he nevertheless cautioned against playing overtly religious music in the planetarium that might tip the planetarium experience over the edge in terms of encroaching

upon the domain of formal religious worship.[106] But if one was left in any doubt as to the quasi-religious nature of this space, its content alone drove home the association, with many American planetariums programming their shows around highlights of the Christian calendar including "The Star of Bethlehem"[107] and "Easter, The Awakening."[108] The Nativity was where "religion, science, history, and philosophy come together to contemplate 'The Star' and the eternal question it poses: natural phenomenon or supernatural miracle?" Or so we are told in a Nativity show program from the Morehead Planetarium in North Carolina.[109] In its spring 1958 circular, the Morehead also offered a program for seventh through twelfth graders entitled "Devils, Demons, and Stars" and "Christ's Passion," a pageant that would "depict the somberness of the Crucifixion and the torture of suffering of Jesus on the Cross, followed by a gradual transition to the glory and happiness of the Resurrection."[110] The Christmas show, a staple of almost all planetarium programs in the United States in the 1950s and 1960s, not only underscored the nonsecular proclivities of planetarium directors and curators but also provided a golden opportunity to showcase special effects. The 1948 Christmas show at the AMNH featured a "very beautiful carousel as part of the show with all sorts of animals on it and sleighs and Christmas effects."[111] It spoke squarely to Chamberlain's 1958 edict on the role of the planetarium in the United States, which in his view was to be "more than just an exhibit. It was an institution with several masters to serve: education, science, pleasure, and the realm of the spirit."[112]

In this Christmas show composite photograph from the Hayden Planetarium (fig. 4.11), audience, projector, and Star of Bethlehem are potent reminders of the roles of theatricality and immersion in shaping the experience; as if appearing on stage, the three wise men are cloaked in a spotlight while the projector protrudes into the sky like some medieval torture device. There's an interesting discursive underlay to the representation of light in this image, which when peeled back provides a fascinating meta-comment on the circulation of meaning, both secular and spiritual. The layering of the biblical, the astronomical, and the commercial kitsch of Nativity iconography in this image speaks volumes to the heterogeneous origins and valences of the planetarium show; the upward "revered gaze" is an extremely dense and potent sign, affirming the neo-spiritualist undercurrent of the planetarium as a quasi-temple of worship, while the iconography of the Nativity scene (the sky, star, and wise men look like they've been lifted from the cover of a Christmas card or children's story of the Nativity) imbues the image with a distinctly populist feel. The Christmas show therefore trod a careful path between astronomical theories for the appearance of the Star, which took place in the first part of the show, and Christian explanations, which were "reverently told in music, lights, colors, and readings."[113] Featuring holiday music and projected images associated with the Nativity, the narration, we are told, "presents all the scientific evidence that could account for the 'star' that brightened the skies in those days, but allows those who wish to attribute it to a miracle. *The explanation of the research makes a fascinating excursion into history and astronomy.*"[114]

The planetarium show thus had to speak to its two masters in the Christmas show—astronomy and popu-

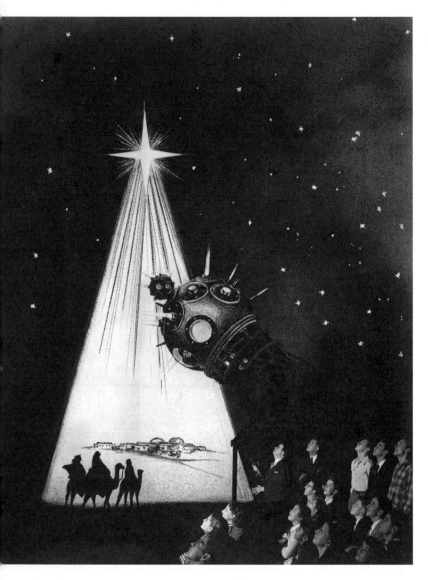

lar culture; Clyde Fisher, quoted in the *Saginaw Michigan News* in 1935, summed it up best when he argued that, "In the face of this wondrous event, science stands offering possible solutions, but not dogmatically proclaiming to have plumbed the depths of the subject."[115] The tension between Christian accounts of the Star of Bethlehem and astronomical theories is carefully annealed in these quotes; without wanting to offend those Christian spectators whose faith would be undermined by a revisionist astronomical explanation, the museum is careful not to alienate its Christian stakeholders. The conceit of time travel back to the first century B.C. deflected attention away from the potentially divisive narrative, as seen in this synopsis of the 1977 Christmas show at the Hayden Planetarium, which, by asking a series of questions, constructs its object of study in scientific terms rather than as a direct challenge to Christian theology: "What was the Star of Wonder . . . What it a comet? A bright meteor? Some have suggested it was a nova—a 'new' star, or a rare grouping of planets. After looking at the brilliant skies of winter, we will use the great planetarium projector to journey back through time to the first Christmas to examine the astronomical possibilities of the Star of Wonder."[116]

Whether to the first century B.C. or to some intergalactic future, time travel is a vital conceptual frame for understanding how immersion functions in the planetarium show; they are mutually informing, with immersion heightening the sensation of virtual travel and vice versa.

Fig 4.11 Composite photograph of a Hayden Planetarium Christmas show from the 1950s. (Neg. no. 322423. Courtesy Department of Library Services, AMNH)

The democratizing potential of the apparatus was also not to be underestimated, as King was quick to point out: "the possibilities of the planetarium are immense, for Man has perfected an instrument which enables anyone to see and understand the wonders of the skies of the past, present or future. In forty minutes he can see more than he might see in a lifetime," [117] Virtual travel was a foundational discourse in the history of planetariums, predating the construction of domes and traceable to the eighteenth- and nineteenth-century fascination with globes and the Grand Tour. As historian Arthur Middleton points out, voyages of discovery such as those taken by Captain James Cook included tracks of the ships on the surface of the globes. Inscriptions documenting Cook's travels—two read "Captain Cook's Outward, 1778" and "Captain, Vancouver, April 1792"—reminded viewers of the relative newness of global travel and the imperial legacy of the British Empire as it left its mark on the sphere. Globes would also be modified in their manufacture by including such updated information as news of Cook's death, which would be incorporated into subsequent versions (one such notation read "Otaheti, Captain Cook Killed Here by the Natives"). Temporality could thus be literally etched onto the surface of the globe.[118] Not surprisingly, this discourse crossed over into the world of domed planetariums, finding a potent mode of address in the Zeiss projector, which, located at the epicenter of the show, even resembled a device for time travel, as King noted in 1959:

> The extraordinary way in which the Zeiss projector compresses time makes it a veritable time machine. The whole pageant of the heavens is speeded up as if by magic; the appearance of a day, a month, a year, passes by in a matter of minutes. The countries can be rolled back until we stand in Palestine at the time of the Nativity and witness the "The Star of Bethlehem." [119]

Whether "speeded up" or "rolled back," time is a key idiom for organizing the planetarium show and something the projector traverses by orienting itself on different axes in order to show changes in the nighttime sky due to the earth's motions. Travel is intrinsic to the show, serving as its lifeblood, organizing principle, and promotional hook. In the same way that panorama designers created darkened corridors prior to entering the dome exhibiting the circular painting so as to enhance the illusion of spatial (and possibly) temporal relocation (and dislocation), so too did some planetarium architects use ramps upon entry into the dome to "create the illusion of traveling up to see the stars." [120] "This is armchair travel at its best," we are told in a brochure for the program "To Show Man's Place in the Universe," which played at the Charles Hayden Planetarium at the Museum of Science in Boston in 1971. As many as 316 visitors at a time, "seated in comfortably upholstered chairs in concentric circles around the projector, are transported around the world, into outer space and backward and forward in time to any moment in history . . . producing the educational and entertaining kaleidoscope of effects." Recycled clichés such as "You're always 'out of this world' at the . . . [fill in the blank]" functioned as both promotional and journalistic shorthand; Billy Arthur, in an article about the Morehead Planetarium in Chapel Hill, North Carolina, entitled "Please

Fasten Seat Belts, Next Stop the Moon," yokes the fantasy world of (male) science fiction adventure comics with the persuasive rhetoric of contemporary / modern advertising appeals: "Day or night, rain or shine, you fasten your seat belt, spin around the world and zoom millions of miles into space in a matter of minutes. Ten minutes, fifteen minutes—faster than Sputniks, Vanguards, Thors, and Jupiters." [121]

Offering escape from the "dulling haze of dust and smoke," planetarium shows let spectators travel both spatially—to the north to see the wonder of the midnight sun or to the south to see the Southern Cross—and temporally "without stirring" from their seats. The projector's ability to virtually transport spectators to outer space and to embark on astral excursions to skies of the past and future was closely bound to the time travel capabilities of the projector. In 1935, author R. L. Bertin defined the projector as an apparatus so devised that "the relative position and motion of the stars and planets may be shown for any time through the ages as viewed from any part of the earth." [122] In the early 1950s, the Hayden Planetarium at the AMNH stretched the time travel analogy to its limits, when it mocked up a travel agency where children could "purchase" tickets to the moon. [123] Posters resembling package holiday ads touted the thrills of the excursion, inviting children (and adults) to mentally assimilate the idea of virtual travel via role-play (museum staff impersonated travel agents). When *Apollo 11* touched down on the moon in 1969 and made this fantasy a reality, the Hayden Planetarium was quick to exploit the enormous public interest in this landmark event. Special coverage of the *Apollo 11* splashdown at the Hayden included the use of ten American Airlines air stewards (all female) who served as "hostesses . . . dressed in space-travel costumes from the popular motion picture *Two Thousand and One: A Space Odyssey*." The soundtrack from Stanley Kubrick's now cult classic 1968 film would "provide background music during the event." After a splashdown celebration luncheon, guests left with tray replicas of the plaque deposited on the moon and containers of space food. [124] Sponsored by Western Union International, the event is early evidence of the museum's unproblematic embrace of Edward Bernays' public relations techniques blended with Hollywood-style razzmatazz. That several corporations (WUI and AA) celebrated this gargantuan achievement in U.S. space exploration suggests the ease with which the planetarium negotiated the worlds of business, astronomy, public relations, and popular culture. In fact, given the enormous impact the *Apollo 11* mission had on planetarium attendance, it would have been shortsighted of the AMNH *not* to jump on the bandwagon.

NASA's ambitious space exploration program of the 1980s offered a similar boost to planetarium attendance, although, as Hayden Planetarium producer and lecturer Larry Brown candidly opined in a 1986 *New York Times* article, it was not the result of a single site of influence but rather a broad intertextual flow of images, sounds, and scientific research: "Renewed interest in the heavens has increased with the rash of science fiction films, radio stations that play space music, the visit of Haley's Comet, the space shuttle and satellite probes." [125] Planetarium shops enjoyed a boost in revenue as a result of this heightened interest in space shows, with sales at the Hayden's gift shop doubling in the period from 1984 to

1986 (the Rose Center for Earth and Space at the AMNH also has its own thematic gift shop). Taking home souvenirs of the virtual space journey (as the VIP guests at the *Apollo 11* splashdown event did) or purchasing objects that help brand or memorialize the experience reminds us of a much earlier example of planetarium promotion—the Pinpoint Planetarium, designed and marketed by Armand N. Spitz in 1928. In light of the fact that the "image of the planetarium sky cannot be taken away in a form which can be studied" (since, at that time, "very few people have an opportunity to attend a regular planetarium lecture"), Spitz's sales pitch seized upon the portability of the device, which, to a large extent, returns us to the tabletop orreries of the eighteenth and nineteenth centuries painted by Joseph Wright: "With the most common of man-made instruments, the heavens can be brought to Earth." [126] The influence could go both ways, though, with the Pinpoint Planetarium also capable, as Spitz himself pointed out in a 1954 interview, of whetting "the appetite for the more elaborate demonstrations that they can see with the larger instruments." [127]

But long before lunar landings became a reality, travel to the heavens had had an indelible hold on the public's imagination with Georges Méliès celebrating the idea of space travel in his 1902 fantastical pageant *A Trip to the Moon*. Journeying to the moon had been a popular (and obvious) theme to develop as a planetarium show; it also provided publicists and reviewers with a rich range of intertextual referents, especially given the role of space travel in the popular imaginary. Envisioning a lunar landing was the subject of teenage columnist/reviewer "Betty Betz's" 1946 newspaper column "Betty Betz Bets":

"hurry down to the Hayden Planetarium," she implored her young readers, and "buy a round trip ticket for this dreamy voyage which was so realistic I had to pinch myself to realize I wasn't really on a rocket powered by atomic energy and piloted by a crew of spacemen. . . . We looked out the big porthole and actually watched our rocket land on one of the smaller craters of the moon. When we landed, there were no trees, grass, or life there because there is no atmosphere, so we just stared around at the rocky lava formations." [128] Another fan of the show in 1950 gushed that, "It was so realistically done I could feel myself flying through space, and then—kerplunk—there I was on the moon." [129]

In ways similar to the stereopticon, which also provided the mechanical means to construct a screen-based virtual tourism in the late nineteenth and early twentieth centuries, the planetarium projector was essentially a giant stereopticon, what Adler Planetarium and Astronomical Museum director Philip Fox defined as "many projectors throwing images on the interior surface of a great hemispherical dome." [130] A "super 'magic lantern'" (the 1935 model contained more than 120 stereopticon lanterns), the projector was even capable of conjuring up the cinematic equivalents of flashbacks and flash-forwards, as William L. Laurence was quick to note in his 1935 *New York Times* review: "the planetarium, by the mere pressing of a button, enables man to make time do his bidding, to go backward or roll forward as he desires." [131] For all intents and purposes, then, the projector was conceived as something of a hybrid lantern/motion picture projector; AMNH curator Dr. Clyde Fisher described it as a "glorified stereopticon, or a series of stereopticons, and since

it moves so that all the motions of the heavenly bodies can be shown, it has the further value of the motion picture."[132] Given the magic lantern's long and fascinating role in popular culture as a conveyor of all manner of subject matter from religion, to science, to tourism, it's important to flag its adaptation for use in astronomy, since the special effects on display for audiences attending planetarium shows in the 1930s and 1940s (and beyond) had a long history within the showmanship and screen practices of the stereopticon or magic lantern show. Temporality, the panorama, and the idea of repeat viewings are thus collapsed in the following proselytizing by Marian Lockwood in her 1935 essay in the *Book of the Hayden Planetarium*: "We shall come again to see a shower of meteors. . . . We shall come again to gaze, wide eyed, at the northern lights which we so seldom see in these latitudes. We shall come again, and then again, for here we shall find the ever changing and dramatic panorama of the heavens."[133] In order for the planetarium experience to be fully appreciated, repeat visits were considered essential: whether gazing wide-eyed at stars or meteor showers or taking in the entire "panorama" (panorama and planetarium as distinct sign systems are collapsed in this construction), "it is impossible to put [the projector] through all its paces in one brief period of forty minutes."[134] Repeat viewings, it was thought, would also afford spectators different vantage points on the night sky, as Dr. W. Villiger claimed in his 1926 book *The Zeiss Planetarium*: "If we assume that the same persons will visit the Planetarium repeatedly, then they will be able, by reason of this concentric seating arrangement, to get comfortable views of the heavens in different directions by changing their seats at different demonstrations."[135]

Franz Fieseler, however, offered another reason for returning to the planetarium, and one that spoke frankly of the somnambulism engendered by the show:

I have never as yet met anyone in a Zeiss Planetarium who was able to attentively follow a lecture from beginning to end. . . . After the first half hour, many visitors to the Planetarium are often so tired that they start yawning, and have difficulty in keeping awake; this is well known to be infectious. . . . Although I have tried hard to follow a lecture I have never quite succeeded in doing so. . . . One object of the lectures is to induce the visitor to regard the Zeiss Planetarium not merely as an object of curiosity, which one *must* simply see, but as a place of instruction and education which should be visited *again and again*.[136]

The imperative latent in these calls for repeat visits shifts the tonal register away from the dispassionate, scholarly, and purely descriptive toward a more liturgical speaking mode, most noticeable in Lockwood's decree. One detects a quasi-religious, almost zealous feel to the spectatorship constructed here, a point reinforced six pages on in the essay through the inclusion of a medium shot of a dozen or so schoolboys gazing up at the screen in the upper right-hand corner of the photograph. With the caption "An audience enthralled. A group of youngsters whose faces show plainly what they think of the Planetarium 'show.' No boredom here?" the photographer used the boys' faces as a rhetorical device to validate and endorse the planetarium "experience," and yet the quotation marks around the word "show" suggests a slight anxiety

about this term in the context of science education at the AMNH (the question of boredom in the caption barely conceals this concern about the performance putting people to sleep). In any event, if being enthralled was considered a sure-fire way to stave off boredom, the planetarium met stiff competition in its attempt to win the hearts and minds of children, especially given the popularity of Saturday morning film shows and, from the 1950s onwards, television.

The iconic upward gaze of seated spectators is rearticulated in the context of Cinerama, 2- and 3-D movies, and IMAX films, where the "wow" effect has to be inscribed onto the faces of the spectators (how else can its size and realism be felt?) (see fig. 1.1). Representations of spectators—rather than the object of their gaze—underscore the centrality of vision and visuality in the planetarium experience. For example, in the final draft script of "The Beginning," a show that ran at the Hayden Planetarium in 1979, the script makes repeated reference to the act of seeing: "If you know exactly where to *look* . . . If you *look* closely" (p. 1); "Perhaps you can *see* the bear's head . . ." (p. 2); "Almost every culture has had a way of *looking* at the night sky" (p. 5). The idea of collective vision toward the stars in the planetarium dome was invoked through the interpellation of the spectator into the role of stargazer—never as an expert though, since that role was reserved for the lecturer or narrator.

Images of spectators (especially children) gazing rapturously up at the planetarium dome were calling cards for the Hayden Planetarium, with this photograph of five young schoolchildren no exception (fig. 4.12); the three children in the left-hand side of the image all crane their necks to gaze up at the dome while the boy in the far right-hand corner of the shot has his hand up to his mouth and gazes off to his right. The most emblematic and memorable face in the photograph, however, belongs to that of a girl who, rather than gaze upward, stares bug-eyed past the camera as if lost in the moment. The look of wonder on her face is mesmeric; choosing to stare directly out into space rather than up at the dome makes the girl a fascinating (if somewhat enigmatic) subject; while clearly enthralled at the ongoing show, she is nevertheless *not* responding the same way as her classmates. And yet her look of wide-eyed wonder is enormously effective in conveying the rhapsodic nature of the experience. We might compare this image with the two young boys in Wright's *Philosopher's Lecture* painting who, while also lost in thought, perhaps long for a more visceral engagement with astronomy. As representations of children's encounters with astronomy, they tell distinct stories of imaginations at work, of bodies and minds deeply affected by presentations separated by some two hundred years.

Four other examples of spectatorship relating to planetariums and astronomy are also worth unpacking, since they offer us a fascinating window onto different yet related instances of immersive spectatorship from two different perspectives. While the first two images are only tangentially related to the planetarium (since their subject matter corresponds so closely to the type of popular astronomy on display in most planetariums), they are definitely worth examining. The front cover (fig. 4.13) of the amateur magazine *Astronomy and You* constructs astronomy as a highly social and bonding experience for

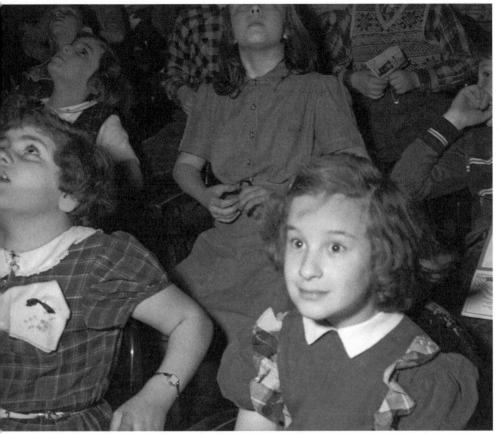

Fig 4.12 "Bug-eyed" girl spectator staring straight ahead during planetarium show. (Neg. no. 2a1509. Courtesy Department of Library Services, AMNH)

yard of their house with a telescope on a tripod.[138] The bush in the foreground and the distant house in the left mid-ground are the only signs of civilization. Two-thirds of the image is taken up by the blue night sky full of twinkling stars. The representation of the family (with their backs to the camera) codes astronomy as a gendered pastime, with women and girls welcome additions providing they stand passively rather than actively participate. In the image, conforming to archetypal representations of the nuclear family, we notice that the older son is the only one actually using the telescope (the magazine, although appealing to boys, is not specifically targeting them), while his father—the "expert"—points out star constellations from behind. With their arms around one another (possibly because the temperature is cool), the mother and daughter are passive onlookers (the girl cannot even reach the eyepiece of the telescope unless the tripod legs are lowered!).

These gender stereotypes are carried through to the back cover of *Astronomy and You* (fig. 4.14), where only two women appear to be in attendance at a "star party," one of the recommended ways of making astronomy a social as well as a scientific pastime. While the main justification for holding a "star party" would be an "expected meteor shower, an eclipse of the sun, or a new comet," more often than not, we are told, "parties are held

both family and friends and is a useful indicator of how popular astronomy had become (and would go on to become).[137] Beneath the bright red title is an oval-shaped, matted drawing of a 1950s nuclear family standing in the

just because fellow hobbyists enjoy getting together for an evening."[139] As one woman fixes drinks on a table (frame right), the other, seated in the foreground, appears to be getting a mini-astronomy lesson from the man standing next to her with a flashlight. These gender stereotypes are echoed in a flier from the Morehead Planetarium, which shows a family with two boys and a girl standing inside the 35-foot orrery (miniature planetarium) and staring up at a representation of the sun and the six closest planets to earth. Incorporating an element of interactivity into the exhibit—visitors could "press a button which sets the planets and their satellites in proper relative motion" while listening to an audio narration—the image once again promotes the collective pleasure of the experience within a conservative construction of the "typical" American family.[140]

The last image (fig. 4.15) of astronomy spectators is a high-angle view of four rows of spectators gazing up at the roof of the dome, which, based on the terrain visible in the upper third of the image, looks like a lunar land-scape with hundreds of stars receding into the distance. Even though it is extremely difficult to come up with an accurate gender profile of the audience, if we identify men through the number of neckties visible in the image, then it would appear that men outnumber women in the image by roughly five to one. More striking, however, than the gender imbalance is the representation and source of light in the image; instead of radiating from the projector, the beams of light are located at the perimeter of the room,

Fig 4.13 Front cover of *Astronomy and You* from the 1950s. (Planetarium Ephemera Collection. Courtesy Department of Library Services, AMNH)

Fig 4.14 Back cover of same issue of *Astronomy and You*, showing a typical "Star Party." (Planetarium Ephemera Collection. Courtesy Department of Library Services, AMNH)

in part 2 of this book, which focuses on the immersive screen cultures of the museum, it is fitting to have the AMNH's Hayden Planetarium lead us toward that endeavor.

THE HAYDEN PLANETARIUM'S COMING OF AGE AND MILLENNIAL MAKEOVER

The first American planetarium to open was the Adler Planetarium and Museum endowed by philanthropist Max Adler in 1930 (it was the nineteenth planetarium to open in the world).[141] Three more would open in the United States in the next five years: the Fels Planetarium in Philadelphia in 1933; the Griffith Planetarium in Los Angeles in May 1935; and the Hayden Planetarium, which opened on October 3, the same year. Some fifteen years before the Hayden began operating, astronomy curator Dr. Clyde Fisher had a clear idea of what his "ideal astronomical hall" at the AMNH would look like; never brought to fruition and carrying a $3 million price tag in 1926, the plans showed a "building, octagonally shaped, with a diameter of 126ft and a height of 5 stories, surmounted by a dome."[142] One of the earliest astronomical exhibits installed at the AMNH was a stationary model of the solar system, on display in the foyer on the ground floor in 1908;[143] as a result of the success of this exhibit, in 1909 a "representation" of Haley's comet was added to the installation. Before 1935, the AMNH consolidated its

just above the horizon. The beams of light traversing the faces of the spectators are evocative of the yet-to-be-developed Laserium show, although it also imbues the image with something of a sci-fi "look" as the spectators assume the role of stunned earthlings transfixed by the bright lights of the alien space ship (à la Steven Spielberg's *Close Encounters of the Third Kind* [1977]). The projector is thus the *object* rather than the *source* of light in this image, an unusual reversal, although one that serves an important discursive function with regard to the constituent parts of the entire planetarium experience. While not evident from its content, this image is an artist's rendition of a planetarium show from the Hayden, one of the last planetariums to be built in the West during the golden era of planetarium construction in the mid-1920s to mid-1930s. It is to the institutional history of the Hayden that we turn to draw this chapter to a close. Since this chapter ushers

Fig 4.15 Representation of spectators inside the dome of the Hayden Planetarium (c. 1950s). (Neg. no. 323981. Courtesy Department of Library Services, AMNH)

astronomical exhibits into the "Pro-Astronomical Hall," adding meteorite fragments and paintings. Plans for an Astronomical Hall proper were implemented gradually over the next two decades, with the museum publishing a report in 1910 entitled "History, Plan, and Scope," but not actually appointing a Director of Astronomy until 1924, when Princeton University professor Henry Norris Russell was hired to prepare "a far more detailed plan of the museum's astronomical exhibits." [144]

The construction of the Hayden Planetarium represented the cumulative efforts of twenty-five years of putting astronomy on the map at the AMNH; as a result of Depression-era fiscal crises, the museum fought hard to realize the project, finally securing an endowment of $170,000 from Charles Hayden to offset costs. [145] In the Background Research Report conducted for the Rose Center by the company Higgins and Quasebarth, mention is made of the fact that the AMNH was self-conscious about the modest nature of the Hayden Building (both in terms of location and architectural design), as imputed from a comment made in the November 1935 *AMNH Bulletin,* which conceded that "the modest-looking structure is more than it appears to be on the outside." [146] Between 1935 and 1985, more than 25 million people visited the Hayden Planetarium, and in 1982 the planetarium closed for almost a month in order to computerize the system (this was the culmination of research to update the equipment that had begun in 1976 and, thanks to another grant from the Charles Hayden Foundation, continued in 1981). [147]

In the years since the Hayden Planetarium opened at the AMNH, a great deal has changed at the institution; in the field of astronomy, the most significant development is the February 19, 2000, opening of the Frederick Phineas and Sandra Priest Rose Center for Earth and Space featuring the Hayden Planetarium, a state-of-the-art science and astronomy center housing the planetarium dome in an enormous glass box visible from Columbus Avenue and 83rd street on Manhattan's Upper West Side and also including the Hall of Planet Earth and the Hall of the Universe. [148] Like the IMAX screen, [149] the two planetarium shows in repertory in 2006 at the Rose Center ("The Search for Life: Are We Alone?," narrated by Harrison Ford, and "Passport to the Universe," narrated by Tom Hanks) charge a separate admission fee of $22 for adults and $13 for children, which includes general admission to the museum. In 2007, *Cosmic Collisions,* narrated by Robert Redford replaced these two shows. [150] Reading the promotional blurbs for these space shows, it is interesting to consider what has changed and what has remained the same in the history of planetarium programming at the AMNH. To be sure, discourses of virtual travel, immersion, and the showcasing of special effects have endured over time. However, the Hayden now includes "Big Bang," where visitors experience a "dramatic, multisensory re-creation of the first moments of the universe," continuing on a sloping walkway that "chronicles the evolution of the universe . . . through 13 billion years of cosmic evolution." [151] In many ways, the existence of a planetarium at the AMNH has been a litmus test for the intersection of science and popular culture throughout almost a century. When it opened in 1935, the Hayden Planetarium was a blank canvas upon which the sociocultural and political zeitgeist of the city writ large its hopes, fears, and fantasies

for an America poised to become a world player following its entry into World War II in 1941.

Planetariums around the world were far from neutral in terms of reflecting the ideological predilections of their host countries; the Moscow Planetarium, which opened on November 5, 1929, espoused a socialist ideology, paying attention, in the words of its director Konstantin Alexeievich Porcevskij, "to the philosophical conclusions on the materialist unity of the world . . . the recognizability of the universe and the boundless possibilities open to mankind armed with science and technology."[152] As an afterthought child of the rush of modernity in the late nineteenth and early twentieth centuries, the planetarium carved out a niche for itself in the museum, integrating special effects modeled on developments in motion pictures and audiovisual technology.

The planetarium thus exists as a fascinating distillation of several of the themes central to this book: as an immersive technology trading in spectacle, science, and popular amusement, the planetarium is an especially rich case study in intermediality, and an important lynchpin in *Shivers Down Your Spine*'s transition from the canvas-based large-scale representational media discussed in this part of the book to the museums that are the focus of the next. That most large science and natural history museums contain both planetariums *and* IMAX screens is testimony not only to their preeminent status as lucrative funding streams (the only source of revenue in the case of the National Museum of Natural History in Washington, D.C., which is free), but to their long-standing success in drawing audiences who are willing to pay for a programmed, thrilling, audiovisual experience that they feel they won't be exposed to if left to their own devices. Akin in some ways to the amusement park, where there are never any free rides, the experience bought will be far and beyond what one can find unassisted; for example, displaying (fetishizing even) the planetarium dome in a glass box at the AMNH as an object of beauty and wonder performs much of the show's discursive work even before the visitors reach the "departure lounge" (a feature of the dome and the projector that has long been exploited by museums). Not only does the AMNH's Hayden Planetarium unite the "subject matters of both the Museum and the Planetarium,"[153] according to a 1995 press release, it openly acknowledges (exploits even) its close resemblance to other cultural forms such as cinema. The FAQ (Frequently Asked Questions) section of the museum's Web site tells us to "Keep in mind that the environment inside the theater is similar to a movie theater, in that it is dark, and the audience is surrounded by sounds and images."[154] Dr. Clyde Fisher hit the nail on the head in 1935 when he made reference to the leveling effect of the planetarium show: "It matters not whether the audience be made up of children, or professional people or laymen, the emotional experience is always the same."[155]

The fact that visitors no longer see the famous murals of Blackfoot mythology showing the young Sun God pursuing the Moon Goddess across the heavens (as painted by Charles R. Knight) should come as no surprise (they have been replaced by artsy black-and-white photographs of the surface of the moon, which hang on the wall opposite the planetarium dome). The traditional Friday / Saturday night Laserium show, "SonicVision," is now a coproduction between the AMNH and MTV2 and promoted as

a "digitally animated alternative music show" that takes audiences on a "mind-warping musical roller-coaster ride through fantastical dreamspace."[156] According to the Web site, this is a "one-of-a-kind computer-generated musical and visual experience, which uses next-generation digital technology to illuminate the Planetarium dome with a dazzling morphing of colorful visions." ("Look Up!," the weekend morning show designed specifically for young children, has been canceled indefinitely.)[157] Fantasy and spirituality have been replaced by indexicality but only on the outside of the dome. On the inside, fantasy cozies up to astronomy, although the AMNH Web site and the show's narrators nudge the discourse back in favor of science by underscoring the scientific credentials of "Passport to the Universe," which takes visitors on an "exhilarating flight through a virtual recreation of our universe . . . [using] data on our solar system from NASA and the European Space Agency, and a statistical database of more than two billion stars developed by the Museum."[158] Claiming to be the "largest and most powerful virtual reality simulator in the world," the Hayden Planetarium has thrown down the gauntlet in terms of its competition, finally reaching a position of dominance in the twenty-first century. If the former Hayden Planetarium suffered from something of an inferiority complex with regard to its modest façade and status at the AMNH, the new Rose Center has surely boosted its ego by elevating it to a position of ascendancy on the world (planetarium) stage, where stars, lasers, and digital effects strut and fret to their heart's delight. If all the special effects in today's planetarium shows make it far less likely to be a place of quiet repose and meditation—what was once referred to as "a place to rest from the hustle-and-bustle of everyday life to become refreshed under the quiet wonders of the stars"[159]—and the price and duration of the show too prohibitive for casual drop-in visitors, the planetarium nevertheless keeps alive the possibility of immersion established by the nineteenth-century panorama (and continued to this day by cinema) of escaping out of the present into another time and space.

II

MUSEUMS

AND SCREEN

CULTURE

IMMERSION

AND INTERACTIVITY

OVER CENTURIES

BACK TO THE (INTERACTIVE) FUTURE

The Legacy of the Nineteenth-Century Science Museum

Around every object more wonderful than the rest, the people press, two or three deep, with their heads stretched out, watching intently the operations of the moving mechanism. You see the farmers . . . *with their mouths wide agape*, leaning over the bars to see the self-acting mills at work.

—Henry Mayhew on the Great Exhibition of 1851[1]

MUSEUMS HAVE LONG played host to planetariums, especially those devoted to the study of science and technology and natural history such as the American Museum of Natural History (AMNH), which we left at the end of part 1 of *Shivers Down Your Spine* and to which we shall head back toward the end of the book. For the time being we will return to the nineteenth century, to forge stronger connections between spaces of immersion and interactivity encountered in part 1, and the museum, which is the backdrop of all the case studies explored in part 2. If part 1 offered a series of eclectic, though indubitably linked, case studies limning the various ways in which immersive modes of spectatorship were available long before virtual reality and contemporary theme park–type rides ratcheted up the experience (and also the discourse), part 2 shifts gears to address not only issues of immersion but also interactivity in the London Science Museum, the Smithsonian Institution in Washington, D.C., and the AMNH, respectively. Spectatorship continues to be the driving force here, particularly as we move into the world of the museum where I argue visitors could be immersed (and invited to interact) in ways both similar and different to audiences entering the cathedral, panorama, planetarium, and IMAX theater. All the spaces in this book are intricately linked: museums are often compared to cathedrals; IMAX theaters are often part of museums, and panoramas are (as we saw in chapter 3) often on display in museums. These are also all "hallowed" spaces where wonder, the sublime, and what I call a "revered" gaze run the risk of overdetermining the

experience for spectators who are asked to let their imaginations run wild as they become immersed in new imaginary vistas.

If much has been written by film historians and others about the spectacular visual culture of nineteenth-century world's fairs and expositions, those heterotopic sites that, while *of* this world, were also uncannily apart from it, less scholarly attention has been devoted to the immersive and interactive modes of spectating peculiar to nineteenth-century science museums, which inherited modes of vision isomorphic with these elaborate public spectacles. For this very reason it is vital that we trace debates around *ideas* of immersion and interactivity to an earlier era in museum history in order to deflate some of the grandiose claims about new media and to ground the discourse historically rather than purely theoretically. So much of what passes for "new modes of immersive and interactive" spectating has precedents in the nineteenth century; it is not just shortsighted but extremely egocentric of us to assume that late capitalism (whenever that is) and postmodernity alone lay claim to these ideas.

Popular visual culture in the nineteenth century encompasses both mainstream amusements and spectacles found in more obscure sites such as science museums, where exhibits included an eclectic mix of instruments, apparatus, machines, failed inventions, and examples of modern manufacturing. While the ways of seeing inscribed in such spaces were similar to those available in other institutions, science museums provided unique opportunities for immersive and interactive encounters with objects long before these concepts became buzzwords in

the late twentieth century. If the quality of the kind of interactions visitors had with exhibits differed from those found in today's high-tech interactive centers such as "Launch Pad" at the Science Museum in London or Frank Oppenheimer's famous "Exploratorium" in San Francisco (a museum of "science, art and human perception" with more than 600 interactive exhibits and artworks), nineteenth-century debates over the popular appeal and pedagogic value of these early instances of spectator interactivity nevertheless inform both the history of museum design and the development of modern visual culture.[2]

Why museum visitors gaped at the technological magic of machines in motion and how curators provided spectators an opportunity to interact with exhibits on the gallery floor are key questions explored here. At the heart of this chapter is a case study on the conditions of possibility for immersive and interactive exhibitry at London's Science Museum in the 1850s. The Science Museum (and its sister institution the Patent Musum) offer especially revealing case studies because together they underscore the longevity of controversies concerning what are considered for the time to be modern modes of museum exhibition. The Science Museum's *Annual Reports* from the 1850s through the 1890s, as well as an 1864 Parliamentary Select Committee Report on the future of the Patent Museum, paint a far more complex and contentious prehistory of immersion and interactivity than one might have imagined.

Despite the recent flurry of professional exchange on the subject of interactivity—an entire issue of *Curator* was devoted to interactive technologies in 2002, and many articles were published in *Museum Management and Cura-*

torship between 2000 and 2004—few have historicized the concept in any real depth and, aside from brief references to antecedents, considered ways in which current debates about the efficacy of immersive and interactive models of exhibiting played out in earlier periods of museum history. This myopia is understandable given the paucity of research on the prehistory of media use in museums. What the second half of this book does, then, is insert some much-needed historical context into current research on new media working with the old adage that in order to know where we're headed, we need to grasp where we've come from. Methodological inspiration for this chapter comes from the anthology *New Media: 1740–1915*, edited by Lisa Gitelman and Geoffrey B. Pingree; titling their introduction "What's New About New Media?" the authors turn to those moments in history when the meanings of new media are still in flux, in identity crisis mode even, a "crisis precipitated at least by the uncertain status of the given medium in relation to established, known media and their functions."[3] If, as the authors contend, "we forget what older media meant, because we forget *how* they meant," it behooves us to look at some of the earliest examples of interactive media to understand the rules for their inclusion, operation, and conditions of possibility. Gitelman and Pingree's argument that the " 'newness' of new media is more than diachronic, more than just a chunk of history, a passing phase; it is relative to the 'oldness' of old media in a number of different ways," is a timely call for contextualization (as they put it, "looking for content apart from context just won't work") and a reminder of the human agency involved in technology

as acts of communication that "mediate among people, pragmatically and conceptually."[4]

I titled this chapter "Back to the (Interactive) Future" to underscore a vital epistemological tenet of this book: that, to a large extent, very little has really changed in the world of museums since the heyday of nineteenth-century exhibition culture. If the high-tech *appearance* of some contemporary galleries stands counter to this claim, the *desire* to create engaging, immersive, and interactive experiences, and the attendant issues raised by this desire, has not. Asking ourselves the same question that David Byrne does in the Talking Heads hit "Once in a Lifetime" ("How did I get here?") is vital, therefore, if we are to grasp more firmly some of the paradigmatic shifts in museum display methods, and appreciate the fact that the investment in the word "new" in the phrase "new media" has suffered exponentially from inflation since at least the early 1990s.

What has changed is the discursive construction of the term *interactivity,* which over time has come to mean a lot more than simply touching an object or manipulating an exhibit to affect an outcome. Conceiving of interactivity within a broader intellectual frame becomes prominent within museum writing beginning in the 1950s; for example, Guggenheim Museum director James Johnson Sweeney drew an analogy between a museum exhibit and a book to make his point about the integration of the senses in museum design; the only major difference in visiting an exhibit, he argued, was that "the visitor actually moves through the exhibition and becomes part of the installation. . . . But each speaks primarily to the sense of

the observer, and each in the end, to have its effect, must be assimilated or digested intellectually." [5] Today, at least in the world of museum education, interactivity—premised upon a constructivist (learn by doing) versus a behaviorist / didactic (learn by being taught) model of learning—connotes agency, a more dialogic model of visitor-centered learning, and some awareness of what Ivan Karp and Steven D. Lavine famously called "the poetics and politics of museum display." [6] But interactive media also provided opportunities for visitor feedback: "A bonus of interactive video technology is that it offers the potential of obtaining visitor reactions to various exhibit halls and / or specific cases or methods on a virtually instantaneous and continuing basis." This was just one of three main benefits of using interactive video discussed in an undated memo from the National Museum of Natural History entitled "Natural History Museum: A Unique Perspective on our Natural World"; the other two were making exhibits more dynamic, and bringing "brief but informative vignettes about current research by the scientific staff and other topics with a behind-the-scenes emphasis." [7]

We begin, however, with an analysis of how visitors might have made sense of more immersive and interactive exhibits as a form of special effects that generated awe for them, but more than a little anxiety for curators who worried that in the absence of explanatory frames, a profusion of spectacle might transform exhibits into a "show" for "holiday types," rather than a serious object-lesson. The Science Museum in London as case study provides a fascinating nexus of aspirations, anxieties, and fantasies about science education in mid-nineteenth-century England. Other organizations that catered to both elite and working-class constituents, such as the Royal Institution in London and the various Mechanics Institutes, are also considered as important informing contexts for hands-on modes of learning. The chapter concludes by addressing late-nineteenth-century debates over the role of museum guides in the gallery and the value of hands-on learning, considering the relevance of these issues in contemporary discourse on the impact and future of interactivity in museums.

VISUAL SPECTACLE AND IMMERSION IN THE NINETEENTH-CENTURY MUSEUM

If Gitelman and Pingree are correct in their assertion that media and technology "incorporate bodies and are incorporated by them," such encounters suggest embodied modes of spectatorship, where people stretched, shoved, and pushed one another in order to see the latest examples of mechanical innovation, touching the machinery and possibly bringing it to life with the crank of a handle. [8] Visual spectacle is a central component of this experience, a defining principle of early modernity and nineteenth-century culture, evoking what Guy Debord would famously describe as "the society of the spectacle." In such societies, Debord argues in the opening lines of his book, "all of life presents itself as an immense accumulation of spectacles. Everything that was directly lived has moved away into a representation." [9] In some ways, what the spectators of the Great Exhibition of 1851 (fig. 5.1), referred to in the epigraph, were experiencing when they looked upon the latest inventions was the nineteenth-

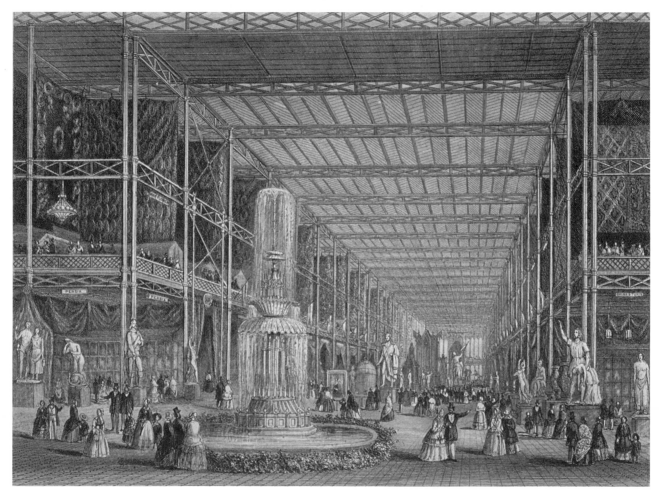

Fig 5.1 Interior view of the Great Exhibition of 1851, showing Crystal Palace from the transept looking east. (Courtesy Guildhall Library Corporation of London)

century equivalent of today's cinematic special effects, "objects of scientific curiosity, aesthetic appreciation, or even vocational aspiration" in the words of special effects historian Michelle Pierson. The wonder generated by these mechanisms, while distinct from the magic and popular science displays Pierson analyzes, nevertheless falls into the category of "'never-before-seen' imagery," spectacular phenomena that had social and cultural significance beyond that of mere technological effect. If the budding mechanics and engineers crowded around the display may have understood the principles behind the mechanism, they nevertheless shared with less informed members of the assembled group the thrill of the spectacle before their eyes; as Pierson explains, "special effects appeared like eruptions of the future in the spatiotemporal fabric of the now, making the unforeseen powers of novel . . . technologies . . . suddenly and spectacularly visible."[10] Ontological differences aside—special effects in the cinema are *representations* of phenomena not the phenomena themselves—we can still appropriate the concept of special effects, as Pierson does, to better understand how nineteenth-century spectators responded to the wonders of the technological sublime.[11]

Stagecraft, technology, display, education, and enlightenment were mutually informing discourses in the nineteenth century, and just as the lecture theater or music hall was transformed into "an immersive environment, creating a sensory, interactive interface between audience and the visual effects of science," so too was the mechanical exhibit changed by being set into motion.[12] But, as Scott Bukatman points out, special effects should be considered neither as merely an artifact of Tom Gunning's "aesthetic of astonishment" nor "relegated to the realm of excess," since special effects "emphasize real time, shared space, perceptual activity, kinesthetic sensation, haptic engagement, and an emphatic sense of wonder."[13] What the nineteenth-century farmers visiting the Great Exhibition witnessed, as Bukatman suggests, was more than just visual spectacle for spectacle's sake, for such effects were grounded in the machines that created them, wider ideological narratives of imperial power and industrial might, and issues of politics, economics, regionalism, and culture. Owning one of these agricultural machines would have had an enormous impact on a farmer's business, promising to transform the enterprise into a larger, more profitable concern. The laborer's job, his livelihood, may literally have hinged on the hunk of metal whirring and hissing behind the rope; if the farmer bought one of these, the laborer could be out of work.

In order to mitigate simplistic accounts of the effect of machinery on Great Exhibition visitors, other factors, such as the division between education and entertainment (which, as Paul Greenhalgh points out, "were resolutely and consistently . . . understood to be not the same thing . . . the one inextricably bound up with work, the other with pleasure"), must be taken into consideration.[14] Although something of a cliché in contemporary museum culture, the education-versus-entertainment debate is nevertheless an enlightening trope to trace over time, the subject of countless articles and conference presentations, and something of an epistemological blind spot for some curators who continue to treat the two variables as if they were mutually exclusive instead of "complimentary aspects of a complex leisure experience."

John H. Falk's research suggests a sophisticated understanding on the part of visitors of the need for both education and entertainment to be "intrinsic ingredients of the museum experience."[15] If visitors have long understood (and demanded) that museum experiences be both educational and entertaining, curators have had a harder time negotiating these two ideologically laden terms (as Falk notes, "to the academic, 'education' connotes importance and quality, while 'entertainment' suggests vacuousness and frivolity").[16] Media theorist Roger Silverstone, writing about the interdependence of the terms *media* and *museum,* especially with regard to the coincidence of process in which they are engaged, argues that similar dilemmas—but with different emphases—exist between "information and entertainment (a dilemma about function); between orality and literacy (a dilemma about mediation); between fact and fantasy (a dilemma about content) . . . between myth and mimesis (a dilemma about narrative); [and] between objectivity and ideology (a dilemma about the act of representation)."[17]

In some ways, little has changed over the course of the twentieth century. Curators were as cognizant of the need to make the learning experience pleasurable at the turn of the century as they are today. The real challenge lay in justifying these techniques within the philosophical remit of the institution. Writing in the *Architectural Record* in 1900, L. A. Gratacap viewed the relationship between high and low culture in uncomplicated terms: "The Popular [sic] system of the scientific Museum is the system of the Dime Museum greatly elevated, dignified, and replenished with culture."[18] AMNH president H. C. Bumpus expressed the ambivalence of many museum professionals concerning the balance between scientific accuracy and respectability versus public accessibility: "For purposes of popular exhibition and profitable instruction we no longer seek the exhaustive collections of 'every known species'; we look askance at extraordinary and monstrous types; we view with some misgivings the elaborately technical schemes of classification . . . and we become thoughtful when we witness the visitor's vacuity of expression as he passes before cases devoted to the phylogeny of the arachnids."[19]

Bumpus's disapproval of the freak-show display of "extraordinary and monstrous types" was echoed by other professional curators at the beginning of the twentieth century. Frank Woolnaugh wrote in the *Museums Journal* in 1904: "The old curiosity shop days of the museum are over. The misguided lamb with two heads, and the pig with two tails, are relegated to a back closet, if they have not already found a resting place in the sphere of the dustbin. There is so much that is beautiful in nature to preserve that we have neither time, space, nor inclination to perpetuate her freaks and errors."[20] However, at the same time as some critics bemoaned the sensationalist leanings of turn-of-the-century museums, others maintained that museums were inaccessible to the general public due to their overly scholarly preoccupations; as Lisa C. Roberts has noted, even George Brown Goode, director of the National Museum at the Smithsonian, expressed this ambivalence toward museums by criticizing them for being "both vulgar sideshows and elitist enclaves."[21]

Museums have been eager to attract and retain the interest of a wide swath of patrons since their institutionalization in the nineteenth century. Competing with such

Fig 5.2 Rows of glass display cases in the nineteenth-century Egyptian exhibit at the British Museum.

paratextual spaces of cheap amusement as dime museums, funfairs, circuses, and freak shows, nineteenth-century museum directors have been (mostly) cognizant of what differentiates their experience from that of their rival institutions. Museums have always been agents of transportation, metaphorical time machines, where objects "free of the drudgery of being useful" (to cite Benjamin)[22] become overdetermined symbols of singularity

or preeminent achievement in the arts, natural history, or the realm of science.[23] Cognizant of these external forces, curators in the early part of the twentieth century hotly debated the future of museum exhibition, considering in particular how screen-based media like photography and lantern slides might be enlisted to help. For example, at the "Museums as Places of Popular Culture" conference held in Mannheim, Germany, in 1903, one Dr. Lichtwark envisioned a "great revolution in the equipment and methods of museums."[24] One of the aims of the conference was to consider ways in which museums could avail themselves to working people (the upper classes, it was argued, were "above instruction") through the media of photography and magic lantern slides.[25] Curators at the conference also discussed the need for exhibits to be designed around a coherent idea rather than function as "overcrowded storehouses of material, purposelessly heaped together."[26] According to the British Museums Association president Francis Arthur Bather, the physical hordes clamoring for a view of display cases in museum galleries was matched by a metaphorical "crowding relative to the mind of the visitor," brought about by gazing at endless rows of identical objects, as suggested in this nineteenth-century engraving (fig. 5.2) of the Egyptian gallery at the British Museum.[27] Speaking at the Museums Association's 1903 Aberdeen Conference, Norwegian curator Dr. Thiis argued that "nothing is more wearisome to the eye, less advantageous for the individual objects, than those long stretches of cases, all to one pattern, covered with black velvet, that are so often seen in museums."[28]

In 1907 the AMNH's H. C. Bumpus complained that the average museum visitor, overwhelmed by the sheer

number of display cases, "became quite lost in the maze of exhibited material, and losing alike both points of the compass and sequence of theme, drifts about a mental derelict." [29] Whether curators have heeded the lessons of time and rescued the "mental derelict" from the fate of aimless wandering is open to debate, since there is still a tendency to cram too many artifacts into the limited space of contemporary exhibit halls and convey too much information on wall panels; a hundred years on from these recommendations, museum scholar George E. Hein still felt compelled to remind curators to display fewer objects in museums. [30] To minimize the sensory overload experienced by the museumgoer, contemporary designers have deliberately included empty or negative spaces in galleries to allow visitors' eyes to rest and to counter overstimulation; [31] the white box aesthetic of the contemporary art gallery can even be found in natural history museums such as the refurbished 77th Street entrance of the AMNH.

In addition to the overcrowding of many nineteenth-century museums, observers also criticized display cases for shoddy construction and for their frequently unpleasing or ostentatious design, which competed with the objects on display for the spectator's attention. [32] Henry Crowther, curator at the Leeds Museum in the north of England, urged curators to consider the inherent limitations of the display case, arguing that an overstuffed, over-labeled case couldn't possibly convey the "mind-thought of the curator or assistant curator who put them up." [33] The most radical suggestion for the redesign of display cases and labels was offered by George Browne Goode, an influential spokesman in his own right on museum design in the early part of the century, who advocated "a collection of well-expressed, terse labels, illustrated by a few well-selected subjects." [34] But the status, design, and function of labels were controversial topics within the turn-of-the-century museological world, with critics taking up positions along a continuum. Dr. E. Hecht, for example, argued that detailed labeling as proposed by Goode was unlikely to have much impact on visitor interest and comprehension: "Certainly we can multiply and amplify the labels . . . we can have, or ought to have, guide-books with their illustrations," Hecht opined, but "labels are not always read, [35] and guide-books, if purchased, seldom read." [36]

As early-twentieth-century museum professionals debated trends in exhibit design, they wrote increasingly of the need to contextualize the objects on display for spectators, a shift in philosophy that in many ways prefigures the use of interactive technologies in contemporary museums, although the outcomes of these endeavors for contextualization are by no means identical. For example, in 1903, British curator F. A. Bather argued that "even when there is nothing strikingly incongruous or offensive in the manner of exhibition, the mere removal of objects from their natural environment places them at a disadvantage." [37] Implicitly recognizing the issues involved in exhibiting artifacts, in 1903 Dr. Hecht recommended the use of "stopping points" in galleries, which he defined as displays relating to the primary exhibit but "chosen in order to arouse, from time to time, the interest of the public, to lead their mind from the view of a single animal to larger ideas, to a general conception." [38] Hecht's "stopping points" prefigure one major use of computer interactives in contemporary exhibition design—inviting visitors to

pause and obtain further information in order to draw connections between an exhibited object and its uses and contexts.

Contextualizing museum objects within realistic and more immersive settings was an important technique used by curators to make display cases more visually appealing and effective in conveying intended scientific object-lessons; even to this day, habitat groups and period rooms, despite the expense and space they demand, remain extremely popular with the public, since the impact of an illusionistically re-created space can reinforce the sensory experience of space and time travel to the scene of the group (museumgoers routinely take photographs of themselves in front of these displays as if they were tourists at the actual site).[39] Habitat groups displaying the flora and fauna of a particular region and life groups (mimetic displays representing indigenous peoples) were among the most appreciated, and costly, display methods used at the turn of the last century.[40] One English commentator remarked that this effort toward realistic exhibits "recognizes the fact that we shall never succeed in infusing into the minds of those who have it not a love of nature, until we get as near as possible to nature herself."[41]

But this view was not shared by all curators; one dissenter at the British Museums Association's 1906 conference took a firm stand against immersive display techniques, arguing that museums "had of late gone a step too far in what might be called 'bringing the scent of the hay over the footlight' "; according to this critic, "Slabs of nature were transported bodily into museum cases and their lessons rendered so obvious that people found it easier to stroll into a museum to learn the habits of animals than to lie in wait for them in their native fields. . . . Thus instead of creating naturalists, our museum helped people to lose the naturalist's chief faculty—observation."[42] More generally, some argued that the habitat and life groups' privileging of sight as the source of scientific knowledge would make spectators lazy and reduce visual acuity. The heightened sense of immersion and overt theatricality and voyeurism of realistic displays, along with their tendency toward sensationalism, constituted the museological equivalent of cheating for some early-twentieth-century critics. If the habitat group's reconstruction of picturesque (or in some cases violent) vignettes of wildlife vivified nature, for this critic at least, the installation's hyper-verisimilitude underscored its own artificiality.

Despite the fact that in the minds of some curators many of today's high-tech, multimedia galleries have pushed the entertainment imperative too far by privileging immersion, interactivity, and multimedia screens over the glass box approach to exhibiting, we should avoid perpetuating the entertainment-versus-education dichotomy for at least two reasons: first, because the two are relative and imprecise terms. For example, the entertainment offered by the late-nineteenth-century museum was not the same as that experienced at the music hall; as Falk explains, "the museum-going public's idea of entertainment, at least for the time when they are at the museum, is not the same as that of the theme park going or shopping-mall-going public."[43] And second, because the dichotomy may end up telling us little about the nature of the experience beyond knee-jerk responses about whether there was too much "fun" and not enough "learning." This tension is encapsulated in a review of Julian Spalding's controver-

sial book *The Poetic Museum,* a scathing attack on museums for their embrace of interactivity and new media, in which Spalding argues that, "In response [to confusion about their role] most museums have decried either that they need to be all-singing, all-dancing interactive theme parks, or to go back in time."[44] Similarly, Paulette M. McManus's meta-critical essay "Reviewing the Reviewers," in which she is struck by the unhelpfulness of journalists' reviews of museum exhibits, blames their use of the term "show" for inferring a "spectacle for entertainment" rather than a serious object-lesson. The word "show," she argues, "is a notion which cannot logically be part of a communication schema employed by those preparing or receiving messages." Enjoyment, in McManus's mind, is not the same as amusement, which the word "show" connotes, as she explains: "The communicator must provide pleasing experiences when 'showing' in the sense of demonstrating, explaining and causing a person to understand, but the central aim is not amusement. . . . *The opening party may be a 'show'—the exhibition is not.*"[45]

If a majority of nineteenth-century curators grasped the futility of purging the museumgoing experience of pleasure, a significant number struggled with issues of mode of address and popularization, although their frustration at controlling the overall tenor of the exhibit was often a thinly veiled attack on the class of visitor walking through the door. An unidentified commentator writing in the *Official Guide* of the 1874 International Exhibition criticized the holiday atmosphere marking exhibitions: "It must always be remembered that the main object of this series of Exhibitions is not the bringing together of great masses of works, and the attraction of great holiday-making crowds, but the instruction of the public in art, science and manufacture, by collections of selected specimens."[46] Fear that the "holiday people" (coded as working class and visible in these comparative images of the one- versus five-shilling visitor to the Great Exhibition, figs. 5.3 and 5.4) might come to exhibitions or museums in search of nothing beyond titillation and amusement was an enduring concern, articulated in the Minutes of an 1864 Select Committee on the future of the Patent Museum, an institution located next to the South Kensington site (although autonomous) from 1857 to 1883, when it was finally incorporated into the collections of the South Kensington Museum (SKM).[47] Comparing the pleasures "holiday people" experience at another major London attraction, the Natural History Museum with the dullness of the Patent Museum, MP (Member of Parliament) Humphrey asked Patent Museum curator Edward Alfred Cowper whether popularizing the exhibits would make a difference: "[I]f there was steam-power introduced," asked Humphrey, and "you had those machines at work at stated times, do you not think that it would be popular?" To which Cowper replied: "I think it would be a more popular museum, and a less instructive museum for those for whom it was intended. If there are a number of holiday people gaping about, it is not easy for others to study the details of mechanism."[48]

Holiday people, or "gapers," regarded by curators as being in search of spectacle and little else, lowered the overall tone of an institution. Gaping, with its dictionary definition of staring "wonderingly or stupidly, often with the mouth open," includes the word "yawning" as a subsidiary definition, suggesting that the stimulus that

The Shilling Day.—Exterior of the Exhibition.

Fig 5.3 The shilling day at the Great Exhibition of 1851, showing the hordes arriving by horse and carriage (from the *Illustrated London News*).

Industrial Revolution and scientific discovery.[49] This faulty mode of looking, ill informed and aimed at sating curiosity in a vulgar, unsophisticated way, was opposed to a sustained, intellectual appreciation of process and mechanics marked by a more sedate and sustained gaze. Gapers were also considered potentially distracting to museum visitors motivated by more refined interests, including the gapers' unwillingness to follow institutionalized codes of behavior, such as moving out of the way for other, more cultured, visitors. For many administrators such visitors took up space that could be better filled by artisans, educators, or students.

This institutional attitude toward visitors has not entirely disappeared; one hundred years later, curators Caroline Gardiner and Anthony Burton of London's Bethnal Green Museum of Children admitted the persistence of an elitist mentality in the world of museums: "One feels like a priest, an initiate, a party to privileged mysteries. The public is allowed in on sufferance, to move about respectfully, talk in hushed tones, and leave quietly when a bell is rung. It is difficult in such circumstances to avoid feeling considerable confidence in one's own status, and a distinct lack of interest in everybody else."[50] As an object of institutional disapproval, the disparaged "holiday types" of the late nineteenth century remain in evidence in contempo-

initially sparks the interest (and thus the gape) is short-lived, since gaping runs the risk of turning into boredom and / or drowsiness. Closely related to the gawker, defined as an "awkward, loutish person," the gaper suggested the undesirable products of modernity for some museum professionals, inscribing a disorganized manner of seeing brought about by the riot of vision ushered in by the

rary museum discourse, accused of coming to museums for assorted prosaic reasons such as "to get out of the cold" or because "it's an inexpensive way to spend the day." Not surprisingly, these visitors are seen as less "educationally motivated" and less likely to come away having grasped the key concepts of the exhibit, although in the absence of extensive summative research or exit data on how visitors learn and what they retain from exhibits, "expectations about learning outcomes must be couched in terms of probabilities rather then certainties."[51]

If the ways of seeing coterminous with gaping or gawking were by-products of modernity and inscribed in the new experiences of sightseeing and window-shopping common to nineteenth-century urban dwellers, they were typically linked to the working class, not to the more affluent visitors to the museum.[52] That more-educated visitors might be less inclined to linger at exhibits was spurious, since *everyone* is capable of gaping (consider rubbernecking, which cuts across socioeconomic barriers), although the upper classes maybe have deemed it uncouth and therefore controlled their behavior in the galleries. Gaping or gawking, according to some commentators, might be mitigated by limiting access to objects likely to trigger this kind of response, especially the display of machines in motion, although the radical step of simply making such

The Five Shilling Day at the Exhibition.

Fig 5.4 The five-shilling day at the Great Exhibition of 1851, showing a more genteel class of visitor (from the *Illustrated London News*).

devices inoperative seemed to many to be the museological equivalent of cutting off one's nose to spite one's face. But why were machines in motion considered inimical to learning? One of the reasons, as Patent Museum curator Cowper explained, was that, "If you make the museum popular you cease to instruct . . . you cannot educate holi-

day-people by merely making machines fly about. *They go to see a show,* and if they find an electrical machine giving off large sparks they are very much better satisfied than if they were forced to study the machine, to learn how the sparks are produced."[53]

While seeing sparks jump remains one of the reasons people continue to visit science museums—especially so in the case of the Boston Museum of Science's "Theatre of Electricity" where enormous lightning bolts and electrical sparks typify the 30-minute demonstration—the decision to exhibit such machinery in motion was quite vexing in the 1860s.[54] On the one hand, exhibits that immersed spectators more fully in their "operational aesthetic" (in Neil Harris's term) were crowd-pleasers, transforming the space around the machine into a more immersive environment that drew visitors into a deeper experience with the object; simply adding sound loosens the object's discursive moorings in the institutional context of the museum, freeing it somewhat by letting it come to life and (metaphorically) taking us with it into an imaginary realm where we might envisage what this machine would be like in situ. Like the oil circulating through the pistons, our imaginations are similarly lubricated as we wrest different meanings—both utopian and dystopian—from the kinetically charged scene that lies before us. On the other hand, some museum administrators feared that such crowd-pleasing came at a price, fostering a more carnivalesque atmosphere around the exhibit, although as Bakhtin makes clear, the concept of carnival is always a double-edged sword, providing an outlet for expressions of anarchic pleasure at the same time as it reintegrates

participants into the existing social order once the carnival is over.[55]

The museums of technology and science which emerged from the great exhibitions of the nineteenth century thus inherited their immersive and interactive modes of exhibiting and patterns of consumption in complex and contradictory ways; few would deny that they functioned as training grounds (along with department stores) for generations of museumgoers who learned how to gaze at the spoils of modernity and internalized the rules of commodity fetishism from navigating the miles of exhibits at world's fairs and exhibitions. The Science Museum in London was one of those institutions, coming of age at the height of modernity and in one of the most industrialized countries in the world. Let us now turn to this institution and consider in more depth how the stakes were raised when machines in motion entered the array.

"THE STOREHOUSE OF THE UNITED KINGDOM": THOSE MAGNIFICENT MACHINES AT THE SCIENCE MUSEUM

The story of the origins of the Science Museum is circuitous.[56] Its beginnings can be traced to London's Great Exhibition of 1851, although it only assumed institutional autonomy in 1909. In the interim, the Science Museum was part of the South Kensington Museum, established in 1857 with exhibits and funding from the Great Exhibition, a showcase for the industrial and artistic products of the British Empire, a trade show promoting Britain's economic strength as a result of the Industrial Revolu-

tion. Sponsored by the Royal Commission, whose president was His Royal Highness Prince Albert, the 1851 Exhibition made an unexpected profit of £186,000, which permitted the twin goals of education and enlightenment to be extended via the permanent exhibition of art and science objects in the SKM.[57] Governed initially by the Department of Science and Art, formed in 1853 under the Board of Trade, the SKM was initially housed in temporary and unsuitable buildings on the east side of Exhibition Road (part of the current Victoria and Albert [V&A] site) and nicknamed the Brompton Boilers for its unsightly appearance (fig. 5.5).[58]

The Science Museum was not the only institution to emerge from the Great Exhibition, however; the V&A, also originally part of the SKM, gained autonomy around the turn of the last century. According to Science Museum historian Xerxes Mazda, the mission of the SKM can be found in an 1851 statement made by the Commissioners of the Great Exhibition, who decreed that the profits from the huge undertaking should "serve to increase the means of Industrial Education and extend the influence of Science and Art upon Productive Industry."[59] When it opened in 1857, the SKM consisted of eight separate collections—five devoted to art and three loosely categorized "science collections," an Educational Museum, an Animal Products Museum, and a Museum of Construction and Building Materials. Through 1907, new collections or "mini museums" were added and older ones dispersed including a Food Museum in 1858 and a collection of naval models in 1864. The year 1867 saw the addition of a collection of machinery and inventions, the objective being to "afford in the best possible manner information and instruction in the immense variety of machinery in use in the manufactures of this country" (fig. 5.6).[60]

A turning point with regard to the display of scientific objects occurred in 1875, when the Lords of the Committee on the Council on Education approved a proposal to exhibit a Special Loan Collection of scientific apparatus; a committee comprising leading figures in the fields of science, engineering, and industry and chaired by the Lord Chancellor oversaw the exhibition, which eschewed the more standard trade fair model of exhibiting where national provenance governed the location of objects in favor of a typological classification. Opened in 1876 by Queen Victoria, the artifacts formed the basis of a collection of scientific instruments and apparatus. If "holiday people" were not the most welcome of visitors—or at least viewed with some suspicion—which constituencies the SKM did actually serve during its early years is somewhat opaque. According to Mazda, the main aim of the collection was to "educate the artisan classes in the application of scientific principles to industry so as to increase national wealth," although some of the collections were also used to train educators. By 1883 the Educational Museum had become something of a traveling showroom, with samples of apparatus circulating among schools around the country so that the "Committee and the Teachers of the Schools may see what really is the kind and amount of appliance that they ought to have for their class instruction."[61]

The science collection officially became the Science Museum in 1885, although it remained under the directorship of the SKM until 1893, when separate directors

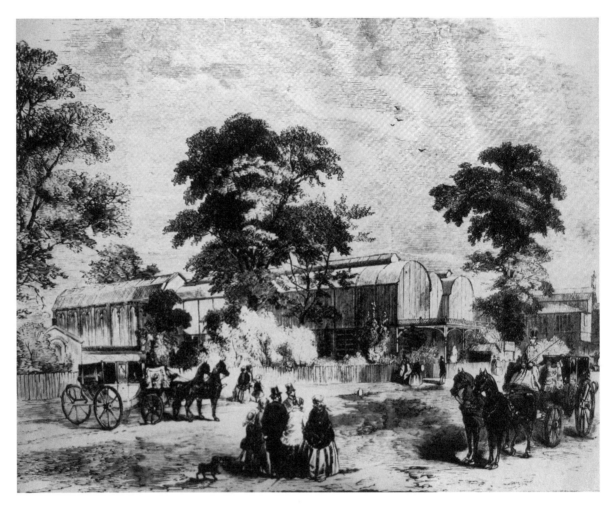

Fig 5.5 Engraving of the South Kensington Museum (from the *Illustrated London News*, 1857).

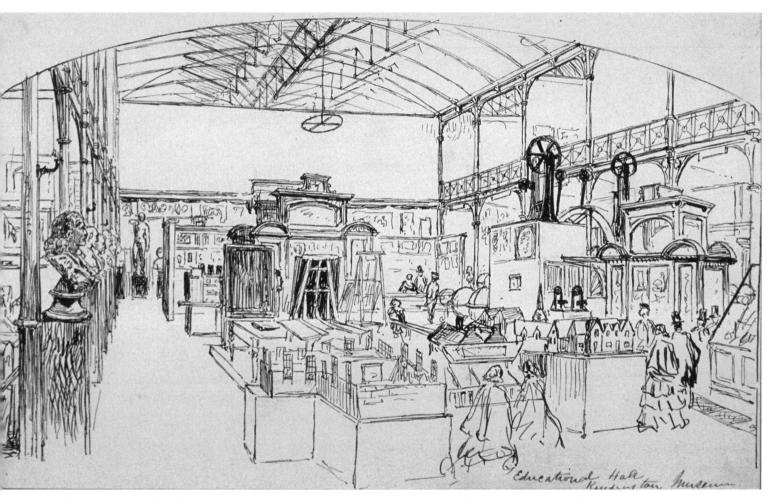

Fig 5.6 Interior view of the Educational Hall in the South Kensington Museum. (Courtesy Guildhall Library Corporation of London)

were appointed to the Art Museum and Science Museum.[62] When Edward VII opened new buildings in 1909, the V&A was the more prominent of the two, with the Science Museum appearing as a mere subheading on the building's entrance hoarding.[63] The Bell Report of 1910, produced by a committee chaired by Sir Hugh Bell, was, as historian David Follett points out, "the greatest and most significant influence in the history of the Science Museum," and the implementation of its recommendations by Director Henry Lyons in the post–World War I period catapulted the museum to the front ranks of science and technology museums (though not surpassing the Deutches Museum in Munich, unprecedented in its wealth of science/technology-related exhibits).[64] The Science Museum workshop played a more central role in exhibit preparation during this period; for example, cross-sections of machinery were created in order to expose their inner workings, and a larger number of models and replicas were placed on display in galleries in order to evince scientific or engineering principles. A new lecture theater opened, allowing experts in various fields to include demonstrations in their talks, although this idea was not extended to the galleries owing to the overcrowding of objects.[65] A loan collection of magic lantern slides was also assembled, making available visual material to schools and local scientific societies. In addition to displaying cross-sectioned objects, one of the most significant developments was the inclusion of working models into the galleries; operated by compressed air or by means of handles on the outside of the cases, they helped visitors better grasp engineering principles which could not be shown to scale; as Follett explains, "some of the actual machines were shown in motion throughout the day, some for fixed periods at appointed times during the day, and in a few cases, the workings of the machines would be demonstrated by an attendant."[66]

Some of the earliest discussion of the desirability of models in the gallery can be traced to the 1870s, including the *Science and Art Department 17th Report,* where Division Keeper H. Sandham argued that "the want of the necessary fittings and appliances to supply the models and machines with motive power, either directly or indirectly, so as to exhibit the several movements and connections of their working parts actually in motion, is a great drawback to the uses of the Collection. Contributors are mostly anxious that their several loans be shown in actual movement." The solution—procuring small working machines and models from large machine-making firms—would "render this portion of the South Kensington Museum one of the most attractive, as well as most instructive, collections in the United Kingdom."[67] Machinery in motion had also been the highlight of the 1862 Great Exhibition, and was considered "the most attractive and the most easily understood part of the machinery department" in the words of one MP.[68] Stairs for visitors to climb in order to secure a better view of the various electrical devices in the "Sautter Lemmonier" exhibit are clearly visible in the lower right-hand corner of this engraving of the 1881 Paris Electrical Exhibition (fig. 5.7).

Pressure to bring the steel structures that framed the galleries of the SKM to life came not only from inventors and curators such as Sandham but also from an attempt to keep up with the latest developments in display techniques and competition from neighboring countries. For example, the *Science and Art Department 20th Report*

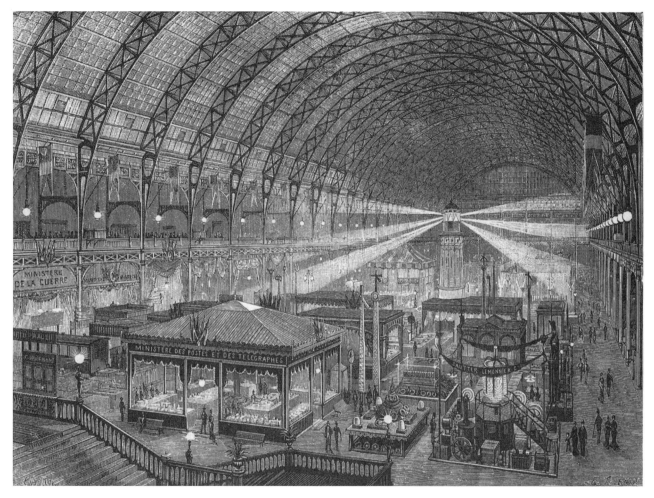

Fig 5.7 The Paris Electrical Exhibition from 1881. (Author's collection)

included a review of both the Polytechnic Exhibition of Moscow and the Scandinavian Industrial Exhibition in Copenhagen, both of which opened in 1872. According to the reviewer, the Moscow exhibition "to a much larger extent than ever before" showed the manufacturing *process* as well as its products, "the operations of several hundreds of artisans . . . watched with great interest, and doubtless profit, by the visitors."[69] In addition to extensive use of wax models illustrating the anatomical structure of invertebrate animals and embryology of the vertebrates, other hands-on techniques, such as microscopes and microscope slides "so placed and kept in order by the attendants as to be available to the public," along with "competent expositors to explain to those interested, the various objects and arrangements of the section," topped off the experience.[70] Trompe l'oeil attractions such as ethnographic villages featuring "life-sized models" and actual Turkistan people engaged in cooking, embroidery, and horsemanship confounded object and representation ("so cleverly is the whole managed . . . [that it is] difficult to distinguish at first which are real and which are models.")[71]

The effect of different display techniques upon museum visitors was taken up in several of the SKM's *Annual Reports;* what might now seem merely commonsense policies, such as displaying objects on flat surfaces and avoiding overcrowding, had to be explicitly spelled out, as seen in this 1860 directive on display policy: "specimens exhibited upon a flat surface produce more impression upon the senses, and a more distinct idea is gained of quantity and quality than when they are enclosed in round glass bottles of various sizes."[72] The SKM was not alone in reporting on innovative modes of exhibiting that could be adapted or appropriated for the gallery; for example, an 1881 report from the Essex Museum of Natural History emphasized, first, the need to design display cabinets "to suit each class of objects"; second, the need to reduce the number of objects on display ("comparatively few species . . . well displayed and explained, are infinitely better than a great collection huddled together and serving only to bewilder the average spectator"); third, the benefits of affordable handbooks; and last, the use of colored models, which, while expensive (one to three guineas), would repay the initial outlay.[73]

Given the sustained interest among nineteenth-century museum professionals in exhibition techniques, what impact did these shifts in exhibition policy and a gradual appropriation of more immersive and interactive displays have upon visitors? What impact did this intellectual and institutional context have on learning expectations or outcomes? What effect did the working models have on spectators who, for the first time perhaps, could touch exhibits without fear of reprimand from a museum guard? Let us turn briefly to the concept and history of interactivity, a blood relative of the idea of immersion, which found a new lease on life in the science and industry museum.

(INTER)ACTIVE IMAGINATIONS: A PREHISTORY OF HANDS-ON EXHIBITS

To a large extent, there is nothing new about the idea of interactivity in museums; if the concept (and its overuse

as a 1990s buzzword) smacks of high-tech, digitized galleries where every exhibit features cool-looking LCD or plasma screens and interactive touch pads, the reality suggests that museums have taken the idea of visitor interaction seriously for quite some time. Museums have *always* been interactive insofar as they invite visitors on occasion to touch artifacts and seek specific information. While the recent proliferation of interactive technologies points to an emerging model of museum spectatorship in which context and interactivity play increasingly important roles in structuring the museum experience, it is striking that such ideas were first articulated a hundred years ago. As one curator noted in 1905, "an hour's worth of teaching would not get so much information into the mind of the child as he would get by finding out the information for himself." [74] One early attempt to make the museum display case more accessible to visitors was the Rotary Cabinet, designed by the Reverend S. J. Ford in 1907, which allowed objects to be viewed at will by the museum spectator, who, by turning a driving handle on the side of the cabinet, could rotate for display each drawer (see fig. 5.8). The advantage of this device was that all the specimens could be brought to the top of the display case for inspection without the "cabinet being opened or the specimens disturbed." Though driven by a relatively simple set of gears, the principle of interactivity enshrined by the Rotary Cabinet's changing trays is important for the time. Advocating its use in museums, schools, and homes, Reverend Ford claimed that "even a blind-folded child" could operate its simple design and mechanism. [75] If keeping objects out of the hands of museumgoers (and ensuring their safe-keeping) was one of the implicit goals of the

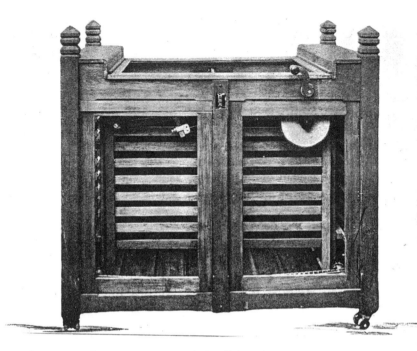

Fig 5.8 Rotary Cabinet, c. 1907. Turning the handle brought new trays of objects to the surface. (Author's collection)

Rotary Cabinet, there were other critics who were equally strident about letting museumgoers, especially children, roll up their sleeves and touch to their heart's content.

Proposals for hands-on exhibits in museums were made by a number of early commentators, many of whom were, interestingly, women. In 1901, Kate M. Hall, curator at the 48-foot by 32-foot Whitechapel Museum in London, stated that when school groups visited the tiny museum, the objects they wanted to study "should, whenever possible, be taken out of their cases." [76] Hall was also a firm be-

liever in making connections between living specimens and the dead ones in the cases in order "not to give a child facts, but to entangle him or her in an interest and love of living things" in order that they "not think the study of natural history a study of dead things only."[77] Present in this discourse on hands-on displays is recognition of the tactile pleasures involved in handling exhibits, an acknowledgment women, as primary caregivers of children, might have internalized in their daily care and education of children (showing and demonstrating to children might have been second nature to women). Children's desire to interact with objects is one of the reasons for the enormous popularity of Discovery Rooms and Hands-On Centers in contemporary museums (as both the AMNH and National Museum of Natural History can attest, demand for entry is so high that timed admission tickets are needed to gain entry, and on busy weekends and holidays it's not unusual for all the afternoon slots to have been allocated). Writing at the time, Bumpus went so far as to criticize the "impounding of specimens in cases," arguing that in some instances, displays should be out in the open, such as the 1906 Elk Group at the AMNH. According to Bumpus, curators should be sensitive to the "touch sense" of their visitors and where possible mitigate against the remoteness visitors felt when all the viewed objects were behind glass.[78] (It is worth pointing out that the haptical pleasures of the exhibition gallery—the fact that people respond to the textural surfaces of the objects on visual display—can be heightened for the museumgoer through the use of different materials on the floors, gallery seating, display panels, and so on.)[79] If Bumpus's plan for freeing exhibits from their glass enclosures created logistical and security problems for museum personnel, his vision for the twentieth-century natural history museum is nevertheless remarkably sympathetic to modern pronouncements on the role of new media in museum pedagogy. To that end, Iwan Rhys Morus's research on scientific exhibition and lecturing in eighteenth-century London, specifically the electricity experiment, may help us better understand the frames through which audiences made sense of exhibits in the Science Museum.

THE ROYAL INSTITUTION AND MECHANICS INSTITUTES: POPULARIZING SCIENCE

Characterizing science as a "species of cultural practice . . . a practical activity, a way of going on, that has connections to and roots in other cultural ways of going on," Morus points to the dearth of protocols or boundaries for the way experimenters went about their work, and as we saw from the previous chapter on planetariums, scientific presentations to the public were highly performative affairs defined as much by self-fashioning as by formal qualifications; theatricality was central to their mode of address, as vital to the overall success as the chemicals, apparatus, and lighting. As Barbara Maria Stafford argues in her masterful book *Artful Science: Enlightenment Entertainment and the Eclipse of Visual Education*, the cult of public science flourished from the 1730s onwards and a "tension between demonstration as audio-visual spectacle and as the textual or numerical rehearsal of claims made about

new objects escalated during the Enlightenment."[80] In the nineteenth-century science experiment, lighting contributed in no small measure to the exciting atmosphere, as evidenced in an 1868 essay on the role of lighting and stage effects in the 350-seat Franklin Institute Lecture Room in Philadelphia; utilizing five large Bunsen burners and sixty smaller ones to light the auditorium, the stage contained the "most brilliant scenery and colored decorations, suddenly illuminated by yellow light . . . [which] presents an appearance of ghastly change, which cannot be appreciated until seen, while sufficient light reaches all parts of the house to allow the audience to repeat the observation of strange metamorphosis upon their neighbors."[81] Lighting in the museum gallery was an attraction in and of itself; the *Fifth Report of the Science and Art Department,* covering the years 1867–1869, remarked that "the looks of surprise and pleasure on the whole party when they first observe the brilliant lighting inside the Museum show what a new, acceptable, and wholesome excitement this evening's entertainment affords to all of them."[82] Powerful lighting might also serve to discourage improper behavior and heighten the salubrious nature of the event since everyone's actions were plainly visible.

Within a context of wonder and alchemic possibilities, audiences were primed in the scientific lecture hall for visual spectacle; had the experimenter not lived up to the role expected of him as wizard, conjurer, and impassioned scientist, disappointment would have registered on the faces of the assembled crowd. There was, therefore, an implicit contract between experimenter and audience in which expectation played a huge role; as Morus explains,

"Electricians needed to define themselves in relation to their experiments and to their putative audiences. To do this they had to fashion themselves in such a manner as to conform to or even construct their potential constituencies' notions of the kind of person an experimenter should be."[83] But where, one might ask, is the anxiety over theatricality, showmanship, and the need to elevate science above spectacle that plagued curators of science museums? If a vital component of the experiment's success—the lecture-theater lighting—was almost as thrilling as the performance itself, what sense should we make of the heightened concern about science on display in a different, yet related venue?

The Royal Institution laboratory and lecture theater, founded in 1799, predated the Great Exposition by some fifty years, and while it clearly influenced the design and rationale of the 1851 exposition in London, it belonged to a different sphere, a milieu that Morus identifies as a coterie of popular lecturers, instrument makers, and mechanics whose "cosmologies were closely connected to their instruments, the machines they used to produce a range of spectacular phenomena." The lecture thus bridged the popular fairground or dime museum (as suggested in this 1802 James Gillray cartoon of a lecture at the Royal Institution entitled "New Discoveries in Pnematicks; or, an Experimental Lecture on the Power of Air" [fig. 5.9]) and the elite circles of the scientific societies, making it possible for similar kinds of spectacle to be put on display. Subject to private membership or the laws of the marketplace, these institutions had different operating logics to those of large public museums, and generally evaded the

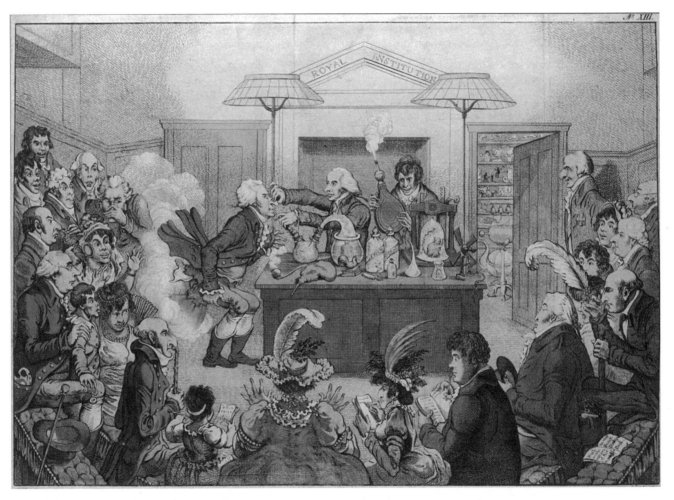

Fig 5.9 James Gillray cartoon of a lecture at the Royal Institution from 1802. (Courtesy Library and Information Center, Royal Society of Chemistry)

close scrutiny governing science museums. Despite these differences, however, the two institutions exercised considerable influence upon one another and were patronized by overlapping audiences.

A parallel development with strong philosophical ties to this scientific milieu was the Mechanics Institute, part of an emerging philanthropic and humanitarian movement to bring science to the working classes and considered by historian Thomas Kelly as a "logical sequel to the development of child education in the charity schools and Sunday-schools of the 18th century."[84] The idea of the Mechanics Institute is credited to Scottish schoolmaster Thomas Dick, who in 1814 made a case in the pages of *Monthly Magazine* for the establishment of "literary and philosophical societies, among the middling and lower ranks of the community, in every town and prosperous village, for the purpose of diffusing general information, as well as making improvements and discoveries in art and science."[85] Taking root originally in Scotland, the first Mechanics Institute was the Edinburgh School of Arts, which opened in 1821; the London Mechanics Institute opened three years later, and its directors called for the establishment of a publicly sponsored National Repository of inventions and industrial products.

The London Mechanics Institute owed its formation to Joseph C. Robertson and journalist Thomas Hodgskin, who lobbied for its inception in the pages of *Mechanics Magazine,* although, as Morus points out, while in favor of a public organization and meeting space, Robertson was vehemently opposed to the idea of a National Repository of inventions (a patent museum) on the grounds that it exposed the inventor to excessive public scrutiny; as Robertson complained: "Is the manufacturer so degraded as to require to be raised in his own estimation by seeing crowds of curious idlers, or fashionable loungers, assembled to admire his productions? . . . Is his competition with his rivals in trade not sufficiently stimulated by the desertion, or the increase of his customers, unless he likewise sends samples of his handicraft to stand a comparison with theirs in the same gallery?"[86] Patent museums or national repositories placed undue pressure on the inventor/mechanic in Robertson's mind; it was not the job of the inventor to educate or enlighten the public, and yet the fluidity of these roles cannot be underestimated, as Morus argues: "the boundaries between private and public, production and consumption, experiment and display were all open to and constructed by negotiation."[87]

Mechanics Institutes were innovative both in terms of their philosophical mission and their privileging of hands-on experiences for members; for example, attending a lecture on electricity and galvanism in Settle, Scotland, in 1823, schoolmaster William Lodge Paley wrote in his diary that "many of us were electrified by putting each hand into a basin of water into which he put a small wire."[88] If receiving a small electric shock was not everyone's cup of tea, the fact that it was available at all forces us to revise claims about the "origins" of hands-on experiences in the museum; here was an immersive experience that was quite literally, "shocking." And yet the historical record suggests that the demand for scientific lectures in mid-nineteenth-century Britain was phenomenal: "These courses were crowded," a contributor wrote in Appendix F to the *First Report of the Department of Science and Art* at the SKM in 1853; "applications for places were

made for at least double the number of working-men that could be accommodated, the size of the lecture theatre not permitting an issue of more than 600 tickets for each course."[89]

Given that towns of every size in the United Kingdom would have had their Mechanics Institute or School of Arts by the mid-nineteenth century, we can safely assume that many members of these institutions would have been familiar faces at the Science Museum. The fact that the SKM published three types of visitor guides targeting popular, generalist, and specialist readers suggests the museum's broad appeal, although it would be misleading to imply that the Science Museum stratified visitors purely on the basis of guidebooks, since, as Morus argues, "to a large extent the economic and cultural boundary between artisans and the lower middle-class was fluid. The gap dividing the journeyman from a small master, shopkeeper, or tradesman, or even a journalist, surgeon, or dissenting clergyman, was often quite small."[90]

Discussion of guidebooks often arose in tandem with debates over whether or not to employ attendants to assist in the explication process, a vital pedagogical addition in the minds of an 1877 contributor to the *Standard* (London) who argued that "it is not enough that objects should be exhibited, they must be so explained that visitors can derive some benefit from what they see. . . . It is only by popularizing science we can ever hope that such an amount of scientific knowledge will become general."[91] "Ordinary attendants" would therefore receive training on how to give a "popular explanation of the objects of special interest" taking place in the galleries, these mini-lectures leading up to the "more scientifically accurate description of penny guidebooks of each department to which the more intelligent and receptive visitors could be referred."[92] The role of attendants generated considerable discussion, not only because "expositors" signified a sea change in display philosophy, becoming synonymous with more modern and open techniques, but also because they encapsulated philosophical tensions between education and entertainment. In addition to their role as "walking guidebooks," attendants were also needed to operate machinery in galleries and to attract the attention of children once a machine was turned on. Despite sticking "very close trying to listen to their teacher's description" of the objects on display, "the moment a sewing machine is set going, or any other instrument . . . the dullest of them all rush up to it at once" (fig. 5.10).[93] Needless to say, things that moved and created noise were a huge draw, although not all curators agreed on their merit. An editorial in *Museums Journal* from 1931 singled out the models in the Children's Museum (shown below in fig. 5.10) as maybe having gone "too far and not quite in the right direction," the argument being that "boys and girls should make models for themselves" rather than simply turn levers. Far from criticizing the principle of interactive exhibits, this author feels they should go a step further and truly expose children to the ideas behind the exhibit.

Attendants could provide temporary relief to museum fatigue, bringing machines to life while explaining their significance; writing to the *Times* in 1912, Lord Sudeley (Charles Hanbury-Tracy, the fourth Lord Sudeley) drew upon his expertise in gallery management by arguing

that, "No one can watch as I have constantly done, a group listening to the well-trained and clear-voiced guide and have observed the interest, indeed the delight, portrayed on every countenance, and then compared it with the lifeless galleries and apathetic visitors of other museums but will be convinced of the inestimable benefits which accrue from the institution of the system of popular 'guide demonstrations.'"[94] Sudeley made a similar case for gallery guides two years later, when testifying during parliamentary debates on "The Public Utility of Museums." Noting that seven institutions in England had a guide lecturer (along with one or two in Scotland),[95] Sudeley reported enthusiastically on the noticeable change in disposition and interest of visitors as a direct result of the guide: "You now witness as you go round keenness, joy, and happiness depicted on the faces of the people, and you no longer see those museum visitors with an uninterested and listless expression."[96] In an editorial the year before, the *Times* viewed the problem of listless museumgoers in purely pragmatic terms: "As far as the mass of the nation are concerned, most of our museums are dead things upon which they occasionally gaze with a bewilderment that quickly destroys even curiosity. Yet museums need only *living exponents* to become *living things* of unrivaled potency for educational ends." Calling for a "race of guide-demonstrators" whose function it would be to "put life into the dry bones by explaining to visitors what is the meaning of the objects around them" the *Times* weighed in on the popularization of museums debate, arguing that humanizing the gallery—literally placing humans among the exhibits—was a first step in

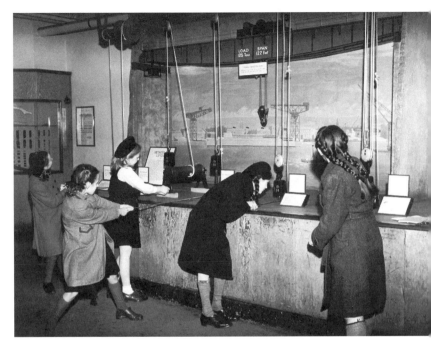

Fig 5.10 Children experimenting with early interactives (Children's Gallery, Science Museum, 1951). (Courtesy London Science Museum Library)

making the gallery a more meaningful space by providing context for the displayed objects. While labels were indispensable, they "cannot take the place of *viva voce* instruction."[97] A similar point was made in the *Times* in 1912, directly echoing Lord Sudeley's recommendations: "Let text-book, labels, and guide-books be ever so clear and ever so attractive, they can never replace the living voice of the skillful expositor."[98] One unintended conse-

quence of the popularity of expositors in the gallery was suggested in a memorandum written in 1891: "Great difficulties are caused by the fact that when anyone is seen conducting the party, or heard addressing remarks to them, the other visitors of the Museum crowd around and in a few minutes stand up on the adjacent seats or cases or even objects. Such crowds are very difficult to deal with and may cause great damage to valuable objects in a Museum, especially in one so crowded as that at South Kensington."[99]

Discussion of the role of attendants or expositors in the gallery raises important questions about the mediation of visual spectacle and the perceived need to reign in its appeal by the museum. Having guides speak extemporaneously in the gallery doubtless changed the overall tenor of the space, making it alternatively more relaxed (as suggested in the crowding anecdote) or more official, if one views the guide as embodying the institutional voice of the museum. While encounters with the scientific sublime at the Royal Institution, which in the 1860s was as fashionable as the opera house and theater and attended by educated and wealthy audiences, was by no means identical to lectures or gallery talks given at the more populist Science Museum, an element of the performative defined both. Historian of science David Knight explains: "getting the lines across in the character of the discoverer or the sage, and making all present witnesses or even accomplices" was a common strategy, and theatrical settings, including a proscenium and curtains, were typical. And yet for the scientific community, special effects had to do more than merely produce a show, as Barbara Maria Stafford explains: "How to transform the deft creator and perceiver of marvelous effects into an impartial *observer* of textualizable facts" was of paramount significance to scientists. Moreover, "the empirical sciences, applied mechanics, 'clinical' medicine, and the visual arts were seen as cognate handiwork and judged according to the same aesthetic and ethical protocols." The term *theater* (or *theatre*) often graced the cover of books involving subjects such as machines or chemistry and, as Knight points out, "it is good to remember how in science events are staged, how dramatic some of them are, and how theatrical the scientific life could be and maybe still is."[100] (The frontispiece of the *Companion* to the Albion Street Museum [fig. 5.11], which opened in 1805, is a perfect illustration of the imbrication of science, mythology, and the theatrical; the angel of Time on the right is unveiling a dome with a multibreasted woman representing Nature standing inside a cylinder, while Science, the woman on the left, holds a beacon of light over the globe.) Sheldon Annis takes the museum / theater metaphor even further, comparing the museum curator to the theater manager who sets up a "sprawling stage with motionless object-symbols" and the audience taking responsibility not only for their own "pacing" but also for writing their own script: "The visitor travels in, about, and through a set of symbols, seeking to tie them together with associations and meanings—as if each visitor were author and star in his [or her] own play."[101] Watching attendants or guides operate machinery or captivate a visitor's attention with intriguing stories of an object's provenance shifts the semantic register of the interlocution, nudging it closer to a more traditional oral-based cultural tradition of storytelling, far more meaningful in the premodern period

where many citizens obtained as much (if not more) information about the world via "word of mouth" than from printed sources. While guides or attendants (aka docents or explainers) still play a role in museums, they have been usurped by an array of electronic and digital handheld guides. Nevertheless, we cannot overlook their historical (and essential) role in facilitating more hands-on modes of interacting with museum objects and, to put it bluntly, keeping the objects and machinery from harm's way. Objects could *not* be removed from cases without the presence of guides; machines could (usually) *not* be started without an employee present to turn a key or push a button; and even in today's highly interactive science museums, visitors are often *unable* to make the interactives work without the help of explainers; as interactive gallery researchers Christian Heath and Dirk vom Lehn point out, "the collaboration that the exhibit produces is therefore largely concerned with trying to operate the exhibit rather than discussing, or even appreciating [its content]." [102]

Issues of control, which Morus argues were "central to the construction of the inventor as showman," since it was only by lording over his machine that the inventor "could also aim to control the audience for his showmanship," remain a vital component of the longterm shift toward interactive galleries. But control also lay at the heart of the debate over a more in-

Fig 5.11 Cover page of guidebook to the Leverian Museum, located on Albion Place, Southwark near Blackfriars Bridge, 1805. *Artist*: Charles R. Ryley; *Engraver*: W. Skelton. (Courtesy Guildhall Library Corporation of London)

A
COMPANION
TO THE
MUSEUM,
(Late Sir Ashton Lever's)
Removed to
ALBION STREET, the Surry End of BLACK FRIARS BRIDGE.

Whilst Time is unveiling, Science is exploring Nature.

LONDON:
PRINTED IN THE YEAR M.DCC.XC.

teractive gallery, as we shall see in the last section of this chapter.

"A MERE CHILD'S TOY": MAKING THE (DIFFICULT) CASE FOR HANDS-ON EXHIBITS

Despite the blurring of boundaries separating private laboratory practice and public presentation, basic research benefiting the larger public good was differentiated from more proprietary motives for inventing; as Morus explains, "the philosophical business of discovery was to be sharply distinguished from the entrepreneurial activity of invention."[103] This tension between proprietary and nonproprietary exhibition was the subject of an exchange during an 1864 Parliamentary Select Committee debate when MP Waldron asked Patent Museum curator Cowper whether an inventor might be able to pay to have his machinery in motion in the gallery.[104] Cowper gave the idea short shrift, arguing that he did not think the museum "ought in any way to be considered as an advertisement shop," and that patent inventors should not be permitted to interfere with exhibition policy. The idea that "putting the machines in motion would rather have the effect of an advertisement" (in the words of MP Augustus Smith) points to the uneasy cultural and economic legacy of the Great Exhibition of 1851 upon museums, since machinery and technology served precisely that purpose in those venues (it also has parallels in contemporary debates around corporate sponsorship and exhibit underwriting). The exchange between Cowper and Smith is revealing of the underlying tensions in the visual display culture of science and technology museums:

> [COWPER]: I think that if an inventor were allowed to say "I will put the machine there, and I will pay so much rent, and you shall keep it going," that would be something like an advertisement, as the inventor would, to a certain extent, be settling what should be exhibited.
> [SMITH]: You think that that would make it a popular exhibition, and that it would interfere with the higher scientific object of the museum?
> [COWPER]: I think that it would be rather derogatory.

Anxieties that machines in motion would transmogrify into advertisements for the inventors, that the displays would become vulgar through their overt commercialization, and that inventors would usurp the authority of curators were not the only concerns voiced. Cowper's comparison of working men to machines ("If you take common workmen, they are really such machines themselves that they do not think about much more than their daily work") suggests that the problem of having working machines was that their object-lessons might be lost on the average museumgoer consumed by the "effect" rather than its means of production. Cowper also worried that "there were many machines in full work at the Exhibition, and a number of persons came and looked at them, who had not the most remote idea with regard to what they were doing." Seeking confirmation that he had understood Cowper's earlier point, MP Ayrton entered

the debate with the following clarification: "Any machinery in motion that had any applicability to some material, would be a mere child's toy to the spectator, unless it were applied to that material; in the presence of the spectator," to which Cowper responded "it would probably be unintelligible, unless some person stood by and explained the peculiarity of the machines as compared with some other machine."

Earlier in the Select Committee hearings Cowper had expressed opposition to the idea of having machines continuously in motion in the gallery; not only was it expensive, but it redefined the museum's mission, turning it into a "popular museum of machinery" rather than a "scientific museum for inventors." More appropriate would be to have an "attendant who, on proper application made to him (say by the leaving of a card or a name) should give the machinery a turn or two" rather than "having the machinery grinding away all day long." Through reference to children and the infantilized spectator, Ayrton queries Cowper for a second time about the motivation for including machinery in motion: "You would not have machines spinning about like tops for the amusement of children and ignorant people," he asked, to which Cowper emphatically replied: "I would not."[105] Cowper had made reference to museum visitors in an earlier exchange where he was less equivocal on the subject of machinery displays: "Women, and children, and holiday folks [return of the gaper] do not learn much by models of machinery; they like to look at pretty things." When asked whether he was implying that "no workmen ever go for a holiday to a place where they can obtain instruction," Cowper partially retracted, saying, "No, I would not go so far, but I think very few do so certainly; engineers never go to such things on holidays, they go somewhere else." Perhaps the presence of working machinery in the gallery brought the world of the harsh, solidly working-class, industrialized factory too squarely into the sedate museum gallery; perhaps the nineteenth-century aesthetic experience and goal of "absorbing the aura of [an] object, immersing oneself in it, becoming transported by it," in museum scholar Michelle Henning's words, was undermined by the presence of the noisy machine. And if, as Henning argues, a display both "puts objects to work and *overcomes* them," then perhaps the working machines undermined the museum's authority over them (despite the fact that curators were the ones who decided when they were turned on) and someone set them free.[106] As unlikely as it may sound, one hundred and forty years on from this exchange, little has really changed in the "Do Visitors Learn in the Gallery" debate. In 1988, Bob Peart and Richard Kool minced few words when they argued: "We should *not* expect that a few minutes in a gallery, or a few seconds in front of an exhibit, could generate a significant and measurable change in attitude. . . . That is, the majority of information in the gallery is not learned by visitors" (visitors spend on average around 18 seconds in front of an exhibit, usually devoting about 14 minutes to a gallery, with an optimal viewing time of 74 minutes); in the words of AMNH president Ellen V. Futter, there are three kinds of visitors: "streakers," who race through; "strollers," who move at a steady pace; and "studiers," who read every label.[107] More significantly for the focus of this investigation, visitors are still attracted

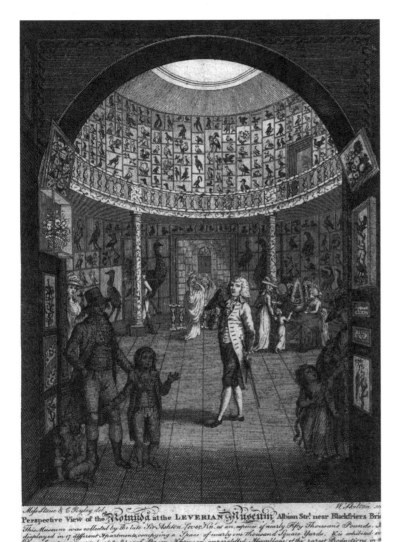

Fig 5.12 Interior view of the Leverian Museum, Albion Place, Southwark, showing visitors in the Grand Salon and Rotunda natural history gallery, 1805. *Artist*: Charles R. Ryley; *Engraver*: W. Skelton. (Courtesy Guildhall Library Corporation of London)

to the most immersive and visually spectacular exhibits (those that generate wonder, awe, and something magical such as large open-diorama exhibits, defined earlier) and are far more willing to devote attention to a machine in motion than static, and become even more engrossed when they can operate the very same machine themselves. In 1972, Arthur Melton conducted an experiment to see whether a working-machine exhibit would garner more visitor interest than a nonworking version (and the residual effect of this interest on visitor attention to objects located adjacent to it). The gear-shaper machine, located to the left of the gallery entrance, received virtually no attention when turned off; with the option of having the machine run continuously, intermittently, or have it be visitor activated, Melton discovered the following: "Manual operation was far superior to either method of automatic operation and continuous automatic operation was inferior to the schedule that allowed for rest between exhibits." When visitors could operate the machine, objects to its immediate left were examined 300 percent more often; the second object 166 percent; and the third, 90 percent.[108]

Awareness of the impact of involvement in an exhibit through some kind of hands-on experience is nothing new, as the anonymous contributor to the (London) *Standard* wrote in 1877: "The bare symbols of scientific language require their definitions to be strengthened by

actual *seeing* and *touching* before any permanent trace can be left in the mind."[109] Indeed, the frontispiece (fig. 5.12) from the Leverian Museum guidebook featuring the doorway into the Rotunda shows spectators situated not only on several different visual planes in the image but soliciting the reader to come and enjoy the visual splendors that lay within. Even more significant, however, are the hands of the children in the image, which reach out dramatically into space, either touching objects or signaling tactile pleasure in a way the adults do not.

A rationale for interactivity in museums was not something whispered in the corridors among museum administrators; it was debated in governmental, popular, and scientific venues, accompanied by frequent calls for access to equipment such as microscopes, especially in the fields of applied physics, botany, and physiology where "a separate demonstration room where the models may be handled for the due explanation of the relations of their parts" brought visitors into more intimate contact with educational technologies. The fact that the Board of Education could report in 1913 that "the special method of exhibition adopted for enabling visitors to make careful and often exhaustive examination of the internal structure of objects and of the motion of parts of machines have long formed one of the most attractive aspects of the Collections" is compelling testimony to the institutionalization of an interactive model of learning. While appearing unsophisticated compared to today's high-tech galleries, such interactive machinery in the nineteenth century is evidence of a paradigmatic shift in exhibition practice. Curators, policymakers, and journalists alike have long argued that little in the way of comprehension of a process or technology would be grasped unless objects were taken out of cases and their mechanisms explained, as MP Ayrton made clear in a question to Sir David Brewster in 1864: "Do you think that if a reflecting telescope were put under a glass case any person could have any idea, by looking at it, of any principles of optics?" To which Brewster replied, "not if the instrument were put under a glass case; it would be necessary to see the inside."[110] For the constituencies served by a more user-friendly exhibition policy, the benefits were immediately visible; an anonymous contributor to the *Examiner* in 1877 spoke approvingly of a significant loan of scientific apparatus to the SKM: "A large number of students had the opportunity given them of examining apparatus they had before perhaps only been able to read about. Even those humbler dabblers in scientific lore who consume the large editions of popular text-books, and in general never get beyond the very elementary stages, have here had opportunities offered them they might never otherwise have enjoyed."[111]

The practical constraints of hands-on exhibits, especially a concern that objects or devices might be damaged as a result of leaving their cases, was a constant fear. Dr. Edwin Lankester opined in the *7th Annual Report*: "The difficulty of employing [the microscope] at first arose out of the delicacy of the instrument, as it would be likely to suffer in the hands of careless and uninstructed persons."[112] Of course one shouldn't forget that visitors also interact with exhibits in corporeal and unintended ways, including the damage inflicted upon paintings in the SKM as a result of coughing, sneezing, and touching, as curator Richard Redgrave reported in 1859: "many spots have already been acted on and chemically changed by the acrid

nature of the expectorations from these causes, and slight injuries also from the touch of visitors."[113] A more recent incidence of what we might call aberrant interaction—and with more devastating consequences—occurred during the 2002 *Body Worlds* show at the Atlantis Gallery in London's East End featuring twenty-five real bodies preserved via "plastination." In a fit of rage, a 51-year-old man attacked one of the exhibits with a hammer and claw after seeing a parent walking around with a 5-year-old child. Another man protesting the content of the exhibit threw paint on the floor and covered the exposed belly of a dissected 8-months-pregnant mother with a blanket.[114] Frustration (and anger) at exhibit content is only one small aspect of an ongoing dialectic between more conservative modes of exhibiting versus provocative ones and an example of a curator's worst nightmare in terms of exhibits coming under attack from disgruntled and / or psychotic visitors.

Viewing such interactive exhibits as evidence of a larger dumbing down of traditional culture, critics have lashed out, arguing, as Josie Appleton did in the *Independent* in 2001, that new technologies in museums have "undermined the quality of the museum experience," by giving people a "less substantial, less intelligent experience than they did before the collections themselves were hidden away and replaced with new technologies." Singling out interactivity, so-called "whole experience" multimedia displays that use reenactments or reconstructions, and an increased "hipness" quotient manifested in attempts to be "noisy and exciting about the 'real world,'" Appleton argues this is ultimately all bad news for the world of museums.[115] Voicing skepticism from different

quarters, Andrew Cameron, writing in the *Millennium Film Journal,* is troubled more by semantics than the jazzing up of previously staid galleries, defining interactivity as the "possibility of an audience actively participating in the control of an artwork or representation" in much more radical (utopian) ways—actually affecting its outcome—rather than simply touching screens or retrieving data.[116]

Other scholars have questioned the relevancy of the very term "interactivity," contending that since the act of moving through gallery space and making choices about what to look at is inherently interactive, why do we need a separate discourse of interactivity to justify exhibits that have buttons to push or screens to touch (an anonymous museum professional cited in Marianna Adams and colleagues' 2004 analysis of interactivity in museums noted acerbically that "biologically speaking, if a person is not interacting the person is dead").[117] Few would disagree that the word *interactivity* is confusing, misleading, overblown, and in dire need of dismantling and contextualization. Cameron is similarly skeptical about the purported "spectator freedom and choice" afforded by interactivity, since the options on offer remain those predetermined by the coding and mediation of the simulation, a point echoed by curator Patrick Hughes, who argues that if "interaction implies some form of reciprocity or mutuality between two elements . . . in which the action or behavior of one has en effect on the other . . . [then] turning a light bulb on and off does not create a reciprocal or mutual relationship with it!"[118]

With digital culture now ubiquitous, we might do well to heed museologist Tomislav Šola's warning of the

"technology trap," where technology is pursued for technology's sake. There is also concern that some museums have little more than "brochureware" [119] on their Web site, an "advertisement for the real [museum] site [rather] than the creation of a new presence," and that the initial novelty of using interactives in the gallery has worn off;[120] the last thing people want after spending the work week in front of a computer is to sit in front of one in a museum, so much so that Greek researcher Maria Economou's 1999 claim that "for a portion of the audience, the *process* of using a touchscreen computer was the prime attraction during the initial period of interaction" no longer holds true (the opposite might even prevail, *not* interacting with technology).[121] In fact in front-end tests conducted for the San Diego Natural History Museum, visitors "repeatedly ranked any reference to computers very low or last in their preferences. Some visitors said that they worked on computers all day and did not want to do that on a museum visit; other visitors did not like or did not know how to work computers." [122]

In one of the earliest (1998) book-length investigations of hands-on exhibits and interactivity in the museum, Tim Caulton spoke prophetically; not only was there a danger that "museums seduced by technology could quickly become dated," but, he argued, there was a real possibility that children would "react against a diet of virtual reality," a state of affairs triggering a return to the practice of museum artifacts being shown in glass cases. Caulton suggested this was already happening to some extent with children responding indifferently to special-effects-driven exhibits and showing more interest in traditional displays.[123] With X-Box, Play Stations 2 and 3, Game Cube,

the Wii, iVideo, and iPhones now standard "must-haves" for the preteen and teen-and-up constituencies, museums are under increasing pressure to deliver on "cool." These younger stakeholders may expect museums to offer a different kind of sensorial immersion that they get from video and handheld interactive games.

Given how rapidly technology, delivery platforms, and interfaces are changing, it's not surprising that today's teens might find interactives in the museums outdated and pretty boring (elementary students in the San Diego study also rated computers fairly low and were more interested in seeing "real stuff"). A study by Heath and vom Lehn conducted in 2002 paints the most negative portrait of interactive use in museums to date. Based on a series of video-based studies in the UK and Europe, particularly the British Galleries at the V&A, they concluded that "despite the apparent success and popularity of the interactives, there is no significant evidence to suggest that visitors connect the activities they undertake with the interactives to the original objects that they are designed to illuminate." In Heath and vom Lehn's opinion, "we know nothing of the effect of these new 'interactives' on how people behave, let alone about their effect on how people understand and learn." [124] For the most part, today's curators (or at least some of them) cannot see the wood for the trees when it comes to new technology, what Adams and her colleagues call a "widely accepted assumption in the museum field that visitors, particularly children, want and must have computer interactives . . . usually some variation of a computer kiosk or touch screen." For Adams, this is "an extremely strong belief and one that seems impervious to research findings on the contrary." [125]

Notwithstanding the imprecise nature of the term *interactivity* and the hyperbolic claims made by some zealous proponents of multimedia use in the museum, for heuristic reasons we have hopefully benefited from tracing this concept to the formation of the science museum in the mid- to late nineteenth century. Modernity, and its attendant utopian and dystopian meanings, are powerfully evoked in the *First Report of the Department of Science and Art,* released in 1853, which referred to the role of museums as beacons of light in the dark cloud of industrialization that then engulfed the nation's manufacturing hubs: "[I]n many of our manufacturing towns, where the population is equally deprived of the beauties of nature and the fragments of art left by our forefathers, the casts or outlines from nature and the antique in the school may be the only inanimate things upon which the eye of a child may rest with pleasure in the course of his education, or even his life."[126] The implicit irony in the fact that the mascots of industrialization found in science museums that people are encouraged to visit were artifacts of the same economy that deprived them of beauty and pleasure in the first place is hard to miss. Given the impossibility of deciphering the minds of visitors who witnessed machines in motion eerily similar to those they increasingly spend their working lives around (déjà vu with computers in today's galleries), we can nevertheless speculate that the visual thrill of seeing the technological sublime was very likely mixed with other powerful emotions. As historians study the consumption of popular visual spectacle in the nineteenth century, it behooves us to consider its complex venues beyond traditional public entertainments of the world's fairs and other mass venues, since the encounter with machines installed in museums and that whizzed and hissed at the crank of a handle might have served to provide no less visceral, memorable, and educational encounters than those available at other, more widely studied contexts of popular amusements. With this in mind, let us now take a trip across the Atlantic to examine an institution that was coming of age around the same time as the Science Museum, namely, the Smithsonian, to consider how corresponding debates about immersion and interactivity played out there. However, rather than simply rehearse the same arguments in a different institutional context (and country), my goal here is to examine more closely the baby steps taken by audiovisual techniques, culminating in case study analyses of multimedia use in the "African Voices" exhibit at the National Museum of Natural History and the emergence of IMAX at the National Air and Space Museum.

FROM DAGUERREOTYPE TO IMAX SCREEN
MULTIMEDIA AND IMAX AT THE SMITHSONIAN INSTITUTION

W HEN THE ICONIC IMAX film *To Fly!* opened at the Smithsonian Institution's National Air and Space Museum (NASM) in 1976 to celebrate the nation's bicentennial, it also marked a turning point in the status of audiovisual display technologies in museums. The late 1960s and 1970s saw multimedia exhibits find permanent homes in museums in unprecedented numbers and ways, a massive modernization effort in which aging nineteenth-century halls were renovated with exhibits reflecting current thought in museological design and curatorship. It therefore goes without saying that a majority of museums have incorporated screen-based media into their exhibits in the past thirty or so years; far from being surprised at video and computer screens in the gallery, visitors have come to expect them. But exactly how cinematic, electronic, and digital media crept into the museum is less clear. When did museums first start supplementing the display of historical or scientific artifacts with film, recorded sound, and interactive computer programs? How do these media technologies affect the experiences of museumgoers and what are the stakes involved for institutions engaged in such modernization efforts? Precisely what is new about "new media" use within the space of the museum, and what has motivated curators to introduce media-based models of learning and interacting? What impact have new media had on the status of the museum object, which, in French theorist Didier Maleuvre's words, is already deprived of "experiential content," imprisoned by the museum in a similar way to a corpse lying in an ossuary?[1]

Rather than trace the general history of this movement, this chapter analyzes the conditions of possibility for new media at one of the nation's largest and most prestigious consortia of museums, the Smithsonian Institution (SI), leaving the more general, abstract questions about multimedia adoption to the following chapter. Due to the size of the institution, the task demands a measure of epistemological and methodological agility; our travels in this chapter will be both horizontal, into neighboring institutions at the SI, such as the NASM and the National Museum of Natural History (NMNH), and vertical, to the late nineteenth century when photography first found a foothold at the Smithsonian (then called the United States National Museum [USNM]). In addition to the role of IMAX at the Smithsonian, the chapter examines the refurbished "African Voices" exhibit at the NMNH, where an ambitious vision for the role of interactive technologies and new media was finally realized in 1999. The chapter is organized chronologically, although research materials often span several decades, focusing first on the institutional context of audiovisual technologies (and modern / interactive exhibition methods in general); then upon the postmodernist design rationale of "African Voices" at the NMNH; and finally the emergence of *To Fly!* at the NASM. This chapter therefore brings ideas of spectatorship, immersion, and interactivity into ever more productive tension, building upon our understanding of IMAX from chapter 3 and raising the epistemological stakes in terms of figuring out how museums are sui generis in the realm of immersion, spectacle, and wonder from chapters 4 and 5. And yet as we discovered in the previous chapter, museum visitors, unless they are pro-fessionally involved in curatorship, have no inkling of the fraught discussion, debate, and general hand-wringing that goes on behind the scenes about the suitability and tone of screen-based and highly illusionistic exhibits, the subject of this chapter and the next.

Drawing together distinct (although related) examples from the world's largest museum complex (whose 18 museums, 140 affiliated museums, and 9 research centers are the twenty-first-century equivalent of medieval fiefdoms) demonstrates how screen-based display technologies emerged less in any straightforward or linear manner but were instead the outcome of historically specific and contingent factors and discursive contexts. The spheres of influence at the SI are complicated, and it is challenging for historians to take on such a large and unwieldy organization. Our scrutiny of screen-based media at the SI will be panoramic (as befits the thematics of this book), although less a synchronic "naturalistic" panorama aimed at providing a seamless sweep of the surrounding 360-degree landscape than a diachronic composite view of media use at the SI over a century of the institution's history.

SCREEN-BASED MEDIA AT THE SMITHSONIAN: EARLY DAYS

The story of how the SI came about is as intriguing as its gradual adoption of photography, film, and multimedia into exhibitions. In 1826, James Smithson, a British scientist who had never stepped foot on American soil, named his nephew as sole beneficiary of his estate, with the pro-

viso that should his nephew die without an heir, the entire estate should go "to the United States of America, to found at Washington, under the name of the Smithsonian Institution, an establishment for the increase and diffusion of knowledge among men." If the exact motives of Smithson's bequest are opaque—theories range from its being a snub of the British authorities for refusing to allow the illegitimate Smithson the right to use his father's name, to evidence of his embrace of Enlightenment ideals of education and democracy—what is clear is that the gift of more than $500,000, after much heated debate over how to spend (or even whether to accept) the money, was ratified through an act of Congress that legislated that the SI would be administered by a Board of Regents and led by a Secretary.[2]

We can trace the Smithsonian's embrace of screen-based exhibit techniques to the collection and exhibition of photography at the SI that began in 1859, when the first Secretary of the Smithsonian, Joseph Henry, proposed that a photographic record be compiled of members of Indian delegations visiting Washington. As David E. Haberstich recalls in his comprehensive survey of the history of photography at the SI, photographs taken of delegates by Alexander Gardner and Antonio Zeno Shindler "formed the basis for the first Smithsonian photograph collection, exhibition, and catalog."[3] One of the key figures in the emergence of photography at the SI was Thomas William Smillie, creator of the History of Photography Collection, established within the Division of Graphic Arts in 1896.[4] Heading a one-man unit for a considerable time, Smillie's title was "Chief of Photography," although he referred in correspondence to his position as curator. Hired by the USNM in 1869, he became head of the photographic service in 1871 and remained in that position until his death in 1917, a remarkable tenure for someone who fielded endless queries from manufacturers, suppliers, museum professionals, and the public, as well as publishing articles and patenting a process for photographing on wood.[5] Given that no exhibitions of photographs were organized by Smillie at the SI between 1871 and 1891, his job consisted mostly of taking photographs—he was a photographer of some repute—mentoring aspiring photographers, and, most significantly, building a photography collection. According to Haberstich, Smillie purchased the first specimen relating to the history of photography for $25 in 1888, the daguerreotype apparatus used by telegraph inventor and photography enthusiast Samuel F. B. Morse.

In many respects, Smillie functioned as a clearinghouse of sorts for photography-related requests within the SI. George Brown Goode's appointment as director of the USNM in 1896 coincided with Smillie's being given the go-ahead to spend $300 to acquire the Capital Camera Club of the Capital Bicycle Club's 1896 exhibition (the first recorded purchase of photographs as works of art by *any* museum, according to Beaumont Newhall), a momentous landmark in the history of photography at the SI.[6] There were, however, some advantages in constantly fielding inquiries; in 1909, Smillie learned (via Richard Rathburn, assistant curator in charge of the USNM) of an experiment in "voice photography" that had been conducted in Stockholm and witnessed by aspiring Finnish anthropologist and USNM colleague Aleš Hrdlička, who single-handedly built up the Department of Physical Anthropology at the SI.[7] The voice would be "transmitted

through a somewhat similar device as used in making gramophone records. The sound produces vibrations of a sensitive diaphragm, and these are then converted into light waves, which are photographed."[8] Making direct use of these experiments with sound technology would doubtless have placed Smillie at the forefront of developments in the museum world and in related scientific milieus. But for the most part Smillie remained preoccupied with ensuring that equipment needed for gallery displays, such as the Reflectoscope (a type of overhead projector for front or rear projection), was operating correctly. The SI's main supplier of reflectoscopes was A. T. Thompson & Co., which in the 1910s introduced a Model C version that could be placed 35 feet from the screen. Smillie was so intrigued by this device that he made inquiries as to whether it could be used with a transparent or translucent screen, only to be told that there had been "no demand whatsoever for translucent screens." To solve the problem, Smillie was advised to "use a very fine white cloth screen which could be stretched at the top of a batten and securely fastened thereon." When wet, the screen would become translucent.[9] Why Smillie would want to project material through an opaque screen is not explained in the letter; however, the correspondence between Smillie and A. T. Thompson reveals that around 1910 the SI was clearly interested in projecting images *other* than magic lantern slides in its galleries, a fact of special significance for this investigation.[10] A new model of the Reflectoscope in 1911 had features that make it in many ways a precursor to the overhead projector (and today's Powerpoint): "all opaque material," we are told, "including books and objects, may be placed on a horizontal rise and fall table and projected on the screen in their *true form* and color. All printed matter so projected is not reversed." All this was "accomplished by the use of one internal, optically plane mirror, the operation of which is controlled by a lever."[11] The Reflectoscope is thus evidence of a nascent screen culture at the Smithsonian, a belief in the value of more mediated and immersive modes of representation beyond that of the artifact-behind-glass approach (not that those objects are unmediated but with less obvious effect).

From about 1911 onwards, the SI was engaged in a variety of photography-based, multimedia-type activities, as it continued to amass prints donated to the institution. However, not all offers of photographs were routinely accepted; a gift of daguerreotypes in 1911 was turned down for the simple reason that the museum already had "hundreds" and would "not care to receive any as a loan unless it was something extraordinary." In 1912 the Photography Division was offered several mutoscope machines which had been donated by the U.S. Post Office, though there is no discussion of how, or indeed whether, these machines were ever used in the gallery. Where apparatuses demonstrating the latest developments in mechanical reproduction could not actually be exhibited in the gallery, Smillie obtained photographs, as he explained in 1912 to E. B. Fish, manufacturer of an apparatus for making photographic copies: "Where the apparatus is too large or expensive to place in our series, we make the exhibit by photographs."[12] Inviting Fish to submit a model of his Cameragraph Duplex, Smillie sweetened the deal by reminding Fish of the fact that "it may be of sufficient benefit to your company to have it placed where it will be constantly seen by the public, to compensate you for your

trouble and expense of getting it up." [13] Contrast this with the reaction of curators at the Science Museum in London (from the previous chapter) who balked at the idea of having manufacturers promote their wares for fear that the tenor of the gallery might be degraded as a result of the ostensibly free advertising. Whether this is a case of Yankee free enterprise versus stolid British anticommercialism is difficult to know; one thing is for sure, the stakes about acknowledging the mutual benefits of including commercially available machinery or objects in the gallery were far lower for Smillie at the Smithsonian in Washington, D.C., than they were for his counterparts at the Science Museum in London. Early recognition of the advantages of free advertising in exchange for the donation of goods comes as no surprise for historians of museum display, especially in the context of mechanical or electronic goods. As large industrial and manufacturing companies warmed to the idea of advertising and began to establish marketing and public relations departments following the advice of Edward Bernays, the so-called "father" of PR, companies were increasingly responsive to Smillie's overtures. [14]

Given the challenge of charting the progress of photography or audiovisual aids in general within an organization as complex as the Smithsonian, this brief overview of the emergence of the photography collection and exhibit offers a brief glimpse of institutional attitudes toward mechanical media and the pressures curators such as Smillie faced in their attempts to introduce and legitimize photography to the museum world. To broaden the context of how film, video, and interactive media eventually gained a foothold at the Smithsonian, it is helpful to construct a partial history of debates anticipating these technological developments—in other words, discussions that specifically addressed the need to modernize exhibits and the role new media might play in this endeavor. If the sense of being immersed in the exhibit was nowhere near as dramatic as the cathedral or panorama, multimedia display techniques and hands-on exhibits nevertheless created opportunities for engagement that went above and beyond what audiences had experienced in the past and paved the way for both IMAX at the NASM and the "African Voices" exhibit at the NMNH (formerly the "Hall of African Cultures"). But it was in the realm of children's education that we see traces of an early interest in interactivity as a legitimate and necessary way of stimulating the young brain and introducing children to artifacts and ideas from the natural and scientific world.

"WE ARE NOT VERY MUCH INTERESTED IN LATIN NAMES": LAYING THE GROUND FOR INTERACTIVE MEDIA AT THE SMITHSONIAN INSTITUTION

An exhibition is a means of communication, and, if we have nothing to say, neither will the exhibit.

—Katherine Beneker (1958) [15]

The Children's Room, a space dedicated to young learners with an explicitly interactive mandate, opened at the Smithsonian on September 24, 1901. The project was the brainchild of Smithsonian Secretary Samuel Pierpoint Langley, who in an effort to heighten the appeal of exhibits had begun experimenting with new display techniques

as early as 1889, when he suggested "the acquisition of live birds to use as a popular attraction."[16] Inspired by the Brooklyn Children's Museum, the world's first museum designed specifically for children, which opened in The Adams House in Bedford Park in Brooklyn on December 16, 1899, Langley was exasperated by the fact that "children in search of knowledge had to roam all over the building." Langley's belief that specimens should not be presented as "scientific oddities to be studied under the microscope and then mounted to stand mute and dead under the public eye" led him to make a number of recommendations about such aspects of design as the height of the display cases (they were too high for children, in his opinion, and new white maple cases were built at a cost of $917.52), the ceiling (Langley wanted a fresco), and the inclusion of live specimens. With a "full panorama of nature before them, all at the level of their noses," children would not be treated as incidental learners or members of a marginalized constituency, but rather addressed on their own terms and in an idiom that was far more accessible to them than the bulk of the exhibitions at the Smithsonian.[17] Conceiving of the display as a "full panorama of nature" is not only an explicit nod to the idea of the nineteenth century's structuring of vision into a sweeping view that we are all too familiar with by now, but speaks to Langley's wish to immerse children in a comprehensive representation of nature, which, at the level of their noses, would feel intimate and possibly quite visceral. By using the word "panorama," which in its moving form in 1901 might still have been a viable mode of entertainment in some regions of the United States, Langley is able to get his vision for the room across to designers and educators.

In an 1898 letter to Rathbun, Langley set forth his philosophy: "We are not very much interested in Latin names and do not want to have our entertainment spoiled by its being made a lesson."[18] According to museum historian Mary McCutcheon, Langley was deeply influenced by the German philosopher, psychologist, and founder of scientific pedagogy Johann Friedrich Herbart (1776–1841), an advocate of experiential learning, although McCutcheon contends that Langley's enthusiasm was also fueled by competition from the Brooklyn Children's Museum.[19] According to Rebecca Curzon, Langley's Children's Room represented such a break from traditional museum exhibits that reproductions of it traveled to significant national events such as the 1905 Louisiana Purchase Exposition in St. Louis, Missouri. Here was a room full of noise, color, and opportunities for interaction, a space replete with odd juxtapositions such as kaleidoscopes containing live fish, which swam against a background of geometric shapes.[20]

While it was rare in the nineteenth century for museums to allow visitors to handle artifacts for fear of breakage or wear and tear, objects were occasionally removed from their cases. For example, cabinets with removable drawers facilitating the handling of selected objects were in use by 1910, and by the early 1930s exhibits had incorporated electrical features such as a 1933 "Electrical Questionnaire for Young Visitors," which consisted of a "box with a number of compartments, in each of which is an exhibit which is not labeled. Against these are lists of possible names, one of which the child can select by pressing a pointer against a disk. An electrical contact is made, and a white light appears for a correct answer and a red light for a wrong one."[21] Where "hands-on" referred

quite literally to handling, manipulating, or exploring a process or mechanism, interactivity has historically been conceived more as a gateway experience, inviting visitors to seek out more information or to test theories through a computer-based framework, what museum commentator Christopher John Nash defines as allowing the user to "reach out in time and space to access and manipulate resources not currently in their immediate environment . . . to contextualize objects more richly, to provoke thought and debate about issues of importance to their communities, and to reach out to more diverse audiences and client groups."[22]

As cutting edge as the Children's Room was in the field of museum education at the turn of the last century, the extent to which its hands-on philosophy and progressive pedagogy could be directly felt in other parts of the SI is difficult to assess, at least in the period between 1910 and 1950. The NMNH's Discovery Room, a direct descendent of the Children's Room, opened in 1974 and was an instant hit with children, so much so that as a result of public demand, a system of timed admissions had to be implemented. A short article on the room's success in the NMNH's *Annual Report* from 1974 underscored what made this room unique: here was a space where children and adults were "urged to keep their hands *on* and not off the exhibits. Elephant tusks, coral and petrified wood, mammoth teeth, and hundreds of other natural history specimens, ordinarily out of reach behind glass or railings in museums, could be grasped, turned over in the hand at one's leisure, and studied with a magnifying glass."[23] A second specialized exhibit for children called the "Naturalist Center" opened in 1975, and while it was meant to

be a four-month-only research exhibit that "documented and evaluated visitor curiosity about touching museum specimens," the project was so successful it became a permanent feature. Two types of materials became the norm in Discovery Rooms: "discovery boxes" and "stumpers," unusual natural history objects located around the room designed to stump the imagination and encourage the curious to ask questions.[24]

If the Discovery Room epitomized the idea of interactivity in a museum, it was by no means unique (or the first) to do so; moreover, while Discovery Rooms break down traditional boundaries between visitor and artifact, they don't necessarily challenge the discursive underpinnings of why these objects are even in a museum and what it might mean to view them out of context. Discovery Rooms, for the most part, simply remove the glass without necessarily challenging intellectual precepts governing the politics of collecting and displaying; by transforming these objects into "treasures" (examples of typical objects include cannonball concretions, a whale's jawbone, a piece of ebony, and Stone Age implements), they may even end up perpetuating antediluvian modes of exhibiting, such as the taxonomic method pioneered by British scientist A. H. F. L. Pitt Rivers, which can still be seen in the Pitt Rivers Museum in Oxford.[25] Some Discovery Rooms eschew (or modify) the "trays and trinkets" approach by contextualizing objects or offering a broader intellectual rationale for why they might be included in the Discovery Room. However, granting the success of Discovery Rooms in making a range of objects more accessible to children and providing young museumgoers with a pleasurable visit, it would be naive to assume that

just because these spaces cater to younger visitors, they are ideology-free. They still carry the same discursive baggage (power relations) whether exhibited in a formal gallery or made available for children to handle in a Discovery Room; ripped from context and assuming a metonymic relation to the culture as a whole, these objects become trophies or novelty items, like the souvenirs tourists purchase on trips to the Southwest or reservation casinos. And yet with all this said and done, Discovery Rooms are enormously popular with children and a wonderful way of experiencing objects at their level and without the fear of reproach from a guard.

Coincident with the development of the Discovery Room at the NMNH were plans to modernize existing halls, efforts that brought the ideas of interactivity and immersion espoused by Langley to entirely new levels of museum design. In February 1975, the Museum Exhibits Committee completed a long-range plan for the reconstruction of virtually all of the museum's halls over the next twenty years, aiming for at least one or two major openings every year.[26] However, six years before this plan in 1969, the idea of using the display environment to create "another world" (the phrase used by the curators) had already found expression in the renovation of Hall 10 at the NMNH (a hall that coincided with the opening of a very similar exhibit entitled "Can Man Survive?" at the American Museum of Natural History [AMNH] in 1969, an exhibit I examine in greater depth in the following chapter), and also presages the Hall of Biodiversity at the AMNH, with its own Dzanga-Sangha Rainforest, which opened in 1997. Hall 10 is a wonderful litmus test of what could be accomplished in immersive and interactive de-

sign in the late 1960s; it also speaks to the zeitgeist in terms of the impact of television, pop culture, and growing ecological awareness. And yet analyzing these three ecological displays today, we can't help but notice the irony in the fact that if we had heeded some of the recommendations made by these thirty-some-year-old exhibits, we might not be dealing with the level of environmental crisis we currently face; these displays are also a prescient reminder of the longevity of this movement. In addition to Hall 10, the following section also briefly examines the "Insect Zoo" at the NMNH, another pioneering exhibit with regards to interactivity; these last two examples lead us into the first of the two substantial case studies of the chapter—"African Voices."

HALL 10 AND THE "INSECT ZOO": NEW APPROACHES IN EXHIBIT DESIGN

Why can't we get rid of the warehouse atmosphere, enlivened, if that is the word, by the type of grouchy attendant who seems older and wearier than the mollusks, mummies, fossils and stuffed dodos among which he sits?

—Robert Moses (1949)[27]

Renovated in the late 1960s, Hall 10 at the NMNH was designed to maximize the sensation of being immersed in the exhibit about the rain forest, so much so that as "he [sic] enters the tunnel he leaves the overwhelmingly confusing world of reality and enters a world of simple specific basic concepts of life—strongly presented by the use of various exhibit (communication) techniques."[28] This

embrace of immersion as a didactic tool to convey some of the exhibit's major themes is fascinating, since it gives us a relatively early rationale for what has become a fairly standard technique in museums (and as we'll see in the following chapter, a technique that the AMNH was trying out at the exact same time with its eco-awareness temporary exhibit "Can Man Survive?"). As one of nature's most complex environments, the rain forest provided the ideal opportunity to stress the interrelatedness of various ecosystems and was part of a larger ecological exhibit called "It All Depends." Curators based their designs (eventually constructed with papier-mâché and plastic) on sketches and photographs taken in the Panama Canal and in the South American jungle; the exhibit's trees and vines were enclosed in a mirrored ceiling-high silo. Walking into this dimly lit enclosure, visitors had the illusion that they were "in the center of a vast tropical rain forest with trees rising 80–100ft above their heads."[29]

The modernization of Hall 10 was initially conceived as a major renovation of the existing space, including the demolition of temporary wall structures and the erection of new steel frames. Scaled back as a result of budgetary constraints, the exhibit nevertheless represented a "new approach in exhibition planning and writing" and was designated a priority program in the updating of core exhibits at the NMNH. The renovation of Hall 10 provides a fascinating window onto the reception of new principles of exhibit design that privileged an immersive and interactive approach to learning; while previous exhibits at the NMNH may have had interactive features, they lacked the same kind of coherent intellectual justification that we see in Hall 10. For example, in 1969, James A. Mahoney,

Director of Exhibits at the NMNH, called the exhibit "interdisciplinary, relating the specialized disciplines of the study of nature as well as impressing upon the visitor the interrelatedness of all living things."[30] But the administration's ambitions for Hall 10 went beyond that of simply embracing interactivity, as NMNH director R. S. Cowan made clear to Secretary of the Smithsonian S. Dillon Ripley in a memorandum: "We feel this is a unique opportunity to offer visitors an introduction to the Museum as a whole, to tie together the approaches of the various halls, and to correct the absence of an ecological approach by our older halls. In summary, what we have in mind is a strong interdisciplinary exhibition in contrast to the discipline-oriented halls of the past."[31]

The Hall was called "It All Depends" and subtitled, "An Exhibition Inviting You to Explore the Roles You Play in the Natural World." It was organized into five zones: Zone 1, "Man Depends on the Natural World"; Zone 2, "Nature Depends on Checks and Balances"; Zone 3, "Life Depends on Adaptation"; Zone 4, "Survival Depends on Man's Use of the Earth"; and Zone 5, which contained various "Eco-quotes" relating to the environment, including one by Ralph Waldo Emerson ("We are taught by great actions that the universe is not the property of every individual in it"). The second-person solicitation in the subtitle of the exhibit made explicit its mode of address and political agenda, and cutting-edge audiovisual media were enlisted as vital tools in the dissemination of the exhibit's main ideas. Visitors entering the exhibit were greeted by a tape-slide presentation in which twelve images appeared on a screen accompanied by narration that lasted approximately four and a half minutes. Zones 2, 3, and 4 all used

audiovisual media; for example, in zone 2, motion picture films located in each of the viewing areas (with their own audio and musical score) played for four minutes, while in zone 3, the rain forest, a narrator's voice could be heard along with forest sounds. In the section entitled "Natural Selection," "the visitor stands by a learning rail and is encouraged to close his or her eyes (by signs as well as cues on the audio tape) to 'visualize' the message." The label next to the rail reminds the visitor that "the pictures that make up this exhibit are inside your head. To see them, and to have them explained, please step inside and close your eyes." [32] Zone 4 used a three-screen motion picture presentation to convey the exhibit's key ideas and slide projectors to deliver information about the various "cause" groups waging war against polluters.

Fans of audiovisual display technologies in museums would doubtless have found "It All Depends" dynamic and ambitious in its integration of film and tape-slide presentations, and eerily similar in its themes and display techniques to the temporary AMNH exhibit "Can Man Survive?" There was even a nod to Thomas Smillie in the inclusion of a series of backlit photographic transparencies "showing man [sic] in all stages of cultural development from [so-called] primitive man to visiting the moon" in the zone 3 section called "Culture Tunnel." "It All Depends" can also be seen as part of a new wave in museum exhibits from the late 1960s and 1970s that addressed eco-political and environmental issues. But while "It All Depends" paved the way for a generation of high-tech exhibits with regard to integrating audiovisual media into its architectonics, it looked to a very old representational medium—the panorama—to create the illusion of immersion in another space and time. At the same time, the exhibit's reliance on sound effects to convey its key themes is in sharp contrast to the ocularcentrism of the circular panorama, which, as we saw in chapters 2 and 3, immersed the spectator in the surrounding view without audio accompaniment.

Screens dominated the visual field of each of these zones, conveying the exhibit's major themes as a text of accretion in which the relatively slow pace of the introductory tape-slide installation gives way to two motion picture films playing on single units and culminates with the three-screen film presentation in Zone 4, the exhibit's conclusion and high point. The logics of visibility enshrined in "It All Depends" resonate with the era of the late 1960s and early 1970s, when pop-music light shows, advances in theatrical lighting design, and disco were all informing contexts. That so many of the exhibit's discursive goals were conveyed via screen technologies says a great deal about the SI's belief in the vital role of audiovisual technologies in delivering the exhibit's major themes.

Anne Friedberg's analysis of the screen as a signifier in the work of Paul Virilio, especially Virilio's discussion in *The Lost Dimension* (1984) of the transfers that occur when the two-dimensional screen occupies a three-dimensional space is prescient here; as Friedberg argues, quoting Virilio, "'the transfer from the materiality of architectural space to the immateriality of the screen image pivots on a 'sudden confusion between the reception of images from a film projector and the perception of architectonic form.'" As a result, architecture ends up "dissolving, mutating into the hyphenate 'wall-screen.'" [33] While "It All Depends" is clearly a modest version of the kind of

hyphenization Virilio discussed in 1984, it nevertheless points to the screen as an increasingly ubiquitous interface in the museum world of the 1970s and to recognition on the part of curators that audiovisual technologies integrated into theatricalized exhibits promised a more immersive and memorable experience for museum visitors. In many respects "It All Depends" was a pioneering site, promising a new era in museum exhibition design when, in the words of NMNH director Peter Farb, "each hall will be an interdisciplinary approach to a central concept, when each hall will draw for examples not upon only one phylum or class, but upon the whole living world from microscopic plants to man."[34] While Farb drew no direct connection between the role of multimedia in Hall 10 and its interdisciplinary focus, one cannot help but impute a small measure of influence, since this new era of hall renovation would have been an opportune moment to think about the overall role of audiovisual technology in conveying exhibit goals in the museum.

Despite a flurry of renovation in the 1970s, it is interesting to see that as late as 1985 a report from the Department of Exhibits and Education at the NMNH complained of the sorry state of "dated and scientifically obsolete exhibits," an "often confusing total organization (both physical and conceptual)," and an "exhibits program that is not as exciting or stimulating as it might be, given the collections and expertise that are available to us." The problem, according to the report, stemmed from the fact that the museum was "structured according to a scheme that was devised more than 75 years ago."[35] Theme-based permanent exhibition halls had clearly become outmoded; but even in those instances where themes were appropriate

in reflecting the basis of certain collections, the museum still faced serious challenges, as Laura Greenberg argued in a 1986 NMNH report: "[T]his Museum is ultimately about life and life processes, but the Museum exhibits medium is most effective showing dead or inert materials."[36] The answer for Greenberg was to "include films (possibly an IMAX format) to show life," something the exhibit planners had clearly thought about during this new era of reenvisioning 50-year-old halls. Film could therefore be enlisted to enliven exhibits and possibly lure visitors away from their television sets and VCR's; as the NMNH Steering Committee explained to Dr. Robert S. Hoffman, director of the NMNH, in 1987: "To attract visitors from other cultural events and to compete with television and videocassettes, natural history exhibits may need to offer more than stark glass cases housing specimens adorned by labels bearing Latin names."[37]

While there is nothing new or surprising about popular culture's status as something of a doppelgänger for the museum, this debate was repeatedly rehearsed in the discussions around Hall 10. Ironically, what troubled museum specialists the most was what one curator coined the "star attraction" policy of exhibiting; in a document entitled "Responsibility," an anonymous curator got straight to the point: "Is this what the United States National Museum is supposed to do? Collect the biggest diamond, the biggest elephant, and the largest whale? We say this is *not* the function of the USNM, and their inclusion as 'main attractions' in the museum is misleading and unfortunate."[38] Arguing the case that these so-called "Believe It or Not" exhibits had "no place in a legitimate educational museum"—the proper place for the Hope Diamond, it

was felt, was an art museum—one curator proposed moving these "trophies" into a special room, where the public could be charged an appropriate fee to see them. No longer "cluttering up our legitimate exhibits . . . both the showman and the purist would be happy." [39] If the term "showman" smacks of Barnumesque humbuggery and seems an unlikely adjective to describe the NMNH, consider the following mission statement from a 1978 strategic-vision document: "We believe that people visit natural history museums to see objects, real objects—those selected for their intrinsic beauty or 'curiosity,' as well as those chosen for the didactic message they can convey." [40] Fully cognizant of the popular appeal of unique artifacts, the USNM saw no reason to abandon its policy.

The overwhelming appeal of the authentic, original, or the real was successfully, if somewhat sensationally, recognized in the hugely successful "Insect Zoo," which first opened as a temporary exhibit in the summer of 1971 (as a result of its enormous success, it became a permanent exhibit in 1976). [41] The six "cheery, well lighted" areas of the exhibit which were designed to "dispel the usual association of insects with dark, dank places" encouraged visitors to interact with the world of insects and arachnids by touching or holding them live, by observing them feeding, and by talking with trained volunteers. [42] Although initially funded by Dr. and Mrs. Ronald Groor, when the Insect Zoo became a permanent feature, the NMNH successfully solicited contributions of over $100,000 from chemical companies, before taking on the new name of its benefactor O. Orkin. [43] While the bugs were undoubtedly the "stars" of this exhibit, it also relied heavily on audiovisual media to illustrate particular insect activities as well as provide sound effects. Despite its popular appeal, the Insect Zoo was not immune from criticism, including its lack of a specific-purpose statement when visitors first entered the space; incomprehensible labels; amplified, unrealistic, and annoying bug sound effects; and, somewhat intriguingly, incoherent films that used too many close-ups of insects, were too dark given the brightness of the room, and whose content and purpose were hard to decipher in the absence of narration. Letters to the museum pointed to other shortcomings of the films, including the inclusion of "colored blobs [that] bounce around before our eyes" and an intense glare on the glass of the screen, which reduced the action to a blur. [44] One letter writer even questioned the relevance of an insectarium in a museum of natural history, arguing that a more appropriate venue would be a zoo. In short, Insect Zoo, an exhibit designed to use audiovisual technology to enhance the experience of visitors, seemed to achieve very mixed results.

More significant than the suitability of the Insect Zoo for a natural history museum is the issue of how it employed audio and visual aids to expand and deepen the visitor's experience. In light of the fact that the live critters were what drew visitors—especially children—to the exhibit in the first place, we're left with the question of how mediated, two-dimensional representational media enhance or detract from an exhibit's main themes; how they are understood by museum visitors; and why curators opted to integrate such tools into a zoological exhibit that would ordinarily occlude audiovisual aids.

Finding the proper balance between traditional and cutting-edge exhibitionary techniques has been a perennial challenge for curators and was a major concern among

designers of "African Voices," an exhibit that opened at the NMNH in December 1999 and is the subject of the next section. While "African Voices" was in development, the NMNH was taking strides to develop "group-oriented interactive-media programs" for its Discovery Room visitors, in part because of the large number of visitors each year (about 9.5 million annually) who couldn't all be accommodated in the Discovery Room. Entitled "Vital Space," the interactive exhibit (located in an auditorium) tells the story of an astronaut who is contaminated by a sample of Mars dust; with fifty touch-screen consoles that can each accommodate two users, audience members influence the narrative by selecting icons such as whether to search for the contaminant either in the brain or the spine. As many as one hundred visitors "collaborate and compete with one another in order to influence the plot of a computerized, fictional drama projected on a high-definition [three-panel, 150-degree wraparound] screen."[45] There is a competitive, video-arcade dimension to the exhibit, with the highest-scoring participant—whoever has prevailed in the fight against the larvae and eggs using electrical, laser, and chemical weapons—winning a prize. Produced without cost to the museum by Immersion Studios in exchange for a share of ticket-sales revenues, the 16-minute video and interactive exhibit was the first in a series of collaborative projects with Immersion; according to CEO Stacey Spiegel, "by creating an experiential environment around real learning and real science, learning must be taking place."[46]

My goal in the next section is to think through some of the enduring features of multimedia use in the museum, to consider how the idea of "immersion," for example, a staple of IMAX promotion and a long-standing trope of illusionistic exhibits such as dioramas and period rooms, continues to define museumgoing. I will also discuss how the concept of branding is relevant to contemporary museum thinking in a multitude of ways (not just in the form of corporate underwriting), but with regard to the trafficking of marketing ideas across retail and museums. Jumping ahead some twenty years, we shall now take a closer look at the "African Voices" exhibit at the NMNH, which throws into sharp relief many of the issues facing exhibitors both in the 1970s and today. If the "African Voices" exhibition hall invited visitor interaction quite different from the frenzied (according to some accounts) "hitting, poking, and slapping" at touch screens that "Vital Space" provoked, it nevertheless underscores a shared belief in the value of "experiential learning" and interactivity as central tenets of modern museological design.

"AFRICAN VOICES": AN EXPLORATORIUM
OF SOUND AND IMAGE

With a price tag of $5.5 million, "African Voices" consists of a 6,500-foot rectangle divided by a colonnade that effectively splits the space in half lengthways.[47] Replacing the "Hall of African Cultures," which had closed in 1992 following accusations of anachronistic display techniques and primitivist representations of African peoples,[48] "African Voices" uses video, sound elements, and interactive displays—including the "Money Talks" installation (fig. 6.1), where visitors turn a wheel to select examples of

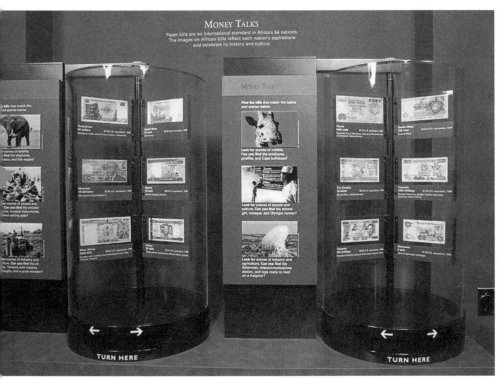

MONEY TALKS
Paper bills are an international standard in Africa's 54 nations.
The images on African bills reflect each nation's aspirations
and celebrate its history and culture.

Fig 6.1 "Money Talks" interactive exhibit with "Turn here" instructions on the base of the wheel. "African Voices" (NMNH). (Courtesy Department of Anthropology, Smithsonian Institution; photo by Donald Herbert)

African currencies—to disseminate the exhibit's intellectual themes and "stories." In addition to computer interactives found on the gallery floor, there is also a Learning Center at one of the exits with eight computers running Microsoft's Encarta Africa CD-ROM, and a viewing gallery where two short documentaries play continuously on a large video screen.[49] In order to create a "more personal and immediate story of contemporary and historical Africa," curators strove to convey a strong sense of the polyphony and dynamism of the continent, using African voices as wall text or in recorded excerpts drawn from literature, songs, poems, proverbs, scholarly essays, and interviews.[50] Greeting you upon entering "African Voices" is a loud, bass-heavy world music–type riff emanating from a 10-foot-tall video-wall situated at both entry points to the exhibit (fig. 6.2). The music is cool and contemporary, blending traditional African sounds with hip-hop beats; the soundscape, which includes a female narrator talking about African life, is arresting, drawing our eyes to the wall of twelve video screens which represent Africa as modern, inviting, knowing, and a space of plural modernities and cultural diversity.

On the face of it, this is an Africa far removed from images of poverty, starvation, civil war, genocide, and political unrest that have filled our television screens for decades. This high-tech symbol of Western commercial culture, along with the ubiquitous reminders of screen-based media in the large number of video installations and computer interactives in the exhibit, clearly enlists technology in the service of resignifying Africa and overcompensating for the allochronic and racist "baggage" it assumes the average audience member carries. As employed in "African Voices," the multimedia approach is doing a lot more than

simply delivering content; it functions as a mnemonic, a reminder to visitors that this is an Africa looking to the twenty-first century rather than a timeless representation from a mid-nineteenth-century colonial past. It creates a context that stakeholder audiences—especially diasporic Africans or African-American visitors—as well as other constituencies will recognize as empowering and contemporary, the kind of Africa that might be invoked in a documentary on global music on VH1 or the Discovery channel. The economic hardship and political realities fracturing the African continent are not immediately addressed; they are instead dealt with in the "Africa Today" section of the exhibit. And yet one can't overlook the irony in the fact that our first impression of Africa in this exhibit comes prepackaged in the video-wall architecture of mass-media "shoppertainment," an iconic form associated with single-brand superstores such as Niketown, the consumerist excesses of Western industrialized capitalism, and the exploitative labor practices of the retailing multinationals that doubtless have manufacturing plants in the struggling economies represented on the screens.

Fig 6.2 Video-wall in the Orientation Section, "African Voices" (NMNH). (Courtesy Department of Anthropology, Smithsonian Institution, Washington, D.C.; photo by James F. DiLoreto)

We therefore view Africa through the cultural lens of corporate branding, since Africa *is* quite literally branded for us at this moment. As a tactical buzzword, branding has assumed preeminence in contemporary advertising; once aimed at the customer, it has come to imbue the very heart of the corporation, turning products into iconic, fetishized objects that function as a form of cultural (global) shorthand. To possess a brand is, therefore, to belong, as British brand analyst Wally Olins explains: "Displaying the brand . . . turns you into a perambulating advertisement . . . [which] in turn relates to membership of a niche group, a club with a wide variety of nuances re-

lating to social, cultural, and economic status."[51] By helping products break through the commercial clutter of a noisy marketplace, and offering consumers consistency, empathy, and neo-tribalist affiliations, the brand has become the lingua franca of both the marketplace and the museum.

The relevance of branding for museums is not a new concern, however, and it extends beyond just borrowing the topos of commercial retail. In 1999, Smithsonian Business Ventures was formed to foster commercial initiatives that exploit the enormous brand equity of the Smithsonian; in 2000, Fathom Knowledge Network Inc., which partners American and British museums with commercial companies, was formed to provide a "premier destination on the Internet for individuals to access, understand, and purchase the best in modern art, design, and culture."[52] These marriages have been anything but stable, however; Fathom has gone out of business, and documentary film producers working with the Smithsonian now find that the institution has an exclusive deal with the Discovery Channel.

While several major museums began to include gift shops at the start of the twentieth century, in recent decades these museums have realized that their outlets have become destination shops, almost as big an attraction as the exhibits. In the UK, many visitors attend the Tate Modern just to use the shops; the redesigned store at the National Gallery hired the same company that refurbished the famous high-end retailer Liberty and began a new product line, and the Science Museum also has an outlet in Selfridges selling a range of popular toys and gadgets. In New York City, the Metropolitan Museum of Art has opened several satellite stores in the area and in major regional airports. Museums also exploit their cultural assets by launching product lines, such as the V&A's brand of fabrics and wall coverings.[53] In addition to commercial franchising of museums' identities and patrimony, blockbuster exhibits underwritten by corporate sponsors (such as the 2003 "Chocolate" exhibit at the AMNH sponsored by Godiva, and the Giorgio Armani and motorcycle shows at the Guggenheim) came under attack for their perceived commercialization and capitulation to popular culture and corporate dollars. Maxwell L. Anderson, director of the Whitney, called these shows "a compromising sponsorship to clean up the bottom line," while Philippe de Montebello of the Met complained that "it's a betrayal of public trust." The Armani show was sponsored by Time Warner's magazine *In Style* and reportedly accompanied by a $5 million gift from Armani to the museum.[54]

Manuela Hoerlterhoff predicted this "new era" of corporate presence in museums back in 1978 when she argued that "decorators and public-relations specialists are beginning to loom alarmingly over curators and scholars. No doubt the point will be easily reached where museums, in search of financial subsidies, will be less interested in providing sober, illuminating fare than in catering entertaining shows that will draw the most impressive numbers through the gates."[55] Interactive media offers opportunities for sponsors to increase their presence in the gallery, since, as Christopher John Nash points out, "sponsors are willing to pay considerably more to put their name and logo on the attract screen of an interactive or to have it appear as part of the credits in a broadcast/narrowcast version." Media material can also exist independently of

the museum, perhaps through distribution on the educational circuit or in different venues, which over time reach even more people than initially visited the exhibition.[56]

How this branding of Africa as hip, modern, and globally savvy jives with audiences and what the future holds in terms of corporate sponsors for "African Voices" is somewhat unclear; what we do know, however, is that this is a recuperative gesture on the part of the NMNH, an undoing of the colonialist legacy of Western stereotyping. Branding Africa in this way is not only an act of reclamation but also a way of connecting with younger museumgoers whose views of the continent may be especially shaped by televised images of political unrest, genocide, and starvation. But just as point-of-purchase video installations offer the "promise of symbolic movement across identity categories, of inhabiting different *social positions,* as well as spaces," to quote Anna McCarthy,[57] so too does this video-wall, the key difference being that the spatiotemporal shape-shifting invited by the "African Voices" installation has an overtly humanist and pedagogic dimension far removed from the starkly consumerist underpinnings of the equivalent installation found in Niketown.

The video-wall therefore succeeds in undergirding the central theme(s) of "African Voices"—Africa's diversity, dynamism, long history, contemporary relevance, and global reach.[58] In the words of the curators: "The kaleidoscope of images of people, objects, and places set against a background of contemporary African music and voiced narration alerts the visitors that they have entered a new and exciting section devoted to present-day Africa." [59] Sharing "authoritative tasks" (McCarthy's phrase) both

similar and distinct from television in public spaces, the natural history museum may be seen as a discrete institutional location for an ambient TV experience, a location that is itself invested in constructing an immersive, educational environment. As we saw in the case of Hall 10, curators often find themselves in something of a double bind, always looking over one shoulder at the uses of audiovisual technologies in point-of-purchase video, theme parks, and Discovery centers, knowing that what works in these commercial spaces might be adapted for use in the not-for-profit space of the museum.[60]

As an orientation device, the video-wall is increasingly a standard feature of contemporary science and natural history exhibits, supplanting the extended wall text or "celebrity artifact" as the traditional contextualizing device upon entry into the museum or gallery. The National Museum of Australia (NMA) in Canberra, for example, includes a 40-seat orientation center where four plasma screens crawl on hydraulic lifts across a rear-projected backdrop depicting Australia's landscape and the impact of humans on the environment. According to Peter Hall at the *New York Times,* when the show is over "the entire theater rotates 90 degrees to face a new presentation on the theme of nation, while a fresh batch of visitors watches the *Land* performance." [61] In the same way that the gramophone in the AMNH tuberculosis exhibit in 1909 (discussed in the following chapter) was used to address the problem of visitor circulation through the gallery spaces, so too do the revolving theaters ensure the smooth flow of visitors in manageable batches of forty or fewer. When asked about maintaining the right balance between the theme park–styled multimedia and traditional object-

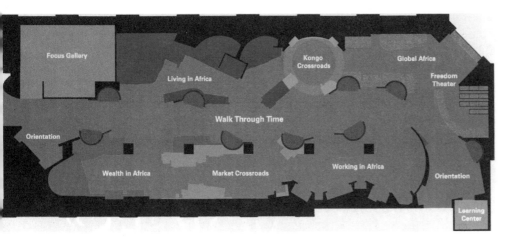

Fig 6.3 Color-coded floor plan of the "African Voices" exhibit (NMNH). The two Orientation zones can be seen on either end of the horizontal hall. (Department of Anthropology, Smithsonian Institution; photo by Donald Herbert)

Putting the architectonics of the exhibition space to work in the service of a more discursively complex articulation of ideas that eschew a linear historiography sounds a great deal like the curator's vision for "African Voices." Embodying revisionist models of history that challenge audience assumptions about grand narratives is a bold one, but also one that demands recognition of the possibility that not all visitors will come away from the exhibit having grasped the "big ideas." For example, "African Voices" uses a color-coded, hierarchically organized "informational architecture"[63] (fig. 6.3) consisting of "Gallery texts," "Main texts," and "Subtexts," that impart information ranging from the general to the specific (highlighting main gallery themes and overarching messages at one end and additional information about a topic at the other). While the hierarchy served as a logical structuring and suturing device during the planning stage, its legibility for audiences is uncertain, with anecdotal evidence suggesting that most visitors are oblivious of the hierarchized organization of texts, not even noticing the color-coding of labels that distinguishes the different thematic galleries.[64] Indeed, based on research conducted with museum visitors, the exhibit planners found it necessary to simplify many themes, knowing that some of their work would have to be corrective, including the impression that Africa is a country rather than a continent.[65] Of course, we need to be careful here not to substitute U.S. museumgoers for *all* museum patrons; the confluence of factors that make

driven exhibits at the NMA, Museum Director Dawn Casey, an Australian Aborigine, defends her approach, arguing that the blend of "scholarship and entertainment . . . contemplation and involvement" is just right and that "everything—from the multi-narrative exhibitions to the building—intends to convey that there are several, sometimes conflicting stories of the country's history."[62] The extent to which Casey's claim is actually grasped by NMA visitors who come to the museum with their own preconceived "grand narratives" about Australia's colonial past is questionable; some visitors, especially Australian Aborigines, may view her remarks as self-serving curatorial rhetoric while others may be oblivious to the dialogism inscribed in the exhibit's themes and architecture.

your average NMNH patron not appreciate the fact that Africa is a continent not a country (isolationism in particular) is unique to the United States and not necessarily a worldwide phenomenon. Curators also found themselves defending the cacophonous audiovisual media in the exhibit, arguing that "it uses audio and video components selectively to enliven the space and emphasize the main message of diversity, dynamism, modernity, and global connections. . . . The decision to fill 'African Voices' with energizing sounds and moving images was a calculated one, meant to offer an approach to African history and culture that is anything but mute and passive." [66]

On a quieter note, the Somali *aqal* exhibit (fig. 6.4), located diagonally across from the video-wall, furthers a similar message about modern African life, combining video and a partially reconstructed Somali *aqal* (a circular house displayed with the outer covering peeled back to reveal the interior) to underscore the "traditional vs. modern" dialectic. In contrast to "environmental" videos (those that play continuously in conventional rectangular black boxes in exhibition halls) (fig. 6.5), this six-foot vertical screen with green LED supertitles located directly above the image—reminiscent of the supertitle translations found above the proscenium arch in American opera houses—at first reminds us of a hologram, but its 2-D flatness quickly registers as we realize we are looking at the equivalent of a virtual docent, or rather two virtual docents, Somalian-Americans Abirahman Dahir and Faduma Mohammed (seen on far right of fig. 6.4). Growing up nomadic in Somalia, the pair ended up working in the United States as part of the extended team of exhibit planners, along with the production crew and filmmakers from Northern Light Productions, the company responsible for the audiovisual component of the exhibit.

The decision to exhibit the *aqal* in the first place had been a fraught one for the curators; the reifying tendencies and fetishizing impulses of the life group diorama, with its illusionistic mannequins and allochronic representations of a petrified culture, made the curators uneasy about working with the life group trope. And yet Dahir and Mohammed recognized the fact that the Somali house had the potential to meld the features of a contemporary nomadic existence with a centuries-old architectural form that is not a relic of an ancient way of living, but rather a compelling example of cultural continuity and vibrancy. [67] Supporters of the *aqal* idea convinced the "African Voices" team that the "primitive housing" connotations of the *aqal* could be transcended if its centrality in the Somali imagination and its value as an object of cultural memory could be conveyed. [68] In addition to the video, above the *aqal* are two large photomurals, one of a group of *aqals* in northern Somalia, the other of the camp's camel herders; at the front of the house is a text-rail stand that includes labels, Somali proverbs, and excerpts from poetry. The team seems to have succeeded in transforming the *aqal* from a static diorama into a "dynamic dialogic display." [69] The question of agency is significant here: by giving voice to both male and female diasporic Somalis through an embodied gaze out at the museum spectator, African subjectivities are foregrounded and the allochronic tendencies of the ethnographic diorama disavowed.

As close cousins of video installations found in contemporary art museums, the audiovisual exhibits in "African Voices" depend to a large extent on the presence of

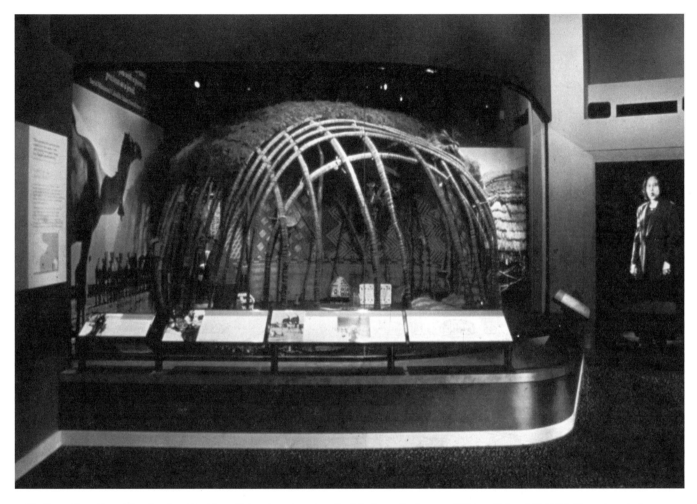

Fig 6.4 Somali *aqal* showing the virtual Somali-American docent on the full-size vertical screen ("African Voices," NMNH). (Department of Anthropology, Smithsonian Institution; photo by Donald Herbert)

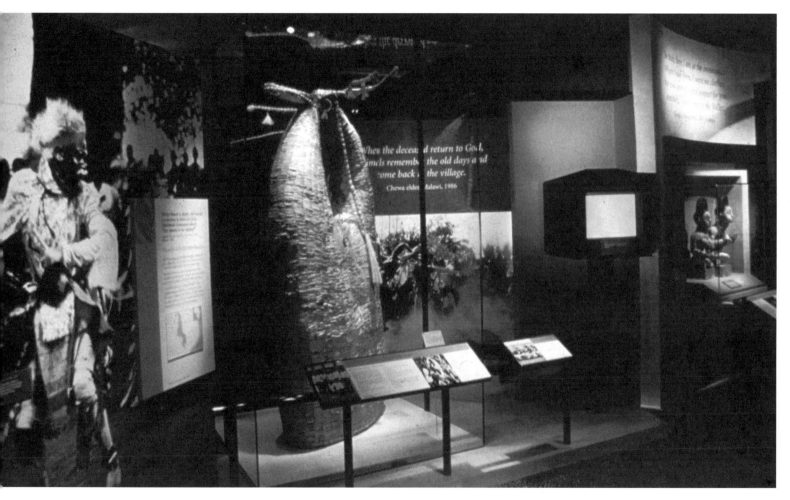

Fig 6.5 Black box video playing alongside Chewa *Kasiyamaliro* mask ("African Voices," NMNH). (Department of Anthropology, Smithsonian Institution; photo by Donald Herbert)

the visitor to close the circuit of meaning; for example, in the absence of spectators, the *aqal* docents resemble virtual shop-floor sales associates making a pitch for the newest kitchen aid as they address an invisible spectator. But with visitors standing in front of them, they are immediately transformed, constructing a quite different notion of "presence," namely, a heightened sense of African subjectivity and agency. Being physically present in front of the exhibit is necessary to engender affect and connectivity between the Somalis represented on screen and the visitor, especially given the size of the video image. But while the life-size *aqal* video screens succeed in arresting our attention and inviting us to listen to the monologues, videos embedded in black boxes seldom compel us to stand around long enough to watch the entire screening of 3–5 minutes. The drawing power of its visuals and the location of the video monitors, whether at eye level (as in the large rectangular photo mural of a Makola market plasma screen) or three feet off the ground (as in the mudcloth artist Nakunte Diarra's computer interactive monitor, which allows visitors to select videos illustrating the mudcloth designs) doubtless determine the degree of interaction, which brings us to the larger question of how documentary footage is resignified by the gallery and how the protocols of nonfiction film viewing are shaped by the exhibit's content.

Documentary films' ideological and affective agendas are potentially destabilized by the contingent nature of museum film spectatorship, in which we are invited to construct our own fragmentary versions of narratives and piece together meaning based on elliptical flashes of objects, images, and sounds that might contribute to a coherent narrative. Beverly Serrell, in a 2002 essay entitled "Are They Watching? Visitors and Videos in Exhibitions," identifies five uses of video in the gallery, including giving an introduction or overview to an exhibition; presenting complex issues; showing changes over time; demonstrating a process; or conveying a personal story. Videos are also seen as alternatives to reading label texts and looking at exhibit objects and photographs.[70] The museum gallery turns us into promenading spectators, absorbing images, sounds, and texts as our feet shuffle through sometimes crowded, sometimes deserted galleries, creeping in for a closer look, backing out carefully to allow other visitors to take our place. The experience is elliptical and thoroughly somatic, as our bodies, tired of standing or wandering, cue the mind to switch gears and move on in search of somewhere to sit down. That mini-screening rooms are often located at the end of exhibits (as is the case in "African Voices") should come as no surprise since our "museum-fatigued" bodies are far more willing to submit to video at the end of an exhibit than at the start. But how likely are people to stop and watch moving images when they're wandering, sometimes aimlessly, through the gallery?

One of the earliest studies to examine the efficacy of audiovisual technology in the museum was conducted in 1979, centering on a temporary exhibit entitled "Protecting Wildlife," located in the North Hall of the British Museum. The study's author, M. B. Alt, utilized E. S. Robinson's 1928 model of the attracting power (the total number of people who stop) versus the holding power

(the quotient of the average viewing time and duration of the program) of exhibits.[71] A successful audiovisual feature would be one with both a high attracting power *and* a high holding power.[72] What Alt discovered in his 1979 research was sobering; of a sample of 220, only 3 visitors watched the tape-slide program for its duration, and 50 percent of the sample remained at the exhibit for less than 35 seconds. The data revealed that visitors are constantly deciding whether to stay or leave a display, suggesting that unless the audiovisual material is compelling—the tape-slide program in "Protecting Wildlife" was criticized for looking amateurish—the visitor is "never truly captured but is continually appraising the program with a view toward leaving."[73] Whether the video-walls and plasma screens found in "African Voices" are any more successful than the audiovisual programs of the past is open to question. What interactive media scholars Christian Heath and Dirk vom Lehn discovered in research they conducted in the new British Galleries at the V&A in 2002 was that "video can and does become a substitute for the original object. . . . It is not unusual for visitors to view the video, occasionally glancing at the exhibit, and then, as the film comes to an end, to look at the piece very briefly before moving on." While the opposite is also likely to occur (look at the object and virtually dismiss the video), these findings are a sobering reminder of what Heath and vom Lehm called the "rather delicate, if not tenuous, relationship between interactives and the objects whose interpretation and exploration they are designed to enhance."[74] Despite this cautionary tale, the pervasive influence of TV and screen culture (including the Internet) continues unabated, with some museums, as George F. MacDonald points out, "utilizing entire internal and external walls as giant film projection screens." Architects are consequently altering their designs for new buildings or additions to accommodate this screen culture driven, as MacDonald rightly argues, "by the needs and preferences of those generations who grew up with film, TV, and the Internet."[75]

Given this state of affairs, in the likelihood that most "African Voices" spectators are not sutured into the conventional subject positions offered by documentary cinema, we must therefore rethink how they negotiate the meaning(s) of electronic media in the exhibit. As a result of the low sound levels of some interactives, which have to compete with the ambient noise and distractions of the public gallery, museum visitors absorb most information visually. "African Voices" uses electronic media to create what Ralph Appelbaum, founder and president of a company responsible for the $210 million Rose Center for Earth and Space at the AMNH and the United States Holocaust Memorial Museum in Washington, D.C., describes as an immersive environment that foregrounds an "emotional" as well as an intellectual interactivity.[76] Exhibits don't just deliver content but shape that content into emotional, sensual, and memorable experiences that clearly affect the visitor's expectations. When film, video, electronic, and now digital images carry significant portions of an exhibit's discursive weight, creating affect that was previously triggered only by objects and installations such as habitat dioramas and life groups (mannequins in realistic settings), something quite radical is going on in

terms of a shift in the hierarchy of the museum's mode of address.

Museums were immersive environments long before electronic media came on the scene—some would argue that more traditional display techniques are infinitely more successful at creating immersive spaces than video and touch-screen interactives. Nevertheless, given that the underlying premise of so much technology in the museum is to enhance environments by enabling visitors to "enter" (immerse) themselves both physically and psychically in the experience, then what kind of "experience" are we actually talking about in the twenty-first-century museum? Visual tropes and interfaces from popular culture have always been mirrored in the museum, although as Marianna Adams and colleagues argue, this is by no means a one-way street: "museums have initiated, mirrored, and contributed to the public's increased interest in experiences that go beyond static looking and listening. . . . Many visitors expect or want to engage with a subject, personally and physically. Visitors see interactive exhibitions as a meaningful way to learn and as an important stimulus for social interaction."[77]

The fact that electronic images are now being summoned to perform this affective work alongside objects is significant. Moreover, some may argue that the balance may have tipped in terms of popular culture's having the upper hand these days in calling the shots in the gallery. For example, the refurbished Milstein Hall of Ocean Life, formerly known as the Hall of Oceanic Life and Biology of Fishes at the AMNH, now features plasma screens above almost every marine diorama (which identifies its corporate or individual sponsor), with a continuous video on ocean life playing on a large screen on the lower level. According to the news release, the $25 million renovation set out to transform the existing exhibit into a "fully immersive marine environment with video projectors, interactive computer stations, and new ocean dioramas." Lighting, video, and sound are central to this exhibit—as *New York Times* art critic Virginia Smith points out, the hall's former silence has been replaced by recorded whale sounds—our eyes darting from 3-D models housed in glass cases to flat, kinetically charged video images of the specimens on display. The shift in spectating registers seems normal for most visitors; there are no buttons to press to trigger the video images, which hang like videographic posters on the cavernous walls of the Oceanic tomb. However, like Smith, I too feel that the magical reaction of wonder that the former dioramas used to engender in visitors (when they weren't competing with the videos) has been lost, and second her lament about spending time "staring mostly at a flat-screen monitor showing seals swimming" rather than absorbing the systematic display of information. While perhaps justified pedagogically, the trade-off is still that, a trade-off, "sounds for silence, information for contemplation, facts for poetry."[78] If the pervasive influence of screen and Internet culture in the increasingly commercial / corporate-looking architecture of museums is disquieting to visitors such as Smith, who seem nostalgic about the idea of museums as serene spaces of quiet reflection rather than vibrant media-saturated heterotopias, new media technologies are creeping into the most unlikely of museum spaces, such as the Pope John Paul II Cultural Center in Washington, D.C., where visitors are encouraged to "design a

stained-glass window out of available motifs on a digital kiosk, practice bell-ringing, and create a giant collaborative collage by floating designs onto a video wall."[79] Even the Vatican, it would seem, is getting hip to immersion and interactivity.

Experimentation with new media in contemporary museums throws into sharp relief a number of enduring tensions in museums of natural history, most obviously the need to balance appealing and intellectually rigorous content with delivery methods that are not only appropriate but best reflect the institution's overall mission. Innovations in new technology have always been double-edged swords for museums, offering on the one hand visible evidence that the institution is staying with (or ahead of) the times with regard to its display techniques but also generating a certain amount of angst about transforming exhibits into multimedia environments. Long before "African Voices" blazed a trail in terms of its innovative use of video, curators had pondered the possibility of using even larger screens—IMAX screens to be precise—to make a bold statement about the institution's overarching goals. But while the idea of IMAX was still a pipe dream at the NMHN, the National Air and Space Museum (NASM) went ahead and secured the financial support to bring IMAX to the SI. Let us return, then, in the final leg of this chapter, to IMAX, which (as we discovered from chapter 3) in the 1970s was still associated with the pavilions of world's fairs and expositions. Its entry into the museum would have a profound and lasting impact on museums of science and natural history; culturally and economically, there was much to be gained and little, it seemed, to be lost in opening one's doors to IMAX.

"DOING FOR LIFE WHAT *TO FLY* DOES FOR FLIGHT": IMAX AT THE SMITHSONIAN INSTITUTION, 1976–1986

Talk of large-screen film presentations at the Smithsonian predates the opening of *To Fly!* at the NASM by quite some time; as early as 1970, in a 153-page evaluation and recommendation document prepared by staff members of the NMNH, the idea of using large-format film was eagerly proposed. Calling the institution a "contemporary communications service . . . an exciting place in which to be, intellectually and psychologically," the report argued that the museum needed to redefine itself as a "contemporary medium of communications," since it was eminently capable of "combining other media in addition to its unique characteristics" of exhibiting three-dimensional objects.[80] (It's not hard to see how this discourse resonates with debates preceding the opening of Hall 10 at the NMNH in the late 1960s.) The NMNH report called for a "giant multifaceted projection experience" (fig. 6.6) capable of showing the "subject matter of the entire museum in one entire dramatic and exciting manner." The "multi-screen cinemascope," as it was called, lent itself "ideally to this approach because of the circular nature of the (rotunda) entrance itself." This "projection of America, showing its land and wildlife" would be followed by footage showing the "intrusions" of technology, and the before-and-after (agrarian versus modern) images of America would be supplemented by predictions of where the country might be heading.

Written by the same group of curators who had condemned the "main attraction" approach to exhibiting mentioned earlier, this assessment of exhibit planning

Fig 6.6 Giant curved IMAX screens in artist's sketch of Rotunda
at the NMNH (c. 1970). (Courtesy Smithsonian Institution
Archives, RU 564, box 4)

at the NMNH ended with McLuhanesque proclamations about the ubiquity and pervasiveness of electronic media and the need for the NMNH to cater to the interests of their key constituents:

> In this electronic age, the rapid change which is affecting us culturally, politically, educationally, and environmentally has defined more clearly the gap between the effectiveness of our public institutions and the needs of the public. . . . The public is looking for sources to answer its questions, to offer new perspectives, to give comfort or at least to explain its anxieties.

The extent to which the public might actually want to be greeted by large screens and flickering electronic images as they entered the NMNH from the Mall in Washington, D.C., is open to question. However, cognizant of the fact that so much of the information the public obtained about the world came from television, the museum was clearly seduced by the idea of jumbo screens serving as a discursive shorthand for key institutional precepts. Successful communication, as exhibit designer Axel Horn argued in 1960, was a "synthesis of media . . . [involving] sight, sound, tactile sensation, kinematics, or montage." [81] Sensing an opportunity to kill two birds with one stone, to help visitors see "the historical forest instead of the trees," in the words of Edward P. Alexander, and come away with the idea that parts of the museum, at least, were closely associated with new media and popular culture, the exhibit functioned as an intermedial barker, announcing to all who passed that what lay ahead was exciting, alive, and belonged to everyone. [82]

A decade after *To Fly!* opened at the NASM in 1977, exhibit planners were still exploring the possibility of incorporating an IMAX screen into an orientation gallery. In "Practical Plans for Conveying Major Themes of the NMNH to Our Six Million Visitors," by Laura Greenberg of the museum's Office of Exhibits, the issue of how visitors were expected to piece together "the sum total of the Museum (its overall concept) from the sum of its parts (its individual halls)" was tackled head-on.[83] The report contained three proposals for orienting visitors as they entered the building: Proposal #1 made recommendations for an "Introductory Gallery" that would be the core element in an introductory/orientation center; Proposal #2 was for an IMAX film to be produced by the NMNH and used as the second element in the introductory/orientation center; and Proposal #3 was for an educational staging ground that could be used by school groups. The first proposal made the case for an "Introductory Gallery" that would have five main functions: to serve as a starting point for visitors; to provide an overview of the museum in terms of objects and subjects; to offer an easily accessible view of natural history for the average 60- to 90-minute visitor (especially if seen in conjunction with an IMAX presentation); to be the "most effective way of presenting those concepts (e.g., classification) that are central to all natural history enterprises but are nowhere made explicit"; and finally, to welcome and comfort rather than overwhelm and confuse the visitor.[84] As a way of countering the tendency for museum visitors to "head for objects they know by name or reputation—the Hope Diamond and the dinosaurs—and wander aimlessly from there," the orientation gallery would command the attention of the visitor, introduce the subject, and inspire a purposeful sense of mission beyond the "main attraction" aesthetic. A hypothetical section entitled "Representable Objects" would involve "virtually no storylines" and contain such innovative displays as "a case consisting of nothing but sound recordings of whales, birds, volcanoes erupting, and people talking or singing in a variety of languages."[85]

Proposal #2 was concerned exclusively with the role of IMAX in the orientation center, making one of the most compelling cases for the role of film in the museum gallery I've come across in museum memoranda. Seeing in film's kinesthesia a capacity for representing life in far-reaching ways (and in large-format filmmaking the myth of Bazinian hyperrealism), the authors enthused about the power of IMAX to get the message across:

> Film in general, and IMAX film in particular (with its scale, presence, and drama), is ideal for presenting life. An IMAX film could show the dimensions and diversity of life. . . . While not suited to a very didactic message, an IMAX presentation would be an excellent way of generating interest and curiosity about life in all its forms (in that sense it could do for life what *To Fly* film does for flight—i.e., show why the whole phenomenon is so fascinating and awesome). It could be designed as part of a larger introductory complex—with exhibits capitalizing on the enthusiasm and interest generated by IMAX and adding the more detailed presentations of the sort that IMAX cannot do effectively.[86]

Summoned to bring spectacle to natural history via its "scale, presence, and drama," IMAX was both showman

and encyclopedia salesman; capable of magnifying natural and man-made phenomena via the 70mm film gauge, IMAX could make "even the most mundane life forms and events (e.g., a caterpillar walking on a branch) seem like something the viewer has never really seen before." IMAX's primary charge was to "evoke wonder, awe, and interest" in the visitor, emphasizing in the process the "diversity of life forms and similarity of life functions." The adjective that really pops here is "presence," which seems to function as a synonym for immersion; IMAX has presence because it makes the audience feel co-present; but it also speaks to the uncanny qualities of IMAX's materialism, the steroid-enhanced 70mm stock that gives it an unsurpassable aura which in turn heightens the drama.

Several assumptions about the effectiveness of IMAX (and film in general) as a conveyor of serious scientific knowledge are embedded in this description. Despite the fact that IMAX is being held up as conveyor of spectacle par excellence, its limitations are also openly acknowledged, including whether IMAX is capable of delivering complex, detailed content. In the minds of the Smithsonian curators, what IMAX does best is transform the prosaic, the petite, and the perfunctory into billboard-size iconography that speaks a language closer to commercial advertising than the prosaic (usually expository) nature documentary. An immersive engagement with the image—embodied spectatorship taken to the extreme—was the order of the day, as seen in this flier for the Johnson IMAX Theater at the NMNH (fig. 6.7). What IMAX does superlatively is "show," "evoke," "emphasize," and "illustrate" (all verbs used by the proposal authors), transforming the prosaic into the spectacular, the petite into

the gargantuan, and the perfunctory into magical perfection, by dint of its ability to magnify, slow down, and aestheticize objects and processes.

It is perhaps ironic (though not entirely surprising) that this proposal for IMAX in the Atrium was not approved and that IMAX ended up in its own purpose-built theater rather than in the NMNH's Rotunda Orientation Center. One of the advantages of screening IMAX films in the orientation center was that they could easily be changed or updated to reflect current shows or IMAX releases, although the expense of producing new exhibit "trailers" might be prohibitive. This idea of relative fluidity in exhibition design and policy was outlined in the strategic planning document "The Exhibits Program We Would Like to Have," which argued for the construction of halls that were neither permanent (15 to 30 years) nor temporary (3 to 12 months), but designed for a mid-range longevity of ten to fifteen years; IMAX films could easily withstand this exhibition shelf-life and probably even longer. If visitors entering the Rotunda might be forgiven for thinking they had entered a theme park, they might find the following justification of multimedia and IMAX a reminder of the interdependency of the museum and popular culture:

> Because of the pervasive influence of television and the expectations generated by theme parks like Disney World, effective communication with today's visitor often requires a different approach in exhibit design. This is not to suggest that we convert the museum to a natural history theme park, but that instead we adapt the more effective

of the exhibit methods and techniques used by those parks to our own ends.[87]

Adaptation seemed as vital in the museum world of display as it was in the natural world; to survive, one needed to respond to the changing environment and appropriate exhibitionary practices relevant to the present era. But the task of preserving a balance between civic mission and the economic market has never been easy for museums, especially as they appropriate the protocols of business into their operations, and retail and leisure complexes look to museums for ways of integrating media into their displays. As retail stores with interactive kiosks increasingly resemble museums, and museums with their flight simulators and corporate logos merge with theme parks, we can't help but wonder about the fate of not-for-profit organizations, especially when companies such as Discovery Zone, a Chicago-based corporation offering for-profit play centers for children, compete aggressively with nonprofit children's museums for patronage.[88]

The imperative of adaptability within the museum world reached an apotheosis with the National Air and Space Museum's 1972 decision to commission an IMAX film to commemorate the 1976 U.S. Bicentennial. *To Fly!* was funded by the oil giant Conoco as a Bicentennial gift to the NASM, with Conoco taking full advantage of the corporate image advertising and public relations opportunities presented by the arrangement (it was labeled a "public service by Continental Oil Co." in promotional materials).[89] Discussion of the corporate advantages of working with museums, especially using film and multimedia, was discussed in a 1969 *Curator* article by

Fig 6.7 Armchair travel and gender stereotypes are signified in 2002 IMAX flyer via the contemplative gaze befitting the sublime sensation of space travel in *Space Station* (3D) versus white-knuckle grip and facial expression of the girl transported via the IMAX camera to the African plains in *Africa: The Serengeti.* (Courtesy IMAX Corporation)

William Kissiloff, partner in the design company Kissiloff and Wimmershoff Inc., who argued that "the exhibition visitor will get your corporate or product message quicker and will retain it longer if you involve him in a meaningful way through all his senses." Describing the "increasingly young decision-maker" as being "less structured in his thinking," television had "loosened him up . . . [making him] more responsive to adventurous communication techniques, to complex audiovisual messages, and less dependent on getting his information totally through print." While assuaging fears about new media's complex delivery methods ("there is nothing mysterious or magical about new media," Kissiloff wrote), he also valorized IMAX and trumpeted its unique properties. While there might be nothing "magical" about new media in Kissiloff's mind, there was nevertheless something "very special about mixed media, about their effects on people." [90]

TO FLY!: IMAX TAKES OFF AT THE NATIONAL AIR AND SPACE MUSEUM

In a 1972 "Prospectus" for *To Fly!* written by the deputy director of the NASM, Melvin B. Zisfein, the film was envisioned as a "new way to see America—through flight-oriented eyes." [91] Calling it a "spectacular . . . ultra-wide screen color film," Zisfein promoted IMAX's "fidelity and freedom from shake," which for him was a "quantum jump better than Cinerama, Circlevision, and older media." Technological improvements aside, what most struck Zisfein about IMAX was the "psychological impact of this new medium," which for him defied description. An experience "far more than a 'wide screen movie,'" IMAX made the "willing suspension of disbelief unbelievably easy," promoting "'on-the-spot' excitement in the viewer." Making the case for IMAX was straightforward for Zisfein—the only misgiving voiced in the historical record regarding the adoption of IMAX came from Congressman Wendell Wyatt, who wrote the Secretary of the Smithsonian, Dr. S. Dillon Ripley, in 1974 concerned that the NASM might use a "foreign-developed mechanism" rather than an American large-screen projection technology. [92] Ripley reassured Wyatt that all steps would be taken to "assure that the domestic system receives full attention," but the Canadian-based IMAX Corporation was by far the more sophisticated (the U.S. version projected in 35mm rather than 70mm).

Issues of national identity were bound up in *To Fly!* from the get-go, and despite being produced by a Canadian company, the film was very much a tribute to American hegemony in aviation history and technology, inscribing the nation as the author and arbiter of this trajectory of flight. Given the high stakes, several treatments for *To Fly!* were considered and discarded before the final one was approved; since these concepts varied significantly in content and approach, they are worth briefly exploring. The first proposed treatment, "The Beautiful Mystery of Flight," scored high on aesthetics but low on technical analysis through its overemphasis of "form, line, performance, and the 'beautiful mystery' of flight." [93] In Zisfein's words, the images on the screen would be "more art than illustration, the narration would be more poetry than

text, and the music and sound effects would be a part of an inner experience." Privileging the transcendental over the empirical, the sensorial pleasure of witnessing flight over developments in aeronautics, here was a treatment that would nevertheless create new frames of reference for visitors, new means of uncovering the significance of the objects on display in the museum proper; as Zisfein saw it: "When they emerge from the theater into the exhibit galleries, the artifacts and displays should mean more to them, and they will sense the drama that each of the items represents in the continuing story of flight. When they leave the museum the birds, insects, and aircraft they see should have deeper significance."[94]

Although "The Beautiful Mysteries of Flight" was ultimately rejected, discussion of its suitability as a possible IMAX film is revealing.[95] The fact that a treatment heavy on aesthetics, while ultimately deemed unsuitable, was given serious consideration gives us insight into what the NASM was looking for in an IMAX film, and, just as importantly, what curators hoped to accomplish by exhibiting *To Fly!* in a museum devoted to flight-related artifacts. But whereas standing next to actual planes with mannequin pilots on the wing might provide concrete evidence of the size of the plane, including vital information regarding the engine, wing span, wheel dimensions, manufacturer, etc., watching *To Fly!* pushes the experience in a different direction by offering visitors an appreciation of the *sensation* of flight via IMAX's hyperkinesthesia. The "wow effect" of IMAX becomes a triggering device to heighten our appreciation for the material objects on display in the NASM. A notion of vicarious participation is implicit in the film's title as infinitive verb: we are repeatedly invited "to fly" in this film through its ubiquitous aerial point-of-view shots. A 1982 review of *To Fly!* from *Natural History* magazine (it was the inaugural film at the AMNH's Naturemax Theater, the first IMAX theater to open in the Northeast), left one in little doubt as to the visceral effect of this film: reviewer Douglas J. Preston informed readers that as soon as the picture explodes to cover a screen four stories high and sixty-six feet across, "we are careering over the forests of Vermont, spinning off the top of Niagara Falls, rushing through the steep valleys and canyons." How do viewers react? We are told that "the audience gasps; there are a few screams and a number of vertiginous viewers hastily leave the theater." With cameras placed in such unlikely places as the underside of an F-4 reconnaissance fighter jet flown in formation by the Blue Angels, the belly of a Boeing 747 taking off, and a stunt pilot's plane that flies upside down and in loops, the film is capable of triggering the motion sickness sensors responsible for nausea, echoing the widely reported effectiveness of the panorama in the same regard.[96] Screaming, gasping, and getting off the ride are behaviors no longer synonymous with two of the most highly embodied sites of spectatorship: the horror genre and the theme park ride. IMAX, too, can now take a seat in the hall of "most visceral spectatorial experiences."

The idea of IMAX having both an immediate and lasting perceptual impact on the visitor tells us a great deal about how museum professionals conceived of film, phenomenologically and discursively, especially regarding how it acted upon the human sensorium differently

from three-dimensional objects. While standing before the *Enola Gay* at the NASM might send shivers down the spines of many NASM visitors (both patriots and antiwar types), it is a different form of embodied spectatorship from that encountered when watching *To Fly!* The semiotic (and mimetic) contract is drawn up in overlapping but not exactly identical ways; if the thrill of standing before the *Enola Gay* derives mostly from its indexicality, then the thrill of IMAX resides in the domain of the indexical *and* synesthesia, where the spectator appreciates the heightened realism of the image and yet feels a lot more through the sense of immersion in the image and virtual movement into the frame.

Finding the right content to match IMAX's specific mode of address while ensuring that the institutional reputation of the Smithsonian remained untarnished was no easy task, and throughout the discussions of possible IMAX films seemed to have lurked a fear of the contaminating effects of the film medium itself. At a time when corporate underwriting was still relatively new in the museum world, the Smithsonian was naturally concerned about protecting its name and reputation, insisting that the contract contain "strict controls over how our name may be used by Conoco or any local television station in any promotion of the film." As scientist David Challinor made clear in a December 16, 1974, memo to Dr. S. Dillon Ripley, Secretary of the Smithsonian, prior approval by the Smithsonian would be required for any use of its name beyond that specified in the contract.[97] While the Smithsonian did grant to Conoco "the limited right to use its name in advertising or promotion of educational uses of the film," the museum's name could not be used in any "commercial, promotional or theatrical (where an admission fee is charged) uses of the film."[98] Keeping a firm grip on the institution's image and reputation was paramount to the Smithsonian, since charges of overt commercialization or unethical behavior would have been damaging, to say the least.

To say that *To Fly!* has been an overwhelming success for the NASM is an understatement; between 1976 and 1980 it attracted more than 6,300,000 paying visitors at the museum, averaging over 77 percent of the capacity of its 500-seat theater, and by 1982 an estimated 100 million people had seen the film at screenings across the country.[99] Through much of the 1980s, the film was regarded among the most popular tourist destinations in Washington, D.C. Recognizing that a follow-up IMAX film was sorely needed in order to keep up the momentum and interest that *To Fly!* had garnered, the NASM turned to the task of selecting a suitable topic. By the time discussions were under way for a sequel, the NASM had a better sense of the kind of content that would work best, having by now internalized some of the formal strengths and weaknesses of the so-called "IMAX eye." This is nowhere more evident than in the following edicts from a NASM memo discussing the need for competent producers fully familiar with the IMAX format for an IMAX film called *Flyers*:

> The scripting, directing, and editing must be completed with a thorough understanding of the psychological relationship between the large screen and the audience. Furthermore, the photography must be composed and lighted with sensitivity to the impact and limitations of the *potentially over-*

powering format. In many ways, IMAX *is* a new way of seeing, and this new way *must* be thoroughly understood by the creative filmmaker.[100]

One of the contenders for the sequel to *To Fly!* was *On the Wing* (Francis Thompson, 1986), which used the giant IMAX screen to explore the analogies between flight by "nature's creatures and that of mankind's various modes of mechanical flight over the past two centuries." With a budget of $3 million, the film was judged not only as a standard-bearer for the NASM's collection, but as evidence of the SI having fully grasped the possibilities of IMAX as an institutionally endorsed mode of address. Hiring the esteemed MacGillivray-Freeman team to produce and direct the film, NASM director Walter J. Boyne, commenting on an early rough cut, was pleased to report that "throughout the film they have avoided the incessant roller coaster action that spoils so many IMAX films." Instead, he opined, they have "long moments of lyrical beauty, smoothly executed, but punctuated by sharp moments of visual terror and / or the illusion of flight."[101] Boyne described "Wing Walker," a scene in which a plane engages in a free-fall drop before being intercepted in midflight by the pilot, as an "absolute show stopper." However, vitiating the suitability of *On the Wing* as a sequel to *To Fly!* was the inclusion of scripted scenes with actors; these characterizations "were not totally successful" in Boyne's words, especially the sequence where the characters are first established in Glacier National Park. Weakened by a "strained situation and dialogue," the film was rejected in favor of *Living Planet* (Dennis Earl Moore, 1979), an aerial tour over five continents, sponsored by Johnson Wax Inc.

(*Living Planet* was followed by *Flyers* [MacGillivray Freeman, 1982], mentioned above, the story of a World War II ace who performs spectacular flying stunts.)

A primary concern for corporate sponsors such as Conoco and Johnson Wax was whether the films would have enough universal appeal to guarantee residual uses such as "successful exposure in other IMAX / OMNIMAX theaters as well as access to television and school audiences."[102] Recognizing the unique demands of each venue and media specificity (television, 35mm projection, and videocassette) demanded that "each scene be composed carefully with each format in mind, and in some cases, photographed several times with varying composition. . . . This method would result in a fully pleasurable small screen film which can be a tremendously profitable tool in TV, educational, cable, home video and other marketing."[103] At the same time, the challenge of watching these films in diminished formats was not addressed, an issue analogous to the current situation facing manufacturers of HDTV televisions, unable to demonstrate its superior visual fidelity via advertisements on conventional television screens. A trip to an electronics retailer is often required for consumers curious about the difference between standard and high-definition television.

The success of *To Fly!* secured the future of IMAX at the NASM and spurred the leaders of the NMNH to include an IMAX screen at this institution. Abandoning the IMAX-fueled orientation center idea, the NMNH went down the same economic path as the NASM in choosing to exploit IMAX's special appeal and reap the benefits of the separate-admission revenue stream. The NASM was itself a little surprised at the blockbuster status of *To Fly!*:

"the success of *To Fly* is incredible," wrote one curator, especially when one considers the "very thin story line, which is, in essence, the use of chronology and the westward flow to tell a vivid story of aviation." Scoring a box office hit with IMAX was not easy, however; in a shot list (i.e., a list of scenes to be shot) proposal for another IMAX film, *The Seasons of Flight,* one curator suggested that during a sequence on spring, they should make use of a split screen with an image of "Big Bird of *Sesame Street* doing a wild spring dance." What might have seemed far-fetched at the time now seems quite feasible, considering that the 2005 Tom Hanks-narrated 3-D IMAX film *Magnificent Desolation: Walking on the Moon 3D* uses animation and a host of other digital effects associated with Hollywood blockbusters.[104] Because it was "not naturally associated with flight," *The Seasons of Flight* ran the risk of leaving the audience "with an experience that would not linger, but would be transitory . . . [and] not intellectually satisfying." The film would also be "open to criticism by film critics, filmmakers, and others" and might encounter difficulties finding sponsors in the absence of strong residual markets. Cognizant of the fact that the success of IMAX weighed heavily on the museum's ability to attract large corporate sponsors, the NASM was careful to promote both its visible and invisible assets, using what might be called a more "dignified" form of marketing and public relations, what curator Helen C. McMahon called "a good PR job on our museum" but done with "style."[105]

Spawned by the world's fairs and expositions of the late 1960s, IMAX was perfectly poised to make the transition into the museum. *Man Belongs to the Earth,* directed by Graeme Ferguson, appeared in the United States Pavilion at the 1974 Spokane, Washington, EXPO, an exhibit in many ways complimentary to Hall 10's "It All Depends" (discussed above). The curved, 65-foot-high screen occupied most of the audience's field of view, although the image quality, while quite good, suffered from occasional "bounce, focus problems, and flutter visible at the edge of the field of view."[106] Experiments with film projection, performance art, and multimedia were going on in other pavilions at the EXPO 74; for example, the Czechoslovakian Pavilion incorporated a female performer into the film presentation, who would stop the film, ask the audience to choose from narrative options, and, after the vote, restart the film. At the same EXPO, the Republic of China featured a multimedia presentation about Taiwan produced by Electrovisions Productions of San Francisco, in which a 73-foot screen was used with three projectors, lighting effects behind the screen, mirror ball reflections, and so-called "envelopmental sound."[107]

The circulation of technologies and practices between expositions and museums was by no means unprecedented; as I have shown elsewhere, anthropologists and curators have been appropriating the techniques of the world's fair pavilion and marketplace since the late nineteenth century. Multimedia at the Smithsonian did not—could not—have evolved in a vacuum but was always in dialogue with broader trends in popular and commercial culture. Not everyone in the museum world was (or is) entirely happy about this mutual influence; in a lament about museums "selling out" to commercialized popular culture, Charles Alan Watkins argued that museums had entered into a Faustian contract, inexorably linking themselves, in his words, to "what is now the capa di tutti *capi*

of the great economic chain of being—tourism." Accusing museums of constructing facilities of "the most minimal economic value, like IMAX theaters," Watkins sarcastically opined that they might as well look instead to "installing roller coasters . . . because they're even more fun than giant-image movies and may be cheaper too." [108] Media technology within the museum was also singled out for criticism by Watkins; in his opinion, museums ought to "stop confusing education with technology [since] technology doesn't educate by itself, and all the bells and whistles and computers and virtual-reality things do nothing more or less than suggest that looking is the equivalent of learning and that hearing is the equivalent of understanding." [109] The case of the IMAX film *Rolling Stones at the Max* (Noel Archambaut, 1991) is relevant here, since it posed a dilemma for museums by providing "fresh ammunition to the debate as to whether museums should, to any degree, become active in the entertainment business." [110] Museums were nervous about programming the film, leery that if they made too much money from ticket sales, their nonprofit status might be jeopardized, a crisis of conscience theme parks would never have experienced. Ultimately, many museums felt they couldn't justify screening the film, especially in the absence of an exhibit on popular music that one might find at the Rock and Roll Hall of Fame in Cleveland, Ohio. [111]

Never a trailblazer in regard to photography, film, and multimedia exhibition, the Smithsonian nevertheless responded to perceived pressure from visitors who expected information to be increasingly concise and visually appealing, and may have done as much as its governmental and corporate sponsors allowed to keep its public audiences happy. Visitors to the NMNH on Friday nights can today enjoy live jazz and drinks at the Smithsonian IMAX and Jazz Cafe in the Atrium of the NMNH (the Rose Space Center at the AMNH has a similar feature), what Eric Brace at the *Washington Post* calls "The Smithsonian's Jazzy Display." Admittance is free with the same-night ticket stub of an IMAX film or $10.00. Sponsored by Samuel C. Johnson (as in the Johnson IMAX Theater), this is one of three venues at the Smithsonian where IMAX films can be viewed; the other locations are the Lockheed Martin IMAX Theater at the NASM and the Steven F. Udvar-Hazy Center in Chantilly, Virginia (as I write, *To Fly!* is playing at both this location and at the Lockheed Theater at the NASM [fig. 6.8]). The promise of an immersive experience is the central marketing trope for these films, as seen in the blurbs on the Smithsonian's Web site: "*Sit* in the pilot's seat of an F-15" (*Fighter Pilot*); "*Experience* Life as an Astronaut" (*Space Station*); and "*Feel* the Earth Drop Away Beneath You" (*To Fly!*). [112] Promoting these film as delivering far more than your average multiplex fare, curators at the Smithsonian trade on audience familiarity with amusement park thrill rides, the graphical interface of video games such as Play Station 2 and X-Box, and even virtual reality chambers. Moving from an IMAX film about underwater mammals to a jazz cafe in a nineteenth-century museum atrium may be discombobulating (or not for some), but it is increasingly the direction museums and certain retail institutions are heading in their attempts to create hybrid retail/infotainment destination venues for their audiences.

But IMAX may be facing a more insidious threat as it strides further and perhaps more confidently into the

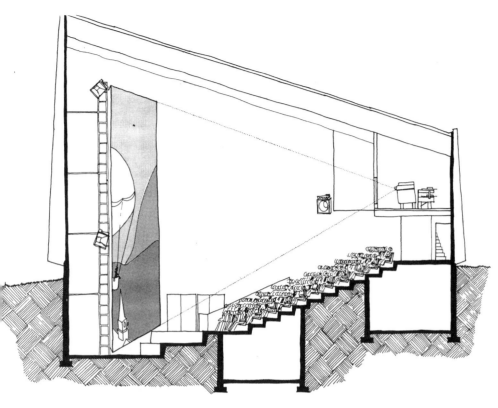

Fig 6.8 Cross-section of IMAX theater at the National Air and Space Museum (c. 1978). (Courtesy Smithsonian Institution Archives)

Giddings, 1999), and *Volcanoes of the Deep Sea* (Stephen Low, 2003) have all come under attack, even though *Volcanoes of the Deep* was vetted by a panel of scientists and sponsored in part by the National Science Foundation. Caving in to pressure, the Fort Worth Museum of Science and History in Texas initially rejected *Volcanoes* (along with about a dozen other science centers located mostly in the South) because some members of the test audience considered the film blasphemous, but then reversed its decision when its cowardice became apparent and was widely criticized. The head of distribution at the company that made *Volcanoes*, Pietro Serapiglia said officials at theaters told him they could not book the film " 'for religious reasons,' because it had 'evolutionary overtones' or 'would not go well with the Christian community' or because the 'evolution stuff is a problem.' " [114] Even though the problem is largely confined to publicly funded science centers as opposed to commercial theaters, it was still indicative, said film director James Cameron (a producer on *Volcanoes*) of a "new phenomenon . . . symptomatic of our shift away from empiricism in science to faith-based science." [115]

Thomas Smillie would have a hard time recognizing high-tech galleries and touch-screen interactives at the NMNH today, although we'd probably be surprised by how quickly he would realize that despite the prolifera-

new millennium: censorship by the religious right. Traditional science center–type IMAX films are now coming under the scrutiny of Christian fundamentalists who object to references to evolutionism (or the Big Bang theory) in their content. *Cosmic Voyage* (Bayley Silleck, 1996),[113] *Galapagos: The Enchanted Voyage* (David Clark and Al

tion of flat screens and computer interactives, exhibition methods as a whole have changed very little in the century since he worked at the Smithsonian. Finding new ways to integrate both established and emerging image technologies such as photography, lantern projection, and film into the museum was a mission both he and his successors at the SI in the 1970s and today felt passionately about. In 1969, long after Smillie had given up his post at the NMNH, curators still complained about the slow uptake of new media: J. W. Borcoman, writing in *Curator,* bemoaned the fact that despite contributing a "whole new approach to vision and . . . a new visual vocabulary that daily increases the richness of the pictorial tradition," the still photograph and motion picture, while "right under our noses [and] part of the public's daily existence," were being ignored by museums.[116] Exasperation at the museum's slow adoption of media technologies is just one side of the coin, however; the other side is represented by perennial curatorial fears that any wholesale appropriation of new media might relegate to the back burner precisely what differentiates museums from other cultural institutions—the aura of the original.

7

FILM AND INTERACTIVE MEDIA
IN THE MUSEUM GALLERY
FROM "ROTO-RADIO" TO IMMERSIVE VIDEO

> Technology may be a conduit for information, but it is not the instrument that defines a "valuable experience."
>
> —James R. Beniger and Georgia Freedman-Harvey (1987)

A T A 2001 Tate International Council Conference entitled "Moving Image as Art: Time-Based Media in the Art Gallery," the opening speaker, British Research Council video artist David Curtis, complained that museum gallery-based film and video art had not been subject to the same sort of historical scrutiny as other media forms. While Curtis's decision to flag this marginalization is worthy, his neglect of museum-based screen and audio culture before 1960s/1970s video art is regrettable.[1] Curtis was not alone in slighting the early history of moving-image technologies (and computer interactives) in the museum, since several delegates who made clarion calls for historicization similarly held up the early 1970s as the field's founding moment. If the confer-

ence theme and the Tate Modern venue overdetermined the focus on 1960s and 1970s experimental video as the ur-text, the event nevertheless underscores the persistent truncation of the historical trajectory of museum-based screen media.

Likewise, nontheatrical film exhibition generally has attracted scant interest among film scholars, with remarkably little discussion of audience's experiences of film and video across the diverse public sites beyond the movie theater, including museums of science and natural history. Also unexplored is the impact of the moving image on the architectonics of the museum space and on the museum visitor's understanding of exhibit goals– both in terms of what exhibit planners *hoped* motion pictures would accom-

plish as discursive aids to learning and what educators and visitors have *thought* of the technology. As we saw from the previous chapter, digital media have infiltrated the contemporary museum, including touch-screen computer interactives, electronic orientation centers, MP3 random-access handheld audio guides, eDocent (handheld computers used by visitors to download information and bookmark Web pages as they move through galleries),[2] 3-D animation, and VR installations. Even a casual stroll through the gallery spaces of the American Museum of Natural History (AMNH) in New York City offers striking contrasts between the high-tech video-walls and touch-screen interactives of many contemporary exhibits and the neoclassical architecture and traditional exhibition of museum artifacts in glass cases which evoke exhibitionary practices from a bygone era.

Building upon the prehistory of immersive and interactive media from the previous chapter, which focused exclusively on developments at the Smithsonian in Washington, D.C., this final leg of our journey narrows the lens even further by constructing a genealogy of how such technologies as the gramophone, radio, film, and video gained a foothold in the galleries of the AMNH and the National Waterfront Museum (NWM) in Swansea, Wales (UK). While one could make the case that the amount of overlap across the two chapters might warrant their consolidation, the distinct institutional settings of each chapter (Smithsonian versus the AMNH and NWM) provide a discursive coherence that is ultimately more logical and satisfying than charting developments in a strictly synchronic fashion. Both chapters provide a historical

overview, although the role of popular culture as the museum's doppelgänger is brought to the fore a lot more in this chapter than the last, and some of the earliest uses of film as an illustrative device in the gallery (as opposed to the museum's auditorium) provide the missing piece of the puzzle. This chapter also considers the stakes involved in the use of screen-based media techniques from the perspective of audiovisual education in the United States from the 1920s and 1930s, an important informing context for the take-up of audiovisual techniques in the gallery since it documents the perceived impact of film upon the minds of young learners and offers a rationale for film use in the museum gallery. Spectatorship continues to be an arterial theme in this chapter, especially since so much of the discourse generated around film's use in the museums is structured around its perceived impact on models of spectatorship.

In the first part of the chapter I examine efforts undertaken by turn-of-the-century curators to formulate new paradigms of museum collection and display, as well as the reaction to these modernization efforts, such as the concern voiced by some museum professionals that modernized display methods might backfire on the curator by making the viewer think that "he is in a raree show" rather than an institution of higher learning.[3] Interspersed through this discussion will be contemporary examples of how these issues continue to challenge curators and designers. We will also consider how the gramophone, radio, and 16mm film were enlisted for use in the gallery, furthering what could be seen as a nascent interactive model of learning and / or a means of manag-

ing visitor flow in the crowded galleries of a popular exhibit such as the AMNH's TB show from 1908. Rather than focus on how film programs gradually became the norm in museums, I want to better understand how the protocols of film spectatorship were adapted to meet the needs of the physical and social context of museumgoing. For example, in preparing to include film exhibition in the gallery, how did curators anticipate and respond to the ambulatory modes of film spectatorship that would be the norm in museums and what strategies were used to mitigate (or accommodate) the distracted gaze of the visitor? Key here is an appreciation of how the conventions of nonfiction film exhibition and reception are destabilized in the museum as a result of an aleatory and highly mobile spectatorial gaze.

The second part of the chapter grounds these ideas in several case studies of gallery-based film and multimedia at the AMNH from the late 1960s and early 1970s and at the NWM from 2006. Coinciding with the emergence of video art in the museum, several temporary exhibits at the AMNH were pivotal in establishing some of the conventions of film use in the gallery; "Can Man Survive?" (1969) is one of these exhibits, experimenting with what were seen as quite radical audiovisual exhibition techniques for the time, techniques that have had a lasting impact upon the continued role of multimedia in the museum. The NWM brings us up to the present in terms of employing some of the most cutting-edge techniques in multimedia and immersive exhibit design. The museum's recent makeover and location in a South Wales city that is itself undergoing regeneration and rebranding give it special significance; the fact that it is in the nearest city to where I grew up in rural Wales adds yet another reason for me to hone in on this institution.

"GO AHEAD MUSEUM PEOPLE": INTRODUCING MEDIA INTO THE MUSEUM

A museum for study does not need to be anything else, but a museum for entertainment, or . . . inspiration, does need livening up a bit.
—*The Museums Journal* (editorial, 1929)

The exhibition of magic lantern slides and motion pictures were de rigeur in large public museums by the mid-1910s, vital forces in the discourse of armchair travel pervading museums. Museumgoers in institutions large and small, urban and provincial, came to expect illustrated lectures, and some upper-class patrons possibly encountered cinema for the very first time in museum settings. While curators have long been interested in the possibilities presented by modern communications media, there have always been dissenters and Luddites, critics who argued that use of such media failed to nurture the intellect of museumgoers, especially children, who were seen as vulnerable to distraction. This long-standing tension between museums as sites of education versus enlightenment is something of a hoary chestnut in museological debate, a point driven home in the analysis of parliamentary debates from chapter 5 on London's Science Museum. British writer F. G. Kenyon, in an essay on children and museums in 1919, wrote that, "The Museum can provide the objects, and furnish labels, guidebooks, picture-postcards, photographs, lantern slides; but it cannot pro-

vide the alert and prepared mind."[4] The winning over of the mind of the child visitor became the holy grail of early museological discourse, with countless articles and editorials devoted to appropriate display methods and the development of the children's museum as a separate institution. Some museum officials recommended altering the tenor of all museums, not just children's museums, by focusing more on "the subjects, which will affect intimately the life and interests of the people." For example, AMNH director Herman Carey Bumpus suggested in 1924 that in the museum of the future, "the abandonment of the technical label and the abandonment of strict scientific arrangement of exhibits would be projected . . . with salutary results."[5]

Clues for understanding contemporary museum attitudes toward new media technologies can therefore be found in a number of experimental exhibits proposed (if not always installed) in American and European museums at the beginning of the twentieth century. At one extreme, French scientist Félix-Louis Regnault's turn-of-the-century plan for an encyclopedic ethnographic archive strikingly anticipates contemporary visions of the multimedia museum and Web site. In Regnault's imagined ethnographic museum, anthropologists and members of the general public could retrieve written texts, sound recordings, and still and moving images of indigenous peoples at the flick of a switch.[6] In a more prosaic fashion, the Metropolitan Museum of Art in New York City experimented with interactive exhibits in 1901, when it designed an installation that allowed visitors to turn the pages of an art book by inserting their hands into the side of the display case.[7] Contributors to such professional museum journals as the British *Museums Journal* (1901–)

and the American *Museum News* (1924–) as well as popular journals such as the *World's Work*, the *Outlook*, the *Independent*, and *Popular Science Monthly* debated the suitability of various methods of visual display for museums highly conscious of their social function in a culture experiencing the stresses of rapid industrialization, urbanization, and immigration. Responding to what they saw as the shrinking attention span of the urban museumgoer, late-nineteenth-century curators charged with the task of making exhibits more accessible turned to novel methods of exhibit design in search of suitable prototypes for the modern museum.

Despite the widespread use of slides and motion pictures in early-twentieth-century museums, there was little professional discussion of the utility of these or related technologies such as the phonograph or gramophone outside of the lecture format or separate screening venue. One of the earliest mentions of an audiovisual aid in a museum is from 1904, when Dr. Ant Fritsch, one of the first curators to recommend the use of phonograph recordings in exhibition installations, argued that, "The time may not be far distant when we shall be able, by dropping a cent into a phonograph by the side of interesting objects in the museum, secure the pleasure of a short discourse on the exhibit."[8] Fritsch's idea of using the phonograph to provide contextual information on an exhibit—one of the key objectives of contemporary interactive technologies—had already been adopted in the display techniques of world's fairs and expositions; it was at such expositions, one commentator noted, that "what you could not see for yourself you could read, for lecturetts were posted conveniently on each side of the case." That these methods

were considered radical for their time, in the same way that computer interactives were once cutting edge, is suggested by the observer's remark that "here was canned science with the can-opener handy!"[9] But we can also detect an undertone of disapproval here, a sense, perhaps, that in making exhibits more accessible to the public, curators risked compromising or oversimplifying scientific ideas.

While this tension between scientific rigor and popular appeal is something of a truism in contemporary museum criticism, it is telling that it became part of the discourse on museum exhibitry at such an early stage. However, many critics seem as uncomfortable now about the influences of advertising, cinema, and the Internet on display methods as they were concerned about an earlier set of technologies at the turn of the last century. When the Internet and email were just emerging as new convergent media forms in 1991, a report from the American Association of Museums Task Force on Education concluded that, "The key to the realization of the higher value of museums lies in the receptivity of those responsible for objects to new interpretations of their roles. It does not lie in new technologies of presentation."[10]

But new technologies of presentation have always piqued the interest of curators and for quite distinct (and obvious) reasons: for making exhibits more appealing to spectators; for delivering information in memorable and innovative ways; and for broadening the pedagogic and intellectual remit / scope of a display that, thanks to new technology, can articulate its aims more effectively. However, in early instances of audiovisual media use at museums, we can only speculate on some of the possible reasons why new media found a place in the ex-

hibit. For example, in the hugely successful International Tuberculosis Exhibit at the AMNH in New York City in 1908–1909 (fig. 7.1), referred to by the AMNH in 2000 as "one of the most timely and popular exhibitions in [the museum's] history," a gramophone provided commentary on photographs and objects on display.[11] The exhibit attracted 10,000 visitors on its opening day, a total of 753,954 over the course of its seven-week run, 72 percent of the museum's recorded attendance for the year. Staying open for thirteen hours a day on weekdays and until 8 p.m. on Sundays, the AMNH did its utmost to cater to the phenomenal public interest in this epidemic, fulfilling a major public service in terms of health education (fig. 7.2).

A review in *Harper's Weekly* pointed out that at "every stopping-place a talking machine delivered short lectures of warning and advice."[12] A light on another exhibit would also go out every two minutes and 36 seconds to show how often someone died from TB in the United States.[13] While there is no extant discussion of the precise rationale among curators for using a gramophone in this exhibit, one might speculate that it would have played a vital role in imparting public health information to the greatest number of visitors unable to read or even get near the wall labels; second, it might have improved the circulation of people through the exhibits by drawing them away from the crowded walls; and finally, as a novelty with respect to museum display technologies, the gramophone fulfilled the role of a public address system, perhaps in the process underscoring the seriousness of the epidemic. This innovative use of sound technology in an exhibit did not spawn immediate imitators how-

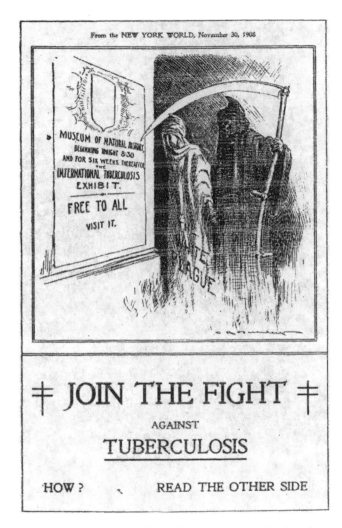

From the NEW YORK WORLD, November 30, 1908

MUSEUM OF NATURAL HISTORY
BEGINNING TONIGHT 8:30
AND FOR SIX WEEKS THEREAFTER
THE
INTERNATIONAL TUBERCULOSIS
EXHIBIT.

FREE TO ALL
VISIT IT.

WHITE PLAGUE

✝ JOIN THE FIGHT ✝

AGAINST

TUBERCULOSIS

HOW? READ THE OTHER SIDE

Fig 7.1 Poster for the wildly popular 1908 International Tuberculosis Exhibit at the AMNH, New York City (From *Harper's Weekly*, 1909)

ever, since one of the next references I have come across to gramophones being used in an exhibit is from 1930, when "automatic gramophones" giving the public information about exhibits were installed in the Deutches Museum in Munich. Gramophones first appeared at the Science Museum in London on May 10, 1931; the visitor pressed a button and the instrument gave "information as to the position of exhibits." The device also described the contents of an adjoining case, and when that was complete "the needle return[ed] to the starting point ready for the next enquirer." [14]

What the appearance of the gramophone in the museum gallery did anticipate, however, was "illustrated radio." The idea was initially conceived as a form of museum extension work (early long-distance learning), offering people in remote regions the opportunity to "listen to the lecture [on radio] with their eyes on the picture the lecturer is talking about." [15] Variously referred to as "Roto-Radio Talks" (talks given in partnership with the Buffalo *Courier-Express* newspaper)[16] or "Radio Photologues," the basic premise was the same: listeners would tune into stations broadcasting lectures while looking at photogravure pictures printed in local newspapers. Some listeners may have been familiar with the idea of remote participation in a concert or talk via the telephone, as seen in this illustration (fig. 7.3) of a woman shown at home listening to the opera (represented live in left panel). The *Chicago Daily News* began carrying photogravure pictures in its Saturday paper. For example, a radio photologue on archaeological excavations at the Mesopotamian city of Kish included maps, numbered and captioned images, and even a "portrait of the lecturer as well as views and exca-

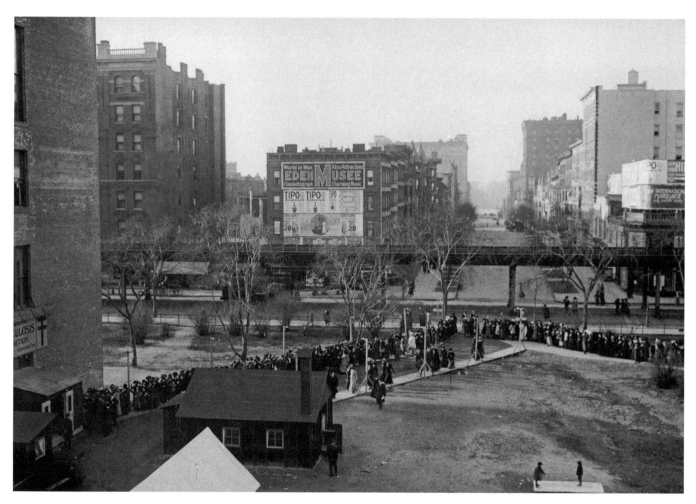

Fig 7.2 School children in line for the AMNH's Tuberculosis Exhibit (January 1909).

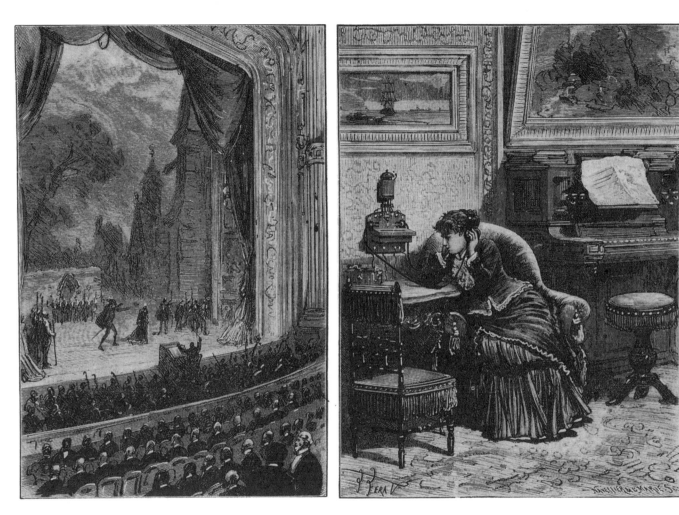

Fig 7.3 Victorian woman listening to opera live on the telephone from the comfort of her home (c. 1890s). (Author's private collection)

vations and striking finds to be contemplated while the loud speaker is in action." [17]

The most common subjects for radio talks were painting, sculpture, and architecture, although the immediate locale of the listening audience also proved a useful resource, such as the series of talks given by officials from the Buffalo Museum of Science and the Buffalo Historical Society on the birds of the region and Native American history in the region (respectively).[18] Schools were quick to exploit the idea with lantern slides projected on auditorium screens substituting for newspaper images. The relationship between museums and broadcasting was not limited to radio, however; the *Field Museum News* reported in 1940 that "looking to the future we see in television a peculiarly efficacious opportunity for the distribution of information to hundreds and thousands of persons simultaneously." As with radio, "instruction, visual as well as auditory" would be transmitted from a central point to school classrooms in "every state of the union." [19]

Of course, this substitution of actual museum artifacts by their mass-produced visual simulacra troubled a few curators, who, despite being generally sympathetic to the democratizing impulse behind the scheme, had reservations about the technique. One writer in 1926 cautioned that, "The use of radio and stereopticon facilities aid materially in reaching a larger audience, but it should be borne in mind that photographs are at best but a substitute for actual objects and that radio talks are usually directed to unselected audiences." [20] Seeing the value in increasing the size of museum audiences, the writer not only predicted the eventual phasing out of radio-museum talks, but identified the key flaw in yoking the new broadcast medium to public institutions such as museums: people wanted to *experience* objects at firsthand and could just as easily borrow a book on a museum-inspired subject from a local library as sit and listen to a radio-broadcast lecture while looking at the Sunday newspaper (the same argument is sometimes made today about audiences possibly being more interested in viewing objects than electronic or digital technologies duplicating information available on the museum's Web site or from the Internet). Radio's status as a mass medium was also regarded with some suspicion; the talks, we are told, are "usually directed to unselected audiences"—suggesting anxieties about the casual and aleatory nature of the broadcast audience.

These anxieties have been reawakened in the museum world's appropriation of the World Wide Web, a radical democratizing effort that nevertheless brings its own set of attendant concerns about audience, control of information, and use patterns. While some may question the extent to which museum-themed radio broadcasts qualify as early examples of interactive media or audiovisual techniques in the museum—the visitor did, after all, remain at home while listening to the lecture—they nevertheless underscored the conditions of possibility for media's role in the museum that were being furthered in the institutions themselves.

They prepared visitors for interactive technologies in several ways: first, they smoothed over the potentially dislocatory effects of a disembodied voice imparting an object lesson (visitors were used to attending lectures but not to listening to machines); second, they required interaction on the part of visitors, who needed to locate the images in order to fully follow the lecture; third, in

similar ways to contemporary computer interactives serving as sponsorship vehicles for large corporations, they functioned as promotional tools for museums and broadcasters who hoped to capitalize on the free publicity; as a reviewer of the 1925 book *Broadcast Over Britain* argued: "Broadcasting will undoubtedly affect the attendance and utility of our museums. . . . Many of these lectures deal directly with material on exhibition in museums, and the general public is not slow to follow up on such lectures by an inspection of the exhibits themselves. . . . Thus there is a link between the 'unseen speaker' and the silent museum exhibit." [21]

Broadcast museum lectures served not only to shore up the idea of radio as a civilizing apparatus, but they also provided a concrete instance of the possible synergy between a very old mode of communication—exhibits in glass cases—and a uniquely modern technology. Such initiatives supported the idea of radio as a democratic force, with the new medium associating itself with the civic and pedagogic prestige of the esteemed institution of museums. Likewise, many museum administrators welcomed radio's purported democratizing influence and educational potential. Radio might also come to the rescue of the museum lecture, which some critics argued was inexorably threatened by the onslaught of modernity; an editorial in the British *Museums Journal* cautioned that "the conditions in our modern cities, with their clamor of bright advertisement, sky signs and cinemas, may have the effect of training the faculty of visual attention at the expense of the auditory, so that people may be beginning to find it harder and more fatiguing to listen than to look." [22]

That the illustrated radio lecture fell prey to a decreased audience attention span may come as no surprise, but ironically radio did prepare the ground for experiments in museum-based radio broadcasts and gramophone sound displays in the gallery itself. For example, in 1929, "listening circles" were established in museums and libraries, an arrangement in which a small group of visitors would sit in comfortable chairs around a loudspeaker and listen to a broadcast lecture while looking at the artifacts being described. According to C.A. Siepmann, head of adult education at the BBC at the time, "With the exhibits ready to their hand, the wireless talk and subsequent discussion would have for listeners a new significance." [23] The mention of comfortable chairs in this experiment with museum-based radio was picked up the following year in a discussion of seating provisions for visitors to technical museums; while the recommendation for the inclusion of stools is no match for comfortable chairs, it is interesting that the suggestion that "anything that will induce visitors to rest at intervals is to their benefit" is nevertheless connected to the role of music and radio in the museum. In the absence of chairs, however, music was likely to generate a quite different response from visitors, as evidenced in this *Daily Telegraph* notice of Strauss waltzes being banned in the London Science Museum's gramophone concerts as a result of people "being inclined to use the polished floors of the museum for dancing." It was concluded that for the twice daily "gramophone concerts" to be a success, "the music has to be of a serious character." [24]

The gramophone and radio were thus conscripted as both enabling and productive as well as disciplinary agents, ways of capturing visitors' attention *and* control-

ling their behavior. For those visitors with specialized interest in exhibits, stools made perfect sense as a way of taking the weight off one's feet while sketches were made or specifications noted.[25] Aids to relaxation in the museum—furniture or music used as a "true accompaniment" to the predominantly visual experience on offer to visitors—were thus part of a growing cultural reconceptualization of the museum as an enveloping space, as explained by an anonymous contributor to *Museums Journal* in 1931: "The moment the sound of music reaches the ear the objects of vision seem enveloped in a new architectural form of space and are seen as it were in a different light . . . aesthetic significance is enormously heightened when the music is so related, and *ear and eye walk as it were together through enchanted space.*" This multisensorial enchanted space is, I would contend, a precursor to an interactive, multimedia space that we find in contemporary museums; we have simply redefined preexisting desires to create novel contexts for objects, be it surrounding them with sound or transmogrifying the space from an ocularcentric one into a more sensually rich encounter with object and its context. That cinema should emerge in the gallery right around this time should come as no surprise; there's even an ironic reversal at play here, since as film slowly crept into the museum gallery, so too did museums slowly creep into film, appearing as dramatic settings in films across the globe. Indeed, such was the demand for images of museums in French films in 1932 that one critic noted that it "has been necessary to draw up a detailed tariff applicable to all manner of films, whether purely documental or for scenarios" (public monuments were also subject to tariffs).[26]

Back in the early 1920s, though, steps toward full adoption of motion pictures in the gallery were taken with ambivalence. For example, falling short of fully endorsing the use of film in the gallery, the 1922 author of "Museums and Movies" tempered optimism with caution:

> Many lessons are best taught by motion-pictures . . . all the processes can readily be explained in a lecture-room with the help of motion pictures. . . . [However], motion-pictures, to have an educational value, must be edited by someone in close touch with the work of the school, and must be presented in the right way and at the right time. . . . From the museum's point of view, the chief difficulty is the preservation of the films.[27]

The thorny issue of the suitability of films for museum use (as I've documented elsewhere, films in the museum generated considerable debate among curators), their proper presentation to audiences, and their storage in the museum emerged in ongoing discussions of film throughout the 1920s.[28] Concern about the "effects" of motion pictures inspired the Payne Fund Studies, a series of thirteen social psychology research projects conducted between 1929 and 1932, some of which were concerned with the deleterious effects of motion pictures on the emotional makeup of young people. Even leaflets produced to accompany lecture series in museums were not immune from criticism, lumped together with motion pictures as yet another example of modernity's mind-numbing tendencies; as one reviewer put it several years before the Payne Studies began: "the danger of a multiplicity of lectures, films, and leaflets is that which has been urged

against cinema, viz., that it may tend to produce a state of mere 'passive receptivity' in the child's mind."[29] Similar criticisms were directed toward broadcasting in general, with arguments made that audiences "may listen and accept the broadcast . . . in an entirely passive and uncritical frame of mind."[30] Barbed comments about the lowbrow status of cinema were voiced across the Atlantic too. The Secretary of the progressive Imperial Institute in London, Major O. J. F. Keatinge, was attacked in the pages of *Museums Journal* in 1928 for exploring retail-inspired shop-window advertising and considering free cinema shows. Worrying that Keatinge's suggestions "might send a crowd of curious to our museums," the editorial equated his vision with that of P. T. Barnum, "too much from the point of view of the business manager of a wax-works show" than of a highbrow institute of cultural enlightenment.[31]

The mid- to late 1920s and early 1930s thus mark a turning point in regard to the adoption of audiovisual media, since it is at this point that we begin to come across references to projectors appearing in the gallery.[32] The larger historical moment here, the late 1920s and early 1930s, clearly played a huge role in nurturing film's emergence in the museum, so much so that one could easily devote several pages to analysis of such issues as the transition to sound in 1929, visual tropes from advertising and popular culture that bled into the iconography of filmmaking, the appropriation of film as a powerful tool of propaganda through Franklin D. Roosevelt's 1933–34 New Deal initiatives, documentary filmmaking, and, as I discuss below, film's pivotal role in the field of audiovisual education, which came of age during this period. In spite of the Depression, film was increasingly looked upon as a powerful force to shape cultural values; as Terry A. Cooney writes in *Balancing Acts*: "Both private organizations and public boards had long worked to control what they regarded as the immoral or socially dangerous possibilities of the movies, and preferably, to turn them into bastions of acceptable middle-class standards."[33] While a lot more could be said about the larger sociocultural moment, suffice it to say that in co-opting film, curators were inevitably inheriting the ideological baggage film carried around with it at this point in its history.

One of the earliest discussions of gallery-based film exhibition I have come across is from 1925, when a "new venture" that had proven to be extremely popular with visitors was tried at the Imperial War Museum, London, namely, "miniature cinematograph machines which show portions of films such as destroyers in action."[34] A name was given to this apparatus five years later, when an article in *Scientific American* reported the invention of the Dramagraph, a projector housed inside a wooden cabinet with a small screen (fig. 7.4). Designed to alleviate the problems of using brittle 16mm film for "nickel-in-the-slot" projectors which "must operate hour after hour and day after day, thus requiring the films to run through the mechanism thousands of times," the apparatus employed thin steel-clad 16mm film.[35] A longer description of the Dramagraph appeared in a spring 1931 issue of *Museums Journal* and is worth quoting in full:

On the front of the projector cabinet are a push button and a framed card announcing the subject of the picture and inviting the visitor to "Press Button Below." When the button is pressed the

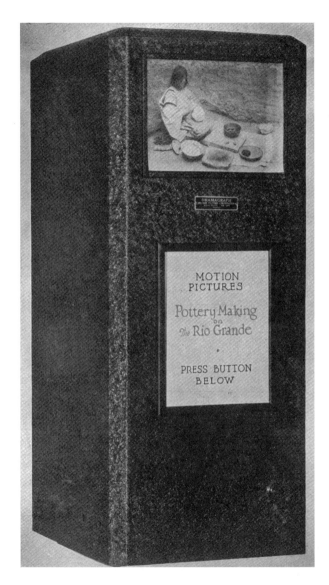

motion picture appears on the translucent window built into the front surface of the cabinet. After the picture has been shown (100 feet of 16 millimeter film—4.5 mins. of duration) the mechanism automatically stops, automatically resets itself, and is ready for the next showing when the button is again pressed. There is no re-winding of film, no need for an attendant or fireproof booth, and no breaking or scratching of film. The apparatus is operated by connection with direct electric current.[36]

Automation was clearly the major appeal of this apparatus, which ostensibly required no attendant to oversee its operation. This was not the first time, however, that an automated device had been used to illustrate museum artifacts. As early as 1922, the Art Institute of Chicago established in its museum instruction room an "automatic lantern, which gives a continuous lecture of forty-six slides." An early version of a tape-slide apparatus (a device that allows recorded narration to be synchronized with 35 mm slides), the lecture lasted nine minutes and took the form of alternating pictures and captions (each slide was projected on the screen for twelve seconds). "The machine is arranged with two parallel magazines, each consisting of two compartments—a delivery compartment and a receiving compartment. The magazines present their slides in alternate rotation. When the forty-six slides

Fig 7.4 The Dramagraph ("Automatic Motion Picture Projector"), showing *Pottery Making on the Rio Grande* in the North American Indian Hall at the American Museum of Natural History, New York City (c. 1930).

have been presented, the lecture is repeated without an interval."

The Dramagraph was clearly building upon preexisting techniques of automated visual instruction in the museum, although unlike the automatic lantern, its novelty would have been considerable, especially for younger visitors who were not old enough to remember the kinetoscope parlors of the 1890s. Constructed by the New York City–based Dramagraph Motion Picture Corporation, the projector found an early home in the North American Indian Hall at the AMNH,[37] showing a film on Pueblo Indian pottery making, and at the Museum of Science and Industry in New York City, where a Dramagraph was enlisted to illustrate an exhibit on the development of weaving. Each machine was equipped with an automatic counting register to check the number of times it had been used; initial surveys indicated that machines in use at the AMNH in 1930 were operated on an average about 80 times per day, increasing to about 100 times daily on weekends. Despite being loaned six machines for a free trial in fall 1928, the AMNH decided not to purchase them two years down the road at a cost of $265 each. The museum quickly discovered that the average life of one of the films was one month and the Dramagraph mechanism was not yet advanced enough to warrant significant investment. Despite overhauling the technology in spring 1929 and installing two new machines in September 1930, by the end of the year the museum declined to purchase the machines, citing budgetary constraints as the primary reason.[38]

Discussions of gallery-based motion picture projectors were also taking place in the UK at the same time, including a reference in a paper delivered to the British Museums Association's 1930 Annual Conference in Worthing by English curator Dr. E. E. Lowe, who enlisted a Kodak representative to demonstrate a "small experimental projector" (possibly a Dramagraph or certainly an instrument modeled on the same principle) to illustrate his talk:[39]

> We should not have a separate cinema hall or room in the building, but that in at least one of the more dimly-lighted corners with which most museums are provided we should fix up a projection apparatus which a visitor could start into action just as he starts a machinery model moving in the Science Museum, by pressing a button or switch. The screen would be small but of sufficient size to be visible in dull daylight to twenty or thirty people, if so many had gathered. . . . By pressing a switch the visitor starts the show and gives himself and his party a performance which lasts say five minutes and then repeats itself.[40]

Thus, the space of the museum would be transformed by the operation of the motion picture projector, arresting the fluid movement of spectators as they are invited to gaze at the screen for the duration of the film's performance. On the other hand, since there is no way of knowing the nature of the movements of a 1930s museum patron, one must also consider the possibility that a five-minute film might have had the opposite effect of indeed quickening a visitor's pace. It is difficult to know whether film in the gallery was likely to be part of the conditions of the contemporary, impatient glance or mitigate against it. Given the novelty of motion pictures in a space where the

only movement one would expect to see is that of another visitor or, possibly, a machine demonstrating an industrial process, I would argue that film *did* have the desired effect of attracting spectators, perhaps even more compellingly than today, when visitors are so familiar with video-walls and plasma displays found in large retail stores that even if they stop for a moment, they usually do not stand for the duration of the screening, unless the visuals are extremely captivating. Of course, there are bound to be exceptions, instances where gallery videos transfix visitors, performing a similar hailing function as diorama life groups (taxidermy specimens or mannequins arranged in naturalistic tableaux), although my sense is that actual objects are far more captivating than flickering images displayed on a monitor, unless the monitor takes up an entire wall and the images are jaw-droppingly beautiful or mesmerizing.

The architectonics of static display thus becomes the time-bound space of performance, as the visitor is expected to divert her or his attention away from the surrounding exhibits toward the motion picture screen. That the projector's position in the gallery warrants a careful selection of lighting conditions (a "dimly-lighted" corner in "dull daylight") suggests a negotiation between the needs of motion picture projection on the one hand and exhibitionary space on the other. While the "projection apparatus" evokes the self-service quality of the early mutoscope in terms of the agency it afforded the spectator, unlike its peep-hole predecessors there is a very public feel to this event; in contrast to the mutoscope, the exhibition is, or at least has the potential to be, a collective experience, should another visitor decide to stop in front of the screen. The London Science Museum referent in the above description helps the reader make the discursive leap between the concept of interactivity as understood in the Science Museum, where visitors activate machinery by flicking switches, and gallery-based motion pictures which demand a similar level of involvement. Recommending that the film subject be changed every month and that, where possible, guide-demonstrators be enlisted to use the projector in conjunction with gallery talks, Lowe ends his proposal with a discussion of the costs incurred in the purchase and upkeep of the film apparatus.[41]

Lowe's paper appeared in a special issue of the *Museums Journal* devoted to film in the museum; in the issue's editorial, entitled "Museums and Movies," science and children's museums were praised for their ability to draw and sustain the interest of audiences through the use of illusionistic dioramas and reconstructions. But now, the journal editor notes, "the cinematograph has come to change all that and to give us real living pictures, to bring all the life and movement of the world onto a few square feet. . . . It is not surprising that a few go-ahead museum people have seized on this as a new and greater aid to their educational activities."[42] In the same way that taxidermy and dioramas could vivify specimens and function as hailing devices in the cluttered gallery spaces, so too could cinema, the novelty of seeing film projected in the gallery a draw in and of itself. The fact that the screening was "automatic and repeating" provided the museum visitor with an experience not dissimilar to that engendered by today's video screens and interactive kiosks.

Similar experiments with gallery motion pictures were taking place at the Deutches Museum in Munich, where

an apparatus that could be "set in motion by the visitor" was on display in 1930. In an announcement of the device in the British *Museums Journal,* the author noted that, "Ordinary museal [sic] illustration of physical and chemical principles is unattractive, but the visitor whose active co-operation is enlisted, if only to the extent of pushing a button, is sure to have his interest aroused."[43] A notice posted by the Secretary of the British Museums Association in a 1934 issue of *Museums Journal* requesting feedback from curators on the inclusion of "mutoscope machines" indicates a level of institutional acceptance by the mid-1930s; the information being sought included how the times of shows were regulated by curators (in other words, "did the projectors function only when set by visitors, are at fixed intervals, or continuously?"); the types and source of machines employed (whether mutoscope or projection screen); whether the apparatus had proved reliable; and finally, the types of films shown.[44]

One can't help but notice that we have come full circle in regard to the selection of suitable titles for museum exhibition in the 1930s; the following list of films programmed by Sir William T. Furse, director of the Imperial Institute in its 1927 Christmas screenings, are virtually identical to IMAX releases exhibited in museums of natural history: *The Epic of Everest, With Captain Scott in the Antarctic,* and *My Polar Adventures with Shackleton in the Antarctic.* In our current Bush-era of neo-imperialist "regime change" and imagined communities of "freedom-loving" citizens, perhaps even *Outposts of Empire,* a film listed in the 1927 lineup, is not too outlandish a title for IMAX to consider.[45] There is, of course, an IMAX screen currently operating at the Science Museum in London,

the reference point in the 1930 Dramagraph example discussed earlier, home also to over sixty interactive exhibits in the high-tech Wellcome Wing (including "Comment," an award-winning exhibit with a track network of 27,000 LED units allowing messages to be sent through a maze suspended over all four floors of the gallery space).[46] Notable too in this special issue on cinema of *Museums Journal* is a discussion of film as an illustrative aid in the exhibit halls *and* as a part of the museum's programs in public auditoriums. In a section on the exhibition of motion pictures at the Imperial Institute in London, where films were shown daily in four separate programs, Furse noted the difficulty of finding suitable film subjects, although he reported that with the formation of the Empire Marketing Board, headed by John Grierson, the situation was improving rapidly.[47] That the Dramagraph or similar devices represented a breakthrough in museum motion picture exhibition is indisputable, since the technology, if not the name, has endured as a means of providing contextual material for exhibits, spawning hands-on computer interactives, and more recently, digital screen-based exhibits.

Interest in "mechanical aids to learning" increased exponentially during this period, as evidenced by a three-day exhibition presented by the British Institute of Adult Education at the London School of Economics in 1930. The event showcased "visual, aural, and other aids to learning," including such subjects as "television, educational talking films, and the use of the cinematograph in schools." A contributor reporting on the exhibition in the *Museums Journal* reminded readers that "in view of the growing importance of the cinema in museum work, cu-

rators should make a point of seeing this exhibition which will include a wide range of immensely interesting instruments and apparatus."[48] Excited by the fact that most of the leading firms connected with the production of the cinematograph, the gramophone, the lantern and Epidiascopes (optical device for projecting flat, opaque images), and the microscope would have stands in the exhibition, the author visited the exhibition in the hope of "finding there a cinematograph instrument of the *press-the-button type* suitable for use in museums. There were, it is true, at least two types of continuous cinematograph on exhibition, but, alas! there were difficulties connected with both which render their use in museums out of the question at present."[49] If this response to "press-the-button type" projection devices is in any way typical, it would appear that in spite of the assurances offered by Dramagraph convert Dr. Lowe, some curators nevertheless remained skeptical of the suitability and durability of these "continuous cinematograph" devices.

Notwithstanding this cynicism, by the late 1930s the dual functions of film in the museum had reached a high degree of intellectual and logistical maturity. The 1930s were instrumental in elevating audiovisual aids in education to a level of institutional recognition (if not widespread adoption) and spawning discussion of best practices along with the challenges involved in acquiring suitable films and increasing their status within the curriculum. Film also gained institutional recognition in other vital arenas, such as the opening of the Film Library at MOMA in 1935, which Haidee Wasson deftly explores in *Museum Movies: The Museum of Modern Art and the Birth of Art Cinema*. The express needs of public education were stated plainly in the Film Library's mission statement to "trace, catalog, assemble, preserve, exhibit and circulate to museums, colleges, educational and study groups, single films or programs of all types of films." The Film Library would also "edit and assemble these films into programs for exhibitions" and "arrange for the circulation of projection machines to colleges and museums lacking this facility."[50]

Writing on the establishment of a National Film Library in the UK (a counterpart to MOMA's Film Library), Ernest H. Lindgren offered the following assessment:

Already some museums are using films to illustrate activities in their particular field, from the short cyclic band of film, which can be seen by pressing a button, to the showing of special films, with or without a lecturer. I am convinced that the day will come when no museum will be without a projector. There is no other way which can so infuse with life and movement the apprehension of a series of objects which ordinarily tend to remain . . . static, isolated articles in a showcase.[51]

The decade spawned considerable literature on the benefits of instruction via film and establishment of guidelines. The phrase "audiovisual aids to instruction" developed a certain cachet at the time, with one author identifying cost, distribution, availability, and misinterpretation of function as the main challenges facing film's development as a teaching tool. While this debate played out in the context of school-based instruction, it is certainly relevant for the emergence of film in the gallery, especially since discourse about how film might effectively

drive home object lessons in a wide range of curricular areas (which had, incidentally, been voiced in the motion picture trade press and popular magazines and journals since the early teens and even before) resurfaced at this time.

One of the themes dominating these discussions was the idea of science and education coming to the rescue of film, which had been decried by some moral conservatives as popular culture's nemesis. In an essay entitled "Is There a Technique for the Use of Motion Pictures in Schools?" J. Edgar Dransfield claimed that once science had come to film's aid, "a future began to become visible on the screen." Writing in 1927, when the audiovisual education movement (if we can call it that) was still evolving, Dransfield ended his essay with a pessimistic assessment of the status quo, which included a "widespread tendency toward [the] introduction of film," a "decided paucity of authoritative literature," the limited number of institutions offering courses in how to use motion pictures, and a lack of training for the classroom teacher. What film had going for it at the time was a belief that it could embed information more fully and permanently in pupils' brains, especially when compared to text-based facts, and that the child had a "better conception of the thing he sees than he has of the thing he hears or reads about." Information could also be imparted faster ("in less than one-fourth of the time required by those who learned the same material from reading and oral discussion") and with even more efficacious results for "students of lower mental capacity." [52]

However, lurking in the shadows of many of these discussions was a fear of passivity, defined as a condition of mental inactivity that threatened to tip the balance of the experience in favor of entertainment versus education, lulling school spectators into a state of somnambulism that offered little more than loose change in terms of the educational return on the initial film-screening investment. An experiment conducted at Hyde Park High School in Chicago in spring 1936 drove home this point, the researcher making the case that "the mental set of the pupil toward the motion picture must be changed," since "the 'movie' has meant recreation to the young American [and] any informational gain has been a by-product of, or a sort of side issue to, the main end of entertainment." [53] The transitory nature of the film experience, the fact that, as study author Grace Hotchkiss put it, "so accustomed are they to watching a picture, enjoying it for the moment, and then forgetting it," that contingency plans were called into place to counter this typical spectatorial response. Activities proposed in the Chicago study included advanced planning of a series of questions, a summary of the film's pertinent points, and such pedagogical techniques as lectures delivered by the class teacher or pupils, extemporaneous teacher comments, reports prepared by a committee of teachers, and lectures by experts.

Dransfield's experience of motion pictures was the complete antithesis of this; with little advance knowledge of a film's arrival (a school was given a "certain 'day' for movies") there was no adaptation to the curriculum, with the pictures shown after school or during an auditorium period where as many pupils as could be crammed into the seats were herded into the hall. As Dransfield explained, "Many times the principle or other person in charge does not know what picture is coming, has never reviewed it, and had had little or no choice in the selection

of it."[54] Finding suitable titles that wouldn't put a strain on a school's already stretched resources became easier when audiovisual instruction was institutionalized in the 1930s and 1940s; many films were produced by government agencies and could be rented either free of charge or for a nominal fee. Figures from the 1936 Chicago study list the average cost per reel as being $1.50 per day (of the 35 films used in the experiment, 27 were loaned free of charge, bringing the total cost of the program to $27.50).[55]

If this discussion of the role of film in public education in the 1930s seems a digression, it's important to point out that any analysis of the emergence of film in the gallery should be sensitive to developments in audiovisual education in general. As part of the general zeitgeist, film's growing stature as an instructional tool would doubtless have informed decisions made in the museum about whether to include audiovisual illustration. Given that the AMNH had significant experience as a lending library with a long history of working closely with schools, curators in its education department would likely have been exposed to many of the key issues governing film use in the gallery through their collaboration with New York City schools. Even if curators in the education department weren't directly involved in shaping film policy at the AMNH and played no role in exhibition design, it's hard to believe they had not at least *considered* the idea of film's role as an educational tool. The decision to include film in the gallery was not made overnight and should be attributed to several developments such as an emerging film education movement in schools and innovations at the museum including the Dramagraph, the use of photographic transparencies in displays, and habitat groups (dioramas). Film in the gallery also came of age in the 1960s and 1970s, coinciding with the nascent video art movement and a spate of temporary exhibits installed at the AMHH in the 1960s and 1970s. Temporary exhibits, by their very nature, are always more conducive to experimentation in display techniques than permanent halls, which require far greater capital outlay in order to be updated. Let us now jump ahead and turn to major developments in gallery-based film at the AMNH in the late 1960s.

MULTIMEDIA AT THE AMNH: "CAN MAN SURVIVE?" AND IMMERSIVE SPECTATORSHIP

The New Word in commercial museum exhibition is Multimedia. This is the SoadChlor in the prescription the doctor wrote to cure the museum's exhibition ills.

—William A. Burns (1969)[56]

The search for innovative methods of immersing spectators in exhibit spaces has been something of a holy grail for museum curators. From ambitious habitat and life groups offering three-dimensional slices of life crammed into glass-fronted dioramas to such relatively simple techniques as scale models, the goal is always the same, as this description of a Walrus Harpooning model displayed at the Brooklyn Children's Museum in 1917 makes clear—encourage viewers to psychically invest in an exhibit so much so that they imbibe its very atmosphere: "The atmosphere of intense cold has been effectively secured by means of colored lights and screens."[57] The idea

of museums appealing to the human sensorium has been the subject of countless articles throughout the twentieth century, with some curators such as 1950s Guggenheim director James Johnson Sweeney comparing museums to traditional communication channels, claiming that the only major difference between a museum and a book was that "the visitor actually moves through the exhibition and becomes part of the installation, while the book always remains an object apart. But each speaks primarily to the *senses* of the observer, and each in the end, to have its effect, must be assimilated or digested intellectually." [58]

Curators and designers thus looked beyond the scientific purview of their subjects when making decisions about displays, influenced the most perhaps by the commercial world of department store window display, whose aesthetics crept into the museum in the late nineteenth century and was still something of a novelty in 1941, when an essay on Native American art at the MOMA praised one of the exhibits for approximating that of a "topnotch modern department store." [59] The same year, a spokesman from the Rochester Museum of Arts and Science pushed the envelope even further with a novel take on the period room and yet-to-be-coined "heritage center" idea of having costumed artisans demonstrating such skills as blacksmithing, glass blowing, and weaving. [60] In his clarion call for "revivification," the author argued that period and group rooms should be viewed as stage settings with actors present to *dramatize the subject presented.*" With this approach, "the old country store will awaken to life; the fire house will present its familiar scenes; the pioneer kitchen will demonstrate what happened there." Anticipating criticism, however, the author went on the defensive:

Is this as undignified and unworthy, as the thin-skinned critic with fixed ideas would claim? Far from it? If it is legitimate to imagine *backgrounds of action* it is just as logical to imagine, with facts for a guide, what the actors did. After all, backgrounds without human action, without the sounds of voices and the bustle of life, are false and at best fragments. Why not make the museum a real institution of ideas—dramatized ideas with the ideas in action just as they are in real life? And why not bring back the life? Let's make the mummies walk and talk our language! [61]

Colonial Williamsburg was among the earliest sites to fully embrace the idea of sensory perception via reconstructed scenes from the past, although the American Wing at the Metropolitan Museum, which opened in 1924, was pivotal in normalizing the period room as a means of museological display in North America; as historian Edward P. Alexander noted in 1961: "These historic houses and villages somewhat haltingly discovered a powerful new principle of educational motivation." Visual, oral, and olfactory registers were all summoned to create a sensory cornucopia at Colonial Williamsburg, as Alexander lyrically recalls: "the flame of a candle flirting with its mirrored self . . . smelling leaves smoldering in a cobblestone gutter, hearing the minor chords of the folksinger's guitar . . . tasting the horehound drops in the odoriferous Apothecary Shop. . . . These sensations take visitors back to their childhoods, remind them of experiences buried deep in the subconscious, and foster a nostalgic feeling of having passed this way before." [62] Latent in both these

examples is the promise of synesthesia, a heightened sensory awareness that occurs when certain exceptional individuals are able to experience information derived from one sense accompanied by a perception in another (the idea of a color radiating a certain smell, for example). This interest in multisensory museum experiences was also driven by *son et lumiere* spectacles in which, according to Alexander, "the audience does not see actors, but its imagination and emotions are stirred by listening to a stereophonic soundtrack carrying dramatic voices and music, and by observing the suggestive and artistic use of light." [63] At a time when film was still attempting to gain a foothold in the gallery in the late 1930s and 1940s, museum curators and commentators continued to make heartfelt pleas about the need to imbue exhibits with life and thus lay the ground for a new wave of exhibit design that would come of age in the 1960s with such exhibits as "Can Man Survive?"

"Can Man Survive?" was a two-year temporary exhibit that explored the deleterious effects of industrialization, overpopulation, and environmental neglect in the first half of the twentieth century. Designed to commemorate the AMNH's centennial (1869–1969), the exhibit opened in the Roosevelt Hall on April 10, 1969, and garnered considerable press coverage due to its controversial content and, more significantly, mode of address. At a cost of $700,000, the 4,200 square foot (approximately 65 feet wide, 64 feet long, and 45 feet high), 110-ton exhibit was unlike anything else that had ever been seen at the AMNH; the outer structure of the exhibit was made of a Takanak Truss (a computer-designed metal frame supporting the entire structure) that was being used for the first time in the United States (Dimensional Communications Inc. of Paterson, New Jersey, was responsible for the exhibit's media content). Reminiscent of a large Russian constructivist sculpture, the external support eliminated the need for any internal reinforcement, thus leaving the interior exhibition space wide open. [64] Promoted as the largest and single most expensive temporary exhibit in the AMNH's history—Gordon Reekie, the museum's Chief of Exhibits and Graphic Arts, went on the record as saying, "we decided from the start that we wanted a 'blockbuster' of a show" [65]— "Can Man Survive?" employed what was then considered cutting-edge "mixed-media," including films, slides, a sound track by Eric Salzman, well-known composer of electronic soundscapes, artifacts, 3-D displays, and a range of textures on the exhibit surface areas including walls, floors, and ceiling (fig. 7.5).

One of the most effective summaries of the tacit goals of "Can Man Survive?" appeared in the June 1969 issue of *A-V Communications*, which described the exhibit as a "controlled communications environment . . . a presentation, which can compel visitors to actually 'experience' a message through a combination of effects that will appeal to their senses. Visitors were not 'preached to.' Instead they see, hear, and feel the message as it unfolds in a series of interrelated experiences." [66] "Can Man Survive?" was quite unlike anything visitors had previously seen or experienced at the AMNH (or in any other museum in the late 1960s for that matter) for three main reasons. [67] First, for its reliance upon mediated modes of communication such as slides, film, and sound to convey the exhibit's central themes; second, for its immersive informational and experiential architecture; [68] and third, for its close ties

Fig 7.5 Interior of "Can Man Survive?" exhibit showing large projection screen (AMNH, 1969). (Neg. no. 334200. Courtesy Department of Library Services, AMNH)

to emerging museum-based video art and activist video. Comprised of four sections—the natural environment and elements necessary for life to exist; the development of technology and exploitation of the environment; how this exploitation is endangering life on earth; and finally, what can be done to minimize ongoing destruction—"Can Man Survive?" made an urgent, if somewhat shrill call for action on the part of the visitor.

Visitors entered the exhibit up a dimly-lighted ramp that was constructed as a sloping tunnel; about halfway up, textures would begin to appear on the walls before the tunnel abruptly opened and the ceiling swept away from the visitor.[69] The exhibit narrative describes the initial setup as follows: "We are standing in the open space of the first area. The walls and ceiling flow together with no abrupt transitions between them. The space is very dimly lit and conveys a feeling of organic unity. Greeting the visitor upon entry are several giant screens (which appear larger than life because of the viewer's deceptively close proximity to them and because they subtend a substantial angle at eye level)" (fig. 7.6). A four-minute film playing on a loop contained the following images:

The dim cold of early dawn covers the upper part of both screens; the lower part of both is black. On the sound track, we hear the gentle sounds of the lapping sea along the shore—the rote that stirs forgotten times in the minds of men. From time to time, the cry of a sea bird is heard. . . . As the sun rises, the volume of the music rises with it, drowning out the sounds of the sea. . . . In measured rhythm, images follow one another of the sun rising over a succession of differing landscapes—differing biomes—the desert, the conifer belt, the tundra, the arctic, and so on. Lastly, it is seen warming the hot, lazy, shallow waters near the edge of the sea.

This introductory sequence performed a narrative function not dissimilar to the classical Hollywood film, establishing an equilibrium that would be threatened by a state of disequilibrium (and not necessarily restored to a state of equilibrium at the end of the exhibit). The rhythmic montage connoted harmony, diversity, stability, warmth, and incredible beauty. The opening area of "Can Man Survive?" corresponded on some levels to the 360-degree panorama, which had audiences ascend a darkened corridor before climbing into the center of the illusionist painting. If the panorama strove to give audiences a transcendental encounter with nature, ancient antiquities, or even the battlefield, then "Can Man Survive?" performed a similar discursive function in terms of transporting audiences whose minds had been prepped—thanks to the darkened entryway—for stimulation and consciousness-raising.

As the visitor entered the second area, a short rear-projection loop film could be seen playing on a hemispherical screen in the background. The opening shot, filling approximately half the screen, was a close-up of a hand, symbolizing the agricultural revolution, soon joined by several hands planting seeds that would turn into crops. Beyond the screen lay the first three-dimensional component of the exhibit, a wall of rocks and logs symbolizing the raw, natural materials exploited by both ancient and con-

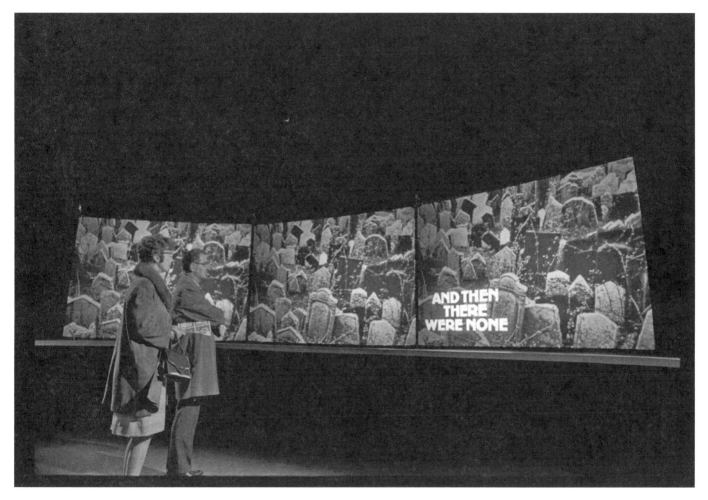

Fig 7.6 Three-paneled screen with caption "And Then There Were None," from "Can Man Survive?" exhibit (AMNH, 1969). (Neg. no. 63942097. Courtesy Department of Library Services, AMNH)

temporary cultures. Museum architect/designer Ralph Appelbaum's notion of the informational architecture of the museum space is literalized here as interruptions in the texture of the wall's surface become opportunities for conveying information about the rise of technology and agriculture. These themes are addressed more comprehensively in a loop film occupying a substantial portion of the end wall which explains how agriculture and technology have made it possible to feed and provide goods for a growing world population. The hypodermic syringe is a powerful image in both this film and in the third area, where it is used to illustrate modern medical advances as well as the catastrophic effects of overpopulation. At one point hundreds of disposable syringes are seen coming off a production line until one is picked up and filled from a bottle. It then moves menacingly toward the camera, virtually filling the frame until it is finally jabbed into the buttocks of a screaming child. Different size black-and-white photographs of people from various races are interspersed with mirrors toward the end of this section to drive home the fact that this is a global problem ("so the viewer will occasionally see himself and more readily identify with the people in the photographs," in the words of the exhibit planners). Photographs of people in groups, at work, school, and play arranged above and below a jagged rising line representing the world's growing population can be seen in the remainder of this second section of the exhibit.

The third area differs from the first two in that its walls and ceilings are heavily encrusted with projecting, truncated pyramids of different sizes, which impinge irregularly on the space, making its exact shape and size uncertain. Addressing global poverty through such heart-wrenching images as a Chilean boy sucking a gasoline-soaked rag and a Biafran child looking for cockroaches to eat, the section's major themes are the challenges of disseminating birth control information to developing nations and combating world hunger (an image of approximately 10,000 people in a crowded stadium corresponds, we are told, to the number of people who die of starvation every day). The overall effect the exhibit planners were after in this third section is "unease" (they actually use this term in the proposal); loop films showing the rise of bacteria, river pollution, and various abuses of the environment from automobile junkyards, burned-out cars, overflowing garbage cans, and a black-and-white film shown on what appears to be a large TV screen of vox populi statements about the negative effects of modern life project a harrowing existence in mid-century America. Initially appearing as photographic stills with a voice-over, the human subjects then begin to speak about the deleterious effects of modernization on their lives.

The architecture becomes even more oppressive in the final section of the exhibit where the "geometrical shapes, no longer truncated, but pointed" protrude further into the space. According to the exhibit planners, the viewer "is assaulted with numerous brief, fragmented statements and displays—graphic, 3-D, projected and oral—bearing on the problems that beset us." Motion picture and slide projectors are housed inside the projecting pyramids, the plastic surface of the pyramid serving as a rear-projection screen. Directional speakers are either placed in the crevices between the pyramids or recessed into the apex of the pyramids and thus closer to

the visitors' ears. The music also reflects the shift in tone from the first area to the third and fourth; earlier melodic themes are "submerged in the dissonant and percussive superstructure . . . [where] rhythms will be broken, irregular and jerky." The final section of the exhibit, the "Virtual Image Sphere," is the most immersive, with the visitor seeing a "rapid succession of various images, mysteriously appearing on both the front and rear surfaces of the sphere simultaneously." Single, contiguous, or superimposed images designed to "rivet the eye of the spectator" are projected, and even though the exit is but a few short steps away from the Virtual Image Sphere, loudspeakers make a last-ditch attempt to "distill the essence of the exhibit's message," insistently, personally, and seriously.

We can differentiate "Can Man Survive?" from contemporaneous and, to some extent, contemporary museum exhibits in several ways. First, the architectural space, as reviewer Richard Danne, writing in *CA Magazine,* noted, "excludes all outside distractions, visual and audible, and allows the viewer to become engrossed in the flow and atmosphere of the exhibit."[70] In this windowless and increasingly airless space (the air conditioning is deliberately turned down to create a more claustrophobic, stifling, oppressive atmosphere), there is no opportunity for diversion, skipping sections, meandering even, since the direction is forward until the light (literally) appears at the end of the tunnel. Upon entering the exhibit, visitors leave behind the neoclassical architecture and pop-up storybook dioramas for a hermetically sealed space that aims to produce a perfect synchrony between exhibit content and design. The same year that "Can

Man Survive?" opened, William Kissiloff wrote at length about multimedia use in the museum, paying particular attention to the role of the total environment, which in Kissiloff's view was "more important in a mixed-media presentation than in a more conventional show because the mixed-media is more involved with effects and fantasy, and less dependent on face-to-face confrontation." (It was also considerably cheaper than the environment for a static show, since the illusionism was done "more with images, lights, and sound than with expensive construction.")[71]

Purged of any distractions, the exhibit delivers its message with a didacticism grounded in its design and multimedia displays; as the museological equivalent of a *gesamptkuntswerk,* the "total environment" is a precursor of today's hypermediated spaces that Jay David Bolter and Richard Grusin explore in *Remediation: Understanding New Media.* Hypermediated spaces are those that appropriate existing media forms to create a dynamic spectatorial experience in which old and new forms are refashioned (they offer the CNN Web site as a classic example of hypermediation through the way it arranges text, graphics, and video in multiple planes and windows joined by hyperlinks).[72] What makes "Can Man Survive?" especially provocative as an example of proto-hypermediacy is its status as a nonplace (it's not even recognizable within the informational architecture of the AMNH), a descriptor coined by the French anthropologist Marc Augé in 1995 to describe such places as airports, supermarkets, multiplexes, and shopping malls. Just as these spaces are drained of meaning when not in public operation, so too is "Can Man Survive?" a "pure perceptual experience"

(Bolter and Grusin's term) that depends almost entirely on moving image and sound to get its message across and is defined not by its associations with local history or place (the global referents are largely free-floating signifiers) "or even with the ground on which they are built" (the Takana Truss lifts the exhibit up off the floor of the AMNH) but primarily "by the reality of the media [it] contain[s]."[73] Since there are no artifacts in "Can Man Survive?," sound and image create a new museological progeny, a cross between a funfair ghost train / Hall of Mirrors and a *Star Trek* set.

In one of the few rave reviews of the exhibit from *Museum News,* curator Michael Robbins saw the "total environment of the exhibit" as a positive feature that offered the opportunity for "presenting its message in a variety of ways to an undistracted audience." Commending the AMNH for exploiting this technique "subtly, not in a manner that might force the limits of audience toleration" (as Robbins notes, "one is *not* compelled to wade through mounds of garbage, while rubbing smog-burned eyes"), Robbins nevertheless pointed out that "instead, a variety of by now tried-and-tested exhibition devices is employed."[74] Despite Robbins's reassurances, one might have *actually* walked through garbage if Gordon Reekie had gone full throttle with the immersive gimmicks he had in mind for the exhibit; Reekie, quoted in Robbins's review, admits that, "We thought about such things as piping in some automobile exhaust smell, things like that. Of course, some of those things are too dangerous. *But we were always thinking along those lines.* Something that could truly reach the audience."[75] That Reekie was aiming for an immersive spectatorial experience in "Can

Man Survive?" goes without saying; in fact the exhibit was truly far-reaching in its vision of what could be accomplished in the museum gallery. One is reminded here of "Smell-O-Vision" films such as the flop A-movie *Scent of Mystery* (Jack Cardiff, 1960), which, with the tagline "First they moved (1895)! Then they talked (1927)! Now they smell!" gave audiences a more embodied spectatorial experience through piping out appropriate smells (tactile or "scratch and sniff" books, always popular with young children, attest to the innate pleasure in adding an additional sensory layer to an experience such as reading).

If Robbins is technically correct in his characterization of loop film and slide projectors as "tried and tested" exhibition devices, the throwaway comment belies just how radical "Can Man Survive?" actually was. While these technologies had previously appeared in museum exhibits, they were by no means commonplace, especially as the primary conduits for an exhibit's main themes (the fact that much of the exhibit's lighting comes from the multiple screens is itself evidence of a paradigmatic shift). Robbins also seems inured to the irony in the exhibit's reliance on multimedia (what he calls "mixed-media") to further its anti-technology message, especially when he makes the point about the exhibit using multimedia to argue that technological advances are worsening instead of bettering our lot.[76] In addition, a comment made by the Dimensional Communications designer responsible for constructing the exhibits, Joseph Wetzel, that the "gadgets are not what's important. The big point is that the AMNH had something really important to say, and chose to say it in an appropriate way," sounds a little defensive.

While few would dispute the fact that the message of "Can Man Survive?" was paramount, the AMNH was doing a lot more than simply using "gadgets"; it was validating multimedia's ability to deliver a more immersive experience for visitors, and going out on a limb in its eschewal of traditional exhibition techniques, especially the sacrosanct artifact. This was also an enormous topic to deal with in a 30-minute exhibit (the average time it took to walk through, including viewing all the media), with each of its subthemes such as population control being glossed in two-minute loop films and other supporting visual material. But what did nonmuseum professionals and the general public make of "Can Man Survive?"?

Judging from the reviews, we can glean that the oppressive, menacing architecture elicited a strong visceral reaction from visitors, who were appealed to via multisensory modes of address as opposed to more traditional (logocentric) channels. "Can Man Survive?" took the idea of an immersive learning environment in an entirely new direction, borrowing less from the heightened illusionism of the diorama than from the amusement park "ghost train" or "chamber of horrors guided tour" where the set and mise-en-scène perform as much, if not more, ideological work than the labels. Spectators were metaphorically "assaulted" during their journey through the exhibit by sounds, images, and architectural elements that were unforgiving in their constant attempts to drive home the doomsday message and jolt the spectator into some form of action or, at minimum, an intellectual response.

Not surprisingly, reviewers picked up on this association: Jo Martin from the *Daily News* called the show a "*nightmare* exploration of the world of tomorrow"; Mark Finson from the *Newark Star-Ledger* said that "all manner of civilized *horror* [was] here, in multimedia display"; while an anonymous reviewer for *Product Engineer* referred to the show as "the *shocker,* a solemn, *chilling* report on the lethal decay of man's environment on Earth."[77] Writing in the *New York Times,* John C. Devlin endorsed those reactions, using words like "savage," "psychedelic," "too noisy," "frenetic," "having a great message," and having "no message." (It is interesting to note that Kissiloff defended the idea of multimedia against charges of gimmickry and psychedelia, arguing that since they had become "part and parcel of our lives—we respond to them not as a gimmick, a somewhat daring extension into psychedelics, but as interesting and worthwhile new dimensions to our lives." Notwithstanding these reassurances, some people attending the preview of "Can Man Survive?" found the sound effects and flashing lights "done somewhat in the manner of some television commercials, extremely abrasive, and tending to destroy the main message of preservation of man and nature."[78] And yet television had its share of supporters in the museum community as evidenced in this endorsement from former television executive and Milwaukee Public Museum curator Robert E. Dierbeck: "Although it is not yet extensively utilized by museums, the medium is capable of vital, visual communication, telling the museum story with immediacy, dramatic focus, high interest, and broad appeal."[79] While Dierbeck is talking about the museum's utilization of television to reach a wider audience, his belief in their ability to "inform, enrich, and educate" one another suggests a marriage made in heaven: "as the professional scientist learned the values of showmanship, the professional broadcaster

gained an increasing respect for scholarship."[80] The exhibit's synergy with or reflection of the 1960s counterculture was picked up in a review entitled "Evolution of a Bad Trip" by Wilfrid Sheed; reacting to what she saw as the exhibit's overly pessimistic message about the destruction of various ecosystems in a postindustrialized world ("the way things are going, there may not even *be* any natural history much longer"), Sheed reserved the most disdain for the exhibit's design: "Inside the truss, walls jab at you, electronic music jangles you, ramps rise and ceilings dip—more like a fun-house than a biological cathedral."[81] The Virtual Image Sphere, on which appeared a "rapid succession of vaporous images, mysteriously appearing on both the front and rear surface of the sphere simultaneously," was the final nail in the coffin for those visitors expressing antipathy toward the exhibit's nerve-jangling mode of address. Richard Danne accused the exhibit of being esthetically uneven and with a "curiously weak ending" and wondered why visitors were not given printed literature to take home with them about suggestions for positive action.[82] Finally, Dan Weissman at the Passaic (New Jersey) *Herald-News* called the exhibit "a psychedelic kaleidoscope that belches discordant sound and forces its visitors to grope their way through a semi-dark crazy quilt of amusing and disturbing sound and picture."[83] To validate his response, Weissman quotes "hippy [*sic*]" visitor John ("long curly hair growing in a free-form sprout, rumpled shaggy clothes, sandals, and long or vacant stares"), who described the exhibit as "like a trip," "organic," and 'really say[ing] something."[84] A spokesperson for the AMNH said that visitors emerged from the 30-minute exhibit "either enraged or happy,"

and while the original idea had been to project one hundred years into the future and predict what impact technology and human development might have on the environment, that approach was deemed too risky in terms of accuracy and it was decided instead to stick with the present. Little did the curators know that just some forty years into the future, the impact of global warming on climate change and damage to the environment would finally elevate these issues to serious international concern and front-page status (even in the face of a recalcitrant U.S. administration).

An excerpt from one of the film loops shown in "Can Man Survive?" was aired on WCBS on June 2, 1969, during a feature about damage to the environment. In his segue to the clip, news anchor Michael Keating described the AMNH as "an organization not given to sensation," although in this instance it had produced an "angry and powerful statement . . . illustrating the type of life urban man is increasingly inflicting upon himself."[85] Excerpts from the films used in "Can Man Survive?" were repurposed on other occasions too, a two-minute piece appearing on the KCET/WGBH Hollywood show *The Advocate* on March 8, 1970, during a segment (before Roe vs. Wade) on "whether the federal government should make birth control means available to every American, regardless of age." The film made the case that overpopulation was really another form of pollution, claiming that "no longer can we separate environmental pollution from population explosion." The AMNH gave producer Gary J. Schlosser free access to the film on the condition that the show credit the museum and exhibit during the broadcast (there was also a credit slide at the end of the program).[86]

So how did the techniques used in "Can Man Survive?" move spectators intellectually, politically, emotionally, and somatically? How did they emerge from the exit ramp somehow altered by the experience inside? How effective was this immersive viewing experience in delivering the exhibit's major themes? Performance theorist Baz Kershaw's work on theater and spectacle is helpful here in tying together the exhibit's explicit activist agenda and how that agenda is enacted through a primarily spectacular emotional register that draws upon such related fields as performance and video art, artistic fields experiencing a similarly explosive birth at the same time as "Can Man Survive?" in the late 1960s.[87] Kershaw's ideas on how spectacle gets deep inside that very human part of us, shaking us to the core in some instances, speaks to the role of affect in triggering an emotional response that sometimes leads to direct action on the part of spectators. Visual, oral, and haptical registers are stretched to their limits in this exhibit, which delivers its message in a performative manner; indeed, one could argue that the talking heads and photographs of people in the exhibit are substitutes for absent performers or not unlike the virtual docents in the "African Voices" exhibit analyzed in the previous chapter.

In contrast to proscenium-arch theaters where spectators are seated safely behind the fourth wall, here visitors are immersed in a borderless black box where they are obliged to walk the entire length of the exhibit with no other means of egress or distractions (turning back and retracing one's steps would not have been appealing unless you were pretty close to the entrance). What we find here is a logistics of perception that foregrounds the moving image as a substitute artifact: the indexicality and veracity of both still and moving images in the exhibit are forced to stand in for the authority of the artifact. And yet one could argue that artifacts possess the same (even greater) rhetorical power as images (think of the piles of Holocaust victims' shoes or resistance leaders waving rifles as iconic images engendering strong emotional reactions): they only achieve that power through context and layers of signification (guns and shoes on display at Wal-Mart mean something quite different). If viewed out of context—which the "Can Man Survive?" films were on several occasions—these texts basically tell the same story but on a different emotional register.

While it's impossible to gauge how audiences might have understood the exhibit's message if it had been constructed as a documentary film screened in the auditorium of the AMNH, one cannot help but wonder whether this crossed the exhibitor's mind when deciding how much of the exhibit's discursive weight should be carried by its media content. How did the configuration of space within "Can Man Survive?" transform it into a spectacular reality that hovers between illusion and realism? How were the protocols of "observation" so commonplace in the museum undercut by the more embodied mode of spectatorship conjured up by immersion? If we think back to some *ur*-immersive spaces we have traveled in this book—the cathedral, the panorama, and the planetarium—then we quickly realize how *sublime contemplation,* a recurring feature of each space, is denied the spectator of "Can Man Survive?" Here is a spectacular space that challenges the very orthodoxies of museum display ("what will happen when I take my scientific friends through?"

queried creator and designer Joseph Wetzel). How are our bodies worked on, troubled, challenged, and disturbed in this spectacle of eco-violence? As quasi-performers traveling through the installation, we can only close the circuit of meaning by moving through the various stages of the show; we thus occupy viewing positions that become increasingly unstable and troubling as we work our way toward the end.

What brings "Can Man Survive?" closer to the realm of video art is the (obvious) use of electronic media, psychedelic sound effects, and still imagery to create an emotional and intellectual response, to invite viewers to think about the deleterious effect of irresponsible modern development upon global issues and to respond critically to how a particular set of meanings or ideas around technology are challenged by their re-contextualization in the museum. The sensationalized delivery style of "Can Man Survive?" is also indebted to the world of 1960s advertising, which broke with television's first decade of broadcast commercials by using innovative, experimental, and risqué techniques. This idea that museums should look over one shoulder to the corporate world of modern advertising for inspiration was reinforced by a belief that learning in museums should be painless and effortless. Lothar P. Witteborg, Chief of Exhibitions at the AMNH in 1960, made both these points in an article entitled "Design Standards in Museum Exhibits." Professing that the visitor should feel that a trip to the museum had been "a spatial and visual experience in which the processes of learning came through an unconscious effort," Witteborg went on to trumpet the success of advertising in increasing public awareness of products. "It is therefore only logical," he argued, "[that] our museums should take advantage of advertising techniques along with many of the methods developed by the commercial exhibition designer . . . [who has] to improve the old and to invent new avenues of approach in visual communication."[88] Witteborg's enthusiastic embrace of advertising's rhetoric belied a more sanguine reality in which there was little consensus among curators on the utility of new communication technologies and audiovisual aids, a point driven home in Norwegian curator Carl Nesjar's complaint that directors and museum staff generally showed "all too little experimental spirit as well as insufficient willingness to meet the public halfway."[89] Echoing this criticism at the other end of the decade, J. W. Borcoman bemoaned the fact that when audiovisual media were introduced into the museum they were "not treated seriously," perceived instead as "light relief to the more serious business of [traditional museum work]."[90]

Little attempt was made to "understand these relatively new media or to exploit their remarkable powers for stimulating visual perception"; viewed largely as illustrative devices, supplements to three-dimensional objects located at the very top of the exhibitionary food chain, mixed media were "enough to send most men involved in exhibition design running for cover" in the words of Kissiloff. And even though such use might be considered "the number one crowd-pleaser in every recent world's fair and the single most important new wrinkle in public education," curators were troubled by such phrases as "sensory deprivation," "expanded consciousness," and "audiovisual

olfactory-intake," which were seen as little more than psychedelic babble that even in 1969 would have "turned off" more conservative curators.[91] Former AMNH director A. E. Parr clearly fell into this camp. A curator who had published extensively on the habitat group, Parr called this display method a "mass medium of individualism," arguing that in the process of contemplating this exhibit we see that "the stillness of 'life' in the museums, for which we sometimes tend to be slightly apologetic, is actually a great advantage, offering the museum unique opportunities to be of service to education in ways that other media cannot follow."[92] For Parr, then, the museum's "quiet" mode of address was something to be celebrated rather than tampered with in the service of reaching new audiences or modernizing display methods. Calling the museum a "bountiful source of primary experiences," Parr felt that long-term pedagogical goals should not take precedent over what he described as "the immediate purpose of improving the passing moment, without ulterior pedantic motives." Parr referred later in the article to the museum's responsibility in bringing maximum return to society from the "tasks and treasures it has entrusted to us," further evidence of his object-oriented belief in older models of exhibiting that privileged wonder, astonishment, and a Benjaminian notion of awe.[93]

"Can Man Survive?" was thus a bold, daring, and radical break with dominant museological practices of the late 1960s. By substituting the endorsed materialities of objects for the flickering pseudo-materialities of the screen, the AMNH not only produced a controversial exhibit about the devastation wrought upon global communities and fragile ecosystems but also produced a meta-comment on the possibilities of audiovisual media as conduits for knowledge. And yet in light of the negative reviews of the show's polyphony, disorganization, noise, and cramped quarters (one disgruntled visitor complained: "I can't react to it. There are too many kids running around and it was difficult to concentrate on what was happening"), one wonders if the underlying message might not have been ultimately compromised by the bells and whistles of its delivery. *New York Times* critic Robert M. Smith's comment that the adult or child who "mounts the nylon-carpeted ramp into the brown multimedia container is subjected to a hammering barrage of visual, aural, and tactile sensations that have him wondering when he leaves whether he—let alone man—can survive," while acerbic in tone, raises an important point about the efficacy of audiovisual techniques in museum exhibits.[94]

Younger visitors who had experienced almost two decades of television and were *au fait* with 1960s popular culture may very well have been the primary targets of the message, given their ability to effect change; if Smith's description of "Can Man Survive?" is anywhere close to the mark—"a mixed-media show of psychedelic pandemonium that may entice teenagers to visit the museum and enjoy themselves rather than just to research dull lessons on the biology of dusty invertebrates"—then the AMNH was killing two birds with one stone by attracting constituencies that (unless attending the museum as part of an organized group) would never have stepped inside its doors. Long after "Can Man Survive?" closed, its impact could still be felt in curators' ongoing efforts

to heighten ecological awareness and social responsibility among visitors, as Hermann Krüger argued in 1984: "In this era of programmed destruction by us of our natural surroundings, natural history museums should not merely pontificate worthily on school bigotry and geography, but rather they should establish values, including ecological yardsticks, and thus encourage the growth of responsibility."[95] But how did the AMNH continue to use multimedia in the wake of "Can Man Survive?"? Rather than attempt an exhaustive overview of which exhibits used audiovisual techniques in the 1970s and 1980s, a few temporary shows will be singled out for discussion in the next section.

IN THE WAKE OF "CAN MAN SURVIVE?": AUDIOVISUAL MEDIA AT THE AMNH

What makes "Can Man Survive?" such a fascinating case study is its unprecedented and precedent-setting status at the AMNH; going through the archive in the Special Collections department at the AMNH, one is hard-pressed to find exhibits that were anywhere near as ambitious as "Can Man Survive?" in terms of delivering the bulk of an exhibit's themes through film, sound, and still imagery. The relatively high-tech "Puerto Ricans—Here and There" exhibit (designed by the Puerto Rican sculptor and designer Ralph Ortiz in 1971) comes closest, using 486 color slides that Ortiz had taken, accompanied by cameo-interviews and sound effects. With a budget of $25,000, the show ran for three months and utilized a 20 × 30 foot oval-shaped room housing a "stand-up theater" equipped with "three [9 × 6 foot] screens and five [10 × 6 foot] mirrors" which offered museumgoers a "feeling of total immersion in the subject matter." While Ortiz was criticized by one reviewer for "zeroing in on the culture of poverty and the difficulties and conflicts" of Puerto Rican identity, most critics praised the show for its use of mixed media (photographs, sound, and films). The exhibit was designed by Museum of the Media, a nonprofit corporation started by three brothers in their twenties, who were inspired by the cinematic exhibits at Expo 67 in Montreal. The 486 images were "rear projected on three screens . . . flanked by mirrored walls so that the images [had] multiple reflections. Viewers either stand or sit on the floor, which younger ones invariably do."[96] The soundtrack consisted of hundreds of cameo-conversations with artists, shopkeepers, politicians, and ordinary Puerto Ricans, and, mixed in with ambient street sounds and music, could be heard from overhead speakers.

"The Gold of El Dorado," an exhibit that opened at the AMNH in November 1978, garnered less positive feedback for its use of "piped music reconstructed" from the instruments and the display of gold ornaments on a plaster mannequin. *Newsday* reviewer Amel Wallach criticized the show for not directing viewers' gaze to the most important pieces, which struggled for attention from the surrounding distractions. Complaining that viewers saw the jewelry in "flashes and different angles," Wallach wondered whether "by going back to the original use of what we consider art today, museums could find a new way of bringing such works to life."[97] Earlier the same year, Manuela Hoerlterhoff complained about the use of a "silly little 8-minute film about Pompeii then and now"

featured in the "Popularity of Pompeii AD 79" exhibit at the AMNH, which contained "nothing too deep, or too long, got to keep the guys moving along—narrated by a smooth male voice of the type that sells everything from Brillo to Buicks."[98]

There is little other discussion of gallery-based film or multimedia in the AMNH through the 1970s or early 1980s, although the 1985–86 *Annual Report* did mention the installation of "state-of-the-art video projection equipment [utilizing] . . . advanced video technology including video disc recordings and front projected images to produce shows that are virtually maintenance free." The film *Forever Gold* played continuously in the newly designed Guggenheim Hall of Minerals while *Earth's Wildfire: Evidence of a Dynamic Planet* occupied the three-screen theater in the Hall of Earth History (an 11-minute video on the role of plate tectonics in the formation of the earth's crust). These developments return us to an earlier "illustrative" model of film exhibition inscribed in the Dramagraph, which didn't invite much interaction beyond pushing a button.

The 1986 temporary exhibit "Wolves and Humans: Coexistence, Competition, and Conflict" did, however, engage more ambitiously with ideas of immersion and interactivity. According to the press release, visitors could "walk into a wolf den and experience its musky smell," play the role of a wolf on a computer program demonstrating the odds that the predator must overcome to obtain its prey, and enter a "'howling booth' where they would be invited to howl like a wolf in order to locate a pack of wolves hidden at some point on a lighted board map."[99] In spite of all these interactive features, the centerpiece of the exhibit spoke to the audience's age-old desires to experience a phenomenon up-close and through as unmediated a channel as possible: it consisted of a 30-foot diameter habitat group of a northern woods environment showing twelve stuffed wolves engaged in the winter kill of a white-tailed deer. But rather than allow the group to "speak for itself"(not that the lifeless lupi could make any sound), the curators mounted video monitors around the pack in order to "add the sights and sounds of lone wolves as well as demonstrate the full range of behaviors depicted during the kill . . . [including] feeding, howling, and scent marking around the deer."[100]

It is striking (though hardly surprising) that in its arsenal of display techniques, the AMNH should give the diorama pride of place, concealing the bullet holes signaling the wolves' demise by making them whole again: these are sanitized bodies that hold decomposition at bay for a very long time (although not forever as signs of decay do eventually begin to appear on the pelt or skin as the decades pass). As an *attraction par excellence,* the habitat group thus sits in uneasy tension with the video footage of electronically embalmed wolves; the video footage fulfills a compensatory role here, "*adding* sights and sounds" that have been lost forever through the silencing of the wolves (it's hard not to miss the irony in the fact that the humans are the ones who now do the howling in the exhibit). Presence is signaled here in complex and contradictory ways: which is most "real," the taxidermied wolves or their electronic simulacra on the video monitors? Neither is alive in the sense of being co-present with the spectator as they might be if witnessed in the wild or in a zoo exhibit, but each strives to offer the visitor an essence of "wolfness" or

wolf behavior, compensating via other sensory channels what is lost in their mummification.

Sound is vital here in reconstructing the sensation of being in the midst of wolves, a reminder of developments with audio technology since the gramophone first made an appearance at the AMNH in 1908. The term "talking labels," used by Winifred G. Doyle in 1959, is a reference not only to interactive devices that can be triggered by visitors (examples discussed by Doyle include push-button units at the Cleveland Health Museum such as the "Ceaseless Heart" exhibit which combined a flashing light with an electronic attachment that simulated the sound of a beating heart and a brain illustration in which visitors used earphones to hear explanatory labels) but also to the notion of institutional voice.[101]

This discussion of audio naturally leads us into an analysis of the role of audioguides, which to a large extent have been at the forefront of innovation in content delivery at museums. Aside from including gramophones in exhibits, as was done in the 1908 TB show (discussed above), one of the earliest devices in use at the AMNH was the "Guide-A-Phone," which, while adding "immeasurably to the museum experience of a large number of visitors, especially on their first visit," in the words of Parr, ran the risk of destroying "one of the museum's greatest educational assets, the freedom of each to contemplate what he sees according to his own speed, inclinations, and point of view." A dyed-in-the-wool skeptic when it came to innovations in exhibition techniques, Parr dismissed the audioguide for its regimentation of knowledge; passivity of mind; diminishment of critical alertness; weakening of intellectual fiber developed by a craving for easy learn-

ing; and a "disinclination towards the individual initiative and the personal effort required for a deeper understanding." The "mechanized voice" might also prepare people for the "blind acceptance of any future propaganda to which such methods might equally be applied."[102] Needless to say, Parr's sentiments played little role in deterring the emergence of a wide range of audioguides aimed at "thickening" visitors' encounters with the objects on display. But how has the AMNH responded to changes in exhibit design since the 1980s? To answer this question I will briefly focus on one final example from the AMNH, the Hall of Biodiversity, which opened to much fanfare on May 30, 1998.

ENVIRO-EXHIBITING: THE HALL OF BIODIVERSITY
AT THE AMERICAN MUSEUM OF NATURAL HISTORY

One can tell one is entering the 11,000 square-foot hall comprising the Hall of Biodiversity by the drop in temperature: the air-conditioning is always more noticeable in newly renovated halls at the AMNH and thus is in stark contrast to the stuffy North American Forests Hall that leads into it. One of the Hall of Biodiversity's biggest claims to fame in the press release was its "innovative exhibition techniques with new technologies to launch a massive educational effort to alert the public to the biodiversity crisis and its vast implications."[103] This was a hall with "*spectacular* features," including the Dzanga-Sangha Rainforest, which "*immerses* the visitor in the complex and ever-changing environment"; "The Spectrum of Life" which "*dramatically* depicts the incredible diversity of life

on Earth"; and a " 'BioBulletin' offering *regular* updates on the changing state of biodiversity." [104] Spectacle, immersion, drama, and immediacy; what more could one ask for in an exhibit? The AMNH is not only selling the exhibit, but an *experience* facilitated by the "vanguard exhibition techniques and innovative uses of technology."

And yet one cannot help noticing a strong sense of déjà vu here, a feeling that, to a large extent, we are back in "Can Man Survive?" What *is* new is the way the entire experience has been conceptualized and semantically packaged around the 1990s buzzword *biodiversity*. As the title of the new hall, the word "still trails its newness behind it . . . gain[ing] currency during a time when multiculturalism and political correctness also became watchwords . . . [and] still carry[ing] a whiff of postmodern sanctimony" in the words of a *New York Times* editorial.[105] Here was a word that was hip, high-tech, and so *not* nineteenth century. But as the *Times* approvingly opined, here was "no better place to grasp the scale and meaning of biodiversity, or to purge the word of its false associations." Praising the exhibit for its "stunning visual and intellectual design," the editorial singled out the rainforest diorama for "encompassing the viewer" and providing a "saturation of detail that is a virtual analogue of the complexity and scale of biodiversity itself." [106]

The Hall of Biodiversity is an interesting legacy to "Can Man Survive?" Disavowing a dystopic vision of man's relationship to the environment, the Hall has more gravitas, optimism, authority (it is, after all, a "Hall" rather than a temporary show), and includes artifacts and a large habitat group diorama. Having said this, Niles Eldredge, chief curator for the Hall of Biodiversity, claimed in the press release that the Hall "represent[ed] a fundamental departure from traditional Museum exhibition," although artifacts weren't entirely abandoned as they were in "Can Man Survive?" The desire to construct a "total environment," one that would, thanks to multimedia and interactive exhibits, offer new subjectivities for spectators who would hopefully leave with a heightened understanding of the fragility of the biosphere and the need to become proactive citizens, is enunciated most clearly in the Hall's description on the AMNH's Web site, which interpellates the visitor into the role of concerned eco-traveler: "Enter the Hall of Biodiversity, and the Spectrum of Life comes alive before your eyes . . . the life-sized Dzanga-Sangha Rainforest, complete with sounds and smells, displays a vast array of specimens inhabiting and interacting within one ecosystem." [107]

Touted as a "walk-through diorama that encompasses the viewer," the Rainforest is traversed not from front to back as one might expect in a "walk *through*" experience, but rather the walking is done along the front of the diorama opposite a built-in wooden bench; it most certainly does not encompass the spectator, who at all times is standing in *front* of it not literally *in* it, which would mean being surrounded by the forest. The darkened space, while smelling vaguely musty, demands patience and fortitude from visitors, who must survey the dense undergrowth carefully to find anything remotely interesting to look at. Children, however, do seem to enjoy the sound their feet make on the wooden decking as they race back and forth; and while the benches invite contemplation by letting you take the weight off your feet, there is little to wonder at other than the dark canopy of the forest (with

perseverance, birds and some monkeys can be spotted). The interactives offering additional Web-based content on conservation, located on the perimeter edge of the Rainforest, are too dark to operate and the labels are also indecipherable because of the lighting and their location just off the ground.

While the AMNH should certainly be praised for having accurately re-created a rain forest, the illusion falls short in my opinion for the simple reason that one of the key ingredients of the diorama's success—its frontality, dramatic lighting, and depth of field—are eschewed in favor of the "walk through," which is actually little more than a corridor running the length of the display. Ironically, our appreciation of the special dimensions of the Rainforest is undermined by the fact that we neither look *at it* as we would in a traditional diorama nor penetrate the space by walking from front to back; the Dzanga-Sangha Rainforest is thus neither fish nor foul in the sense of fully delivering on the promise of spectacle and immersion. This was clearly not meant to happen since the diorama's overarching mission, in the words of Diane Treon, a former fund-raiser at the AMNH who worked on the Hall, was to "simultaneously destabiliz[e] the spectator's position as observer." The visitor would then "experience the change of vision necessary to effect [the necessary] change in the world."[108] But the total sensory immersion that seemed so radical in 1998 now pales in comparison to actual rain forest environments at various botanical gardens (such as "Amazonia" at the National Zoo in Washington, D.C., Central Park Zoo, and the Brooklyn Botanical Gardens), theme-park installations, or even our negotiation of Web-based hypermediated spaces; what were cutting-edge in-

novations in 1998 now seem passé, banal even, with few visitors appearing inclined to watch the videos playing on the "Transformation" or "Solution" walls or interact with the computers.

Australian journalist and public intellectual Donald Horne's idea of the museum as "dreamland" through its suspension of reality and the ways in which we each create and re-create our own interpretation of the objects on display is apposite here, especially in relation to the "Spectrum of Life" exhibit, which stands at the entrance to the rerevamped Milstein Hall of Ocean Life. Of course the "Spectrum of Life" is an oxymoron since there is nothing alive here save for the people walking around; the taxidermied animals hanging from the ceiling or displayed in glass cases are also a relic of an earlier mode of museum display in which, as Treon observes, "splayed and arrayed, transversed by pins, tacked to walls, stacked up neatly according to taxonomies of size, habitat, species, order, kingdom, the obedient corpses behind the glass privilege the cool gaze of the observer who passes through the halls for the sheer purpose of mass visual consumption."[109] The "Spectrum of Life" wouldn't be amiss in Barnum's nineteenth-century American Museum, although the plasma screens nestled alongside the wall-hung specimens are there to remind us that, like the exhibit's overarching concept, this show is contemporary, cutting edge, and media savvy. The "Spectrum of Life" nevertheless provides much of the raw material for the experientially rich and immersive dreamworlds we construct from the Hall of Biodiversity: the taxidermied tiger and its entourage of stuffed companions linger in the mind long after we have left and are what young children make a beeline

for during return visits. This eclectic mix of animals and blending of synthetic models of ocean-dwelling creatures suspended from the ceiling privileges a certain interpretation of life's diversity, as David R. Prince explains: "to be able to share fully in the exhibition's interpretation (to become part of, if only for a short while, of the institutionalized dreamland) the visitor must have access to the same overriding criteria that allow such judgements and interpretations to be made and to become accepted."[110]

As worthy as the Hall of Biodiversity may be in imparting vital information about various ecosystems and the threat our existence poses to them, the institution is still producing knowledge along traditional axes of information (diorama and taxidermy specimens); and while the "powerful new electronic tools for learning" may have been considered "new" and exciting back in 1998 when the exhibit opened, they now smack of an era where the glow of the electronic screen or computer interactive was the beacon that would not only hail visitors to the exhibit but somehow recruit technology in the salvage process itself. If "Can Man Survive?" alienated certain visitors by holding them hostage for the duration of the show to its relentless dystopic vision of the future, not only implicating them in the process but punishing them through an array of visual and verbal assaults, then the Hall of Biodiversity similarly runs the risk of alienating visitors through its incoherent space and high-concept but low-on-delivery displays.

If visitors are jaded by the sensory overload of the Hall of Biodiversity and, after one quick dash through the Rainforest, 30-second stare at the "Spectrum of Life" animals, and quick fiddle with the knobs of the interactive stations,

move on in search of more visual spectacle, immersion, and wonder (and are usually not disappointed if they walk straight into the Milstein Hall of Ocean Life where the infamous—recently remodeled—giant whale greets them), what conclusions can we draw about the role of multimedia and screen-based technologies in museums as a whole? Around the same time as the Hall of Biodiversity opened, the AMNH ran a marketing campaign with the tagline "Scientifically committed to blowing your mind" (fig. 7.7). In light of some of the issues raised here, it's unclear whether the hip rhetoric of the tagline superimposed upon the nineteenth-century Romanesque façade is an altogether accurate way of drawing in audiences; it certainly speaks to a desire on the AMNH's part to recuperate a 1960s-era idea (of the mind being blown) to promote the experience as being anything but banal and boring.

A concern that habitat groups and other illusionistic exhibits generate wonder and little else has been something of a bête noire within the museum community; in 1968 design consultant Duncan F. Cameron cautioned that "some observers go so far as to argue that many modern science exhibits teach the visitor how to manipulate the demonstration equipment but fail to teach what is being demonstrated."[111] Visitor studies pioneer Chandler Screven, for example, has argued that "the three-dimensionality of exhibits and their novelty, gadgetry, and manipulatory aspects can have intrinsic interest and generate attention but distract viewers from the main ideas, distinctions, or story line."[112] Subscribing to a similar view, Lisa C. Roberts feels that evocative display settings and high-tech gadgetry may in fact end up "overshadow[ing] the objects they were designed to set

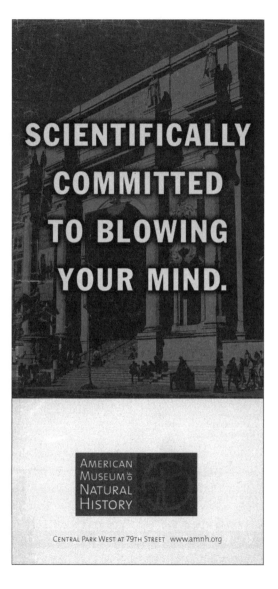

off. Not only do these innovations compete for attention, they compete for space: every new device represents a reduction in display area."[113] While it is difficult to know with certainty how visitors responded to the Dramagraph in the 1930s, there were inevitably dissenters who disapproved of the device (as we saw above, some curators were skeptical of *all* forms of audiovisual technology or even hyper-illusionist display methods). To evoke the term metaphorically, galleries were being branded as signifiers of a popular culture; the Dramagraph, for example, looks very much like early (1950s) television sets housed in expensive-looking wooden cabinets.

Like the shopping mall, airport, restaurant, and sports bar, the museum is a public spectatorial space, where bodies either stand shoulder to shoulder or drift through galleries drawn toward objects, sounds, and haptic sensations. That the museological community hasn't fully formulated a theory of museum spectatorship with regard to interactive media and video installation—despite the fact that film and audio have been in the museum for some time—is apparent from the haphazard way in which the spatiotemporal logic of the screen gets configured in the museum. While some research suggests that the presence of computer interactives influences the way visitors attend to and process information, with more visitors likely to become involved with an exhibit, stay longer, and recall information better if they have obtained that data from a screen-based source,[114] there is the fear that museums may never fully understand how visitors interact with the

Fig 7.7 Full-page ad for the AMNH from the *New York Times Magazine*, Oct. 3, 1999.

technology or what it means to view video in the gallery versus the movie theater or home.[115] We are reminded by museum curator and theorist Suzanne Keene that multimedia productions are not only the dominion of the computer screen: there is, she argues, an entire spectrum of delivery means from "handheld portable devices to wall-sized screens and even installations where the interface is the whole space occupied by the user."[116] While Keene is right to broaden the platforms of interactive and video delivery in the gallery, her argument that the costs and benefits of gallery interactives can be judged in a "straightforward manner" oversimplifies the complexity of visitor interaction with screen- and audio-based technologies.

If interactivity within the museum today encompasses both the hands-on sophistication of many Exploratorium-type science centers as well as the simple push-button kiosks found in "African Voices," it also refers to the way in which exhibit spaces are being branded not just literally, via corporate tie-ins or sponsors, but through the incorporation of marketing-like strategies for exhibitions where the brand experience (and branded environments) are rearticulated in the not-for-profit setting (although the presence of the corporate sponsor, such as Godiva's role in the 2002 "Chocolate" exhibit at the AMNH and its strategic positioning, signaled a new high—or low, depending on how you look at it—in terms of brand identity permeating visitors' perceptions of the show). While this may appear to be in stark contrast to an earlier era of media use in the museum, it would be inaccurate to assume that corporations and museums have only recently formed synergistic ties. Despite the fact that branding conjures up distinctly late-twentieth-century notions of corporate

marketing techniques promoting the emotional properties of consumer goods, it has precedents much earlier in the century, as exhibit designers turned to department store display windows and audiovisual technologies to support exhibit themes. Indeed, there is a long history of museums and department stores appropriating one another's display techniques in pursuit of a common didactic, disciplinary role regarding visitor behavior, what British museum scholar Tony Bennett calls "civic seeing."[117]

In 1906, for example, Philadelphia department store magnate Rodman Wanamaker organized educational lectures in his store while museum curators employed the visual rhetoric of advertising in their exhibits. There's even discussion of corporate underwriting from 1908, when British curator Dr. Hoyle suggested to his colleagues that they should follow the American model of corporate sponsorship by persuading "rich Corporations or individuals to start [i.e., sponsor] one or two [diorama] cases."[118] The logic of commodity fetishism is alive and kicking in museums, with on-site and ancillary stores and Web sites eager to exploit visitors' desires to own the objects on display by selling replicas (a classic example of brand extension from gallery to store). Experientially, too, we can trace several continuities across these distinct periods in museum history. Part of the appeal of multimedia exhibits has been their ability to immerse visitors in reconstructed environments while attempting to give equal status to both cognitive and emotional registers. Display techniques using video-walls are thought to be especially effective in this regard, since not only do they draw a visitor's attention to an exhibit—especially if a large screen or video-wall is used—but, in the case of multimedia

interactives, increase the likelihood that at least some learning goals will be met. Let us bring this chapter to a close with an examination of the National Waterfront Museum in Swansea, UK which distills so many of the themes addressed so far.

THE NATIONAL WATERFRONT MUSEUM: REBRANDING THE MUSEUM EXPERIENCE

At the National Waterfront Museum (NWM) in Swansea, Wales, relaunched in October 2005, you can be "plunged into poverty, wallow in wealth, dabble in danger or even risk your health." You can also experience "noise, grime, high finance, upheaval, consumerism, and opportunity." "Be exploited!" we are exhorted on the "Visitor Zone" page of the Web site and "watch as families cope under pressure." If the alliterative activities on offer leave little doubt as to the immersive nature of the experience (which sounds a little exhausting even before you get to the museum), the promise that a visit to the NWM "will be unlike any visit you've ever made to any museum. Ever" drives home the cutting-edge message.[119] Featuring an interactive projection theater and the very latest in multimedia technologies, the revamped museum relentlessly deploys the word "interactive" as its branding buzzword, appearing at least a dozen times in the Web site and brochure. Evoking the popular culture sites and tropes of theme parks, reality television, and soap opera, the Web site assures potential visitors that despite the moniker "museum," this will simultaneously be a familiar *and* unfamiliar experience, like television but not quite like it.[120]

Illustrative of Michael Wolf's idea of the "entertainment economy," in which consumers increasingly seek out leisure options that combine value for money with lots of fun, the NWM goes some way toward illustrating George F. MacDonald and Stephen Alsford's observation that "the theme park, rather than the museum, is increasingly becoming the model of choice when facilities for presenting heritage are created in the UK."[121] The experience promised is similar to the one British media theorist Roger Silverstone had at the Ontario Science Center, where the exhibition was "entirely at one with the current media environment, transforming science and technology into a game and breaking down science's classificatory and explanatory structures into a multimediated rhetoric all of its own. The visitors move in and out of this synaesthetic experience like viewer's through an evening's television, alighting on one interactive machine after another, like butterflies on a buddleia, in an eccentric narrative all of their own."[122] Silverstone's 1987 musings on the phenomenology of a visit to an interactive science center is remarkably prescient and evidence of the extent to which multimedia and a discourse of interactivity have crept into museums that may have very little to do with science. Given the close proximity of the NWM to Swansea Museum (less than five blocks away), a poster child for the late-nineteenth-century town-hall-style museum replete with neoclassical architecture, an imposing edifice, and, sad to say, very few visitors, one may better appreciate why the NWM is anxious to emphasize the fact that this is not your typical museum experience. God forbid visitors should think they are going to see exhibits imprisoned in glass cases as they would in the Swansea Museum (and

there are very few, one of the weaknesses of the NWM in my opinion), an edifice that appears increasingly anachronistic in the architectural landscape of a part of the city that has undergone extensive urban renewal since 1997. And yet the NWF is not the only institution in Swansea to have undergone a facelift; at the time of writing, the city of Swansea itself is experiencing an image makeover overseen by Swansea Bay Futures, Ltd., a company that in March 2006 rebranded the city "A Bay of Life." [123]

While the presence of the commercialized entertainment culture of popular television, cinema, and theme parks can be felt at the NWM, it is not oppressive, with most of the displays employing a sleek, postmodernist aesthetic that evinces generally good taste in design. But as Bernard F. Reilly Jr. reminds us: "In the bricks and mortar world many cultural institutions are trying to compete with the entertainment and 'infotainment' industries for the scarce leisure time of their audiences," which for the NWM means luring audiences away from the shopping mall and home theater (they at least have the weather as an ally, since the high level of rainfall in South Wales doubtless brings in visitors on a rainy day.) [124] And yet with terms like "affective learning" and "experiential enrichment" being thrown around alongside "edutainment" and "infotainment," it is hardly surprising that, as MacDonald and Alsford point out, the "showbiz connotations of 'entertaining' make it impossible to invoke the term without arising hostility" from some in the museum world. [125] Appropriating the discursive tropes of prime-time television ("It's no soap opera—it's what really happened," we are told on the "Visitor Zone!" of the Web site) helps prospective visitors make the associative leap between the NWM as a place

of interactivity—defined by Christopher John Nash in 1992 as the ability to "reach out in time and space to access and manipulate resources not currently in their immediate environment"—and heightened involvement in a branded, immersive "experience" rather than a traditional glass-box driven display; learning about the industry and culture of the South Wales region is no longer based on a linear communication model in which the museum serves as encoder and the visitor as decoder, but is instead organized around an intersubjective connection visitors are expected to make with (virtual) historical actors whose social, cultural, and economic lives can be summoned up—thanks to simulation in immersive, interactive displays—not unlike nineteenth-century phantasmagoria. [126] The spectacular phenomena demonstrated by London's professional and popular scientists in the early nineteenth century share a great deal with today's immersive galleries, where mulitsensory experiences conjure up similarly chimerical visions. Digital projectors offer the sounds and images of historical figures, and the active verbs and embodied encounters with individuals from the past belie the virtuality of these interactions. And yet for some visitors to the NWM, simply getting the device to work is a challenge; eschewing the traditional computer interactive with buttons to press, some displays employ motion-sensor technology where visitors interact with virtual icons in the space in front of them which activate images appearing on screens five feet ahead. Even for the computer-savvy, this was a steep learning curve that took quite a while to get the hang of.

The imbrication of the museum with the textual forms and pleasures of popular culture (the frameless

graphic interface used in Steven Spielberg's *Minority Report* [2002] is not exactly the effect of using this interactive, but close), while far from revolutionary, seems to have reached a new level of institutionalization, although there are some dissenters, such as Dr. Alan J. Friedman of the New York Hall of Science in Flushing, Queens, who not only spearheaded a remodeling of the museum but also held out against IMAX, which he opposed on philosophical grounds: "You leave the theater on such an emotional high that you're not in the mood to contemplate some stunning but subtle phenomenon of nature." Friedman also eschewed computers and simulations, arguing that they do not promote activity and become quickly obsolete. Resisting the lure of commercial culture is not without its challenges though; despite being supported by the city, which pays for maintenance, utilities, and security, the museum will have to raise a significant proportion of its budget itself, and the appeal of commercial sponsors may be hard to resist. Giving underwriters credit is one thing, but Friedman felt the museum had "successfully resisted any exhibit where there was a clear attempt to sell a product." [127]

The NWM nevertheless serves as a window into the current state of immersive museum display methods and discourses of interactivity. On the one hand there are few surprises here; as this book has shown, electronically *mediated* modes of display, especially digital platforms, are the new conventions of exhibiting, as Miriam R. Levin recently argued in *Curator*: "in order to compete for audiences, museums have buffed up their displays, incorporated new technologies . . . and opened gift shops selling replicas. In short, they have become more like their

competitors while co-opting these technologies of communication into a multimedia experience of the past." [128] What is new, however, is the way in which institutions like the NWM are increasingly designing their spaces to be experienced more and more like the successful brands of consumer culture where cognitive understanding of a product's benefits are overshadowed by the affiliations, sensations, and identifications purchasers are invited to make with the brand, as Nicholas Foulkes argued in the *Financial Times Magazine*: "Today's museum director is no longer a custodian functioning in an arid academic vacuum; he or she is as much an impresario, the manager of an entertainment complex . . . analogous to that of a film producer." [129]

SOME FINAL THOUGHTS ON IMMERSION AND INTERACTIVITY IN THE MUSEUM

Despite being around for close to a quarter of a century, immersion and interactivity are still prominent touchstones within the contemporary museum world, as shown by the marketing rhetoric of the NWM. And yet running as a leit motif throughout the discourse on interactivity is a measure of skepticism, including early research in 2002 from Christian Heath and Dirk vom Lehn on interactive computers, which concluded that "most visitors either don't have time or patience for the kind or amount of detail computer interactives try to give them." Heath and vom Lehn, who conducted research in the new British Galleries at the V&A, delivered a far from glowing report on the use of interactives in the exhibit: "despite the ap-

parent success of these interactives," they argued, "there is no significant evidence to suggest that visitors connect the activities they undertake with the interactives to the original object(s) that they are designed to illuminate." [130] The sense that we know little about *how* or *what* types of information visitors retain from media installations in galleries was voiced as long ago as 1969 in the conclusions of one of the earliest studies of audiovisual media, conducted in the museum at the Fort Parker Historic Site in Texas. Citing the dearth of such research information as a national problem, the authors called for more "effective interpretation . . . and knowledge of the relative effectiveness and visitor preference for the media" since "various kinds of interpretive audiovisual media are used for historical interpretation without being field tested for user effectiveness or preference in terms of perception and retention of correct factual information." [131]

However, it took until the mid-1980s for skepticism toward interactive media to gain momentum, appearing in the pages of the North American museum journal *Curator* at a time when interactivity was *the* buzzword.[132] For example, in 1986, Sara Kerr warned that "every exhibit topic does not lend itself to intensive interaction. Activity that is purely for entertainment may be fine in an amusement park, but a museum activity should be a goal in museum exhibits only if the interaction has a clear purpose." [133] Echoing calls for the need for more research, David Phillips argued that "what is not so well researched and keeps alive the possibility that, in a contrived effort to make museum display conceptually informative, a role for which they are not in fact as well suited as other media, the opportunity is being lost to let them just provide the kind of quiet experience which they really do very well." [134] Judicious use of interactive technologies was also recommended by Betty Davidson and colleagues in 1991; the authors suggested that rather than replace artifacts with hands-on interactive exhibits—some science museums were going so far as to substitute objects with "videoscreens, models and other components that make hands-on interaction easier"—access should be increased by adding "multisensory interpretive components." [135] The following year, Beverly Serrell and Britt Raphling speculated on whether the "promise to *deliver* so much" along with a desire "to create a look, enhance an atmosphere, and show off a technological *tour de force*" were obfuscating more measured assessments of whether computer interactives were appropriate or even effective in museums.[136] In an article subtitled "The Fetish of the Interactive Exhibit," curator Patrick Hughes launched a scathing attack on interactives as little more than "buttons, switches or touch screens through which to activate parts of a display—which in some instances meant little more than turning light bulbs on and off." And as Andrea Witcomb argues in *Re-Imagining the Museum*: "adding a multimedia station to an exhibit . . . [does not] necessarily challenge a one-way flow of communication which the exhibition as a whole may be premised upon. Nor does multimedia itself necessarily represent a more democratic, open medium of communication." [137]

A one-size-fits-all approach to interactive media may be seriously misguided, especially if we consider museum visitor behaviorist Judy Diamond's assessment that "visitors may in fact be as diverse in how they process information in a museum as in how they behave in other

respects."[138] Writing in *Curator* in 2004, Daniel Spook characterized the debate around interactivity in us-versus-them terms, with exhibit designers engaged in epistemological handwringing on the one hand and the public ostensibly craving for more on the other: "for decades, the museum field has nervously nibbled around the subject of interactivity. Without question, the public embraces museum interactives wholeheartedly."[139] Recognizing the inherent weakness of a great many Discovery-style interactives, Spook argued that "something is necessary beyond the bare categorical descriptions of 'hands-on,' 'participatory,' 'immersive'—words that describe only functional qualities, not purpose. . . . Functionally there are so many places an interactive design can go awry—from placement, to lighting, to cultural sensitivity—and any one of them can prove fatal."[140] Spook called for flexibility and recognition of the myriad ways in which people learn and behave in museums, promoting a view of objects and interactives not as separate exhibit elements but part of a "mutually supportive endeavor in which interactives can be experienced in many different worthwhile ways—both separate from the overall interpretive schema, and as an integrated part of a larger interpretive context."[141]

One question curators were eager to answer when interactives were introduced was "Will they enhance the experience or detract from it; can collections immobilized behind railings or glass cases compete with animated simulations or color displays on computerized units?" In an early investigation of the impact of interactive computers on visitors in 1988, D. D. Hilke noted that there was a 15 percent increase in the average number of visitors when the computer was turned on, concluding that "though statistically uncertain, findings suggest that the presence of the computer may have sensitized visitors to exhibition themes in other areas, even when those themes were not treated by the computer."[142] If the reason(s) for this optimism can be largely attributed to the early novelty-stage of computer interactives in 1988, there is nonetheless ongoing interest in expanding the conditions of possibility for computer interactives, such as accommodating groups via wall-size displays, random access audioguides, and seat-activated interactives in purpose-built auditoriums. For Roderick Davies, it comes down to giving the user of media programs the opportunity to "behave conceptually in the same way that he / she would behave in the real museum environment and provide . . . an experience which is synonymous with it."[143] But as Heath and vom Lehn point out, "one of the difficulties with interactivity is that it tends to reflect a particular model of human interaction that is not primarily concerned with interaction between people. . . . Unfortunately, interactivity is conflated with human social interaction. However, 'interactives' are rarely designed to support or enhance social interaction; rather, in most cases they are principally concerned to provide individual users with the ability to operate or manipulate a system or object."[144]

Audioguides epitomize this idea of interactivity in the museum as antisocial, since the user is hermetically sealed off from co-visitors as they walk around pushing buttons while listening to disembodied voices coming from their wand (or from their own cell phones if the program is available for downloading wirelessly). Part of a drive toward "augmented reality experiences" which use computerized technology to enrich visitors' encoun-

ters in and perceptions of the environment, audioguides are touted as offering improved access for visitors with disabilities; increased retention levels (from 6 to 30 percent according to one study); and, thanks to random access technology, the ability of visitors to break from the set tour and view objects at their own pace. The digital audioguide "lets museums provide more information and deliver it in more creative ways," says Marjorie Schwarzer, writing in *Museum News*.[145] Infrared transmitters located in galleries can now offer audio commentary that visitors can access on iPod-like devices (visitors can select commentary from different perspectives). Other developments include lightweight random-access wands attached to small digital players that resemble the Sony Walkman, and a radio-based intercom system that enables docents to speak softly into a small microphone as the tour group receives the information via headphones. While more could be said about the emergence of digital audio technologies in the museum, space precludes detailed discussion of these services, which are marked by rapid changes in technology.

To be sure, digital audio technology in the museum has pushed the notion of the "enhanced learning experience" in the direction of what Christine Rosen in the *New Atlantis* coined "the age of egocasting" (as opposed to broadcasting), epitomized by the success of the iPod.[146] If digital media have allowed the creation of personalized contexts for consuming mass media and new experiences of public space, then why should the museum experience be any different? One could argue that museums have always permitted visitors to perform cognitive mapping exercises that are analogous in many ways to downloading digital files from the Internet (a central tenet of egocasting, where we "impute God-like powers to our technologies of personalization").[147] What handheld devices promise to add to this experience is an intellectual, emotional, and personal connection to the art, as stories are told about its history, influence, circulation, legacy, mystery, and sheer beauty. If some visitors (and curators) shun such technologies, others find them both effective and affective.

In 2002 the Tate Modern was among the first museums to pilot a handheld screen-based device which used proximity computing via a wireless network to pinpoint the location of visitors; lasting forty-five minutes, the tour provided "contextual information that enhance[d] the viewing experience without becoming a substitute for looking at the artwork itself. The interactive program allowed visitors to respond to questions, create their own soundtrack for art, and email themselves further information."[148] Audioguides are more ubiquitous in art museums than in museums of natural history, while natural history museums have relied more upon interactive kiosks to enhance learning opportunities. Just as visitors walking through a gallery make choices about whether or not to read panels, so too do visitors equipped with audioguides; moreover, thanks to an audio technique called "branching," users now have choices about what to listen to, analogous to the links found on a Web site (or their iPod playlists), which permit deeper understanding of a topic.[149]

The technologically enhanced contemporary interactive gallery may return visitors to an informational architecture corresponding to the heyday of attendants at the

London Science Museum discussed in chapter 5. Leonard Steinbach, chief information officer at the Cleveland Museum of Art, praises digital audio handhelds for their ability to "enhance the emotional quality of, and personal connections to, art through the telling of stories, [since] . . . visitors connect better to aural stories than label text."[150] The stories visitors now hear on their audioguides are echoes of the live voices that once filled the galleries of nineteenth-century museums but were silenced when audioguides became the norm (some larger museums have retained docents but many have dispensed with the idea as a cost-cutting measure or rely upon volunteers to staff this service).

As I have argued throughout this book, in this age of hypermediacy and remediation we are confronting paradoxes—those between old-versus-new media; action versus inaction; mediation versus transparency; image versus text; object versus interface; and surface versus depth—similar to those faced by curators in the second half of the nineteenth century. If, as curators Nicky Levell and Anthony Shelton of London's Horniman Museum contend, "to touch a screen to decide which of three stories one wants to hear regarding the history of an object is no less mechanical than turning the pages of a book or looking at a text panel containing the same stories," then where, one may ask, is the epistemic shift?[151] I therefore take issue with Levell and Shelton's argument that digital technologies are undermining the epistemological foundations of our world (a shift they argue is analogous to that occurring in the mid-eighteenth century when a text-centered epistemology overtook an oral-visual culture). Their argument that a "radical change" took place

in early-nineteenth-century museum practices, when the "semaphore for wonder, enchantment and speculation gave way to the encyclopedic ideal of classificatory illustration," while accurate insomuch as the cabinet of curiosity was replaced by the more rational epistemological order of taxonomy, slights the fact that wonder, enchantment, and speculation were never fully purged from display methodologies and continue to inform even the most rule-bound systems of classification. Indeed, as Witcomb points out, "electronic technologies have not entirely displaced objects but rather brought into question absolute claims about their meaning."[152]

Museums have been, and always will be, places of wonder; more to the point, the cabinet-of-curiosity approach, which best bespeaks the idiom of wonder found in the museum is alive and well, as we saw in its recuperation and resignification in the "Spectrum of Life" wall from the Hall of Biodiversity. When the oldest dioramas at the AMNH in the Hall of Asian Mammals were reexhibited in their original state in 2000, they garnered extremely positive reviews; Michael Kimmelman wrote in the *New York Times* that despite the fact that the dioramas looked "quaint" today, in the age of "virtual reality, when the museum is updating many of its displays with computer technology, dioramas are still more realistic than most photographs or film."[153] The "museum without walls" idea instantiated in the institution's Web site is definitely a significant benchmark in our increasingly information-rich societies; however, it would be naive to think that, before the Web, there were no alternative ways for visitors to acquaint themselves with museums after hours. The lavishly illustrated coffee table guidebooks published by

museums since the turn of the last century evince the same postcard gloss as images from the Web site; what is different is the sheer numbers of images now available on some sites (many for purchase), and the ability to virtually "encounter" and interact with an object in cyberspace (such as rotate it 360 degrees), as is possible in the British Museum's Compass Project, which offers visitors access to 5,000 objects from its art and culture collection, and thematic search options which help narrow down the choices and provide a suggested visitor itinerary.

The anxiety generated by any new technology in its novelty phase quickly fades as patterns of consumption build slowly around it. This process is vividly illustrated by curator George F. MacDonald, writing in *Museum News* at the end of the twentieth century. According to MacDonald, museums were (finally) starting to "pull out of that period of angst and concern about being taken over, made irrelevant, by the slick presentations of Disney . . . [having] taken the best of Disney and realized . . . that it's the authority that gives the museum the edge." But taking the best of Disney is no guarantee of success, as the Te Papa, the new National Museum of New Zealand, realized after it installed a dark ride (Universal Studio-type motion simulation ride). With a population of only 3.5 million, New Zealanders are simply not revisiting the ride, which threatens to push the museum's budget into the red.[154] Theme park–inspired rides also enunciate differences in the relationship between public spaces, as Alan Friedman suggests: "for science museums, the visitor manipulates the exhibit. For theme parks and most edutainment media, the exhibit manipulates the visitor." Tim Caulton made a similar observation in 1988, arguing that while the theme park experience may be "thrilling, scaring or exciting for the visitor," it is nevertheless highly controlled and commodified, ensuring that everyone receives it exactly the same way.[155] Caulton also argued that there is little empirical evidence that interactive exhibits have any lasting effect on visitor comprehension of exhibit themes or are effective in altering misconceptions: "The educational arguments in favor of interactive exhibitions may be compelling, but the evidence to date is patchy and largely anecdotal. Interactive exhibitions remain a largely untapped laboratory for systematic research to investigate how people learn in an informal environment." [156] Despite the lack of studies supporting the educational benefits of interactive exhibits, there is little doubt that electronic media and digital technologies have been secured a home in the twenty-first-century museum.[157]

However, discussion of the collapse of the distinct representational regimes of museums, theme parks, and retail spaces often paints these differences in broad brush strokes rather than more nuanced, institutionally specific terms including how a museum's mission and interpretative techniques either call for or mediate the presence of a screen or audio-based culture. In other words, while our ability to make sense of computer interactives and video monitors clearly comes from competencies acquired in distinct cultural spaces, including the home, the office, and the shopping mall, these skills don't fully govern the meanings circulating between object and image in the increasingly busy museum gallery. Digital culture is certainly superimposing itself upon the traditional spaces of galleries, with many visitors (especially younger ones) finding the iconography of the computer interface entic-

ing. Indeed, a 1999 London Science Museum survey on visitor use of computer interactives suggested that "techno-fatigue" rather than "techno-phobia" was more likely to be a problem with (some) adult audiences and that lessons from the 1930s about the desirability of providing seating and sound in the gallery were still relevant. Visitors are clearly drawn to computer interactives (as they may have been to the Dramagraph in the late 1920s), finding the computer screen "several billion times more interesting than any printed text around the screen."[158] Despite the fact that the buzz on the efficacy of screen-based media is still largely favorable, we have a long way to go before we fully grasp just how a digital interface is unraveling the discursive underlay of the early-twenty-first-century museum, forming heterotopias where meanings are not ontologically bound to the aura of the object or the museum face, but are co-constructed in the interstices of object, image, sound, and interactive screen. In addition, the Science Museum study cited above is already dated, and attitudes toward screens and interactive displays have probably shifted since 1999 as increasingly more homes and classrooms expose younger children to computers and multiple media platforms.

Audio-video technology and its practical culmination in post-1970s video in the museum was an inevitable by-product of early-twentieth-century modernist tendencies that looked to technology as a way to kill several birds with one stone: to utilize technological novelty to draw audiences into a gallery; to reinforce educational themes by providing contextual material on the exhibit objects themselves; and to continue the long-standing project of integrating popular culture into museum display techniques. Interactivity and immersive displays have thus become a near prerequisite for contemporary museums hoping to attract visitors, especially children. As galleries constructed in the 1950s and 1960s undergo renovation, new museums, such as the NWM and the International Spy Museum in Washington, D.C., integrate interactive elements at every level of the experience. Visitors explore the world of espionage by adopting a "cover," "crawling through an air duct designed for eavesdropping, deciphering code, and identifying disguised spies."[159] Offering an opportunity to experience interactive exhibits about "disguise, surveillance, [and] threat analysis,"[160] museum organizers hope the $36 million building will attract at least 50,000 visitors a year (at a cost of $16 per adult ticket and $13 for children 12 and up).

But gimmick-driven museums like the International Spy Museum are not the only institutions turning to interactive media and ideas of immersion; these elements even extend to memorials commemorating individuals lost to acts of terrorism, including the Oklahoma City National Memorial, which opened in 2000, five years after the bombing, and which features a park as well as a museum offering background material on the Murrah Building, testimony from victims, memorabilia, and photographs of those killed. In the Memorial Museum's "Exhibit Walk-Through" section of the Web site (Chapter 4A, "Chaos"), we are told that in addition to seeing retrieved objects from the bomb blast and hearing the sounds of rescue vehicle sirens, we will also "feel the chaos many experienced moments after the bombing." However, not everyone approves of the edutainment approach; reviewing the memorial in the *New Yorker,* Paul Goldberger ar-

gued that the indoor museum provided a "much more American experience" than the outdoor memorial, "since it is grounded in the belief that almost anything, including the most horrendous events imaginable, can be made entertaining." [161]

Notwithstanding the contemporary embrace of immersion and interactivity as structuring principles of the exhibit / memorial, museums still have a reputation for being late adopters of new technology (although a few large urban museums, including the Whitney Museum of American Art in New York City, the American Museum of the Moving Image in Queens, New York, and the Walker Art Center in Minneapolis are exceptions).[162] At the 2002 Whitney Biennial, kiosks allowed visitors with Palm electronic organizers to download a digital dancer (male or female) from James Buckhouse's digital artwork "Tap," while eDocent, piloted at the American Museum of the Moving Image, enables visitors to download information into handheld computers and to bookmark Web pages. Finally, the Walker Art Center, as part of a $90 million renovation and expansion, designed a wireless network offering visitors a chance to access far more of the collection, what design director Andrew Blauvelt calls "social computing," where groups of visitors sitting at "smart" tables touch screens embedded in tabletops giving them access to the Walker's collections and resources.[163] Not losing sight of the artwork or exhibition content is critical for curators, even those with a large stake in the success of interactive technologies such as Whitney director Maxwell L. Anderson, who says that "museums are not in the hardware business, we're not in the software business—we're in the content-development business." [164] The immersion / interactive media glass may be half empty or half full for museums curators; with corporate underwriting and sponsorship of exhibits the sine qua non of the museum world today, the screen may very well be the format of choice for displaying logos, corporate "messages" (read ads), and forging associations that are only obliquely registered via other means of exhibition rhetoric.

What is needed, therefore, is ongoing assessment of what museums set to gain and possibly lose through the integration of video-walls and other screen-based practices into exhibit narratives and how technology augments the overall space and the visitor's understanding of its central ideas. Adrian Searle, writing in the *Guardian,* drives home this point in his argument that "the gallery is not a cinema or a living room, so the experience of projected images and works presented on TV monitors is not to be compared to going to the movies or watching TV. . . . [W]e arrive not knowing where we are in the story, how close to the beginning or to the end, or even if what is unfolding has a resolution." [165] Compounding the problem visitors may encounter trying to decipher what it is they're actually looking at is the larger issue of how museums assess the effectiveness of video material or even answer the more prosaic question of who, in fact, stops to watch. Arguing as early as 1998 that the "relation between each new electronic media and the traditional medium 'museum' has never been smooth," Hans-Peter Schwartz characterized the museum's attitude to new media as a "fear of being overcome by a flood of images devoid of any content on the one hand," and on the other as completely ignoring the electronic image as a result of "dogmatically holding to the idea of possessing the only legitimate way

of representing images."[166] Given the distracted nature of film and video spectatorship in the museum, it is vital to differentiate between "playings," the number of times a video is activated or runs throughout the day, as opposed to "viewings," the number of people to whom it is exposed, and the larger of the two numbers (playings can be converted to guesstimated viewings by multiplying by three).[167]

In any event, as the wide-ranging examples explored in this chapter have shown, museums have long been interested in the pedagogical and thrill value of electronic (and more recently) digital technologies; however, the promise of immersion, interactivity, spectacle, and heightened understanding is neither guaranteed nor somehow inscribed in the technology itself. The inclusion of multimedia and screen images does not de facto guarantee responses from audiences; as Andrew Cameron explains: "In learning the museum language, the visitor must learn not only the perceptual skills necessary to its visual and tactile qualities, but also the inductive skills necessary to the synthesis of ideas from the pattern of displayed information."[168] These inductive skills may be hastened or impeded by multimedia and screen-based technologies. As curators ponder the ontological status and pedagogical value of the electronic and digital artifact, they might do well to consider what lessons can be learned from the past, given the perennial nature of debates on the introduction of new museum technologies.

I N 1984, HERMANN Krüger sketched out a model of museum spectatorship in which visitors proceeded through a four-part viewing process from an initial glimpse, through a more sustained gaze, followed by a grasp of the phenomenon at hand, and finally a desire to study the exhibit. Beyond its linearity, prescriptive qualities, and somewhat utopian rendering of the museum experience, Krüger's model resonates with the reported encounters with many of the spectacular displays discussed in this book.[1] If Krüger's "grasp" and "study" stages are less likely to be consistently achieved—a "gasp" rather than a "grasp" would be the adjective of choice to characterize reactions to the vivisected bodies on display in such spectacular displays as *Body Worlds* (or its international competitors *Bodies, Body Exploration, The*

Universe Within, and *Bodies Revealed*), these contemporary popular exhibits remind us that the search for novel visual experiences never ceases. Efforts to sate this popular appetite are endlessly replayed in new technologies and media platforms that strive to improve upon their predecessors (often with limited success) with heightened verisimilitude, immersion as an integral part of the experience, and hefty price tags. An example may elucidate my point.

Shortly before finishing this book I visited the *Bodies* exhibit at Manhattan's South Street Seaport. Having heard mostly positive reviews of the show from family and friends I decided to experience it for myself and see how its display of human cadavers might make me *feel* as well *educate* me about human biology. Though I wished

otherwise, gazing at the polymer-preserved cadavers in the *Bodies* exhibit—the tagline is "A Phenomenal Look at the Phenomenon We Call the Human Body"—sent few shivers down my spine, although the racially and sexually homogeneous bodies (all from northern China and all but three male) did trouble me in terms of their doubly Othered status (dead and nonwhite) and pernicious gender stereotypes (the few female bodies in the show were associated exclusively with obesity and childbearing).[2] While I did proceed through Krüger's four-part process by dutifully reading all the captions and gazing for prolonged periods of time, there was no magical frisson, possibly because there was no trompe l'oeil, no illusionism, little sense of the uncanny that had enveloped me while visiting Madame Tussaud's wax museum. These bodies were bound by signifying chains that let them do little more than evince anatomy, functionality, and occasionally, pathology.

The contemporary exhibition of preserved bodies no doubt evokes the display of the unidentified corpses in Parisian morgues in the early twentieth century discussed by Vanessa Schwartz in her book *Spectacular Realities*.[3] A reverse trajectory is at play in the contemporary cadaver exhibits, which eschew individuality in favor of the homogenizing effect of the sliced-open body, a human taxidermy, although rather than stuffing the body (or remounting it over a plaster cast or aluminum frame as is done with animals today), it is turned inside out, or at least, its insides, rather than discarded as in taxidermy, become the point of the display. While the taxidermy specimen and cadaver evince their realism via distinct modes of becoming, they are nevertheless united by shared ontologies: life

heaved from flesh and skin. As Susan Sontag wrote in her last book *Regarding the Pain of Others,* in addition to the provocation "can you look at this?" and the "satisfaction of being able to look at the image without flinching," there is also the *pleasure* of flinching.[4] How the public would react to bodies mounted in the same way as animal taxidermy specimens is anybody's guess, although I doubt the bodies wearing their skin would be deemed as suitable for public display as those stripped down to the muscle and relieved of their skin (or carrying it in their hand as one subject in the original franchise *Body Worlds* did). Clearly my response to *Bodies* does not (and cannot) stand in for other spectators who felt the $26.50 ($27.50 on weekends and holidays) admission fee was good value for money.

As this book has demonstrated, we can never predict just how we might respond to sensational displays (immersive or not), despite the marketing hype or recommendations from friends. The spectator who described a "shiver down his spine" when witnessing a battle panorama in 1799 definitely hit the nail on the head for me, however, since of all the spectacles I have beheld while researching this book, nothing holds a candle to the uncanny realism of the nineteenth-century panorama. But even the eponymous waxwork has succumbed to new technology and special effects, including Madame Tussaud's "Scenerama" waxworks in Amsterdam, which explores Dutch history and culture from the sixteenth century to the present day. According to the editor of *Museum Management and Curatorship*, the static waxworks have been transformed into animatronics tableaux vivants, and though some element of movement has occasionally been

incorporated into waxworks since their invention, the new display strategy has something of the aesthetic of "total theater": "Part traditional waxworks, part theatrical experience, all of the senses are assaulted in this extravaganza which culminates in the Dome of Fame where Einstein and Charlie Chaplain float in space like saints in a Baroque vault decoration."[5]

The journey taken in this book has spanned many centuries and continents; in considering works from twelfth-century English cathedrals to the twenty-first-century "SonicVision" laser show at the American Museum of Natural History in New York City, my aim has been to analyze the puzzle of immersive and interactive spectatorship, an experience that can be had in many different guises and yet is made sense of by spectators across a vast historical canvas in remarkably similar ways. I defined immersion in the introduction to this book as that sense of being in closer communion with something other than the here and now, something that takes us into a "virtual" reality that could be defined as an interstitial space where we are never fully "there" because our bodies can never fully leave the "here." The "revered" gaze is the most effective way of explaining, I believe, how spectators experience such visual spectacles as cathedrals, panoramas, planetariums, IMAX, and immersive museum exhibits as spaces where the senses are heightened through an embodied mode of spectatorship. And while Mary Anne Doane, in her erudite analysis of cinematic time, is correct in her claim that it is the "cinema which directly confronts the problematic question of the *representability* of the ephemeral, of the archivability of presence," this quest

has also been the preoccupation of many of the spaces examined in this book, especially those most committed to delivering an immersive spectatorial experience.[6] But we should also not lose sight of the many paradoxes besetting large-scale imaging technologies and museums; Scott Bukatman's analysis of Disney World is a reminder of the limitations of so many hypermediated spaces and technologies such as virtual reality, which allow us to navigate simulacral worlds but only on the contractual terms of the simulator which, in the case of Disney, is hidden from view.[7] Realism in some way, shape, or form is essential here, providing, as Ellen Strain points out, a smooth transition between *immersion, reality effects,* and even *authenticity.* Strain's differentiation between *representational* realism (sight as the primary sense organ) and *experiential* realism (multisensory) is helpful, since so much of what Disney World (and virtual reality) offers visitors is *experiential* realism, although clearly a blending of the two.[8]

Can spectacle exist without some degree of immersion, and does being immersed necessarily invoke a certain measure of spectacle and even interactivity? I would argue that most spectacles do invite immersive modes of looking and engagement. In the case of the large-scale images and imaging technologies discussed in this book, there are three defining characteristics that not only separate them from ordinary two-dimensional representational forms but also come to infuse their very ontologies. The first is remediation. All of the case studies examined here provide instances of remediation insomuch as they co-opt existing tropes and ways of seeing at the same time as they resignify within stunningly new environments;

so the panorama borrows from landscape painting at the same time as it launches a new way of experiencing the world; the planetarium is a bricolage of effects drawn from astronomy and popular culture; even screen-based interactive 3-D environments such as VRML worlds (virtual reality modeling language, a file format for representing 3-D graphics) appropriate cinema's rectangular framing, as Lev Manovich points out. Even within the most immersive of virtual environments, the spectacle is contained by older formal constraints; as Manovich argues, the "frame creates a distinct subjective experience that is much closer to cinematic perception than it is to unmediated sight."[9]

The second defining characteristic is reverence. What marks these spectacular forms as different is the way they invoke what I call a "revered gaze," a response marked as much by recognition of the labor and effort involved in creating the spectacle as in the spectacle itself. It also speaks to the quasi-spiritualist motif stitched into the fabric of so many of the examples discussed here, the way in which they float—sometimes quite literally in the case of the panoramic painting, or the roof of the Gothic cathedral, or in the signature phantom ride shot in IMAX—between terrestrial and nonterrestrial spheres, as if some higher force had lent a hand in their design and construction. It's what triggers the shiver, or sometimes even a tear, when one enters these spaces. While always aware of the surrounding architecture, the revered gaze must, as Guiliana Bruno argues, "forget itself so that the geometry of the screen might disappear in favor of a boundless experience of absorption in the surface, which is infinite

space." As a place where "attention turns inward and individual boundaries give way to waves of perceptual unity," we become one with a higher force that brings reverence and inevitably loss.[10] And the final defining characteristic is fantasy. The desire to *be* elsewhere without actually *going* elsewhere seems to be hardwired into the human psyche, as the evidence of centuries of both secular and profane culture suggests. Immersive technologies bring that fantasy a bit closer to our reality. But is the fantasy really about playing with states of being that speak to a subconscious fear we all share? Could it be that being somewhere or someone without actually occupying the space or assuming that subject's position gives us a chance to try on death without cost? What is it exactly we fear when we wait to enter the virtual reality simulator or the funfair ride? Nausea, a fear of being discombobulated, or taking our bodies into a realm that is too close to the ultimate unknown?

Shivers Down Your Spine has cast some old experiences in a new light and invited us to step into the past in order to make sense of the spectacular images and technologies that now define our daily lives in this era of media convergence and digitopia. Ideas of immersion and interactivity are only new insomuch as they have been conscripted by the pundits of new technology to promote the experiences supplied by cutting-edge technologies. Some spectators may be moved by the promotional rhetoric that inflates the experience, but most people, even if they have never stepped foot in a cathedral, a panorama, or even a planetarium can probably find a relatable experience, a sense memory that if triggered would remind them of where

they have felt like this before. It is this sense memory that inspired me to examine the various sites traversed in this book; while there are clearly other human experiences that are eminently capable of sending "shivers down the spine," the spaces privileged here are exemplary, impelling us to rethink all aspects of spectatorship, not just film but the myriad ways in which we encounter, and actively seek out, images and sensations that seem to relish in their ability to deliver spectacle, immersion, and an interactive experience.

INTRODUCTION

1. Oliver Grau, *Virtual Art: From Illusion to Immersion* (Boston: MIT Press, 2003), 13.
2. For an analysis of new media that fills in this vital prehistory, see William Boddy, *New Media and Popular Imagination: Launching Radio, Television, and New Media in the United States* (Oxford: Oxford UP, 2004).
3. For these and other wonderful case studies, see Lisa Gitelman and Geoffrey B. Pingree, eds., *New Media: 1740–1915* (Cambridge: MIT Press, 2003).
4. Chris Jenks, "Watching Your Step: The History and Practice of the *flaneur*," in *Visual Culture* (London: Routledge, 1995), 144.
5. See Alison Griffiths, *Wondrous Difference: Cinema, Anthropology, and Turn-of-the-Century Visual Culture* (New York: Columbia UP, 2002).
6. For more on the introduction of new media into museums with both "banal and far-reaching" consequences, see Michell Henning, "Legibility and Affect: Museums as New Media," in Sharon MacDonald and Paul Baus, eds., *Exhibition Experiments* (Oxford: Blackwell, 2007), 25–46.
7. Erwin Panofsky, "Style and Medium in the Motion Pictures," *Bulletin of the Department of Art and Archaeology* (Princeton University, 1934); reprinted in Leo Braudy and Marshall Cohen, eds., *Film Theory and Criticism: Introductory Readings* (New York: Oxford UP, 2004), 289–302, cited in Anne Friedberg, *The Virtual Window: From Alberti to Microsoft* (Cambridge: MIT Press, 2006).
8. Laurent Mannoni, "*Magie Lumineuse* in the Country and the City," in *The Great Art of Light and Shadow: Archaeology of the Cinema* (Exeter: U of Exeter P, 2000), 88. The Zograscope measured 2 m in height by l.4 m in depth and was made for a noble Venetian family at the end of the eighteenth century. As described by Mannoni, the Zograscope consisted of a pedestal of turned wood (either boxwood or mahogany) screwed vertically into a base plate, which supported a frame carrying a biconvex lens. A mirror, which could be pivoted up or down as required, was also attached to the frame. A *vue d'optique*, an engraving, was placed behind the device and the mirror's angle of inclination adjusted so it could be viewed through the lens (84–85).
9. Not to be confused with Gunther von Hagen's more gory and sensational *Body Worlds* exhibition (www.bodyworlds.com).
10. For more on the London Eye, visit www.londoneye.com. The site claims that it has become the most popular admission-charging attraction in the UK, visited by an average 10,000 people a day (3.5 million a year).
11. Scott Bukatman, *Matters of Gravity: Special Effects and Superman in the 20th Century* (Durham, N.C.: Duke UP, 2003), 110.

1. IMMERSIVE VIEWING AND THE "REVERED GAZE"

1. Pamela Sheingorn, "Gender, Performance, Visual Culture: Medieval Studies in the 21st Century," lecture delivered at Columbia University, Feb. 15, 2006. I am grateful to Pam Sheingorn for directing me toward much of the medieval primary and literature discussed in this chapter.

2. Michael Camille, "Before the Gaze: The Internal Senses and Late Medieval Practices of Seeing," in Robert S. Nelson, ed., *Visuality Before and Beyond the Renaissance* (Cambridge: Cambridge UP, 2000), 198.

3. David Freedberg, *The Power of Images: Studies in the History and Theory of Response* (Chicago: U of Chicago P, 1989), 1 and 19.

4. Michel de Certeau, *The Writing of History.* Trans. Tom Conley (New York: Columbia UP, 1988), 20 (italics in original).

5. *Webster's New Collegiate Dictionary* (Springfield, Mass.: Merriam, 1977).

6. Susan Stewart, *On Longing: Narratives of the Miniature, the Gigantic, the Souvenir, the Collection* (Durham, N.C.: Duke UP, 1993), 108.

7. Otto von Simson, *The Gothic Cathedral: Origins of Gothic Architecture and the Medieval Concept of Order* (New York: Harper and Row, 1964), xvii and xxi.

8. Von Simson, *The Gothic Cathedral,* 54.

9. Ibid., xix.

10. Günther Binding, *High Gothic: The Age of the Great Cathedrals* (Köln: Taschen, 1999), 11. For more on the emergence of the term "Gothic" and its redolent symbolism, see 29–52.

11. Binding, *High Gothic,* 44.

12. Von Simson, *The Gothic Cathedral,* xxi. Michael Camille, *Gothic Art: Visions and Revelations of the Medieval World* (London: Everyman Art Library, 1996), 12. For more on the background of Gothic as an emergent style, see Von Simson, *The Gothic Cathedral,* 63–64.

13. Camille, *Gothic Art,* 11–12.

14. Ibid., 11.

15. Georges Duby, *The Age of Cathedrals: Arts and Society, 980–1420* (Chicago: U of Chicago P, 1981), 147

16. Ibid., 28.

17. Camille, *Gothic Art,* 14.

18. Von Simson, *The Gothic Cathedral,* 31.

19. Ibid., 10.

20. Emile Mâle, *The Gothic Image: Religious Art in France in the Thirteenth Century* (New York: Harper and Row, 1972), 29.

21. David Morgan, *Visual Piety: A History and Theory of Popular Religious Images* (Berkeley: U of California P, 1998), 66.

22. Camille, *Gothic Art,* 81.

23. Audrey Erskine, Vyvyan Hope, and John Lloyd, *Exeter Cathedral: A Short History and Description* (Exeter: Dean and Chapter of Exeter Cathedral, 1988), 124. For more on the construction process, see François Icher, *Building the Great Cathedrals* (New York: Abrams, 1998).

24. Von Simson, *The Gothic Cathedral,* 35 and 51; Camille, *Gothic Art,* 37.

25. Von Simson, *The Gothic Cathedral,* 50. The French Abbot Suger, who was responsible for the construction of the cathedral at St. Denis, a major religious center of the time, is considered the first to elevate windows to a primary place within Gothic architecture and to conceive of them "not as wall openings but as translucent surfaces to be adorned with sacred paintings" (121).

26. Von Simson, *The Gothic Cathedral,* 164.

27. Morgan, *Visual Piety,* 60.

28. The term "autohagiographer" is Richard Kieckhefer's from his book *Unquiet Souls: Fourteenth-Century Saints and Their Religious Milieu* (Chicago: U of Chicago P, 1984), 6, cited in Sarah Salih, "Staging Conversion: The Digby Saint Plays and *The Book of Margery Kemp,*" in Samantha J. E. Riches and Sarah Salih, eds., *Gender and Holiness: Men, Women, and Saints in Late Medieval Europe* (New York: Routledge, 2002), 122. For more on Margery Kempe, a "master performance artist" who cast herself as star of her visionary work *The Book of Margery Kempe,* see Nanda Hopenwasser, "A

Performance Artist and Her Performance Text: Margery Kempe on Tour," in Mary A. Suydam and Joanna E. Zeigler, eds., *Performance and Transformation: New Approaches to Late Medieval Spirituality* (New York: St. Martin's, 1999), 97–131. Hopenwasser's bibliography is a wonderful resource for Kempe scholars.

29. Von Simson, *The Gothic Cathedral*, 79.
30. Morgan, *Visual Piety*, 63.
31. Gabriele Finaldi, *The Image of Christ* (London: National Gallery Company, 2000; New Haven: Yale UP, 2000), 58 and 75.
32. Giorgia Frank, "The Pilgrim Gaze in the Age Before Icons," in Nelson, ed., *Visuality*, 98–99.
33. Ibid., 103–104.
34. Barbara Amiel, "Mel Gibson's 'Passion of Christ' is an Act of Faith, Not Hatred," *Daily Telegraph* (London), Feb. 23, 2004, 18.
35. Duby, *The Age of Cathedrals*, 151.
36. Von Simson, *The Gothic Cathedral*, xxi.
37. The fourteen stations are the condemnation of Jesus by Pilate; Jesus' acceptance of the cross; his first fall; the encounter with his mother Mary; Simon of Cyrene helping Jesus; Vernonica wiping Jesus' face; his second fall; the encounter with the women of Jerusalem; his third fall; Jesus being stripped of his garments; the Crucifixion; Jesus' death; Jesus' removal from the cross; and the burial of Jesus.
38. Camille, *Gothic Art*, 51.
39. Ibid., 14.
40. Cynthia Hahn, "Vision Dei: Changes in Medieval Visuality," in Nelson, ed., *Visuality*, 171 and 174.
41. Ibid., 179 and 182; Robert S. Nelson, "Introduction," in Nelson, ed., *Visuality*, 11.
42. Morgan, *Visual Piety*, 66.
43. Ken Hillis makes a connection between a medieval understanding of emblems and the "contemporary implosion of image, reality, and discourse" in simulated, virtual technologies. Ken Hillis, *Digital Sensations: Space, Identity, and Embodiment in Virtual Reality* (Minneapolis: U of Minnesota P, 1999), 67.
44. Camille, *Gothic Art*, 72.
45. Frank Kendon, *Mural Paintings in English Churches During the Middle Ages: An Introductory Essay on the Folk Influence in Religious Art* (London: John Lane The Bodley Head, 1923), 118–19.
46. Gertrud Schiller, *Iconography of Christian Art*, vol. 2 (Greenwich, Conn.: New York Graphic Society, 1972), 10; Hahn, "Vision Dei," 182.
47. Schiller, *Iconography of Christian Art*, 52 and 11.
48. Ibid.
49. Kendon, *Mural Paintings*, 88.
50. Camille, "Before the Gaze," 214.
51. Jody Enders, *The Medieval Theater of Cruelty: Rhetoric, Memory, Violence* (Ithaca: Cornell UP, 1999), 13.
52. Ibid., 14.
53. Amy Hollywood, "Kill Jesus," in Timothy K. Beal and Tod Linafelt, eds., *Mel Gibson's Bible* (Chicago: U of Chicago P, 2006), 160, citing Mary Carruthers, *The Craft of Thought: Meditation, Rhetoric, and the Making of Images, 400–1200* (Cambridge: Cambridge UP, 1998).
54. Enders, *The Medieval Theater*, 193.
55. Darwin Smith, "The Role of Christ in Medieval French Passions: What Can We Know?" Doctoral Program in Theater Studies lecture given at the CUNY Graduate Center, Oct. 14, 2004.
56. Jody Enders, "Seeing Is Not Believing," in Beal and Linafelt, eds., *Mel Gibson's Bible*, 187. Despite his wearing both full-body and facial prostheses, there were accounts of James Caviezel sustaining injuries while the film was in production.
57. Philippe de Vigneulles, cited in Heinrich Michelant's edition of the *Gedenkbuch des Metzer Bürgers Philippe von Vigneulles*, 244–45, quoted and translated in Enders, *The Medieval Theater*, 194–95.
58. Ibid., 197 and 201.

59. Terrence McNally, *Corpus Christi* (New York: Grove Press, 1998), 79.
60. Schiller, *Iconography of Christian Art,* 66–68.
61. Siegfried Wenzel, "'Somer Game' and Sermon Reference to a Corpus Christi Play," *Modern Philology* 86 (1988–89): 274–83, in Glending Olson, "Plays as Play: A Medieval Ethical Theory of Performance and the Intellectual Context of the *Tretise of Miraclis Pleyinge,*" *Viator* 26 (1995): 213.
62. Arnoul Gréban, *The Mystery of the Passion: The Third Day* (Asheville, N.C.: Pegasus Press, 1996). My thanks to Pamela Sheingorn for her input on the meanings of this image.
63. Camille, *Gothic Art,* 83.
64. Clifford Davidson, "Introduction," *A Tretise of Miraclis Pleyinge,* Early Drama, Art, and Music Monograph Series 19 (Kalamazoo, Mich.: Medieval Institute, 1993), 1. For an insightful interpretation of the *Miraclis,* see Erick Kelemen, "Drama in Sermons: Quotation, Performativity, and Conversion in a Middle English Sermon on the Prodigal Son in *A Tretise of Miraclis Pleyinge,*" *ELH* 69 (2002): 1–19. Kelemen makes a compelling argument about the anxiety surrounding mimesis and conversion in the *Tretise* using semiotics to make his point: "the mimetic performance of God's word strays too far from the word and causes the audience to be caught up in the spatial lure of dramatic activity and spectacle, caught up in the world of the signifier and missing entirely the world of the signified" (16).
65. Garrett P. Epp, "Ecce Homo," in Glen Berger and Steven F. Kruger, eds., *Queering the Middle Ages* (Minneapolis: University of Minnesota Press, 2001), 237–8.
66. Olson, "Plays as Play," 213.
67. See Camille's discussion of *imitatio Christi* in relation to nuns being surrounded by images (*Gothic Art,* 24).
68. For more on the representation of the Passion narrative in the early cinema period, see Roland Cosandey, André Gaudreault, and Tom Gunning, eds., *An Invention of the Devil* (Sainte-foy and Lausanne: les Presses de l'université–Laval / Éditions Payot, 1993).
69. Epp, "Ecco Homo," 241.
70. Ibid.
71. This factoid appeared in William G. Little's essay, "Jesus's Extreme Makeover," in Beal and Linafelt, eds., *Mel Gibson's Bible,* 176.
72. R. N. Swanson, "Passion and Practice: The Social and Ecclesiastical Implications of Passion Devotion in the Late Middle Ages," in A. A. MacDonald, H. N. B. Ridderbos, and R. M. Schlusemann, eds., *The Broken Body: Passion Devotion in Late Medieval Culture* (Groningen, The Netherlands: Egbert Forsten, 1996), 6.
73. Ibid., 6 and 8.
74. For more on her performance, see Susan Rodgers and Joanna E. Ziegler, "Elisabeth of Spalbeck's Trance Dance of Faith: A Performance Theory Interpretation from Anthropological and Art Historical Perspectives," in Suydam and Ziegler, eds., *Performance and Transformation,* 299–355.
75. Morgan, *Visual Piety,* 64.
76. Ibid., 65.
77. Camille, *Gothic Art,* 104.
78. Abraham H. Maslow, *Religions, Values, and Peak-Experiences* (New York: Penguin / Arkana, 1994), 65 and 68 (italics in original).
79. F. David Martin, *Art and the Religious Experience: The "Language" of the Sacred* (Lewisburg, Penn.: Bucknell UP, 1958), 235.
80. *Cyclorama of Jerusalem*: *The Unforgettable Moment* (brochure), 2.
81. "Jerusalem and the Crucifixion," *New York Times,* June 17, 1888, 6 (emphasis added).
82. Morgan, *Visual Piety,* 33.
83. Camille, *Gothic Art,* 19.
84. Morgan, *Visual Piety,* 66.
85. Davidson, "Introduction," 96 (italics in original), cited in Epp, "Ecce Homo," 245.
86. Camille, *Gothic Art,* 155.

87. The phrase (grim reaper / androgynous milk-eyed devil) is Joe Williams's from "'The Passion of the Christ': Gibson's Film Is Overkill on Jesus' Death Not Life," *St. Louis Post-Dispatch*, Feb. 25, 2004, E1; Jack Miles, "The Art of *The Passion*," in Beal and Linafelt, eds., *Mel Gibson's Passion*, 14.

88. Morgan, *Visual Piety*, 9.

2. SPECTACLE AND IMMERSION IN THE NINETEENTH-CENTURY PANORAMA

1. Brochure for *The Siege of Paris* panorama (1877) painted by Paul Philippoteaux on exhibition daily at the corner of Columbus Avenue and Ferdinand Street, Boston, 8. Theater Collection, New York Public Library.

2. "The Cyclorama," *Scientific American* 55 (1886): 296 (emphasis added). The author is referring to Paul Philippoteaux's panorama *The Battle of Gettysburg* painted in 1884, which I discuss in greater depth later in the chapter.

3. Vivian Sobchack, *Carnal Thoughts: Embodiment and Moving Image Culture* (Berkeley: U of California P, 2004), 4.

4. Lee Parry, "Landscape Theater in America," *Art in America* 59 (Dec. 1971): 54. For more on panoramas, see Stephan Oettermann, *The Panorama: History of a Mass Medium* (New York: Zone Books, 1997); Ralph Hyde, *Panoramania! The Art and Entertainment of the "All-Embracing" View* (London: Refoil Publications in association with the Barbican Art Gallery, 1988); Richard Altick, *The Shows of London* (Harvard: Belknap Press of Harvard UP, 1978); Mimi Colligan, *Canvas Documentaries: Panoramic Entertainments in Nineteenth-Century Australia and New Zealand* (Victoria: Melbourne UP, 2002); John Francis McDermott, *The Lost Panoramas of the Mississippi* (Chicago: U of Chicago P, 1958); Angela Miller, "The Panorama, the Cinema, and the Emergence of the Spectacular," *Wide Angle* 18.2 (April 1996): 34–69; and Vanessa R. Schwartz, *Spectacular Realities: Early Mass Culture in Fin-de-Siècle France* (Berkeley: U of California P, 1998),

149–76. For a revisionist reading of Alberti's idea of the frame as an open window, see chapter 1 of Anne Friedberg's *The Virtual Window*.

5. Evelyn J. Fruitema and Paul A. Zoetmulder, *The Panorama Phenomenon*, catalog produced for the preservation of the Centarian Mesdag Panorama (The Hague: Mesdag Panorama, 1981), 18.

6. However, there are important differences in the organization of vision in the church versus the panorama. The boundless vision characterizing the nineteenth-century panorama and the seemingly infinite height of the cathedral ceiling, which gradually doubled from 22 meters to 48 meters over time, drew the spectators' gaze in different directions. While the cathedral invited the eye of the spectator to the heavens, upward to the flying buttresses of the roof (fig. 1.3), in the case of the panorama the eye is more likely to survey the painting in a horizontal sweep across the canvas, usually in a clockwise direction

7. Barker, quoted in David Martin, *Art and the Religious Experience*, 243.

8. Barker, quoted in Oettermann, *The Panorama*, 6–7.

9. Monas N. Squires, "Henry Lewis and His Mammoth Panorama of the Mississippi River," *Missouri Historical Review* 27 (April 1933): 246, cited in Bertha L. Heilbron, "Making a Motion Picture in 1848: Henry Lewis on the Upper Mississippi," *Minnesota History* 17.2 (June 1936): 132; Heilbron, "Making a Motion Picture," 133; Joseph Earl Arrington, "William Burr's Moving Panorama of the Great Lakes, the Niagara, St. Lawrence, and Saguenay Rivers," *Ontario History* 51.3 (Summer 1959): 141; and C. W. Ceram, *Archaeology of the Cinema* (London: Hudson and Thames, 1965).

10. Binding, *High Gothic*, 225.

11. A third genre, not discussed here, is the illustrated sermon panorama depicting religious scenes, exemplified by the famous *Panorama of John Bunyan's Piligrim's Progress* (Joseph Kyle and Jacob Dallas, 1850–51). Since this subgenre of panorama painting makes claims to verisimilitude in different

ways to battle and river panoramas, it will not be covered in this chapter. For more on the *Pilgrim's Progress Panorama,* see the catalog published by the Montclair Art Museum (California) entitled *The Grand Moving Panorama of Pilgrim's Progress.* The exhibit was installed at the museum from January 31 to May 2, 1999, before touring to the Portland Museum of Art (Maine) and the Edwin A. Ulrich Museum of Art at Wichita State University in Wichita, Kansas.

12. According to Scott B. Wilcox, the initial flurry of panorama activity begun in the 1790s had dwindled by the 1820s. Wilcox, "Unlimiting the Bounds of Painting," in Hyde, *Panoramania!,* 21.

13. Shelley Rice, "Boundless Horizons: The Panoramic Image," *Art in America* 81 (1993): 70.

14. Mark Twain, *Life on the Mississippi* (1883; New York: Grosset and Dunlap, 1917), 159 (emphasis added).

15. Edgar Allan Poe, *Eureka: A Prose Poem* (New Edition with line numbers, exploratory essay, and bibliographic guide by Richard P. Benton). Transcendental Books, Drawer 1080, Hartford 06101). Copyright 1973 by Kenneth Walter Cameron. (Emphasis added).

16. Some items did not receive further explication, although there does not seem to be a particular rule for determining which numbers are written about and which ignored.

17. Kevin J. Avery, "Movies for Manifest Destiny: The Moving Panorama Phenomenon in America," in *The Grand Moving Panorama of Pilgrim's Progress* exhibit catalog organized by the Montclair Art Museum, 1999, 1. For more on the rollers, see Wolfgang Born, "The Panoramic Landscape as an American Art Form," *Art in America* 1 (January 1948): 3.

18. According to Gwendolyn Waltz, moving panorama backgrounds were often combined with treadmills on stage scenes to give the illusion of movement through perspective space in plays such as *The Country Fair* (1889), *Ben Hur* (1899), and *Bedford's Hope* (1906). For more on the multimedia and staged performance, see Waltz, "Embracing Technology: A Primer of Early Multi-Media Performance,"

in Leonardo Quaresima and Laura Vichi, eds., *The Tenth Muse: Cinema and Other Arts* (originally, *Lat decima musa: Is cinema e le alter arte*), Domitor (Udine, Italy: Forum, 2001), 543.

19. The first panorama to be shown in America was English artist William Winstanley's painting of Westminster and London in 1795; according to Lee Parry, it may have been copied from engravings by Robert Barker. Parry, "Landscape Theater," 54.

20. "Mr. Banvard's Moving Panorama," *Times* (London), in John Banvard and Family Papers (hereafter, BFP), Minnesota Historical Society, microfilm M360.

21. Oettermann, *The Panorama,* 7.

22. Yvonne van Eekelen, "The Magical Panorama," in *The Magical Panorama: The Mesdag Panorama, An Experience in Space and Time,* trans. Arnold and Erica Pomerans (Zwolle / The Hague: Waanders Uitgevers / B.V. Panorama Mesdag, 1996), 11.

23. Fruitema and Zoetmulder, *The Panorama Phenomenon,* 33.

24. Oettermann, *The Panorama,* 176.

25. This panorama was Henry Aston Barker's biggest success, grossing £10,000. Altick, *The Shows of London,* 177.

26. Oettermann, *The Panorama,* 32.

27. Ibid., 115.

28. According to Oettermann, John Thomas Serres's panorama called *The Pandemonium of Boulogne* is the most compelling example of nineteenth-century amusements foreshadowing contemporary television journalism, "providing as up-to-date visual information as possible on the current military situation." Oettermann, *The Panorama,* 125.

29. *Journal London und Paris* 7 (1801): 105–106, cited in Oettermann, *The Panorama,* 115.

30. *Journal London und Paris* 7 (1801): 103 and 113, cited in ibid., 117.

31. Guide for *View of Gibraltar* (1805), British Library.

32. See Oettermann's discussion of this in *The Panorama,* 106–126.

33. Anon., "The Panorama, with Memoirs of Its Inventor Robert Barker, and his Son, the Late Henry Aston Barker," *Art-Journal* 9 (1847): 46–47. Conflicts with Napoleon had been successfully represented in panoramic form, including *The Battle of the Nile* (1798) and *The Battle of Trafalgar* (1805): Herbert C. Andes, "The Leicester Square and Strand Panoramas," *Notes and Queries* 159.4–5 (July 26, 1930): 59. Napoleon, too, was struck by the panorama's potential for propaganda, although as Lee Parry notes, his plan to construct eight rotundas to display the great battle of the Revolution and Empire was defeated by the events of 1812–1815. Parry, "Landscape Theater," 54.

34. Evelyn Onnes-Fruitema, "Of Panoramas Old and New," in *The Magical Panorama*, 31; For example, the modern *Battle of Al-Qadisiyah* panorama in Iraq depicts a battle that took place in A.D. 637; reaching the viewing platform either by stairs or elevator, the spectator is encircled by combat. By way of heightening the spectacle and illusionism, recorded sound effects of the war play continuously in the background (ibid.).

35. Flier for Waterloo panorama playing at the Westminster Panorama, no date, Regent's Street Theatres scrapbook, Westminster Panorama file, Guildhall Library Corporation of London, hereafter abbreviated to GLCL. (Emphasis added.)

36. *Description of a View of the City of Nanking, and the Surrounding Country, Now Exhibiting at The Panorama, Leicester Square*, brochure of panorama painted by Robert Burford (1845), British Library (emphasis added).

37. Martin Meisel, *Realizations: Narrative, Pictorial, and Theatrical Arts in Nineteenth-Century England* (Princeton: Princeton UP, 1983), 61.

38. Peter Paret, *Imagined Battles: Reflections of War in European Art* (Chapel Hill: U of North Carolina P, 1997), 68.

39. Flier for the Rotunda, Great Surrey St. and Blackfriars Bridge (Regent Street Theatres scrapbook, GLCL).

40. Flier for *Mr. Charles Marshall's Great Moving Diorama Illustrating the Grand Route of a Tour Through Europe*.

41. Van Eekelen, "The Magical Panorama," 16.

42. Allison Patricia Whitney, "The Eye of Daedalus: A History and Theory of IMAX Cinema," Ph.D. diss. (University of Chicago, 2005), 22. For more on IMAX's mythology, see chapter 1 of Whitney's dissertation. My thanks to Tom Gunning for recommending Whitney's dissertation.

43. George Clinton Densmore Odell, *Annals of the New York Stage* (New York: Columbia UP, 1927–49), vol. 2, 239, cited in Oettermann, *The Panorama*, n53, 360.

44. Paul Kerr et al., *The Crimean War* (London: Boxtree, 1998). For more on Nightingale, see 78–95; for women's firsthand accounts of the war, 61–62.

45. Jean Gallagher, *The World Wars Through the Female Gaze* (Carbondale: Southern Illinois UP, 1998), 3. Gallagher argues that "vision has functioned . . . not only as a mark of and basis for authenticity and authority in writing [and imaging] about war but has played an important role in the developing and gendering of cultural discourses about war" (ibid).

46. "Zweytes Panorama. Seeansicht von Margate. Blick auf die Stadt," *Journal London und Paris* 4 (1799): 3–5, cited in Oettermann, *The Panorama*, 107.

47. "Modebelustigungen in London. Neues Panorama. Grausende Darstellung der Schlacht bei Abukir," *Journal London und Paris* 3 (1799): 309–311, cited in Oettermann, *The Panorama*, 107 (emphasis added).

48. Paret, *Imagined Battles*, 66.

49. From Helmut von Erffa and Allen Stanley, *The Paintings of Benjamin West* (London: New Hand, 1986), 222, cited in ibid., 50 (emphasis added).

50. For a detailed discussion of the panorama's construction and special effects, see "The Cyclorama," 296.

51. The panorama was open from 9 a.m. to 11 p.m. each day. For more information, see ibid.

52. *Chicago Tribune*, Dec. 2, 1883, review of Philippoteaux's painting, cited in brochure "Panorama of the Battle of Gettysburg, permanently located at the corner of Wabash

Avenue and Hubbard Court, Chicago" (c. 1884), New York Historical Society (hereafter abbreviated to NYHS).

53. The antiwar *Bourbaki Panorama* painted by the Swiss artist Edouard Le Castre in 1871 has a most impressive faux terrain in which a real railway wagon merges almost imperceptibly with the painted rails on the canvas. Fruitema and Zoetmulder, *The Panorama Phenomenon*, 65.

54. "War in Egypt" National Panorama guidebook (1883), London Playbill Scrapbook, GLCL, 142.

55. "On Cosmoramas, Dioramas, and Panoramas," *Penny Magazine* 11 (1842): 364.

56. "The Cyclorama," 296.

57. Ibid.

58. Theodore R. Davis, "How a Great Battle Panorama Is Made," *St. Nicholas* (December 1886): 112.

59. R. B. Beckett, ed., *John Constable's Correspondence*, vol. 2: *Early Friends and Maria Bicknell (Mrs. Constable)*, Suffolk Records Society 6 (1964): 34.

60. R. M. Hayes, *3-D Movies: A History and Filmography of Stereoscopic Cinema* (Jefferson, N.C.: MacFarland, 1998), 1.

61. "The Cyclorama," 296.

62. Van Eekelen, "The Magical Panorama," 16. For a discussion of the spectator's negotiation of the interaction between the represented image and the painted surface of the canvas, see Richard Wolheim, "What the Spectator Sees," in Norman Bryson, Michael Ann Holly, and Keith Moxey, eds., *Visual Theory: Painting and Interpretation* (New York: HarperCollins, 1991), 101–150.

63. The Gettysburg panorama was restored in 1980–1982. *The Battle of Atlanta*, another circular panorama, was painted by William Wehner and can be viewed in Atlanta. It was restored at the same time as the Gettysburg panorama. For a list of extant panoramas around the world, see Oettermann, *The Panorama*, 345–47.

64. Philippoteaux, "Panorama of the Battle of Gettysburg" brochure. For a fascinating account of the construction of this panorama, see Davis, "How a Great Battle Panorama Is Made," 99–112.

65. The panorama—and the entire site—is again scheduled for extensive renovation. The faux terrain has been removed and for some bizarre reason appears on the outside of the panorama, which spectators see on their way up the ramp.

66. The quotation "sublime triumphs of art" in the heading for this section is from "On Cosmoramas," 363. The epigraph is from Henry Longfellow, *Life of Henry Wadsworth Longfellow with Extracts from His Journals and Correspondence* (Boston: Ticknor, 1886), vol. 2, 67–68, cited in John Hanner, "The Adventures of an Artist: John Banvard, 1815–1891," Ph.D. diss. (Michigan State University, 1979), 68. Longfellow went to see Banvard's panorama on December 16, 1846, and wrote: "One seems to be sailing down the great stream and sees boats, sandbars and the cottonwoods in the moonlight. Three miles of canvas of great merit." Longfellow quoted in Estelle V. Newman, "The Story of Banvard's Folly," *Long Island Forum* 15.5 (May 1952): 83–84 and 95–97, in Banvard Family Papers, Minnesota Historical Society (hereafter abbreviated to BFP).

67. By the mid-1850s, there were at least seven river panoramas on tour in the United States, a clear indicator of their popularity (Lisa Lions, "Panorama of the Monumental Grandeur of the Mississippi Valley," *Design Quarterly* [July 1977]: 32). Only one of these panoramas is extant, the Dickeson-Egan *Panorama of the Monumental Grandeur of the Mississippi Valley* painted in tempera on muslin by Dr. Montroville William Dickeson and John J. Egan in 1850. Rather than a continuous portrait of the river, the panorama, as Lions points out, is a collection of "vignettes depict[ing] dramatic, idealized river views and quasi-historical events." Dickeson's panorama consisted of 25 pictures of the Mississippi from the mid-sixteenth century to the mid-nineteenth century (ibid.).

68. *Reveille*, St. Louis, Oct. 29, 1848, cited in Joseph Earl Arrington, "The Story of Stockwell's Panorama," *Minnesota History* 33.7 (Autumn 1953): 286.

69. Review of Banvard's panorama, Bristol *Gazette*, cited in McDermott, *The Lost Panoramas*, 14.

70. Between 1830 and 1842, the following places and subjects were represented in panoramic form at the Pano-

rama Leicester Square: Rome, Damascus, Acre, Lima, Jerusalem, Bombay, Stirling (Scotland), the Siege of Antwerp, the Cemetery of Père la Chaise at Paris, the Arctic Region of Boothia, etc. Information from "On Cosmoramas," 364.

71. Peter Galassi, *Before Photography: Painting and the Invention of Photography* (New York: MOMA, 1981), 21.

72. Miller, "The Panorama," 43.

73. John Banvard, *Descriptions of Banvard's Geographical Painting of the Mississippi River, extensively known as the* Three Mile Picture, *with new additions of the naval and military operations on that river, exhibiting a view of the country 1,500 miles in length, from the mouth of the Missouri to the Balize* (New York: L. H. Bigelow, 1862).

74. Marie L. Schmitz, "Henry Lewis: Panorama Maker," *Cultural Heritage: Quarterly Journal of the Missouri Historical Society* 3 (Winter 1982): 41.

75. Altick, *The Shows of London,* 174.

76. Advertisement for Sinclair's *Grand Peristrephic or Moving Panorama of the Battle of Waterloo, St. Helena,* at the Mechanics Hall in Panoramas clipping file, New York Public Library, Billy Rose Theater Collection (hereafter, NYPL-BRTC).

77. "Moving (Dioramic) Experiences," *All the Year Round* 17 (Mar. 22, 1867); 304, cited in Richard Carl Wickham, "An Evaluation of the Employment of Panoramic Scenery in the Nineteenth Century," unpublished Ph.D. diss. (Ohio State University, 1961), 121.

78. Valentine writes: "Allowing amateur film-makers access to such expensive equipment seems to result in very grand public information films." "Another Dimension," *Design Week,* May 7, 1999, 6.

79. Hanner, "The Adventures of an Artist," 60.

80. Ibid., 61. Newspaper clippings from the Banvard scrapbook describe his lecture as containing "racy anecdotes" and "short pithy remarks" (ibid).

81. Ibid., 62.

82. Unidentified clipping from the *North of Scotland Gazette* featured in a flier advertising Banvard's panorama at the City Hall, Perth, Australia, 1852; "Banvard's Panorama of the Mississippi River," unidentified clipping in BFP.

83. According to John Francis McDermott, five panoramas of the Mississippi were painted in the 1840s alone, the shortest being 425 yards long. McDermott, "Gold Rush Movies," *California Historical Society Quarterly* 33.1 (March 1954): 29.

84. *The Examiner* (London), Dec. 16, 1848, cited in Oettermann, *The Panorama,* 32; reprinted in Charles Dickens, *Works* (London: Chapman & Hall, 1897–1908), vol. 35 ("Miscellaneous Paper 1"), pp. 139–41. The same article was also published as "The American Panorama," in *Littel's Living Age* the following year: vol. 20 (Jan.–Mar. 1849): 314–15.

85. The fact that Banvard's panorama became the subject of satirical attack in famous humorist Artemus Ward's Mississippi-style panorama, which opened at Dodworth Hall, a dancing academy at 806 Broadway in New York City in October 1861, is a clear indication of his national reputation as a panorama exhibitor. Ward's lecture parodied all the clichéd panorama conventions, including Ward's brandishing of a dilapidated umbrella instead of a pointer; as Curtis Dahl notes, "[Ward] used and abused all the customary tricks, submitting his audience in turn to fictitious autobiographical allusions, teary sentiment, blatant flag-waving, and mournful pathos." Dahl, "Artemus Ward: Comic Panoramist," *New England Quarterly* 32.4 (Dec. 1959): 483.

86. Banvard's panorama was enormously popular for two years in the United States following its initial exhibition, touring New Orleans, Boston, New York, and Washington, D.C. For more on Banvard, see McDermott, *The Lost Panoramas,* and Hanner, "The Adventures of an Artist."

87. *Description of Banvard's Panorama of the Mississippi River painted on Three Miles of Canvas Exhibiting a View 1,200 Miles in Length extending from the Missouri River to the City of New Orleans* (Boston: John Putnam, 1847), 7. This is a useful primary resource for information on the construction of panoramas; it also contains a detailed description of the views represented along the length of the painting.

88. Miller, "The Panorama," 47.

89. "The Mareorama at the Paris Exposition," *Scientific American* 83 (1900): 198.

90. Established in 1837, Messrs. Poole Brothers were successors to Messrs. Poole and Young and the celebrated M. Gompertz (self-styled "Father of the Panorama" who claimed to be the "oldest established and greatest panorama and dioramic proprietors in the world"). According to the publicity brochure, the company owned six panoramas and kept them up to date by adding new features such as motion pictures: "In the present go-ahead times each entertainment to be successful must beat its predecessor, and in submitting the present Myriorama, painted by the very best obtainable artists, regardless of cost, and bringing his great practical knowledge to bear upon the Machinery and effects, and selecting a first-class Variety Company, Mr. Chas. W. Poole has no hesitation stating that anything . . . compare[d] with this Entertainment has never been produced in this or any other country." Publicity flier in panorama file, NYPL-BRTC.

91. "Moving (Dioramic) Experiences," 304.

92. Review of Philippoteaux's *Panorama of the Battle of Gettysburg* in *Chicago Times*, Dec. 2, 1883, n.p., cited in brochure for panorama at the NYHS.

93. J. R. Smith, "Descriptive book of the tour of Europe, the largest moving panorama in the world, at the Chinese Rooms, 539 Broadway, NY. Painted on 30,000 square feet of canvas, from views taken on the spot, and at an expense of $10,000." Petitioner and Gray, 1855, 3 (emphasis added).

94. *Webster's New Collegiate Dictionary* (Springfield, Mass: Merriam, 1977).

95. Ivone Margulies, "Exemplary Bodies: Reenactments in *Love in the City, Sons,* and *Close-Up,*" in Margulies, ed., *Rites of Realism: Essays on Corporeal Cinema* (Durham: Duke UP, 2003), 217–44.

96. Ibid.

97. Avery, "Movies for Manifest Destiny," 8.

98. According to Joseph Earl Arrington, Godfrey Frankenstein was assisted by his two other brothers (unnamed) and by American painter William Burr, who in 1848 had painted his own moving panorama of the Great Lakes, Niagara, St. Lawrence, and Sergeant rivers. Information in Arrington, "John Banvard's Moving Panorama of the Mississippi, Missouri, and Ohio Rivers," *Filson Club Historical Quarterly* 32.3 (July 1958): 211; and Arrington, "William Burr's Moving Panorama, 141–62.

99. Anon., "Review of Mr. Frankenstein's Panorama of Niagara," *Literary World,* July 23, 1853, cited in promotional brochure of "Frankenstein's Panorama of Niagara," 9, housed at the NYHS.

100. Anonymous and untitled review of Frankenstein's panorama from the *U.S. Argues,* n.d., n.p., cited in promotional brochure of "Frankenstein's Panorama of Niagara," 6, NYHS; review of Frankenstein's panorama from the *True National Democrat,* cited in ibid.

101. Avery, "Movies for Manifest Destiny," 8.

102. "Frankenstein Panorama of Niagara," *The Observer,* Aug. 18, 1853, cited in promotional brochure, "Frankenstein's Panorama of Niagara," 12, housed at the NYHS. Emphasis added.

103. London Playbills Scrapbook, GLCL, 52.

104. "Mr. Frankenstein's Panorama," *U.S. Argues,* cited in promotional brochure, "Frankenstein's Panorama of Niagara," 12, housed at the NYHS; "Frankenstein's Panorama of Niagara," *Evening Mirror,* July 25, 1853, cited in ibid., 10, NYHS.

105. "On Cosmoramas," 363.

106. "Mr. Frankenstein's Niagara," *Spiritual Telegraph,* cited in promotional brochure, "Frankenstein's Panorama of Niagara," 16, housed at the NYHS.

107. Margulies, "Exemplary Bodies," 217–44.

108. Wolfgang Born, *American Landscape Painting* (Westport: Greenwood press, 1948), 86.

109. André Bazin, "The Myth of Total Cinema," in *What Is Cinema?,* ed. Hugh Gray (Berkeley: U of California P, 1967), 21.

110. While a great deal more could be said about the correspondences between the panorama, reenactment, and waxwork, space precludes going into greater depth on the subject. For

more on how discourses of realism and spectacle play out in the waxwork exhibit, in particular the late-nineteenth-century Musée Grevin in Paris, see Schwartz, *Spectacular Realities*, 89–148.

111. Ibid., 90 and 104.

112. In the UK, *Crimewatch* is the most notable; in the United States, infotainment shows such as *America's Most Wanted* and *Inside Edition* make extensive use of the reenactment in sensationalist ways. An attack on television reconstructions from *The Guardian* pokes fun at what Catherine Bennett calls "the current vogue for reconstructions over other less vibrant forms of moving wallpaper [in which] they chose to hire a look-alike, switch to black and white, and turn up the menace." BBC guidelines on the use of reconstructions state that while they can be a "great help in explaining an issue . . . [they] must always be done truthfully with an awareness of what is reliably known. Nothing significant which is not known should be invented without acknowledgement." Bennett, "Beware of Cheap Imitation: On the Creeping Menace of TV Reconstructions," *The Guardian*, Feb. 3, 2000.

113. For more on the connection between landscape and death in art history, which is often represented via the theme of "Et in arcadia ego," see Erwin Panofsky's essay, "Et in Arcadia Ego: Poussin and the Elegaic Tradition," in *Meaning in the Visual Arts: Papers in and on Art History* (Garden City, N.Y.: Doubleday Anchor, 1955), 295–320. My thanks to Tom Gunning for this reference.

114. Mieke Bal, *Reading Rembrandt: Beyond the Word-Image Opposition* (New York: Cambridge UP, 1991), 362 and 375.

115. Ibid., 375.

116. W. Telbin, "The Painting of Panoramas," *Magazine of Art* 24 (1900): 557 (emphasis added).

117. Maxim Gorky, "The Kingdom of Shadows," originally published in the *Nizhegorodski listok* newspaper, July 4, 1896, and signed I. M. Pacatus (Gorky's pseudonym). Translation by Leda Swan from Jay Leyda, *Kino* (London: Allen and Unwin, 1960). Reprinted in Kevin MacDonald and Mark Cousins, *Imagining Reality: The Faber Book of Documentary* (London: Faber and Faber, 1996), 6–10.

118. The Mesdag Panorama in The Hague has a narration that highlights all the salient features of the painting. It plays in Dutch, German, English, French, or Spanish depending on the linguistic profile of tourist groups, who can request to hear the narration in their native language when purchasing tickets. When the museum is quiet, a CD playing ambient sound effects such as birdcalls and the ocean surf substitutes for the narration. Mesdag Panorama director Marijnke de Jong notes that some visitors complain about the narration in email messages to her, finding it intrusive and distracting. While sympathetic to their wish to experience the panorama in silence, the ambient sound is rarely turned off, since the majority of visitors seem to quite like it. Author interview with de Jong, July 14, 2001, The Hague.

119. Telbin, "The Painting of Panoramas," 557.

120. Bruno Ernst, "Perspective and Illusion," in *The Magical Panorama*, 123. For more on the Mesdag Panorama, visit www.panorama-mesdag.nl.

121. For more on the connection between panoramas and large-screen imaging technologies, see chapter 3.

122. Miller, "The Panorama," 52.

123. Ibid., 56.

124. While space precludes examining early cinema panorama films in any detail, examples of films include *Panorama of Niagara Falls in Winter* (Biograph, 1899); *Panorama of Eiffel Tower* (Edison, 1900); *Panorama of the Exposition* (Lubin, 1901); *Panorama of the Paris Exposition, from the Seine* (Edison, 1900); *Panoramic View of State Street* (Selig, c. 1900); and *Panoramic View of Multnomah Falls* (Selig, 1903). Including the word *panorama* in the title, however, was no guarantee of a smooth-flowing lateral pan of the landscape; for example, the *Panorama of the Golden Gate* consists of a phantom ride shot in which the camera is attached to the front of a moving vehicle, in this case a train. For discussion of some of these films, see Charles Musser, *The Emergence of*

Cinema: The American Screen to 1907 (New York: Scribner's, 1990). For more on the relationship between landscape painting and early cinema, see Iris Cahn, "The Changing Landscape of Modernity: Early Film and America's 'Great Picture' Tradition," *Wide Angle* 18.3 (July 1996): 85–100.

125. Charles Baudelaire, "The Salon of 1845," *Selected Writings on Art and Literature*, trans and ed. P. E. Charvet (New York: Penguin, 1992), 87–88, cited in Paret, *Imagined Battles*, 80.

126. Ibid.

127. Fruitema and Zoetmulder, *The Panorama Phenomenon*, 30.

3. EXPANDED VISION IMAX STYLE

1. Vincent Canby, "Big Screen Takes on New Meaning," *New York Times*, Apr. 19, 1987, B18 (hereafter abbreviated to *NYT*).

2. My thanks to Barbara Kirshenblatt-Gimblett for allowing me to reproduce this image which appears on the frontispiece of her excellent book *Destination Culture: Tourism, Museums, and Heritage* (Berkeley: U of California P, 1998).

3. For an interesting discussion of why the moniker "new" continues to be used with relatively stable media technologies, see Jonathan Sterne, "Out with the Trash: On the Future of New Media," in Charles R. Acland, ed., *Residual Media*, (Minneapolis: U of Minnesota P, 2007), 16-31. For more on these companies, visit their Web sites www.ipix.com and www.behere.com. IPIX, which developed as a Small Business Innovation Research contract through the Langley Research Center, originated with the support of NASA, which used the technology for guiding robots in their shuttle and space station programs, and the U.S. Department of Energy, which needed technology that could offer remote viewing of potentially hazardous environments.

4. Oettermann, *The Panorama*, 88.

5. Allison Whitney defines OMNIMAX as a system "where films are projected onto a hemispheric dome positioned above the audience, angled between 20–25 degrees toward the horizon." The theaters are usually between 20–30 meters in diameter and seat anywhere from 200 to 500 people. The first IMAX Dome opened at the Reuben H. Fleet Science Center in San Diego, California, in 1973; the first OMNI-MAX film was *Garden Isle* (Roger Tilton, 1973), about the Hawaiian island of Kauai. IMAX Solido premiered in the Jujitsu Pavilion at the Expo '90, Osaka, Japan. Whitney, "The Eye of Daedalus," 70–74.

6. Whitney, "The Eye of Daedalus," 7. For more on IMAX's mythology, see chapter 1 of Whitney's dissertation.

7. Søren Pold, "Panoramic Realism: An Early and Illustrative Passage from Urban Space to Media Space in Honoré Balzac's Novels *Ferragus* and *Le Père Goriot*," *Nineteenth-Century French Studies* 29.1-2 (Fall-Winter 2000–2001): 54. For a classic analysis of nineteenth-century travel itself as somehow panoramic, see chapter 4 of Wolfgang Schivelbusch, *The Railway Journey: The Industrialization of Time and Space* (Berkeley: U of California P, 1986).

8. Whitney, "The Eye of Daedalus," 155.

9. Charles R. Acland, "IMAX Technology and the Tourist Gaze," *Cultural Studies* 12.3 (1998): 431.

10. Anon., "A Reminiscence of the Days when Panoramas were Highly Popular," c. 1874, in Panoramas: Portfolio of clippings and pamphlets, New York Public Library Billy Rose Theater Collection (hereafter abbreviated to NYPL-BRTC).

11. Scott B. Wilcox, "Unlimiting the Bounds of Painting," in Hyde, *Panoramania!*, 28.

12. Ibid.

13. Jennifer Peterson, "The Cinematic Geography of Early Travelogues," paper presented at the Society for Cinema Studies conference, Miami Beach, Apr. 1999, 10–11.

14. For more on early travelogues, see Tom Gunning, "'The Whole World Within Reach': Travel Images Without Borders," in Jeffrey Ruoff, ed., *Virtual Voyages: Cinema and Travel* (Durham: Duke UP, 2006), 25–41; Jennifer Peterson,

"'Truth Is Stranger Than Fiction': Travelogues from the 1910s in the Nederlands Filmmuseum," in Daan Hertogs and Nico de Klerk, eds., *Uncharted Territory: Essays on Nonfiction Film* (Amsterdam: Stichting Netherlands Filmmuseum, 1997), 75–90; Peterson, "World Pictures: Travelogue Films and the Lure of the Exotic, 1890–1920," Ph.D. diss. (University of Chicago, 1999); Charles Musser, "The Travel Genre in 1903–1904: Moving Towards Fictional Narrative," in Thomas Elsaesser, ed., *Space, Frame, Narrative* (London: BFI, 1990), 123–31; X. Theodore Barber, "The Roots of Travel Cinema: John L. Stoddard, E. Burton Holmes, and the Nineteenth-Century Illustrated Travel Lecture," *Film History* 5 (1993): 85–95; and Alison Griffiths, "'To the World the World We Show': Early Travelogues as Filmed Ethnography," *Film History* 11.3 (Sept. 1999): 282–307.

15. Whitney, "The Eye of Daedalus," 132.

16. Lauren Rabinovitz, "The Miniature and the Giant: The Perceptual Spectacular of Postcards and Early Cinema," *The Tenth Muse: Cinema and Other Arts*, Proceedings of VI Covegno Domitor (Udine: Forum, 2001), 46.

17. Canby, "Big Screen Takes on New Meaning," 18.

18. Stan Kinsey, quoted in David Everett, "Putting Filmgoers in the Big Picture," *NYT*, Aug. 8, 1993, B16.

19. James M. Phillips, quoted in Shira Levine, "A Web Walk: IPIX Brings 3-D to the Internet," *Telephony*, Aug. 18, 1997.

20. Michael Marriott, "Video Technology to Make the Head Spin," *NYT*, Mar. 2, 2000, G10.

21. Anne Friedberg, *Window Shopping: Cinema and the Postmodern* (Berkeley: U of California P, 1993), 3.

22. Marriott, "Video Technology," G10.

23. Gelfond, quoted in Matthew Gurevitch, "The Next Wave? 3-D Could Bring On a Sea Change," *NYT*, Jan. 2, 2000, B1.

24. "With IPIX Virtual Tours from Mount Everest," IPIX Press Pelease (5/25/00).

25. Cahn, "The Changing Landscape of Modernity," 85–100.

26. Whitney, "The Eye of Daedalus," 13.

27. Oettermann, *The Panorama*, 90.

28. For an overview of the issues here, see Cornelia Dean, "A New Test for IMAX: The Bible vs. the Volcano," *NYT*, Mar. 19, 2005, A11.

29. Charles Dickens, "Some Account of an Extraordinary Traveller," *Household Worlds* 1 (1850): 77, cited in Wilcox, "Unlimiting the Bounds," 37.

30. Panoramas of Constantinople were exhibited at the Leicester Square Panorama in 1804, 1846, and 1853–54. Altick, *The Shows of London*, 178.

31. Ibid., 180.

32. Jonathan Culler, "Semiotics of Tourism," *American Journal of Semiotics* 1 (1981): 127; John Urry, *The Tourist Gaze: Leisure and Travel in Contemporary Societies* (London: Sage, 1990), 4.

33. Cited according to William Henry Pyne, "The Panorama," *Somerset House Gazette Literary Museum* 2 (London, 1823–24): 153 (in Oettermann, *The Panorama*, 113).

34. IMAX *Extreme* (Jon Long, 1999) brochure. The film features world champion athletes in giant-wave surfing and windsurfing in Hawaii, skiing and snowboarding in Alaska, rock climbing in Utah, and ice climbing in British Columbia.

35. Ben Shedd, cited in William H. Honan, "A Movie Process in Which the Screen Disappears," *NYT*, Mar. 30, 1990, 15.

36. *London Times*, Apr. 7, 1827, cited in Altick, *The Shows of London*, 188.

37. William C. Symonds, "Where Buying a Ticket Puts You Right in the Action," *Business Week* 3361 (Mar. 7, 1994): 73.

38. Altick, *The Shows of London*, 142.

39. See IPIX Press Release (5/22/00) for more on IPIX movies, RealPlayer, and Spielberg, and Press Release (5/24/00), "IPIX Provides First Ever Personalized Imaging Over the Internet for Makeover Networks Inc.," for more on virtual makeovers.

40. Oettermann, *Panorama*, 135. For a discussion of the challenges involved in painting a panorama of this magnitude, and the difficulties the Colisseum ran into over the course of its lifetime (1829–1876, when it was torn down), see Oetter-

mann, *Panorama,* 135–39, and Altick, *The Shows of London,*
142–60.

41. Julie Rekai Rickerd, "Movie Magic," *Lighting Dimensions*
(Sept. 1999).

42. Oettermann, *Panorama,* 128–29.

43. Ibid., 129.

44. Ibid., 323.

45. Gurevitch, "The Next Wave?" B28.

46. Gelfond, IMAX co-chairman, quoted in Gurevitch, "The
Next Wave?" B1. In December 2001, IMAX announced plans
to develop a large-format video projector, which would use
a microchip covered with tiny mirrors to reflect light on the
screen. For more on the technology, see Barry Fox, "Altered
Image," *New Scientist* 2319 (Dec. 1, 2001): 23.

47. For an excellent institutional history of IMAX's emergence
from world fairs and expositions, see Whitney, "The Eye of
Daedalus," 16–56. According to Whitney, the first per-
manent IMAX theater opened in 1971 at Ontario Place, a
government-sponsored amusement park in Toronto (55).

48. Didier Maleuvre, *Museum Memories: History, Technology, Art*
(Stanford: Stanford UP), 16.

49. Media critic and public intellectual Douglas Rushkoff
discusses memetics in *Media Virus* (New York, Ballantine,
1994). See also Guiliana Bruno, *Atlas of Emotion: Journeys in
Art, Architecture, and Film* (New York: Verso, 2002), 73–111.

50. Canby, "Big Screen Takes on New Meaning,"18. For a
plethora of information about IMAX, visit www.giantscreen-
biz.com. There is also a journal devoted to large-screen film
formats entitled *LF Examiner.*

51. Whitney, "The Eye of Daedalus," 4.

52. India is considered the second fastest-growing market in
IMAX's history (there were six theatres in India in 2006)
with the possibility of repurposing Bollywood films not be-
ing ruled out. "IMAX Signs Deal for Three IMAX Theatres
in India," *PR Newswire,* Apr. 29, 2003. IMAX has also
developed a lower-cost system called IMAX MPX that can
be installed in an existing multiplex for $1.5million (cost of

equipment and retrofitting the theater) (Ron Insana, "IMAX
Chief Sees a Big Future in Big Screens," *USA Today,* Dec. 5,
2005, 4B). The Becaon Theater in New York City was the
first to be retrofitted by IMAX so it could feature the Rolling
Stones film *At the Max* (*Variety,* Nov. 18, 1991, 10).

53. Eastern Europe is also a vibrant market; in addition to
theaters in Prague, Krakow, and Budapest, a Moscow IMAX
screen has opened and in summer 2003 was playing *The
Matrix: Reloaded* at $12 a head. David Haffenreffer, "IMAX
Corporation CO-COE Bradley Wechsler," guest on CNNfn,
July 31, 2003, 12:30 p.m. EST.

54. Shlomo Schwartzberg, "IMAX: Oscar Nominated Canadian
Company on the Leading Edge of Technology," *Performing
Arts & Entertainment in Canada* 28.1 (Spring 1993): 42. The
first IMAX Ridefilm simulator opened on May 27, 1995, in
the IMAX Mechanical Motion Theater at the indoor-themed
resort Magical World of Fantasy Island in Lincolnshire, Eng-
land. Anon., "Island Life," *Leisure Week,* June 2, 1995, 26.

55. Mat Zoller, "Haunted Castle," *New York Press,* Feb. 28,
2001, 38.

56. "Kiefer Sutherland Joins the Field on *NASCAR 3D: The
IMAX Experience,*" *PR Newswire,* Sept. 22, 2003.

57. Some museums, such as the Fort Worth Museum of Science
and History in Texas, are frank in their discussion of the
revenue-generating appeal of IMAX; investing heavily in
IMAX films playing at the domed Omni Theater (only the
third in the world), museum president Don Otto admits that
it is "demand for these kind of 'wow' programs that drives
what the museum does financially." Competing with a
commercial IMAX theater which opened in Dallas in 2001,
the museum realized it would have to reach some level of
market exclusivity in terms of its programming. Natalie
Gardner, "Museum Takes Profitable Approach to Exhibits,"
Business Press 11.38 (Jan. 15, 1999).

58. Sony Theaters Lincoln Square in New York was the first
IMAX theater built in a multiplex. The screen measures 75.6
feet high by 97.6 feet wide, a format ratio with a relatively

"natural" field of vision that provides no edges. Gurevitch, "The Next Wave?" B1. The first IMAX films to play at the theater were *Into the Deep* and *The Last Buffalo* in November 1994.

59. Whitney, "The Eye of Daedalus," 89.
60. Hollywood is also placing bets on a 3-D renaissance thanks to the conversion of movie theaters to digital projection technology. For more, see Ian Austen, "Mining the 3rd Dimension for Bigger Profits," *NYT*, Mar. 14, 2005, C1; and David M. Halbfinger, "Going Deep for Digital: A Bet on 3-D Movies to Push Theaters Beyond Celluloid," *NYT*, Sept. 26, 2006, C1 and C5.
61. *Fantasia* (James Algar and Samuel Armstrong, 1940) was the first full-length Hollywood movie to be shown in the giant-screen IMAX format and a test of whether IMAX Corporation "can solve its biggest problem: getting out of the special-effects ghetto and entering the movie mainstream." Disney's 10-year-old *Beauty and the Beast* (Gary Trousdale and Kirk Wise, 1991) took in $15.4 million at the IMAX box office during its re-release, while *Fantasia 2000* (James Algar and Gaëtan Brizzi, 2000) earned $70 million in IMAX theaters. Roger Ricklefs, "IMAX Hopes to Take Vast Screen into Mainstream—A New 'Fantasia' Tests Film Strategy of Canadian Firm," *Wall Street Journal*, Dec. 10, 1999, A15.
62. The film was released as *Spider-Man 3: The IMAX Experience*. "Two IMAX 3D Films Reach New Box Office Milestones," *PR Newswire*, May 8, 2003. In November 2002, Disney became the first studio to simultaneously release its holiday film *Treasure Planet* (Ron Clements and John Musker 2002) on IMAX and standard-size screens, while *Lion King* (Roger Allers and Rob Kinkoff, 1994) has been playing to sizable IMAX audiences since December 2002. Lisa Gubernick, "Hollywood Thinks Bigger—Your Favorites, Only Taller: Can Re-Released Movies Breathe Life into IMAX?" *Wall Street Journal*, Feb. 12, 2002, W5.
63. Greg Hernandez, "Big Pictures Push IMAX to Its First Profitable Year Since 1999," *Los Angeles Daily News*, Feb. 28, 2003; "IMAX and EuroPalace to Open IMAX Theatre at Disneyland Resort Paris," *PR Newswire*, June 23, 2003. There are over forty-six IMAX theaters in Europe.
64. "Coming Soon to an IMAX Theatre: Stronger Profit," *Toronto Star*, Feb. 28, 2003, E6. There are currently two theaters in the Shanghai Science and Technology Museum, with six more scheduled to open. Twenty-five screens are predicted to be open in China by 2008. For more on China's IMAX theater openings, see Leslie Chang, "IMAX Aims to Turn China into its Number 2 Market," *Toronto Star*, Feb. 11, 2003, DO3, and Insana, "IMAX," 4B.
65. Peter M. Nichols, "Going Beyond the 'Wow' Factor on Giant Screens," *NYT*, Sept. 15, 1999, E3.
66. John Belton, *Widescreen Cinema* (Cambridge: Harvard UP, 1992), 28.
67. For more on the relationship between Cinerama and travelogues, see Belton, *Widescreen Cinema*, 91–94.
68. Ibid, 1, 2.
69. Ibid, 89–90.
70. Ibid.
71. *To Fly!* has been viewed by 100 million visitors at the Smithsonian's National Air and Space Museum. Ted Johnson and Diane Goldner, "Big Screens Make Mainstream Breakout Bid," *Variety*, Jan. 27, 1997, 5. See chapter 6 for a detailed institutional history of *To Fly!* at the National Air and Space Museum, Washington, D.C. For more on IMAX and nationalist discourses in the Canadian context, see Charles R. Acland, "IMAX in Canadian Cinema: Geographic Transformation and Discourses of Nationhood," *Studies in Cultures, Organizations and Societies* 3 (1997): 289–305.
72. Some important works on landscape and nationalist ideologies include Angela Miller, *The Empire of the Eye: Landscape Representation and American Cultural Politics, 1825–1875* (Ithaca: Cornell UP, 1993); and Andrew Wilton and Tim Barringer, *American Sublime: Landscape Painting in the United States 1820–1880* (London: Tate, 2002).
73. Mark Neumann goes so far as to draw a direct analogy between the film and nineteenth-century world's fairs and

expositions, which flaunted America's industrial might and prosperity. "Emigrating to New York in 3-D: Stereoscopic Vision in IMAX's Cinematic City," in Mark Shiel and Tony Fitzmaurice, eds., *Cinema and the City* (Oxford and New York: Blackwell, 2001), 109–121.

74. *Across the Sea of Time* press packet, 4.

75. Neumann, "Emigrating to New York,"114.

76. Rabinovitz, "The Miniature and the Giant," 43.

77. Whitney offers a helpful overview of the three types of 3-D glasses used in IMAX: anaglyph (using red and green filters and primarily for black and white); the polarized system where the polarization for the left and right eye corresponds to the polarization of the two projector lenses; and Liquid Crystal Display Glasses (LCD) where the glasses are made of a liquid crystal material than can become opaque. The LCD glasses system used at the Sony IMAX Theater in New York incorporates headphones that use an additional sound channel called a Personal Sound Environment. It premiered at the theater in 1995 with *Wings of Courage* (Jean-Jacques Annand, 1995). Whitney, "Eye of Daedalus," 80.

78. James Donald, "The City, the Cinema: Modern Spaces," in Chris Jenks, ed., *Visual Culture* (New York: Routledge, 1995), 77–95.

79. Neumann, "Emigrating to New York," 115.

80. Urry, *The Tourist Gaze*, 1–2.

81. Paul Arthur, "In the Realm of the Senses: Imax 3-D and the Myth of Total Cinema." *Film Comment* 32.1 (Jan.-Feb. 1996): 79.

82. Rick VanderKnyff, "See to Shining Sea." Unidentified unpaginated clipping in NYPL-BRTC.

83. Jonathan Romney, "Back to the Future," *New Statesman* 127.4415 (Dec. 11, 1998). Romney was reviewing the 1998 3-D IMAX release *T-REX: Back to the Cretaceous*, directed by Brett Leonard.

84. VanderKnyff, "See to Shining Sea."

85. Arthur, "In the Realm,"79.

86. Stephen Low, quoted in William Grimes, "Is 3-D IMAX the Future or Another Cinerama?" *NYT*, Nov. 13, 1994, H15.

87. *Cirque du Soleil: Journey of Man* (2000) director Keith Melton describes the 3-D IMAX pop-out effect as follows: "In 3D, the convergence point is where the lines of sight from the two camera lenses meet. The interocular is the distance the two cameras are set apart from each other. Convergence allows the lenses to toe in toward the subject, separate the background, and pop the subject out in the foreground. If filmmakers do not rack the convergence properly, the shot will strain the viewer's eye." Melton, quoted in Darroch Greer, "A Different Cirque: Cirque de Soleil in IMAX 3-D," *Global Telephony*, June 1999.

88. Anon., "Virtual Innovations: Roundtable Product Review: Inside IMAX 3D," *Playback*, Feb. 9, 1998, vi.

89. Canby, "Big Screen Takes on New Meaning," 18.

90. Whitney, "The Eye of Daedalus," 110.

91. Susan Stewart, *On Longing*, 71.

92. Judith Adler, "Origins of Sightseeing," in Carol T. Williams, ed., *Travel Culture: Essays on What Makes Us Go* (Westport, Conn.: Praeger, 1988), 15.

93. Mary Louise Pratt, *Imperial Eyes: Travel Writing and Transculturation* (New York and London: Routledge, 1992).

94. Urry, *The Tourist Gaze*, 4.

95. Ibid.

96. James Clifford, *Travel and Translation in the Late Twentieth Century* (Boston: Harvard UP, 1997), 2.

97. Information from "MacGillivray Freeman's 'Everest' Becomes Highest Grossing Documentary of All Time," press release, Jan. 23, 2003, 1. *Everest* became the first large-format film to appear on *Variety's* Top Ten Box Office Chart, a major accomplishment given it only played at 243 theaters worldwide (a total of 236 cities on six continents), giving it an unprecedented per-screen average of $496,296 (ibid).

MacGillivray Freeman Films has produced 27 large-format films including *The Living Sea* (Greg MacGillivray, 1995) ($84.4 million) and *Dolphins* (Greg MacGillivray, 2000) ($66.6 million). The fastest-grossing 3-D IMAX film is *Space Station* (Toni Myers, 2002), which made more than $50 million in just 55 weeks of release. *T-Rex: Back to the Cretaceous*

(1998) takes credit for being the highest-grossing 3-D IMAX film to date. "Two IMAX 3D Films Reach New Box Office Milestones," *PR Newswire,* May 8, 2003.

98. Mark Singer, "One Deadly Summit," *Sight and Sound* 9.1 (Jan. 1999): 26. For more on the conditions leading to the deaths of the climbers, see John Krakauer, *Into Thin Air: A Personal Account of the Mt. Everest Disaster* (New York: Villard, 1997).

99. The 3-D camera weighs 240 pounds and can take up to 15 minutes to reload with three minutes of film. See Peter Vamos, "IMAX Takes LF to the Stars," *Playback,* Oct. 4, 1999, vi. A modified IMAX camera weighing only 35 pounds (standard weight is 80 pounds) was developed for use in *Everest* after MacGillivray Freeman spent $35,000 in research and development. The camera body was made of magnesium—lighter than aluminum—and a 12-ounce motor with polyurethane drive belts was used. Given that the camera would be sitting in −40 degrees overnight, the camera, battery (a 6-pound, 32-volt lithium cell), and film would have to work efficiently without a heating system. Even the knobs and lens mounts were modified (made larger) to make it easier for the crew to operate the camera wearing bulky gloves. For a detailed discussion of the film's preproduction, see Naomi Pfefferman, "On Top of the World," *American Cinematographer* (August 1995). For more on the challenges of actually shooting on the mountain, see Kathleen Fairweather, "The Towering Challenge of Everest," *American Cinematographer* (May 1998): 48–52. Ironically, for David Breashers, expedition leader and co-director, the greatest challenge was not transporting the camera up the summit or braving the high altitude but "finding good light in a place where the spring sun quickly gets up high in the sky, making for very flat, unattractive shots" (quoted in Pfefferman, "On Top," 37).

100. Stewart, *On Longing,* 74.
101. Ibid.
102. James Clifford, *Routes: Travel and Translation in the Late Twentieth Century* (Cambridge: Harvard UP, 1997), 7.

103. Pfefferman, "On Top of the World,"36.
104. Edmund Burke, "A Philosophical Inquiry into the Origin of Our Ideas of the Sublime and the Beautiful; with an Introductory Discourse Concerning Taste," in *Works* 1 (London: Oxford UP, 1925), 39.
105. Given the incredibly high altitude and weight of the camera / film, only three minutes of footage were taken at the summit. However, all but 20 seconds of this did make it into the final cut. Jerry Adler, "Take It from the Top," *Newsweek,* Mar. 9, 1998.
106. Rimpoche, a lama whom Tenzing Norgay consults before the ascent, obtained these blessing strings. One was given to each team member and, according to Norgay's memoir, David Breashers "even tied one to the IMAX camera." Jamling Tenzing Norgay (with Broughton Coburn), *Touching My Father's Soul: A Sherpa's Journey to the Top of Everest* (San Francisco: Harper, 2001), 60.
107. MacGillivray, quoted in David Heuring, "IMAX Presses to the Limit," *American Cinematographer* 71 (Mar. 1990): 35.
108. Romney, "Back to the Future."
109. Stewart, *On Longing,* 58.
110. Whitney, "The Eye of Daedalus," 15.
111. Oettermann, *The Panorama,* 6–7.
112. Whitney, "The Eye of Daedalus," 69 & 174.
113. Hillis, *Digital Sensations,* xxviii.
114. Ibid., xxixxx.
115. See Ian Edwards, "Invest: Films in Future," *Playback,* July 26, 1999, 1
116. Jeffrey Newman, www.ABCNEWS.com from www.TheStreet.com, Dec. 9, 1999.

4. "A MOVING PICTURE OF THE HEAVENS"

1. "Onlookers Lost in the Stars," *Life* magazine (1958). Clipping from Special Collections, AMNH (hereafter abbreviated to SC-AMNH).

2. Robert R. Coles, untitled document, American Museum of Natural History General Information File, 1935–1986, SC-AMNH.

3. "Hayden Planetarium," *Hart's Guide to New York City* (New York: Hart, 1964), 815.

4. Quote taken from the following page: www.amnh.org/rose/hayden-spacetheater.html.

5. For an analysis of the emergence of the planetarium in the United States, see Jordan D. Marché II, *Theaters of Time and Space: American Planetaria, 1930–1970* (New Brunswick, N.J.: Rutgers UP, 2005).

6. Examples of references to the panorama can be found in several promotional fliers from the Buhl Planetarium in Pittsburgh from the 1950s: "new *panoramas*, stage effects and music" in "Behold the Heavenly Host," a Christmas show from 1957, and in a 1958 Easter show, "Rebirth of the World," referring to "newly-staged effects [that] proclaim the joy of this new dawn with *panoramas* of motion and color." Both from Buhl Planetarium file, SC-AMNH.

7. Anon., "Heavenly Adventures," *Vogue*, Dec. 15, 1935, SC-AMNH.

8. The quote is from a promotional flier for "Black Holes." For more on the show, visit www.adlerplanetarium.org.

9. Joseph Miles Chamberlain, "The Development of the Planetarium in the United States," *Smithsonian Report for 1957* (Washington, D.C.: Smithsonian Institution, 1958), 276.

10. Elly Dekker, "The Globe in Space," from *The World in Your Hands: An Exhibition of Globes and Planetaria from the Collection of Rudolf Schmidt*. An Exhibition at Christie's Great Rooms, Aug. 25–Sept. 9, 1994, and at the Museum Boerhaave, Leiden, Mar. 18–Sept. 24, 1995 (London and Leiden: Christie's / Museum Boerhaave, 1994), 80.

11. Giovanni de Dondi, *The Planetarium of Giovanni de Dondo Citizen of Padua*. A manuscript of 1397 translated from the Latin by G. H. Baillie, with additional material from another Dondi manuscript translated from the Latin by H. Alan Lloyd. Translations edited by F. A. B. Ward (London: Antiquarian Horological Society, 1974; emphasis added).

12. Henry Charles King, *The London Planetarium* (London: London Planetarium, 1958), 5. Galileo's experiments with the telescope revealed remarkable findings; using it to look at the moon, he was amazed at the craters and dark areas that he thought might be oceans. Identifying Jupiter's four largest moons, he also discovered that the Milky Way consisted of innumerable stars. Sue Becklake, *The Official Planetarium Book* (Rocklin, Calif.: Prima, 1994), 13.

13. Becklake, *Official Planetarium Book*, 12. Copernicus' book challenged the theory of the earth's centrality in our solar system. Despite this radical discovery, Copernicus still wrongly believed that the planets moved in perfect circles (ibid).

14. Dekker, "The Globe," 80. While neither space nor the focus of this chapter permits in-depth analysis of the fascinating developments in tabletop planetariums throughout the course of the seventeenth, eighteenth, and nineteenth centuries, the gendering of globes as indispensable accessories for the proper gentleman is one of the more interesting discourses to consider. Before the mass production of globes made them a must for every late-nineteenth-century schoolroom, they were considered the "necessary furnishings" of a gentleman, the perfect complement to one's library or country house. These extremely ornate globes were useful objects to have at hand to illustrate one's travels on the Grand Tour, the eighteenth-century right of passage for wealthy or merchant class men. Arthur Middleton, "Globes of the Early 19th Century," from *The World in Your Hands*, 90.

Children were targeted by toy and globe makers by the end of the nineteenth century, including for a wide array of globes and globe paraphernalia such as cut-out globes published on card in magazines, inflatable balloon globes, umbrella globes, puzzle globes, building block globes, etc. Beginning in the 1930s, globes were the thematic inspiration of ladies pendants and brooches (gold and silver) and even cocktail cabinets. Jeremy Collins, "Educational, Ornamental, and Toy Globes," from *The World in Your Hands*, 98.

15. The eighteenth century saw the development of a number of orreries and planetariums, ranging from simple hand-driven

devices to elaborate clock-driven systems. For background information and wonderful illustrations of these instruments, see Dekker, "The Globe," 80–84.

16. The painting is very often represented in the form of the famous mezzotint engraving by William Pether. The original painting can be seen in the Derby Museum and Art Gallery, Derby, England (ibid., 84).

17. Both definitions of "presence" are from *Webster's New Collegiate Dictionary* (Springfield, Mass.: Merriam, 1974).

18. "Heavenly Adventures."

19. David Riesman, "The Zeiss Planetarium," *General Magazine and Historical Chronicle* 31 (1928) (Burlington, N.J.): 240.

20. Report by Higgins and Quasebarth for Polshek and Partners, *AMNH Planetarium and North Side Project*, Background Research Project commissioned by the AMNH, Oct. 5, 1995, 26. Housed in Special Collections Department, AMNH.

21. Dorothy A. Bennette, "A Planetarium for New York," *Scientific Monthly* 41 (1935): 475.

22. Tom Gunning, "An Aesthetic of Astonishment: Early Film and the [In]Credulous Spectator," in Linda Williams, ed., *Viewing Positions* (New Brunswick, N.J.: Rutgers UP, 1995), 114–33.

23. Anon., "A Historical Survey," *The McLaughlin Planetarium*, Royal Ontario Museum, Ontario, Toronto, 19. Planetarium ephemera files, SC-AMNH.

24. Ibid.

25. Higgins and Quasebarth, *AMNH Planetarium*, 24.

26. I was fortunate enough to experience Atwood's Celestial Dome during a visit to the Adler Planetarium; no more than six or so people can enter at once and the "show" lasts about ten minutes. The platform you sit on resembles a roofless railway coal-car; claustrophobics may want to skip the experience, especially since the motorized car takes you into a dome barely large enough to hold all the people. The mini-lecture and dome are very quaint, especially when contrasted with the Adler's main planetarium and the SkyRider theater. It is very much like experiencing three distinct eras of planetarium design in one building.

It's also worth mentioning that the Children's Museum of Maine in Portland also offers an old-fashioned planetarium "star-gazing" experience for children that is quite wonderful; parents and children enter a 10-foot diameter dome and sit on the carpet while two teenage girls (summer interns?), using a magic lantern–type projector and pointer, identify stars and astrological configurations on the dome. Short breaks are incorporated into the 20-minute show so that bored and grumbling children have an opportunity to exit the dome and the show can continue in relative quiet.

27. For a contemporaneous description of the planetariums at the Deutches Museum, see Anon., "The Deutches Museum, Munich," *Nature* 3156.125 (Apr. 26, 1930): 638–41.

28. "A Historical Survey," 23.

29. R. L. Bertin, "Construction Features of the Zeiss Dywidag Dome for the Hayden Planetarium Building," *Journal of the American Concrete Institute* 31 (May-June 1934): 451.

30. Higgins and Quasebarth, *AMNH Planetarium*, 4.

31. Riesman, "The Zeiss Planetarium," 36.

32. Ibid.

33. Ibid.

34. Chamberlain, "Development of the Planetarium," 64.

35. Riesman, "The Zeiss Planetarium," 238.

36. Tom Gunning, "Phantom Images and Modern Manifestations: Spirit Photography, Magic Theater, Trick Films, and Photography's Uncanny," in Patrice Petro, ed., *Fugitive Images: From Photography to Video* (Bloomington: Indiana UP, 1995), 42.

37. Antonia Lant, "Egypt in Early Cinema," in Roland Cosandey and François Albera, eds., *Images Across Border: 1896–1918* (Zurich and Lausanne: Nuit Blanche / Éditions Payot, 1996), 89–90.

38. Nils Hogner and Guy Scott, "Hayden Planetarium," in *Cartoon Guide of New York City* (New York: J. J. Augustin, 1938), 31.

39. Quote from the November 1935 *Bulletin* of the AMNH, cited in Higgins and Quasebarth, *AMNH Planetarium*, 28. Tests conducted at the Hayden Planetarium rated the sound level

at 15 decibels, two less than had been recorded in a country field on a windless night. The 15 level was caused by "sound and vibration from elevated trains, street cars, and the rumble of 5:15pm traffic a block away." Anon., "City Discovers Planetarium Is Quietest Spot," *New York Herald Tribune,* Sept. 29, 1935.

40. Steven M. Spencer, "The Stars Are His Playthings," *Saturday Evening Post* (1954), n.p. Atmospheriums are another subgenre of the planetarium about which little has been written. The Desert Research Institute of the University of Nevada developed the idea in 1961. The daytime (as opposed to nightime) sky is reproduced on the domed interior of the building: "special time-lapse motion picture cameras have been fitted with the new 'fish-eye' 180 degree lenses to produce fast motion films of the whole sky. The surface inch of the 5/8-inch diameter film image is enlarged approximately 400,000 times to cover the 30-ft diameter domed ceiling—the projection screen." In half an hour the audience can witness a day's worth of weather. The goal of the Atmospherium-Planetarium was to include films of all kinds of weather phenomena including hurricanes, tornadoes, and many other dramatic weather events. For more information see "The Fleischmann Atmospherium-Planetarium of the Desert Research Institute, University of Nevada," untitled journal (45.7 [July 1964]): 394–95.

41. Riesman, "The Zeiss Planetarium," 236.

42. Walter Kaempffert, "Now America Will Have a Planetarium," *New York Times Magazine,* June 23, 1928.

43. Bennette, "A Planetarium for New York," 475.

44. Franz Fieseler, "A Layman's Views on Lectures in the Zeiss Planetarium," n.d., 8 pp., SC-AMNH.

45. Arthur Draper, "Notes on the Fels Planetarium," Apr. 1934, 7-page document from SC-AMNH, 1. In addition to chair design, Draper also recommended cooler air that he felt would "heighten the illusion of reality. It would not have to be drafty or unhealthful, merely sufficient to allow the observer to forget momentarily that he is seated in the confines of an auditorium" (5). Other issues discussed by Draper in this fascinating document include the amount of talking done by the lecturer; musical accompaniment; special effects; amount and placement of technical explanations; and distraction caused by bright exit signs.

46. Wayne M. Faunce, "Problems of Construction," in *The Book of the Hayden Planetarium, the American Museum of Natural History* (New York: AMNH, 1935), 210.

47. Anon., "Model VI," *The New Yorker,* Sept. 20, 1969.

48. "Maestros of the Universe," *Museums New York* (Apr. 1996).

49. Thomas Greenwood, *Museums and Art Galleries* (London: Simpkin, Marshall, 1888), 29.

50. Kaempffert, "Now America," 13; and Gutsch, quoted in Douglas J. Preston, "A Domeful of Stars," *Natural History* 94.10 (Oct. 1985): 92–101.

51. Lauren Rabinovitz, "More than the Movies: A History of Somatic Visual Culture Through *Hale's Tours, IMAX, and Motion Simulation Rides,*" in Rabinovitz and Abraham Geil, eds., *Memory Bytes: History, Technology, and Digital Culture* (Durham: Duke UP, 2004), 102.

52. Unidentified director of the Royal Danish Observatory, quoted by Clyde Fisher, Curator of Astronomy at the AMNH, in "The Hayden," *Popular Astronomy* (May 1934), cited in Higgins and Quasebarth, *AMNH Planetarium,* 29.

53. Rabinovitz, "More Than the Movies," 102.

54. Dr. H. C. King, "The Planetarium and Adult Education," in H. Kaminski, ed., *Proceedings from the Second International Planetarium Directors Conference* (Bochum, Germany, 1966), 36.

55. King, *The London Planetarium,* 7.

56. Higgins and Quasebarth, *AMNH Planetarium,* 26.

57. Ibid.

58. Ibid.

59. Bertin, "Construction Features," 451.

60. Higgins and Quasebarth, *AMNH Planetarium,* 5.

61. Ibid., 9.

62. Riesman, "The Zeiss Planetarium," 240.

63. William L. Laurence, "'Tour of the Sky' Opens Planetarium; 800 Get a New Vision of Universe," *NYT*, Oct. 3, 1983, 1.

64. Riesman, "The Zeiss Planetarium," 36; "Museum to Make the Known Universe Visible," *NYT*, May 2, 1926, n.p; Anon., "Stellar Performance," *NYT*, Dec. 1, 1984, clipping from Planetarium General Information File 1935–1986, SC-AMNH.

65. King, *The London Planetarium*, 17.

66. Ibid., 12

67. John J. O'Neill, "Progress of Science: Magnifying Time," *New York Herald Tribune*, Sept. 15, 1935, in box 1, News Clips 1926–67, SC-AMNH.

68. Stewart, *On Longing*, 89.

69. Oettermann, *The Panorama*, 9.

70. Anon., "The Unique Boston Skyline . . . Meticulously Modeled Panorama," in Boston Charles Hayden Planetarium Guidebook in SC-AMNH. The guidebook states that special projectors placed behind the dome at twelve locations on the horizon produce twelve additional panoramas.

71. Dr. I. M. Levitt, "The Planetarium," *The Planetarium: A Special Edition Commemorating the Dedication of the New Fels Planetarium of the Franklin Institute* (Sept. 18. 1962), 13.

72. Bennette, "A Planetarium for New York," 476.

73. Jacqueline Glass, "I Saw Stars," *Travellers Beacon* 17.7 (Jan. 1936): 6.

74. My thanks to Tom Gunning for this important connection.

75. Tom Gunning, "Loïe Fuller and the Art of Motion," in *The Tenth Muse*, 30.

76. Lewis, quoted in Chamberlain, "Development of the Planetarium," 270.

77. King, *The London Planetarium*, 5.

78. Armand N. Spitz, "Planetarium: An Analysis of Opportunities and Obligations," *The Griffith Observer* (June 1959). The standard Spitz model was the size and shape of a schoolroom globe, was motor-driven, precision built, and weighed about 25 pounds. Selling anywhere from $1,500 to $4,500, the price varied depending on "the number of planet projectors, 'twilight room illuminators' and other accessories that might be added to the basic star projector." Information taken from Spencer, "The Stars Are His Playthings." For more on Spitz, see chapter 5 of Marché, *Theaters of Time and Space*, 87–115.

79. In an experiment conducted in 1969 by Dennis H. Gallagher, director of the planetarium in the Manitoba Museum of Art and Science, Winnipeg, Canada, audiences were asked to complete a questionnaire on whether they thought the planetarium show they had just seen had been live or taped (the planetarium had just made the transition from live to taped performances). When shown the taped lecture 46% guessed it was live; 18% taped; and 36% could not say. When they learned the truth, 65% were for a live lecture versus 35% against. Gallagher, "The Potential of the Planetarium Medium," in Ruth Mucke and Herman Mucke, eds., *Proceedings of the Third International Planetarium Directors Conference* (Vienna, 1969), 44.

80. Kaempffert, "Now America," 11 (emphasis added).

81. Marian Lockwood, "The Hayden Planetarium," in *The Book of the Hayden Planetarium*, 188.

82. Flier for "World of Wonders" show at the Hayden Planetarium, 1945, file #10 (Car Cards 1939–40), in box 1, Guest Relations 1936–1948, SC-AMNH.

83. Laurence, "'Tour of the Sky,'" 1.

84. Fieseler, "A Layman's Views," 3.

85. Riesman, "The Zeiss Planetarium," 240.

86. Philip Fox, quoted in Clyde Fisher, "The Hayden," in Higgins and Quasebarth, *AMNH Planetarium*, 29.

87. Spitz, "Planetarium," 81.

88. Memo from T. D. Nicholson to Albert E. Parr, May 5, 1961, SC-AMNH.

89. Gallagher, "The Potential," 43.

90. Fieseler, "A Layman's Views," 6.

91. While Laserium shows play a significant role in the emergence of the planetarium, space precludes dealing with them in any detail in this chapter. The company that partnered with the Hayden Planetarium, Laser Images Inc., was in-

corporated in 1971 and performed its first concert at Griffith Park Observatory in 1973. The idea was the brainchild of Ivan Dryer, founder and president of Laser Images Inc. The Hayden signed a contract with Laser Images in 1974 to perform shows on Fridays and Saturdays at 7.30 p.m., 9 p.m., 10:30 p.m., and possibly midnight if attendance warranted it. The marriage between Laser Images and the Hayden was often fraught; the AMNH's biggest concern was that audiences might misconstrue the Laserium as being the only public program offered by the Hayden Planetarium, and that with access to a far smaller advertising budget the AMNH would have no means to correct this. In a letter written to Dryer in 1977, it was proposed that the gate be split 50–50, as it was when the deal was first struck, which would put the AMNH on a fairer playing field (Laser Images had started taking a larger cut). Letter to Dryer from Mark R. Chartrand III, Feb. 22, 1977.

The show previewed on September 27 and opened to the public on September 30, 1974 (information all in file #1 [Laserium 1974–75], box 6, Lectures, Courses, Symposia, Special Events, Laserium, Albert Einstein, SC-AMNH). For background information, see Michael Cassutt, "Laserium: A Behind-the-Scenes Tour of Tomorrow's Multimedia Entertainment," *Future Life* (Nov. 1979): 52–55. In an interview with Dryer in 1980, Dryer compared the Laserium experience to having the right side of one's brain reopened, letting imaginations reawaken, and creating an opportunity for greater communication. When asked whether Laserium shows would oversaturate and numb audience minds in the same way film and TV acted upon the brain, Dryer retorted: "I see the ultimate art experiences 20 years in the future in a space colony. In a sphere instead of a hemisphere, in which the audience doesn't sit, but in which they fly among the holographic images they create themselves with their own thoughts, their own imaginations and that they control by means of what they wish to project. Their physical orientation, their speed of flight and where they go in this place will

also affect the way these images are presented." Ben Singer, "Illuminating World of Laserium," *Probe* (Sept. 1980): 51.

One could also write at length about the drug culture that found a home in these psychedelic shows of the 1970s; there are countless letters of complaint in the Hayden's Laserium archives, ranging from marijuana use, to inappropriate behavior, to stragglers being permitted late entry, to concerns about the potential harmful effects of the lasers. One written by Patricia A. Reilly (a woman in her twenties) in 1974 referred to 16- to 20-year-old members disrupting the show so badly that it had to be stopped for ten minutes. These "kids," she says, were "either drunk or stoned on pot . . . [and] even had the audacity to pass around a lighted joint during the show." Letter from Reilly to Hayden Planetarium, AMNH, 12/16/74 in file #1 (Laserium 1974–75), cited above.

92. Lewis, quoted in Chamberlain, "Development of the Planetarium," 270.

93. Billy Arthur, "Please Fasten Your Seat Belt, Next Stop the Moon." *Tarheel Wheels* 15.2 (Feb. 1958): 3.

94. "Hayden Planetarium," *Hart's Guide*, 816.

95. "Heavens!" *Franklin Institute News* (Spring / Summer 1971): 5.

96. Memo from William H. Barton Jr. to Director A. E. Parr, n.d., in File #8 (A. E. Parr, Director 1939–64), box 3, Correspondence, SC-AMNH.

97. Buhl Planetarium, "Sky Dramas," *Orbit* (Apr.-May): n.d. and n.p. Item in Buhl Planetarium folder in SC-AMNH.

98. Donald S. Hall, brochure for the Strasenburgh Planetarium, Rochester, 1969, 19, in Strasenburgh Planetarium folder, SC-AMNH.

99. Flyer for "Shots Seen Around the World,"(ran through April 1, 1962) at the Charles Hayden Planetarium, Boston. File QB 70 H35, SC-AMNH.

100. The term "Heavenly Adventures" in the heading is borrowed from the title of an anonymous review of the Hayden Planetarium in *Vogue* (Dec. 15, 1935). Epigraph from Kaempffert, "Now America," 11.

101. Hogner and Scott, "Hayden Planetarium," 31.

102. Armand N. Spitz, *The Pinpoint Planetarium* (New York: Holt, 1940), 1–2.
103. Arthur, "Please Fasten," 1; and "Genealogy of the ZEISS Planetarium," in *The Zeiss Planetarium* brochure, 1959, SC-AMNH.
104. Spitz, *Pinpoint Planetarium*,81.
105. Heinz Kaminski, "Symphonic Museum in the Planetarium," in Kaminski, ed., *Second International Planetarium Directors Conference,* 97. In November 1966, Bochum Planetarium introduced the "calm hour," in autumn and winter, in which planetarium shows would play symphonic music instead of a lecture (ibid).
106. Ibid.
107. "The Star of Bethlehem" theme was one of the major crowd-pullers for most planetariums; for example, in 1949 the Morehead Planetarium recorded its highest attendance levels for the show, a total of 31,863 patrons.
108. In 1978, "The Star of Wonder" Christmas show at the Hayden Planetarium was the second-longest-running Christmas show in New York City after Radio City Music Hall's annual extravaganza. "Department of Astronomy and the American Museum Hayden Planetarium," *Report of the Scientific and Education Departments,* AMNH, July 1977–June 1978, 7.
109. Untitled pamphlet in the University of North Carolina Morehead Planetarium File, SC-AMNH.
110. Arthur, "Please Fasten," 3.
111. Letter to Antoinette Gioudano from Gordon A. Atwater, Oct. 27, 1948, in File #14 (Correspondence Oct.-Dec. 1948), in box 1, Guest Relations Bureau 1936–1948, SC-AMNH. The first Christmas show in Spanish was given at the Hayden Planetarium on December 16, 1970, with 600 children in attendance. The idea was that of graduate astronomy student intern Tom Carey, who had served in the Peace Corps in Colombia. "Giggles, applause, and 'vivas'" were reportedly heard during the show. Meriemil Rodriguez, "Planetarium Tells the Story of la Navidad," *Daily News,* Dec. 17, 1970, in file #2 (News Clips), box 2, News Clips 1968–84, SC-AMNH.
112. Chamberlain, "Development of the Planetarium," 267.
113. Levitt, "The Planetarium," 16.
114. "Stellar Performance," *NYT,* Dec. 1, 1984 (emphasis added).
115. Anon., "Astronomer Shows Star of Bethlehem," *Saginaw Michigan News,* Dec. 3, 1935, file #1, box 1, News Clips 1926–1967, SC-AMNH.
116. Letter to Kenneth A. Briggs, religion editor of the *NYT,* from Hayden Planetarium associate astronomer K. L. Franklin, Nov. 26, 1976, containing synopsis of upcoming Christmas show. File #2, box 19, Administrative Papers Correspondence Exhibits—Expositions, SC-AMNH.
117. King, *The London Planetarium,* 15.
118. Middleton, "Globes of the Early 19th Century," 90.
119. King, *The London Planetarium,* 15.
120. AMNH president Henry Fairfield Osborn, cited in Higgins and Quasebarth, *AMNH Planetarium,* 33.
121. Arthur, "Please Fasten," 1.
122. Bertin, "Construction Features," 449.
123. Joseph Kaselow, writing in the Feb. 19, 1967, issue of *World Journal Tribune,* quoted the National Aeronautics and Space Administration as predicting that commercial travel to the moon would not start until the year 2000 ("Selling Trips to the Moon, n.p.).
124. Press Release, "Special Event Coverage of Apollo Splashdown, 1969, Western Union International, New York, July 23, 1969, in General Information File 1935–1986, 2, SC-AMNH. Western Union International, which also commissioned a ten-minute film that was screened before the splashdown, sponsored the event. Entitled *The Right People at the Right Time,* it featured the men of the recovery ship the USS *Hornet.*
125. Brown, quoted in "For Sale: The Moon and Stars," *NYT,* Mar. 3, 1986, Clipping in General Information File 1935–86, SC-AMNH
126. Spitz, *The Pinpoint Planetarium,* 1–2.

127. Spitz, quoted in Spencer, "The Stars Are His Playthings," n.p.

128. "The Teen Set, Betty Betz Bets," unidentified newspaper column, c. 1946, in file #12 (Guest Relations Bureau Press and Periodical Promotions, 1946–48) in box 1, Guest and Relations Bureau 1936–48, SC-AMNH.

129. Letter to Mrs. Hauser from Miss Nella Johnson, Nov. 6, 1950, in file #1, box 9, Administrative Papers, Correspondence, Exhibits–Expositions, SC-AMNH.

130. Philip Fox, *Adler Planetarium and Astronomical Museum: An Account of the Optical Planetarium and a Brief Guide to the Museum* (Chicago: Lakeside Press, June 1933): 13.

131. Laurence, " 'Tour of the Sky,' " 1.

132. Fisher quoted in ibid., 21.

133. Lockwood, *The Book of the Hayden,* 189.

134. Ibid.

135. Dr. W. Villiger, *The Zeiss Planetarium* (London: W & G. Foyle, 1926), 52–53.

136. Fieseler, "A Laymen's Views."

137. Martin J. Shannon, writing in *Wall Street Journal,* reported on the popularity of astronomy in 1967, arguing that "with imaginations fired by a decade of space achievements that make centuries of prior advances pale by comparison, businessmen, housewives, and other nonscientific types are taking up astronomy as a hobby." To support his claim Shannon referred to the doubling of subscriptions to *Sky and Telescope* in the past decade, from 20,000 to 40,000 with 10 to 15 percent gains expected the following year. Shannon, "Gazing at the Stars: Hobby of Astronomy Lures More People," *Wall Street Journal,* Oct. 23, 1967, n.p.

138. We see a corollary of the social aspect of stargazing in an outdoor stargazing program developed by the Hayden Planetarium in conjunction with the NYC Department of Parks in 1969; called "Star Gazing—With or Without Stars," it took place at 11 p.m. every other Wednesday on the Great Lawn in Central Park. In addition to an audio system and flashlight pointer that would help the lecturer address the crowd, a recommendation was also made to play soft background music to set the mood. Information in memo 4/4/68 in file #14 ("Stargazing in the Park, 1969, May-August") in box 1, Special Events at the Planetarium, 1949–73.

139. Text is from the back cover of *Astronomy and You* (no date), produced by the Morrison Planetarium, California Academy of Sciences, Golden Gate Park, San Francisco. From Manila Envelope, Morrison QB70 M65 #1, SC-AMNH.

140. The planetarium came of age in the 1950s and 1960s at the same time as interactive, push-button–type exhibits became ubiquitous in the gallery (for more on their emergence within the museum, see the next chapter); for example, a proto-computer called "Elecom" installed near the time capsule on the second floor of the Hayden Planetarium in 1954 was a "computing machine . . . geared to compute prepared problems for visitors." Questions relating to space travel (speed, weight, distance, etc. on planets) would be written out on forms and handed to an operator from the electrical division of Underwood Corporation; the machine would then "type out answers on another form which will be given to the visitors as a souvenir." The machine could also "compute taxes, tell what day of the week a given day falls on and play a game called 'Nim.' " The Elecom was so successful in attracting visitors that overcrowding became a serious concern. To address the problem, Hayden's chairman, Joseph M. Chamberlain, sent a memo to his staff advising them not to mention the exhibit in planetarium lectures but rather to end the lecture fifteen minutes early and direct the group en masse to the exhibit where one or two visitors could be selected to present problems to the Underwood technician. Memo, Feb. 18, 1954, from Chamberlain to Mr. Heely et al. In file #1, box 9, Administrative Papers Correspondence Exhibits–Expositions, SC-AMNH.

141. The Adler cost $750,000 to build and during its first ten months of operation it had a total attendance of 1,532,437, of which 441,461 were paid admissions and 1,090,976 were free. Gross receipts were barely enough to cover operation

costs, and the Depression had a deleterious effect on paid attendance. Information in letter to President Davidson from Clyde Fisher, Apr. 25, 1933, SC-AMNH.

142. Chamberlain, "Development of the Planetarium," 269.

143. All information on the early history of astronomy at the AMNH is taken from Higgins and Quasebarth, *AMNH Planetarium*, 30ff.

144. Ibid., 31.

145. The following information on the construction of the Hayden is from Higgins and Quasebarth, *AMNH Planetarium*, 34. In order to garner city funds, the AMNH created the AMNH Planetarium Authority, making it eligible for a loan from the Reconstruction Finance Corporation, one of the New Deal's federal relief agencies, for $600,000.

146. Ibid., 5.

147. For more on the technical upgrade, see Anon., "Planetarium Technology Comes of Age," *Grapevine*, Sept.-Oct. 1982.

148. For more on the Rose Center project, see AMNH press release 1/26/95, "Museum Unveils Plans to Transform Hayden Planetarium for Twenty-First Century," SC-AMNH. The Zeiss Mark VI Projector, which originally cost $250,000, has become something of a projector parts "organ donor" for a consortium of the five planetariums that still use the Mark VI since it was donated to the Adler Planetarium in Chicago. Pat Frendreis of the Adler arranged the transfer, although he is not a fan of the newer planetarium shows whose effects are mostly accomplished using video projectors: "You're looking at a video image, so the stars are greenish and soft," he says, unlike the "*real* stars of the Zeiss [Mark VI]" (emphasis in original). Fred Bernstein, "A Chicago Chop Shop Takes the Hayden's Guts," *The New Yorker*, Nov. 4, 2001.

149. The new planetarium is expected to generate $76 million in retail sales and an additional $5.8 million in tax revenue for New York City. In addition, one million more visitors are expected at the AMNH per year, rising from 3.5 million in 1999 to over 4.5 million after the opening. Glenn Collins, "Outer Space vs. Parking Space: Planetarium and Wary Neighbors Prepare for Opening," *NYT*, Jan. 25, 2000, B1. The two IMAX films playing at the AMNH at the time of writing were *Jane Goodall's Wild Chimpanzees* (David Lickley, 2002) and *Vikings: Journey to New Worlds* (Marc Fafard, 2004). The AMNH programs seven screenings a day for each.

150. The script for "Passport to the Universe" is available at www.amnh.org/rose/spaceshow_scripts/passport_script.pdf.

151. See www.amnh.org/rose/hayden-bigbang.html.

152. Konstantin Alexeievich Porcevskij, "Education in Moscow Planetarium," in Marcel Grun, ed., *The 5th International Planetarium Directors Conference* (Prague, Czechoslovakia, 1975), 28.

153. "Museum Unveils Plans," 4.

154. See www.amnh.org/rose/faq.html.

155. Clyde Fisher, "The Hayden Planetarium," *Natural History* 34.3 (1935): 251.

156. Quotes are from www.amnh.org/rosecenter.

157. For a fascinating discussion of the Hayden Planetarium's Laserium show "SonicVision" when it first opened, see Bill Corsello, "Super Sonic," *Where New York* (Dec. 2003), and David Weiss, "New York Metro," *Mix* (Feb. 2004).

158. Quote from www.amnh.org/rose/dome. Back when it was first launched, reviewers of the Laserium were quick to exploit its psychedelic, sensorial effect: quotes from regional newspapers include comments such as "will take you to faraway places—all inside your head"; "a novel, heady, stimulating entertainment experience that borrows its imagery from any number of sources, including abstract art, atomic energy and the aurora borealis"; "a powerful sensory experience"; and "a near-tactile three-dimensionality, floating, soaring into vast loops, pirouetting and diminishing into gauzy underwater dreamshapes." All quotes from press release from Laser Images Inc., undated, SC-AMNH.

159. Dr. Charles F. Hagar and Alexander F. Morrison, "A Look at Planetarium Philosophy and Community Relations," in Mucke and Mucke, eds., *Third International Planetarium*, 47, SC-AMNH.

5. BACK TO THE (INTERACTIVE) FUTURE

1. Henry Mayhew, "The Shilling People" (1851), quoted in Humphrey Jennings, ed., *Pandaemonium, 1660–1886: The Coming of the Free Press* (New York: Free Press, 1985), cited by Paul Greenhalgh, "Education, Entertainment, and Politics: Lessons from the Great International Exhibitions," in Peter Vergo, ed., *The New Museology* (London: Reaktion, 1989), 75 (emphasis added).

2. Peter Richards, "From London to Nagasaki—The Roots of Interactive Art @ the Exploratorium," in Christa Sommerer and Laurent Mignonneau, eds., *Art @ Science* (Springer-Verlag Telos, 1998), 215–24.

3. Gitelman and Pingree, eds., *New Media*, xii. A collection with a similar genealogical conceit in terms of debunking claims of newness is *New Media, Old Media: A History and Theory Reader* (New York: Routledge, 2005), edited by Wendy Hui Kyong and Thomas Keenan. Notable exceptions in terms of historical context are Kathleen McLean, *Planning for People in Museums* (Washington, D.C.: Association of Science-Technology Centers, 1993); Sharon MacDonald, *Behind the Scenes at the Science Museum* (Oxford: Berg, 2002); and Michelle Henning, *Museums, Media, and Cultural Theory* (Milton Keynes, UK: Open University Press, 2006).

4. Gitelman and Pingree, eds., *New Media*, xiv, xx, xv.

5. James Johnson Sweeney, "Some Ideas on Exhibition Installation," *Curator* 2.2 (Spring 1959): 151–56.

6. Ivan Karp and Steven D. Lavine, eds., *Exhibiting Cultures: The Poetics and Politics of Museum Display* (Washington, D.C.: Smithsonian Institution Press, 1991). For a useful overview of the pedagogical differences between behaviorist / didactic versus constructivist models of learning (idea of interactivity grounded in the latter), see the four essays in part 4 ("Visitors, Learning, Interacting") of Sharon MacDonald, ed., *A Companion to Museum Studies* (Oxford: Blackwell, 2006), 319–76.

7. "Natural History Museum: A Unique Perspective on our Natural World," NMNH, RU 564, box 4, Smithsonian Institution Archive (hereafter abbreviated to SIA).

8. Gitelman and Pingree, eds., *New Media*, xx.

9. Guy Debord, *The Society of the Spectacle* (New York: Black and Red, 1977), 1.

10. Michelle Pierson, *Special Effects: Still in Search of Wonder* (New York: Columbia UP, 2002), 7, 13, 29.

11. This phrase is the title of David E. Nye's book on the role of technology in American culture, *American Technological Sublime* (Cambridge: MIT Press, 1996).

12. Pierson, *Special Effects*, 28.

13. Bukatman, *Matters of Gravity*, 115.

14. Greenhalgh, "Education," 82.

15. John H. Falk, "The Effect of Visitors' Agendas on Museum Learning," *Curator* 4.2 (1988): 117.

16. Ibid., 117 and 115.

17. Roger Silverstone, "Museums and the Media," *Museum Management and Curatorship* 7 (1988): 231. Hereafter abbreviated to *MMC*, the journal was formerly known as the *International Journal of Museum Management and Curatorship*.

18. L. A. Gratacap, "The Making of a Museum," *Architectural Record* 9 (Apr. 1900): 399.

19. H. C. Bumpus, "A Contribution to the Discussion on Museum Cases," *MJ* 6.9 (Mar. 1907): 299.

20. Frank Woolnough, "Museums and Nature Study," *Museums Journal* (hereafter abbreviated to *MJ*) 4.8 (Feb. 1905): 265.

21. Lisa C. Roberts, *From Knowledge to Narrative: Educators and the Changing Museum* (Washington, D.C.: Smithsonian Institution Press, 1997), 22.

22. Walter Benjamin, *Reflections: Essays, Aphorisms, Autobiographical Writings* (New York: Schocken, 1978), 155.

23. For more on museums and the politics and poetics of collecting, see the following anthologies: Robert Lumley, ed., *The Museum Time Machine* (New York: Routledge, 1988); Peter Vergo, ed., *The New Museology*; and John Elsner and Roger Cardinal, eds., *The Cultures of Collecting* (Boston: Harvard UP, 1994).

24. Quoted in Anon., "The Mannheim Conference on Museums as Places of Popular Culture," *MJ* (Oct. 1903): 105.

25. Ibid., 107.

26. Prof. Dr. Ant. Fritsch, "The Museum Question in Europe and America," *MJ* 3.8 (Feb. 1904): 252.

27. Francis Arthur Bather, "Museums Association Aberdeen Conference, 1903," *MJ* 3.3 (Sept. 1903): 80.

28. Dr. Thiis, "Museums Association Aberdeen Conference, 1903," *MJ* 3.4 (Oct. 1903): 119.

29. Bumpus, "A Contribution," 299.

30. George E. Hein, *Learning in the Museum* (London: Routledge, 1998), 44.

31. McLean, *Planning for People*, 128.

32. A. B. Meyer, "The Structure, Position, and Illumination of Museum Cases," *MJ* 6.7 (Jan. 1907): 237.

33. Henry Crowther, "The Museum as Teacher of Nature-Study," *MJ* 5.1 (July 1905): 8.

34. Goode, quoted in Frank Collins Baker, "The Descriptive Arrangement," *MJ* 7.4 (Oct. 1902): 108. One should point out that curating as an occupation was undergoing professionalization throughout this period; influential museum spokesman Sir William Flower—president of the British Zoological Society of London before becoming director of the British Natural History Museum in 1884—argued in 1889 that, "What a museum really depends on for its success and usefulness is not its buildings, not its cases, not even its specimens, but its curator. . . . He and his staff are the life and soul of the institution, upon whom its whole value depends" (in "Discussion," *MJ* 5.4 [Oct. 1905]: 61).

 In lyrico-poetic terms, F. A. Bather described the successful curator as "a man of enthusiasm, of ideas, of strictest honor, of sincerity, with the grip and devotion of a specialist, yet with the wisdom born of wide experience, with an eye for the most meticulous detail, but with a heart and mind responsive to all things of life, art, and nature." Bather, quoted in "The Man as Museum-Curator," *MJ* 1.7 (Jan. 1902): 188.

35. Contemporary studies on the effect of labeling on visitor interest and retention of information suggest that combining labels with photographs, drawings, objects, and other sensory elements can make a difference (McLean, *Planning for People*, 106). The supplement to the April 1999 issue of *Museums Journal* (99.4) included step-by-step guidelines on the basics of label production (font, size, position, etc.), suggesting perhaps that, almost a hundred years on from these discussions, there is no consensus on the virtue of labels, and museum professionals can still benefit from being reminded of good practice. For a discussion of the challenges of knowing how visitors respond to labels (and the findings of a fascinating study of visitor interaction with exhibit texts at the British Museum of Natural History, see Paulette M. McManus, "Oh Yes, They Do: How Museum Visitors Read Labels and Interact with Exhibit Texts," *Curator* 32.3 (1989): 174–89.

36. Dr. E. Hecht, "How to Make Small Natural History Museums Interesting," *MJ* 3.6 (Dec. 1903): 188.

37. Bather, "Museum's Association," 81.

38. Hecht, "How to Make," 189.

39. McLean, *Planning for People*, 23. For more on the impact of the introduction of new media into the gallery, see Henning, "Legibility and Affect," 25-46.

40. An editorial in *Museums Journal* entitled "The Question of Groups" stated that habitat groups could only be "properly executed by institutions having at their command considerable sums of money and a large and efficient corps of workers." *MJ* 8.12 (June 1909): 446.

41. Anon., "National Museums: British Museum," *MJ* 5.12 (June 1906): 291–96.

42. "Discussion on the Papers on Museum Cases Read at the Bristol Conference, 1906," *MJ* 6.12 (June 1907): 405. For more on the discursive construction of habitat groups and life groups in primary literature from the period (particularly on issues of verisimilitude, authenticity, and scientific accuracy), see chapter 1 of Griffiths, *Wondrous Difference*, 3–45.

43. Falk, "Effect of Visitors' Agendas," 117.

44. Jackie Kemp, "Becoming a Thing of the Past," *Glasgow Herald*, Mar. 27, 2002.

45. Paulette M. McManus, "Reviewing the Reviewers: Toward a Critical Language for Didactic Science Exhibitions," *MMC* 5.3 (Sept. 1986): 217 (emphasis added).

46. Greenhalgh, "Education," 82.

47. The Patent Museum was owned by the Commissioners of Patents and, according to Xerxes Mazda, was not strictly an accurate repository of current patents. Some of its more interesting exhibits include objects that were not patented or on which the patents had long run out. Its purpose, writes Mazda, "seems to have been more inspirational than educational." Xerxes Mazda, "The Changing Role of History in the Policy and Collections of the Science Museum, 1857–1973," Master of Science diss., University of London (1996), 9.

48. Humphrey and Cowper (1864), quoted from the *Minutes of Select Committee,* Science Museum Library (hereafter abbreviated to MSC-SML). Nineteen years after the Parliamentary Select Committee Hearings on the Patent Museum cited above, the institution was fully amalgamated with the SKM's collections in 1883, although its was administered by the Commissioners of Patents independently of the Science and Art Department. Mazda, "The Changing Role of History," 13–14.

49. For more on the concept of "gawking" and spectatorship, see Tom Gunning, "From the Kaleidoscope to the X-Ray: Urban Spectatorship, Poe, Benjamin, and *Traffic in Souls (1913), Wide Angle* 19.4 (1997): 25–61.

50. Caroline Gardiner and Anthony Burton, "Visitor Survey at the Bethnal Green Museum of Childhood," *MMC* 6.2 (1987): 156.

51. Falk, "The Effect of Visitors' Agendas," 116; Terry Russell, "Collaborative Evaluation Studies Between the University of Liverpool and National Museums and Galleries on Merseyside," in Patrick Sudbury, Peter Reed, Paul Rees, and Terry Russell, eds., *Evaluation of Museums and Gallery Displays,* CRIPSAT Papers (Liverpool: Liverpool UP, 1995), 14.

52. Rob Semper, "Designing Hybrid Environments: Integrating Media into Exhibition Space," in A. Mintz and S. Thomas, eds., *The Virtual and the Real: Media in the Museum* (Washington, D.C.: American Association of Museums, 1998), 119–27, cited in Roderick Davies, "Overcoming Barriers to Visiting: Raising Awareness Of, and Providing Orientation To, a Museum and Its Collections Through New Technologies," *MMC* 19.3 (2001): 285. For a postmodern theoretical assessment of virtual travel and spatial mobilities, see Anne Friedberg's *Window Shopping.*

53. Humphrey and Cowper, "Minutes of Evidence Taken Before Select Committee," June 10, 1864, MSC-SML (emphasis added).

54. According to the Boston Museum of Science's Web site, the Theatre of Electricity houses the world's largest air-insulated Van de Graaff generator, designed and built by MIT professor Dr. Robert J. Van de Graaff and donated to the museum by MIT. Originally used as a research tool in early atom smashing and high-energy X-ray experiments, the machine has found a retirement home in the Thomson Theatre of Electricity where it is demonstrated daily. The demonstration has all the hallmarks of a nineteenth-century sideshow replete with engaging scientist, warnings about sound and fear factors, lots of buildup and suspense, and a big climactic lightning storm as a finale. See www.mos.org/sln/toe/history.html.

55. Mikhail Bakhtin, *Rabelais and His World* (Cambridge: MIT Press, 1968), 21.

56. The quoted phrase in the heading refers to the South Kensington Museum (out of which emerged the Science Museum) and was used by Gasgoine Salisbury and C. B. Adderley in "Attendance at the South Kensington Museum," *Fifth Report of the Science and Art Department* (1867-8-9), 88.

57. According to exhibition historian Paul Greenhalgh, the period from 1851 to 1971 was when "all the ingredients of succeeding events were invented and first exploited and the advantages and problems of the exhibition medium, especially in relation to education, politics, and the masses, exposed." Greenhalgh, "Education," 75.

58. David Follett, *The Rise of the Science Museum Under Henry Lyons* (London: Science Museum, 1978), 1.

59. *Second Report of the Commissioners of the 1851 Exhibition* (London, 1852), 11, cited in Mazda, "The Changing Role of History," 13.

60. Follett, *Rise of the Science Museum*, 2.

61. Unattributed quote in Mazda, "The Changing Role of History," 17.

62. In 1857, 268,291 visitors were recorded at the SKM for the year. In the early 1860s, the SKM had approximately 2,000 visitors per week, although by 1865 that number had fallen to 1,500, a drop attributed to the cramped quarters and the lack of new objects. By 1870 over a million visitors were coming to the SKM every year, although the National Exposition in 1862 saw the highest figures with 1,241,369. *Science and Art Department 18th Annual Report.* (1871). By 1915 the daily average was 955, with a total for the year of 350,000. *Board of Education Report on the Museums, Colleges, and Industry Under the Administration of the Board of Education* (1915), 5.

63. Follett, *Rise of the Science Museum*, 4 and 7.

64. Opening in 1906, the Deutsches Museum's aim was to "instruct students etc. etc. as to the effects of the multifarious applications of science and technology to the problem of human existence, to stimulate human progress, and to keep alive in the whole people a respect for great investigators and inventors and for their achievements in natural science and technology," Mazda, "The Changing Role of History," 6.

65. Ibid., 25–26.

66. Follett, *Rise of the Science Museum*, 15 and 13.

67. H. Sandham, "Report on the Collection of Machinery," *Science and Art Department 17th Report* (1870), 453.

68. Humphrey and Cowper, "Minutes of Evidence Taken Before Select Committee" (1864), 35 (MSC-SML).

69. Thomas C. Archer, "Report on the Polytechnic Exhibition of Moscow and the Scandinavian Industrial Exhibition at Copenhagen," *Science and Art Department 20th Report* (1872), 554, SML (emphasis added).

70. Ibid., 555.

71. Wax models demonstrating human anatomy were fairly commonplace in the Science Museum; for example, the Biology Section in 1902 displayed a life-size model of a man, a fetus at term, the peritoneum, and tongue. These models were made by the Parisian Mme A. Montaudon. For more on the display of waxworks at this time, see Marc B. Sandberg, *Living Pictures, Missing Persons: Mannequins, Museums, and Modernity* (Princeton: Princeton UP, 2003).

72. Dr. Edwin Lankester, *Appendix O to the 8th Report of Science and Art Department* (1860), 135.

73. William Cole, *A Short Statement of the Constitution, Methods, and Aims of the Essex Museum of Natural History* (1881).

74. "Discussion," *MJ* 5.4 (Oct. 1905): 118.

75. Rev. S. J. Ford, "A Rotary Cabinet for Museum Specimens," *MJ* 6.9 (Mar. 1907): 304–305.

76. Kate M. Hall, "The Smallest Museum," *MJ* 1.2 (Aug. 1901): 42.

77. Ibid.

78. Bumpus, "A Contribution," 298.

79. McLean, *Planning for People*, 135–36.

80. Iwan Rhys Morus, *Frankenstein's Children: Electricity, Exhibition, and Experiment in Early Nineteenth-Century London* (Princeton: Princeton UP, 1998), ix and xi; Barbara Maria Stafford, *Artful Science: Enlightenment Entertainment and the Eclipse of Visual Education* (Cambridge: MIT Press, 1999), 144 and 153.

81. Anon., "The Magic Lantern as a Means of Demonstration," *Journal of the Franklin Institute of the State of Pennsylvania* 55.4 (1868): 278.

82. Salisbury and Adderley, *Fifth Report*, 81. Gas lighting was used in the gallery and was itself the subject of discussion in the *Annual Reports* in the late 1850s and early 1860s. A machine enabling the lines of burners in the gallery to be "almost simultaneously lighted" was invented by Royal Engineer Capt. R. E. Fowke in 1859; recommendations were also made to light the burners as quickly as possible, without the use of rods, and that the "products of combustion should

be thoroughly got rid of." Richard Redgrave, "Documents Relating to the Administration of the South Kensington Museum," *Appendix N to the 7th Report of Science and Art Department* (1859), 122; and Capt. R. E. Fowke, "Report on the New Building," *Appendix K to the 10th Report of the Science and Art Department* (1862), 128. Fowke recommended that the quantity of light on the objects in the court of the new building should illuminate "as nearly as possible as at the same angle as daylight" (ibid.). Fore more on the impact of electric lighting in the nineteenth century, see Wolfgang Schivelbusch, *Disenchanted Night: The Industrialization of Light in the Nineteenth Century* (Berkeley: U of California P, 1995).

83. Morus, *Frankenstein's Children*, xi.

84. Thomas Kelly, "The Origin of Mechanics Institutes," *British Journal of Educational Studies* 1.1 (1952): 17.

85. Dick, letters to *Monthly Magazine* 37 (1814): 219-21, 507-510, quoted and cited in ibid., 23.

86. Morus, *Frankenstein's Children*, 72; Joseph C. Robertson, "National Repository," *Mechanics Magazine* 11 (1829): 58–59, cited in Morus, *Frankenstein's Children*.

87. Morus, *Frankenstein's Children*, 72.

88. Paley, quoted in ibid., 19. The first American Mechanics Institute was the Franklin Institute of Philadelphia, founded in 1824.

89. Appendix F to the *First Report of the Department of Science and Art*, 188.

90. Appendix G to the *First Report of the Department of Science and Art*, 230; Morus, *Frankenstein's Children*, 71.

91. Anon., "Popularizing Science," *The Standard*, Jan. 2, 1877.

92. Ibid.

93. Francis Petit Smith, curator of the Patent Museum, when examined by the Select Committee (June 24,1864), MSC-SML, 89.

94. "Science Museum Staff Reception," *MJ* 31 (Apr. 1931): 39; "Guides at the Museums: Lord Sudeley's Suggestions" (editorial), *The Times* (London), Nov. 5, 1912, in file ED 79/7, Z-Archive, SML (hereafter, ZA-SML).

95. The British Museum began utilizing guides in 1911 and within seven months, 11,000 visitors had taken a tour; in 1912, 20,000 people; and in 1913, 23,000 availed themselves of a guide service. The British Natural History Museum introduced guides in 1912, and the V&A in 1913. Between 1911 and 1914, guides showed more than 84,000 people the collections of these three institutions. "The Public Utility of Museums." Extract from Parliamentary Debates and "Official Guide Demonstrators" (1914): 2, ZA-SML.

96. Sudeley, "The Public Utility of Museums," Official Parliamentary Debate Imperial Institute—Victoria & Albert Museum—Kew Gardens (1914), ZA-SML.

97. "The Public Utility of Museums" (editorial), *The Times* (London), Oct. 21, 1911 (emphasis added), ZA-SML.

98. "Guides at the Museum," and a notice that appeared in a 1931 issue of MJ about the National Institute for the Blind publishing a list of UK museums with facilities for blind visitors to touch objects (*MJ* 31: 44).

99. Memo from J.F.D.D., May 6, 1891, ZA-SML.

100. David Knight, "Scientific Lectures: A History of Performance," *Interdisciplinary Science Reviews* 27.3 (2002): 217 and 223; Stafford, *Artful Science*, 140, 158–59.

101. Sheldon Annis, "The Museum as a Staging Ground for Symbolic Action," *Museum* 38.3 (1986): 168.

102. Christian Heath and Dirk vom Lehn, "Misconstruing Interactivity," paper presented at the Victoria and Albert Conference on Interactive Learning in Museums of Art and Design (London, 2002), cited in Marianna Adams, Jessica Luke, and Theano Moussouri, "Interactivity: Moving Beyond Terminology," *Curator* 47.2 (2004): 60.

103. Morus, *Frankenstein's Children*, 92 and xii.

104. All the following quotations are from *Minutes of Select Committee; Edward Alfred Cowper Recalled and Further Examined* (June 14,1864): 41–43, MSC-SML.

105. The anxiety that children might perceive interactive galleries as little more than playgrounds is vividly captured in a Science Museum gallery guide admonishment from the 1930s: "Do not think of the exhibits as things to play with but try to understand and learn from them." From Follett, *Rise of the Science Museum,* as quoted in David Phillips, "Science Centers: A Lesson for Art Galleries," *MMC* 5.3 (Sept. 1986): 260.

106. Henning, *Museums, Media, and Cultural Theory,* 37.

107. Bob Peart and Richard Kool, "Analysis of a Natural History Exhibit: Are Dioramas the Answer?" *MMC* 7.2 (1988): 125 and 120; Ellen V. Futter quoted in Glenn Collins, "Outer Space vs. Parking Space."

108. Arthur W. Melton, "Visitor Behavior in Museums: Some Early Research in Environmental Design," reprinted from the American Association of Musums, *Museum News* (June 1, 1936), in *Human Factors* 14.5 (1972): 401.

109. "Popularizing Science." Tactile exhibitions—catering to the needs of the sight-impaired by including objects that could be studied via touch—first come into vogue in the late 1970s and early 1980s; the British Museum opened its first ever tactile exhibition entitled "Please Touch" in spring 1983. For more on the exhibit, see Anne Pearson, "Please Touch: An Exhibition of Animal Sculptures at the British Museum," *MMC* 3.4 (Dec. 1984): 373–78. Museums had been catering to sight-impaired children far earlier than this; see, for example, George Sherwood, "The Story of the Museum's Service to the Schools," *Natural History* 27.4 (July-Aug. 1927): 315-38.

110. Sir David Brewster, "Parliamentary Hearings" (1864).

111. Anon., "Science and Science Museums," *The Examiner,* Jan. 13, 1877, ZA-SML.

112. Edwin Lankester, "Report of the Superintendent of the Food and Animal Collections," *Appendix T to the 7th Report of Science and Art Department* (1859), 146.

113. Redgrave, "Documents Relating," 124.

114. Adam Fresco, "Lecturer Takes Hammer to Corpse Exhibit," *The Times* (London), Mar. 28, 2002, 10.

115. Josie Appleton, "New Technology Is Dumbing Down Our Museums," *The Independent,* Apr. 24, 2001.

116. Andrew Cameron, "Dissimulation: The Illusion of Interactivity," *Millennium Film Journal* (1995): 33 and 46.

117. Adams, Luke, and Moussouri, "Interactivity," 157.

118. Patrick Hughes, "Making Science 'Family Fun': The Fetish of the Interactive Exhibit," *MMC* 19.2 (2001): 178.

119. Tomislav Šola, *Essays on Museums and Their Theory: Towards the Cybernetic Museum* (Helsinki: Finnish Museums Association, 1997), cited in Ross Parry, "Digital Heritage and the Rise of Theory in Museum Computing," *MMC* 20 (2005): 333. Media galleries on museum Web sites featuring instructional videos go some way toward addressing the "brochureware" criticism; the J. Paul Getty Museum in L.A. includes a video on how to make a Greek vase. For more information, see Gillian Engberg, "Virtual Field Trips," *Book Links* 11.1 (Aug.-Sept. 2001): 35–39.

120. Michael A. Fopp, "The Implications of Emerging Technologies for Museums and Galleries," *MMC* 16.2 (June 1997): 145.

121. Maria Economou, "The Evaluation of Museum Multimedia Applications: Lessons from Research," *MMC* 17.2 (1999): 175. Economou injects a healthy dose of skepticism into her own findings, arguing that curators need to "keep an open mind about the benefits to be derived from the new technology" and that a "larger body of knowledge needs to be built up before we can generalize about the characteristics of users of museum computer interactives" (183).

122. Adams, Luke, and Moussouri, "Interactivity," 163.

123. Tim Caulton, "The Future of Hands-On Exhibitions," in *Hands-on Exhibitions: Managing Interactive Museums and Science Centers* (London: Routledge, 1998), 139.

124. Heath and vom Lehn, "Misconstruing Interactivity."

125. Adams, Luke, and Moussouri, "Interactivity," 60.

126. "To the Right Hon. Edward Cardwell, MP, President of the Board of Trade," *First Report of the Department of Science and Art* (1853), xx.

6. FROM DAGUERREOTYPE TO IMAX SCREEN

1. Maleuvre, *Museum Memories*, 16.
2. For more on Smithson's life and his bequest to the United States, see "From Smithson to Smithsonian: The Birth of an Institution," an online exhibit available at www.sil.si.edu/ Exhibitions/Smithson-to-Smithsonian/. For scholarly works on the emergence of the Smithsonian, see Paul H. Oehser and Louise Heskett, *The Smithsonian Institution* (Boulder: Westview, 1983); Gore Vidal, *The Smithsonian Institution* (New York: Random House, 1998); and Steven D. Lubar and Kathleen M. Kendrick, *Legacies: Collecting America's History at the Smithsonian* (Washington, D.C.: Smithsonian UP, 2001).
3. David E. Haberstich, "Photographs at The Smithsonian Institution: A History," *Picturescope* 32.1 (Summer 1985): 5. My thanks to David Haberstich for his insights on the history of photography at the Smithsonian Institution and for pointing me toward this excellent article.

 For more on the photographing of Native American delegations at the SI, see chapter 2 of Paula Richardson Fleming and Judith Luskey, *The North American Indians in Early Photographs* (London: Phaidon, 1986), 20–43. For a native, "insider" perspective on Native American photography in general, see Lucy Lippard, ed., *Partial Recall* (New York: The New Press, 1992). For related books on the relationship between photography and anthropology, see Elizabeth Edwards, *Anthropology and Photography, 1860–1920* (New Haven and London: Yale UP in association with the Royal Anthropological Institute, 1992); chapter 2 of Griffiths, *Wondrous Difference*, 86–124 ; and Thomas Ross Miller and Barbara Mathé, "Drawing Shadows to Stone," in Laurel Kendall et al., *Drawing Shadows to Stone: The Photography of the Jesup North Pacific Expedition, 1897–1902* (New York and Seattle: AMNH in association with the U of Washington P, 1997), 19–40.
4. See Haberstich, "Photography," 11, for a trajectory of the administrative changes governing the photography collection at the SI.
5. Ibid., 6.
6. Ibid., 8. Beaumont Newhall, *The History of Photography: From 1839 to the Present* (New York: MOMA, 1982).
7. Hrdlička was a key figure in the development of physical anthropology in the United States who in 1903 became assistant curator in charge of the new division of Physical Anthropology. Hrdlička was a very influential anthropologist who lectured widely in both academic and popular circles.
8. Letter to Richard Rathburn from Aleš Hrdlička, May 14, 1909, in RU 529: Smithsonian Institution Archives (hereafter, SIA).
9. Letter to Smillie from A. T. Thompson & Co., Nov. 14, 1910, in ibid.
10. Lectures illustrated with magic lantern slides had begun at the SI in the 1890s, with Irish anthropologist James Mooney among the first in a lecture sponsored by the Anthropological Society of Washington on April 18, 1893. Entitled "The Indian Messiah and the Ghost Dance," the lecture was the only one of three delivered that day illustrated with lantern slides. Very few talks given during the 1893–1895 seasons were illustrated; the next one listed as having slides was on April 30, 1895, by Dr. Frank Baker and entitled "The Mechanism of Sensation." There may very well have been talks illustrated with magic lanterns slides long before this date; however, based on research I conducted at the SIA and at the National Anthropological Archives (hereafter, NAA), this was one of the earliest references to illustrated lectures I came upon in my research. I would be happy to hear of other instances. Information from Anthropological Society of Washington, No. 4821, box 15, series 6, Records of Secretary,

NAA-NMNH (SIA). My thanks to Paula Richardson Fleming for her unstinting support at the NAA.

11. Letter to Smillie from A. T. Thompson & Co., April 12, 1911, RU 529:1 SIA. The cost of remodeling the SI's existing Reflectoscope was $57.00, a reduced price (emphasis in original).

12. Letter to E. B. Fish from Smillie, Dec. 5, 1912, RU 529:1 SIA.

13. Letter to E. B. Fish from Smillie, Dec. 2, 1912, 82:026 SIA.

14. For more on Bernays, see his canonical *Propaganda* (New York: Liveright, 1928); Larry Tye, *The Father of Spin: Edward L. Bernays and the Birth of PR* (New York: Crown, 1998); and Stuart Ewen, *PR: A Social History of Spin* (New York: Basic Books, 1996).

15. Katherine Beneker, "Exhibits—Firing Platforms for the Imagination," *Curator* 1.4 (Autumn 1958): 80.

16. Rebecca Curzon, "Children of the Castle," written for the "Children in Museums" symposium, Office of Museum Programs, SI, Oct. 28–31, 1979, 2.

17. Ibid., 6 and 8.

18. Letter to Rathbun from Langley, Nov. 30, 1898, RU 55:17, folder 2, SIA, cited in ibid., 8. In 1904, Anna Billings Gallup, a pioneer of children's museums, carried on Langley's vision, appointed Curator, Director, and finally Curator-in Chief of the museum until her retirement in 1937. The current Brooklyn Children's Museum building, designed by architects Hardy, Holzman Pfeiffer Associates and with interactive exhibits by Edwin Schlossberg, opened on the original site on May 17, 1977. In 2002, architect Rafael Vinoly, unveiled plans for the museum's $39 million Capital Expansion plan, which will double the size of the existing museum to 102,000 square feet and increase its capacity from 250,000 to 400,000 visitors annually. It is scheduled for completion in 2008. Information on the history of the BCM is from www.bchildmus.org/about/hist.

19. Mary McCutcheon, "The Children's Room at the Smithsonian, 1901–1939," *Curator* 35.1 (Mar. 1992): 7–9.

20. Curzon, "Children of the Castle," 11 and 9.

21. "Electrical Questionnaire for Young Visitors," *Museums Journal* 33.6 (Sept. 1933): 236.

22. Christopher John Nash, "Interactive Media in Museums: Looking Backwards, Forwards, Sideways," *Museum Management and Curatorship* (hereafter, *MMC*) 11.2 (June 1992): 173 and 178.

23. Smithsonian Institution *Annual Report* (1974), in RU 363:8, 75, SIA.

24. Victor J. Danilov, "Science Exhibits for the Very Young," *MMC* 5.3 (Sept. 1986): 243.

25. A Discovery Room for adults called the Naturalist Center opened two years later in 1976, making available to the "serious amateur naturalist the natural history collections that traditionally have been only behind plates of glass in exhibit cases. Here, a person can sit down at a table and compare his own specimens with reference collections of shells, minerals, insects, pets, Indian pottery fragments, or many other natural history objects." Microscopes and a well-stocked library of illustrated reference guides were also available for use by visitors. "The Exhibits Program at the NMNH: A Restatement of the Long-Range Plan Prepared on the Occasion of the Fall 1978 Meeting of the Smithsonian Council," Oct. 1978, 7 (RU 564, SIA).

26. Smithsonian Institution *Annual Report* (1975), 92, SIA.

27. Robert Moses, "The City's Museums—A Fresh Appraisal," *New York Times Magazine*, Nov. 13–20, 1949, 3, in file #2, Correspondence *NYT*, 1949–76, in Administrative Papers Correspondence, Department of Special Collections, AMNH (hereafter, SC-AMNH). Moses launches a stinging attack on several of New York's cultural institutions for failing to address the needs and interests of urban spectators; the Hayden Planetarium is especially hard-hit (7).

28. Letter to Peter Farb (director, National Museum of Natural History) from James A. Mahoney (Chief, Office of Exhibits, NMNH), Nov. 5, 1968, in RU 363:8, NMNH Exhibitions Records, c. 1955–1990, SIA (hereafter abbreviated to NMNH ER 55–90).

29. Smithsonian Institution *Annual Report* (1974).

30. Memo from J. A. Mahoney, Oct. 17, 1969, in RU 363:8, SIA.

31. Memo to S. Dillon Ripley from R. S. Cowan, Jan. 24, 1968, in RU 363:8, SIA.

32. Hall 10 Log Material in RU 363:8, SIA.

33. Anne Friedberg, "Virilio's Screen: The Work of Metaphor in the Age of Technological Convergence," *Journal of Visual Culture* 3.2 (2004): 187.

34. Memo, "Proposals for Exhibits in Hall 10," to Dr. Richard Cowan, Jan. 16, 1968, from Peter Farb, RU 363: 8, SIA.

35. *Public Programs at the NMNH: A Joint Report to Secretary Adams from the Departments of Exhibits and Education at the NMNH*, Aug. 1985, in RU 564, Office of Exhibits, NMNH Records, c. 1974–1986, SIA.

36. Laura Greenberg, *Exhibit Themes for the NMNH*, Report to the Director, Dec. 1986 (ibid.).

37. Letter to Dr. Robert S. Hoffman, Jan. 21, 1987, from NMNH Steering Committee, in RU 564, Office of Exhibits, NMNH Records, c. 1974–1986, SIA.

38. Anon., "Responsibility," in ibid.

39. "US NMNH Evaluation and Recommendations, Museum Planning, 1970," 153-page document in RU 564, box 4 of 4, Office of Exhibits, NMNH, c. 1974–1986, 126, SIA.

40. "The Exhibits Program at the NMNH," 2.

41. The Insect Zoo's popularity spawned many imitators including Cincinnati's Insect World, Fort Lauderdale's Museum of Discovery and Science, the Denver Museum of Natural History, the Boston Children's Museum, and the Bronx Zoo. "The Exhibits Program at the NMNH," 7.

42. Ibid. Gene Behelen was charged with supervising the development of the exhibit; Terry Erwin wrote the script, and Sue Willis edited it. When it opened as a permanent exhibit in August 1976, it was overseen by a staff of three scientists and 80 volunteers.

43. "Insect Zoo" file, RU 363, box 32, SIA.

44. Letters from 1976 in the "Insect Zoo" file, RU 363, box 32, SIA.

45. Jessica Ludwig, "Smithsonian's Interactive Exhibit Allows Museum-Goers to Collaborate and Compete," *Chronicle of Higher Education* (http://chronicle.com).

46. Spiegel, quoted in ibid.

47. Initial corporate sponsors for the exhibit included the Shell Oil Foundation and the Coca-Cola Foundation.

48. Similar criticisms were directed toward Hall 11 (Native Peoples of North America) in the 1980s. According to an untitled, undated memo in the Smithsonian Institution Archives, "cases in this hall reflect concepts prevalent more than 100 years ago and say virtually nothing of current significance about present-day Native Americans. Worse yet, the halls convey outdated attitudes and misinformation about Native Americans that are patronizing and offensive to these groups." Excerpt from untitled, undated memo, 13–15, in RU 564, box 4, SIA.

49. The two videos, made by Northern Light Productions, which was also responsible for the *aqal* video and computer interactives (to be discussed later), are *Struggle for Freedom* (20 min) and *Struggle for Justice* (18 min). They are both expository in style, combining archival footage, narration, and interviews with Africanist scholars.

50. Mary Jo Arnoldi, Christine Mullen Kreamer, and Michael Atwood Mason, "Reflections on 'African Voices' at the Smithsonian National Museum of Natural History," *African Arts* 34.2 (Summer 2001): 16.

51. Wally Olins, "How Brands Are Taking Over the Corporation," in Majken Schultz, Mary Jo Hatch, and Mogens Holten Larsen, eds., *The Expressive Organization: Linking Identity, Reputation, and the Corporate Brand* (New York: Oxford UP, 2000), 63.

52. MOMA press release cited in Bernard F. Reilly, Jr., "Merging or Diverging? New International Models from the Web," *Museum News* (hereafter, *MN*) (Jan.-Feb. 2001): 49. For a full list of participating partners, see www.fathom.com/special/bhm.

53. Bryony Gordon, "Artistic Licenses," *Daily Telegraph* (London), Apr. 13, 2002, 4. At the Royal Academy in London,

approximately 50 items of merchandise are created for each exhibition, ranging from $1 postcards to a $200 reproduction of a sculpture. Some 50,000 postcards were sold for Monet's *The Grand Canal Venice* show. Colin Gleadell, "See the Show, Buy the T-Shirt," *Daily Telegraph* (London), Mar. 2, 2002.

54. Mark Honigsbaum, "McGuggenheim?" *The Guardian*, Jan. 27, 2001, 4. For an insightful discussion of museum and corporate sponsorship, see "The Sponsored Museum; or, The Museum as Sponsor," in Mark W. Rectanus, *Culture Incorporated: Museums, Artists, and Corporate Sponsorship* (Minneapolis: U of Minnesota P, 2002).

55. Manuela Hoerlterhoff, "The Fine Art of Packaging Big Art Shows" (May 26, 1978), unidentified clipping in "Temporary Exhibits" file, SC-AMNH.

56. Nash, "Interactive Media," 183.

57. Anna McCarthy, *Ambient Television: Visual Culture and Public Spaces* (Durham: Duke UP, 2001), 2, 14, 4.

58. Arnoldi, Kreamer, and Mason, "African Voices," 21.

59. Ibid., 26.

60. McCarthy, *Ambient Television*, 14.

61. Peter Hall, "Now Showing: Something Dazzling," *NYT*, May 2, 2001, H17 (special section on museums).

62. Casey, quoted in ibid.

63. The phrase is Ralph Appelbaum's and refers to the mutual imbrication and support of the museum's architecture and the exhibition. Since this exhibit is one space in a larger institution, the term "architecture" in this context refers to the topographical design of the gallery space, how the different areas are partitioned, and the overall design schema. Ralph Appelbaum, "Designing an 'Architecture of Information'—The United States Holocaust Memorial Museum," *Curator* 38.2 (June 1995): 89.

64. Arnoldi, Kreamer, and Mason, "African Voices," 21.

65. During a visit to the exhibit in May 2002, I overhead two women talking about wanting one day to visit Africa, but fearing for their safety since the "country" seemed so politically volatile. The plan to include an exhibit on the history of African paper currencies was also modified when it transpired through visitor testing that many people didn't realize that as members of global economies, Africa actually used modern paper currencies. Ibid., 24.

66. Ibid., 26.

67. Ibid., 29.

68. Ibid.

69. Ibid.

70. Beverly Serrell, "Are They Watching? Visitors and Videos in Exhibitions," *Curator* 45.1 (Jan. 2002): 50.

71. E. S. Robinson, *The Behavior of the Museum Visitor*, Publications of the American Association of Museums New Series, No. 5 (Washington, D.C.: American Association of Museums, 1928), cited in M. B. Alt, "Improving Audio-Visual Presentations," *Curator* 22.2 (1979): 86.

72. Alt, "Improving," 87.

73. Ibid., 93.

74. Heath and vom Lehn, "Misconstruing Interactivity."

75. George F. MacDonald (interview), "Digital Visionary: George F. MacDonald and the World's First Museum of the Internet Century," *MN* (Mar.-Apr. 2000): 74.

76. Appelbaum, "Designing," 87.

77. Adams, Luke, and Moussouri, "Interactivity," 155–56.

78. Virginia Smith, "Swimming in the Sea of Memory," *NYT*, June 15, 2003, 3.

79. Hall, "Now Showing," H17.

80. "US NMNH Evaluation, 1970," 115. The following quotes are either from this page or 116.

81. Axel Horn, "Communicating Science in 'Four Dimensions,'" *Curator* 3.1 (1960): 91.

82. Edward P. Alexander, "Bringing History to Life: Philadelphia and Williamsburg," *Curator* 4.1 (1961): 67. The idea of the museum as an inviting, vibrant space that would be welcoming to a cross-section of the population was voiced quite frequently in museum discourse; the following quote from a summary statement of long-term goals for the NMNH makes explicit the connection: "To the extent possible, we want ours to become a *'living museum,'* where individuals,

school groups, and families from around the nation can come and gain an appreciation of our natural world in an exciting, informative, and pleasant setting" (emphasis added). "Public Program Goals? Summary Statement of Long-term Plans for the NMNH, SI," RU 564, box 1, SIA.

83. Laura Greenberg, Office of Exhibits, "Practical Plans for Conveying the Major Themes of the NMNH to Our Six Million Visitors" (Feb. 1987).

84. "Proposal #1 'Preliminary Proposal for an Introductory Gallery as a Core Element in an Introductory / Orientation Complex,'" n.d., in RU 564, box 1, SIA.

85. Ibid.

86. "Proposal #2 'Preliminary Proposal for an IMAX film to be Produced by the NMNH and Used as the Second Element in the Introductory / Orientation Center,'" n.d., in RU 564, box 1, SIA.

87. Ibid., 15.

88. Ann Mintz, "That's Edutainment," *MN* 73.6 (1994): 32.

89. *To Fly!* was produced by noted documentary film producer Francis Thompson, who was paid $750,000 by Conoco (including rights). The NASM would show the film for the duration of the Bicentennial year (1976–77) and longer at the discretion of the NASM. The Smithsonian would have ultimate control of issues such as historical accuracy and matters pertaining to protecting its reputation. Information in memo to Mr. Ripley from SI scientist David Challinor, Dec. 16, 1974, in RU #338 18/33 NASM, 1972–89, *To Fly!* file, SIA.

90. William Kissiloff, "How to Use Mixed Media in Exhibits," *Curator* 12.2 (1969): 84–85.

91. Melvin B. Zisfein, "'To Fly' Film Concept" memo, Aug. 10, 1972, in RU 346, box 14, c. 1961–1982, SIA. The following quotes are all from this memo.

92. Wyatt asked Ripley to "take all steps to assure that the domestic service receives full evaluation all along the line, so we don't by inadvertence miss an opportunity to support the American film industry." Ibid.

93. Untitled memo by Melvin B. Zisfein, Oct. 20, 1976, in RU 338 18/33 NASM, 1972–1989, *To Fly!* file, SIA.

94. Ibid.

95. Other proposed IMAX treatments that were rejected include "Flying for Fun" (viewed as "Too restricted. Not much for us") because of its emphasis on flight hobbyists and stunt pilots; "The Evolution of Flight" (from prehistory to future interplanetary travel, rejected for requiring too much animated or reconstructed footage; and such titles as "To the Stars and Beyond" (which educated the public about space flight in "real terms as opposed to *Star Trek* type entertainment") and "Speed," which would "make excellent use of the capabilities of the IMAX screen in putting people in the driver's seat or behind the controls of different vehicles." Zisfein memo (Oct. 20, 1976).

96. Douglas J. Preston, "The Naturemax Theater," *Natural History* 91 (Feb. 1982): 94–95.

97. Memo to Dr. S. Dillon Ripley from David Challinor, Dec. 16, 1974, in RU #338 18/33, NASM, 1972–89, *To Fly* file, SIA.

98. Memo to Noel W. Hinners, director of NASM (from 1979 to 1982) from NASM deputy director Walter J. Boyne, Apr. 20, 1982, in RU #346, box 14, Deputy Director NASM, c. 1961–1982, *To Fly* Film Concept file, Apr. 20, 1982, SIA.

99. Undated IMAX Brochure, 13 in RU #338 8/33 NASM Office of the Director, 1972–1989 IMAX file, SIA.

100. "Introduction to Project [the IMAX film *Flyers*]," in RU #338 6/33 NASM Office of the Director, 1972–1989 IMAX file, 20, in SIA.

101. Walter J. Boyne, "Trip Report" (undated memo), RU #346, box 14, Deputy Director, NASM, c. 1961–1982, *To Fly!* Film Concept File, SIA.

102. "Introduction to Project," 1.

103. Ibid., 19.

104. "Proposed Shot List" in ibid., 1.

105. Memo to SI astronomer Von del Chamberlain from curator Helen C. McMahon, Mar. 2, 1979, in RU #338 6/33 NASM Office of the Director, 197289, Imax file, SIA.

106. United States Pavilion Guidebook, EXPO 74, Spokane, Washington. The U.S. Pavilion was dedicated to the theme "Man and Nature: One and Indivisible." In RU #338 8/33 NASM, Office of the Director, 1971–1989 IMAX file, SIA

107. Memo to Michael Collins, first director of the NASM in 1971, and M. B. Zisfein, deputy director from Von del Chamberlain entitled "IMAX Projector at EXPO 74," May 23, 1974, in ibid.

108. Charles Alan Watkins, "Are Museums Still Necessary?" Curator 7.1 (Mar. 1994): 29.

109. Ibid., 33. For a critique of Watkins's claims, see Lisa C. Roberts, "Rebuttal to 'Are Museums Still Necessary,'" Curator 37.3 (Sept. 1994): 152–53. Roberts argues that museums have long embraced commercial and educational goals ("Today's theme parks are yesterday's world fairs, department stores, and sideshows") and that Watkins's desire to return museums to some golden era when they were "unsullied by matters of finance, audience need, and interpretive complexity" is naive to say the least (154).

110. George F. MacDonald and Steven Alsford, "Museums and Theme Parks: Worlds in Collision?" MMC 14.2 (June 1995): 130.

111. Ibid., 129–30.

112. Eric Brace, "The Smithsonian's Jazzy Display," Washington Post, Feb. 22, 2002, T6. See www.si.edu/visit/ (emphasis added).

113. Cosmic Voyage contained more computer-generated imagery (CGI) and scientific visualization than any other IMAX movie made to date. Given the scale of IMAX, the CGI content was a challenge since the slightest error in the 4,000-pixel resolution would have been magnified by the scale of the screen pixels. Funded by the NASM, Motorola Foundation, and the National Science Foundation, the film was "a visual story about the vastness of the universe: the relative size of things from galactic clusters to quarks." Information from Donna J. Cox, "What Can an Artist Do for Science: 'Cosmic Voyage' IMAX Film," in Sommerer and Mignonneau, eds., Art @ Science, 53–59.

114. "Censorship in Science Museum" (editorial), NYT, Mar. 28, 2005, A16; Serapiglia, quoted in Cornelia Dean, "A New Test for IMAX: The Bible vs. the Volcano," NYT, Mar. 19, 2005, A11.

115. Dean, "A New Test," 11.

116. J. W. Borcoman, "Public Education in the Visual Arts," Curator 12.1 (1969): 42.

7. FILM AND INTERACTIVE MEDIA IN THE MUSEUM GALLERY

1. A Webcast of the conference can be found at www.tatemodern.uk. All quotes are taken from this site.

2. For more on developments in new technology, see Karen Jones, "New 'Smart' Galleries, Wireless and Web-Friendly," NYT, Apr. 24, 2002, G27.

3. Jeffrey Bell, "On 'Good Form' in Natural History Museums," Museums Journal (hereafter, MJ) 3.5 (Nov. 1903): 160.

4. F. G. Kenyon, "Children and Museums," MJ 19.1 (July 1919): 10.

5. Herman Carey Bumpus, cited in Anon., "Human Interest to Shape Exhibits of Future," Museum News (hereafter, MN) 1.1 (Jan. 1, 1924): 2.

6. For a brief discussion of Regnault's proposal, see Peter Bloom, "Pottery, Chronophotography, and the French Colonial Archive," unpublished paper presented at the Screen Studies Conference, Glasgow, Scotland, June 1993.

7. F. A. Bather, "The Museums of New York State," MJ 1.3 (Sept. 1901): 73.

8. Fritsch, "The Museum Question," 255.

9. Anon., "The Spectator," The Outlook (May 29, 1909): 274.

10. American Association of Museums Task Force on Museum Education, "Excellence and Equity: Education and the Public

Dimension of Museums," *Journal of Museum Education* 16.3 (Fall 1991): 92.

11. Catalog (p. 1) accompanying the AMNH temporary exhibit "Epidemic! The World of Infectious Diseases," which ran at the AMNH from February 27 to September 6, 1999. For background information on the exhibit, see www.amnh.org/museum/press/feature/epidrelease.html.

12. Anon., "Weapons in the War Against Tuberculosis: The Exhibition in the New York Museum of Natural History," *Harper's Weekly* (Nov.-Dec. 1908): 7, cited in Geraldine Santoro, " 'To Stamp Out the Plague of Consumption': 1908–09," *Curator* 36.1 (Mar. 1993): 24.

13. For discussion of the exhibit, see the Mar. 1908 and Feb. 1909 issues of the *American Museum Journal,* the magazine of the AMNH which later became *Natural History.* Other reviews include John Martin, "The Exhibition of Congestion Interpreted," *Charities* 20 (Apr. 4, 1908): 27–60; and Everett B. Mero, "An Exposition That Mirrors a City," *American City* 1 (Nov. 1909): 100.

14. See *MJ* 31.7 (Jan. 1931): 290, for a brief announcement about the "automatic gramophone."

15. Anon., "Illustrates Talk by Radio," *MN* 2.4 (June 15, 1924): 2.

16. In conjunction with the Buffalo Historical Society, Buffalo Fine Arts Academy, and the Buffalo Museum of Science, printed photographs of museum objects appeared in the "Rotogravure" section of the Sunday paper. Listeners tuning in to WKBW at 6 p.m. on Sunday evenings would "hear a talk on the pictures shown therein." Anon., "Museum and Newspapers Co-operate in Roto-Radio Talk," *MN* 6.21 (Apr. 15, 1929): 1.

17. Anon., "Radio Photologues," *MN* 3.10 (Nov. 1, 1925): 2.

18. "Museum and Newspapers Co-operate," 1.

19. Clifford C. Gregg, "Television an Ideal Educational Medium for Future," *Field Museum News* (May 1940): 3.

20. "Museums and Radio," *MN* 4.10 (Nov. 1, 1926): 2.

21. Review of J. C. W. Reith, *Broadcast Over Britain* (London: Hodder and Stoughton, 1925), in *MJ* 24.9 (Mar. 1925): 212.

22. Anon., "Lectures and the Public," *MJ* 25.8 (Feb. 1926): 215.

23. C. A. Siepmann, "The Relation of Broadcast Education to the Work of Museums," *MJ* 29.5 (Oct. 1929): 120.

24. Unattributed *Daily Telegraph* quote in Anon., "Science Museum: Radiogramaphone," *MJ* 35.9 (Dec. 1935): 358–59.

25. Anon., "The Dissemination of Information by Exhibition and Display," *MJ* 30.6 (Dec. 1930): 218.

26. Anon., "Music and Museums," *MJ* 31.5 (1931): 208 (emphasis added); Anon., "Museums and Cinematographers," *MJ* 32.2 (May 1932): 76.

27. "Museums and Movies" (editorial), *MJ* 21.9 (Mar. 1922): 200.

28. For more on the emergence of film at the AMNH, see chapter 6 of Griffiths, *Wondrous Difference.*

29. Review of "Museum Stories for Children," *MJ* 24.6 (Dec. 1924): 145.

30. R. A. Rendall, [no title], *MJ* 32.11 (Feb. 1933): 419.

31. Anon., "Brighter Museums," *MJ* 27.9 (Mar. 1928): 292.

32. The validation of motion pictures in museum work may be gleaned from the topic of the 16th Annual Meeting of the American Association of Museums held in Cleveland in 1921: "Motion Pictures as a Phase of Educational Work in Museums." Reference in Anon., "The Activities of Museums in America," *MJ* 21.1 (July 1921): 9.

33. Terry A. Cooney, *American Thought and Culture in the 1930s* (New York: Twayne, 1995): 79.

34. Review of J. C. W. Reith, *Broadcast Over Britain,* 220. By 1936, the Imperial War Museum housed 700 official war films (over 450, 000 feet) representing the Navy, Army, and Air Force on various fronts. Copies of certain films were available for hire and, in collaboration with the Admiralty, War Office, and Air Ministry, had been used by commercial film companies. Information from H. Foster, "Imperial War Museum," *MJ* 36.5 (Aug. 1936): 221.

35. Anon., "Unbreakable Movie Film: Steel-Sheathed Film Reduces Replacement Costs; Has Great Educational Value," *Scientific American* (Apr. 1930): 299.

36. "The Dramagraph," *MJ* 31.1 (Apr. 1931): 24.

37. Film was first exhibited at the AMNH in 1908. In 1923 the AMNH formed a Motion Picture Library, "an international depository for the very best nature films, with a view to preserving valuable records for study and research." The films included those shot in Africa by Paul. J. Rainey, Carl E. Akeley, and James Barnes, and the Asiatic films of Roy C. Andrews. *MJ* 23.4 (Oct. 1923): 115.

38. Ibid.

39. Reference to the demonstration projector appears in Anon, " In the Magazines: Movies in Museum," *MN* 8.1 (May 1930): 7.

40. E. E. Lowe, "The Cinema in Museums," *MJ* 29.10 (Apr. 1930): 343.

41. Lowe estimated that the cost of a camera outfit capable of projecting black-and-white films would be £25 and for color £120. The cost of changing the film each month would be about 35 shillings (£1.75).

42. "Museums and Movies," 334.

43. Anon., *MJ* 31.7 (Jan. 1931): 439. At the same time as interactive film exhibition technologies were being experimented with in museums, curators still contended with the dearth of suitable subjects for screening in museum lecture theaters; one British author complained in 1933 that "films for Museums are at present practically non-existent," although such organizations as the Central Information Bureau for Educational Films did publish leaflets on the availability and distributor information of educational films. Mary Field, "The Film in the Museum," *MJ* 33.10 (Jan. 1934): 350; *MJ* 33.8 (Nov. 1933): 239.

44. Reginald V. Crow, "Correspondence. The Film in the Museum: An Inquiry," *MJ* 34.8 (Nov. 1934): 336.

45. Ibid., 335.

46. Anon., "Interactive Service," *Design Week*, Mar. 28, 2002, 16. Another notable interactive is the Human Genome Interactive, which introduces visitors to the concept of genetics by letting people " 'see the genome—an artifact that is as much an information abstraction as a physical reality. We made the interactive controls like an aircraft. Users can fly into the genome, seeing more detail as they got deeper into it.' " Exhibit founder David Small, quoted in ibid. A separate admission charge is made for IMAX (currently about $12) and special shows ($10), although general admission to the museum is free.

47. Sir William T. Furse, "The Panoramas and the Cinema at the Imperial Institute," *MJ* 29.10 (Apr. 1930): 339. The Cinema building at the Imperial Institute was about 120 feet long and contained 329 seats. Finding films of suitable subjects and that are not too long were just two of the major difficulties the institute faced; according to Furse, "We beg, borrow, and occasionally hire these films, and we are much indebted for the loan of films to the High Commissioners of the various Dominions and India, to many big firms and corporations which have established industries in various parts of the Empire, and to private individuals" (339).

48. Anon., "Exhibition of Visual and Aural Aids to Education," *MJ* 30.2 (Aug. 1930): 65.

49. Anon., "Exhibition of Mechanical Aids to Learning," *MJ* 30.5 (Nov 1930): 206 (emphasis added).

50. Haidee Wasson, *Museum Movies: The Museum of Modern Art and the Birth of Art Cinema* (Berkeley: U of California P, 2005); Douglas L. Baxter, "The Film Library of the Museum of Modern Art," *Bulletin of the Association of American Colleges* (Dec. 1939): 581–82.

51. Ernest H. Lindgren, "The National Film Library," *MJ* 37.12 (Mar. 1938): 549.

52. Dransfield, "Is There a Technique?" 122; *Audio-Visual Aids to Instruction* (no author, date, or publication information available), 152–55. The author classifies educational films into six subgroups: classroom films; industrials; school-made; documentary; newsreels; and photoplays (158).

53. Grace Hotchkiss, "The Use of the Motion Pictures as a Technique of Instruction," *Social Studies* 28.1 (Jan. 1937): 7.

54. Dransfield, "Is There a Technique?" 122.

55. Hotchkiss, "Use of the Motion Pictures," 8. The most expensive film used was *Headlines of a Century*, which cost $15.00.

56. William A. Burns, "Museum Exhibition: Do-It-Yourself or Commercial?" *Curator* 12.3 (1969): 163.

57. "Harpooning the Walrus," exhibit description in *The Geographical Models*, Brooklyn Institute of Arts and Sciences Children's Museum, May 1917, 4.

58. Sweeney, "Some Ideas on Exhibition Installation," 152.

59. Anon., "Display Methods at the Museum of Modern Art, New York: Lay-Out and Lighting of an Exhibition of American Indian Art," *MJ* 41 (Oct. 1941): 156.

60. Mark Sandberg has written an excellent essay on costumed role-playing docents which examines the open-air Swedish museum Skansen: "Effigy and Narrative: Looking into the Nineteenth-Century Folk Museum," in Leo Charney and Vanessa Schwartz, eds. *Cinema and the Invention of Modern Life* (Berkeley: U of California P, 1995), 320–61. Also see Sandberg's book on the history of wax and folk museums in Scandinavia, *Living Pictures, Missing Persons: Mannequins, Museums, and Modernity* (Princeton: Princeton UP, 2003), which examines the topic in even greater depth, again focusing on Scandinavia.

61. Anon., "What Next Will We Do?" *Museum Service*, October 1941, 3.

62. Edward P. Alexander, "Bringing History to Life: Philadelphia and Williamsburg," *Curator* 4.1 (1961): 63.

63. Ibid., 67. The Museum of the Upper Lakes at Wasaga Beach, Ontario, developed an "Electronic Theater" in 1968, a three-room space in which the battle between three American vessels and the HMS *Nancy*, loaded with supplies, is told through sound and light. Describing the show, curator James W. McLean said was it was less like cinema or the legitimate stage where audiences "sit *here* and the action takes place *there*." More than anything else, he said, it was "an extension of the techniques of radio drama" (299). McLean, "Battle in a Time Machine," *Curator* 10.4 (1968): 297–304.

64. Information from Press Release, "Facts on the Centennial Exhibit at the AMNH," Temporary Exhibits Folder, Special Collections, AMNH (hereafter abbreviated to TEF-AMNH).

65. Reekie, quoted in Michael Robbins, "An Exhibit Asks the Question of the Century," *MN* (Sept. 1969): 13.

66. Anon., "Can Man Survive," *A-V Communication* (June 1969): 14.

67. Passaic (New Jersey) *Herald-News* reviewer Dan Weissman said the same in his May 24, 1969, review of the exhibit: " 'Can Man Survive' departs dramatically from what has traditionally been seen at the sprawling museum on New York's west side."

68. Appelbaum, "Designing an 'Architecture of Information,' " 95–110.

69. The following description of the exhibit is from an internal AMNH document entitled "Description of Centennial Exhibit: 'Can Man Survive,' " in TEF-AMNH. All subsequent citations are from this document.

70. Richard Danne, "Can Man Survive?" *CA Magazine* (Aug-Sept. 1969): n.p.

71. Kissiloff, "How To Use Mixed Media in Exhibits," 91.

72. Jay David Bolter and Richard Grusin, eds., *Remediation: Understanding New Media* (Cambridge: MIT Press, 1999): 9.

73. Ibid., 179.

74. Robbins, "An Exhibit Asks the Question of the Century," 12.

75. Reekie, quoted in ibid., 13 (emphasis added).

76. Robbins, "An Exhibit Asks the Question of the Century," 12. For a discussion of sound, smell, and touch in the museum, see Burns, "Museum Exhibition," 160–67.

77. Jo Martin, "In Conservation's Corner," *Daily News*, May 16, 1969; Mark Finson, "A Horrible Way to Spend an Afternoon," *Newark Star-Ledger*, May 16, 1969; and Anon., "Come Now the Hero. Or Does He?" *Product Engineer*, June 2, 1979. (Emphasis added in all quotes.)

78. Kissiloff, "How to Use Mixed Media in Exhibits," 91; John C. Devlin, "Museum Show Here About Survival Is Good—Or Bad?" *NYT*, May 16, 1969.

79. Robert E. Dierbeck, "Television and the Museum," *Curator* 1.2 (Spring 1959): 34.

80. Ibid., 38.

81. Wilfrid Sheed, "Evolution of a Bad Trip," *Life Review,* July 11, 1969.
82. Danne, "Can Man Survive?"
83. Weissman, no title review of "Can Man Survive?", *Herald-News,* May 24, 1969.
84. Ibid.
85. Keating, quoted in Robbins, "An Exhibit Asks the Question of the Century," 11.
86. Letter to Public Information Officer Robert Rendueles, March 6, 1970, from Gary J. Schlosser, in TEF-AMNH.
87. Baz Kershaw, "Curiosity or Contempt: On Spectacle, the Human, and Activism," *Theatre Journal* 55.4 (Dec. 2003): 591–611.
88. Lothar P. Witteborg, "Design Standards in Museum Exhibits," *Curator* 1.1 (Jan. 9, 1958): 38 and 41.
89. Carl Nesjar, "The Artist and the Museum," *Curator* 3.2 (1960): 107.
90. Borcoman, "Public Education in the Visual Arts," 42.
91. Kissiloff, "How to Used Mixed Media in Exhibits," 83.
92. A. E. Parr, "Mass Medium of Individualisation," *Curator* 4.1 (1961): 41.
93. A. E. Parr, "Marketing the Message," *Curator* 12.2 (1969): 77 and 82.
94. Robert M. Smith, "Museum Uses Psychedelic Lights and Electronic Museum to Show That Life Can Be Ugly," *NYT,* May 19, 1969.
95. Hermann Krüger, "Planning and Layout of Museums," *MMC* 3.4 (Dec, 1984): 354.
96. "Night Owl Reporter," *Daily News,* Mar. 19, 1971.
97. Amel Wallach, "Art Review: Gold of El Dorado," *Newsday,* Nov. 16, 1978.
98. Manuela Hoerlterhoff, "The Fine Art of Packaging Big Art Shows," unnamed journal, May 26, 1978, in TEF-AMNH.
99. Press release, " 'Wolves and Human: Coexistence, Competition, and Conflict' to Open Here, June 11, 1986," AMNH, 1.
100. Ibid., 2. The show was produced by the Science Museum of Minnesota. To coincide with the opening of the exhibit, the AMNH reissued a recording entitled "The Language and Music of Wolves," which had attracted nationwide attention when it was first released in 1971. Narrated by actor and conservationist Robert Redford, the recording was first issued free to *Natural History* subscribers in 1971 but was in 1986 released commercially with a new cover by Columbia Records (AMNH Press Release, 6/2/86).
101. Winifred G. Doyle, "Can the Health Museum Flourish in America?" *Curator* 2.1 (Spring 1959): 78–79 and 82.
102. Parr, "Mass Medium of Individualism," 47.
103. "AMNH Unveils 11,000-Square-Foot Permanent Hall Devoted to Biodiversity," Press release, May 1998, 1. The following quotes are all taken from this 8-page document housed in the SC-AMNH.
104. Ibid. (emphasis added).
105. "In the Hall of Biodiversity" (editorial), *NYT,* June 1, 1998.
106. Ibid.
107. Text from www.amnh.org/exhibitions/permanent/biodiversity/rainforest.
108. Diane Treon, "Hall of Biodiversity," unpublished paper completed for "Spectacular Realities" course at the CUNY Graduate Center (Fall 2005), 5. No expense was spared in constructing the diorama. Interdisciplinary teams of scientists embarked on several expeditions to the rain forest, returning with countless samples that would be used as molds for the casts (made by hand) of specimen plants and leaves. Even a fragrance specialist was brought in to perfect the rain forest odor.
109. Donald Horne, *The Great Museum: The Representation of History* (London: Pluto Press, 1984); Treon, "Hall of Biodiversity," 4.
110. David. R. Prince, "The Museum as Dreamland," *MMC* 4.3 (Sept. 1985): 244.
111. Duncan F. Cameron, "A Viewpoint: The Museum as a Communications System and Implications for Museum Education," *Curator* 11.1 (1968): 37–38.
112. Chandler Screven, quoted in Roberts, *From Knowledge to Narrative,* 19.

113. Roberts, *From Knowledge to Narrative*, 86.

114. Suzanne Keene, *Digital Collections: Museums and the Information Age* (London: Butterworth-Heinemann, 1998), 31

115. Kristine Morrissey, "Visitor Behavior and Interactive Video," *Curator* 34.2 (1991): 109–118.

116. Keene, *Digital Collections*, 52.

117. Tony Bennett, "Civic Seeing: Museums and the Organization of Vision," in Sharon Macdonald, ed., *A Companion to Museum Studies* (Oxford: Blackwell, 2006), 263–81; and Bennett's seminal study, *The Birth of the Museum: History, Theory, Politics* (New York: Routledge, 1995). For more on these connections and ensuing debates, see chapter 2 of Griffiths, *Wondrous Difference*.

118. Dr. Hoyle, "Egyptological Collections," *MJ* 8.5 (Nov. 1908): 158.

119. All quotes from www.museumwales.ac.uk/en/swansea/visitor/ (accessed on 4/17/06). The NWF received £11.1 million ($19 million) from the Heritage Lottery Fund and was also a recipient of a European Union Objective One Grant. Maritime museums in the UK and Australia have been at the forefront of a great deal of developments in interactive design; for a case study analysis of "'spatial' interactivity" at the Australian National Maritime Museum, see Andrea Witcomb, *Re-Imagining the Museum:Beyond the Mausoleum* (London: Routledge, 2003), 141–56.

120. Other notable science centers in the UK include the Wellcome Wing at the Science Museum, Explore Bristol, Techniquest in Cardiff, and the Glasgow Science Center.

121. Michael Wolf, *The Entertainment Economy: How Mega-Media Forces Are Transforming Our Lives* (New York: Times Books, 1999), cited in Hughes, "Making Science 'Family Fun,'" 177; MacDonald and Alsford, "Museums and Theme Parks," 136.

122. Silverstone, "Museums and the Media," 233.

123. Quote from www.abayoflife.com. The branding exercise aims to reposition Swansea as an excellent place to live in the UK, boasting natural beauty, leisure industries, and less than three hours from London. Swansea Bay Futures is a nonprofit organization with a board of directors and spanning both public and private sectors. My thanks to Fiona Rees, executive director of Swansea Bay Futures, for this information. For more on the branding of cities, see Timothy A. Gibson, "Selling City Living: Urban Branding Campaigns, Class Power and the Civic Good," *International Journal of Cultural Studies* 8.3 (2005): 259–80; and P. Kotler, D. Haider, and I. Rein, "There's No Place Like Our Place: The Marketing of Cities, Regions, and Nations," *Futurist* 27.6 (1993): 14–21.

124. Reilly, "Merging or Diverging?," 84.

125. MacDonald and Alsford, "Museums and Theme Parks," 138.

126. Nash, "Interactive Media in Museums," 173. According to Nash, simulation is the preferred communication and learning mode within interactive and virtual media (173).

For more on the concept of "learning" in the museum, see part 4 of Macdonald, *A Companion*, entitled "Visitor, Leaning, Interating," especially the essay by John H. Falk, Lynne D. Dierking, and Marianna Adams, which explores *"personal meaning mapping,"* an idea measuring how a "specified learning experience uniquely affects each individual's understanding or meaning-making process." Falk, Dierking, and Adams, "Living in a Learning Society: Museums and Free-choice Learning," 333–34.

127. Friedman, quoted in Marcia Biederman, "Making a Science Center Grow, Without IMAX," *NYT*, July 11, 1999, C4.

128. Miriam R. Levin, "Museums as Media in the Emerging Global Context," *Curator* 49.1 (2006): 33.

129. Nicholas Foulkes, "Show of Strength," *Financial Times Magazine*, March 9, 2002.

130. Heath and vom Lehn, "Misconstruing Interactivity."

131. Ben D. Mahaffey, "Relative Effectiveness and Visitor Preference of Three Audio-Visual Media for Interpretation of an Historic Area." *Departmental Information Report* 1, Texas Agricultural Experiment Station (June 1969): 48.

132. Despite the fact that both the 1991 and 1993 International Conferences on Hypermedia and Interactivity served as showcases and test beds for new systems, interactivity as a whole was still in its infancy and, according to David Bearman, suffering from both cultural and technological lags, legal barriers, and the absence of museum information interchange standards. David Bearman, "Interactivity in American Museums," *MMC* 12.2 (June 1993): 190.

One of the earliest organizations to investigate new technology in the museum was the Museum Education Consortium, a collaborative effort among educational departments of seven museums including the Art Institute of Chicago, the Museum of Fine Arts, Boston, and other flagship institutions of large northeastern urban conurbations to investigate "the roles that technology might play in museum and art education in efforts to provide more effective access to the arts." Kathleen S. Wilson, "Multimedia Design Research for the Museum Education Consortium's Museum Visitor's Prototype," in David Bearman, ed., *Hypermedia and Interactivity in Museums: An International Conference* (Pittsburgh: Published as Proceedings of the Conference, Archives and Museum Informatics Report #14, Fall 1991), 27.

133. Sara Kerr, "Effective Interaction in a Natural Science Exhibit," *Curator* 29.4 (Dec. 1986): 276.

134. Phillips, "Science Centers," 263.

135. Betty Davidson, Candace Lee Heald, and George E. Hein, "Increased Exhibit Accessibility Through Multisensory Interaction," *Curator* 34.4 (1991): 289.

136. Beverly Serrell and Britt Raphling, "Computers on the Exhibit Floor," *Curator* 35.3 (Sept. 1992): 181. For a list of interactive media guidelines drawn up by the authors at a time when the idea was still pretty cutting edge, see 183–88. Such issues as the quantity, quality, and duration of information placed on computer interactives are included along with fairly obvious advice about staving off boredom. For more discussion of interactive design issues from the same period, see Jeffrey Jones, "Museum Computers: Design Innovations," *Curator* 35.3 (1992): 225–36, and John Stevenson, "The Long-Term Impact of Interactive Exhibits," *International Journal of Science Education* 13.5 (1991): 521–31.

137. Hughes, "Making Science 'Family Fun,'" 178; Witcomb, *Re-Imagining the Museum*, 130.

138. Judy Diamond, "Desert Explorations—A VideoDisc Exhibit Designed for Flexibility," *Curator* 32.3 (Sept. 1999): 161–73. Also see Diamond, "The Behavior of Family Groups in Science Museums," *Curator* 29.2 (1986): 139–54.

139. Daniel Spook, "Is it Interactive Yet?" *Curator* 47.4 (2004): 369.

140. Ibid., 373.

141. Ibid., 374.

142. D. D. Hilke, "The Impact of Interactive Computer Software on Visitors' Experiences: A Case Study," *ILVS Review* 1.1 (1988): 34, 44, and 47. It's worth mentioning that Hilke found proportionately more women using computers than men (41). The bottom line for Hilke was that the computer enhanced visitors' understandings of exhibit themes, encouraging them to read, discuss, and question topics not only while engaged with the interactive but in other areas of the exhibit (48). Research conducted three years later by different authors on age distribution of computer users found the following: 28% under 15; 25% between 15 and 25; 35% between 25 and 44; 9% between 45 and 65; and 3% over 65. Research conducted by David K. Allison and Tom Gwaltney, "How People Use Electronic Interactives: 'Information Age—People, Information, and Technology,'," in Bearman, ed., *Hypermedia and Interactivity in Museums*, 62–73.

143. Davies, "Overcoming Barriers to Visiting," 285.

144. Heath and vom Lehn, "Misconstruing Interactivity."

145. Marjorie Schwarzer, "Art Gadgetry: The Future of the Museum Visit," *MN* (July-Aug. 2001): 38. The following information on audioguide technology is taken from this very informative article (36–73). The Dayton Art Institute became the first museum to use MP3 audioguides in its permanent collection galleries (38).

146. Christine Rosen, "The Age of Egocasting," *The New Atlantis* 7 (Fall 2004–Winter 2005): 51–72.
147. Ibid.
148. "Tate Multimedia Tour of the Collection," unpublished, internal document, 2002.
149. Schwarzer, "Art Gadgetry," 38.
150. Steinbach, quoted in ibid., 38.
151. Nicky Levell and Anthony Shelton, "Text, Illustration and Reverie: Some Thoughts on Museums, Education and New Technologies," *Journal of Museum Ethnography* 10 (1998): 31–32 and 16.
152. Witcomb, *Re-Imagining the Museum*, 104.
153. Michael Kimmelman, "Trompe L'Oeil on Nature's Behalf," *NYT,* Jan. 7, 2000, E39. The AMNH recently published a book about its celebrated dioramas, *Windows on Nature: The Great Habitat Dioramas of the American Museum of Natural History* (New York: AMNH and Harry N. Abrams, 2006), by Stephen Quinn, Senior Project Manager in the Department of Exhibition.
154. MacDonald, "Digital Visionary," 41.
155. Alan Friedman, "Are Science Centers and Theme Parks Merging? *Informal Science* 25 (July 1997): 4; and Caulton, *Hands-on Exhibitions*, 136.
156. Caulton, *Hands-on Exhibitions*, 2. A study conducted by John Stevenson in 1991 found that six months after a visit to Launch Pad, an interactive exhibit at the Science Museum in London, people were able to talk about the exhibits in detail and recalled that their experience had been enjoyable. Stevenson, "The Long-term Impact of Interactive Exhibits," 521–31.
157. According to one study, the presence of a computer interactive in an exhibit enhanced the experience for visitors by encouraging them to spend more time in the gallery and to work cooperatively around the computer. Hilke, "The Impact of Interactive Computer Software," 34–49.
158. Ben Gammon, "Visitors' Use of Computer Interactives: Findings from Five Grueling Years of Watching Visitors Getting It Wrong," unpublished report, Science Museum Wellcome Wing Exhibition Development, May 1999, 2–3.
159. Karen McPherson, "International Spy Museum," *Pittsburgh Post-Gazette*, May 28, 2002, D1.
160. See www.spymuseum.org for more information about exhibits.
161. Paul Goldberger, "Requiem: Memorializing Terrorism's Victims in Oklahoma," *The New Yorker*, Jan. 14, 2002, 90.
162. Schwarzer, "Art Gadgetry," 36.
163. Karen Jones, "New 'Smart' Galleries," G27.
164. Anderson, quoted in ibid.
165. Adrian Searle, "The Never-Ending Story," *The Guardian,* Apr. 20, 2002, 12.
166. Hans-Peter Schwartz, "New Art Needs New Art Venues— Art, Technology, and the Museum: Ars sine scientia nihil est," in Sommerer and Mignonneau, eds., *Art @ Science,* 208.
167. Allison and Gwaltney, "How People Use Electronic Interactives," 65.
168. Cameron, " A Viewpoint," 37.

CONCLUSION

1. Krüger, "Planning and Layout of Museums," 355.
2. According to the Web site (www.bodiestheexhibition.com), the specimens are first preserved according to standard mortuary science before being immersed in acetone, which eliminates body fluid. They are then placed in a large bath of silicone or polymer before being prepared for exhibition.
3. Schwartz, *Spectacular Realities,* ch. 2.
4. Susan Sontag, *Regarding the Pain of Others* (New York: Picador, 2003), 41.
5. "Museums, Theme Parks, and Heritage Experiences" (editorial), *Museum Management and Curatorship* 10.4 (Dec. 1991): 354.

6. Mary Anne Doane, *The Emergence of Cinematic Time: Modernity, Contingency, the Archive* (Cambridge: Harvard UP, 2002), 25.
7. Scott Bukatman, "There's Always . . . Tomorrowland: Disney and the Hypercinematic Experience," in *Matters of Gravity*, 13–31.
8. Ellen Strain, "Moving Postcards: The Politics of Mobility and Stasis in Early Cinema," in *Public Places, Private Journeys:* *Ethnography, Entertainment, and the Tourist Gaze* (New Brunswick: Rutgers UP, 2003), 105-123.
9. Lev Manovich, *The Language of New Media* (Cambridge: MIT Press, 2001), 81–82.
10. Bruno, *Atlas of Emotion*, 47.

1895 *Arrival of a Train at La Ciotat* (Auguste and Louis Lumière)

1902 *A Trip to the Moon* (Georges Méliès)

1929 *Man with a Movie Camera* (Dziga Vertov)

1940 *Fantasia* (James Algar and Samuel Armstrong)

1952 *This Is Cinerama* (Merian C. Cooper and Gunther von Fritsch)

1953 *Rebel Without a Cause* (Nicholas Ray)

1955 *Cinerama Holiday* (Robert L. Bendick and Philippe De Lacy)

1960 *Scent of Mystery* (Jack Cardiff)

1968 *2001: A Space Odyssey* (Stanley Kubrick)

1970 *Tiger Child* (Donald Brittain)

1973 *Garden Isle* (Roger Tilton)

1976 *To Fly!* (Jim Freeman and Greg MacGillivray)

1977 *Close Encounters of the Third Kind* (Steven Spielberg)

1977 *Jaws* (Steven Spielberg)

1979 *Living Planet* (Dennis Earl Moore)

1982 *Flyers* (MacGillivray-Freeman)

1984 *Grand Canyon: The Hidden Secrets* (Keith Merrill)

1985 *Back to the Future* (Robert Zemeckis)

1986 *On the Wing* (Francis Thompson)

1988 *The American Experience* (Stephen Ives and Ben Loeterman)

1988 *The Last Temptation of Christ* (Martin Scorsese)

1990 *The Last Buffalo* (Stephen Low)

1991 *Beauty and the Beast* (Gary Trousdale and Kirk Wise)

1994 *Africa: The Serengeti* (George Casey)

1994 *Into the Deep* (Howard Hall)

1994 *The Lion King* (Roger Allers and Rob Kinkoff)

1994 *Rose Red* (Simon Pummell)

1995 *Across the Sea of Time* (Stephen Low)

1995 *Apollo 13* (Ron Howard)

1995 *Wings of Courage* (Jean-Jacques Annand)

1995 *The Living Sea* (Greg MacGillivray)

1996 *Cosmic Voyage* (Bayley Silleck)

1998 *Everest* (David Breashears and Stephen Judson)

1999 *Extreme* (Jon Long)

1999 *Galapagos: The Enchanted Voyage* (David Clark and Al Giddings)

1999 *Struggle for Justice* (Northern Light Productions)

2000 *Cirque du Soleil: Journey of Man* (Keith Melton)

2000 *Dolphins* (Greg MacGillivray)

2000 *Fantasia 2000* (James Algar and Gaëtan Brizzi)

2001 *Haunted Castle* (Ben Stassen)

2002 *Jane Goodall's Wild Chimpanzees* (David Lickley)

2002 *Kilimanjaro: To the Roof of Africa* (David Breashers)

2002 *Minority Report* (Steven Spielberg)

2002 *Space Station 3D* (Toni Myers)

2002 *Treasure Planet* (Ron Clements and John Musker)

2003 *Ghosts of the Abyss* (James Cameron)

2003 *The Matrix: Reloaded* (Andy Wachowski and Larry Wachowski)

2003 *The Matrix Revolutions* (Andy Wachowski and Larry Wachowski)

2003 *Volcanoes of the Deep Sea* (Stephen Low)

2004 *Fighter Pilot: Operation Red Flag* (Stephen Low)

2004 *NASCAR: The IMAX Experience* (Simon Wincer)

2004 The Passion of the Christ (Mel Gibson)

2004 *The Polar Express: An IMAX 3-D Experience* (Robert Zemeckis)

2004 *Vikings: Journey to New Worlds* (Marc Fafard)

2005 *Magnificent Desolation: Walking on the Moon 3D* (Mark Cowen)

2007 *Spider-Man 3* (Sam Raimi)

AMNH American Museum of Natural History
MJ *Museums Journal*
MMC *Museum Management and Curatorship*
MN *Museum News*
NAA-
NMNH National Anthropological Archives, National Museum of
 Natural History, Washington, D.C.
SIA Smithsonian Institution Archive, Washington, D.C.
SML Science Museum Library (London)

PRIMARY SOURCES

"The Activities of Museums in America." *MJ* 21.1 (July 1921): 9.

Andes, Herbert C. "The Leicester Square and Strand Panoramas." *Notes and Queries* 159.4–5 (July 26, 1930): 59.

Archer, Thomas C. "Report on the Polytechnic Exhibition of Moscow and the Scandinavian Industrial Exhibition at Copenhagen." *Science and Art Department 20th Report* (1872).

Arthur, Billy. "Please Fasten Your Seat Belt, Next Stop the Moon." *Tarheel Wheels* 15.2 (Feb. 1958): 1, 3, and 5.

"Astronomer Shows Star of Bethlehem." *Saginaw Michigan News*, Dec. 3, 1935.

Baker, Frank Collins. "The Descriptive Arrangement." *MJ* 7.4 (Oct. 1902): 106–110.

Banvard, John. *Descriptions of Banvard's Geographical Painting of the Mississippi River, extensively known as the* Three Mile Picture, *with new additions of the naval and military operations on that river, exhibiting a view of the country 1,500 miles in length, from the mouth of the Missouri to the Balize.* New York: L. H. Bigelow, 1862.

Bather, Francis Arthur. "Museum's Association Aberdeen Conference, 1903." *MJ* 3.3 (Sept. 1903): 80.

———. "The Museums of New York State." *MJ* 1.3 (Sept. 1901): 72–76.

Baxter, Douglas L. "The Film Library of the Museum of Modern Art." *Bulletin of the Association of American Colleges* (Dec. 1939): 581–82.

Bennett, Catherine. "Beware of Cheap Imitation: On the Creeping Menace of TV Reconstructions." *The Guardian*, Feb. 3, 2000, n.p.

Bennette, Dorothy A. "A Planetarium for New York." *Scientific Monthly* 41 (1935): 475–77.

Bernays, Edward. *Propaganda.* New York: Liveright, 1928.

Bertin, R. L. "Construction Features of the Zeiss Dywidag Dome for the Hayden Planetarium Building." *Journal of the American Concrete Institute* 31 (May-June 1934): 449–60.

Board of Education Report on the Museums, Colleges, and Industry Under the Administration of the Board of Education (1915).

The Book of the Hayden Planetarium, the American Museum of Natural History. New York: AMNH, 1935.

Brewster, Sir David. "Parliamentary Hearings" (1864).

"Brighter Museums." *MJ* 27.9 (Mar. 1928): 292.

Bumpus, H. C. "A Contribution to the Discussion on Museum Cases." *MJ* 6.9 (Mar. 1907): 297–301.

Burford, Robert. *Description of a View of the Bay of Islands, New Zealand, and the Surrounding Country; Now Exhibiting at the Panorama, Broadway.* New York: W. Oxborn, 1840.

Burke, Edmund. "A Philosophical Inquiry into the Origin of Our Ideas of the Sublime and the Beautiful; with an Introductory Discourse Concerning Taste" In *Works* 1:55–219. London: Oxford UP, 1925.

"City Discovers Planetarium Is Quietest Spot." *New York Herald Tribune*, Sept. 29, 1935, n.p.

Cole, William. *A Short Statement of the Constitution, Methods, and Aims of the Essex Museum of Natural History* (1881).

Coles, Robert R. Untitled Document. American Museum of Natural History General Information File, 1935–1986, Special Collections. Hereafter abbreviated to SC-AMNH.

Crow, Reginald V. "Correspondence. The Film in the Museum: An Inquiry." *MJ* 34.8 (Nov. 1934): 336.

Crowther, Henry. "The Museum as Teacher of Nature-Study." *MJ* 5.1 (July 1905): 5–14.

Culler, Jonathan. "Semiotics of Tourism." *American Journal of Semiotics* 1 (1981): 127–40.

"The Cyclorama." *Scientific American* 55 (1886): 296.

Dahl, Curtis. "Atriums Ward: Comic Panoramist." *New England Quarterly* 32.4 (Dec. 1959): 476–85.

Danne, Richard. "Can Man Survive." *A-V Communication* (June 1969): 14.

Davis, Theodore R. "How a Great Battle Panorama Is Made." *St. Nicholas* (Dec. 1886): 99–112.

"Department of Astronomy and the American Museum Hayden Planetarium." *Report of the Scientific and Education Departments*, AMNH, July 1977–June 1978.

Devlin, John C. "Museum Show Here About Survival Is Good—Or Bad?" *NYT*, May 16, 1969.

Doyle, Winifred G. "Can the Health Museum Flourish in America?" *Curator* 2.1 (Spring 1959).74–83.

"The Dramagraph." *MJ* 31.1 (Apr. 1931): 24.

De Dondi, Giovanni. *The Planetarium of Giovanni de Dondo Citizen of Padua.* A manuscript of 1397 translated from the Latin by G. H. Bataille, with additional material from another Dondi manuscript translated from the Latin by H. Alan Lloyd. Translations edited by F. A. B. Ward.

Description of Banvard's Panorama of the Mississippi River painted on Three Miles of Canvas Exhibiting a View 1,200 Miles in Length extending from the Missouri River to the City of New Orleans. Boston: John Putnam, 1847.

"The Deutches Museum, Munich." *Nature* 3156.125 (Apr. 26, 1930): 638–41.

Dickens, Charles. "Some Account of an Extraordinary Traveller." *Household Worlds* 1 (1850): 77.

Dierbeck, Robert E. "Television and the Museum." *Curator* 1.2 (Spring 1959): 34–44.

"Discussion." *MJ* 5.4 (Oct. 1905): 118.

"Discussion on the Papers on Museum Cases Read at the Bristol Conference, 1906." *MJ* 6.12 (June 1907): 405.

"Display Methods at the Museum of Modern Art, New York: Lay-Out and Lighting of an Exhibition of American Indian Art." *MJ* 41 (Oct. 1941): 154–56.

"The Dissemination of Information by Exhibition and Display." *MJ* 30.6 (Dec. 1930): 217–21.

Dransfield, J. Edgar. "Is There a Technique for the Use of Motion Pictures in Schools?" *Educational Screen* 6 (Mar. 1927): 121–22, 150.

"Electrical Questionnaire for Young Visitors." *MJ* 33.6 (Sept. 1933): 236.

The Examiner (Dec. 1828), cited in Mimi Colligan, Canvas Documentaries: Panoramic Entertainments in Nineteenth-Century Australia and New Zealand. Victoria: Melbourne UP, 2002.

"Exhibition of Mechanical Aids to Learning." *MJ* 30.5 (Nov. 1930): 206.

"Exhibition of Visual and Aural Aids to Education." *MJ* 30.2 (Aug. 1930): 65.

"The Exhibits Program at the NMNH: A Restatement of the Long-Range Plan Prepared on the Occasion of the Fall 1978 Meeting of the Smithsonian Council," Oct. 1978, 7 (RU 564, SIA).

Faunce, Wayne M. "Problems of Construction." In *The Book of the Hayden Planetarium*.

Field, Mary. "The Film in the Museum." *MJ* 33.10 (Jan. 1934): 348–50.

Fieseler, Franz. "A Layman's Views on Lectures in the Zeiss Planetarium" (n.d.). In file #12, Guest Relations Bureau Press and Periodical Promotions, 1946–48, in box 1 (Guest and Relations Bureau 1946–48), SC-AMNH.

Finson, Mark. "A Horrible Way to Spend an Afternoon." *Newark Star-Ledger*, May 16, 1969.

Fisher, Clyde. "The Hayden Planetarium." *Natural History* 34.3 (1935): 187–258.

Ford, Rev. S. J. "A Rotary Cabinet for Museum Specimens." *MJ* 6.9 (Mar. 1907): 304–305.

Foster, H. "Imperial War Museum." *MJ* 36.5 (Aug. 1936): 215–222.

Fowke, Capt. R. E. "Report on the New Building." *Appendix K to the 10th Report of the Science and Art Department* (1862).

Fox, Philip. *Adler Planetarium and Astronomical Museum: An Account of the Optical Planetarium and a Brief Guide to the Museum.* Chicago: Lakeside Press, June 1933.

"Frankenstein Panorama of Niagara." *The Observer*, Aug. 18, 1853, n.p.

Fritsch, Prof. Dr. Ant. "The Museum Question in Europe and America." *MJ* 3.8 (Feb. 1904): 247–56.

Furse, Sir William T. "The Panoramas and the Cinema at the Imperial Institute." *MJ* 29.10 (Apr. 1930): 339.

Gratacap, L. A. "The Making of a Museum." *Architectural Record* 9 (Apr. 1900): 376–402.

Gregg, Clifford C. "Television an Ideal Educational Medium for Future." *Field Museum News* (May 1940): 3.

"Guides at the Museums: Lord Sudeley's Suggestions." *The Times* (London), Nov. 5, 1912, in file ED 79/7, Z-Archive, SML.

Guide for *View of Gibraltar*, 1805, British Library, London.

Hall, Kate M. "The Smallest Museum." *MJ* 1.2 (Aug. 1901): 38–45.

"Hayden Planetarium." *Hart's Guide to New York City*. New York: Hart, 1964.

"Heavenly Adventures." *Vogue*, Dec. 15, 1935, n.p.

"Heavens!" (By George! And lev and bob and oskars). *Franklin Institute News* (Spring-Summer 1971): 5.

Hecht, Dr. E. "How to Make Small Natural History Museums Interesting." *MJ* 3.6 (Dec. 1903): 188–91.

Heilbron, Bertha L. "Making a Motion Picture in 1848: Henry Lewis on the Upper Mississippi." *Minnesota History* 17.2 (June 1936): 132 and 133.

"A Historical Survey." *The McLaughlin Planetarium*. Royal Ontario Museum, Ontario, Toronto. Planetarium ephemera files, SC-AMNH.

Hogner, Nils and Guy Scott. "Hayden Planetarium." In *Cartoon Guide of New York City*. New York: J. J. Augustin, 1938.

Hotchkiss, Grace. "The Use of the Motion Pictures as a Technique of Instruction." *Social Studies* 28.1 (Jan. 1937): 6–13

Hoyle, Dr. "Egyptological Collections." *MJ* 8.5 (Nov. 1908): 152–62.

"Human Interest to Shape Exhibits of Future." *MN* 1.1 (Jan. 1, 1924): 2.

"Illustrates Talk by Radio," *MN* 2.4 (June 15, 1924): 2.

"In the Magazines: Movies in Museum." *MN* 8.1 (May 1930): 7.

Kaempffert, Walter. "Now America Will Have a Planetarium." *New York Times Magazine*, June 23, 1928, n.p.

Kaminski, Heinz, ed. *Proceedings from the Second International Planetarium Directors Conference.* Bochum, Germany, 1966.

Kelly, Thomas. "The Origins of Mechanics Institutes." *British Journal of Educational Studies* 1.1 (1952): 17–27.

Kendon, Frank. *Mural Paintings in English Churches During the Middle Ages: An Introductory Essay on the Folk Influence in Religious Art.* London: John Lane The Bodley Head, 1923.

Kenyon, F. G. "Children and Museums," *MJ* 19.1 (July 1919): 8–10.

King, Henry Charles. *The London Planetarium.* London: London Planetarium, 1958.

Kissiloff, William. "How to Use Mixed Media in Exhibits." *Curator* 12.2 (1969): 83–95.

Lankester, Dr. Edwin. *Appendix O to the 8th Report of Science and Art Department* (1860).

———. "Report of the Superintendent of the Food and Animal Collections." *Appendix T to the 7th Report of Science and Art Department* (1859), 146.

"Lectures and the Public." *MJ* 25.8 (Feb. 1926): 215–16.

Levitt, Dr. I. M. "The Planetarium." *The Planetarium: A Special Edition Commemorating the Dedication of the New Fels Planetarium of the Franklin Institute* (Sept. 18. 1962).

Lindgren, Ernest H. "The National Film Library." *MJ* 37.12 (Mar. 1938): 545–49.

Lions, Lisa. "Panorama of the Monumental Grandeur of the Mississippi Valley." *Design Quarterly* (July 1977): 32.

Longfellow, Henry. *Life of Henry Wadsworth Longfellow with Extracts from His Journals and Correspondence.* Boston: Ticknor, 1886.

Lowe, E. E. "The Cinema in Museums." *MJ* 29.10 (Apr. 1930): 342–43.

"The Magic Lantern as a Means of Demonstration." *Journal of the Franklin Institute of the State of Pennsylvania* 55.4 (1868): 278.

"The Man as Museum-Curator." *MJ* 1.7 (Jan. 1902): 185–92.

"The Mannheim Conference on Museums as Places of Popular Culture." *MJ* 3.4 (Oct. 1903): 105–109.

"The Mareorama at the Paris Exposition." *Scientific American* 83 (1900): 198–200.

Martin, F. David. *Art and the Religious Experience: The "Language" of the Sacred.* Lewisburg, Penn.: Bucknell UP, 1958.

Martin, John. "The Exhibition of Congestion Interpreted." *Charities* 20 (Apr. 4, 1908): 27–60.

McCutcheon, Mary. *The Lost Panoramas of the Mississippi.* Chicago: U of Chicago P, 1958.

McDermott, John Francis. "Gold Rush Movies." *California Historical Society Quarterly* 33.1 (March 1954): 29–38.

McLean, James W. "Battle in a Time Machine." *Curator* 10.4 (1968): 297–304.

Melton, Arthur W. "Visitor Behavior in Museums: Some Early Research in Environmental Design." *Human Factors* 45.5 (1972): 393–403. Reprinted from the AAM, *Problems of Installation in Museums of Art, n.s.* 14 (1935).

Mero, B. "An Exposition That Mirrors a City." *American City* 1 (Nov. 1909): 100.

Meyer, A. B. "The Structure, Position, and Illumination of Museum Cases." *MJ* 6.7 (Jan. 1907): 231–43.

"Modebelustigungen in London. Neues Panorama. Grausende Darstellung der Schlacht bei Abukir." *Journal London und Paris* 3 (1799): 309–311.

"Model VI." *The New Yorker,* Sept. 20, 1969.

Mooney, James. "The Indian Messiah and the Ghost Dance" (lecture), Apr. 18, 1893. Information from Anthropological Society of Washington, D.C., No. 4821, box 15, ser. 6, Records of Secretary, National Anthropological Archives, NMNH, SIA.

"Moving (Dioramic) Experiences." *All the Year Round* 17 (Mar. 22, 1867): 304.

"Mr. Banvard's Moving Panorama," *Times* (London). In "John Banvard and Family Papers." Minnesota Historical Society, microfilm M360.

Mucke, Ruth and Herman Mucke, eds. *Proceedings of the Third International Planetarium Directors Conference.* Vienna, 1969.

"Museum and Newspapers Co-operate in Roto-Radio Talk." *MN* 6.21 (Apr. 15, 1929): 1.

"Museums and Cinematographers." *MJ* 32.2 (May 1932): 76.

"Museums and Movies" (editorial). *MJ* 21.9 (Mar. 1922): 200.

"Museums and Radio." *MN* 4.10 (Nov. 1, 1926): 2.

"Natural History Museum: A Unique Perspective on our Natural World" (n.d.). NMNH, RU 564, box 4, SIA.

Nesjar, Carl. "The Artist and the Museum." *Curator* 3.2 (1960): 107–117.

Newman, Estelle V. "The Story of Banvard's Folly." *Long Island Forum* 15.5 (May 1952): 83–44, 95–97.

"Night Owl Reporter." *Daily News,* Mar. 19, 1971.

Odell, George Clinton Densmore. *Annals of the New York Stage.* New York: Columbia UP, 1927–49.

"On Cosmoramas, Dioramas, and Panoramas." *Penny Magazine* 11 (1842): 364.

O'Neill, John J. "Progress of Science: Magnifying Time." *New York Herald Tribune,* Sept. 15, 1935, n.p.

Panofsky, Erwin. "Style and Medium in the Motion Pictures." *Bulletin of the Department of Art and Archaeology* (Princeton University, 1934). Reprinted in Braudy and Cohen, eds., *Film Theory and Criticism*, 289–302.

"The Panorama, with Memoirs of Its Inventor Robert Barker, and his Son, the Late Henry Aston Barker." *Art-Journal* 9 (1847): 46–47.

Parr, A. E. "Marketing the Message." *Curator* 12.2 (1969): 77–82.

———. "Mass Medium of Individualization." *Curator* 4.1 (1961): 39–48.

Parry, Lee. "Landscape Theater in America." *Art in America* 59 (Dec. 1971): 52–61.

"Popularizing Science." *The Standard*, Jan. 2, 1877.

"The Public Utility of Museums" (editorial). *The Times* (London), Oct. 21, 1911.

Pyne, William Henry. "The Panorama." *Soberest House Gazette Literary Museum* 2 (London, 1823–24): 152.

"The Question of Groups." *MJ* 8.12 (June 1909): 446–47.

"Radio Photologues." *MN* 3.10 (Nov. 1, 1925): 2.

Rathburn, Richard. *Report on the Progress and Condition of the U.S. National Museum for the Year Ending 1914.* Washington, D.C., 1915.

Redgrave, Richard. "Documents Relating to the Administration of the South Kensington Museum." *Appendix N to the 7th Report of Science and Art Department* (1859).

"A Reminiscence of the Days when Panoramas were Highly Popular" (c. 1874). In Panoramas: Portfolio of clippings and pamphlets. New York Public Library Billy Rose Theater Collection.

Rendall, R. A. [No title.] *MJ* 32.11 (Feb. 1933): 419.

Review of J. C. W. Reith, *Broadcast Over Britain* (London: Hodder and Stoughton, 1925). In *MJ* 24.9 (Mar. 1925): 212.

Review of "Museum Stories for Children." *MJ* 24.6 (Dec. 1924): 145.

Riesman, David. "The Zeiss Planetarium." *General Magazine and Historical Chronicle* 31 (Burlington, N.J.) (1928): 236–41.

Robbins, Michael. "An Exhibit Asks the Question of the Century." *MN* (Sept. 1969): 13.

Robertson, Joseph C. "National Repository." *Mechanics Magazine* 11 (1829): 58–59.

Robinson, E. S. *The Behavior of the Museum Visitor.* Publications of the American Association of Museums New Series, No. 5. Washington, D.C.: American Association of Museums, 1928.

Rodriguez, Meriemil. "Planetarium Tells the Story of la Navidad." *Daily News*, Dec. 17, 1970.

Rushkoff, Douglas. *Media Virus.* New York, Ballantine, 1994.

Salisbury, Gasgoine and C. B. Adderley. "Attendance at the South Kensington Museum." *Fifth Report of the Science and Art Department* (1867–8–9): 88.

Sandham, H. "Report on the Collection of Machinery." *Science and Art Department 17th Report* (1870).

Science and Art Department 18th Annual Report (1871).

"Science Museum: Radiogramaphone." *MJ* 35.9 (Dec. 1935): 358–59.

"Science and Science Museums." *The Examiner*, Jan. 13, 1877.

Second Report of the Commissioners of the 1851 Exhibition (London, 1852).

Sheed, Wilfrid. "Evolution on a Bad Trip." *Life Review*, July 11, 1969.

Siepmann, C. A. "The Relation of Broadcast Education to the Work of Museums." *MJ* 29.5 (Oct. 1929): 116–23.

Smith, Robert M. "Museum Uses Psychedelic Lights and Electronic Museum to Show That Life Can Be Ugly." *NYT*, May 19, 1969.

Smillie, Thomas W. "The Section of Photography of the United States National Museum." *American Photography* (Sept. 1911): 514–16.

Spencer, Steven M. "The Stars Are His Playthings." *Saturday Evening Post* (1954).

Spitz, Armand N. *The Pinpoint Planetarium* (1928). Rpt., New York: Holt, 1940.

———. "Planetarium: An Analysis of Opportunities and Obligations." *The Griffith Observer* (June 1959).

Squires, Monas N. "Henry Lewis and His Mammoth Panorama of the Mississippi River." *Missouri Historical Review* 27 (Apr. 1933): 246.

Sweeney, James Johnson. "Some Ideas on Exhibition Installation." *Curator* 2.2 (Spring 1959): 151–56.

Telbin, W. "The Painting of Panoramas." *Magazine of Art* 24 (1900): 555–58.

Thiis, Dr. "Museum's Association Aberdeen Conference, 1903. "*MJ* 3.4 (Oct. 1903): 110–31.

"To the Right Hon. Edward Cardwell, MP, President of the Board of Trade." *First Report of the Department of Science and Art* (1853).

Twain, Mark. *Life on the Mississippi*. New York: Grosset and Dunlap, 1917. Originally published in Boston by James R. Osgood (1883).

"Unbreakable Movie Film: Steel-Sheathed Film Reduces Replacement Costs; Has Great Educational Value." *Scientific American* (Apr. 1930): 299.

Villiger, Dr. W. *The Zeiss Planetarium*. London: W & G. Foyle, 1926.

"War in Egypt." National Panorama Guidebook (1883). London Playbill Scrapbook, GLCL, 142.

"Weapons in the War Against Tuberculosis: The Exhibition in the New York Museum of Natural History." *Harper's Weekly* (Nov.-Dec. 1908): 7.

Weissman, Dan. [Review of "Can Man Survive?" at AMNH.] *Herald-News* (Passaic, N.J.), May 24, 1969.

"What Next Will We Do?" *Museum Service* (Oct. 1941): 3.

Witteborg, Lothar P. "Design Standards in Museum Exhibits." *Curator* 1.1 (Jan. 9, 1958): 29–41.

"Zweytes Panorama. Seeansicht von Margate. Blick auf die Stadt." *Journal London und Paris* 4 (1799): 3–5.

SECONDARY SOURCES

Acland, Charles R. "IMAX in Canadian Cinema: Geographic Transformation and Discourses of Nationhood." *Studies in Cultures, Organizations, and Societies* 3 (1997): 289–305.

———. "IMAX Technology and the Tourist Gaze." *Cultural Studies* 12.3 (1998): 429–45.

Adams, Marianna, Jessica Luke, and Theano Moussouri. "Interactivity: Moving Beyond Terminology." *Curator* 47.2 (2004).

Adler, Jerry. "Take It from the Top." *Newsweek*, Mar. 9, 1998.

Adler, Judith. "Origins of Sightseeing." In Carol T. Williams, ed., *Travel Culture*, 3–24.

Alexander, Edward Porter. "Bringing History to Life: Philadelphia and Williamsburg." *Curator* 4.1 (1961): 58–68.

———. *The Museum in America: Innovators and Pioneers*. New York: Sage, 1997.

Allison, David K. and Tom Gwaltney. "How People Use Electronic Interactives: 'Information Age—People, Information, and Technology.'" In Bearman, ed., *Hypermedia and Interactivity in Museums*, 62–73.

Alsford, Steven. "Museums as Hypermedia: Interactivity on a Museum-Wide Scale." In Bearman, ed., *Hypermedia and Interactivity in Museums*, 7–16.

Alsford, Steven and Frederick Granger. "Image Automation in Museums: The Canadian Museum of Civilization's Optical Disc Project." *IJMMC* 6.6 (Sept, 1987): 187–200.

Alt, M. B. "Improving Audio-Visual Presentations." *Curator* 22.2 (1979): 85–95.

Altick, Richard. "The Panorama in Leicester Square." In *The Shows of London*, 128–40.

———. *The Shows of London*. Harvard: Belknap Press of Harvard UP, 1978.

American Association of Museums Standing Professional Committee on Education, *Journal of Museum Education* 14.3 (Fall 1989): 11–13. Reprinted as "Professional Standards for Museum Educators" (preface by Patterson B. Williams) in *Patterns in Practice: Selections from the Journal of Museum Education*(1992), 60–65.

American Association of Museums Task Force on Museum Education. "Excellence and Equity: Education and the Public Dimension of Museums." *Journal of Museum Education* 16.3 (Fall 1991): 3–17. Reprinted in *Patterns in Practice* (1992), 79–94.

Amiel, Barbara. "Mel Gibson's 'Passion of Christ' Is an Act of Faith, Not Hatred." *Daily Telegraph* (London), Feb. 23, 2004, 18.

Annis, Sheldon. "The Museum as Staging Ground for Symbolic Action." *Museum* 38.3 (1986): 168–70.

Appelbaum, Ralph. "Designing an 'Architecture of Information'—The United States Holocaust Museum." *Curator* 38.2 (June 1995): 95–110.

Appleton, Josie. "New Technology Is Dumbing Down Our Museums." *The Independent*, Apr. 24, 2001.

Arnheim, Rudolf. *The Power of the Center: A Study of Composition in the Visual Arts*. Berkeley: U of California P, 1988.

Arnoldi, Mary Jo, Christine Mullen Kreamer, and Michael Atwood Mason. "Reflections on 'African Voices' at the Smithsonian National Museum of Natural History." *African Arts* 34.2 (Summer 2001): 16–35, 94.

Arrington, Joseph Earl. "John Banvard's Moving Panorama of the Mississippi, Missouri, and Ohio Rivers." *Filson Club Historical Quarterly* 32.3 (July 1958): 207–40.

———. "Samuel A Hudson's Panorama of the Ohio and Mississippi Rivers." *Ohio Historical Quarterly* 66.4 (Oct. 1957): 355–74.

———. "The Story of Stockwell's Panorama." *Minnesota History* 33.7 (Autumn 1953): 284–90.

———. "William Burr's Moving Panorama of the Great Lakes, the Niagara, St. Lawrence, and Saugeunay Rivers." *Ontario History* 51.3 (Summer 1959): 141–62.

Arthur, Paul. "In the Realm of the Senses: Imax 3-D and the Myth of Total Cinema." *Film Comment* 32.1 (Jan.-Feb. 1996): 79–81.

Avery, Kevin J. "Movies for Manifest Destiny: The Moving Panorama Phenomenon in America." In *The Grand Moving Panorama of Pilgrim's Progress*, exhibit catalog organized by the Montclair (California) Art Museum, 1999: 1.

Bakhtin, Mikhail. *Rabelais and His World*. Trans. Hélène Iswolsky. Cambridge: MIT Press, 1968.

Bal, Mieke. *Reading Rembrandt: Beyond the Word-Image Opposition*. New York: Cambridge UP, 1991.

Baudelaire, Charles. "The Salon of 1845." In *Selected Writings on Art and Literature*, 87–88. Trans. and ed. P. E. Charvet. New York: Penguin, 1992.

Baugh, Lloyd. *Imagining the Divine: Jesus and Christ-Like Figures in Film*. Lanham, Md.: Sheed and Ward, 1997.

Bazin, André. "The Myth of Total Cinema." In *What Is Cinema?* Ed. Hugh Gray. Berkeley: U of California P, 1967.

Beal, Timothy K. and Tod Linafelt, eds. *Mel Gibson's Bible*. Chicago: U of Chicago P, 2006.

Bearman, David, ed. *Hypermedia and Interactivity in Museums: An International Conference* (Pittsburgh: Published as Proceedings of the Conference, Archives and Museum Informatics Report #14, Fall 1991).

———. "Interactivity in American Museums." *MMC* 12.2 (June 1993): 183–93.

Beckett, R. B. *John Constable's Correspondence*. Vol. 2: *Early Friends and Maria Bicknell (Mrs. Constable)*. Suffolk Records Society 6 (1964): 34.

Becklake, Sue. *The Official Planetarium Book*. Rocklin, Calif.: Prima, 1994.

Bell, F. Jeffrey. "On 'Good Form' in Natural History Museums." *MJ* 3.5 (Nov. 1903): 159–68.

Belton, John. *Widescreen Cinema*. Cambridge: Harvard UP, 1992.

Beneker, Katherine. "Exhibits—Firing Platforms for the Imagination." *Curator* 1.4 (Autumn 1958): 76–81.

Benjamin, Walter. *Reflections: Essays, Aphorisms, Autobiographical Writings*. Trans. Edmund Jephcott. New York: Schocken, 1978.

Bennett, Catherine. "Beware of Cheap Imitation: On the Creeping Menace of TV Reconstructions." *The Guardian* (Feb. 3, 2000).

Bennett, Tony. *The Birth of the Museum: History, Theory, Politics*. New York: Routledge, 1995.

———. "Civic Seeing: Museums and the Organization of Vision." In Sharon Macdonald, ed., *A Companion to Museum Studies*, 263–81. Oxford: Blackwell, 2006.

Bevington, David. *Medieval Drama*. Boston: Houghton Mifflin, 1975.

Binding, Günther. *High Gothic: The Age of the Great Cathedrals*. Köln: Taschen, 1999.

Bloom, Peter. "Pottery, Chronophotography, and the French Colonial Archive." Unpublished paper presented at the Screen Studies Conference, Glasgow, Scotland, June 1993.

Blüm, Andreas and Louise Lippincott. *Light! The Industrial Age, 1750–1900: Art and Society, Technology and Society.* London: Thames and Hudson, 2001.

Boddy, William. *New Media and Popular Imagination: Launching Radio, Television, and New Media in the United States.* Oxford: Oxford UP, 2004.

Bolter, Jay David and Richard Grusin, eds. *Remediation: Understanding New Media.* Cambridge: MIT Press, 1999.

Borcoman, J. W. "Public Education in the Visual Arts." *Curator* 12.1 (1969): 39–44.

Born, Wolfgang. *American Landscape Painting.* Westport, Conn.: Greenwood Press, 1948.

Borun, Minda, Margaret Chambers, and Ann Cleghorn. "Families Are Learning in Science Museums." *Curator* 39.2 (June 1996): 123–38.

Boyne, Walter J. "Trip Report" (undated memo), RU #346, box 14, Deputy Director, NASM, c. 1961–1982, *To Fly* Film Concept File, SIA.

Braudy, Leo and Marshall Cohen, eds. *Film Theory and Criticism: Introductory Readings.* New York: Oxford UP, 2004.

Bruno, Guiliana. *Atlas of Emotion: Journeys in Art, Architecture, and Film.* New York: Verso, 2002.

Brunstad, P. O. "Jesus in Hollywood: The Cinematic Jesus in a Christological and Contemporary Perspective." *Studies Theologica* 55 (2001): 145–56.

Bukatman, Scott. *Matters of Gravity: Special Effects and Superman in the 20th Century.* Durham: Duke UP, 2003.

Burns, William A. "Museum Exhibition: Do-It-Yourself or Commercial?" *Curator* 12.3 (1969): 160–67.

Burr, Ty. " 'The Passion of the Christ.' " *Boston Globe*, Feb. 24, 2004, D1.

Cahn, Iris. "The Changing Landscape of Modernity: Early Film and America's 'Great Picture' Tradition." *Wide Angle* 18.3 (July 1996): 85–100.

Cameron, Andrew. "Dissimulation: The Illusion of Interactivity." *Millennium Film Journal* (1995) 33–47.

Cameron, Duncan F. "A Viewpoint: The Museum as a Communications System and Implications for Museum Education." *Curator* 11.1 (1968): 37–39.

Camille, Michael. "Before the Gaze: The Internal Senses and Late Medieval Practices of Seeing." In Nelson, ed., *Visuality,* 197–223.

———. *Gothic Art: Visions and Revelations of the Medieval World.* London: Everyman Art Library, 1996.

Canby, Vincent. "Big Screen Takes on New Meaning." *NYT,* Apr. 19, 1987, B18.

Carr, David. "Alliance Against Compromise." *MN* (Mar.-Apr. 2000): 29–31, 62.

Carruthers, Mary. *The Craft of Thought: Meditation, Rhetoric, and the Making of Images, 400–1200.* Cambridge: Cambridge UP, 1998.

Cassutt, Michael. "Laserium: A Behind-the-Scenes Tour of Tomorrow's Multimedia Entertainment." *Future Life* (Nov. 1979): 52–55.

Caulton, Tim. "The Future of Hands-On Exhibitions." In *Hands-on Exhibitions,* 135–39.

———. *Hands-on Exhibitions: Managing Interactive Museums and Science Centers.* London: Routledge, 1998.

Ceram, C. W. *Archaeology of the Cinema.* London: Hudson and Thames, 1965.

Chamberlain, Joseph Miles. "The Development of the Planetarium in the United States." *Smithsonian Report for 1957.* Washington, D.C.: Smithsonian Institution, 1958.

Chang, Leslie. "IMAX Aims to Turn China into its Number 2 Market." *Toronto Star,* Feb. 11, 2003, D03.

Charney, Leo and Vanessa Schwartz, eds. *Cinema and the Invention of Modern Life.* Berkeley: U of California P, 1995.

Chew, Ron. "Toward a More Agile Model of Exhibition Making." *MN* (Nov.-Dec. 2000): 47–48.

Chilton, Bruce. "Mel Gibson's Lethal *Passion.*" In Beal and Linafelt, eds., *Mel Gibson's Bible,* 51–58.

Clifford, James. *Routes: Travel and Translation in the Late Twentieth Century*. Cambridge: Harvard UP, 1997.

Colligan, Mimi. *Canvas Documentaries: Panoramic Entertainments in Nineteenth-Century Australia and New Zealand*. Victoria: Melbourne UP, 2002.

Collins, Glenn. "Outer Space vs. Parking Space: Planetarium and Wary Neighbors Prepare for Opening," *NYT*, Jan. 25, 2000, B1.

Collins, Jeremy. "Educational, Ornamental, and Toy Globes." From *The World in Your Hands: An Exhibition of Globes and Planetaria from the Collection of Rudolf Schmidt*.

"Come Now the Hero. Or Does He?" *Product Engineer*, June 2, 1979.

"Coming Soon to an IMAX Theatre: Stronger Profit." *Toronto Star*, Feb. 28, 2003, EO6.

Conrad, Peter. "The Art of Pain." *The Observer* (London), Apr. 4, 2004, 6.

Cook, Olive. *Movement in Two Dimensions*. London: Hutchinson, 1963.

Cook, Pam. "The Last Temptation of Christ." *Film Comment* 24.5 (Sept.-Oct. 1988). Reprinted in Pam Cook, *Screening the Past: Memory and Nostalgia in Film* (London: Routledge, 2005).

Cooney, Terry A. *American Thought and Culture in the 1930s*. New York: Twayne, 1995.

Corsello, Bill. "Super Sonic." *Where New York* (Dec. 2003).

Cosandey, Roland and François Albera, eds. *Images Across Border: 1896–1918*. Zurich and Lausanne: Nuit Blanche / Editions Payot, 1996.

Cosandey, Roland, André Gaudreault, and Tom Gunning, eds. *An Invention of the Devil*. Sainte-foy and Lausanne: les Presses de l'université–Laval / Éditions Payot, 1993.

Cox, Donna J. "What Can an Artist Do for Science: 'Cosmic Voyage' IMAX Film." In Sommerer and Mignonneau, eds., *Art @ Science*, 53–59.

Curzon, Rebecca. "Children of the Castle." "Children in Museums" symposium, Office of Museum Programs, SI, Oct. 28–31, 1979.

Danilov, Victor J. "Science Exhibits for the Very Young." *MMC* 5.3 (Sept. 1986): 241–57.

Davidson, Betty, Candace Lee Heald, and George E. Hein. "Increased Exhibit Accessibility Through Multisensory Interaction." *Curator* 34.4 (1991): 273–90.

Davidson, Clifford. "Introduction." *A Tretise of Miraclis Pleyinge*. Early Drama, Art, and Music Monograph Series 19. Kalamazoo, Mich.: Medieval Institute, 1993.

Davies, Roderick. "Overcoming Barriers to Visiting: Raising Awareness Of, and Providing Orientation To, a Museum and Its Collections Through New Technologies." *MMC* 19.3 (2001): 285.

de Certeau, Michel. *The Writing of History*. Trans. Tom Conley. New York: Columbia UP, 1988.

Debord, Guy. *The Society of the Spectacle*. New York: Black and Red, 1977.

Dekker, Elly. "The Globe in Space." From *The World in Your Hands: An Exhibition of Globes and Planetaria from the Collection of Rudolf Schmidt*.

Diamond, Judy. "The Behavior of Family Groups in Science Museums." *Curator* 29.2 (1986): 139–54.

———. "Desert Explorations—A VideoDisc Exhibit Designed for Flexibility." *Curator* 32.3 (Sept. 1999): 161–73.

Doane, Mary Anne. *The Emergence of Cinematic Time: Modernity, Contingency, the Archive*. Cambridge: Harvard UP, 2002.

Donald, James. "The City, the Cinema: Modern Spaces." In Chris Jenks, ed., *Visual Culture*, 77–95. New York: Routledge, 1995.

Driscoll, John. "Designing the Public Interface." In Bearman, ed., *Hypermedia and Interactivity in Museums*, 35–45.

Drury, John. *Painting the Word: Christian Pictures and Their Meanings*. New Haven: Yale UP in association with National Gallery Publications, 1999.

Duby, Georges. *The Age of Cathedrals: Arts and Society, 980–1420*. Chicago: U of Chicago P, 1981.

Dutka, Elaine. "'Passion of the Christ' to Be Given Wider Release." *Los Angeles Times*, Feb. 20, 2004, C2.

Economou, Maria. "The Evaluation of Museum Multimedia Applications: Lessons from Research." *MMC* 17.2 (1999): 173–87.

Edwards, Elizabeth. *Anthropology and Photography, 1860–1920*. New Haven and London: Yale UP in association with the Royal Anthropological Institute, 1992.

Edwards, Ian. "Invest: Films in Future." *Playback*, July 26, 1999, 1.

Eigo, F. A., ed. *Imaging Christ: Politics, Art, Spirituality*. Villanova, Penn.: Villanova UP, 1991.

Elmer-Dewitt, Philip. "Grab Your Goggles, 3-D is Back!" *Time*, Apr. 16, 1990, 78.

Elsner, John and Roger Cardinal, eds. *The Cultures of Collecting*. Boston: Harvard UP, 1994.

Enders, Jody. *The Medieval Theater of Cruelty: Rhetoric, Memory, and Violence*. Ithaca: Cornell UP, 1999.

———. "Seeing Is Not Believing." In Beal and Linafelt, eds., *Mel Gibson's Bible*, 187–94.

Engberg, Gillian. "Virtual Field Trips." *Books Links* 11.1 (Aug.–Sept. 2001): 35–39.

Epp, Garrett P. "Ecce Homo." In Glen Berger and Steven F. Kruger, eds., *Queering the Middle Ages*, 237–38. Minneapolis: U of Minnesota P, 2001.

Erskine, Audrey, Vyvyan Hope, and John Lloyd. *Exeter Cathedral: A Short History and Description*. Exeter: Dean and Chapter of Exeter Cathedral, 1988.

Everett, David. "Putting Filmgoers in the Big Picture." *NYT*, Aug. 8, 1993, B16.

Ewen, Stuart. *PR: A Social History of Spin*. New York: Basic Books, 1996.

Fairweather, Kathleen. "The Towering Challenge of Everest." *American Cinematographer* (May 1998): 48–52.

Falk, John H. "The Effect of Visitors' Agendas on Museum Learning." *Curator* 4.2 (1988): 107–20.

Fauteux, Kevin. "The Final Portrait of Christ," *Journal of Religion and Health* 28.3 (Sept. 1989): 195–206.

Feher, Elsa. "Interactive Museum Exhibits as Tools for Learning: Explorations with Light." *International Journal of Science Education* 12.1 (1990): 35–49.

Finaldi, Gabriele. *The Image of Christ*. London: National Gallery Company, 2000; New Haven: Yale UP, 2000.

Fleming, Paula Richardson and Judith Luskey. *The North American Indians in Early Photographs*. London: Phaidon, 1986.

Follett, David. *The Rise of the Science Museum Under Henry Lyons*. London: Science Museum, 1978.

Fopp, Michael A. "The Implications of Emerging Technologies for Museums and Galleries." *MMC* 16.2 (June 1997): 143–53.

"For Sale: The Moon and Stars." *NYT*, Mar. 3, 1986.

Foulkes, Nicholas. "Show of Strength." *Financial Times Magazine*, Mar. 9, 2002.

Fox, Barry. "Altered Image." *New Scientist* 2319 (Dec. 1, 2001): 23.

Frank, Giorgia. "The Pilgrim Gaze in the Age Before Icons." In Nelson, ed., *Visuality*, 98–115.

Freedberg, David. *The Power of Images: Studies in the History and Theory of Response*. Chicago: U of Chicago P, 1989.

Fresco, Adam. "Lecturer Takes Hammer to Corpse Exhibit." *The Times* (London), Mar. 28, 2002, 10.

Friedberg, Anne. *Window Shopping: Cinema and the Postmodern*. Berkeley: U of California P, 1993.

———. "Virilio's Screen: The Work of Metaphor in the Age of Technological Convergence." *Journal of Visual Culture* 3.2 (2004): 183–93.

———. *The Virtual Window: From Alberti to Microscoft*, Cambridge: MIT Press, 2006.

Friedman, Alan J. "Are Science Centers and Theme Parks Merging?" *Informal Science Review* 25 (July-Aug. 1997): 1 and 4.

Fruitema, Evelyn O. and Paul A. Zoetmulder. *The Panorama Phenomenon*, Catalog for the preservation of the Centarian Mesdag Panorama. The Hague: Mesdag Panorama, 1981.

Gallagher, Jean. *The World Wars Through the Female Gaze*. Carbondale: Southern Illinois UP, 1998.

Gammon, Ben. "Visitors' Use of Computer Interactives: Findings from Five Grueling Years of Watching Visitors Getting It Wrong." Unpublished report, Science Museum Welcome Wing Exhibition Development, May 1999, 2–3.

Gardiner, Caroline and Anthony Burton. "Visitor Survey at the Bethnal Green Museum of Childhood." *MMC* 6.2 (1987): 155–63.

Gardner, Natalie. "Museum Takes Profitable Approach to Exhibits." *Business Press* 11.38 (Jan. 15, 1999).

Grau, Oliver. *Virtual Art: From Illusion to Immersion.* Boston: MIT Press, 2003.

Gentry, Ric. "*Rolling Stones at the Max:* All Muscle, No Moss." *American Cinematographer* (Aug. 1991): 34–38, 40.

Gibson, Timothy A. "Selling City Living: Urban Branding Campaigns, Class Power and the Civic Good." *International Journal of Cultural Studies* 8.3 (2005): 259–80.

Gitelman, Lisa and Geoffrey B. Pingree, eds. *New Media: 1740–1915.* Cambridge: MIT Press, 2003.

Gleadell, Colin. "See the Show, Buy the T-Shirt." *Daily Telegraph* (London), Mar. 2, 2002.

Gleiberman, Owen. "Faith Healer?" *Entertainment Weekly*, Mar. 5, 2004, 46.

Goldberger, Paul. "Requiem: Memorializing Terrorism's Victims in Oklahoma." *The New Yorker*, Jan. 14, 2002, 90.

Gordon, Bryony. "Artistic Licenses." *Daily Telegraph* (London), Apr. 13, 2002, 4.

Gréban, Arnoul. *The Mystery of the Passion: The Third Day.* Trans. Paula Guiliano. Asheville, N.C.: Pegasus Press, 1996.

Greenberg, Laura. *Exhibit Themes for the NMNH*, Report to the Director, Dec. 1986. In *Public Programs at the NMNH: A Joint Report to Secretary Adams from the Departments of Exhibits and Education at the NMNH,* Aug. 1985, in RU 564, Office of Exhibits, NMNH Records, c. 1974–1986, SIA.

Greenhalgh, Paul. "Education, Entertainment, and Politics: Lessons from the Great International Exhibitions." In Vergo, ed., *The New Museology*, 74–98.

Greer, Darroch. "A Different Cirque: Cirque de Soleil in Imax 3-D." *Global Telephony*, June 1999.

Griffiths, Alison. "'The Largest Picture Ever Executed by Man': Panoramas and the Emergence of Large-Screen and 360 Degree Technologies." In John Fullerton, ed., *Screen Culture: History and Textuality*, 199–220. London: John Libbey Press, 2004.

———. *Wondrous Difference: Cinema, Anthropology, and Turn-of-the-Century Visual Culture.* New York: Columbia UP, 2002.

Gubernick, Lisa. "Hollywood Thinks Bigger—Your Favorites, Only Taller: Can Re-Released Movies Breathe Life into IMAX?" *Wall Street Journal*, Feb. 12, 2002, W5.

Gunning, Tom. "An Aesthetic of Astonishment: Early Film and the [In]Credulous Spectator." In Linda Williams, ed., *Viewing Positions*, 114–33.

———. "Phantom Images and Modern Manifestations: Spirit Photography, Magic Theater, Trick Films, and Photography's Uncanny." In Petro, ed., *Fugitive Images: From Photography to Video*, 42–71.

Gurevitch, Matthew. "The Next Wave? 3-D Could Bring On a Sea Change." *NYT*, Jan. 2, 2000, B28.

Gurian, Elaine Heumann. "A Blurring of Boundaries." *Curator* 38.1 (Mar. 1995): 31–37.

Haberman, Clyde. "Last Temptation Creates Furor at Venice Festival." *NYT*, Sept. 8, 1988, 19.

Haberstich, David E. "Photographs at The Smithsonian Institution: A History." *Picturescope* 32.1 (Summer 1985): 3–20.

Haffenreffer, David. "IMAX Corporation CO-COE Bradley Wechsler," guest on CNNfn, July 31, 2003, 12:30 p.m. EST.

Hahn, Cynthia. "Vision Dei: Changes in Medieval Visuality." In Nelson, ed., *Visuality*, 169–96.

Hall, Peter. "Now Showing: Something Dazzling." *NYT*, May 2, 2001, H17.

Hanner, John. "The Adventures of an Artist: John Banvard, 1815–1891." Ph.D. diss., Michigan State University, 1979.

Hayes, R. M. *3-D Movies: A History and Filmography of Stereoscopic Cinema.* Jefferson, N.C.: MacFarland, 1998.

Heath, Christian and Dirk vom Lehn. "Misconstruing Interactivity." Paper presented at the Victoria and Albert Conference on Interactive Learning in Museums of Art and Design (London, 2002).

Hein, George E. *Learning in the Museum*. London: Routledge, 1998.

Heinen, Tom. "'Who Do You Say That I Am?': 'The Passion of the Christ' Could Shape Our Image of Jesus for Decades." *Milwaukee Journal Sentinel*, Feb. 24, 2004, A1.

Hernandez, Greg. "Big Pictures Push IMAX to Its First Profitable Year Since 1999." *Los Angeles Daily News*, Feb. 28, 2003.

Hendershot, Heather. *Shaking the World for Jesus: Media and Conservative Evangelical Culture*. Chicago: U of Chicago P, 2004.

Henderson, Anne and Susy Watts. "How They Learn: The Family in the Museum." *MN* (Nov.-Dec. 2000): 41–45, 67.

Henning, Michelle. "Legibility and Affect: Museums as New Media." In Sharon MacDonald and Paul Baus, eds., *Exhibition Experiments*. Oxford: Blackwell, 2007.

———. *Museums, Media, and Cultural Theory*. Milton Keynes, UK: Open University Press, 2006.

Heschel, Susannah. "Christ's Passion: Homoeroticism and the Origins of Christianity." In Beal and Linafelt, eds., *Mel Gibson's Bible*, 99–107.

Heuring, David. "IMAX Presses to the Limit: Greg McGillivray Explains the Big Format." *American Cinematographer* 71 (Mar. 1990): 34–44.

Hilke, D. D. "The Impact of Interactive Computer Software on Visitors' Experiences: A Case Study." *ILVS Review* 1.1 (1988): 34–49.

Hillis, Ken. *Digital Sensations: Space, Identity, and Embodiment in Virtual Reality*. Minneapolis: U of Minnesota P, 1999.

Hollywood, Amy. "Kill Jesus." In Beal and Linafelt, eds., *Mel Gibson's Bible*, 159–68.

Honan, William H. "A Movie Process in Which the Screen Disappears." *NYT*, Mar. 30, 1990, 15.

Honigsbaum, Mark. "McGuggenheim?" *The Guardian*, Jan. 27, 2001, 4.

Hopenwasser, Nanda. "A Performance Artist and Her Performance Text: Margery Kempe on Tour." In Suydam and Zeigler, eds., *Performance and Transformation*, 97–131.

Horn, Axel. "Communicating Science in 'Four Dimensions,'" *Curator* 3.1 (1960): 88–95.

Hughes, Patrick. "Making Science 'Family Fun': The Fetish of the Interactive Exhibit." *MMC* 19.2 (2001): 175–85.

Hyde, Ralph. *Panoramania! The Art and Entertainment of the "All-Embracing" View*. London: Refoil Publications in association with the Barbican Art Gallery, 1988.

Icher, François. *Building the Great Cathedrals*. New York: Abrams, 1998.

"IMAX and EuroPalace to Open IMAX Theatre at Disneyland Resort Paris." *PR Newswire*, June 23, 2003.

"Imax Signs Deal for Three Imax Theatres in India." *PR Newswire*, Apr. 29, 2003.

"In the Hall of Biodiversity" (editorial). *NYT*, June 1, 1998.

"Interactive Pictures Debuts Nikon / iPIX Digital Camera Kits." *Imaging Update* 8.10 (Aug. 1999): n.p.

"Interactive Service." *Design Week*, Mar. 28, 2002, 16.

"Island Life." *Leisure Week*, June 2, 1995, 26.

Jenks, Chris. "Watching Your Step: The History and Practice of the *flaneur*." In *Visual Culture*, 142–60. London: Routledge, 1995.

Jennings, Humphrey, ed. *Pandaemonium, 1660–1886: The Coming of the Free Press* (New York: Free Press, 1985). Cited by Greenhalgh, "Education, Entertainment and Politics," in Vergo, ed., *The New Museology*.

Johnson, Ted and Diane Goldner. "Big Screens Make Mainstream Breakout Bid." *Variety*, Jan. 27, 1997, 5.

Jones, Jeffrey. "Museum Computers: Design Innovations." *Curator* 35.3 (1992): 225–36.

Jones, Karen. "New 'Smart' Galleries, Wireless and Web-Friendly." *NYT*, Apr. 24, 2002, G27.

Karp, Ivan and Steven D. Lavine, eds. *Exhibiting Cultures: The Poetics and Politics of Museum Display*. Washington, D.C.: Smithsonian Institution Press, 1991.

Kavanagh, Gaynor ed. *Museum Languages: Objects and Texts*. Leicester: Leicester UP, 1991.

Keene, Suzanne. *Digital Collections: Museums and the Information Age*. London: Butterworth-Heinemann, 1998.

Kelemen, Erick. "Drama in Sermons: Quotation, Performativity, and Conversion in a Middle English Sermon on the Prodigal Son in *A Tretise of Miraclis Pleyinge*," *ELH* 69 (2002): 1–19.

Kelly, Katy. "Scourging and Buzz." *U.S. News & World Report*, Mar. 8, 2004, 45.

Kemp, Jackie. "Becoming a Thing of the Past." *Glasgow Herald*, Mar. 27, 2002.

Kendall, Laurel, ed. *Drawing Shadows to Stone: The Photography of the Jesup North Pacific Expedition, 1897–1902*, New York and Seattle: AMNH in association with the U of Washington P, 1997.

Kerr, Paul et al. *The Crimean War*. London: Boxtree, 1998.

Kerr, Sara. "Effective Interaction in a Natural Science Exhibit." *Curator* 29.4 (Dec. 1986): 265–77.

Kershaw, Baz. "Curiosity or Contempt: On Spectacle, the Human, and Activism." *Theatre Journal* 55.4 (Dec. 2003): 591–611.

"Kiefer Sutherland Joins the Field on *NASCAR 3D: The IMAX Experience*." *PR Newswire*, Sept. 22, 2003.

Kimmelman, Michael. "Trompe L'Oeil on Nature's Behalf." *NYT*, Jan. 7, 2000, E39.

Knight, David. "Scientific Lectures: A History of Performance." *Interdisciplinary Science Reviews* 27.3 (2002): 217–24.

Kohn, Sherwood Davidson. "It's OK to Touch at the New-Style Hands-On Exhibits." *Smithsonian* 9.6 (1978): 78–84.

Kotler, P., D. Haider, and I. Rein. "There's No Place Like Our Place: The Marketing of Cities, Regions, and Nations." *Futurist* 27.6 (1993): 14–21.

Krakauer, John. *Into Thin Air: A Personal Account of the Mt. Everest Disaster*. New York: Villard, 1997.

Kraus, Amanda. "Heart of Starkness." *MN* (Jan.-Feb. 2000): 11–17, 62–63.

Krüger, Hermann. "Planning and Layout of Museums: The Central Importance of the Room," *MMC* 3.4 (Dec, 1984): 351–56.

Kuhn, Annette, ed. *Alien Zone: Cultural Theory and Contemporary Science Fiction Cinema*. London: Verso, 1990.

Kyong, Wendy Hui and Thomas Keenan, eds. *New Media, Old Media: A History and Theory Reader*. New York: Routledge, 2005.

Lant, Antonia. "Egypt in Early Cinema." In Cosandey and Albera, eds., *Images Across Border: 1896–1918*, 73–94.

Laurence, William L. "'Tour of the Sky' Opens Planetarium; 800 Get a New Vision of Universe," *NYT*, Oct. 3, 1983, 1.

Lawrence, Christine. "Rats, Street Gangs and Culture: Evaluation in Museums." In Kavanagh, ed., *Museum Languages*, 9–32.

Levell, Nicky and Anthony Shelton. "Text, Illustration and Reverie: Some Thoughts on Museums, Education and New Technologies." *Journal of Museum Ethnography* 10 (1998): 15–34.

Levin, Miriam R. "Museums as Media in the Emerging Global Context." *Curator* 49.1 (2006): 31–35.

Levine, Shira. "A Web Walk: iPIX Brings 3-D to the Internet." *Telephony*, Aug. 18, 1997.

Lippard, Lucy, ed. *Partial Recall*. New York: The New Press, 1992.

Little, William G. "Jesus's Extreme Makeover." In Beal and Linafelt, eds., *Mel Gibson's Bible*, 169–78.

Litwak, Howard. "Design Considerations for Interactive Videodisc." In Bearman, ed., *Hypermedia and Interactivity in Museums*, 144–49.

Lockwood, Marian. "The Hayden Planetarium." In *The Book of the Hayden Planetarium*.

Lubar, Steven D. and Kathleen M. Kendrick. *Legacies: Collecting America's History at the Smithsonian*. Washington, D.C.: Smithsonian UP, 2001.

Lucas, A. M. "'Info-tainment' and Informal Sources for Learning Science." *International Journal of Science Education* 13.5 (1991): 495–504.

Ludwig, Jessica. "Smithsonian's Interactive Exhibit Allows Museum-Goers to Collaborate and Compete." *Chronicle of Higher Education* (http://chronicle.com).

Lumley, Robert, ed. *The Museum Time Machine*, New York: Routledge, 1988.

MacDonald, George F. (interview). "Digital Visionary: George F. MacDonald and the World's First Museum of the Internet Century." *MN* (Mar.-Apr. 2000): 35–41, 72–74.

MacDonald, George F. and Steven Alsford. "Museums and Theme Parks: Worlds in Collision?" *MMC* 14.2 (June 1995): 129–47.

MacDonald, Kevin and Mark Cousins. *Imagining Reality: The Faber Book of Documentary*. London: Faber and Faber, 1996.

"MacGillivray Freeman's 'Everest' Becomes Highest Grossing Documentary of All Time." Press release, Jan. 23, 2003, 1.

Madden, Joan C. "To Realize Our Museum's Full Potential." *Journal of Museum Education* 10.4 (Fall 1985): 3–5. Reprinted in *Patterns in Practice* (1992), 35–40.

———. "Responses to Schlereth, Stapp, and Williams." *Roundtable Reports* 9.1 (Winter 1984): 12–14, 22. Reprinted in *Patterns in Practice* (1992), 123–25.

"Maestros of the Universe." *Museums New York* (Apr. 1996).

The Magical Panorama: The Mesdag Panorama, An Experience in Space and Time. Trans. Arnold and Erica Pomerans. Zwolle / The Hague: Waanders Uitgevers / B. V. Panorama Mesdag, 1996.

Mahaffey, Ben D. "Relative Effectiveness and Visitor Preference of Three Audio-Visual Media for Interpretation of an Historic Area." *Departmental Information Report* 1, Texas Agricultural Experiment Station (June 1969): 48.

Mâle, Emile. *The Gothic Image: Religious Art in France in the Thirteenth Century.* Trans. Dora Nussey. New York: Harper and Row, 1972.

Maleuvre, Didier. *Museum Memories: History, Technology, Art.* Stanford: Stanford UP, 1999.

Mannoni, Laurent. "*Magie Lumineuse* in the Country and the City." In *The Great Art of Light and Shadow: Archaeology of the Cinema.* Exeter: U of Exeter P, 2000.

Manovich, Lev. *The Language of New Media.* Cambridge: MIT Press, 2001.

Marché II, Jordan D. *Theaters of Time and Space: American Planetaria, 1930–1970.* New Brunswick, N.J.: Rutgers UP, 2005.

Maresco, Peter A. "Mel Gibson's *The Passion of the Christ*: Market Segmentation, Mass Marketing and Promotion, and the Internet." *Journal of Religion and Popular Culture* 8 (Fall 2004).

Margulies, Ivone. "Exemplary Bodies: Reenactments in *Love in the City, Sons,* and *Close-Up.*" In Margulies, ed., *Rites of Realism: Essays on Corporeal Cinema,* 217–44. Durham: Duke UP, 2003.

Marriott, Michel. "Video Technology to Make the Head Spin." *NYT,* Mar. 2, 2000, G10.

Martin, J. W., C. E. Ostwalt Jr., R. Kinnard, and T. Davis, eds. *Divine Images: A History of Jesus on the Screen.* New York: Citadel, 1992.

Martin, Jo. "In Conservation's Corner." *Daily News,* May 16, 1969.

Maslow, Abraham H. *Religions, Values, and Peak-Experiences.* New York: Penguin / Arkana, 1994.

Mayhew, Henry. "The Shilling People" (1985). Quoted in Jennings, ed., *Pandemonium,* as cited by Greenhalgh, "Education, Entertainment and Politics," in Vergo, ed., *The New Museology.*

Mazda, Xerxes. "The Changing Role of History in the Policy and Collections of the Science Museum, 1857–1973." Master of Science diss., University of London (1996).

McCarthy, Anna. *Ambient Television: Visual Culture and Public Spaces.* Durham: Duke UP, 2001.

McCutcheon, Mary. "The Children's Room at the Smithsonian, 1901–1939." *Curator* 35.1 (Mar. 1992): 6–20.

McLean, Kathleen. *Planning for People in Museums.* Washington, D.C.: Association of Science-Technology Centers, 1993.

McManus, Paulette M. "Oh Yes They Do: How Museum Visitors Read Labels and Interact with Exhibit Text." *Curator* 32.3 (1989): 174–89.

———. "Reviewing the Reviewers: Toward a Critical Language for Didactic Science Exhibitions." *MMC* 5.3 (Sept. 1986): 213–26.

McNally, Terrence. *Corpus Christi.* New York: Grove Press, 1998.

McPherson, Karen. "International Spy Museum." *Pittsburgh Post-Gazette,* May 28, 2002, D1.

Meisel, Martin. *Realizations: Narrative, Pictorial, and Theatrical Arts in Nineteenth-Century England.* Princeton: Princeton UP, 1983.

Middleton, Arthur. "Globes of the Early 19th Century." From *The World in Your Hands: An Exhibition of Globes and Planetaria from the Collection of Rudolf Schmidt.*

Miles, Jack. "The Art of *The Passion*." In Beal and Linafelt, eds., *Mel Gibson's Bible*, 11–20.

Miles, Margaret R. "The Passion for Social Justice and *The Passion of the Christ*." In Beal and Linafelt, eds., *Mel Gibson's Bible*, 121–28.

Miller, Angela. "The Panorama, the Cinema, and the Emergence of the Spectacular." *Wide Angle* 18.2 (Apr. 1996): 34–69.

Miller, Thomas Ross and Barbara Mathé. "Drawing Shadows to Stone." In Kendall et al., *Drawing Shadows to Stone*, 19–40.

Miller, Toby. "Who Owns the Passion?" Symposium organized by the Center for Religion and Media, New York University, Mar. 12, 2004.

Miller, Vincent J. "Contexts: Theology, Devotion, and Culture." In Beal and Linafelt, eds., *Mel Gibson's Bible*, 39–50.

Mitchell, Elvis. "Jesus Christ Movie Star." *NYT*, Sept. 22, 1988, 42.

Moore, Kevin. "Feasts of Reason: Exhibitions at the Liverpool Mechanics Institution in the 1840s." In Kavanagh, ed., *Museum Languages*, 157–77.

Morgan, David. *Visual Piety: A History and Theory of Popular Religious Images*. Berkeley: U of California P, 1998.

Morris, Meaghan. "Of God and Man." *American Film* 14:1 (Oct. 1988): 44–49.

Morrissey, Kristine. "Visitor Behavior and Interactive Video." *Curator* 34.2 (1991): 109–118.

Morus, Iwan Rhys. *Frankenstein's Children: Electricity, Exhibition, and Experiment in Early Nineteenth-Century London*. Princeton: Princeton UP, 1998.

"Museum Unveils Plans to Transform Hayden Planetarium for Twenty-First Century" (Press release 1/26/95), SC-AMNH.

Nash, Christopher John "Interactive Media in Museums: Looking Backwards, Forwards, and Sideways." *MMC* 11.2 (June 1992): 171–84.

"National Museums: British Museum." *MJ* 5.12 (June 1906): 291–96.

Nelson, Robert S., ed. *Visuality Before and Beyond the Renaissance*. Cambridge: Cambridge UP, 2000.

Ness, Patrick. "A Prey to Temptation in the Bible Belt." *Sunday Telegraph*, Feb. 15, 2004, 4.

Neumann, Mark. "Emigrating to New York in 3-D: Stereoscopic Vision in IMAX's Cinematic City." In Mark Shiel and Tony Fitzmaurice, eds., *Cinema and the City*, 109–121. Oxford and New York: Blackwell, 2001.

Nevius, C. W. and Joshunda Sanders. "Movies in the News: 'The Passion of the Christ.'" *San Francisco Chronicle*, Feb. 26, 2004, A13.

Nichols, Peter M. "Going Beyond the 'Wow' Factor on Giant Screens." *NYT*, Sept. 15, 1999, E3.

Oehser, Paul H. and Louise Heskett. *The Smithsonian Institution*. Boulder: Westview, 1983.

Oettermann, Stephan. *The Panorama: History of a Mass Medium*. New York: Zone Books, 1997.

Olins, Wally. "How Brands Are Taking Over the Corporation." In Schultz, Hatch, and Larsen, eds., *The Expressive Organization*. 51–65.

Olson, Glending. "Plays as Play: A Medieval Ethical Theory of Performance and the Intellectual Context of the *Tretise of Miraclis Pleyinge*," *Viator* 26 (1995): 195–211.

O'Malley, John W. "A Movie, a Mystic, a Spiritual Tradition." *America* 190.9 (Mar. 15, 2004), 13.

Onnes-Fruitema, Evelyn. "Of Panoramas Old and New." In *The Magical Panorama*, 27–36.

Panofsky, Erwin. "Et in Arcadia Ego: Poussin and the Elegaic Tradition." In *Meaning in the Visual Arts: Papers in and on Art History*, 295–320. Garden City, N.Y.: Doubleday Anchor, 1955.

Paret, Peter. *Imagined Battles: Reflections of War in European Art*. Chapel Hill: U of North Carolina P, 1997.

Pascoe, David. *Peter Greenaway: Museums and Moving Images*. London: Reaktion Books, 1997.

Paskal, Cleo. "Pilgrimage to Christorama." *Canadian Geographic* 121.2 (Mar. 2001): 98.

"'Passion of the Christ' Creates Passionate Divide." *Houston Chronicle*, Feb. 25, 2004, 8.

The Passion: Photography from the Movie "The Passion of the Christ." Rockford, Ill.: Tan Books, 2004.

"The Passion of the Christ at Easter." *Sydney Morning Herald*, Apr. 9, 2004, 28.

Patterns in Practice: Selections from "The Journal of Museum Education." Washington, D.C.: Museum Education Roundtable, 1992.

Pearson, Anne. "Please Touch: An Exhibition of Animal Sculptures at the British Museum." *MMC* 3.4 (Dec. 1984): 373–78.

Peart, Bob and Richard Kool. "Analysis of a Natural History Exhibit: Are Dioramas the Answer?" *MMC* 7.2 (June 1988): 117–28.

Peterson, Jennifer. "The Cinematic Geography of Early Travelogues." Paper presented at the Society for Cinema Studies conference, Miami Beach, Apr. 1999.

Petro, Patrice, ed. *Fugitive Images: From Photography to Video.* Bloomington: Indiana UP, 1995.

Pierson, Michelle. *Special Effects: Still in Search of Wonder.* New York: Columbia UP, 2002.

Pfefferman, Naomi. "On Top of the World." *American Cinematographer* (Aug. 1995).

Phillips, David. "Evaluating Time-Lapse Video Evaluation." *MMC* 14.1 (Mar. 1995): 19–29.

———. "Recipe for an Interactive Art Gallery." *MMC* 7.3 (Sept. 1988): 243–52.

———. "Science Centers: A Lesson for Art Galleries." *MMC* 5.3 (Sept. 1986): 259–66.

"Planetarium Technology Comes of Age." *Grapevine*, Sept.-Oct. 1982.

Pold, Søren. "Panoramic Realism: An Early and Illustrative Passage from Urban Space to Media Space in Honoré Balzac's Novels *Ferragus* and *Le Père Goriot.*" *Nineteenth-Century French Studies* 29.1–2 (Fall-Winter 2000–2001): 47–63.

Porcevskij, Konstantin Alexeievich. "Education in Moscow Planetarium." In Marcel Grun, ed., *The Fifth International Planetarium Directors Conference*, 25–29. Prague, Czechoslovakia.

Pratt, Mary Louise. *Imperial Eyes: Travel Writing and Transculturation.* New York and London: Routledge, 1992.

Preston, Douglas J. "A Domeful of Stars." *Natural History* 94.10 (Oct. 1985): 92–101.

———. "The Naturemax Theater." *Natural History* 91 (Feb. 1982): 94–95.

Prince, David R. "The Museum as Dreamland." *MMC* 4.3 (Sept. 1985): 243–50.

Quinn, Stephen. *Windows on Nature: The Great Habitat Dioramas of the American Museum of Natural History.* New York: AMNH and Harry N. Abrams, 2006.

Rabinovitz, Lauren. "More Than the Movies: A History of Somatic Visual Culture Through *Hale's Tours, IMAX,* and *Motion Simulation Rides.*" In Rabinovitz and Geil, eds. *Memory Bytes*, 99–125.

Rabinovitz, Lauren and Abraham Geil, eds. *Memory Bytes: History, Technology, and Digital Culture.* Durham: Duke UP, 2004.

Rafferty, Terrence. "The Last Temptation of Christ." *The New Yorker* 64:29 (Sept. 5, 1988): 78–9.

Rectanus, Mark W. *Culture Incorporated: Museums, Artists, and Corporate Sponsorship.* Minneapolis: U of Minnesota P, 2002.

Reilly, Jr., Bernard F. "Merging or Diverging? New International Models from the Web." *MN* (Jan.-Feb. 2001): 48–55, 84–86.

Reinhard, David. "What I Saw at 'The Passion of the Christ.'" *The Oregonian*, Feb. 29, 2004, E4.

Richards, Peter. "From London to Nagasaki—The Roots of Interactive Art @ the Exploratorium." In Sommerer and Mignonneau, eds., *Art @ Science*, 215–24.

Riches, Samantha J. E. and Sarah Salih, eds. *Gender and Holiness: Men, Women, and Saints in Late Medieval Europe.* New York: Routledge, 2002.

Ricklefs, Roger. "Imax Hopes to Take Vast Screen into Mainstream—A New 'Fantasia' Tests Film Strategy of Canadian Firm." *Wall Street Journal*, Dec. 10, 1999, A15.

Riley, Robin. *Film, Faith, and Cultural Conflict: The Case of Martin Scorsese's "The Last Temptation of Christ."* Westport, Conn.: Praeger, 2003.

Roberts, Lisa C. *From Knowledge to Narrative: Educators and the Changing Museum.* Washington, D.C.: Smithsonian Institution Press, 1997.

———. "Rebuttal to 'Are Museums Still Necessary.'" *Curator* 37.3 (Sept. 1994): 152–53.

Robbins, Michael. "An Exhibit Asks the Question of the Century." *MN* (Sept. 1969): 12.

Rodgers, Susan and Joanna E. Ziegler. "Elisabeth of Spalbeck's Trance Dance of Faith: A Performance Theory Interpretation from Anthropological and Art Historical Perspectives." In Suydam and Ziegler, eds., *Performance and Transformation*, 299–355.

Romney, Jonathan. "Back to the Future." *New Statesman* 127.4415 (Dec. 11, 1998).

———. "Pulp Crucifixion: Medieval Horror on a Biblical Scale." *Independent on Sunday* (London), Mar. 28, 2004, 16–17.

Russell, Terry. "Collaborative Evaluation Studies Between the University of Liverpool and National Museum and Galleries on Merseyside." In Sudburg and Russell, eds., *Evaluation of Museum and Gallery Displays*, 13–25.

Salih, Sarah. "Staging Conversion: The Digby Saint Plays and *The Book of Margery Kemp*." In Riches and Salih, eds., *Gender and Holiness*, 121–34.

Sandberg, Mark B. "Effigy and Narrative: Looking into the Nineteenth-Century Folk Museum." In Charney and Schwartz, eds., *Cinema and the Invention of Modern Life*, 320–61.

———. *Living Pictures, Missing Persons: Mannequins, Museums, and Modernity*. Princeton: Princeton UP, 2003.

Santoro, Geraldine. "'To Stamp Out the Plague of Consumption': 1908–09." *Curator* 36.1 (Mar. 1993): 13–27.

Schiller, Gertrud. *Iconography of Christian Art*. Vol. 2. Trans. Janet Seligman. Greenwich, Conn.: New York Graphic Society, 1972.

Schlereth, Thomas J. "Object Knowledge: Every Museum Visitor an Interpreter." *Roundtable Report* 9.1 (Winter 1984): 5–9. Reprinted in *Patterns in Practice* (1992), 102–11.

Schmitz, Marie L. "Henry Lewis: Panorama Maker." *Cultural Heritage: Quarterly Journal of the Missouri Historical Society* 3 (Winter 1982): 36–48.

Schultz, Majken, Mary Jo Hatch, and Mogens Holten Larsen, eds. *The Expressive Organization: Linking Identity, Reputation, and the Corporate Brand*. New York: Oxford UP, 2000.

Schwartz, Hans-Peter. "New Art Needs New Art Venues—Art, Technology, and the Museum: Ars sine scientia nihil est." In Sommerer and Mignonneau, eds. *Art @ Science*, 207–214.

Schwartz, Vanessa R. *Spectacular Realities: Early Mass Culture in Fin-de-Siècle France*. Berkeley: U of California P, 1998.

Schwartzbaum, Lisa. "Faith Healer?" *Entertainment Weekly*, Mar. 5, 2004, 47.

Schwarzer, Marjorie. "Art Gadgetry: The Future of the Museum Visit." *MN* (July-Aug. 2001): 38.

———. "Review of Mary Maher, ed., *Collective Vision: Starting and Sustaining a Children's Museum* (Washington, D.C.: Association of Youth Museums, 1997)." In *Curator* 41.1 (Mar. 1998): 66–71.

Searle, Adrian. "The Never-Ending Story." *The Guardian*, Apr. 20, 2002, 12.

Serrell, Beverly. "Are They Watching? Visitors and Videos in Exhibitions." *Curator* 45.1 (Jan. 2002): 50–64.

Serrell, Beverly and Britt Raphling. "Computers on the Exhibit Floor." *Curator* 35.3 (Sept. 1992): 181–89.

Seu, Andree. "After the Movie." *World Magazine* 19.11, Mar. 20, 2004, n.p.

Shapiro, James. *Oberammergau: The Troubling Story of the World's Most Famous Passion Play*. New York: Pantheon, 2000.

Sharpe, Elizabeth. *Touch-Screen Computers: An Experimental Device at the NMNH*. Visitor Study no. 1. Washington, D.C.: National Museum of Natural History, 1983.

Sharrett, Christopher. "The Last Temptation of Christ." *Cineaste* 17:1 (1989): 28–29.

Sheingorn, Pamela. "Gender, Performance, Visual Culture: Medieval Studies in the 21st Century." Lecture, Columbia University, Feb. 15, 2006.

Shelley Rice. "Boundless Horizons: The Panoramic Image." *Art in America* 81 (1993): 70.

Silverstone, Roger. "Museums and the Media." *MMC* 7 (1988): 231–41 (formerly, *International Journal of Museum Management and Curatorship*).

Simon, Jeff. "Gibson's Gospel: A Religious Zealot's 'The Passion of the Christ' Is Not Sacred, Just Sadistic," *Buffalo News*, Feb. 25, 2004, D1.

Singer, Ben. "Illuminating World of Laserium." *Probe* (Sept. 1980): 51.

Singer, Mark. "One Deadly Summit." *Sight and Sound* 9.1 (Jan. 1999): 26, 28, and 30.

Smith, Virginia. "Swimming in the Sea of Memory." *NYT*, June 15, 2003, 3.

Sobchack, Vivian. *Carnal Thoughts: Embodiment and Moving Image Culture.* Berkeley: U of California P, 2004.

Šola, Tomislav. *Essays on Museums and Their Theory: Towards the Cybernetic Museum* (Helsinki: Finnish Museums Association, 1997). Cited in Ross Perry, "Digital Heritage and the Rise of Theory in Museum Computing," *MMC* 20 (2005).

Sommerer, Christa and Laurent Mignonneau, eds. *Art @ Science.* Springer-Verlag Telos, 1998.

Sontag, Susan. *Regarding the Pain of Others.* New York: Picador, 2003.

Spook, Daniel. "Is it Interactive Yet?" *Curator* 47.4 (2004): 369–74.

Stafford, Barbara Maria. *Artful Science: Enlightenment Entertainment and the Eclipse of Visual Education.* Cambridge: MIT Press, 1999.

Starr, Kenneth. "MER at Twenty: Some Observations on Museum Education." *Journal of Museum Education* 15.1 (Winter 1990): 18–19. Reprinted in *Patterns in Practice* (1992), 66–70.

Steinfels, Peter. "Beliefs: In the End, Does 'The Passion of the Christ' Point to Christian Truths, or Obscure Them?" *NYT*, Feb. 28, 2004, A13.

"Stellar Performance." *NYT*, Dec. 1, 1984.

Stern, R. C., C. N. Jefford, and G. DeBona. *Savior on the Silver Screen.* New York: Paulist Press, 1999.

Sterne, Jonathan. "Out with the Trash: On the Future of New Media." In Charles R. Acland, ed., *Residual Media*, 16–31. Minneapolis: U of Minnesota P, 2007.

Stevenson, John. "The Long-Term Impact of Interactive Exhibits." *International Journal of Science Education* 13.5 (1991): 521–31.

Stewart, Susan. *On Longing: Narratives of the Miniature, the Gigantic, the Souvenir, the Collection.* Durham: Duke UP, 1993.

Strain, Ellen. "Moving Postcards: The Politics of Mobility and Stasis in Early Cinema." In *Public Places, Private Journeys: Ethnography, Entertainment, and the Tourist Gaze*, 105–123. New Brunswick: Rutgers UP, 2003.

Sudbury, Patrick, Peter Reed, Paul Rees, and Terry Russell, eds. *Evaluation of Museums and Gallery Displays.* CRIPSAT Papers. Liverpool: Liverpool UP, 1995.

Sullivan, Bryan. "Imax in the Grand Canyon." *American Cinematographer* (Dec. 1984): 78.

Sullivan, Robert. "Were Those Indians Hit by Cars?" Reprinted in *Patterns in Practice* (1992), 99–101.

Suydam, Mary A. and Joanna E. Zeigler, eds. *Performance and Transformation: New Approaches to Late Medieval Spirituality.* New York: St. Martin's, 1999.

Swanson, R. N. "Passion and Practice: The Social and Ecclesiastical Implications of Passion Devotion in the Late Middle Ages." In A. A. MacDonald, H. N. B. Ridderbos, and R. M. Schlusemann, eds., *The Broken Body: Passion Devotion in Late Medieval Culture*, 1–30. Groningen, The Netherlands: Ebgert Forste, 1996.

Symonds, William C. and Neil Gross. "Today the Stones, Tomorrow Stalone?" *Business Week* 3244 (Dec. 16, 1991): 88.

Szabo, Liz. "*Passion of Christ* Moves Film's Early Viewers." *USA Today*, Feb. 18, 2004, 1D.

Tatum, W. B. *Jesus at the Movies: A Guide to the First Hundred Years.* Santa Rosa, Calif.: Polebridge, 1997.

Thomas, Selma. "Interactive Media and the Museum Experience." In Bearman, ed., *Hypermedia and Interactivity in Museums*, 164–68.

Torjesen, Karen Jo. "The Journey of the Passion Play from Medieval Piety to Contemporary Spirituality." In J. Shawn Landres and Micheal Berenbaum, eds. *After the Passion*

Is Gone: American Religious Consequences. Walnut Creek, Calif.: Altamira, 2004.

Tsichritzis, Dennis and Simon Gibbs. "Virtual Museums and Virtual Realities." In Bearman, ed., *Hypermedia and Interactivity in Museums,* 17–25.

"Two Imax 3D Films Reach New Box Office Milestones." *PR Newswire,* May 8, 2003.

Tye, Larry. *The Father of Spin: Edward L. Bernays and the Birth of PR.* New York: Crown, 1998.

"The Uncertain Profession: *Perceptions and Directions.*" Series of commentaries in *Journal of Museum Education* 12.3 (Fall 1987): 4–10. Reprinted in *Patterns in Practice* (1992), 48–59.

Urry, John. *The Tourist Gaze: Leisure and Travel in Contemporary Societies.* London: Sage, 1990.

Vamos, Peter. "Imax Takes LF to the Stars." *Playback,* Oct. 4, 1999, 6.

Van Eekelen, Yvonne. "The Magical Panorama." In *The Magical Panorama,* 11–26.

Vergo, Peter, ed. *The New Museology.* London: Reaktion, 1989.

Vidal, Gore. *The Smithsonian Institution.* New York: Random House, 1998.

Virilio, Paul. "Cataract Surgery: Cinema in the Year 2000." In Kuhn, ed., *Alien Zone,* 169–76.

"Virtual Innovations: Roundtable Product Review: Inside IMAX 3D." *Playback,* Feb. 9, 1998, vi.

Von Erffa, Helmut and Allen Stanley. *The Paintings of Benjamin West.* London: New Hand, 1986.

Von Simson, Otto. *The Gothic Cathedral: Origins of Gothic Architecture and the Medieval Concept of Order.* New York: Harper and Row, 1964.

Wallach, Amel. "Art Review: Gold of El Dorado." *Newsday,* Nov. 16, 1978.

Wanning, Tine. "Evaluating Museum Visitors' Use of Interactive Video." In Bearman, ed., *Hypermedia and Interactivity in Museums,* 46–52.

———. "Image Database for Museum Staff, Visitors and the Outside World: The Same Basic Material." In Bearman, ed., *Hypermedia and Interactivity in Museums,* 57–61.

Wasson, Haidee. *Museum Movies: The Museum of Modern Art and the Birth of Art Cinema.* Berkeley: U of California P, 2005.

Watkins, Charles Alan. "Are Museums Still Necessary?" *Curator* 37.1 (Mar. 1994): 25–35.

Wazlawick, Raul S. et al. "Providing More Interactivity to Virtual Museums: A Proposal for a VR Authoring Tool." *Presence* 10.6 (Dec. 2001): 647–56.

Weil, Stephen E. *Rethinking the Museum and Other Meditations.* Washington, D.C.: Smithsonian Institution Press, 1990.

Weiss, David. "New York Metro." *Mix* (Feb. 2004).

Wenzel, Siegfried. "'Somer Game' and Sermon Reference to a Corpus Christi Play." *Modern Philology* 86 (1988–89): 274–83.

White, Judith, Dale Marcellini, and Sharon Barry. "Learning about Reptiles and Amphibians: A Family Experience." *Journal of Museum Education* 11.2 (Spring 1986): 3–4. Reprinted in *Patterns in Practice* (1992), 276–78.

Whitney, Allison Patricia. "The Eye of Daedalus: A History and Theory of IMAX Cinema." Ph.D. diss., University of Chicago, 2005.

Williams, Carol T., ed. *Travel Culture: Essays on What Makes Us Go.* Westport, Conn.: Praeger, 1988.

Williams, Joe. "'The Passion of the Christ': Gibson's Film Is Overkill on Jesus' Death Not Life." *St. Louis Post-Dispatch,* Feb. 25, 2004, E1.

Williams, Linda, ed. *Viewing Positions.* New Brunswick, N.J.: Rutgers UP, 1995.

Williams, Patteson B. "Object Contemplation: Theory into Practice." *Routable Reports* 9.1 (Winter 1984): 10–12. Reprinted in *Patterns in Practice* (1992), 118–22.

Wilson, Kathleen S. "Multimedia Design Research for the Museum Education Consortium's Museum Visitor's Prototype." In Bearman, ed., *Hypermedia and Interactivity in Museums,* 26–34.

Witcomb, Andrea. *Re-Imagining the Museum:Beyond the Mausoleum.* London: Routledge, 2003.

Wolf, Michael. *The Entertainment Economy: How Mega-Media Forces Are Transforming Our Lives.* New York: Times Books, 1999.

Wolheim, Richard. "What the Spectator Sees." In Norman Bryson, Michael Ann Holly, and Keith Moxey, eds. *Visual Theory: Painting and Interpretation.*, 101–150. New York: HarperCollins, 1991.

Woolnough, Frank. "Museums and Nature Study." *MJ* 4.8 (Feb. 1905): 265–71.

Woolsey, Kristina and Rob Semper. "Multimedia in Public Spaces." In Bearman, ed., *Hypermedia and Interactivity in Museums*, 46–52.

The World in Your Hands: An Exhibition of Globes and Planetaria from the Collection of Rudolf Schmidt. An Exhibition at Christie's Great Rooms, Aug. 25–Sept. 9, 1994, and at the Museum Boerhaave, Leiden, Mar. 18–Sept. 24, 1995. London and Leiden: Christie's / Museum Boerhaave, 1994.

Yells, Ken. "Unhanding the Visitor." *Roundtable Reports* 9.1 (Winter 1984): 12–14, 22. Reprinted in *Patterns in Practice* (1992), 126–28.

Zoller, Mat. "Haunted Castle." *New York Press*, Feb. 28, 2001, 38.

Corporation, 245; principle behind, 243–44; transformation of space, 245–46; visitor response, 270

Dransfield, J. Edgar, 249

Draper, Arthur, 129, 308n45

Dryer, Ivan, 309n91

Duby, George, 21

Dzangha-Sangha Rainforest (AMNH), 266–68

early cinema, 97

Economou, Maria, 193, 319n121

Edison, Thomas, 97

Edward VII, 176

Edwards, Elizabeth, 320n3

Edwards, Ian, 305n115

Egyptian Hall (London), 92–94

Eldredge, Niles, 267

"Elecom" (interactive astronomy computer), 312n140

Elisabeth of Spalbeck, 31, 292n74

Ellis Island, 98

Elsner, John, 314n23

Emerson, Ralph Waldo, 82

Enders, Jody, 27

Enlightenment, 122, 181

environmental issues, 203–205

Epp, Garth, 29–30

Ernst, Bruno, 76

Essex Museum of Natural History, 178

Eureka: An Essay on the Material and Spiritual Universe (poem, 1848), 43

Everest (film, 1998), 10, 82, 96, 105–109, 110–11, 304n97

Exeter cathedral, 19, 290n23

exhibition: strategies, 11; tactile pleasure, 180

Exploratorium (San Francisco), 160

Expo '67 (Montreal), 56, 81, 94–95, 264; Expo '70 (Osaka), 94; Expo '74 (Spokane), 228

extramission, 24

Extreme (film, 1999), 87, 301n34

fairground, 116–17

Fairweather, Kathleen, 305n99

Falk, John H., 165, 168, 330n126

Farb, Peter, 205

Faunce, Wayne M., 129

Fels Planetarium (Franklin Institute/Philadelphia), 129, 136, 140, 152

Ferguson, Graeme, 94–95

Field, Mary, 327n43

Fieseler, Franz, 138, 148

Fighter Pilot (film, 2004), 229

Fish, E. B., 198

Fisher, Clyde, 122, 144, 147, 155

flagellation, 28–29, 31

flaneur, 5

Fleming, Paula Richardson, 320n3, 320n10

Flower, William Sir, 315n34

Follett, David, 176

Ford, Rev. S. J., 179

Fort Parker Historic Site, 275

Fort Worth Museum of Science and History, 230, 302n57

Foster, H., 326n34

Foulkes, Nicholas, 274

Fowke, Capt., R. E., 317n82

Fox, Barry, 302n46

Fox, Philip, 139–40, 147

Frank, Giorgia, 21

Frankenstein, Godfrey N., 67, 72–73, 298n98

Franklin Institute (Philadelphia), 140, 181

Freedberg, David, 17

Friedberg, Anne, 84, 204, 293n4, 316n52

Friedman, Alan J., 274, 279

Friedrich, Caspar David, 43

Fritsch, Dr. Ant, 235

Furse, Sir William T., 247

Futter, Ellen V., 189

Gaddi, Taddeo, 23

Galapagos: The Enchanted Voyage (film, 1999), 230

Galassi, Peter, 67

Galilei, Galileo, 120, 306n12

Gallagher, Jean, 57, 295n45

Gallagher, Dennis, H., 139, 309n79

Gallup, Anna Billings, 321n18
Gance, Abel, 81
gaper, 169–71; as "holiday types," 169–72, 188; vs. gawker, 170–71; vs. working men, 188–89
Gardiner, Caroline, 170
Gardner, Natalie, 302n57
Gaudreault, André, 292n68
gawker, 170–71
gaze: distracted, 139; lingering, 7; return, 103; revered, 9, 15–16, 116, 159, 285–86; tourist, 86, 102, 105, 129; upward, 16, 117, 129, 149; vs. glance, 7
Geddes, Norman Bel, 118, 129
Gelfond, Richard, 85
Ghosts of the Abyss (film, 2003), 110
Gibson, Mel, 16, 21, 23, 35
Gibson, Timothy A., 330n123
gigantic, 8; and IMAX, 9, 106; and immersion, 8–9; and Mount Everest, 105; and sublime, 9; and Zeiss projector, 135
Gillray, James, 181
Gitelman, Lisa, 161–62
Glass, Jacqueline, 136
Gleadell, Colin, 322n53
globes, 119, 145, 306n14
Goldberger, Paul, 280–81
Goldner, Diane, 303n71
Goode, George Brown, 165, 167, 197
Goodnow, Elizabeth, 68

Gorky, Maxim, 75, 299n117
Gothic: art, 24; light, 20, 23–24; as multimedia space, 19; style, 18, 290n12; and vision of heaven, 18, 24
Gothic cathedral, 7, 9, 24, 31, 41, 95, 101, 159; as advertisements in stone, 18; color, 19
gramophone, 11, 211, 233, 235–36, 266; "automatic," 237, 241–42
Grand Canyon: The Hidden Secrets (film, 1984), 111
The Grand Fleet at Spithead panorama (1793), 37
Grand Tour, 60, 86, 105, 135, 145
Gratacap, L. A., 165
Grau, Oliver, 3
Great Exhibition (1851), 162, 164, 169, 172–73, 181, 188; Great Exhibition (1862), 176
Gréban, Arnoul, 29
Greenberg, Laura, 205, 221
Greenhalgh, Paul, 164, 316n57
Griffith Planetarium (Los Angeles), 152
Grusin, Richard, 257
Gubernick, Lisa, 303n62
Guggenheim Museum (New York), 161, 210
Gulliver's Travels (Swift), 109
Gunning, Tom, 122, 125, 128, 131, 136, 164, 292n68, 300n14, 316n49

Gurevitch, Matthew, 94, 302n46
Gutsch, William A., 130

Haberstitch, David E., 197, 320n3
habitat groups, 168, 217, 269, 315n42
Haffenreffer, David, 302n53
Hahn, Cynthia, 24
Halbfinger, David M., 303n60
Hale's Tours, 70, 130–131
Hall 10 ("It All Depends," NMNH), 202; and audiovisual techniques, 203–204; background/rationale, 203; compared to panorama, 204; use of screens, 204–205
Hall of Biodiversity (AMNH), 6, 202; compared to "Can Man Survive?" 267; Dzanga-Sangha Rainforest, 266–69, 278; exhibit rationale, 266–67; "Spectrum of Life," 268, 278
Hall, Donald S., 141
Hall, Kate M., 179–80
Hall, Peter, 211
Hamilton, W. 73
hands-on exhibits. See interactivity
handheld devices, 12, 187
Hanner, John, 67, 69, 296n66
Harris, Neil, 172
Haunted Castle (film, 2001), 96
Hayden Planetarium (New York), 114, 118, 122, 128–30, 140,

Spencer, Steven M., 128, 308n40
Spider-Man 3 (film, 2007), 97
Spiegel, Stacey, 207
Spielberg, Steven, 87, 90
Spitz, Armand, 137, 139–40, 147, 309n78
Spook, Daniel, 276
Squires, Monas N., 41, 293n9
Stafford, Barbara Maria, 180–81, 186
stained glass window, 19–20, 24, 28
stars, 119–20, 136
Stations of the Cross, 17, 21, 23, 291n37
Steinbach, Leonard, 278
stereoscope, 10, 95, 99; and American Civil War, 65; and immersion, 100–104
Sterne, Jonathan, 300n3
Stevenson, John, 332n156
Stewart, Susan, 17, 106, 135
St. John the Heavenly Jerusalem (1250), 34
Stockwell, John, 66
Storming of Seringapatam panorama (1801), 49–50
St. Paul's cathedral, 8
Strain, Ellen, 285
Strasenburgh Planetarium (Rochester), 141
sublime, 9–10, 19, 94, 128–29, 159, 261; and the Grand Tour, 105; in

IMAX, 82, 87–90; and Mount Everest, 108; technological, 164, 194
Sudeley, Lord Charles Hanbury-Tracy, 184–85
supernatural, 120, 122
Swansea Bay Futures, 273, 330n123
Swansea Museum, 273
Swanson, R. N., 31, 33
Sweeney, James Johnson, 161, 251
Swift, Jonathan, 109
Symonds, William C., 90
synesthesia, 252

tapestry, 95
Tate Modern, 210, 232, 277
taxidermy, 284
Taylor, Clyde, 152
Telbin, W., 76
telephone, 237–38
television, 118, 273; influence on museum, 220, 222, 259, 263; HDTV, 227
Te Papa (New Zealand), 279
theatricality, 122, 137
theme park, 15, 90, 118, 130, 141, 222–23, 229, 272, 279
This Is Cinerama (film, 1952), 98
Thompson, A. T., 198
Thompson, Francis, 324n89
Tibet, 106–109
Tiger Child (film, 1990), 94

tilting, 104
To Fly! (film, 1976), 3, 11, 98, 105, 195, 223–29, 303n71; blockbuster status, 227; camera work, 225; and corporate sponsors, 227; and national identity, 224; vs. *On the Wing* (1986), 227
tracking shot, 104
travel/transportation, 105; Grand Tour, 60, 86, 105, 135, 145; travelogue, 10, 54, 85, 95, 97, 102, 105–106, 111, 300n14
Tretise of Miraclis Pleyinge (1380–1425), 29
Treon, Diane, 268, 329n108
A Trip to the Moon (film, 1902), 147
trompe l'oeil, 284; in *Bodies* exhibit, 284; in Crucifixion, 33; 178; in panorama, 59, 61, 67; in planetarium, 117; and wax models, 178
Tussaud, Madame, 74
Twain, Mark, 43
Twin Towers, 111

uncanny, 126, 222
Urry, John, 86, 102

V&A, 173, 193, 210, 217, 318n95
Valenciennces (1547 Passion Play), 27
VanderKnyff, Rick, 103
van Eekelen, Yvonne, 48, 56, 65